C🔵M-CC

CW00828631

12th Meeting Lyon 29 August–3 September 1999

.1

ICOM COMMITTEE
FOR CONSERVATION

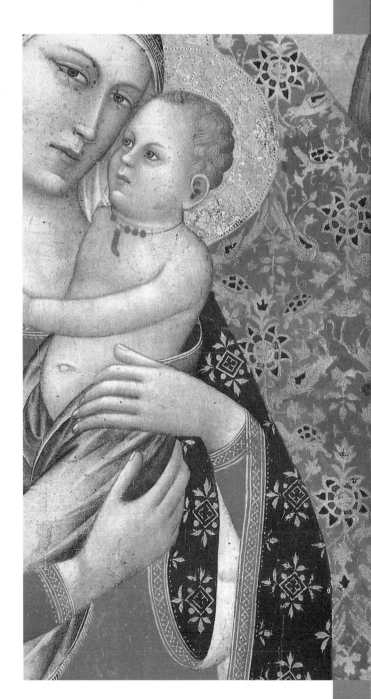

COMITÉ DE L'ICOM
POUR LA CONSERVATION

Preprints Volume I

JAMES
JAMES

EDITOR
Janet Bridgland

ASSOCIATE EDITOR
Jessica Brown

PREPRINTS COMMITTEE
Jonathan Ashley Smith
Victoria & Albert Museum
London, UK

Agnes Ballestrem
Instituut Collectie Nederland
Amsterdam, The Netherlands

Françoise Flieder
Centre de Recherche sur la Conserva-
tion des Documents Graphiques
Paris, France

J. Cliff McCawley
Department of Canadian Heritage
Ottawa, Canada

Caroline Villers
Courtauld Institute of Art
London, UK

A catalogue record for this book is available from the British Library

ISBN 1 873936 92 3

Printed in the UK by Alden Group Ltd

Available from:

James & James (Science Publishers) Ltd.
35–37 William Road
London NW1 3ER
United Kingdom
fax: +44 171 387 8998
email: orders@jxj.com
http://www.jxj.com/

ICOM-CC Secretariat
c/o IRPA
1, parc du Cinquantenaire
1000 Brussels
Belgium
Fax: +32 2 732-0105
Email: francoise.rosier@kikirpa.be
http://www.natmus.min.dk/cons/icom_cc/

A NOTE ON THE COVER
Allegretto Nuzi, ca. 1370–
*Virgin enthroned, surrounded by six
angels*. Detail of brocade. Musée du
Petit-Palais, Avignon. Photograph by:
Musée du Petit-Palais, Avignon.

Allegretto Nuzi, vers 1370–
La Vierge en majesté entourée de six
anges. Détail des brocards. Musée du
Petit-Palais, Avignon. Photographie du:
Musée du Petit-Palais, Avignon.

Contents/Table des matières – Volume I

Preventive conservation / Conservation préventive

Training in conservation and restoration / Formation en conservation-restauration

Paintings II: Scientific study of paintings (methods and techniques) / Peinture II: Etude scientifique des peintures (méthodes et techniques)

Sculpture and polychromy / Sculpture et polychromie

Editor's Note

These 12th Triennial Meeting Preprints mark our Committee's final collective contribution to the professional conservation literature before we embark on the new millennium. In an age of increasing societal and technological change, where "virtual reality" has become the buzzword, preserving the tangible evidence of our cultural heritage seems more vital than ever.

Once again these volumes represent the impressive diversity of interest and research by our members. Unfortunately, once again, there is not sufficient room to publish all the worthy contributions that were received. The quality – and number – of papers submitted continues to grow. We thank all the authors, published and otherwise, and hope that all will have the opportunity to present and discuss their findings in the Working Group sessions at Lyon.

To aid these discussions, the Committee is posting the contributions of two Working Groups online prior to the Triennial Meeting. This experiment may influence future dissemination strategies for these proceedings.

My thanks to all those who made these Preprints possible: the authors, the Working Group Coordinators, the Preprints Committee, the staff at James & James, and my Associate Editor, Jessica Brown. We hope that these volumes will serve as a useful reference, and stimulate further dialogue and research in our field.

Janet Bridgland
Monticello, USA
August 1999

Directory Board / Bureau Directeur 1996–1999

Working Group Coordinators / Coordinateurs des groupes de travail 1996–1999

1. Preventive conservation / Conservation préventive
Stefan Michalski
Canadian Conservation Institute
1030 Innes Road
Ottawa, Ontario
Canada K1A OM5
Tel: +1 613 998 3721
Fax: +1 613 998 4721
Email: stefan_michalski@pch.gc.ca

Including:
Care of Works of Art in Transit / Protection des œuvres d'art pendant le transport
Lighting and Climate Control / Eclairage et contrôle du climat
Control of Biodeterioration / Contrôle de la biodétérioration
Prevention of Disaster / Prévention des catastrophes

2. Training in conservation and restoration / Formation en conservation-restauration
Kathleen Dardes
The Getty Conservation Institute
1200 Getty Center Drive, Suite 700
Los Angeles, CA 90049-1684
USA
Tel: +1 310 440 6826
Fax: +1 310 440 7702
Email: kdardes@getty.edu.

3. Theory and history of conservation-restoration / Théorie et histoire de la conservation-restauration
Françoise Hanssen-Bauer
Nasjonalgalleriet
Universitetsgate 13
PB 8157 DEP
N-0033 Oslo
Norway
Tel: +47 22 20 04 04
Fax: +47 22 36 11 32
Email: francoisehb@oslo.online.no

4. Scientific methods of examination of works of art / Méthodes scientifiques d'examen des œuvres d'art
Marie-Claude Corbeil
Canadian Conservation Institute
1030 Innes Road
Ottawa, Ontario
Canada K1A OM5
Tel: +1 613 998 3721
Fax: +1 613 998 4721
Email: Marie-Claude_Corbeil@pch.gc.ca

5. Documentation / Documentation
Working group suspended
(see CIDOC and AVICOM)

6. Paintings I: Conservation and restoration of paintings / Peinture I: Conservation et restauration des peintures
Alan Phenix
Dept. of Conservation and Technology
Courtauld Institute of Art
University of London
Somerset House, Strand
London WC2R ORN
UK
Tel: +44 171 873 2190
Fax: +44 171 873 2878
Email: alan.phenix@courtauld.ac.uk

7. Paintings II: Scientific study of paintings (methods and techniques) / Peinture II: Etude scientifique des peintures (méthodes et techniques)
Jørgen Wadum
Mauritshuis
PO Box 536
2501 CM The Hague
The Netherlands
Tel: +31 70 346 9244
Fax: +31 70 365 3819
Email: collectie@mauritshuis.nl

Research areas under Paintings I and II / Aires de recherche sous Peinture I et II:
Flexible supports / supports souples
Rigid supports / supports rigides
Study of Painting Techniques / Etude des techniques picturales (see Painting II)
Modern and Contemporary Art / Art moderne et contemporain
Icons / Icónes
Far Eastern Painting (suspended this triennium) / Peintures de l'Extrême-Orient (suspendu durant le triennat)

8. Sculpture and polychromy / Sculpture et polychromie
Myriam Serck-Dewaide
IRPA
1, parc du Cinquantenaire
1000 Bruxelles
Belgium
Tel: +32 2 739 6839
Fax: +32 2 732 0105
Email: myriam.serck@kikirpa.be

9. Mural paintings, mosaics and rock art / Peinture murale, mosaïques et art rupestre
Ivo Hammer
Fachhochschule Hildesheim
Holzminden
Studiengang Restaurierung
Bismarckplatz 10/11
D-35135 Hildesheim
Germany
Tel: +49 51 2178 2412
Fax: +49 51 2178 2450
Email: hammer@eunet.at

10. Graphic documents / Documents graphiques
Gerhard Banik
Akademie Bildende Künste Stuttgart
Höhenstrasse 16
D-70736 Fellbach
Germany
Tel: +49 711 58 29 20; +49 711 58 29 40
Fax: +49 711 58 64 53

11. Photographic records / Documents photographiques
Bertrand Lavédrine
C.R.C.D.G.
36, rue Geoffroy St Hilaire
75005 Paris
France
Tel: +33 1 44 08 69 93
Fax: +33 1 47 07 62 95
Email: lavedrin@cimrsl.mnhn.fr

12. Ethnographic collections / Collections ethnographiques
Sherry Doyal
Ethnographia Conservator
Royal Albert Memorial Museum
Queen Street
Exeter EX4 3RX
UK
Tel: +44 1392 265 307
Fax: +44 1392 265 858
Email: sherrydoyal@compuserve.com

13. Wet organic and archaeological materials / Matériaux organiques et archéologiques gorgés d'eau
Per Hoffmann
Deutsches Schiffahrtsmuseum
Van-Ronzelen-Strasse
D-27568 Bremerhaven-Mitte
Germany
Tel: +49 471 482 070
Fax: +49 471 482 0755
Email: postmaster@deutsches-schiffahrtsmuseum.de

14. Textiles /
 Textiles
Rosalia Varoli-Piazza
Istituto Centrale del Restauro
Piazza S. Francesco di Paola 9
00 187 Rome
Italy
Tel: +39 6 488 96262
Fax: +39 6 481 5704
Email: restauro@mailcity.com

15. Leather and related materials /
 Cuir et matériaux apparentés
Claire Chahine
C.R.C.D.G.
36, rue Geoffroy St Hilaire
75005 Paris
France
Tel: +33 1 44 08 69 96
Fax: +33 1 47 07 62 95
Email: chahine@cimrsl.mnhn.fr

16. Natural history collections /
 Collections d'histoire naturelle
Chris Collins
Geology Conservation
Earth Sciences Department
Maddingley Road
Cambridge CBE OEZ
UK
Tel: +44 223 362522
Fax: +44 223 366860
Email: chris@esc.cam.ac.uk

17. Stone / Pierre
Josef Riederer
Staatliche Museen zu Berlin
Preussischer Kulturbesitz
Rathgen-Forschungslabor
Schlosstrasse 1a
D-14059 Berlin Charlottenburg
Germany
Tel: +49 30 3 20 91297
Fax: +49 30 322 1614
Email: rfsmb@snafu.de

18. Glass, ceramics and related
 materials /
 Verre, céramique et matériaux
 apparentés
Alice Boccia Paterakis
Agora Excavations
American School of Classical Studies
54 Souidias St
Athens 106-76
Greece
Tel: +301 331 0964
Fax: +301 729 4047
Email: apaterakis@ascsa.edu.gr

19. Metals / Métal
Stéphane Pennec
LP3 Conservation
8, rue des Tanneries
21140 Semur-en-Auxois
France
Tel: +33 3 80 96 64 09
Fax: +33 3 80 97 29 43
Email: lp3.conservationsp@wanadoo.fr

20. Lacquer / Laques
Marianne Webb
Conservation Dept.
Royal Ontario Museum
100 Queen's Park
Toronto, Ontario
Canada M5C 2C6
Tel: +1 416 586 5511
Fax: +1 416 586 5863
Email: mariannw@rom.on.ca

21. Furniture and wooden objects /
 Meubles et objets en bois
Valerie Dorge
1200 Getty Center Drive, Suite 700
Los Angeles, CA 90049-1684
USA
Tel: +1 310 440 7325
Fax: +1 310 440 7702
Email: vdorge@getty.edu

22. Resins: Characterisation and
 evaluation /
 Résines: caractérisation et
 évaluation
Andrew Thorn
2 McCabe Place
North Melbourne
3051 Australia
Tel: +61 3 9326 9326
Fax: +61 3 9326 9327
Email: Artcare@citicomp.com.au

23. Modern materials /
 Matériaux modernes
Yvonne Shashoua
Department of Conservation
The National Museum of Denmark
PO Box 260, Brede
DK-2800 Lyngby
Denmark
Tel: +45 33 473 560
Fax: +45 33 473 327
Email: yvonne.shashoua@natmus.dk

Preventive conservation

Conservation préventive

Abstract

The monitoring and control of environmental parameters play an important role in minimising the decay of works of art. The use of sensors that reproduce the pictorial structure of paintings as closely as possible can help in evaluating the effect induced on works of art by the "global" indoor environment. These sensors, which are made with specific pigments and dyes, were aged under different conditions in ageing chambers. Subsequently, a reduced set of the most sensitive sensors was used to prepare a dosimeter panel that was placed in the Uffizi Gallery. The comparison between the natural and artificial ageing sensors provided information on the alteration processes induced by environmental factors.

Keywords

indoor, environmental monitoring, colour change, tempera, dosimeters, colorimetry

Indoor environmental monitoring of colour changes of tempera-painted dosimeters

Mauro Bacci,[*] Marcello Picollo, Simone Porcinai, Bruno Radicati

Istituto di Ricerca sulle Onde Elettromagnetiche "Nello Carrara" – CNR
via Panciatichi 64
I-50127 Florence
Italy
Fax: +39 055 410893
Email: Bacci@irde.fi.cnr.it

Introduction

Colour variation is one of the main forms of deterioration in paintings caused by environmental factors. Among these factors, light is one of the most hazardous as regards the preservation of many artworks, even though at the same time it is essential for a full enjoyment of their visual aspect. In fact, alone or in combination with other environmental factors (temperature, humidity, pollutants, etc.), light has been shown to be the cause of fading and discoloration on a wide range of materials, producing serious and often irreversible damage (Saunders and Kirby 1994). Also, pollutants can strongly affect paintings, inducing colour variation through chemical reactions. In particular, their action becomes more dangerous when high concentrations of gaseous pollutants exist together with a high level of relative humidity (RH). Temperature changes are not as damaging as the changes in the other parameters but they do reinforce the effect of RH, light, and pollutants on colour alteration (Thomson 1986).

It follows that the monitoring and control of these parameters are of utmost priority for minimising the deterioration of artefacts and materials. However, their control is most critical, since they may change with different rates and intensities. Different sensors are usually applied for the separate monitoring of each environmental parameter. In general, the information obtained from these kinds of sensors is not directly correlated with all the alteration effects produced on paintings. The use of sensors that reproduce as closely as possible the pictorial structure of paintings may solve the problem of measuring the effect induced on artworks by the "global" indoor environment. These sensors are not selective to only one or two parameters, but instead integrate the damages produced on paintings by all the environmental factors. To obtain alteration values that most closely correspond to those occurring in actual paintings, the preparation of these sensors must strictly follow the same procedures and contain exactly the same materials as those used in the past. The effect of the exposure is monitored by acquiring the reflectance spectra in the visible region and by evaluating their colour and/or spectral variations. This analysis is non-invasive, easy and fast to perform. Moreover, the data obtained could be better related to the actual damage produced on paintings, starting from the fact that colour changes are a macroscopic and global index of alteration.

For this reason, it was decided to use strips of tempera-painted sensors for the study of painting deterioration. These paint-tempera sensors were prepared according to traditional recipes. The selected pigments and dyes were chosen on the basis of both their use in tempera paintings and their chemical stability under different ageing processes.

In this study, the sensors were artificially aged under light, thermal, and pollutant exposures, varying only one parameter at a time in each case. The damage induced on the sensors under different exposures was evaluated according to their colour changes over the course of time. The data obtained were compared to the preliminary results obtained from a set of these sensors that were naturally aged at the Uffizi Gallery.

[*] Author to whom correspondence should be addressed

Materials and methods

The tempera dosimeters were prepared using Melinex (a polyethylene terephtalate, thickness 125μm) sheets (A4-size) so as to have an inert, light and stable substrate for the tempera-pigment system. The choice of the selected pigments and dyes had to meet the following requirements: a) different stability when in contact with the investigated environmental factors; b) different electronic structure of the chromophore; c) natural and artificial origins; d) the presence or absence of metal ions; e) good compatibility with the egg tempera technique.

Accordingly, the pigments and dyes selected were: azurite, indigo, smalt, lead (II) chromate (chrome yellow), curcumin, lead antimonate yellow (Naples yellow), alizarin, cinnabar, and lead white. The above-mentioned materials were purchased from various firms, and their quality was checked. The tempera was prepared using the whole egg (yolk and white), mastic varnish (a few mL), and a few drops of apple vinegar. When the tempera was ready for painting, water was added in order to keep the medium-pigment mixture easy to spread.

The tempera was spread over the Melinex using a film applicator (Braive Instruments, mod. Bird Film Applicator), in order to obtain a constantly thick painted layer (200μm). The painted sheets of Melinex (one for each pigment or dye) were cut into small strips. Two sets of strips were prepared for each pigment and dye: the first was artificially aged; the second was used for preparing the dosimeters to be placed in a natural environment (i.e. galleries and museums). Each set had its own reference strip.

Light ageing was performed at the Tate Gallery (London, England), where samples were exposed in a light box for 4, 8, 16, 32, and 64 days. Philips TLD94 58Watt daylight rendering fluorescent tubes were used. These were filtered with Perspex VE ultraviolet filters which had a cut-on wavelength at about 400nm and maintained a constant sample illuminance of approximately 20klux. During this ageing process, the temperature and relative humidity (RH) in the light box were around 30°C and 30%, respectively. Thermal ageing was also done at the Tate Gallery. The samples were placed in an oven without any lights at 60°C and at 55% RH for 7, 14, and 21 days. Exposure to air pollutants was carried out at TNO (Delft, The Netherlands) for four days under a continuous flow of SO_2, NO_x, and air, so that the overall concentrations of SO_2 and NO_x in the gas chamber were approximately 10ppm and 20ppm, respectively (T = 23°C; RH = 55%). The naturally aged strips were exposed for nine months in the Leonardo Room at the Uffizi Gallery (16 December 1996–29 September 1997).

The reference and exposed strips were analysed using the Perkin-Elmer lambda 19 spectrophotometer in the Visible (Vis) and near-IR regions (360–2500nm, step 1nm) in order to monitor the exposure effect on the different pigments and dyes. The resolution of the spectrophotometer was ±0.2nm and ±0.8nm for the Vis and near-IR ranges, respectively. The spectra obtained were recorded without any damage to the samples, and each sample was measured three times (three different cycles of measurements) in order to reduce possible errors which might be introduced by external sources. Barium sulphate ($BaSO_4$) tablets were used as 100% diffuse reflectance.

The measurement of the alteration of the sensors was described by their colour changes according to the CIELab76 recommendation. The data on the artificially aged samples were used for grouping the applied pigments/dyes into fugitive, durable, and permanent categories under the different exposure conditions. Colour change was expressed by:

$$\Delta E = |E_2 - E_1| = [(\Delta a^\star)^2 + (\Delta b^\star)^2 + (\Delta L^\star)^2]^{1/2}$$

where E_1 and E_2 are the vectors characterising the colour of the object at times t_1 and t_2 ($t_2 > t_1$), respectively; L^\star is related to the lightness of the sample, while a^\star and b^\star take into account two antagonistic chromatic processes (red-green and yellow-blue, respectively) (Wyszecki and Stiles 1982).

Results and discussion

The colour variations (ΔE) for the artificially aged pigments and dyes are reported herein (See Fig. 1). By means of these data, it was possible to divide the painted

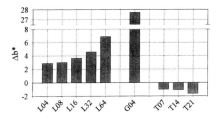

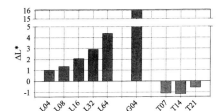

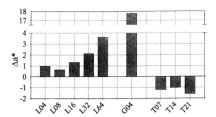

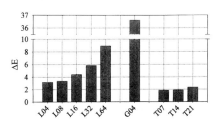

Figure 1. ΔE on the entire set of pigmented sensors after artificial ageing processes (light ageing = 64 days; thermal ageing = 21 days; gas ageing = 4 days).

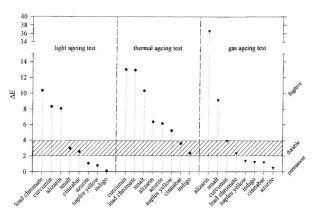

Figure 2. Complete set of colorimetric data (ΔE, Δa⋆, Δb⋆, ΔL⋆) for the artificially aged alizarin pigmented sensor. L04, L08, L16, L32, L64 refer to 4-, 8-, 16-, 32-, and 64-day light exposure. G04 indicates 4-day gas exposure. T07, T14, T21 refer to 7-, 14-, and 21-day thermal exposure.

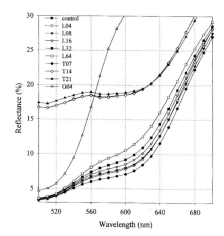

Figure 3. Reflectance spectra of the artificially aged alizarin pigmented sensor in the 500–700nm range. L04, L08, L16, L32, L64 refer to 4-, 8-, 16-, 32-, and 64-day light exposure. G04 indicates 4-day gas exposure. T07, T14, T21 refer to 7-, 14-, and 21-day thermal exposure.

tempera sensors into three groups: fugitive, durable, and permanent, in regard to the three ageing sources. The classification was based on the ΔE between aged and non-aged samples, and took into account the mean error of the colour measurement (E), due to incorrect re-positioning operations, non-homogeneous layers, etc., which was evaluated as about ±0.7. On the basis of these results, it was decided to use the following assembly of tempera strips: lead white, lead chromate, alizarin, and smalt as an "indicator" of the natural environmental risk.

The complete set of ΔE, Δa⋆, Δb⋆, and ΔL⋆ values obtained under the three ageing conditions for the alizarin-tempera sensor is reported in Figure 2. From these data, it can be seen that the alizarin-tempera mixture was very sensitive to pollutant ageing (ΔE=36.6) and sensitive to light ageing (ΔE=8.9). The main contribution to ΔE was given by Δb⋆, which was linked to a relevant increase in reflectance in the 500–700nm range (See Fig. 3). This increase produced a shift in the colour evaluation towards a reddish-yellow hue, compared with the reference strip. This sensor was not very sensitive to thermal ageing, since the ΔE value for the 21-day-aged sample was slightly above the proposed threshold ΔE value for the permanent tempera-pigments and dyes.

The colorimetric data regarding lead white, lead chromate, and smalt tempera sensors are reported in Tables 1, 2, and 3, respectively.

The data for the lead white-pigmented tempera sensor (See Table 1) indicate that the strongest variation was due to pollutants, and that the trend of ΔE for light and thermal ageing processes was in accordance with the exposure times. Regarding ΔE's components, it should be stressed that light ageing produces a shift towards green-blue hues, since Δa⋆<0 and Δb⋆<0, respectively. On the other hand, thermal ageing effects induce colour variation towards red-yellow hues as Δa⋆±0 and Δb⋆>0, respectively. Pollutant gas ageing has a stronger effect on yellow hue than on green hue, as Δa⋆<0 and Δb⋆>0 where Δa⋆<<Δb⋆. Lastly, ΔL⋆ values split the aged samples into two groups: lightness increases for light-aged samples, while it decreases for both pollutant- and thermal-aged samples.

The artificial ageing data for lead chromate pigmented tempera sensors (See Table 2) showed that these were more affected by both the light and thermal ageing processes than by the pollutant gas ageing process. Moreover, this pigmented tempera was the most fugitive as regards light ageing, when compared with all the

Table 1. Colorimetric data (ΔE, Δa⋆, Δb⋆, ΔL⋆) for the artificially aged lead white pigmented sensor.

Ageing process	ΔE	Δa*	Δb*	ΔL*
Light 4 days	0.96	-0.16	-0.87	0.35
Light 8 days	1.10	-0.17	-0.94	0.54
Light 16 days	1.90	-0.26	-1.64	0.92
Light 32 days	1.99	-0.29	-1.78	0.84
Light 64 days	2.38	-0.22	-2.13	1.04
Temperature 7 days	1.51	0.44	5.37	-1.01
Temperature 14 days	2.24	0.01	1.04	-0.78
Temperature 21 days	2.59	0.04	2.10	-1.17
Pollutant gases	5.52	-0.92	2.31	-0.86

Table 2. Colorimetric data (ΔE, $\Delta a\star$, $\Delta b\star$, $\Delta L\star$) for the artificially aged lead chromate pigmented sensor.

Ageing process	ΔE	$\Delta a*$	$\Delta b*$	$\Delta L*$
Light 4 days	2.70	-1.94	-1.19	-1.45
Light 8 days	4.57	-1.22	-3.91	-2.02
Light 16 days	6.23	-4.68	-2.45	-3.31
Light 32 days	6.83	-2.84	-5.19	-3.40
Light 64 days	7.52	-3.14	-5.71	-3.76
Temperature 7 days	4.64	-2.22	-3.40	-2.25
Temperature 14 days	7.11	-3.83	-4.92	-3.41
Temperature 21 days	10.46	-5.16	-8.67	-2.76
Pollutant gases	2.35	-1.55	1.67	-0.60

Table 3. Colorimetric data (ΔE, $\Delta a\star$, $\Delta b\star$, $\Delta L\star$) for the artificially aged smalt pigmented sensor.

Ageing process	ΔE	$\Delta a*$	$\Delta b*$	$\Delta L*$
Light 4 days	5.07	1.94	-4.52	1.25
Light 8 days	3.56	1.79	-3.04	-0.43
Light 16 days	5.31	2.72	-4.55	-0.27
Light 32 days	5.79	3.00	-4.95	-0.19
Light 64 days	6.08	3.07	-5.25	-0.05
Temperature 7 days	1.97	-0.48	1.56	-1.10
Temperature 14 days	1.84	-0.54	0.41	-1.71
Temperature 21 days	4.33	-1.42	3.71	-1.65
Pollutant gases	3.42	-1.58	2.82	1.11

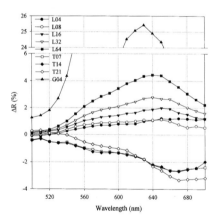

Figure 4. Different reflectance spectra ($\Delta R = R_{aged} - R_{control}$) for the artificially aged alizarin pigmented sensor. L04, L08, L16, L32, L64 refer to 4-, 8-, 16-, 32-, and 64-day light exposure. G04 indicates 4-day gas exposure. T07, T14, T21 refer to 7-, 14-, and 21-day thermal exposure.

other pigmented sensors (i.e. lead white, alizarin, and smalt pigmented tempera sensor). The fact that the light-aged values for $\Delta a\star$ and $\Delta b\star$ were not in good agreement with the time exposure (L08, L16) may have been caused by the non-homogeneity of the painted samples and/or by the small size (due to technical reasons) of the investigated samples. It should be noted that the value of $\Delta b\star$ for pollutant gas exposure is the only one that was positive. A decrease in lightness (darkening) was observed for the whole artificially aged lead chromate pigmented tempera sensors.

The data for artificially aged smalt pigmented tempera sensors are reported in Table 3. The artificial light exposure data indicate that light induced the fastest (but not the strongest, if a comparison is made with the other pigmented tempera sensors) rate of alteration on smalt-tempera sensors. Indeed, the four-day ΔE value was very close to the ΔE value after 64 days of exposure. The regular increase of the colour change by increasing light exposure was not followed by the eight-day light-aged smalt sensor. Its cause may have been the same as for lead chromate sensors. Light exposure seems also to have been the most effective factor on the alteration of smalt-tempera sensors. However, light may not be sufficient to explain the colour change of the pure smalt pigment: indeed, light absorption in the visible range corresponds to a *d-d* transition into the cobalt(II) ion in a tetrahedral arrangement. Under light exposure (in addition to other environmental factors), interactions of the cobalt with the medium and/or modifications of the silica structure of the "glass" could modify the co-ordination sphere of the metal ion so as to shift the energy of the *d-d* transition. Moreover, a successive photo-oxidation of cobalt(II) to cobalt(III) has also been suggested in the literature (Giovanoli and Muhlethaler 1970).

The above results, obtained by following the colorimetric procedure, were also consistent with the observed variation in the raw reflectance spectra. In fact, alteration processes of the chromophore can be highlighted by subtracting the reflectance spectrum of the reference sensor from those of the aged samples. For example, the aged and control reflectance spectra of the alizarin-pigmented tempera were considered (See Fig. 3). Their different spectra (ΔR) are reported in Figure 4: they could be grouped for each ageing process, giving the same results obtained with the colorimetric procedure. The other three pigmented sensors (lead white, smalt, and lead chromate-pigmented sensors) gave results in accordance with colorimetric analysis.

Another way to highlight the effects of the artificial ageing processes on the dosimeters was to evaluate the integral data of the difference spectra in the 360–830nm range. The integral data for the alizarin tempera sensor are shown in Figure 5.

The comparison between the data obtained from the Uffizi dosimeter and the artificially aged sensors provided an estimate of the role played by the different environmental factors. With regard to the colorimetric values of the alizarin-, lead white-, lead chromate- and smalt-pigmented sensors obtained at the Uffizi Gallery, it turned out that the environment within the Gallery did affect the dosimeter during nine months of exposure. The calculated ΔE, in fact, gave non-negligible values compared to those for the sensitivity of the human eye . In general, the thermal ageing process did not play an effective role in the final colour variation of the selected sensors. In fact, all the components of ΔE ($\Delta a\star$, $\Delta b\star$, and $\Delta L\star$) showed a different trend for the Uffizi (See Fig. 6) when compared with those coming from the thermal-aged sensors (See Fig. 2, Tables 1, 2 and 3). From the data reported in Figure 6, light alone or together with pollutants seemed to be the main factor inducing colour alteration of the pigmented sensors.

For the naturally aged alizarin and lead white sensors, ΔR was positive, while the lead chromate sensor displayed a small positive ΔR value around 530nm and large negative values above 550 (See Fig. 7). The comparison between these data and those concerning artificially aged sensors (See Figs. 4 and 8) strongly supported a fundamental role played by light in the Uffizi ageing mechanism, and excluded a significant role for temperature. On the basis of these measurements, the role of pollutants was uncertain. Indeed, the behaviour of alizarin and lead chromate (around 530nm) was also in agreement with the effect of pollutants (SO_2 and NO_x), while lead white was not correlated to the effect of pollutants (See Figs. 4 and 8). However, other pollutants not considered in the present artificial ageing (i.e.

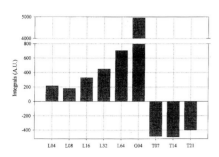

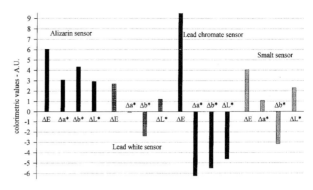

Figure 6. ΔE, Δa⋆, Δb⋆, ΔL⋆ for the Uffizi selected sensors referring to their control painted strip.

Figure 5. Integral data for different spectra of the artificially aged alizarin pigmented sensor. L04, L08, L16, L32, L64 refer to 4-, 8-, 16-, 32-, and 64-day light exposure. G04 indicates 4-day gas exposure. T07, T14, T21 refer to 7-, 14-, and 21-day thermal exposure.

ozone, carbon dioxide, hydrogen sulphide, etc.) could be effective in natural ageing conditions. In particular, carbon dioxide could affect the surface pH of the sensors, thus contributing to the observed change in the spectral features of alizarin. Schweppe and Winter (1997) confirmed that lowering pH produced a decrease in absorbance exactly at the wavelengths in which an increase of reflectance was observed.

Conclusion

The tempera painted strips proposed herein make possible the indoor monitoring of the "global" environmental risk after a reasonable time period. Moreover, a suitable assembly of different pigments/dyes can provide information about the most influential environmental factors in the alteration processes. Lastly, it must be stressed that, owing to the actual nature of the sensors, the observed damage, though amplified, is very close to that suffered by paintings on exhibit.

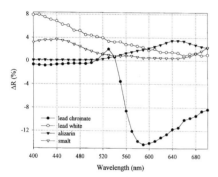

Figure 7. Different reflectance spectra (ΔR = R_{aged} - $R_{control}$) for the Uffizi selected sensors.

Acknowledgements

This work is part of the contribution of the authors' Institute to the EC Project Environmental Research for Art Conservation (EC Environment Project, contract no. EV5V-CT94-0548) in collaboration with Birkbeck College (London) and the FOM Institute (Amsterdam). The authors wish to thank Dr. Marianne Odlyha (Birkbeck College), Prof. Jaap Boon and Dr. Oscar van den Brink (FOM) for providing them with the artificially aged samples. They are also grateful to the staff of the Tate Gallery (London) and of the TNO (Delft) for having performed the ageing test, and to Mr. Bellucci of the Opificio delle Pietre Dure (Florence) for having prepared the tempera samples.

Moreover, the authors thank Dr. O. Casazza and Dr. A. M. Petrioli Tofani, for enabling them to place the sensors in the Leonardo Room inside the Uffizi Gallery.

This work was supported by the EC Project Environmental Research for Art Conservation (ERA, Contract No. EV5V CT 94 0548) and, partially, by the Progetto Finalizzato "Beni Culturali" of the National Research Council of Italy.

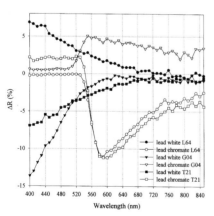

Figure 8. Different reflectance spectra (ΔR = R_{aged} - $R_{control}$) for (a) the artificially aged lead white pigmented sensor and (b) for the artificially aged lead chromate pigmented sensor. L64 refers to 64-day light exposure. G04 indicates 4-day gas exposure. T21 refers to 21-day thermal exposure.

References

Giovanoli R and Muhlethaler B. 1970. Investigation of discoloured smalt. Studies in conservation 15(1): 37–44.

Saunders D and Kirby J. 1994. Wavelength-dependent fading of artists' pigments. In: Roy A and Smith P, eds. Preprints of the IIC Congress, Ottawa. London: International Institute for Conservation of Historic and Artistic Works: 190–194.

Schweppe H and Winter J. 1997. Madder and alizarin. In: FitzHugh EW, ed. Artists' pigments. A handbook of their history and characteristics. Vol. 3: 109–142.

Thomson G. 1986. The museum environment. 2d ed. Oxford: Butterworth-Heinemann.

Wyszecki G and Stiles WS. 1982. Color science: concepts and methods, quantitative data and formulae. New York: Wiley.

Abstract

The effect of the indoor pollutant gases reduced sulphides and organic acids and aldehydes on artefacts in the British Museum collections has been the subject of a long-term study. An evaluation of the data from the study, and experimental work, has shown that alteration by sulphide pollutants is most difficult to prevent; that carbonyl pollutants can be present but not cause alteration of objects; and that five factors influence the alteration of objects. These are the composition and conservation history of the object, the concentration of pollutant gas, the relative humidity and the temperature.

Keywords

pollution, sulphur, carbonyl, museum collection

The pollution problem in perspective

Susan Bradley★ and David Thickett
Conservation Research Group
Department of Conservation
British Museum
London WC1B 3DG
UK
Fax: +44 (0)171 323 8636
Email: s.bradley@british-museum.ac.uk

Introduction

The adverse effects of indoor-generated pollutant gases on artefacts in museums are well known. The gases of concern are the reduced sulphur gases which tarnish silver and cause blackening of some pigments; and organic acids and aldehydes which corrode lead and other metals and can affect non-metals. The gases are given off by many materials which have been, and in some cases still are, used in the construction of storage units and showcases. The reduced sulphur gases are present in the atmosphere at reactive levels (Brimblecombe 1990), whereas the organic acids and aldehydes are present in the ambient atmosphere at negligible levels but can be present inside store cupboards and showcases at high levels (Leissner et al. 1996).

In the British Museum the effect of indoor pollutants on artefacts in the collection has been studied since 1919. Although the tarnishing of silver and corrosion of lead were recognised problems, no specific research on prevention and the dangers of out-gassing of materials was undertaken until the 1960s (Werner 1972). Since 1972 research has been carried out on methods of evaluating materials for use with the collection, evaluating sorbents, identifying alteration products on objects, and monitoring pollutant levels.

One of the advantages of working in a Museum with direct access to the collection is that it is possible to monitor the stability of the collection long-term, and to review the effects of both conservation treatments and preventive strategies.

Testing materials for use in display and storage

Between 1972 and 1975 a standard corrosion test was developed in the Museum (Oddy 1975). The test was used to establish whether materials being considered for use in the construction of showcases gave off gases that were corrosive to metals. The materials tested included wood, fabrics for lining showcases, adhesives, sealants, paints and varnishes (Blackshaw and Daniels 1978). The test has since undergone a series of modifications and different workers have used different versions – sometimes devising their own methodologies – leading to inconsistency in the results. An inter-laboratory comparison was carried out (Green and Thickett 1993a) resulting in a definitive methodology (Green and Thickett 1995). The standard corrosion test should be carried out as described in the 1995 publication to ensure reproducibility between operators in different laboratories. In the Museum internal controls are run to ensure the validity of the testing.

The advantages of the test are that it takes into account the ageing of the material being tested and the potential for emissions to change with time; and that any conservator with an oven and basic laboratory equipment can carry it out. A potential disadvantage is that the test takes 28 days to reach completion.

The test is essentially failsafe. Since 1975 to the date of writing we have tested 4080 materials. During this period there have been no instances of materials that passed the test causing the corrosion of objects. When corrosion has occurred it has been caused by the use of a material that failed the test or as a result of out-gassing

★ Author to whom correspondence should be addressed

from other objects in the showcase. In 1982 white spots of corrosion were noticed on two Chinese bronzes (1960 2-20.1 and 1936 11-18.66). The corrosion was identified as lead methanoate. On investigation it was found that the showcase lining fabric had been mistakenly replaced with a fabric that had failed the test for lead. In 1995 several bronze objects in a showcase of Celtic objects were found to be covered with a black powdery corrosion which was identified as copper sulphide. All of the materials used in the construction of the showcase some 15 years earlier had been passed for use. Several ceramic objects in the showcase smelled of sulphide and in tests were found to be emitting a gas which caused the formation of silver sulphide on silver test coupons. The ceramic objects were from a waterlogged site (Green 1992).

The test has proved extremely useful in reducing incidents of corrosion of objects on exhibition in the Museum. However there is one material which we continue to use inside showcases simply because we can find no satisfactory replacement – wood.

Design of showcases

Until the mid-1980s showcases in the Museum were constructed with wood frames, backboards and case inserts. As wood was corrosive towards lead, conservation was keen for the amount of wood in the construction to be reduced. The Museum exhibition designers were also keen to change the showcase design because the wood frames were heavy and intrusive. In 1988 a metal and glass showcase was introduced. Because no stable alternative that was easy to work with and to pin into could be found wood still had to be used in the case inserts and back boards. For pinning of objects a composite particleboard is used, laminated to a medium-density fibreboard (MDF) support for structural strength. To reduce emissions the boards were wrapped in Melinex, presenting a barrier to vapour movement, and then covered with fabric. Experimental work has shown that Melinex is not the best barrier and that pinning reduces the level of protection obtained. As a result the boards are now covered with an aluminium/polyethylene laminate, sold as a moisture barrier (Thickett 1998).

Other materials used in the construction of the showcases are tested. If a material does not pass all of the tests carried out and an alternative is not available, the proximity of the material to the objects and the surface area exposed are taken into account in making a decision on use.

The showcases now in use substantially meet both conservation requirements and design requirements.

Reduced sulphur gases

The reduced sulphur gases hydrogen sulphide, H_2S, and carbonyl sulphide, COS, are present in the atmosphere at levels high enough for sulphides to form on the surface of silver and other metals, and for pigments such as lead white (hydrocerussite) to be converted to black lead sulphide. The rate at which silver tarnishes at these background levels is slow and more or less constant. In the Museum newly cleaned silver objects exhibited inside showcases can take between one and three years to re-tarnish. If materials which give off reduced sulphur gases, such as wool and polysulphide adhesives are used inside a showcase the rate of tarnishing is substantially increased.

Because the majority of galleries in the Museum are not air-conditioned (Bradley 1996) the background levels of hydrogen sulphide and carbonyl sulphide are not removed from the gallery environment. Showcases are well sealed but there is still an exchange of air between the cases and the gallery. An evaluation of the effectiveness of sorbents for sulphide gases in preventing silver tarnishing has recently been carried out. The method of discrimination used was a visual assessment of silver metal test coupons coupled with analysis of the surfaces by X-ray photoelectron spectroscopy (Lee 1996). This analysis revealed that sulphide was only one component of the silver tarnish; oxide, sulphate and chloride were also present. The sorbents activated charcoal and zinc oxide slowed down the formation of silver sulphide, but alteration of the silver surface was not prevented.

Carbonyl pollutants

Lead and other metals including copper alloys, copper alloys containing lead, zinc and magnesium; calcareous stone and ceramics containing soluble salts; and glass are potentially at risk from the carbonyl pollutants methanoic (formic) and ethanoic (acetic) acid and methanal (formaldehyde) (Green and Thickett 1993b: Tennent and Grzywacz 1994). The corrosive carbonyl pollutants are not present in the atmosphere at levels that initiate corrosion (Leissner et al. 1996). Hence by using construction materials which do not emit these gases the problem can be avoided. However since wood products are still used in showcases and the Museum has many stores with shelving and cupboards constructed from wood, the problem still exists.

Within the Museum levels of these pollutants have been monitored using passive diffusion sensors. In non-air-conditioned galleries, some with wood floors, levels have been at or below the limits of detection for the analytical method. In showcases, monitored levels have been higher than expected, given the precautions taken to minimise the effects of out-gassing from wood. Levels of carbonyl pollutants have been monitored in some wood store cupboards and found to be very high (See Table 1).

Table 1. Carbonyl pollutant levels at locations in the British Museum.

Location	Objects	Methanoic acid µg/m³	Ethanoic acid µg/m³	Methanal µg/m³	Ethanal µg/m³
Gallery 34, case 23	leaded brass, leaded bronze, silver	ND	303±41	24±1	N/A
Gallery 42, ambient		ND	<153	18	N/A
Gallery 42, case 5	enamel, gold, silver	797±47	2094±60	631	N/A
Gallery 46, ambient		ND	ND	14±1	N/A
Gallery 46, case 15	lead, copper alloy pewter, silver	ND	262±41	171±9	N/A
Gallery 68, ambient		ND	ND	16	N/A
Gallery 68, case 3	lead, copper alloy	ND	317±41	470±24	N/A
Gallery 73, ambient		ND	ND	23±1	14±1
Gallery 73, case 69	silver, copper alloy	401	ND	255	80
Store, ambient		ND	143±41	42	40
Wood cupboard R	lead, bronze	ND	1404±39	16	87
Wood cupboard S	lead, bronze	ND	1201	13	76
Wood cupboard G	lead, bronze	149±63	2473±43	11	
Wood cupboard U	lead, bronze	139±63	2745	6	

ND = not detected, N/A=not applicable

During collection surveys and the conservation of objects, analysis of salt efflorescence, corrosion products and surface deposits is often carried out. Between 1972 and 1998 over 2000 samples have been analysed, and less than 1% have contained methanoates and ethanoates. For analysis relating to objects mentioned in this paper see Table 2.

Table 2. Alteration products attributed to the effects of carbonyl pollutants.

Object	Registration number	Date of analysis	Form	Identification
Chinese Bronze	OA 1960 2-20.1	March 1982	White crystals	Lead methanoate $C_2H_2O_4Pb$
Chinese Bronze	OA 1936 11-18.66	March 1982	White crystals	Lead methanoate $C_2H_2O_4Pb$
Zinc coins	Private collector	July 1982	White corrosion	Zinc methanoate hydrate $C_2H_2O_4Zn.2H_2O$
Marble relief	MLA OA 10562	Sept.1995	White efflorescence	Calcium ethanoate methanoate hydrate
Egyptian bronzes		1997	Turquoise blue corrosion	sodium copper carbonate ethanoate
Glass weight	EA 1990 2-7.26	June 1997	White crystals	sodium ethanoate
Glass unformed matrix	EA6665	August 1998	White crystals	sodium ethanoate hydrate $CH_3COONa.2H_2O$
Enamel plaque	MLA AF 2763	August 1997	White crystals	sodium methanoate CH_2OONa

The largest incidence of corrosion attributable to carbonyl pollutants was on Egyptian bronzes stored in wood cabinets (Thickett et al. 1999). The salt was a complex mixture of sodium, copper, carbonate and ethanoate and was present on 6.4% of the collection of 3500 objects. Sodium was not present in the composition of the bronze, but many of the affected objects had previously undergone conservation treatments with sodium-based chemicals. Levels of ethanoic acid in the cupboards were high (See Table 1) and the cause of the corrosion was attributed to its reaction on the corroded surface of the bronzes. The corrosion product was present on the bronzes 20–25 years ago and has not been actively forming in recent years. Lead coupons placed in the cupboards to monitor the environment have not corroded, despite the high levels of ethanoic acid present. Also, lead objects stored in the cupboards with the bronzes have not corroded, even though lead is normally more readily corroded by ethanoic acid than copper-based metals. The relative humidity (RH) in the cupboards has been below 45% since monitoring started some five years ago. It appears that a higher RH is required to promote the corrosion reaction on the bronzes. Ambient RH levels in the Museum have fallen during the last 25 years – particularly in winter – due to the improved heating system.

Experimental work has indicated that ethanoic acid is more corrosive than methanoic acid and methanal is the least corrosive species (Thickett et al. 1999). This work also showed that lead was the metal most readily corroded by ethanoic and methanoic acids at 50% RH. Copper was not affected at 50% RH and ambient temperature. These findings confirm observations on the collection. Other instances of corrosion of copper alloy objects have been limited to periods of high ambient RH and temperature and have occurred on uncorroded copper alloy objects displayed in wood-framed showcases with painted backboards or stored in oak drawers.

Efflorescences containing ethanoate or methanoate have been found on stone and glass (See Table 2). Approximately 2000 Egyptian stele and other stone objects are stored in oak boxes with glass fronts. The marble relief MLA OA 10562 had evidence of water staining on the reverse which had caused the migration of colour from the box. A surface efflorescence was identified by Fourier transform infrared (FT-IR) spectroscopy as a calcium ethanoate methanoate hydrate; the presence of ethanoate and methanoate was confirmed by ion chromatography.

The Egyptian stela EA 1332 had on the surface a salt efflorescence which contained methanoate, nitrate and chloride in a 3:2:1 ratio. The stela had undergone previous conservation, which included removal of soluble salts. The stela had been returned to its box before adequate drying time had elapsed. The extent to which the stela was contaminated with organic acids was determined by drilling almost through the depth of the stone (85mm rear to obverse) and sampling in 15mm aliquots. Ion chromatography was used to analyse the aqueous extracts obtained from the drillings. Methanoate and ethanoate ions were present at 0.01–0.05% w/w concentration in each aliquot. Chloride ions were present at 0.18–0.28% w/w and nitrate ions at 0.64–0.72% w/w. The uniform distribution of the anions was attributed to the salt removal treatment.

For comparison the investigation was repeated on a stela (EA 646) which had not undergone conservation treatment. Again methanoates and ethanoates were present in all the aliquots of the stone at concentrations in the range 0.01–0.06%w/w and the chlorides and nitrates were also uniformly distributed within the stone (Bradley and Thickett forthcoming). This indicated that wetting was not responsible for the distribution of the anions; and the volatile acids emitted by the oak boxes had migrated throughout both stele. The absence of efflorescence on EA 646 suggests that residual moisture in EA1332 promoted the reaction between the organic acid, soluble salts and calcite matrix.

Analysis has been carried out on the droplets from the surface of weeping glass. The results of this analysis suggest that methanoates and ethanoates are present and may promote weeping. White crystals on the surface of an enamelled plaque, MLA AF 2763, were identified by ion chromatography as sodium methanoate. The plaque was exhibited in a wood-framed island showcase and the baseboard was not covered with a barrier film to limit out-gassing. The environment in the

showcase was monitored. Methanoic acid and methanal levels were high, 797 and 631μg/m³, respectively, but the ethanoic acid level was very high, 2094μg/m³. The identification and the pollutant levels raised several questions. Why was methanoate formed when ethanoic acid was present at such high levels? Do methanoic acid and methanal act in a synergistic manner to promote the formation of methanoates? Why were carbonates and sulphates which have been reported on the surface of deteriorated glass by others (Organ and Bimson 1957: Pilz and Troll 1997) not found?

Discussion

Methanoates and ethanoates have formed on objects in environments containing high levels of methanoic and/or ethanoic acid. The measures taken since 1989 to reduce levels of emissions within showcases have been effective and objects made of, or containing lead have not undergone alteration on exhibition. If the showcase environment is corrosive, alteration is normally seen in less than one year. These observations suggest that up to 400μg/m³ of the organic acids can be present within a showcase, or other closed environment at the normal ambient RH (up to 60%) and temperature in the Museum without alteration of metal objects. Observations within the Museum suggest that in wood showcases and storage, corrosion due to out-gassing is promoted at periods of high RH and temperature. In experimental work the rate of out-gassing was found to be both RH and temperature dependent; and levels of organic acids monitored in showcases are normally higher in the summer than in the winter.

Examples of alteration due to carbonyl pollutants on non-metals have been found where high levels of organic acids have been present. The take-up of organic acids by porous stone objects is not unexpected as they have been stored in oak boxes for periods of up to 100 years. The probability that the reaction between the acids and the objects is linked to moisture from a conservation process is of concern, since many Egyptian limestone stele have undergone desalination treatments in the past. It seems probable that as long as the objects are now not exposed to a high RH the formation of mixed salt efflorescence on the surface of the objects can be controlled.

On glass objects there is a need for more investigation to fully understand the long-term effects of the organic acids, and the effects of the chemicals used in previous conservation treatments. This work is being planned.

For all types of objects the composition is an important consideration, as is the conservation history. Lead is the most vulnerable metal but leaded bronzes can be equally vulnerable because of their metallurgy. At high concentrations of organic acids and aldehydes, corrosion on leaded bronzes can occur at RH levels as low as 30% (Eremin and Wilthew 1998). Unleaded copper alloy objects only undergo alteration at an RH >70%; but residues from previous conservation, such as the sodium ions present on the Egyptian bronzes may promote a reaction at a lower RH.

Conclusions

The effects of the reduced sulphur gases are extremely difficult to prevent by passive means as they are present in the atmosphere. Corrosive carbonyl pollutants can be completely eliminated by using materials that do not emit them. However wood is still used in the construction of showcases. From observation of the objects on exhibition and monitoring levels of carbonyl pollutants inside showcases it has been concluded that levels of ethanoic acid below 400μg/m³ can be present and corrosion does not occur at normal ambient conditions. The composition of an object (e.g. lead in a bronze, and soluble salts in limestone) and the conservation history (e.g. residues of a treatment on Egyptian bronzes and residual moisture in a limestone following desalination) both affect the reactivity of an object to the carbonyl pollutants. Relative humidity and temperature also affect the rate of corrosion since at high levels they promote out-gassing and hence reactions.

Pollutant gases are a problem in museums but one that can be contained by good management of the environment and the collection.

Acknowledgements

The authors would like to thank their curatorial colleagues, particularly Stephen Quirke and Aileen Dawson, and their conservation colleagues particularly Denise Ling, Sarah Watkins and Fleur Sherman for bringing examples of alteration to their attention; and their colleagues in the Conservation Research Group for their assistance and support.

References

Blackshaw SM and Daniels VD. 1978. Selecting safe materials for use in the display and storage of antiquities. In: Preprints of the 5th Triennial meeting of the ICOM Committee for Conservation. Paris: International Council of Museums: 78/23/2/1.

Bradley SM. 1996. The development of an environmental policy for the British Museum. In: Bridgland J, ed. Preprints of the 11th triennial meeting of the ICOM Committee for Conservation. London: James and James: 8–13.

Bradley SM and Thickett D. In press. The study of salt and moisture movement in porous stone at the British Museum 1993–1995. In: Tennent N, ed. Conservation Science in the UK 1995. London: James and James Science Publishers Ltd.

Brimblecombe P. 1990. The composition of museum atmospheres. Atmospheric environment 24B(1): 1–8.

Green LR. 1992. Low fired ceramics and H₂S. Museums Journal Nov 1992: 36.

Green LR and Thickett D. 1993a. Interlaboratory comparison of the Oddy test. In: Tennent N, ed. Conservation Science in the UK. London: James and James Science Publishers Ltd.: 111–116.

Green LR and Thickett D. 1993b. Modern metals in museum collections. In: Grattan D, ed. Saving the twentieth century, The deterioration of modern materials. Ottawa: CCI: 261–272.

Green LR and Thickett D. 1995. Testing materials for the storage and display of artefacts – a revised methodology. Studies in conservation 40(3):145–152.

Lee LR. 1996. Investigation of materials to prevent the tarnishing of silver. British Museum, Department of Conservation, Conservation Research Group Internal Report: 1996/1.

Leissner J, Beuschlein S, Pilz M, Martin G, Blades N and Redol P. 1996. Assessment and monitoring the environment of cultural property. Environment programme 1991–1994: Topic II.4: Environmental protection and conservation of Europe's cultural heritage. CEC-Contract EV5V-CT92-0144 "AMECP".

Oddy WA. 1975. The corrosion of metals on display. In: Leigh D et al., ed. Conservation in applied archaeology and the applied arts: London: IIC: 235–237.

Organ R and Bimson M. 1957. The safe storage of unstable glass. The Museums journal 56: 265–272.

Pilz M and Troll C. 1997. Simulation of gold enamel deterioration. In Bradley S, ed. The interface between science and conservation. British Museum occasional paper 116. London: The British Museum: 193–202.

Tennent N and Grzywacz CM. 1994. Pollution monitoring in storage and display cabinets: carbonyl pollutant levels in relation to artefact deterioration. In Roy A and Smith P, eds. Preventive conservation practice, theory and research. London: IIC: 164–170.

Thickett D. 1998. Sealing of MDF to prevent corrosive emissions. The Conservator 22: In press.

Thickett D, Bradley SM, Lee LR. 1999. Assessment of the risks to metal artefacts posed by volatile carbonyl pollutants. In postprints of the ICOM-CC Metals Working Group meeting Metal 98. In press.

Werner AEA. 1972. Conservation and display: environmental control. Museums journal 72(2): 58–60.

Abstract

The disinfestation of an iconostasis with low oxygen concentrations and an experimental solarisation heat treatment in Romania is described. Application of low oxygen concentrations proves no problem but the method will always require sponsoring when applied in poorer countries. A single item approach is labour intensive, but has the advantage of combining treatment with improving storage conditions. The solarisation experiments show that it is possible to generate a temperature of 55°C in the core of wooden objects and maintain it long enough for successful disinfestation within one day of sunshine. However, one has no control over temperature and moisture loss from the wood and ground layer. So far, the method can only be recommended for treatment of undecorated wood.

Keywords

biodeterioration, low-oxygen treatment, solarisation, heat treatment, pest control

Figure 1. Probota iconostasis (ca. 6 × 8 m).

Low-oxygen treatment and solarisation of the Probota iconostasis: Alternative pest control methods in the field

Agnes W. Brokerhof
Netherlands Institute for Cultural Heritage
Gabriël Metsustraat 8
1071 EA Amsterdam
The Netherlands
Fax: +31 20 3054700
Email: nwo@icn.nl

Introduction

The last decade has seen the development of several non-toxic pest control methods as alternatives for toxic fumigants and liquids. Those that are by now well known are freezing, heat treatment, CO_2 fumigation and low oxygen exposure. These methods are being applied by the bigger museums and research institutes and are being introduced to the smaller museums and private restorers, but they are the privilege of industrialised countries. Even though the methods are generally simple, limited access and lack of practical experience keep conservators in other countries from applying them. The UNESCO project 'International support for the restoration and preservation of the Probota Monastery' in Romania offered the opportunity to share knowledge and experience with one of the poorer European countries and to test the applicability of alternative methods in situations where financial means are limited.

Moldavia, in northeastern Romania, is famous for its painted churches. Probota is one of the 16th-century monasteries listed as a World Heritage Site (Theodorescu 1994). It is the first monastery built by Prince Petru Rares and dates from 1530; it is one of the first churches with exterior wall paintings (1532). The UNESCO project involves stabilising the building, establishing climate control, conservation of the wall paintings, both interior and exterior, and archaeological excavations. To enable work on the mural paintings and excavations in the altar, the iconostasis (dating to the early 19th century) had to be removed from the church. This partition between altar and nave in an Orthodox church is formed of icons of various sizes mounted in a richly decorated wooden frame, containing three gates to allow access to the altar (See Fig. 1). As the iconostasis was dismantled and prepared for transport to storage, a serious wood borer infestation (mainly the furniture wood borer *Anobium punctatum*) was discovered. Pest control treatment and conservation of the iconostasis were included in the project. The Netherlands Institute for Cultural Heritage was asked for advice. Initially, the icons, decorative parts and their support structure were to be treated with gamma radiation as facilities were available. Yet, apart from reservations about application of radiation, calculations showed that the radiation source was not powerful enough for a successful treatment. In the interest of the objects, the conservators, and the environment, it was decided to carry out a safe and non-toxic low oxygen treatment, a method that had not been used in Romania before.

During the preparations two sets of icons belonging to older iconostases were discovered and the decision was made to give highest priority to the treatment of the icons. Together with a team of Romanian graduate students from TABOR Research Center, 120 icons were treated by exposure to low oxygen concentrations in the summer of 1997. The decorative and support parts of the 19th-century iconostasis were sealed in polyethylene bags to contain the infestation in anticipation of treatment in a later stage.

Although the low-oxygen method had been successful, it was decided to use the opportunity to build up experience with another possibly cheaper and simpler method. The decorative parts (columns, capitals and floral decorations) still needed disinfestation. They were damaged by insects and the ground layer and gilding were brittle and flaking in places. Several of the attached flowers and leaves had become detached. These parts would need extensive conservation and partial

replacement of wood before remounting. Therefore, some damage due to an experimental disinfestation treatment was accepted. The method of choice was heat treatment using solar power, 'solarisation'. This method has been used in the tropics for the protection of stored grain and rice and Strang (1995) has conducted some experiments with solarisation, but it is not a highly developed technique. The experiments were conducted in the summer of 1998, again in co-operation with the Romanian team.

Low oxygen treatment of the icons

The icons were treated with the static/dynamic low oxygen method (Daniel et al. 1993). Bulk treatment in a tent was considered but would have required regular monitoring by someone on the site during the entire treatment period. The advantage of the chosen single item approach was that, once the bags were sealed, only occasional oxygen measurements would be needed, failures would be limited to a few objects only, the controlled atmosphere provided improved storage conditions until conservation when bags could be opened one at a time, and the icons were protected against reinfestation, not requiring re-packing after treatment.

Oxygen-proof bags were sealed from barrier film (Heliothen P12/50 PEEV, Amcor Flexibles, Haarlem, NL) to fit one or two icons. The icons were placed inside the bags, with little blocks of polystyrene foam as spacers and to avoid damage to the bags from sharp parts, and covered with acid-free tissue paper to avoid direct contact between the plastic and the icons. The bags were rapidly flushed with nitrogen from cylinders (98% N_2) to an oxygen concentration of 2–5% by filling the bag with nitrogen and subsequently drawing it out with a vacuum cleaner. Four cycles were required. For the final flush humidified nitrogen was used. Sachets of Ageless® oxygen absorber Z-1000E (Mitsubishi Gas Chemical Co., Tokyo, Japan) were placed in the bags and the bags were sealed. The required amount of Ageless oxygen absorber was calculated based on an amount of 5% remaining oxygen in bag and object after flushing and a leak rate of 50cm³/m²/ 24 hours oxygen into the bags during a treatment period of 45 days. (One sachet of Ageless Z-1000E absorbs 1L of oxygen). The sealed objects were placed horizontally in racks in the storage room at a temperature of 18–23°C. Research results show that at this temperature a treatment time of 30 days at an oxygen concentration of less than 1% is sufficient to reach 100% mortality (See Fig. 2). To build in a safety margin for lower temperatures and higher oxygen concentrations

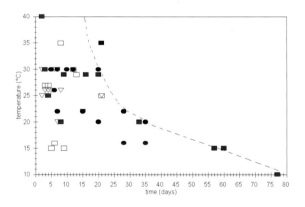

Figure 2. Compiled literature data on the relationship between temperature and exposure time required to reach complete mortality at oxygen concentrations of less than 1%. (■ = grain beetles-internal feeders; □ = external feeders; ● = wood borers; ▽ = other museum pests).

Figure 3. Temperature-time relationship for complete insect mortality; compiled literature data.
1: A. punctatum (L), Becker and Loebe (1961) in Strang (1992);
2: A. punctatum (L), Cymorek (1971) in Strang (1992);
3: H. bajulus (L), Cymorek (1971) in Strang (1992);
4: H. bajulus (L), Becker and Loebe (1961) in Strang (1992);
5: L. brunneus (L), Becker and Loebe (1961) in Strang (1992);
7: L. brunneus (L), Ebeling et al. (1989) in Strang (1992);
8: All, Nicholson (1996–1997);
9: All, Child (1994);
10: S. oryzae (A), Back and Cotton (1924) in Strang (1992);
11: H. bajulus (L), Pinniger (1996).

a treatment time of at least 45 days was maintained. Oxygen concentrations were measured using a Teledyne 340 FBS oxygen meter (Landré-Intechmij BV, Diemen, NL).

During the entire treatment, oxygen levels in the range of 0.1–0.9% were maintained. Even after nine months, most oxygen concentrations were still below 2%. Out of 90 bags, four showed leaks and the treatment was repeated for those bags.

Solarisation treatment of the decorative parts

Principles of solarisation

At temperatures exceeding 35°C, the development of most insects stops and above 40°C mortality occurs, caused by changes in protein structure, lipids and ion activity, disturbance of metabolic processes and dehydration. Data from insect mortality studies at high temperatures show that insects cannot withstand temperatures of more than 45°C for several hours. There is an exponential relationship between temperature and exposure time required for complete mortality. Strang (1992) and Fields (1992) have published extensive lists of temperatures, exposure times and mortality levels for stored product and museum pests. When these data, supplemented with later studies (Child 1994: Nicholson 1996–97: Pinniger 1996), are plotted in a graph, one can determine minimum exposure times needed for successful treatment (See Fig. 3). The drawn curve in Figure 3 gives the exposure times that are required to reach complete mortality of the common wood borers *A. punctatum* and *X. rufovillosum* at varying temperatures. It ignores the data for the exceptionally tolerant species, *H. bajulus* and *S. oryzae*. If one aims at a temperature of 55°C in the core of the objects a successful treatment requires exposure of at least one hour.

Solarisation is based on the principle of heating a 'black body' by absorption of radiation. A surface is black because UV and visible light are absorbed. The radiation that is reflected, has undergone a shift to the longer wavelength infrared (IR) region. This IR-radiation can be felt as warmth. The energy difference between absorbed and reflected radiation is converted into heat. There are three processes that determine the transfer of heat from the black surface to its surroundings:

1. radiation (IR-radiation)
2. conduction (contact with another material)
3. convection (warming the air around the material)

Pest control by solarisation uses these processes to heat an object by placing it inside a black plastic bag. Heat generation should be maximised while heat loss should be minimised. In practice this means:

- generate as much IR-radiation as possible (large black surface)
- minimise IR-radiation loss (contain the reflected rays)
- maximise conduction from the black surface to the object (close contact)
- minimise heat loss through conduction with the ground (insulation)
- maximise convection input (heat up the air surrounding the black bag)
- minimise convection loss (contain the warm air)

There is a potential risk of damage to materials. Paper, textiles and leather are sensitive to high temperatures as the rate of (degradation) reactions increases. Wood is less vulnerable. Yet, at increasing temperatures organic materials release moisture, which can eventually result in dehydration, shrinkage and cracking of the wood and its finishes. Table 1 lists the melting points, glass transition temperatures and temperatures at which visible changes in paint layers of some typical materials used in painted wooden objects take place. Except for paraffin and beeswax, melting points are higher than 70°C. The maximum temperature should be 60°C to avoid the melting of waxes and resins.

Table 1. Melting points, glass transition temperatures (Tg) and temperatures at which changes in properties can be observed of some common materials used in painted wooden objects and materials used for solarisation (Gay 1970: Horie 1987).

Material	Melting point (°C)	Tg (°C)	Observations (°C)
Polymerised oil	160		180 browning
Egg yolk	200		170 browning
Egg white			200 mat
Carnauba wax	83–86		
Bees wax	63–70		
Paraffin wax	35–75		
Shellac	115–120	40	
Sandarac	135–145		
Mastic	95–120	72	
Dammar	80–150	100	
Copals	>120		
Colophony	120–150		
Polyvinyl acetate		16–29	
Polyvinyl alcohol		75	>200 yellowing
Plextol B500 (acrylic dispersion)		<29	
Paraloid B-72 (acrylic resin)	40		
Gelatin		210	200 mat
Animal glue	>200		
Casein			180 browning
Fish glue			200 mat
Polyethylene LD	80–110	-20	
Polyethylene HD	120–130		
Polypropylene	150–160		

Experimental method

Designs for solarisation

Several experimental designs were investigated for their ability to build up enough heat for a successful treatment during one day of sunshine and for their performance:

1. Object in black plastic bag, placed on polystyrene insulation directly in the sun (single bag).
2. Object in black plastic bag, sealed in a second, transparent polyethylene bag to reduce convection loss, placed on polystyrene (double bag).
3. Object in black plastic bag, sealed in a transparent second bag, placed on a frame 1m above the ground, with an aluminium film underneath acting as mirror (mirror).
4. Object in black plastic bag, placed in an insulated box of cement beams, polystyrene insulation, and black plastic lining. A transparent film covers the top of the box, allowing sunlight to come in but containing the heat inside (black box).
5. Object in black plastic bag, placed on thick polystyrene insulation covered with black plastic that also covers the wall away from the sun. From the wall down to the ground, the structure is covered with transparent plastic (black half-box, See Fig. 4).

Materials and equipment

All the experiments were carried out with simple materials. Thick polyethylene sheet (250μm) clear and black, and polystyrene (3cm) were purchased locally. Cement beams, $10 \times 10 \times 250$cm, timber and stones were found at the monastery.

Temperatures and relative humidity were measured with Axiom data loggers (ATAL, Purmerend, NL), K-type thermocouplers and thermosensitive resistors (PTCs and NTCs). Resistance was determined with a UNI-T M890G digital multimeter. Resistors and thermocouplers were calibrated at the laboratory and the calibration curves were used to determine temperatures.

Figure 4. Design of the black half-box for solarisation.

Dimensional changes in the wood during treatment were studied using thin, glass microscope cover slides which were glued to the wood surface with a non-flexible epoxy adhesive (Bison Metal, two-component epoxy glue, 24-hour hardening time). In case of dimensional changes these 'crack sensors' would break.

Formation of condensation water inside the black plastic bags and on the surface of the wood was determined using 'condensation sensors'. These were made of toilet paper stuck onto a 30cm strip of adhesive tape with a string attached to it and marked with a water-soluble ink line. The sensors were placed inside the bag, either with the water-sensitive side towards the wood surface or towards the plastic bag. During the treatment they could be pulled out of the bag, through a small opening in the seam. When water drops are formed, they will make the ink run. In this way the moment at which condensation occurred could be determined. The surface moisture content of the wood was determined with a Sovereign Moisture Master 452.

Results of the solarisation treatment

The results of the experiments are summarised in Table 2. Inside the single black bag the temperature increased to a maximum of just over 40°C, slightly higher than the air temperature. Consequently, the wood temperature increased slowly and never rose above the temperature in the black bag. The generation of heat was insufficient and the loss through radiation, conduction and convection was too great for a successful treatment. Placing the black bag inside a clear bag resulted in a higher temperature inside the bag and the wood. The second bag reduced heat loss through radiation and convection. Nevertheless, the design was unable to generate enough heat during one day of sunshine. Both methods had a problem with condensation on the side facing away from the sun and underneath, where the temperature was lower.

In the mirror design the double incoming radiation was powerful and sped up heating. However, there was not enough insulation to avoid heat loss through convection. Thus, while the maximum temperature in the black bag was reached within two hours, it did not exceed 56°C. The temperature gradient was too small to build up enough heat in the wood. As the sun moved, the position of the mirror had to be adjusted to catch all the incoming light. Nevertheless, temperature and RH in the black bags showed large fluctuations. At the end of the afternoon the mirror lost its effect and condensation occurred.

The black box design generated high temperatures. The extra black surface provided additional IR radiation. Covering the black box with a clear plastic sheet, allowed the full spectrum of radiation to enter the box while a large part of the

Table 2. Summary of the results of the various solarisation designs.

Method	Single bag	Double bag	Black box	Mirror	Half box
Air Temp shade(°C)	34	34	30	30	29
Temp outside/in box (°C)	n	n	75	49	80
time to reach (hr)	n	n	2	1.5	<1
Temp in black bag (°C)	41	50	79	56	80
time to reach (hr)	5	7	3.5	2	3.5
Temp in wood (°C)	35	46	55	53	57
time to reach (hr)	7	7	5.5	5	5
Temp gain effects:					
IR radiation	+[1]	+	++	+++	++
Conduction	+	+	+	+	+
Convection	o	+	++	+	++
Temp loss effects:					
IR radiation	—[2]	-	o	-	o
Conduction	—	—	—	-	o
Convection	—	-	o	—	o
Shade effect	—[3]	—	—	-	-
Condensation	++[4]	++	+ end	+ end	+ end

n= not relevant; 1: more +, more gain; 2: more -, more loss; o: no gain, no loss; 3: more -, stronger shade effect; 4: more +, more condensation; end = condensation occurring at the end

reflected IR-radiation was held inside. The warm air inside the box added convection heat. The temperature inside the bag increased rapidly to 80°C, providing a gradient large enough to heat the core of the wood blocks to the required 55°C. This was achieved in 5.5 hours, leaving sufficient time for a successful treatment. When the sun set at the end of the afternoon, shade effects occurred. Even though the sensors showed no signs of condensation during the treatment, water droplets could be seen on the inside of the black plastic bag upon opening.

The black half-box was an improvement over the black box. With only one wall catching the incoming radiation behind the black bag and no shadow-casting wall in the front, the temperature difference between front and back was reduced. Thick polystyrene insulation on the ground reduced convection loss. The temperatures inside the box and inside the bag increased rapidly to 80°C, requiring one hour and 3.5 hours respectively. The core of the wood was heated to 57°C in five hours (Fig. 5).

The half-box still had a problem with condensation at the end of the treatment when the black bags were taken out of the box. The moisture released from the wood at increasing temperature caused the RH in the small free space in the bag to almost reach saturation (90–95%, Fig. 5). A small temperature difference in the plastic bag, between the sunny and the shady side or between the warm wood and the cooling black plastic at the end of the treatment, was enough to cause condensation. As the formed water droplets had no time to evaporate and return to the wood, moisture was lost. This could be avoided by keeping the bags closed until the wood regained the moisture. However, during this time, the paint layer and gilding can become damaged when in contact with the droplets.

Condensation can be avoided by minimising temperature differences or by reducing the air space around the object by vacuum wrapping. Yet, one cannot avoid moisture transport within the wood and from the wood to the surface layer, which may lead to condensation in the outer layer of wood or in the ground layer when they cool down while the core is still warm. Measurements of the surface moisture content showed an initial increase of moisture at the surface directly after treatment, but a decrease after two days when the wood had cooled down and moisture equilibrium was re-established. This decrease did not give dimensional changes though, the 'crack sensors' were still intact, but the ground layer had become more brittle.

It was observed that a cloud of hot, smelly air escaped when the bags were opened after treatment. Remains of old pesticide treatments can evaporate, therefore, the objects must be allowed to off-gas after treatment.

Conclusions

Apart from some practical challenges, such as finding reducing valves and tubing, applying the low-oxygen method was no problem in Romania. The nitrogen had a purity of 98%, so additional oxygen absorbers were required to lower the oxygen concentration to <1%. Even when barrier film and oxygen absorbers are provided free of charge, the method is expensive (shipping a box of oxygen absorbers from

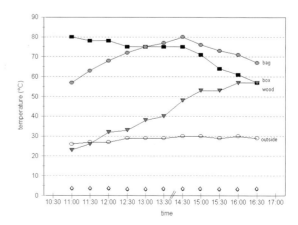

Figure 5. Temperature profile in black half-box. Temperatures (°C) in box, bag, wood and outside and relative humidity (% RH) inside the bag.

Japan already equals several times the average Romanian monthly wage) and will always require sponsoring when applied in poor countries.

The chosen single item approach is labour intensive, but in situations where decisions take time and work does not always proceed according to plan, the approach has the advantages of combining treatment with improving storage conditions.

The solarisation experiments showed that the 'black half-box' is capable of generating a temperature of 55°C in the core of wooden objects within several hours. When held for one hour, this is sufficient for successful disinfestation. In principle, solarisation provides an effective, cheap and easy to control method. All it requires is sunshine and an outside air temperature of around 30°C.

However, the method has disadvantages. It is rough; one has no control over the temperature increase or over the moisture loss from the wood and the surface layers. The lost moisture condenses inside the black bag and affects the surface layers. So far, the method can only be recommended for treatment of undecorated wood.

Neither of the described treatments provides any long-term protection. Therefore, after conservation and before reinstallation in the church, the iconostasis may need a surface treatment with a residual pesticide when other measures cannot prevent reinfestation.

Acknowledgements

The work described in this paper was carried out as a joint project of the Netherlands Institute for Cultural Heritage and the UNESCO project 'International Support for the Restoration and Preservation of the Probota Monastery, Romania', Project 536/ROM/70. The author would like to thank the project manager, Ignazio Valente, Maarit Elo-Valente and the staff of the UNESCO office in Iasi for their support; Professor Dr Ion Sandu, Anca Sandu, Cleopatra Afilipoie, Juliana Nechita, Cristian Bucur, Nicusar Vacaru, Maica Veniamina Chiriac, Gabriel Fadur and Octav Uliuliuc of TABOR Research Center, Iasi, for their enthusiastic input, creative solutions and hard work; Archbishop Pimen, Anton Hrib, St. Ion Monastery and Teodoreni Monastery, Suceava, for their hospitality and support; and Mitsubishi Gas Chemical Co., Inc., Tokyo, Japan, for donating the Ageless® oxygen absorbers and Amcor Flexibles, Haarlem, The Netherlands, for donating barrier film.

References

Child RE. 1994. The thermo lignum process for insect pest control. Paper conservation news 72: 9.
Daniel V, Maekawa S, Preusser FD, Hanlon G. 1993. Nitrogen fumigation: a viable alternative. In: ICOM-CC Preprints of the 10th Triennial Meeting, Washington DC, Vol 2. Paris: ICOM: 863–867.
Fields PG. 1992. The control of stored-product insects and mites with extreme temperatures. Journal of stored product research 28(2): 89–118.
Gay MC. 1970. Essais d'identification et de localisation des liants picturaux par des colorations spécifiques sur coupes minces. Annales de Laboratoire de Recherche des Musées de France: 8–24.
Horie CV. 1987. Materials for conservation. Butterworth series in conservation and museology. London: Butterworth.
Nicholson M. 1996–97. The thermo lignum controlled heating/constant humidity treatment. In: Pest attack and pest control in organic materials. UKIC: 13–19.
Pinniger D. 1996. Insect control with the thermo lignum treatment. Conservation news 59:27–29.
Strang TJK. 1992. A review of published temperatures for the control of pest insects in museums. Collection forum 8(2): 41–67.
Strang TJK. 1995. The effect of thermal methods of pest control on museum collections. In: Aranyanak C and Singhasiri C, eds. Biodeterioration of cultural property 3. Bangkok: 334–353.
Theodorescu R and Dumitru C, eds. 1994. Bucovina, the Moldavian mural paintings in the fifteenth and sixteenth centuries. Bucharest: Romanian National Commission for UNESCO.

Abstract

The National Trust has used ISO Blue Wool standards as simple dosimeters to assess light exposure for sensitive objects in a wide range of its properties. The colour change for these dosimeters has been measured instrumentally and compared with calibration curves produced by exposing blue wool samples to known doses of light, with and without ultraviolet radiation present, at different relative humidities and using different illuminants. The results indicate that in most of the rooms surveyed, the annual level of light exposure is less than the recommended maximum light exposure per year for sensitive objects. The findings are used to inform decisions about opening hours and light control measures.

Keywords

National Trust, Blue Wool standards, light exposure, calibration, dosimeter, fading, relative humidity

Measurement of cumulative exposure using Blue Wool standards

Linda Bullock★
The National Trust
36, Queen Anne's Gate
London SW1H 9AS
UK
Fax: +44 171 447 6540

David Saunders
The National Gallery
Trafalgar Square
London WC2N 5DN
UK
Fax: + 44 171 839 3897
Email: david.saunders@ng-london.org.uk

Introduction

The historic houses owned by the National Trust in England, Wales and Northern Ireland cover a wide spectrum, from the modest homes of some historically significant figures, such as Isaac Newton or Winston Churchill, to the largest private house in England, Knole in Kent.

The primary curatorial aim is to retain the 'spirit of place' reflecting the families who had previously lived there and to present these properties, as far as possible, with their original contents. The rooms are generally lit by daylight through side windows. In practice, this usually means avoiding museum-like displays in showcases with controlled levels of electric lighting. This paper describes in more detail the use of ISO Blue Wool standards (British Standards Institute 1992) as dosimeters to survey exposure of artefacts in these historic houses to ultraviolet (UV) and visible radiation (Staniforth and Bullock 1997), a technique described in the literature (Feller 1978: Feller and Johnson-Feller 1978: Tennent and Townsend 1987: Staniforth and Bullock 1997), but rarely used outside the laboratory. The hurdles of interpretation have been addressed here by further experimental work on the rates of fading of the standards, with and without UV components in the light source, and at different levels of relative humidity (RH).

Unlike most museum displays, the contents of showrooms in National Trust houses are very mixed. Within almost every room are artefacts that would fall into the fugitive category, such as textiles with dyes of organic origin; there may also be watercolours or paintings with fugitive pigments or glazes. A thorough literature review of the damage to museum objects by visible and ultraviolet radiation has been published (Michalski 1987).

We know many artefacts have changed in their lifetime, and that with the exception of the catastrophic risks of fire, flood and physical forces, light is the most important and insidious cause of deterioration. Changes to both colour and strength have occurred, which can often be seen by comparison with areas that have not been exposed to light. Examples include the reverse of carpets or tapestries, silk wall coverings that have been protected by paintings or mirrors, areas of paintings or watercolours that have been hidden by a frame or mount, and the inside of marquetry cabinets or keyboard instruments.

Managing the risk of light damage

Firstly, we eliminate ultraviolet radiation. The UV content of the daylight penetrating window glass, i.e. in the range 325 to 400 nm, is filtered out by the application of UV-absorbing polyester-based films to the inside of the glazing by

★ Author to whom correspondence should be addressed

specialist installers. Guidance on window cleaning is given to property staff; to maximise the life of the filters they should not be abraded (Allen et al 1999).

Secondly, we reduce exposure to visible radiation. It has been shown that damage is proportional to the exposure, the product of light level and time of illumination, measured in lux-hours (lux.h) (Saunders and Kirby 1996). The twin strategies of blackout when the house is closed and the use of sun curtains or window blinds when open, provide flexible control.

The Trust's policy on opening hours is closely linked with the need to limit the light exposure of interiors, especially those with particularly sensitive contents (Lloyd 1997). The Trust is faced with the question of whether to try to adhere to the widely accepted museum-recommended maximum illuminances of 50 lux for objects in the most sensitive category and 200 lux for those of moderate sensitivity (Thomson 1986). These recommendations are not based on rates of deterioration but were derived from levels of illumination considered to be sufficient for the reasonable perception of detail and for the discrimination of colour differences, in the knowledge that a balance had to be struck for conservation (Thomson 1986: Boyce 1987: Loe 1987). It should be remembered that these are not levels below which objects are safe, nor do they directly relate to damage.

Given that it is best to measure cumulative exposure there are two options for measuring lux-hours in an illuminant as variable as natural daylight:

1. Logging illuminance levels at the surface of an object at regular intervals and averaging over time; the smaller the time interval, the greater the precision (Saunders 1989: Staniforth 1990). The National Trust has a few battery-powered UV/visible light sensors linked to radio-telemetric environmental monitoring systems in houses with particularly light-sensitive collections. These log, usually hourly, and compute cumulative exposure. We also have a few discrete stand-alone loggers which can be set to log at minute intervals, but only store an hourly average, in order to save memory. Data from both models of logger are accessed using a PC.

2. Using a device that will integrate the light dose, which can then be related to lux.h of exposure. ISO Blue Wool (BW) standards, whose rates of fading are known, can be used as dosimeters. Much has been published on the use of these BWs for estimating the lightfastness of pigments, dyed textiles and papers, and on the determination of the photochemical stability of materials used in conservation. It has been demonstrated that the lightfastness of many organic dyes is comparable to BWs 1, 2, and 3 (there are a total of 8 in the range, No 8 being the least fugitive).

A wide and systematic survey of light exposures in National Trust historic houses was started in 1994, and has now broadened to cover many rooms in 80 properties in England, Wales and Northern Ireland (Staniforth and Bullock 1997). BWs 1, 2 and 3 were fixed in card mounts that obscured part of each sample from light. These were placed in many rooms close to light sensitive material (See Fig. 1). The Trust's regional conservators were requested to note the following information on the reverse of each mount:

Figure 1. Blue Wool dosimeter in Ham House, Surrey.

- Property
- Room
- Location and orientation relative to windows
- Dates of installation/removal
- Efficacy of UV filtration at window

The dosimeters were placed for periods of a full year, or for the open (Easter until the end of October) or closed seasons only. The results of the fading can be assessed in two ways:

1. Opening the dosimeter to reveal the difference between the faded and unfaded areas can provide a powerful visual impression of the extent of fading. A comparison of the faded and unfaded areas with a standard grey scale, or the

use of the Damage Calculator slide rule produced by the Canadian Conservation Institute, can be used to give a semi-quantitative measure of exposure.

2. Instrumental colorimetric or spectrophotometric measurements which generate chromaticity values. These can then be compared with data for the fading of these wools.

The advantage of visual estimation methods is that they are quick and inexpensive, but they do show significant variation in judgements between observers. The second method is more expensive but considerably more precise. If there is no access to colour-measuring equipment within the museum, there may be such facilities at a university department or commercial company.

Measuring equipment

Initially, the colour measurements were all made at the National Gallery, using a Minolta CR200 series chroma meter. In the last year, the colour of the dosimeters has been measured using a Minolta CM508d portable spectrophotometer, purchased by the National Trust.

Measurements and uniform colour space

The illuminant for both measuring instruments is a pulsed Xenon lamp. Each measurement was the average of three separate measurements, made in slightly different positions over the BW sample in order to minimise the effect of any surface texture. The Minolta CR200 series chroma meter was used in conjunction with a CR200 measuring head, which provides diffuse illumination to a sample area 8mm in diameter and measures the reflected light perpendicular to the surface of the sample (standard d/0 measuring geometry). The Minolta CM508d spectrophotometer provides diffuse illumination to a sample area 8mm in diameter and measures the reflected light at an angle of 8° (d/8 measuring geometry).

The measurements from both instruments were converted into Commission Internationale de l'Eclairage (CIE) L\star, a\star and b\star coordinates under standard illuminant D65 using data for the 2° observer (Commission Internationale de l'Eclairage 1978).

Problems

While the measurement process is straightforward, difficulties lie in the conversion of the fading into an exposure in lux.h. The published data come for a range of illuminants using different units, scales and 'uniform' colour spaces. Many of these experiments have been done at very high illuminances, using sources with a very high UV content and at high temperatures and low RHs. Most of these fading studies have been carried out in Fadeometers using light sources with a spectral power distribution very different from daylight. The published data are frequently expressed as logarithmic plots of change in lightness (given as the tristimulus Y value or as the Munsell Value) against millions of footcandle hours (1 footcandle » 10lux). The plots are often published in a small format, making them difficult to read. They also contain few sample points, especially for low exposure, which can lead to errors of interpolation, particularly with logarithmic plots.

Initially, the measurements on the dosimeters were expressed as 1931 CIE XYZ tristimulus values so that changes in the luminance component (Y) could be compared with Feller's data (Feller and Johnson-Feller 1981). There was a real need for a set of curves relating colour change in a more uniform colour space to lux.h exposure, with UV radiation included and excluded, using a source similar to natural daylight and at a temperature and RH not wildly different from those monitored at the dosimeter sites.

Determining calibration curves for the dosimeters

In order to express the colour changes measured in the Blue Wool samples exposed in National Trust houses in terms of a cumulative light exposure, we performed a

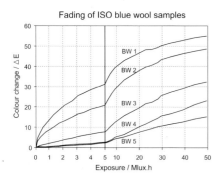

Figure 2. Plot of colour change (in ΔE units) against light exposure (in Mlux.h) for Blue Wool standards Nos 1 to 5.

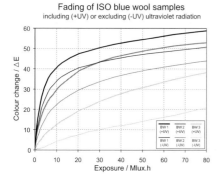

Figure 3. Plot of colour change (in ΔE units) against light exposure (in Mlux.h) for Blue Wool standards Nos 1 to 3, showing the effect of ultraviolet filtration on the rate of colour change.

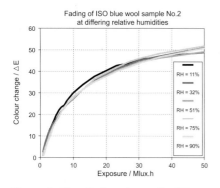

Figure 4. Plot of colour change (in ΔE units) against light exposure (in Mlux.h) for Blue Wool standard No 2 at different relative humidities.

number of calibration experiments. First, samples of BW Nos 1 to 5 were subjected to accelerated light ageing using a Thorn Artificial Daylight fluorescent lamp. This source has a similar colour temperature to average daylight and a comparable UV content (c. 510μ lumen⁻¹). The conditions in the fading chamber were: illuminance c. 10,000 lux; temperature 26–31°C; relative humidity 45–55%. The colour of each BW was measured prior to exposure and periodically during the accelerated ageing programme.

The colour measurements for the BWs used in the calibration experiments were made with one of the instruments used to measure the dosimeters from National Trust houses, the Minolta CR200 series chroma meter. The measurements were again converted into Commission Internationale de l'Eclairage (CIE) L★, a★ and b★ coordinates (Commission Internationale de l'Eclairage 1978); a procedure described in more detail elsewhere (Saunders and Kirby 1994). The colour difference (ΔE) between the sample prior to light exposure and at each measurement during the experiment was calculated using the 1994 CIE colour difference equation (McDonald and Smith 1995). The error in colour measurement was approximately ΔE ±0.25.

The results from the first experiment are presented in Figure 2 in which colour change (in ΔE units) is plotted against cumulative exposure in Mlux.h. The cumulative exposure has been corrected to account for the decline in illuminance as the lamps in the fading chamber age and the scale has been modified to allow the colour changes that occur in the first 5Mlux.h of exposure to be seen more clearly. In theory, the exposure required to produce a particular colour change in BW No 4 is approximately double the exposure required to produce the same colour change in BW No 3. The same relationship will also apply between BWs 3 and 2 or BWs 2 and 1. It is apparent that while this relationship holds between BWs 4 and 3 and between BWs 2 and 1, there is a discontinuity between BWs 2 and 3; for example a colour difference of 30ΔE units results from exposing BW No 2 to 10 Mlux.h but BW No 3 to 40 Mlux.h. It is as if there should be a further sample, intermediate in behaviour between BWs 2 and 3. It would also appear that BW No. 5 is fading more rapidly than might be expected from a comparison with the data for BWs 3 and 4.

Under most, but not all, circumstances, the BW samples in National Trust properties were exposed to light from which all ultraviolet radiation had been removed by use of an appropriate ultraviolet-absorbing filter. A second experiment compared the colour change in BWs 1, 2 and 3 during accelerated ageing under the same artificial daylight illuminant. One sample of each BW was exposed directly to the illuminant while a second was protected by an efficient ultraviolet filter, which removed all radiation with a wavelength of less than 390 nm and had a transmittance at 400 nm of c. 16%. The data for this second experiment are presented in Figure 3, after correcting for the reduced transmission of the ultraviolet filter in the visible range.

The RH in historic buildings owned by the National Trust is not controlled as stringently as in many museums. For collections containing hygroscopic materials, the Trust aims to maintain the RH in the range 50–65%. As a result, the BW cards in Trust properties might be exposed to light at different RHs; the temperature and RH are logged in those rooms where BWs are exposed. To assess the effect of RH, we subjected samples of BW No. 2 to light exposure at five different RHs. The five samples of BW No. 2 were placed in well-sealed glass vessels conditioned to different RHs using saturated salt solutions: RH 11%, LiCl; RH 32%, MgCl; RH 51%, Mg(NO₃)₂; RH 75%, NaCl; RH 90%, BaCl₂. The glass lid of the vessels absorbed some short-wavelength ultraviolet (below 320nm) but most of the ultraviolet radiation generated by the Artificial Daylight lamps reached the samples. Figure 4 shows that despite the wide range, the colour change of BW No 2 is independent of RH.

Finally, the effect of fading BW samples under other illuminants was considered. Samples of BW Nos 1 and 2 were subjected to accelerated ageing under three different illuminants and natural ageing in a room at the National Gallery. Data were already available for the fading of these samples under the Artificial Daylight fluorescent lamp. These were supplemented by results from the exposure of the BW samples to a fluorescent lamp with a correlated colour temperature of c. 3400K

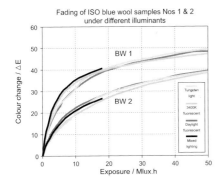

Figure 5. Plot of colour change (in ΔE units) against light exposure (in Mlux.h) for Blue Wool standards Nos 1 and 2, showing the effect of different illuminants on the rate of colour change.

(Philips Colour 84 triphosphor lamp: illuminance c. 18,000lux; temperature 25 ±1°C; relative humidity 55 ±2%) and to a tungsten incandescent lamp (illuminance c. 7,000 lux; temperature 23–26°C; relative humidity 45–55%). The fourth set of samples were attached to a wall in one of the rooms at the National Gallery, at a point where the cumulative exposure could be logged using the light sensors installed in the room (illuminance c. 200 lux; temperature 19–25°C; relative humidity 50–60%). Ultraviolet radiation was filtered from the light emitted by all the sources in this experiment.

The results are presented in Figure 5; note that the cumulative exposure for the sample in the Gallery room did not reach the same level as those in the accelerated ageing experiments. It can be seen that the colour change is essentially independent of the type of illuminant, despite the rather different spectral power distribution of the sources used in this experiment. Although the rate of fading of BWs 1 and 2 is not independent of wavelength (Saunders and Kirby 1994a), it is clear that, in the visible region at least, there is no dramatic variation in the fading caused by different sources. Despite the very different levels of illumination for the different samples, it is clear that a given colour change can be related to a particular exposure; that is, reciprocity is followed (Saunders and Kirby 1996).

A similar natural ageing experiment is in progress in a room at the National Trust. Samples of BW Nos 1–3 have been attached to all the walls and to the window facing outwards. On one of the walls BW Nos 4–8 are also being exposed; the temperature and RH in the room is being logged and alongside each sample set is a sensor to record light exposure.

Results of survey

Using the calibration data from these experiments, the light exposure was determined for the dosimeters placed in National Trust properties.

The recommended illuminance for particularly sensitive exhibits is 50 lux (Thomson 1986). It is impractical to restrict illumination on curtains to 50lux and expect reasonable viewing conditions, particularly for older visitors, in the depths of a room. The annual exposure in lux.h of a light-sensitive object lit at 50lux in a museum open for 3000 hours per year is 150 klux.h (assuming blackout during closed time). National Trust houses are, on average, lit for about 1000 hours in total; 600 hours when open to visitors and 400 hours for cleaning and educational or connoisseur visits. An equivalent exposure of 150 klux.h, could be achieved for very sensitive objects in Trust properties by a light level of 150 lux for those 1000 hours. Accordingly, the National Trust accepts that the light level will change as daylight fluctuates and aims to achieve an average illuminance of 150lux during opening hours.

The results of the survey using BWs show that some rooms with particularly fragile textiles receive only 10 klux.h per annum, while others, where no sensitive materials are displayed, reach as high as 7 Mlux.h. Typical results from one property are shown in Figure 6. Seventy percent of all annual exposures monitored were found to be at or below the museum cumulative exposure of 150 klux.h. Of the remaining 30%, about half exceed 250 klux.h, prompting a reassessment of light control and blackout in these rooms.

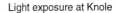

Figure 6. Survey results from rooms at Knole, Kent over a four year period.

Conclusions

The results indicate that many National Trust properties compare favourably with standards in National and local museums, with annual cumulative exposures less than 150 klux.h. The Trust has developed room light plans, which include details of sensitive objects and also of control measures. They indicate the location in a room at which light readings should be taken in order to adjust the setting of the Holland blinds. These plans can be reviewed if the dosimeter results show cumulative exposures substantially different from 150 klux.h.

The fading demonstrated by the dosimeters is a valuable visual aid in training staff and room stewards, to ensure they understand why light control may be necessary, so that they can, in turn, offer an explanation to visitors.

Monitoring with dosimeters has provided the impetus for improving inadequate blackout during the closed periods and for improving daylight control during open hours, in some cases preventing direct sunlight from entering a room. As the level of sunlight can be as high as 50,000 lux, just three hours would use up an object's entire annual 'light budget'.

It is hoped that the information generated by the survey will lead to a broader discussion at individual properties and ensure that a consensus is reached between curator, conservator and property manager (often the budget holder) on the balance between conservation, visitor access and income generation.

References

Allen G, Black L, Hallam K, Berry J, Staniforth S. 1999. A preliminary investigation into the effect of self-adhesive ultraviolet-absorbing films on window glass. In: ICOM committee for conservation 12th triennial meeting, Lyon. 757–763.

Boyce P. 1987. Visual acuity, colour discrimination and light level. In: Lighting in museums, galleries and historic houses. London: Museums association London: 50–57.

British Standards Institution 1992. British standard 1006: 1990 (issue 2, October 1992), British standard methods of test for colourfastness of textiles and leather. Milton Keynes: B01/1–7.

Commission Internationale de l'Eclairage 1978. Recommendations on uniform color spaces, color difference equations, psychometric color terms. Supplement no.2 to CIE publication no.15 (E-2.3.1), 1971/(TC-1.3).

Feller RL. 1978. Further studies on the international blue wool standards for exposure to light. In: ICOM committee for conservation 5th triennial meeting. Zagreb: 78/18/2/1–10.

Feller RL, Johnson-Feller RM. 1978. Use of the ISO blue wool standards for exposure to light. 6th AIC meeting: Fort Worth: 73–80.

Feller RL, Johnson-Feller RM. 1979. Use of the ISO blue wool standards for exposure to light (ii) instrumental measurement of fading. American institute for conservation: Toronto: 30–36.

Feller RL, Johnson-Feller RM 1981. Continued investigations involving the ISO blue wool standards of exposure. In: ICOM committee for conservation 6th triennial meeting. Ottawa: 81/18/1/1–7.

Loe D. 1987. Preferred lighting for the display of paintings with conservation in mind. In: Lighting in museums, galleries and historic houses. London: Museums association London: 36–49.

Lloyd H. 1997. Balancing opening with conservation. In: Museum practice 4: 54–55.

McDonald R, Smith KJ. 1995. CIE94 - a new colour difference formula. Journal of the society of dyers and colourists 111: 376–379.

Michalski S. 1987. Damage to museum objects by visible radiation(light) and ultra-violet radiation (UV). In: Lighting in museums, galleries and historic houses. London: Museums association London: 3–16.

Saunders D. 1989. A portable instrument for the logging of light levels. In: The conservator 13: 25–30.

Saunders D, Kirby J. 1994. Light-induced colour changes in red and yellow lake pigments. In: National Gallery technical bulletin 15: 79–97.

Saunders D, Kirby J. 1994a. Wavelength-dependent fading of artists' pigments. In: Roy A, Smith P. ed. Preventive conservation: practice, theory and research, London: IIC: 190–194.

Saunders D, Kirby J. 1996. Light-induced damage: Investigating the reciprocity principle. In: ICOM committee for conservation 11th triennial meeting. Edinburgh: 87–90.

Staniforth S. 1990. The logging of light levels in National Trust houses. In: ICOM committee for conservation 9th triennial meeting. Dresden: 602–607.

Staniforth S, Bullock L. 1997. Surveying light exposure in National Trust houses. In: Museum practice 6: 72–74.

Tennent N, Townsend J. 1987. Light dosimeters for museums, galleries and historic houses. In: Lighting in museums, galleries and historic houses. London: Museums association 31–35.

Thomson G. 1986 .The museum environment, second edition. London: Butterworths.

Abstract

An exhibition of the works of the Flemish painter, Francisco Henriques, who lived in Portugal between 1503 and 1518, was to be installed in a 16th-century building in Évora, Alentejo. The building is located in the historical centre of the city, and the number of visitors was expected to average between 400 and 500 per day, up to 1000 during weekends. The building characteristics were assessed by thermohygrograph for approximately three months before the exhibition. It appeared possible to keep environmental conditions stable simply by compensating for the heat and humidity gains from visitors with a conventional temperature and humidity controlled ventilation system. The results were according to expectations. Energy consumption remained low, but overall performance can still be improved by reducing the total capacity of the air handling units. The results achieved, partly due to the thermal characteristics of the building, prove the importance for museums in this part of Europe of Thomson's concept of "a museum Temperate Zone".

Keywords

climate control, building, museum temperate zone

Climate control in a 16th-century building in the south of Portugal

Luís E. Elias Casanovas★
Universidade Nova de Lisboa
Lisbon
Portugal

Ana Isabel Seruya
Instituto de José de Figueiredo
Lisbon
Portugal

Introduction

It is usually difficult to have curators accept that not all collections should be kept at 20°C and 50% relative humidity (Ashley-Smith 1995). Even when such values are almost impossible to achieve, they remain a mystical target they believe we should try to reach in spite of the data that have been gathered proving the difficulties, and the dangers, of their use.

For the exhibition of the works of Francisco Henriques, a Flemish painter who worked in Portugal between 1503 and 1518, it was obvious that the "correct" or "ideal" values should not be used as reference, not only because the majority of the paintings (oil and tempera on wood) came from churches and small museums with no environmental control whatsoever, but also because of the combination of the structure of the exhibition building and the local climate. We decided therefore to rely on the advice on relative humidity levels given by de Guichen (1980) and on the conclusions of Michalski (1993) and Erhardt and Mecklenburg (1994) and ignore the "ideal" conditions quoted in so many standards for museums today.

Taking advantage of the stability of the environment in the exhibition room, which had been evaluated by thermohygrograph readings, it was decide that the air treatment plant should be designed to compensate only for the heat and humidity gains from visitors, expected to be between 400 and 500 per day, maximum 1000, keep RH at 65% ± 5% and temperature at 20–25°C. Later we realised that the relative humidity level was in agreement with the values suggested by the Louvre in the ICOM survey of 1955 (Hilbert 1987, 186).

In achieving those values, energy consumption remained low and it was found that the structure of the exhibition itself played an important role in the process.

The building – the Old Collective Barn (Antigo Celeiro Público) – and the local climate

The Old Barn is situated in the centre of the World Heritage historical town of Évora, in the south of Portugal.

During the first half of the 16th century, several renowned Portuguese and foreign artists lived in Évora, amongst them Francisco Henriques. The present exhibition, built around his work, was in a sense a commemoration of all the important works produced under the patronage of the king and the church alike.

The Barn is a typical 16th-century Portuguese limestone masonry construction (See Fig. 1), with external walls 1.5m thick, stone floor, vaulted ceiling and no basement; all the windows are closed off, the only opening to the barn being the main entrance door. The thermal conductivities of the outside walls and of the floor are respectively 1.14 W/m² h°C and 0.26 W/m² °C. The ceiling was reinforced in the 1940s by a concrete slab, thus creating an attic between the ceiling of the barn and the roof (ceramic tiles).

Prior to the planning of the environmental conditions, a survey of the local climate (outside and inside the building) was carried out the previous year during the same months (July–September) when the exhibition was expected to be held.

Figure 1. Main drawing of the Old Collective Barn. The space of the Barn (length 30m, width 21,5m; height 4,5m) is now part of a government office that occupies the south and east wings; the outside walls thus face west and north. (The star marks the thermohygrograph location).

★ Author to whom correspondence should be addressed

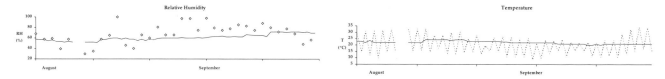

Figure 2. Environmental conditions inside the Barn during August and September 1996. Dotted lines represent outside temperature in Évora; ◊ outside RH.

Figure 2 shows the data collected from the local meteorological station, located approximately 100m from the Old Barn, alongside the results from the monitoring of the exhibition room environment during the same period.

As expected, owing to the characteristics of the building, the interior conditions were stable. As the heat transmission coefficient of the walls is not exceptionally low, this stability can be explained primarily by the moderate annual temperature range which seldom exceeds 36°C (2°C to 38°C). Thus the overall thermal performance of the building corresponds to what has been reported in other countries (Beck and Koller 1980).

One must also bear in mind that the traditional Portuguese masonry acts as a very effective relative humidity buffer system because of the type of materials used not only for the building structure but also for the painting and finishing of the outside walls which remain damp most of the winter (no central heating). During the summer the humidity slowly evaporates and we think that this is one of the reasons why in Évora, and generally all over the country, relative humidity levels seldom fall below 35% RH inside old buildings.

We should emphasise the fact that one of the characteristics of the traditional Portuguese museum environment is the low humidity during the summer season and the high humidity during the winter season (the reverse of many museums in northern countries). By summer season we mean from the end of April to the beginning of October.

Solution

We considered that the results of the 1996 survey, as they confirmed previous analysis made in the Évora Museum, could be used as a basis to work out the main characteristics of the climate control system. In our opinion, the system had to be conceived mainly as a reinforcement of the overall stability of the structure itself, designed primarily to keep relative humidity always above 50%.

Although there is only random information on the indoor climate of Portuguese churches, we were confident that the prior humidity history of the paintings from the churches covered a seasonal range from about 40% RH to well over 85% RH. Their annual average RH was probably well over 65% RH. Those paintings from the National Museum for Ancient Art, however, would have been exposed to less extreme conditions. We therefore chose a target of 65% RH as a reasonable balance between the various RH histories for all the paintings in the exhibition. We selected 70% RH as a peak maximum, and 50% RH as the peak minimum, with the a target of only ±5% RH fluctuation most of the time.

At the beginning we had some difficulty in making curators and engineers accept the fact that relative humidity – not temperature – was our main concern, and that the sacred figure of 50% RH was not our target but a value we wished to avoid.

Furthermore, we suggested that total air circulation be kept at a moderate level, i.e. 4.5 volumes/hour. We wanted to avoid the very high air circulation rates common in Portuguese air-conditioning installations. In spite of all our efforts to emphasise conservation conditions over visitor comfort, the engineers still considered the project essentially just a peculiar form of air-conditioning.

Since the Old Barn is a classified building, and Évora is a World Heritage historical town, the air treatment equipment could not be visible from surrounding streets, nor could any openings be made in the outside walls or in the ceiling. Therefore, it was decided to use the five windows of the south wall to install roof-top handling type units equipped with steam humidifiers.

The specifications for the environmental conditions were the following:

relative humidity: 65°5%; temperature: 20–25°C;
outside air: 3000m³/hour (30 × 1000)

and for the unit characteristics:

cooling capacity: 11kW; total air volume: 3000m³/h
outside air: 600m³/h

The air was delivered through a duct system with supply and return grilles at floor level. No make-up air was considered necessary since the entrance door infiltration would be enough.

Monitoring was carried out with two thermohygrographs, but as the differences between the two were extremely small, we consider only the results from unit 1 (See Fig. 1).

Results

The results of Figure 3 show that our main objective for the exhibition *Francisco Henriques, a painter in Évora at the time of D. Manuel I* was achieved: the relative humidity level remained stable and within the set limits.

Energy consumption remained low, compared to the total power installed (Table 1).

Table 1. Power consumption.

Unit Capacity	5 × 5,3 kW	26,5 kW
Time	10 hours/day × 51 days	510 hours
Power Consumption – Actual		7.208 kWh
Power Consumption – Theoretical		13.515 kWh

After the exhibition, a survey of the state of preservation of all the paintings confirmed that they had remained stable, with no signs of further damage.

In 1998 we decided to apply the same criteria, i.e., priority to the stability of relative humidity through compensation of heat and humidity gains from visitors, on two exhibitions: the first in Évora in the Old Barn and the second in Oporto, in the 18th-century Old Customs building "Alfândega do Porto". In spite of some differences in behaviour caused by the layout of these exhibitions, the results were similar: relative humidity was stable and energy consumption low.

In the case of the Old Barn the relative humidity was at first more difficult to control and we did not achieve the same stability we had before. It seemed to be just a problem of the humidifying equipment which had not been properly serviced; even after servicing we discovered that during the night the relative humidity levels would change 3% RH to 5% RH more then in the previous exhibition.

We realised then that there was a significant difference in the new design: the plywood panels had been entirely removed, thereby removing their humidity buffering capacity, just as Thomson had shown for wood in cases (Thomson 1966). Bearing in mind the overall stability of the room when empty and with all doors closed, it appears that these panels were at least partially responsible for the overall performance of the Barn during the Francisco Henriques Exhibition.

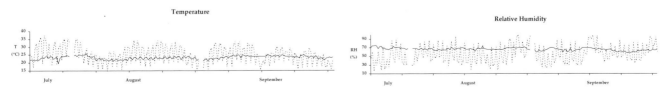

Figure 3. Temperature and humidity inside the Barn during the Francisco Henriques *exhibition – July, August and September 1997. Dotted lines: temperature and RH outside.*

Conclusions

The unusual design target we adopted was determined by the specific requirements of the works to be exhibited. The design solution was determined primarily by the characteristics of the building, but also to some extent by the engineer's caution about "inadequate" mechanical systems. It is useful to compare this project to one carried out earlier in a similar building in the same climate involving one of the authors (Casanova) and A. Lopes de Sousa. This was the Lisbon National Tile Museum, for the 17th Exhibition of the European Council. In that project, despite 2000 visitors per day, environmental conditions were kept within correct limits simply through the use of temperature-controlled ventilation, i.e., much less mechanical intervention than even the Barn project. Therefore, if one considers carefully the thermal and hygroscopic behaviour of the building, very simple mechanical systems can succeed for museums in this type of climate. Garry Thomson (1981, 88) once speculated about such places:

> Is there such a climate as a museum Temperate Zone, where throughout the year average daily RH remains within the moderately safe limits of 40 to 70% and heating is rarely required? There are a few such favoured places scattered along the Mediterranean littoral...

We think that, although slightly removed from that particular area, the Old Collective Barn in Évora is one such favoured place.

Ackowledgements

The authors gratefully acknowledge Isabel Ribeiro, of the Instituto de José de Figueiredo Laboratory, for kindly preparing the figures included in this paper.

References

Ashley-Smith J. 1995. IIC Bulletin (2, April): 4.

Beck W and Köller M. 1980. Problems of heating within historic buildings of Austria. In: Conservation within historic buildings. London: IIC: 22–29.

De Guichen G. 1980. Climate in museums. Rome: ICCROM.

Erhardt D and Mecklenburg M. 1994. Relative humidity re-examined. In: Preventive conservation practice, theory and research. London: IIC: 32–38.

Hilbert GS. 1987. Sammlungsgut in Sicherheit – Teil 2 Lichtschutz . Klimatisierung. Berlin: Gebr. Mann Verlag.

Michalski S. 1993. Relative humidity: a discussion of correct/incorrect values. In: Preprints of the 10th triennial meeting of the ICOM Committee for Conservation. Paris: ICOM: 624–629.

Thomson G. 1966. Relative humidity – variations with temperature in a case containing wood. Studies in conservation 11: 8–30.

Thomson, G. 1988. The museum environment. 1st ed. London: Butterworths.

Abstract

An air-conditioned museum and a naturally ventilated museum in a highly polluted part of London were compared for effectiveness of pollution control. Nitrogen dioxide, sulphur dioxide and hydrogen sulphide concentrations were measured inside and outside using diffusion tubes. Airborne particles were measured using a Grimm laser counting device. It was found that the benefits normally attributed to air-conditioning with filtration were not as great as might be thought. Only nitrogen dioxide and particle levels were significantly lower in the air-conditioned museum than in the naturally ventilated museum.

Keywords

preventive conservation, pollution, particles, natural ventilation, air-conditioning

Air pollution levels in air-conditioned and naturally ventilated museums: A pilot study

May Cassar
Museums & Galleries Commission
16 Queen Anne's Gate
London SW1H 9AA
UK

Nigel Blades★ and Tadj Oreszczyn
The Bartlett School of Architecture
Building, Environmental Design and Planning
University College London
Gower Street
London WC1E 6BT
UK
Fax: +44 171 916 3892
Email: n.blades@ucl.ac.uk

Introduction

There is an accumulating body of evidence that, from the conservation standpoint, relative humidity and temperature conditions in air-conditioned buildings are no better and may, in some cases, be worse than those achievable in naturally ventilated buildings (Oreszczyn et al. 1994). However, little is known in museums about the comparative behaviour of other important environmental parameters, namely pollutants and particles, under these different ventilation methods.

This study is a pilot investigation of these issues to determine the effectiveness of pollution control in an air-conditioned and a naturally ventilated museum building in a polluted urban environment. The air-conditioned Museum of London and the naturally ventilated National Museum of Childhood at Bethnal Green, also in London, were monitored for nitrogen dioxide, sulphur dioxide and hydrogen sulphide. These gaseous pollutants were selected because they had been identified as causes of object deterioration (Brimblecombe 1990) and were suitable for passive monitoring. Particle concentrations and fresh air ventilation rates were measured at the same time as the gaseous pollutants. Monitoring was carried out at internal and external locations so that indoor/outdoor ratios could be calculated. The aim was to obtain a snapshot of the effects of different ventilation regimes on gaseous and particulate pollution.

Measurement methods

Concentrations of nitrogen dioxide, sulphur dioxide and hydrogen sulphide were measured using diffusion tubes. These passive samplers contain a pollutant-specific chemical reagent which reacts with the pollutant to form a non-volatile compound that can later be analysed quantitatively in the laboratory. Diffusion tubes were exposed in triplicate sets at locations at each museum, for one month. The diffusion tube methods used have all been described in the literature. See, for example, Shooter (1993), Hargreaves et al. (1991) and Shooter et al. (1995).

A Grimm particle counter was used to measure airborne particles. This uses a laser-scattering technique to monitor the mass of particles in the size range 0.75–15μm per cubic metre of air. In still-air particles >15μm settle out whereas smaller particles can remain indefinitely suspended until they deposit on a surface. Particles in the range 0.1–2μm are normally considered the most important for museums (Thomson 1986), as this range normally contains the combustion-related particles that include sulphates and nitrates. This type of laser-scattering technique is not generally considered accurate for absolute measurements of particle mass. However reliable it is, the equipment is portable and relatively unobtrusive, and so it is ideal for taking measurements to compare one location with another.

★ Author to whom correspondence should be addressed

ENTRANCE LEVEL

1 Associates Room
2 Schools and Family Area
3 Entrance Hall
4 Orientation gallery
5 Temporary Exhibitions gallery
6 Prehistoric London
7 Roman London
8 Dark Age London
9 Saxon London
10 Medieval London
11 Tudor London
12 Early Stuart London

LOWER LEVEL

13 Late Stuart London
14 Eighteenth Century London
15 Nineteenth CenturyLondon
16 The Imperial Capital
17 Early Twentieth Century London
18 Second World War London
19 Temporary Exhibitions gallery
20 Treasury

Figure 1. Sampler locations at the Museum of London: (14) Eighteenth Century Gallery, (6) Prehistoric Gallery, (12) Stuart Gallery, (11) Tudor Gallery, (A) External, by entrance, (B) External, roadside, (C) External, a/c intake. Map reproduced by kind permission of the Museum of London.

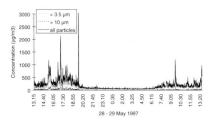

Figure 2. External particle concentrations at the Museum of London, 28–29 May 1997.

Measurements of the fresh air ventilation rate were carried out using the tracer gas technique (Liddament 1996). Sulphur hexafluoride, an inert gas not normally present in the atmosphere, was released into the museum air and its decay sampled at several locations.

Museum of London monitoring and results

Gaseous pollution monitoring tubes were exposed at 10 locations, between February and March 1997, with a subsequent batch of tubes (at the external air intake of the air-conditioning system and by the roadside) exposed between March and April 1997. Particle measurements were taken over three days in May 1997 at internal and external locations where gaseous pollutant measurements had previously been carried out. The locations are marked on the site map (Fig. 1).

Gaseous pollution

At the Museum of London there was an average external nitrogen dioxide concentration of 31ppb (Table 1), typical of a highly polluted urban location. The highest individual value, 37ppb, was measured at the roadside, closest to vehicle traffic which is the principal source of nitrogen dioxide in urban areas. Inside the museum the average concentration was 6ppb, only 19% of the average external concentration. Sulphur dioxide concentrations also showed a large decrease from 8ppb externally to 1ppb internally, which was also only 19% of the external concentration. In contrast to the behaviour of these two gases, hydrogen sulphide occurred at much more widely varying concentrations within the museum (ranging between 41 and 111ppt), and on average the internal concentration of hydrogen sulphide was slightly greater than the external concentration.

Particles

High external particle concentrations, comparable to those measured by the Government's tapered element oscillating microbalance (TEOM) monitor in central London, were found outside the Museum of London (Fig. 2). These appeared to correlate with traffic activity around the Museum. Concentrations

Table 1. Gaseous pollution measurements at the Museum of London, February–April 1997. Values are given as the mean result of three tubes exposed at each location. Detection limits (2-sigma) were NO$_2$ 0.1ppb, SO$_2$ 0.4ppb and H$_2$S 25ppt.

Location	Nitrogen dioxide (ppb)	Sulphur dioxide (ppb)	Hydrogen sulphide (ppt)
Eighteenth Century Gallery Ambient	6.2	1.4	41
Death and Burial Case			107
Pawnbrokers Shop Case 1 (with charcoal cloth)			37
Pawnbrokers Shop Case 2			84
Prehistoric Gallery Ambient	6.1	1.3	102
Prehistoric Gallery, Case T6 (vented)	1.8	<0.4	71
Prehistoric Gallery, Case T9 (unvented)	2.5	0.9	228
Stuart Gallery Ambient	5.2	0.6	111
Stuart Gallery Case 6	4.4	0.4	<25
Stuart Gallery Case 7 a	4.4	0.5	117
Stuart Gallery Case 7 b (near archaeological material)			250
Tudor Gallery Case T22			<25
External (under main entrance canopy)	27.9	8.8	86
External (roadside)	37.2	6.4	82
External (by air-conditioning intake)	26.7		< 25
Average indoor	5.8	1.1	85
Average outdoor	30.6	7.6	84
Average indoor concentration as % average outdoor	19	14	101

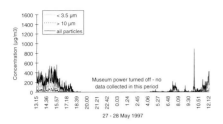

Figure 3. Internal particle concentrations at the Museum of London, 27–28 May 1997.

Figure 4. Sampler locations at the Bethnal Green Museum: (A) Store Room 24, (B) Main Gallery upper floor, (C) Main Gallery far end, (D) Main Gallery by front entrance, (E) External, south side, (F) External, east end, (G) external, north side. Map reproduced by kind permission of the Bethnal Green Museum.

began to rise in the early morning rush-hour period from 07.00 hours onwards. A steady concentration was maintained through the morning, rising in the afternoon to a peak level of around $100\mu gm^{-3}$ between the hours of 17.00 and 19.00. By 20.00 hours concentrations had fallen off considerably, and then declined further to a background level of less than $25\mu gm^{-3}$ which was maintained until the following morning.

Whilst external particle concentrations seemed closely associated with traffic levels, inside the Museum of London (Fig. 3) they seemed to depend more on the number of visitors and the level of human activity. In the early morning, from 04.00 to 07.00 the internal particle concentration was below $10\mu gm^{-3}$. As daytime employees started arriving for work, and the Museum was cleaned prior to opening, concentrations began to rise. There was a sharp rise just after 10.00, when the Museum opened to the public and concentrations picked up quite rapidly from then to around $40\mu gm^{-3}$. Between 14.00 and 16.00 concentrations were at their highest, with a maximum of $84\mu gm^{-3}$. From 16.00 levels fell slowly until 18.00, after which time there was a rapid decrease to less than $10\mu gm^{-3}$. Thus, the internal particle concentration had already reached a low level whilst the external concentration was still quite high. Although data were not collected in the Museum between 19.00 and 04.00 because of a power failure, it seems likely that the concentration remained below $10\mu gm^{-3}$ throughout this period, when there was minimal activity in the Museum.

This air-conditioned museum had a measured fresh air ventilation rate of 1.3 air changes per hour (ach^{-1}). However, as approximately 80% of the air is recirculated, the overall ventilation rate was probably close to $6.5ach^{-1}$. This means that there was considerable air movement within the galleries and that this quantity of mixed fresh and recirculated air passed through the filters. The level of fresh air (20%) is considered high for such a large building, which may be good in terms of dissipating pollutants generated by the visitors but results in high energy consumption. Given the age of the services at the Museum of London, the system is considered to be a well-maintained and well-run system, which incorporates both high specification particle and gaseous filtration.

Bethnal Green Museum monitoring and results

Pollution monitoring tubes were exposed at seven locations, between March and April 1997. Particle measurements were taken over three days in May 1997 at internal and external locations where gaseous pollutant measurements had previously been carried out. The locations are marked on the site map (Fig. 4).

Gaseous pollution

The Bethnal Green Museum is located 3km east of the Museum of London, in a similarly urban and highly-polluted environment. The average monitored external

Table 2. Gaseous pollution measurements at the Bethnal Green Museum, March–April 1997. Values are given as the mean result of three tubes exposed at each location. Detection limits (2-sigma) were NO_2 0.1ppb, SO_2 0.4ppb and H_2S 25ppt, nd = not detected.

Location	Nitrogen dioxide (ppb)	Sulphur dioxide (ppb)	Hydrogen sulphide (ppt)
Store Room 24	19.8	2.5	nd
Main Gallery, upper floor, top of Sleep case	25.2	3.3	nd
Main Gallery, far end, top of Puppet Theatre	22.7	2.3	nd
Main Gallery by front entrance, above Dolls case	22.8	6.6	nd
External – East End	26.2	19.2	nd
External – South Side	28.6	26.3	nd
External – North Side	25.7	23.1	nd
Average indoor	22.6	3.7	
Average outdoor	26.8	22.9	
Average indoor concentration as % average outdoor	84	16	

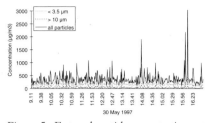

Figure 5. External particle concentrations at the Bethnal Green Museum, 30 May 1997.

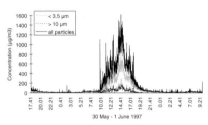

Figure 6. Internal particle concentrations at the Bethnal Green Museum, 30 May–1 June 1997.

nitrogen dioxide concentration at the Bethnal Green Museum was 27ppb (Table 2). This only decreased slightly inside the building to an average value of 23ppb, representing 84% of the external concentration. External sulphur dioxide was higher at this site than at the Museum of London, with an average level of 23ppb. However, this showed a pronounced decrease inside the museum where the average concentration was only 4ppb, representing 16% of the external concentration. No hydrogen sulphide was detected at this museum.

Particles

External levels of particles were again high during the day (Fig. 5) and remained at a steady level throughout the day. The working day average concentration was 62μgm$^{-3}$, compared to 53μgm$^{-3}$ at the Museum of London. Because data were only collected during the daytime, it was not possible to say with certainty that external particle concentrations correlated with diurnal traffic flow, though given the similarity of the external environment to that of the Museum of London, this seems probable.

Inside the Bethnal Green Museum (Fig. 6), it appeared that particle concentrations could again be correlated with visitor numbers. Concentrations began to rise sharply after the Museum opened at 10.00, and reached a peak of 303μgm$^{-3}$ between 14.00 and 16.00, declining gradually thereafter. There was no evidence of a similar peak on the previous day, a Friday (time 1741, at the very beginning of the graph), when the Museum was closed to the public. This confirmed the view that particles in the Museum happened to correlate with visitor numbers.

The Bethnal Green Museum air exchange rate measured 0.3ach$^{-1}$. This is a low level of ventilation for a domestic-scale, old, naturally ventilated building. However, the measurements were taken when the wind speed was low and there was little temperature difference between outside and inside. This would result in the ventilation rate being close to its lowest value. The actual ventilation rate during the gaseous pollution monitoring may have been higher because there was a greater temperature difference between inside and outside and possibly higher wind speed. These factors tend to increase the ventilation rate, especially in a naturally ventilated building. Ideally, several air exchange measurements would have been made under a variety of temperature and wind conditions, to determine the range of the air change rates that occur in the Museum.

Discussion

One of the most notable aspects of this study was the difference in nitrogen dioxide concentrations inside the two museums. At the Bethnal Green Museum the average internal concentration was 84% of the external concentration. This result is typical of naturally ventilated museum buildings (see e.g. Blades 1995). At the Museum of London the average internal nitrogen dioxide concentration was only 19% of the external concentration, indicating that the museum's air-conditioning and filtration system was effective at removing nitrogen dioxide.

The sulphur dioxide concentration at the Bethnal Green Museum followed a typical pattern for a naturally ventilated building, in that the high external concentration fell rapidly as measurements were taken further into the interior of the building. This is thought to occur because sulphur dioxide is more reactive than nitrogen dioxide, more readily reacting with surfaces such as interior walls and floors, and objects on open display. So, the further into the interior the gas penetrates, the more opportunity it has to react with a surface, and hence the lowest concentrations should occur at the heart of the building. This is apparent from the Bethnal Green Museum data, where the highest internal value occurs close to the main entrance, with reduced concentration at the far end of the gallery and in store room 24. At the Museum of London there is a similar pattern of high sulphur dioxide externally and very low values of about 1ppb internally.

Although the absolute levels of sulphur dioxide were higher at Bethnal Green Museum (around 25ppb), compared with those at the Museum of London (around 8ppb), there was very little difference in the internal/external ratios, which were 16% and 14%, respectively. While it is possible to attribute the Museum of London's reduction in concentration to the air-conditioning system, this is only of

the same order as that achieved by the building fabric and reduced air exchange rate at the Bethnal Green Museum. Studies of other similar naturally ventilated museums have found internal sulphur dioxide values at 20–40% of the external values (Leissner et al. 1997).

Whereas nitrogen dioxide and sulphur dioxide have mainly external sources, such as motor vehicle emissions and fossil fuel combustion respectively, hydrogen sulphide can originate from a wider range of sources, external and internal, such as motor vehicles, standing water, decay of biological matter and other biological processes, construction and decorative materials. This fact is reflected in the behaviour of hydrogen sulphide measured at the Museum of London. In contrast to the fairly uniform nitrogen dioxide and sulphur dioxide concentrations in the gallery, hydrogen sulphide occurred at varying concentrations throughout the galleries, suggesting that indoor point sources for the gas were important. The average internal hydrogen sulphide concentration exceeded the external concentration, indicating that the air-conditioning and filtration system is not effective at reducing the hydrogen sulphide concentration to below the external level, despite both fresh and recirculated air being passed through activated carbon filters.

High concentrations of external particles were measured at both museums, with daytime averages of $53\mu gm^{-3}$ at the Museum of London and $62\mu gm^{-3}$ at the Bethnal Green Museum (Table 3). It was apparent that the Museum of London's air-conditioning and filtration system was effective at reducing internal particle levels: the daytime internal concentration was $29\mu gm^{-3}$ which was 55% of the external value. The particle size distribution inside the Museum of London was different from that outside, with a lesser proportion of small particles and a higher proportion of large particles. The air-conditioning's filtration system may be less effective at removing larger particles because these tend to be generated locally, rather than carried in with external air (Weschler et al. 1996). At the Bethnal Green Museum the average daytime internal particle concentration ($93\mu gm^{-3}$) was 1.5 times greater than the external concentration, and the ratio of small to large particles was approximately the same inside and outside the Museum. In both museums, once the visitors had departed, the particle levels fell back rapidly to overnight concentrations of less than $10\mu gm^{-3}$.

Conclusion

The Bethnal Green Museum is a well-sealed, naturally ventilated building, with a low air exchange rate of $0.3ach^{-1}$, albeit measured under conditions favouring low values. The Museum of London has a well-maintained and well-operated air-conditioning system incorporating both chemical and particle filtration, producing a fresh air exchange rate of $1.3ach^{-1}$, which is high for an air-conditioned building. It would be reasonable therefore, to consider both buildings as good examples of their respective type, that is, producing the most favourable conditions for pollutant removal.

What then were the relative merits of their different ventilation regimes, from the point of view of pollution control?

Both museums in this study are located in one of the most highly polluted areas of the United Kingdom. Yet, it is apparent that the benefits of the air-conditioning/filtration system were not as great as might have previously been

Table 3. Summary of particle monitoring data.

Particle size range		Bethnal Green Museum Concentration (μgm^{-3})	Museum of London Concentration (μgm^{-3})
Data from daytime (9am–5pm) only:			
<3.5μm	Average indoor	8	2
	Average outdoor	6	13
>10μm	Average indoor	42	17
	Average outdoor	27	16
Total particles	Average indoor	93	29
	Average outdoor	62	53
All data:			
Total particles	Average indoor	26	12
	Average outdoor	62	41

thought. The main pollution benefit of the air-conditioning system with carbon filtration was in the reduction in nitrogen dioxide concentrations. The limit suggested by Thomson (1986) of 10μgm⁻³ (5ppb) for this pollutant was not exceeded at the Museum of London, but was exceeded at the Bethnal Green Museum. Damage effects attributed to nitrogen dioxide include the loss of colour of pigments (Whitmore and Cass 1989), weakening of textiles and synergistic effects with metal tarnishing-pollutants (Brimblecombe 1990; Fiaud and Guinement 1986). However, with the exception of large metal objects and large textiles, these objects are likely to be displayed in cases that are known to achieve large reductions in external pollutant concentration (Leissner et al. 1997), usually below the Thomson limit. It should be stated that whilst this limit is a useful guide, as yet there is no international agreement as to what level of pollutant would constitute an acceptable level of damage.

Thomson (1986) also suggests a limit of 10μgm⁻³ (4ppb) for sulphur dioxide. The Museum of London's internal locations all had values well below this level. However, this standard was also achieved at three of the four internal locations at the Bethnal Green Museum, the exception being the location closest to the main entrance. This suggests that from the point of view of reducing sulphur dioxide concentrations, the Museum of London's air-conditioning system did not represent a significant advantage. It is true that inside the Bethnal Green Museum some sulphur dioxide deposition will take place on object surfaces, but the surface area of objects on open display represents only a small fraction of the total interior surface area, and so only a small fraction of internal sulphur dioxide will be deposited on museum objects.

Hydrogen sulphide did not appear to be controlled by the filtration system at all. Theoretically, carbon filters should be able to trap hydrogen sulphide, but they may fail to do so for a number of reasons. The measured ambient hydrogen sulphide concentrations, although able to tarnish metals, were all extremely low – in the parts per trillion range – some 100 times lower, than the nitrogen dioxide and sulphur dioxide concentrations. It may be difficult to design a filter that is efficient at removing such a low concentration from the large volumes of air that are being filtered. Even if this was achieved, gallery air-conditioning may not solve the problem of sulphide tarnish which is frequently caused by hydrogen sulphide emissions from inside display cases.

These conclusions are further substantiated by comparing the monitored results from this study with a similar study of internal/external pollutant levels measured in a naturally ventilated office and air-conditioned office without carbon filtration (Kukadia and Palmer 1996). The naturally ventilated building in this study has lower sulphur dioxide and nitrogen dioxide levels than Kukadia (Table 4) because of the lower ventilation rate. For gases which are less reactive such as nitrogen dioxide, ventilation rate has a smaller impact. The data from the office study and from this study show less reduction in sulphur dioxide in the building without recirculation or filtration. An even greater impact can be seen with nitrogen dioxide where the conventional air-conditioned office building with no recirculation or carbon filtration reduces the external pollution concentration by only 20% whereas recirculation plus carbon filtration in the museum reduces the external concentration by 60%.

The Museum of London's filtration system reduced particle concentrations significantly. The air-conditioned building was able to mitigate short-term peaks

Table 4. Average indoor concentrations as percentage of average outdoor concentrations for two different studies

Study	Ventilation method	Air exchanges per hour	Sulphur dioxide	Nitrogen dioxide
This study	Natural ventilation	0.3	16%	84%
Kukadia and Palmer	Natural ventilation	1.6	40%	90%
This study	a/c with recirculation and carbon filtration	1.3	14%	19%
Kukadia and Palmer	a/c with no recirculation or carbon filtration	1.2	40%	80%

in particles much better than the naturally ventilated building. However, at both museums particle concentrations declined quickly once the visitors had departed. This may have implications for the management of public areas in museums. Storage areas and less visited parts of the building may maintain low particle concentrations without air-conditioning, whatever the external environment. It may be possible to develop strategies that reduce particle concentrations by changing cleaning regimes and using floor surfaces or coverings that do not retain dust.

As a result of this pilot study, further research is underway to verify and expand on these conclusions. A wider sample of museum buildings is being studied, ozone will be monitored, and controlled interventions carried out in an attempt to improve pollution control in naturally ventilated and air-conditioned museums.

Acknowledgements

This project was initiated and financed by the Museums & Galleries Commission of the UK. We would like to thank the Bartlett School for its support, and in particular the following staff and students: Dr Alan Young, who surveyed the building services; Dr Ian Ridley, who carried out the ventilation measurements; and James Murphy, who carried out the particle measurements. We would particularly like to acknowledge the Museum of London and Bethnal Green Museum for providing support and access to their sites for this work. We also wish to acknowledge the contribution of the School of Environmental Sciences, University of East Anglia, where part of the analytical work was carried out.

References

Blades NW. 1995. Measuring pollution in the museum environment. V&A Conservation Journal 14: 9–11.

Brimblecombe P. 1990. The composition of museum atmospheres. Atmospheric Environment 24B(1): 1–8.

Fiaud C and Guinement J. 1986. The effect of nitrogen dioxide and chlorine on the tarnishing of copper and silver in the presence of hydrogen sulphide. Proceedings of the Electrochemical Society 86(6): 280–304.

Hargreaves KJ, Atkins DHF, Bennett SL. 1991. The measurement of sulphur dioxide in the outdoor environment using passive diffusion tube samplers: a first report. Environment and Energy, Harwell Laboratory.

Kukadia V and Palmer J. 1996. The effects of external atmospheric pollution on indoor air quality. In: Proceedings of the 17th AIVC Conference 'Optimum Ventilation and Air Flow Control in Buildings', Gothenberg, Sweden, 17–26 September 1996. Coventry: Air Infiltration and Ventilation Centre: Vol. 1, 41–49.

Leissner J, Beuschlein S, Pilz M, Martin G, Blades N and Redol P. 1997. Assessment and monitoring the environment of cultural property. Final report 1993–1996. EC Environment Programme; Contract number EV5V-CT92-0144 'AMECP' (Brussels: European Commission).

Liddament MW. 1996. A guide to energy efficient ventilation. Coventry: The Air Infiltration and Ventilation Centre.

Oreszczyn T, Cassar M, Fernandez K. 1994. Comparative study of air-conditioned and non-air-conditioned museums. In: Roy A and Smith P, eds. Preprints of the Contributions to the Ottawa Congress, 12–16 September 1994, Preventive Conservation: Practice Theory and Research. London: IIC: 144–148.

Shooter D. 1993. Nitrogen dioxide and its determination in the atmosphere – a simple method for surveying ambient pollutant concentrations. Journal of Chemical Education 70(5): A133–A140.

Shooter D, Watts SF, Hayes AJ. 1995. A passive sampler for hydrogen sulphide. Environmental monitoring and assessment 38: 11–23.

Thomson G. 1986. The museum environment. 2d ed. London: Butterworths.

Weschler CJ, Shields HC, Shah BM. 1996. Understanding and reducing the indoor concentration of submicron particles at a commercial building in Southern California. Journal of the Air and Waste Management Association 46: 291–299.

Whitmore PM and Cass GR. 1989. The fading of artists' colorants by exposure to atmospheric nitrogen dioxide. Studies in conservation 34: 85–97.

Abstract

The Victoria and Albert Museum houses a large and diverse collection of works of art on paper. Each year approximately 1,500 paper objects will go on display either within the museum or as travelling exhibitions and loans. This large number of works of art on paper that are exposed annually has led to a desire for a policy to protect the more light-sensitive objects. On the other hand, the sheer quantities involved have tended to ensure that these good intentions have not been implemented for fear of overburdening both curators and conservators with unrealistic demands for rotation. It became apparent that any light policy one could hope to introduce would have to be 'user friendly' and workable so as not to put a drain on resources. This paper looks at the formation and introduction of a light policy for works of art on paper at the V&A Museum. A simplified categorisation system was eventually opted for in which objects are classified as 'Sensitive' if they are coloured or on discoloured paper and 'Durable' if they are black-and-white on good quality, white paper. A special 'Zero tolerance' category is also suggested for objects that should only be considered for display under exceptional circumstances.

Keywords

paper conservation, light policy

A proposed practical lighting policy for works of art on paper at the V&A

Alan Derbyshire* and Jonathan Ashley-Smith
Conservation Department
Victoria and Albert Museum
London SW7 2RL
UK

Introduction

Towards the end of 1993 the Prints, Drawings and Paintings Department at the V&A indicated their desire to have a light policy. Their main concern centered on the repeated demand for certain key objects to be loaned or displayed. It was felt that a light policy should be one of the criteria used in considering these requests. The Paper Conservation section was asked to produce a draft paper.

In 1994 a draft discussion paper was written based largely on the three-tier categorisation system evolved by Feller (material stability categories A, B, C) and modified by Michalski (1990) into sensitive, intermediate and durable categories according to their ISO ratings.[1] Table 1 below shows the relevant data on which these calculations are based. Table 2 shows the system first suggested for the V&A.

The paper was well-received but was never implemented for two main reasons. Firstly, doubt was cast as to how objects could be categorised without time-consuming and technically difficult pigment analysis. Secondly the suggested exposure levels allowed for sensitive category objects to be exposed for only four weeks in any one year – the implications for increased workload were felt to be too great.

Implementation of a workable light policy

In 1998 the need for a light policy became apparent again with the proposed re-designing of the British Galleries at the V&A. This major project due to open in July 2001 will involve the permanent display of some 500 works of art on paper and other related, light-sensitive objects such as portrait miniatures on ivory. It was necessary to ensure that objects not normally considered for permanent display would be protected from overexposure.

It was decided that the proposals for a light policy should be revisited.

Table 1. The amount of exposure in million lux hours to cause one just noticeable fade. Assumes no UV. Data derived from Michalski 1990.

ISO level	I	2	3	4	5	6	7	8
Million lux hours to cause one just noticeable fade[2]	0.4	1.2	3.6	10	32	100	300	900
Categories	Category A Sensitive			Category B Intermediate			Category C Durable	

Table 2. Recommended annual exposure levels, 1994 draft, for the three main categories of objects.

	Exposure to cause one just noticeable fade	Recommended annual exposure limit	Just noticeable fade in years	Light level
Category A Sensitive ISO levels 1, 2 & 3	1.2 million	4 weeks	115	50 lux
Category B Intermediate ISO levels 4, 5 & 6	10 million	12 weeks	320	50 lux
Category C Durable ISO levels 7, 8 and above	300 million	24 weeks	4,785	50 lux

* Author to whom correspondence should be addressed

If the policy were to be accepted and used it would be necessary that:

- the categorisation of objects be simple
- any increased use of resources be kept to a minimum
- light-sensitive objects be offered better protection

Categorisation of objects

At the time of considering this paper, the V&A's Environment Policy (Martin 1993) covered the issue of light in a general way. It recommended that light levels should be between 50 lux and 250 lux with 'a maximum annual exposure of 200,000 lux hours for highly light-sensitive materials'. This meant that works of art on paper could be on annual display at 50 lux for 4,000 hours, i.e. 10 hours a day, seven days a week all year round. There was no attempt to distinguish between a black-and-white print on good quality paper or a watercolour with potentially fugitive colours.

The previous attempt (1994 draft) to categorise objects as sensitive, intermediate or durable seemed good in theory but had failed in practice for the reasons already mentioned. However there was an increased level of awareness of the problem and it soon became apparent that, when asked for advice on an object's sensitivity to light, a general rule of thumb was emerging.

Objects that are coloured or on poor quality/discoloured paper are thought of as being sensitive. Black-and-white objects on good quality/white paper are considered durable.

This is based on the assumption that many coloured objects are likely to contain at least one pigment that is particularly sensitive to light; also white paper reflects visible radiation and will not be damaged by it.

This seemed to be a simple and effective way of broadly categorising objects. Both curators and conservators would be able to follow this rule without a need for pigment analysis or any great knowledge of materials and techniques.

In terms of ISO levels the following two broad categories approximate to the above rule of thumb:

- ISO levels 1–4 to cover sensitive pigments and materials as might be found in watercolours, Indian miniatures, portrait miniatures (on ivory and vellum), pastels, Old Master drawings in sepia and bistre, coloured prints and Japanese prints. Various coloured and early photographic processes would also be included. Works of art on poor quality paper or paper that had discoloured would also be included.
- ISO levels 5–8 to cover more durable pigments and materials on good quality white paper such as drawings in graphite or charcoal, black-and-white engravings and etchings etc. Black-and-white fibre based photographs would also be included.

Having categorised objects as either sensitive or durable it was then necessary to decide on an acceptable rate of fading. Table 3 below looks at the amount of annual exposure that will cause one just noticeable fade (1 JNF) within various time scales from 10 years to 200 years. Choosing a fading rate will inevitably be a subjective decision. However it has been estimated that 30 JNF's will cause complete fading of an object and that 10 JNF's will probably cause unacceptable change or damage to an object.

Table 3. Annual exposure of 3,000 hours (@ 8 hours a day) at 50 lux to produce one JNF within various time scales.

ISO Level	1 JNF within 200years	100 years	50 years	20 years	10 years
1	1 week	2 weeks	4 weeks	10 weeks	20 weeks
2	2 weeks	4 weeks	8 weeks	20 weeks	40 weeks
3	6.5 weeks	13 weeks	26 weeks	65 weeks	2.5 years
4	18 weeks	36 weeks	72 weeks	3.5 years	
5	1 year	2 years	4 years		
6	3.5 years				
7	10 years				
8	31 years				

It is interesting to look at the consequences of choosing a fading rate of 1 JNF in 50 years, for example. If 10 JNF's were considered to bring an object to a point of unacceptable fading then this would give an object a life of some 500 years. This is not a particularly long time especially if we consider that many objects have been around for a fair proportion of this time and probably at higher light levels than 50 lux. Consequently if ISO level 2 is chosen as the average for the sensitive category (ISO 1–4), an object should only be displayed for eight weeks per year at 50 lux, i.e. about 20% of the time. However objects that fall into the durable category can be on permanent display at 150 lux.

A practical example of the implications of the above reasoning can be considered for the Nehru Gallery at the V&A. Indian miniatures, classified as being in the Sensitive category (ISO 1–4) are, at the moment, rotated every two years, having been on continuous display at 50 lux. According to the above scenario these objects should only be on display 20% of the time at this level. To maintain the acceptable rate of fading to 1 JNF within 50 years would mean that these miniatures should come off display after the two year period and be in dark storage for the next eight years. As this ties in broadly with current practice, there would not be a greatly increased workload for curators or conservators.

It should be noted we still recommended the traditionally suggested figure for lighting works of art on paper of 50 lux for sensitive category objects. This figure was first suggested back in the early 1960s by Thomson (1961) as a maximum level for the display of works of art on paper. 50 lux is a somewhat arbitrary figure based on trying to balance good viewing with good conservation. Still the 50 lux figure is reasonable in that for most people it allows them to discriminate between colours and see detail (Boyce, 1987). Michalski (1997) has suggested that a factor of ×3 be introduced to compensate for the following variables: low contrast, dark surfaces, older viewers and limited viewing time. Although the reasoning behind this is acknowledged, it was decided that allowing sensitive category objects to be viewed at 150 lux (50 lux ×3) would require an unacceptable increase in the rate of fading.

Recording the information

For this policy to work it will be necessary to log each object's sensitivity category and its cumulative exposure. With this in mind the museum's computerised Collections Information System (CIS) will have fields to record this information. Once a request for display or loan is confirmed an object's details can be entered onto CIS. Subsequent requests will have to be checked against the object's 'exposure history'.

Where rotation of sensitive category objects is neither possible nor desirable i.e. in primary galleries, then in order not to exceed the desired percentage of displayable time other systems will have to be employed. For example the display of portrait miniatures in the new British Galleries could rely on the use of curtains or push button lighting systems. We would then have to assume that the public would on average only expose the miniatures a certain percentage (20%) of the time. It would be necessary to monitor this to check that the desired exposure is not being abused. It is proposed that push-button lighting systems in the British Galleries are fitted with loggers to total the amount of time they are switched on.

Zero tolerance category

It is also argued that a third category, a 'zero tolerance category', should exist for objects that are extremely sensitive to light such as some photographic processes or objects where the colour itself is of archival value. Some light-sensitive objects in pristine condition could also be included in this category. These types of object should only be examined by scholars or only be on display to the public for exceptionally short periods of time – if at all.

Conclusion

The intent of this paper was to propose a policy that would be readily accepted. This has meant simplifying the categorisation system for ease of use, suggesting a

fading rate that does not increase the need for rotation to unmanageable levels and yet offering better protection for light-sensitive objects.

Curators from all departments within the museum have been consulted and have voiced their approval of the policy as detailed below.

It is recommended that a three-tier system be employed for categorising objects:

1. Zero Tolerance Category to include extremely light-sensitive objects, objects where colour is of archival importance and some objects in pristine condition.
2. Sensitive Category to include coloured objects or objects on poor quality or discoloured paper.
3. Durable Category to include black-and-white objects on good quality paper.

It is further recommended that we accept a fading rate of 1 JNF in 50 years. This would allow sensitive category objects to be displayed at 50 lux for 20% of the time i.e. approximately 10 weeks in any one year or one year in any five-year period. However in order to avoid an object's quota of exposure being used up too rapidly, sensitive category objects should be rotated after a maximum of two years, if on continuous display.

Sensitive category objects in primary galleries, e.g. the British Galleries, will rely on a publicly operated system such as push-buttons or curtains to reduce their annual exposure to the 20% level. The effectiveness of this display-type regulation should be monitored over a suitable period, e.g. two years.

Durable category objects can be on permanent display at 150 lux.

The zero tolerance category may be a somewhat controversial idea but if accepted it would offer the extra protection that some objects need. Objects placed in this category should only be considered for display in exceptional circumstances.

It is envisaged that this policy, once initiated, will be reviewed within five years.

Acknowledgements

The authors would like to thank their colleagues at the V&A for their assistance and suggestions in writing this paper.

Footnotes

1. In an attempt to acknowledge the different effects of light on various materials and pigments it is now common practice to place objects in various categories, which reflect their sensitivity to light. This categorisation is normally done using ISO (International Standards Organisation) Standard R105 (equivalent to British Standard BS 1006). This is a series of eight blue-dyed wool cloths that fade at a known rate, each one fading at about half the rate of the preceding standard in the series. The material being tested is exposed to light and compared to these blue wool standards and is classified from ISO 1 to ISO 8 – ISO 1 being the most sensitive and ISO 8 being the least.
2. This concept of 'just noticeable fade' or JNF needs some explanation. Again it can be related to a British Standard, BS2662, and is a measure of the change in contrast between a faded and an unfaded part of the same material. This GGS (geometric grey scale) classified as GGS1–GGS5 is rated such that GGS5 is unchanged whilst GGS1 shows considerable change in contrast. Essentially GGS4 is considered to be a just perceptible change equivalent to 1 JNF.

References

Boyce P. 1987. Visual acuity, colour discrimination and light level. In: Lighting in museums, galleries and historic houses. London: Museums Association: 36–49.

Martin G. 1993. Preventative conservation guidelines for developments July 1993 Science Group report number 96/38gm. London: Victoria and Albert Museum.

Michalski S. 1990. Time's effects on paintings. In: Shared responsibility. Ottawa: National Gallery of Canada: 39–53.

Michalski S. 1997. The lighting decision. In: Fabric of an exhibition: an interdisciplinary approach. Ottawa: Canadian Conservation Institute: 97–104.

Thomson G. 1961. A new look at colour rendering, level of illumination, and protection from ultraviolet radiation in museum lighting. Studies in conservation 6: 49–70.

Abstract

A problem faced in many countries is the difficult adaptation of historic buildings into museums, galleries and storage areas, making environmental control problematical. In addition to this, institutions have to work with low budgets to conserve their collections. In this paper we present our experience with the improvement of the climatic conditions in the storage room at Museu Mineiro. It has been done with few financial resources by adopting simple measures that have led to good results.

Keywords

museum artifacts, storage room, climate control, tropical climate

Practical climate control at the Museu Mineiro, Belo Horizonte, Brazil: A cheap and simple solution

Maria Cecília de Paula Drumond
Superintendência de Museus do Estado de Minas Gerais
Av. Joao Pinheiro, 342
Belo Horizonte, MG 30130-180
Brazil
Fax: +55 31 2691102

Márcia Almada★
R. Rio Grande do Norte, 355/202
Funcionários
Belo Horizonte, MG 30130-130
Brazil
Telephone/fax: +55 31 2246715
Email: campos2@uol.com.br

Introduction

The climatic conditions in tropical countries like Brazil are unfavorable to conservation of artworks. High temperature and relative humidity all year round and the large daily fluctuations of these levels do not contribute to good conservation of the artistic and historical handicrafts (de Guichen 1984). The adaptation of buildings into museums, galleries and storage areas makes it difficult to develop effective environmental control. In addition to this, institutions have to work with very low budgets to conserve their collections.

The situation at SEC/MG (Culture Secretary of the State of Minas Gerais) is no different from that of other Brazilian institutions. The main museum of SEC/MG, the Museu Mineiro in Belo Horizonte, has always functioned with few resources, just like many other public departments. There are more than 2,000 works of art in the storage room at the Museu Mineiro, including valuable *Barroco Mineiro* handicrafts. In this paper we present our experience with the improvement of the climatic conditions in the storage room at the Museu Mineiro. It has been done with few financial resources by adopting simple measures that have led to good results.

History

The Museu Mineiro is installed in one of the most beautiful buildings in Belo Horizonte and dates to the foundation of the city. It was originally built in the late 19th century as a residence for the Secretary of State for Agriculture in the State of Minas Gerais. The building has undergone many architectural interventions, on its façade as well as in the interior, to adapt to its various functions.

The Museu Mineiro was created in 1977. Its collection of coins, armory, furniture, art on paper, documents, maps, stone objects and religious art from the 18th and 19th centuries represents an important collection of this period in Minas Gerais. The main museum goal is to offer to the public a complete vision of the art and history in the state of Minas Gerais, inserting that into the larger context of the history of Brazil as a colony of Portugal, an empire and a republic.

Storage room

When the Museu Mineiro was created, an 81m² room was chosen to store the collection. This room is situated at the ground level to make access easier. It has external walls facing two corridors and used to have two external windows. The two windows were removed and security was improved; however, soon the climate problem appeared. Paint loss on sculptures, deformation of canvas, mold growth and termite infestation were problems created by this unsuitable place. In 1985, when Museu Mineiro was opened, not much could be done: we could just

★ Author to whom correspondence should be addressed

measure the temperature and relative humidity levels with dial hygrothermographs. These measurements were done twice daily and manually registered. High temperature and relative humidity levels, and worse, high daily RH fluctuations were observed. In the summer (rainy period from November to February) RH reached up to 90% and during the winter (dry period) RH was around 60%. On September 25, 1989 a 13.5% RH variation was registered.

Climatic stabilization measures were tried using dehumidifiers and fans, but they did not solve the problem due to the difficulty controlling the levels and the time operation of the equipment. Beside this, we did not have the appropriate equipment to measure relative humidity and temperature and to control the amount of water vapor that had to be taken out of the room. Fans were installed to make the air circulate and control the mold growth (Lee 1988). In addition to that a small Brazilian-made piece of equipment, called Sterilair®, was used to eliminate the mold spores in air by circulating the air through it at high temperatures.

Modifications implemented

In later 1991 it was possible to implement some modifications in the conservation laboratories and in the storage room. Although we did not have the resources to execute a total modification of the space, we believed that something could be done to improve the climate conditions. We considered the possibility of installing an air-conditioning system, but this solution would not be compatible with our budget. Many people can argue that maintaining a climatic control system is cheap if you consider the value of the collection. But even if resources had been available to implement a whole system at that time, we were sure that we would not have the money to maintain it (Lee 1988). Another important consideration is that we could not use a climatic control system only in the storage room while the exhibition and working areas remained under poor conditions. So we had to work with alternative strategies.

Considering that the adoption of an air-circulation, temperature and relative humidity control system would be very expensive, we sought alternative measures to adapt the storage room (Stehkamper 1988). The room had a precarious rain drainage system, which was the main source of water inside the room. So, the first step was to eliminate the external cause of humidity by improving the rain drainage system of the external area. The second step was to find a material to make the floor and walls impermeable, avoiding the admittance of water by capillarity. The material chosen was Sika1® – inorganic salts watertight additive – through consideration of its quality and low price. The original floor revetment was removed and three layers of Sika1® were applied. After this, another cement floor was made. The revetments of walls were removed to the height of 80cm and the Sika1® was applied in three layers.

In order to improve the air circulation, two windows were opened between the conservation laboratories and the storage room. They were covered with non-woven tissue stretched over a wood frame to reduce the incoming dust and pollution.

Table 1. *Climatic features of Belo Horizonte: mean values, 1910–1981.*

Month	Temperature (° C)			Relative Humidity (%)	Rain (mm)	Evaporation (mm)
	Minimum	Medium	Maximum			
January	18.5	22.0	27.7	76.0	296.0	98.7
February	18.5	22.7	28.1	75.1	200.4	77.0
March	18.0	22.0	27.9	75.3	178.9	84.7
April	16.6	21.1	27.0	74.0	66.7	83.4
May	14.1	19.1	25.4	70.0	23.2	79.1
June	12.4	17.9	24.5	68.4	11.3	83.7
July	12.0	17.4	24.2	67.3	10.1	92.0
August	13.4	19.0	26.0	62.9	13.1	119.3
September	15.4	20.6	27.1	64.1	36.5	123.0
October	17.0	21.4	27.1	69.6	127.9	107.9
November	17.6	21.7	26.5	73.7	235.0	87.4
December	18.0	21.8	26.7	76.9	317.5	78.0
Annual Values	16.0	20.6	26.5	71.1	1516.6	1114.2

Figure 1. Temperature and RH inside the storage room; weekly variation; September, 1993.

Figure 2. Temperature and RH in the conservation laboratory; weekly variation; September, 1993.

The goal of these measures was to reduce the RH but the results obtained were better than we had expected. Five months after the adoption of these measures, the temperature and RH came to adequate levels, considering the history of the objects (Cassar 1985) (See Table 1) and the conditions of the exhibition areas.

Nowadays, the RH is around 75% in the rainy period and 60%, in the dry period. The maximum weekly RH variation is 6%. The temperature remains around 25°C. It must be noted that these values were obtained with hygrothermographs installed in the storage room and in the laboratories after the implemented modifications (See Figs. 1, 2).

Conclusion

The situation had been drastic for many years, in fact, since the Museum was created. The museum staff worked as a team, using our experience analyzing many similar situations in the institutions we had visited and with the collaboration of experienced professionals. We also based our work on specialized literature most of which, unfortunately, is about temperate climate.

In spite of our few resources, a very successful job could be done, with simple measures, to solve the problem of the climatic conditions in the storage room at Museu Mineiro. Dr. Cecily M. Grzywacz of the Getty Conservation Institute

wrote, in a letter to the superintendent of Museu Mineiro: "I must say we were very impressed with the Museu Mineiro. The changes you have implemented in the last few years are especially remarkable. You and your staff should be commended for the excellent work you have done to raise the level of preventive conservation both in the galleries and in the storage area. I hope you will allow us to mention the Museu Mineiro as a example to strive towards" (Grzywacz 1994).

References

Cassar M. 1985. Checklist for the establishment of a microclimate. The conservator (9): 14–16.

Grzywacz, C. 1994. Correspondence to Helena Machado Hermeto.

Guichen G. 1984. Le climate dans le museé. 2eme ed. Rome: ICCROM.

Lee MW 1988. Prevention and treatment of mold in library collections with an emphasis on tropical climates: a Ramp study. General Information Programme and UNISIST, Paris.

Stehkamper H. 1988. "Natural" air conditioning of stacks. Restaurator (9): 163–167.

Abstract

The new Museum of Scotland opened to the public on 30 November 1998 as part of the National Museums of Scotland in Edinburgh. The new £52M building has 12500m² of floor space to exhibit Scottish material including geological, archaeological, historical, industrial and 20th-century collections. The building has been designed with energy conservation considerations in mind to provide a stable and well-buffered environment in which the amount of air handling plant and capital and running costs can be kept low. Prior to this, the NMS had developed an environmental policy for the collections, which specifies acceptable seasonal RH and temperature conditions for galleries and stores rather than continuous tight control.

This paper gives preliminary data about how the building has behaved since opening compared to the design specifications. It describes the environmental conditions during installation of the collections as the building and displays were completed and the monitoring of gaseous and particulate pollutants. The work undertaken to specify and test display materials is summarised and the results of measurements of display case performance are given. Some practical steps undertaken to try and minimise risk to the collections during installation are outlined and the success – or otherwise – considered. Many of the challenges faced in the Museum of Scotland are likely to be common to projects involving major building work and transfer of collections, and it is hoped that experience from this project can contribute towards the planning of other new developments.

Keywords

museum, environmental policy, installation, display

The Museum of Scotland: Environment during object installations

Katherine Eremin and James Tate
Conservation & Analytical Research
National Museums of Scotland
Chambers Street
Edinburgh EH1 1JF Scotland
UK
Fax: +44 (0)131 247 4306
Email: ke@nms.ac.uk; jot@nms.ac.uk

Introduction

The Museum of Scotland is an entirely new museum that opened to the public on 30 November 1998 at a cost of around £52M. It forms a major part of the National Museums of Scotland. The museum contains Scottish material from all departments within the NMS: archaeology, history and applied art, geology, natural history and science and technology. This paper gives an overview of environmental issues during installation. The publication of more specific data is planned.

Design of the building

The building was designed by Benson + Forsyth following an international architectural competition in 1991 which attracted over 300 entries. Building work commenced in 1993 with installation of display cases early in 1998 and installation of cased objects in July 1998. The building has a central block of display galleries in the middle of which there is an atrium space from the first floor upwards. There are gallery and circulation spaces around these core galleries, which are linked at several levels with light wells between. It is therefore a complex series of spaces with open-air circulation between galleries.

At the design stage to predict environmental performance the consultants modelled the buildings behaviour. The information from the study was used to advise the museum on the likely temperature and RH conditions and to inform decisions about the extent of air handling plant which would be needed to modify these conditions.

As a result of this dialogue the initial specifications for environmental conditions of 50 ± 5% RH and 18 ± 2°C throughout the building were relaxed. Taking account of the wide variety of materials in the collection, their condition and previous history, it was concluded that the general RH conditions should be maintained between 45% and 60% RH. Ideally, the rate of change of RH between these limits should be slow, and various specifications were given to quantify this to compare with the model data. Different summer and winter temperature set points were given, and it was suggested that where appropriate the temperature should be allowed to vary to control RH. This was in line with the NMS environmental policy which, for cost and holistic environmental reasons, aims to provide the minimum intervention necessary to assure the long-term preservation of the collections. Both the policy and conservation object reports recommend that closer control of conditions be provided locally where required by the condition or composition of particularly sensitive artefacts or collections.

The design solution was for a central air handling plant which would control the RH to within the upper and lower limits over 95% of the time. The model predicted that under certain external conditions (particularly a series of consecutive warm and wet days with high visitor numbers) the upper RH or temperature level could be exceeded. Adding significantly more plant with associated capital and running costs would be required to prevent this.

The engineering solution was for a modular system, which takes account of the possible need to provide closer control in some areas. It provides full air handling

in all areas from two AHU which condition (heat/cool and humidify) and chemically filter the air, mixing varied amounts of fresh and recycled air. An extensive dehumidification plant is not included, although it could be added later. The tempered air is supplied to 20 secondary units which control humidity and input air to the museum through a number of ducts and vents. The need for air exchange is determined by continuous monitoring of carbon dioxide levels from visitors. The performance of the active carbon filtration is monitored by sensors which measure SO_2, NO_2 and O_3 levels.

It was estimated at the final design stage that the running costs for this "peak control" system would be approximately £65K per annum as compared to nearly twice this, £123K, for the full air-conditioning system. The capital cost was £3.2M compared with £3.9M for air-conditioning.

Independently from the Buildings Management System (BMS) environmental conditions are monitored throughout the building using a Hanwell telemetry system, with 40 sensors placed in gallery areas and in cases containing particularly sensitive or unique objects. Generally the sensors monitor temperature and RH but a smaller number measure light and UV to record both spot and cumulative light doses.

Design of the display cases

Originally the architects planned to design and commission the cases, which were to be connected directly to the air-conditioning system. This was, however, rejected in favour of using a specialist case manufacturer and controlling conditions in the galleries directly as outlined above. From an early stage the case locations were identified as being "built-in" to the internal walls: this meant that the majority of cases required the doors to open with a recessed sliding mechanism rather than hinges. The manufacturer was chosen after a tendering exercise for which the architects, design and conservation provided specifications, including airtightness, inertness and, most importantly, suitability of operation. Fibre optic systems were specified for all internal case lighting.

To meet the requirements the cases in the Museum of Scotland were all custom-built. Those in the Scotland in History displays are highly individual, with the architects having overall design responsibility for the displays. They include cases with curved glass doors and backboards. In contrast, in the Early Peoples and Beginning displays the cases are more conventional and are mainly free-standing. It was initially proposed that all cases should have the provision for passive control of conditions with service compartments for silica gel accessible independently from the case display volume. This provision was, however, estimated as adding 15% to the case manufacturing costs and was cut for financial reasons at the tendering stage.

At the stage when case specifications had to be finalised, the exhibition display was still being developed so it was not possible to identify for certain which cases would require conditioning. It was considered that, provided the galleries remained within the specified 45% to 60% RH range, conditions within cases would be suitable for most mixed object displays and that any short-term changes would be buffered by good case design. It was noted that some control would be needed where more sensitive artefacts required closer control of RH and in cases with loan artefacts where the lenders specified tighter conditions. It was therefore planned that these cases would be actively controlled with independent conditioning units for each. Again, however, cost and design criteria reduced this to active control of only one case (to meet a loan specification), with passive control using Artsorb in containers hidden from view in the other cases.

A further dilution of the ideal brief was the original specification for an air change rate of 0.1 air changes per day, which was modified to better than 0.25 air changes per day on cost grounds. In order for the museum to assess the performance and design, it was proposed that a prototype of both sliding and hinged case systems should be made available for testing.

It was specified that cases should be constructed entirely of inert materials, metal and glass. Wood products should be avoided if possible, and if essential should be sealed using barrier foils. The case carcass was indeed designed to meet these

specifications, but for the internal linings and fittings the flexibility of medium density fibreboard (MDF) was required. No suitable, and affordable, alternative could be identified in the time available. The design team did not approve of the use of barrier foils as a paint finish was required and the foils can only be covered with fabric finish. Furthermore, some surfaces were to have complex shapes making foil covering difficult. Although a study (Eremin and Wilthew 1996) of emissions from wood products sealed with barrier foils and liquid sealants concluded that only the barrier foils provide an adequate seal for all gases, it was found that one liquid sealant, Nextel, significantly reduced emissions. It was hence proposed that cases should be assessed individually on the basis of the sensitivity of the artefacts within them and three categories were suggested:

- Cases with very sensitive objects should have ZF MDF and barrier foil
- Cases with less sensitive objects could have ZF MDF with Nextel
- Cases with insensitive objects could have ZF MDF with any finish

Use of the three categories was, however, rejected in favour of simplicity, with one treatment to be used throughout the non-archaeological displays. This was the Nextel paint finish. As a result, all cases were to be fitted out with ZF MDF coated with the manufacturers recommended number of coats of Nextel on all surfaces. Prototype cases were provided to assess display considerations, including mounting and lighting, but there was insufficient time for the manufacturers to provide full specification with regard to sealing and materials. As a result, testing of pollutant levels and air change rates prior to full manufacture of the cases was not possible.

Case installation and testing

The case installation started well before the galleries themselves were completed, very often before the internal walls had been completed and while extensive building work continued round about. As soon as the first available group of cases had been structurally completed an independent group, the Buildings Services Research and Information Association (BSRIA), was commissioned to measure the air leakage rate to confirm that this met the specification. The cases had to be tested prior to installation of case fittings and furniture and to fitting of the case fronting (ash veneer panels or stone).

It was expected that the cases would pass, and there was considerable pressure to dispense with the costly testing. Despite a number of problems resulting from the nature of the site (e.g. the on-going building work, difficulty of access, lack of mains electricity), two sliding door cases and one hinged door case were tested. The initial measurements indicated daily air change rates of 0.74 to 1.0, all significantly above the specified 0.25. Discussions with the case manufacturers suggested a number of possibilities, chiefly air leakage through the locks as the lock barrels were not fitted and through the loose fibre optics in the case roof. These problems were addressed and the cases were prepared for re-testing by the case installers. It was noticed, however, that the seals between glass sliding doors and the metal at the sides of the case were imperfect in some sliding door cases, that seal was consistently missing from some metal-to-metal joints and that the hinged door case lacked sealant around the box housing the lock barrels. These areas were therefore sealed with an inert, silicone sealant and the cases were re-tested. Although the air leakage rates had improved, ranging between 0.4 and 0.5, they still failed to meet the specification and a smoke test was required to identify other areas of leakage. Once these had been sealed, three sliding-door cases were tested (as the three original cases had by then been fitted with ash panelling so were no longer available for re-testing) and values of 0.2 to 0.3 were obtained. No further remedial work was feasible to bring all these cases within the specifications, but higher levels of quality control on the detailed finishing was sought on the remaining cases.

After case installation, a program of case inspection by a team of designers and conservators was initiated. This identified problems such as imperfect sealing of MDF boards and poor sealing of doors. Poorly sealed boards were removed and

resealed and the seals on doors etc. improved. It was noted that many cases had a strong chemical odour. Due to concern about the efficacy of sealing the organic elements, the levels of aldehydes and organic gases were monitored in one case and gallery in July. In addition, metal coupons of lead, copper and silver were used as visual indicators, to assess whether there was an immediate and observable risk to the artefacts. A high level of acetaldehyde was detected in the case (0.596 µg/L), but the formaldehyde level was very low (0.056 µg/L compared to 0.038 µg/L in the adjacent gallery) and no corrosion was observed on any of the metal coupons in the case. It was suspected that the odour resulted mainly from off-gassing of high molecular weight aldehydes during curing. Recommendations were therefore given for the cases to be vented daily where possible before object installation.

The pollution monitoring was repeated in late October with Cecily Grzywacz from the Getty Conservation Institute, to check the current levels. High levels of formaldehyde were obtained in cases (90–530 ppb) and galleries (306–443 ppb), with moderate–high levels of higher molecular weight aldehydes in some cases. The high formaldehyde was attributed to the on-going building work as this involved cutting of wood products (including MDF) in galleries and adjacent areas. The higher molecular weight aldehydes were attributed to continued off-gassing of products used in the cases.

A third stage of pollution monitoring was therefore undertaken in December 1998 once the building was opened. Measurements of gallery levels indicated low levels of formaldehyde (0.014–0.030 µg/L) and acetaldehyde (0.01–0.025 µg/L). A forth stage of monitoring of both gallery and case levels is planned for 1999 once the museum has been open a few months.

Dust

The timetable for installation of the collections – some 10000 objects were identified – meant that cases and some large open display artefacts had to be brought into position while building and finishing work was still underway. A key environmental problem was, therefore, the control of dust within the galleries as case fittings, furniture and artefacts were installed and, because of the linked galleries, within the adjacent Royal Museum. A significant factor in this was that the galleries had not all been "handed over" to the museum and control of conditions remained with the external buildings management team. This led to considerable difficulty, not least because the interpretation of "dust free" varied widely between conservation, buildings management and the workmen. Near 24-hour building work meant that it was extremely difficult to maintain informed supervision and in many areas dust levels were often high. One casualty of this was the sensitive fibre optics in the cases, some of which were damaged during installation.

Various steps were taken to try to minimise the risk to collections. Object installation occurred in an area only once all the "dirty" building work was completed apart from the floor sealing. Building work continued in adjacent areas and it was therefore necessary to contain the areas in which installation was occurring and to provide local environmental control where required. The installation areas were contained using temporary walls and doors of board and double layers of plastic sheeting. The entrance was through a lobby area with doors at each end and dust control carpets. Plastic overshoes were provided to cover the steel toe-capped boots, which were statutory for access through the rest of the site. This partially isolated the environment in these areas from the rest of the building site and spot monitoring of dust levels indicated that these were lower than outside, but still above those in the existing museum galleries.

As the building advanced, the number of areas where installation could proceed increased and the number of dust partitions flourished. Many areas were extremely difficult to seal effectively and it proved impossible to maintain un-punctured plastic screens throughout, especially when traditional pathways were blocked – on more than one occasion the sheeting was simply cut open during the nightshift! The risk to cased objects was minimised by keeping them covered and then sealed inside the cases themselves. The situation was stressful for museum staff already under

pressure from the timetable and frustrated by the changing conditions and the uncertainty of the building programme. It became apparent that real understanding of the building activities and the consequences of "quick no-mess jobs" was essential; it is all too easy to be persuaded that great care will be taken and often too late to then do anything about protection when the truth dawns. Regular and informed communication to the museum staff involved, the understanding of delays to building programmes and the modification of plans on a day-to-day basis were essential to maintain team morale and effectiveness.

The removal of dust screens and barriers caused, as expected, considerable mess and fall-out. It also re-opened some of the earlier pathways and required more control of workmen. In some areas it was subsequently found that the air and dust circulation remained excessive and, where possible, temporary plastic sheeting was used to reduce access through doorways. The dust-sensitive large objects were all covered for as long as possible. Nevertheless, a repeated sequence of dust removal and surface cleaning had to be initiated up to and following the opening of the building.

Light

The building uses natural light in many areas, mainly from a light well running round the central core galleries. While the levels are controlled in most galleries, they are high in the main first floor gallery, where mainly industrial artefacts but including textile banners are on display, and on the ground floor where there is a west-facing window. The window has been treated with solar control film (the maximum absorption deemed acceptable without excessive external reflectance was an MSC 47% sputtered stainless steel film with a neutral absorption spectrum), and fitted with opaque blinds to stop low-level direct sunlight. This is the gallery with some of the most light-sensitive artefacts and light levels are being monitored continuously to establish the cumulative light dose in the cases most at risk. The building design is complex and light levels will be monitored regularly over the first year to record any areas where sensitive material is at risk.

Temperature and RH

Data from the telemetry system was recorded from early 1998, before the galleries were completed and well before any air handling plant was commissioned. Not surprisingly the data showed that conditions were initially strongly controlled by the external environment. The large objects, which had had to be installed early in the building programme, had been sealed within substantial crates. Monitors had been included in these to ensure that conditions remained at low RH. Only one object could not be hermetically sealed, a railway locomotive, and an industrial dehumidifier was kept constantly running within the protective covering to keep the RH around 40%.

The first galleries were dust-sealed in late summer/early autumn in preparation for cased object installation, and the system indicated that all had high humidity and low temperatures. Contrary to the expectation that object installation would follow testing and confirmation of the environmental control plant, it was decided that the central plant would not be commissioned until all building work was complete because of the risk of getting dust into the ducting. Industrial heaters and dehumidifiers were hence placed in each of the zones to improve the environmental conditions. As these were controlled by the builders and the air inlets and controlling thermostats were outside the hand-over areas, environmental control was initially poor and object installation was delayed until this was rectified and conditions became more suitable.

At this stage the temperature was raised to lower the RH. As building work progressed and the site became more isolated from the external environment the humidity dropped and the temperature began to get too high. The heaters were removed and local control achieved in some areas using humidifiers. Throughout this period only 110V electrical equipment could be used and the supplies were not entirely reliable (e.g. extension cables tend to disappear rapidly and unexpectedly on building sites).

In-case environment

Although frequent fluctuations occurred within the hand-over areas, monitoring of conditions in the cases indicated that these were remarkably efficient at buffering the RH. Fluctuations within cases even without silica gel buffering were significantly less than the external gallery variations. Where conditioned silica gel (or Artsorb) is included the RH remained extremely stable with monthly variations in RH limited to 2–3%.

Commissioning the air handling system

As mentioned above, the planned extensive run-in period for the air-handling system had to be abandoned and the system was only turned on once the building was finally completed. This was done in stages to reduce the danger of sudden large variations in RH. For the first month, the unit was only controlling temperature. As a result the RH reached levels well below those required, remaining in the low 30% range in some areas for several weeks. In the second month the humidification modules were gradually turned on and more acceptable gallery conditions were gradually achieved. By the end of January 1999, two months after the museum opened to the public, the humidity has increased to 50% in some galleries, but there are areas where it is still in the 30% range. There also seems to be a vertical RH gradient in the ground and second floor galleries, presumed to be due to the introduction of warm air at high level, giving cause for concern for wooden artefacts, particularly painted panels and screens.

Summary

The new Museum of Scotland building is being monitored to assess how well the "peak control" environmental handling system responds to external conditions and whether the initial computer modelling was accurate. Installation of the collections was undertaken in an extremely tight time-scale, which left little scope for traditional preparation and organisation of the galleries before the objects were installed. Local protection from dust and excessive environmental conditions was established, although with some difficulty as more galleries became available. High dust levels and low RH were problematic in the month before and after opening but gradual increase in RH has been achieved to bring conditions into the acceptable RH band. Conditions within cases, which are generally well sealed, are extremely stable and can be well controlled by passive systems. Case fittings, particularly ZF-MDF boards that had been sealed with Nextel, were initially smelly and very high levels of aldehydes were measured both in cases and in the galleries. However there has been no detectable corrosion of metal tokens and further sampling is being undertaken to establish the current concentrations.

Acknowledgements

This paper draws on the work of many people involved in the MoS project teams, and we are particularly indebted to Paul Wilthew, Jane Clark, Stuart McDonald and others in the C&AR department; the NMS Director Mark Jones and MoS Project Director Ian Hooper; to members of the Architectural and building services design teams; to Cecily Grzywacz and the Getty Conservation Institute for help in carbonyl monitoring; and to Stuart Adams at Queen Mary & Westfield College for dust monitoring.

References

Eremin K and Wilthew P. 1996. The effectiveness of barrier materials in reducing emissions of organic gases from fibreboard: results of preliminary tests. In: ICOM-CC Edinburgh Preprints: 27–35.

An evaluation of three mounting conditions for pastels

Francisca Figueira,★ Rita Fontes
Instituto de Jos de Figueiredo
R. Janelas Verdes, 37
1249-018 Lisboa
Portugal
Fax: +351 01 397 0067

Abstract

An evaluation of three different storage conditions for pastels is presented. Eleven pastels from the same Portuguese artist, José Malhoa (1855–1933), with paper supports completely covered with pigment, were originally framed by a method using glass encapsulation. All were kept in a small museum close to the coast, without central air conditioning. In the early 1980s three of the frames were modified to increase the space between glass and pastel. In the early 1990s, six other pastels were removed from their frames and placed in mats. Only two of the eleven have remained in their original frames, untouched. The comparison of these three framing methods suggests that encapsulation between glass is not necessarily the worst option.

Keywords

pastel, framing, mould, foxing, humidity, encapsulation

Introduction

The Museu de José Malhoa situated in Caldas da Rainha, a small town near the coast, is in the centre of a park with a small lake. Built in 1940, it was the first museum in Portugal to have been especially constructed to house the collection of the Portuguese naturalist painter José Malhoa whose works date from the turn of the century.

As the museum is near the coast and inside a park, its microclimate is humid. Abundant daylight enters the museum through the skylights, which were covered annually with white paint as a preventive conservation measure, before ultraviolet and infrared filters came on the market. UV filters were installed in 1983. The lux measurements taken at 3 p.m. on a cloudy day gave values between 200–400 lux on various walls.

These skylights increased day/night changes in temperature and humidity, as well as summer and winter extremes. Relative humidity of up to 100% was recorded. Although these values are not fully reliable because calibration probably was not done regularly, staff from the museum mention that condensation was noticed dripping down the walls on certain occasions. There was no climate control except for the air circulation due to the natural ventilation system. This was comprised of horizontal openings near the ground and at the roof. It is believed that this ventilation was one of the reasons why very little mould occurred in the collection. The museum was very cold for human comfort and the ventilation caused drafts. Because of these disagreeable conditions for visitors, a test was done with the horizontal openings for air circulation closed, but condensation started to occur more often. A compromise was reached by reopening the vents, but adding sliding glazed doors between rooms.

Exhibition policy

From 1934–1940, before the opening of this museum, the artist's works were exhibited annually at a boat house (*A Casa dos Barcos*) in the same park, from the end of April to October. This transit process, which took place twice a year, subjected the works to a certain amount of vibration and risk of glass breakage during transport. From 1940–1990, the works were placed on permanent exhibition in the museum, and thus experienced large daily fluctuations of temperature and relative humidity.

The 1989 survey

In 1989 a survey was carried out by our department at the request of the museum curator who wished to install a controlled air conditioning system. Our report was not supportive of alterations to the existing conditions because the works on paper exhibited extraordinarily good appearance (we had read Thomson's 1986 revised edition!). The pastels in their original frames looked wonderful: they lay flat, there

★ Author to whom correspondence should be addressed

Figure 1. Cross-section showing the original frame with the pastel encapsulated between two sheets of glass.

Figure 2. The original front glass sheet, showing image transfer from Portrait of Sousa Pinto's Mother.

Figure 3. Raking light photo of Portrait of Sousa Pinto's Mother.

was no foxing or fungi visible, and the colours seemed as rich as ever. In the original frames the glass plate stood in direct contact with the pastel surface. At the time only three portraits had been reframed and the glass plate no longer lay against the pastel. Instead, there was an air space approximately 1cm deep. We noticed then that these three pastels were strongly cockled. We realized that in this museum, all that we had learned as correct, that is, to provide an air space inside a frame, very low light and controlled RH, seemed detrimental to the works where the opposite appeared to do no harm.

In 1991 another six original frames were removed from their pastel paintings. Passe-partout mountings were carried out an acid free boards, and the works were stored in metal drawers. This was done at the request of the museum, which wished to alter its exhibition policy. At the time it was thought a shame to alter the existing exhibition conditions in consideration of their historical aspects but no thought was given to evaluating their condition over time. Our experience up until then had been that storage in drawers was a good preservation measure. However, in 1977 when these six works were surveyed, there was cause for alarm: one of them (*Susana Sagastume's Portrait*) had developed foxing in that short period.

From these results we concluded that in this museum with no artificial climate control, the best storage procedure for pastels seemed to be between two glass plates. Realising that this was a controversial approach which needed more study, a research proposal was proposed to Rita Fontes, a final year paper conservation student, to evaluate their mounting conditions in detail and study their materials.

Study undertaken

The eleven pastels that arrived for study at the Instituto José de Figueiredo were portraits dating from 1917–1931. We were lucky to have eleven works from the same artist with very similar characteristics (size, material, technique, ageing conditions). They had undergone different framing histories, whose consequences could now be studied in order to establish future preservation policy for storage conditions in that specific museum, i.e., one with a natural air ventilation system and no air conditioning.

For these portraits Malhoa used mostly a rag cream paper with a film of glue applied to the surface and synthetic fibres spread randomly on top. Viewed through a binocular microscope, this structure is very similar to a velvet paper, which was often used for pastel painting to maintain the velvety characteristic of the technique as well as to improve pigment attachment (Alves 1997). Pastels have low binding material content, so they have a powdery surface which requires special care in handling and storage. Also, the characteristics of pastels cause fungi to appreciate this type of material: the thickness of the paper and pigment concentrates more humidity but at the same time allows enough airflow to enable just the right amount of oxygen that favours mould growth.

Three works were chosen, one from each framing type, for careful study. After dismantling the frames, analysing and registering the differences between pastels, their condition was evaluated. These three works are presented in order of their condition, from best to worst.

Encapsulated: *Portrait of Sousa Pinto's Mother* (1930) (See Figs. 1, 2, 3)

This pastel has been encapsulated between two glass plates since 1934. The glass is manually blown plate glass 2mm thick. The glass is slightly larger than the work by about 2mm all round and was sealed with gummed tape, firmly adhered. This sandwich was placed inside the frame's rabbet and its back was covered with a fibre board, attached to the frame by screws. The frame had carved woodwork and was gilded with gold leaf. The inside of the frame was plain red wood (*Pinus silvestris*).

The *Portrait of Sousa Pinto's Mother* was in excellent condition when taken from its encapsulated mounting. In 1990, when the other six works were taken from their glazing sandwich and placed in mat boards, their condition had been noted as equally excellent. The colours of the entire portrait were brighter than the others. This brilliance must be due to the fact that it is cleaner: no dust had been deposited on top of it. On the front glass more pigment residues were visible than on the other

Figure 4. Cross-section of the matted works.

Figure 5. Raking light photo of Portrait of Susana Sagastume.

Figure 6. Detail of the foxing stains on Portrait of Susana Sagastume *in 1998. These were not present in a similar photo from 1991.*

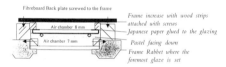

Figure 7. Cross-section of the double air chamber frame.

Figure 8. Raking light photo of Portrait of Eliezer Kamenezky.

two but care could be taken to minimise this loss. This pigment transfer can be minimised by placing the glazing and work face up and allowing the inside RH to dry somewhat before removing the glazing in this position (Beguin). If this slight image transfer is weighed against sixty years of otherwise excellent protection, it may compare favourably with the framing methods described next.

After this study the two works that had been encapsulated between two glazings were reassembled, taking care to do it in the summer months when dry conditions prevailed.

Matted: *Portrait of Susana Sagastume* (1912) (See Figs. 4, 5, 6)

In 1991, this pastel was mounted on an acid free mounting board (Framex™) (See Fig. 4) edge bound (window and backboards) with linen tape and covered by a mat board lid. The mat window covers the pastel painting 5 mm all round. The hinges on the artwork were Japico's Kinugawa ivory adhered with 4% methyl hydroxy cellulose 300cp.

This mat board cover was intended to provide protection from accidental abrasion. In 1991 no humidity treatment had been applied to these works as they demonstrated no need for it. Only one photograph existed from the 1990s, but it showed that the foxing now present was not present in 1991.

The *Portrait of Susana Sagastume* had pigment transfer to the window mat where it touched the work, especially on the mat corners. Transfer was also visible near the centre, where the mat sank with the weight of others placed on it while in the drawer. Apart from this it no longer lay flat as in 1991 (See Fig. 5), because it was imprisoned by the mat window and the pressure from other mats placed on top. The contraction and expansion movements were thus restrained. However the greatest cause for alarm was the detection that some kind of foxing staining had occurred since 1991 (See Fig. 6).

Double air chamber: *Portrait of Eliezer Kamenezky* (1923) (See Figs. 7, 8)

This modification maintained the original frame and glazing plates but significantly altered its original framing geometry (See Fig. 7). In 1982, the back of the frame was augmented to the back by 1cm in order to make space for a double air chamber. The wood used for this increase was *Pinus silvestris*. The first glass plate was placed normally against the frame's rabbet. A wooden strip 7mm × 5mm was mounted over the glass plate, creating an air chamber 7mm high. The paper support of the pastel was spot glued to a medium thick Japanese paper which in turn was completely adhered to the second glazing and overlapped towards the back. This second glazing was placed over the wooden strips. On the back of this glass plate another four wooden strips 8mm × 5mm were mounted, forming a second 8mm air chamber. Finally, the whole was sealed by the back fibre board, which was screwed down.

The *Portrait of Eliezer Kamenezky* was in the worst condition of the three pastels considered here (See Fig. 8). This is attributed to a larger air chamber, 7mm deep. The larger the air space created, the more moisture changes occur (Sozzani 1997). Another aspect to be considered is that a longer period had elapsed in this framing condition: 16 years as compared with 7 years in the mat board. However, this might not be a plausible reason for the difference detected because the time needed for physical adaptation is perhaps much shorter. This portrait not only had foxing but also had dead hyphae from previous mould contamination. The cockling was also more intense. Its colour tones are bricks, browns and blacks which are darker than in the *Portrait of Susana Sagastume*. Darker pigments are normally favoured by fungi; however, this does not make up for the difference because *Sousa Pinto's Mother* is even darker and has no fungi. The glazing had some pigments attached to it, although not as much as in *Sousa Pintos' Mother*.

UV Fluorescence

The 11 works were subjected to UV light and all fluoresced quite similarly, that is, an intense yellow fluorescence uniform throughout the pastels. The places where

Table 1. Average values of summer and winter extremes. Thes values correspond to measurements done by a thermohygrograph. With a newly calibrated theremohygrograph we've received from the museum, recent readings after a very cold dry spell were: 16–23 Nov. 14°C–9°C/76%–50%; 23–30 Nov. 12°C–9°C/80%–55%; 30 Nov–7 Dec. 11°C–5°C/67%–49%.

		1975 Wint	Sum.	1976 Wint	Sum.	1977 Wint	Sum.	1978 Wint	Sum.	1979 Wint	Sum.	1980 Wint	Sum.	1981 Wint	Sum.	1982 Wint	Sum.
Jan.	H.R.%	—	—	95	60	98	70	—	—	86	9	100	44	100	65	100	70
	°C	—	—	2	9	7	11	—	—	80	10	3	14	4	8	6	9
Feb.	H.R.%	—	—	100	68	98	68	—	—	—	—	—	—	100	60	100	80
	°C	—	—	5	12	5	11	—	—	—	—	—	—	5	11	5	8
Mar	H.R.%	90	52	83	59	91	46	—	—	—	—	—	—	100	65	100	50
	°C	7	15	10	14	5	13	—	—	—	—	—	—	7	12	4	11
Apr.	H.R.%	94	32	96	58	92	57	—	—	—	—	96	52	100	74	100	66
	°C	12	18	9	16	8	14	—	—	—	—	6	16	9	13	4	12
May	H.R.%	90	32	88	53	94	56	—	—	—	—	100	56	—	—	—	—
	°C	13	21	11	19	9	15	—	—	—	—	10	18	—	—	—	—
June	H.R.%	90	54	88	39	90	58	—	—	—	—	100	66	—	—	—	—
	°C	13	22	13	22	11	17	—	—	—	—	12	20	—	—	—	—
Jul	H.R.%	82	58	94	56	88	70	—	—	—	—	98	72	—	—	—	—
	°C	17	24	16	23	13	17	—	—	—	—	19	15	—	—	—	—
Aug.	H.R.%	—	—	94	80	—	—	—	—	—	—	100	72	98	69	—	—
	°C	—	—	16	19	—	—	—	—	—	—	15	21	15	19	—	—
Sep.	H.R.%	93	62	98	52	90	76	84	50	—	—	100	65	100	73	—	—
	°C	13	19	12	19	13	18	14	19	—	—	12	20	13	18	—	—
Oct	H.R.%	100	56	98	70	—	—	90	50	—	—	100	70	100	80	—	—
	°C	10	18	10	16	—	—	8	15	—	—	10	18	7	15	—	—
Nov.	H.R.%	100	56	98	72	—	—	92	62	—	—	100	63	100	70	—	—
	°C	6	15	5	10	—	—	6	10	—	—	4	12	7	12	—	—
Dec.	H.R.%	86	64	92	64	—	—	92	61	—	—	100	60	100	64	—	—
	°C	1	10	2	12	—	—	4	12	—	—	5	12	6	11	—	—

there was less pigment or none at all fluoresced more intensely. The following conclusion was made: the fluorescense was attributed to the glue film used in the velvet paper and those which fluoresced less were more dense in terms of pastel powder. This permitted a comparison among the three different mounting conditions in terms of powder stability.

Conclusion

Encapsulation between two layers of glass, if executed in dry conditions, seems to maintain good conditions, and is unaffected by the RH fluctuations of this uncontrolled museum. Given the fact that pastels are favoured by mould attack and that their treatment is risky, encapsulation seems to present the best option for pastel works on paper in an uncontrolled environment. The examined works stored this way are flat and without noticeable deformations. No mould development or foxing stains are present. The works have a clean appearance, as if new. The only drawback is that if they ever need dismounting, some pigment will transfer to the glazing.

These works fluoresced much less under UV. If we attribute fluorescence to the underlying glue, then encapsulation seems to have prevented the greater loss of pigment.

One of the most critical problems with pastels is directly related to its powdery nature, and hence its need to be protected by glazing. However, this glazing cannot have static electricity and therefore no acrylic glazing is allowed, but there is a glass which is a sandwich of two glass plates and an acrylic sheet.[1] This type of glazing would also prevent accidental breakage, although this should be tested beforehand.

The UV protection, which comes from the acrylic sheeting, might in this case be detrimental, inasmuch as UV offers some inhibition of mould.

An experiment is underway to study the phenomenon of image transfer to the glass. Four model pastels have been made, mounted in four different ways, and placed on a window panel facing south. These four mounting methods are:

1. The pastel is placed between two glass plates with nothing in between.
2. The pastel is inside matted with a board 1.7mm thick. This sandwich is then placed between two layers of glass.
3. The pastel is on top of a 1.7mm mat board and a 5mm window of polystyrene foam. The sandwich is then placed between two layers of glass.
4. The same as 3, but with a 10mm polyurethane foam.

All four were edge sealed with P90 adhesive tape. Although this study is only eight months old, an interesting fact has emerged: some pigment has fallen from the three models which were not completely encapsulated.

Notes

1. Schott Mirogard Protect Magic Glass, type 22.1, a nonreflective glass acrylic laminate (Norville-Day 1993).

References

Alves MT. 1997. Personal communication at Museu de Arte Antiga, Lisboa.

Béguin A. Dictionnaire technique et critique du dessin. Oyez: Brussels: 421

Norville-Day H, Townsend JH, Green T. 1993. Degas pastels: problems with transport and examination and analyses of materials. The conservator 17. London: UKIC: 46–55.

Thomson G. 1986. The museum environment. 2nd edition. London: Butterworths.

Sozzani LSG. 1997. An economical design for a microclimate vitrine for paintings using the picture frame as the primary housing. JAIC Volume 36, n.2. AIC, Washington DC: 95–108.

Abstract

It is commonly presumed that historic material in Antarctica should be well preserved because of the severe, 'dry' cold. Examination of several historic Antarctic sites, however, reveals that many buildings and artefacts suffer deterioration from humidity. A project rationale is described for measuring temperature, humidity and other factors controlling deterioration of materials, especially timber and metals. The location chosen is the Main Hut at Cape Denison, the largest of four wooden huts built in 1912 by Australian explorer Douglas Mawson. Temperatures are rarely above 0°C, yet paradoxically fungi and corrosion occur inside this building which is partly filled with ice. Monitoring is proposed through-out the building using electronic sensors to record data for modelling the potential effects of ice removal. Preliminary results from limited monitoring indicate an increased risk of high fluctuating relative humidity if ice is removed.

Keywords

monitoring, datalogging, Antarctica, relative humidity, time of wetness, cold climate, corrosion

Monitoring of environmental conditions in a severe climate: How this can assist in development of conservation strategies for historic buildings and artefacts in Antarctica

Janet Hughes★
National Museum of Australia
GPO Box 1901
Canberra ACT
Australia
Fax: +61 2 6208 5299
E-mail: j.hughes@nma.gov.au

Colin Pearson
Cultural Heritage Research Centre
University of Canberra
Canberra ACT 2601
Australia

Vinod Daniel
Research Centre for Materials Conservation and the Built Environment
Australian Museum
6 College Street
Sydney, NSW 2000
Australia

Ivan Cole
Division of Building Construction and Engineering
Commonwealth Scientific and Industrial Research Organisation
PO Box 56
Highett Victoria 3190
Australia

Introduction

International context for preservation of historic buildings in Antarctica

Antarctica was the Earth's last continent to be explored. There are seven extant historic timber buildings dating from the early exploration of Antarctica (1895–1914) which are protected under the Antarctic Treaty. The best-known, Scott's Terra Nova hut at Cape Evans, filled with ice after Scott's ill-fated expedition. The ice was excavated in the early 1960s with no archaeological or conservation documentation.

A less well-known building, in an even more isolated location, is the subject of the research discussed in this paper: the Main Hut at Cape Denison (See Fig. 1). This is the largest of four timber buildings built in 1912 by the Australasian Antarctic Expedition led by Australian scientist, Douglas Mawson. There has been strong public debate about whether the ice which partly fills the hut should be removed to allow tourists to enter, as has been done at Scott's Cape Evans hut.

The project involves monitoring of several parameters to gain a better understanding of how the external climate influences the conditions inside the building. Data derived from monitoring will be used in the development of conservation strategies for the huts, particularly the question of whether or not the ice should be removed.

Environmental conditions and preservation in polar conditions

Antarctica is the world's coldest and driest continent. Air temperatures in coastal Antarctica (latitudes 63°S to 77°S) vary from winter minima of approximately –40°C to summer maxima which are rarely above 0°C. Rain rarely occurs: most precipitation is in the form of snow. There are long periods without sun in winter, but in summer there is continuous daylight south of the Antarctic Circle. There are often significant differences between surface temperature (a building can be warm to touch) yet air temperature may be well below 0°C.

★ Author to whom correspondence should be addressed

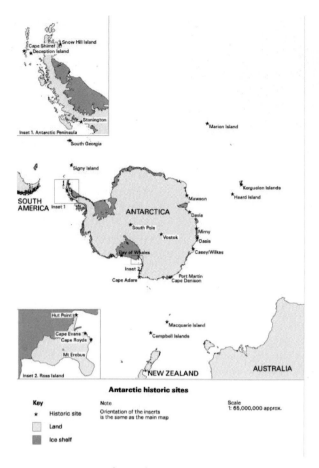

Figure 1. Location of some historic sites in Antarctica.

Even when ice inside a building is not melting, humidity can still be very high since ice produces vapour even at temperatures below 0°C. Vapour pressure data for ice are not widely available since most researchers are mainly concerned with temperatures around human comfort level. Paradoxically, the relative humidity may be 100% despite low absolute humidity.

Deterioration in Antarctic climates

A review of publications concerning Antarctic historic buildings (see extensive bibliography in Hayman et al. 1998) indicates that all have similar deterioration problems and preservation issues.

- Antarctica is the earth's windiest continent: strong winds have caused structural concerns and some actual damage to buildings. Wind-borne ice particles erode timber surfaces.
- Fungi and bacteria are recorded in most buildings affecting food, clothing and timber.
- Corrosion is prevalent affecting structural elements (e.g. nails) and artefacts (e.g. tin cans).
- Salt deposits occur inside several buildings, although the extent of any adverse effects is unknown.
- Tourists and other visitors are generally carefully briefed and controlled to prevent souveniring, moving and handling of artefacts inside huts but interference with artefacts has been observed at several buildings.

Ice accumulation has occurred inside the following buildings: Scott's Cape Evans hut; Nordenskjold's Snow Hill Island hut; Byrd's East Base on Stonington Island; Borchgrevink's hut at Cape Adare; various buildings at Wilkes; and Mawson's main hut. Ice has been removed from all except the latter two with varying results, but more importantly none were monitored before or after ice removal.

Figure 2. Interior of Mawson's Main hut showing ice ingress in 1985.

Ice accumulation inside Mawson's hut

Mawson found that ice particles are especially small (0.1–0.4mm across) in Antarctica, (Jacka and Jacka 1988, 61). Because this is the windiest place on earth (annual average wind speed of 80kmh and gusts over 300kmh) particles are forced through the tiniest gaps in the cladding of the hut.

Ice particle ingress has occurred in this building since its construction in 1912. (See Fig. 2 for ice ingress of the interior in 1985.) The timber travelled as deck cargo on an overloaded sailing ship and was frequently wet by waves during the voyage. The timber dried rapidly after the hut was hastily erected, leading to gaps in the tongue-and-groove cladding.

Despite frequent recommendations (Hayman et al. 1998) only very limited temperature and humidity monitoring has so far been carried out inside the hut. Unfortunately, approximately 30 tonnes of ice was removed before monitoring could commence (Ashley 1998). The monitoring of temperature and RH is essential, although insufficient, to determine the condition and risk of deterioration of building materials. This is determined by the interaction of the material surface with the microclimate and is thus controlled by local parameters such as surface wetness and surface temperature for metals and moisture content and surface/bulk temperature for timbers. These parameters will be measured in strategic locations above and next to ice in Mawson's hut.

Issues and hypotheses concerning ice removal

The hut has progressively filled with ice, although without any measurable distortion of the shape of the building and with limited damage to only two structural members inside the building (Ashley 1998). Recent repairs on the skylights, believed to be a major source of ingress, may have reduced the rate of ingress. While penetration via the Workshop roof may have been reduced by the recent recladding, it must be remembered that ice particles will penetrate through the smallest gap, so some ingress is inevitable. Frequent maintenance would thus be required to keep ice from accumulating, yet because of the cost and difficult logistics it may not be possible to get to Cape Denison for up to 10 years.

Previous proposals have been made to remove all ice from the hut and to install polymer membranes to prevent further ingress (Blunt 1985) or to cover the hut with a clear dome (Australian Geographic 1992). Complete removal of ice and keeping the hut free of ice are no longer considered viable so only two competing proposals arise:

1. 'Partial removal': Ashley (1998) proposed that ice should only be removed from the interior of the Living Hut and Workshop but be allowed to remain in the verandahs.
2. 'No ice removal' would permit or encourage ice to refill the hut's interior.

From these, two hypotheses can be constructed:

- H_1: Partial ice removal will have no adverse effect on the structural stability of the entire building.
- H_2: Partial ice removal will have no effect on the thermal and hygrometric stability inside the entire building.

Structural analyses are beyond the scope of this paper, although the methodology for monitoring of structural factors and location of sensors is discussed below.

Thermal and hygrometric stability is a fundamental issue since temperature and RH underlie all the processes of deterioration inside the Hut. Deterioration processes associated with high and variable RH include defibring of timber (where wood fibres separate from the surface of the timber giving a furry appearance) and dimensional changes which stress timber leading to bending and cracking. Defibred timber was observed both inside and outside the Cape Evans, Cape Royds and Cape Adare huts. Salt accumulation is evident inside the Cape Evans and Cape Royds huts where trails of water carrying dissolved salts run down inside

Table 1. Summary of factors in favour of and against ice removal.

In Favour	Against
Facilitates access for visitors and to do repairs, although few visitors are expected and the need for repairs is not evident.	No visitor access. Few repairs would be needed if the building were stabilised by ice.
May reduce structural loads, although no evidence exists of distortion of the hut due to the ice accumulation.	Ice may consolidate the hut reducing vibrations, controlling temperature and RH fluctuations and stabilising the foundations during winter blizzards. Summer melt-water may be beneficial in winter when it freezes the foundations in place.
Vapour-permeable barriers inserted under the cladding may prevent ice ingress.	Large logistics costs for removing and keeping out ice. No evidence exists demonstrating membranes are effective in preventing ice ingress. Membranes may increase humidity-related problems. Damage by salts may increase.
Ice removal from Scott's huts is stated to have been successful.	There is insufficient humidity data from the Scott huts to determine if the ice removal has caused problems or not. Cape Denison's climate is warmer and much windier making comparison difficult. Access by air to the Scott's huts means that maintenance can (and has to) be carried out each year.

the ceiling and walls and then evaporate leaving white crystals. Salt is a major factor in defibring (Wilkins and Simpson 1988) and also absorbs moisture, increasing RH variability. Salts also strongly increase corrosion rates, especially affecting nails embedded in timber.

Salt and humidity damage has affected two historic plaques at Cape Denison which were enclosed in bronze boxes in 1977 to protect them from damage by wind-borne ice particles. Enclosure increased the daily temperature and RH fluctuations and ice particles; salt penetrated the seal causing corrosion, which stained the wood and resulted in severe defibring. Poor understanding of the conditions at Cape Denison led to false assumptions about what would protect the plaques resulting in an inappropriate treatment which caused more damage and necessitated their return to Australia by 1985.

Madigan (1929) observed that moist, salt-laden air is drawn in from the sea by a vortex caused by the predominant southerly winds at Cape Denison. If ice is removed from the Main Hut at Cape Denison it is likely that salt will be deposited inside the building by these northerly sea breezes and is likely to concentrate over time by evaporation/sublimation. Salt deposition data (such as using ISO 9225 Salt Candle method) would allow assessment of this risk (See Table 1).

Review of existing data on deterioration parameters inside the building

Direct observations of conditions *inside* Mawson's huts have been made by a conservator only once, in 1985 (Hughes 1986). Other interpretation has been made from photographs used for archaeological recording. Observations by Hughes and the archaeologist (Lazer) indicate that there is a daily cycle in summer of melting of hoar-frost on the ceiling of the Living Hut (See Table 2). The melt-water runs down the ceiling, sometimes forming icicles and ice stalagmites on the floor. Staining of the interior cladding occurs where melt-water persists.

The 1985 data showed relative humidity is persistently above 90% with air temperatures varying between -2 to -6°C. Original magazines inside the hut felt limp and damp with rusting staples and spots of mould. This confirms that humidity is high despite fears that the thermohygrograph may be too inaccurate at low temperatures and high RH.

In January 1998 one logger (ACR A) was placed close to the apex of the Living Hut ceiling and the other (ACR B) close to the floor near the centre of the Living Hut. The logger close to the ceiling showed temperature variation between -10 to +14°C and RH variation from 60 to 100%. The logger at floor level showed

Table 2. Summary of available temperature and relative humidity data.

Date	Instrumentation	Data obtained
23 Jan–1 Feb 1985	Thermohygrograph UV and visible light	One point, Mawson's cubicle Spot measurements
1–28 Jan 1998	2 ACR loggers (temperature and RH) at two different points, 2 TOW monitors (see below)	Four weeks, one near ceiling, one near floor of Living Hut

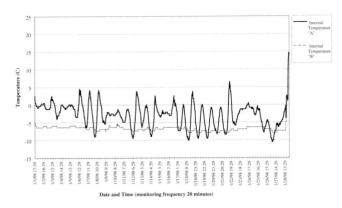

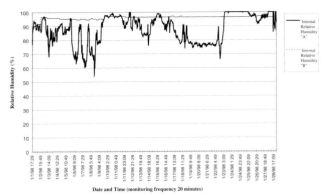

Figure 3. Temperature variations measured by ACR A and ACR B.

Figure 4. Relative humidity variations measured by ACR A and ACR B.

consistently low temperatures (-6 to -8°C) and stable high RH (95–98%) over a four-week period (See Figs. 3, 4).

The conditions at floor level indicate what might be expected if the building remains filled with ice. The ice mass appears to stabilise the temperature since large quantities of heat are required to raise the temperature even one degree Celsius. If the building were filled with ice, then relative humidity – while high – would be stable, which is preferable to frequent variations of temperature and humidity.

The logger at the ceiling provides an indication of the conditions at the walls and roof if the ice were removed from the interior of the building. Solar heating of the walls is more significant than at the roof since the maximum height of the sun above the horizon is 46° and the sun travels around the horizon without setting during summer.

Temperatures above 0°C in the RH range 60–100% will allow fungi to grow and will promote corrosion of metals. Frequent RH variation will cause swelling and shrinkage of timber which promotes cracking and thus reduces the structural strength of the timber. This alone strongly suggests that ice removal may be detrimental to the survival of the building.

Corrosion and Time of Wetness (TOW)

According to ISO Standard 9223 (1992) corrosion is only possible when air temperature is above 0°C and relative humidity is above 80%, conditions corresponding to the existence of a thin film of moisture on the metal surface. The time for which these conditions exist is called 'Time of Wetness'. Temperatures inside most of Mawson's hut are consistently below zero, except near the ceiling, yet corrosion is found on metal fittings and nails in all areas of the building.

CORROSION RATE MEASUREMENTS OUTSIDE THE BUILDING

Two Zincorr units were exposed on racks outside Mawson's hut for one year. A Zincorr unit comprises zinc wire wrapped around nylon, iron and copper bolts and standardises measurement of seasonal corrosion rate. The combination of zinc wire and the iron or copper bolts provides a galvanic coupling which accelerates corrosion enabling the aggressivity of the environment to be measured in short time.

Comparison with standard Zincorr indexes for Australian climates show that the environment outside Mawson's hut is typical of a moderately (not low) corrosive Australian environment.

Surface temperatures

The above observation is consistent with previous work of Hughes, King and O'Brien (1996) who found that significant corrosion occurred in Antarctica despite the low temperatures. To investigate the factors controlling corrosion in Antarctica, galvanised steel plates instrumented with TOW sensors and surface temperature probes were exposed on racks adjacent to the hut. Unfortunately the TOW sensors did not function and the surface temperature measurements only worked for 50 hours indicating that the surface temperature was above 0°C for 48

of these 50 hours. This research will be repeated in 1999–2000. However, it does illustrate that surface temperature controls 'wetness' and thus corrosion on metals can occur during summer despite colder air temperatures.

Fungi

Fungal growth is generally believed not to occur when the temperature is below 0°C. Fungi grew inside Mawson's Hut when it was occupied and fungi are still visible on wood, cloth, food and paper inside the hut (Hughes 1986). The rate of growth of fungi since the hut was abandoned is unknown although the odour of decay suggests that biodeterioration is active although growth rates may be slow. Fungi samples were collected from timber for identification and growth rate studies in artificial conditions.

Fungi found at Scott's Huts and elsewhere in Antarctica (Greenfield 1982) suggest that cold-tolerant strains have survived. The presence of cold-tolerant cellulolytic fungi could have adverse implications for the survival of timber in Antarctic conditions, if growth rates are significant.

Additional data required to resolve hypotheses

The following additional data is essential to resolve the two hypotheses prior to any further ice removal:

H_1: Effect of ice on structural stability

To measure wind loading on the walls and roof it is necessary to measure wind speed at a minimum of six points to map wind flow around the building. Anemometers

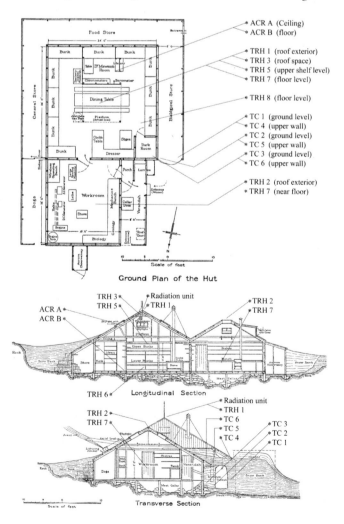

Figure 5. Plan and section views of the hut showing sensor locations.

are vulnerable to damage in such extreme conditions so more durable pressure sensors are proposed. Insufficient funding necessitates postponing this monitoring. If additional funding becomes available it is also proposed to install strain gauges on key structural elements in the roof (such as areas of repaired broken beams) to directly measure wind loads on roofs and walls.

Vibration data from structural elements of the partly ice-free Living Hut and the ice-filled Workshop would enable risk assessment of the effect of partial ice removal on the structure as a whole. Photos taken in 1912 show that snowdrifts build up around the hut during the winter blizzards, leaving only the apex of each roof exposed to the force of the wind. Vibration monitoring was also postponed since this requires a dedicated monitor taking very frequent readings to detect the vibrations and is therefore particularly expensive.

H_2: Effect of ice on thermal and hygrometric stability

Temperature and relative humidity vary on a daily and seasonal basis throughout the building. Using eight temperature and RH sensors and six thermocouplers (Fig. 5), it will be possible to determine the effect of ice on conditions inside the building by comparing conditions in the partly ice-free Living Hut with the ice-filled Workshop, accounting for dimensional and construction differences.

Melt-water forms outside the hut each summer especially along the eastern and western walls. Ashley (1998) has suggested that the damming of the melt-water by a pile of sealskins on the east side causes melt-water to flow inside the hut where it may re-freeze. The extent of melt-water formation outside varies throughout summer as well as from year to year. Research comparing contemporary temperatures recorded by an Automatic Weather Station on the exact site used for AAE records suggests that melt-water may increase due to climate change. Two melt-water detectors are required to confirm whether water is in the liquid or solid state at $0°C$ since this is difficult to determine from temperature and RH data alone.

The effects on the foundations of partial ice removal are difficult to predict. Does the winter re-freezing of melt-water protect the foundations by securing timber into holes in the rock thus reducing vibrations and other stresses? Will partial ice removal increase solar heat absorption inside the hut thus increasing melting? Will this melting of ice from the verandah walls reduce the stabilisation against vibration damage? If ice in the verandahs melts, will the melt-water flow into the interior of the hut and refreeze? If so, this could refill the hut with ice, defeating the purpose of partial ice removal.

Draining melt-water is difficult since the hut is in a hollow. A siphon is unlikely to be effective since freezing of water in the pipe could block it and cause backflow. Melt-water around the foundations may reduce oxygen access to the wood surface thus reducing the risk of fungal growth (Johnson, personal communication).

Datalogger equipment

The temperature, relative humidity, melt-water sensors (soil moisture blocks) and other monitors (locations shown in Fig. 5) will provide data needed to accurately measure the microclimate climate conditions determining deterioration rates of materials throughout the building. While the sensors to be installed in summer 1999–2000 will provide data on thermal and hygrometric behaviour, lack of funding for sensors for structural studies may delay decisions on conservation methods.

Data analysis

Data from the sensors in both vertical and horizontal arrays inside the Workshop and Living Hut will enable heat absorption to be modelled and calculated throughout the building for the whole year. Correlation of RH and melt-water data will indicate when sufficient heat has been absorbed to cause phase change. Computer modelling and SPSS statistical software will be used to examine:

- Whether there is sufficient thermal stability from the ice in the verandahs to prevent it from melting. If not, increased melting may increase the risk of vibration and physical stresses.
- Simulation of removal of different quantities of ice to determine effects on thermal stability without the risks associated with actual removal.
- Whether or not the mass of ice inside the building stabilises the conditions inside the building which favour preservation.

Conclusions

1. Preliminary data indicate that conditions in the Antarctic normally considered to be protective can actually result in corrosion, fungi and severe moisture fluctuations inside historic buildings.
2. Accurate and precise microclimate studies are needed for Antarctic historic building to resolve complex issues such whether ice removal will control or accelerate deterioration.

References

Ashley G. 1998. Mawson's Huts – conservation report of the AAP Mawson's Huts Foundation Expedition 1997/98. Godden Mackay Heritage Consultants.

Blunt W. 1985. History of the site from 1914 and conservation proposal. Project Blizzard, Sydney (unpublished).

Greenfield LG. 1982. Thermophilic microbes in Shackleton's Pony Fodder, Cape Royds
NZ Antarctic Record, 41:21–22.

Hayman S, Hughes J, Lazer E. 1998. Report to the Australian Heritage Commission (Environment Australia) on NEGP Grant: Deterioration monitoring and tourism management at Cape Denison (Mawson's Huts), Australian Antarctic Territory
Department of Architecture and Design Science, University of Sydney.

Hughes JD. 1986. Materials Conservator Materials Conservation Report on Mawson's Huts. Volume 6: Project Blizzard – the preservation of Mawson's Hut, Commonwealth Bay, Antarctica.

Hughes JD, King GA, O'Brien D. 1996. Corrosivity map of Antarctica - revelations on the nature of corrosion in the world's coldest, driest, highest and purest continent. In: 6th International Corrosion Conference, Melbourne, November 1996.

Jacka F and Jacka E. 1988. Mawson's Antarctic diaries. Allen and Unwin Adelaide, South Australia.

Madigan CT. 1929. Meteorology – tabulated and reduced records of the Cape Denison Station, Adelie Land. Australasian Antarctic Expedition Scientific Reports Series B Vol IV. Sydney: New South Wales Government Printer.

Wilkins AP. and Simpson JA. 1988. Defibring of roof timbers. Journal of the Institute of Wood Sciences 11(3): 121–125.

Résumé

De nombreux objets patrimoniaux sont sensibles à la lumière et susceptibles de se dégrader rapidement si un contrôle des conditions d'exposition n'est pas effectué. Il existe à cet effet des appareils électroniques mais ils sont onéreux et encombrants si l'on doit les laisser en permanence près de chaque œuvre. L'utilisation de gammes d'échantillons de laine bleue normalisées s'est répandue, mais leur domaine de sensibilité ne correspond pas à celui des objets très fragiles. Nous avons donc proposé un actinomètre qui se décolore rapidement et dont le changement de couleur, du bleu au violet, au rose puis au blanc, puisse permettre d'évaluer visuellement une exposition lumineuse jusqu'à 100.000 lux.heures. Ce travail a pour but de déterminer l'influence de divers paramètres environnementaux sur le comportement de cet actinomètre.

Mots-clés

lumière, dosimètre, actinomètre, photographie

Mise au point d'un actinomètre pour le contrôle de l'exposition des photographies et des objets sensibles à la lumière

Bertrand Lavédrine,★ Martine Gillet, Chantal Garnier
Centre de recherches sur la conservation des documents graphiques
36, rue Geoffroy-Saint-Hilaire
75005 Paris
France
Fax: +33-1 44 08 69 90
Mél: lavedrin@mnhn.fr

Introduction

La demande croissante de prêt et d'exposition d'objets patrimoniaux ces dernières années a conduit à édicter des recommandations très strictes pour leur manipulation, leur transport et le contrôle des conditions environnementales dans les salles d'exposition. Les conditions thermohygrométriques et l'éclairement des œuvres doivent être surveillés et des dispositifs de mesure et de protection ont été élaborés et largement installés dans les galeries et les réserves. On dispose ainsi de multiples modèles de thermo-hygromètre enregistreur, de radiomètre, de luxmètre et d'UVmètre. Les sondes pour la mesure du climat sont généralement situées à divers endroits représentatifs. L'éclairement fait plus souvent l'objet d'une mesure ponctuelle lors de la mise en place des œuvres. Une telle procédure peut s'avérer efficace lorsque l'éclairage est artificiel et stable. Dans le cas d'un éclairage naturel très fluctuant dans l'espace et dans le temps, il convient de placer à proximité de chaque œuvre une cellule qui enregistre l'éclairement. De tels dispositifs existent mais le coût devient vite prohibitif s'il faut en acquérir autant que d'œuvres exposées, sans compter l'encombrement qui peut être difficilement compatible avec la présentation de petits objets.

Notre objectif était donc de développer un dosimètre ou plus précisément un actinomètre à l'usage des collections patrimoniales. Les actinomètres ont largement été utilisés dans les laboratoires de physique et également proposés aux photographes avant que ceux-ci ne disposent de cellules photo-électriques pour déterminer les temps de pose. La description que l'on en donne dans un « traité général de photographie en noir et en couleurs » du début du siècle est la suivante :

« Les actinomètres (de ακτις, rayon et μετρον, mesure) font connaître le temps de pose d'après celui qu'emploie à prendre une teinte déterminée un papier sensible à la lumière » (Coustet 1927).

Notre recherche a donc consisté à développer un dispositif photosensible dont la couleur évolue proportionnellement à la lumination (produit du temps d'exposition par l'éclairement). Son domaine de sensibilité devait correspondre à celui des recommandations les plus strictes et permettre ainsi de vérifier visuellement que les œuvres exposées n'ont pas été soumises à un niveau d'irradiation excessif.

Les recommandations

Parmi les œuvres les plus fragiles à la lumière on compte principalement des objets constitués de matériaux organiques comme les documents graphiques, photographiques et les textiles.

Pour cette classe d'objets un consensus s'est formé autour d'un niveau d'éclairement maximal, en général 50 lux, les rayonnements UV étant éliminés et l'exposition limitée dans le temps. Toutefois la prise en considération de la lumination conduit à plus de souplesse et permet d'augmenter l'intensité lumineuse si l'on raccourcit temps d'exposition et inversement. Des auteurs ont formulé des propositions quant aux luminations à ne pas dépasser annuellement (Bergeron 1992) (voir Tableau 1). Ces seuils ont été établi en relation avec la stabilité d'échantillons de laine bleue

Tableau 1. Recommandations pour l'exposition à la lumière.

catégorie	stabilité à la lumière	seuil de lumination
catégorie 1	particulièrement sensible	12000 lx.h
catégorie 2	assez sensible	42000 lx.h
catégorie 3	sensible	84000 lx.h

★Auteur auquel la correspondance doit être adressée

Tableau 2. Comparaison des valeurs de lumination recueillies dans la littérature.

catégorie	seuil de lumination estimation basse	seuil de lumination estimation haute
catégorie 1	12000 lx.h	12500 lx.h
catégorie 2	42000 lx.h	150000 lx.h
catégorie 3	84000 lx.h	600000 lx.h

décrits dans les normes internationales et destinés à évaluer la solidité à la lumière des colorants de textiles (British standard 1971). Il existe huit échantillons de laine de stabilité croissante, le premier étant le plus fragile. Ces échantillons ont servi de référence pour créer trois catégories de sensibilité à la lumière des biens culturels : la catégorie n°1 pour les œuvres dont la sensibilité à la lumière correspond à celle des échantillons n°1, 2 ou 3 ; la catégorie 2 correspond aux échantillons n°4, 5 ou 6 ; la catégorie n°3, correspond aux échantillons n°7 et plus.

Cependant les seuils proposés sont parfois très différents d'un auteur à l'autre (Bergeron 1992 : Ezrati 1995) (Tableau 2). Ces variations s'expliquent aisément. Les valeurs sont choisies plus ou moins arbitrairement, car on sait qu'il n'existe pas de niveau en dessous duquel la lumière n'aurait pas d'effet nocif à terme.

Evaluation de la sensibilité des œuvres

Une autre difficulté réside dans l'évaluation de la catégorie où placer les œuvres. Elles sont d'origine et de nature diverses, leur histoire est souvent mal connue ce qui conduit à une certaine incertitude quant à leur sensibilité à la lumière. Le patrimoine photographique illustre parfaitement cette hétérogénéité de comportement. Des tirages au gélatino-bromure d'argent ont été exposés à des millions de lux.heures sans manifester aucun signe d'altération visuelle, tandis que d'autres ont rapidement présenté des dégradations importantes. L'évaluation de la photosensibilité des œuvres est devenu l'objectif de plusieurs recherches, des travaux sont en cours pour développer une méthodologie et un appareillage afin de déterminer la fragilité des matériaux colorés (Garcia 1995 : Ware 1996 : Whitmore 1998). Il s'agit de soumettre une très petite portion de l'œuvre à un vieillissement accéléré à l'aide d'un micro-faisceau lumineux de haute énergie, jusqu'à l'observation d'une modification évaluée colorimétriquement ou densitométriquement. Il est certain que de tels instruments, bien qu'ils soient (micro)destructifs, vont être une aide précieuse pour le choix des œuvres et de leurs conditions d'exposition. Toutefois ce type d'essai ne prend en considération que l'aspect visuel. Ainsi une exposition à la lumière peut induire une oxydation, une dépolymérisation qui se traduiront par une fragilisation qui n'est pas forcément mesurable optiquement.

Mise au point d'un actinomètre

Quel que soit le seuil d'exposition maximum que l'on recommande, il convient de contrôler la dose reçue par les objets. Les rayonnements UV entre 290 et 400nm sont suivis à l'aide d'un dosimètre constitué d'un film de poly(chlorure de vinyle) dopé avec de la phénothiazine (Tennent 1982). Pour la lumière, l'utilisation d'un dosimètre constitué des gammes normalisées de laine bleue a été proposée par Feller (1978), il y a une vingtaine d'années. Après l'exposition on estime par comparaison visuelle ou par densitométrie les éventuels dommages subis par la gamme. Ce système, réduit souvent aux deux échantillons de laine les plus sensibles (Tennent 1987), est utilisé de nos jours dans certaines demeures historiques (Staniforth 1997). Ces gammes ont l'avantage d'être disponibles dans le commerce et s'avèrent utiles dans le cas d'éclairements importants. D'autres types de dosimètres ont été proposés dans la littérature : papier teinté avec de la Rhodamine B (Kenjo 1986), acétate de cellulose imprégné de violet cristal (Allen 1993) ou support en verre enduit d'une substance photosensible. Toutefois ces dispositifs ne sont pas assez sensibles pour donner des indications dans le cas de luminations inférieures à 100 000 lux.heures. Leur usage sera donc peu adapté au suivi des expositions d'œuvres de sensibilité de 1 à 3 (voir Tableau 1).

Le but de nos travaux a été de développer un dosimètre qui permette d'estimer des luminations comprises entre 5000 et 100 000 lux.heures, et éventuellement de les évaluer visuellement.

Nous avons d'abord testé des papiers imprégnés de sels photosensibles comme des sels d'argent, de mercure ou de fer ou des supports photographiques mordancés. Cette démarche a rapidement révélée ses limites : sensibilité inadéquate, manque de stabilité dans le temps, toxicité... Nous avons donc orienté nos travaux vers l'utilisation d'un polymère coloré. Ces recherches nous ont conduits à mettre au

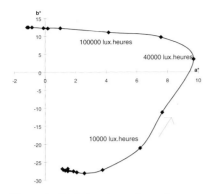

Figure 1. Variation des couleurs de l'actinomètre exposé à une lumière halogène (CieLab★, D65) ; 300 lux, 55% HR, 23°C.

point un prototype (Brevet 1998). Il se présente sous forme d'une feuille de carton recouvert d'un polymère coloré. Lors d'une exposition à une source lumineuse, la couleur vire du bleu au violet puis au rose et enfin au blanc (voir Fig. 1). Ce changement de teinte—sur un principe identique à celui des indicateurs d'humidité—facilement qualifiable visuellement, donne une idée approximative de la dose d'éclairement reçue. Cette étude préliminaire vise a étudier l'influence de divers paramètres comme l'humidité, la température, la source d'éclairage sur le comportement de cet actinomètre.

Nous avons été confronté à la difficulté d'obtenir un lot homogène d'échantillons : le couchage étant réalisé manuellement au laboratoire, l'épaisseur de la couche peut varier d'un échantillon à l'autre. Ces échantillons ont été soumis à différentes sources de lumière sous diverses conditions environnementales. Afin de simplifier les opérations, nous les avons placés sous des films photographiques, comprenant 19 plages grises de densité croissante de 0,08 à 3,40, jusqu'à ce que les parties les plus exposées soient incolores. On calcule l'exposition lumineuse reçue derrière chaque plage en divisant la lumination par l'opacité de cette plage. On peut alors tracer les courbes de décoloration en fonction de l'exposition lumineuse (lux.heures).

Influence de la composition de l'air

Des expositions à la lumière ont été faites dans des atmosphères dépourvues d'oxygène en utilisant des plastiques transparents étanches et contenant des capteurs d'oxygène (Ageless®). Dans ces conditions d'exposition, la coloration passe très rapidement du bleu au rose, ce qui semble indiquer un mécanisme de photo-réduction. L'oxygène de l'air jouerait donc un rôle important en limitant la vitesse de décoloration par oxydation des substances décolorées et donc régénération de la couleur bleue.

L'influence des polluants comme le dioxyde de soufre, le dioxyde d'azote ou l'ozone n'a pas encore été étudiée.

Effet de la distribution spectrale sur la décoloration

Quel que soit le type de source utilisée, l'actinomètre se décolore après une exposition correspondant à 100 000 lux.heures, le blanchiment est alors presque total. Il est certain que toutes les parties du spectre de la lumière visible n'ont pas la même action, en particulier la lumière rouge est plus active car absorbée par la couche bleue. L'exposition de l'actinomètre sous des filtres dichroïques bleu (bande passante de 400 à 460 nm), vert (bande passante de 500 à 600 nm), et rouge (bande passante de 580 à 700 nm) montre en effet une décoloration bien plus rapide derrière le filtre rouge que celle observée en appliquant un filtre vert ou bleu. Selon la richesse de la source lumineuse on peut donc s'attendre à des vitesses de décoloration différentes. Les essais ont été faits avec des lampes tungstène, halogène et fluorescentes (voir Tableau 3) à 300 lux, 55% HR et 23°C. On observe une assez bonne corrélation après des expositions sous des lampes tungstène et halogène. Par contre, selon les caractéristiques des tubes fluorescents, des comportements différents peuvent être observés (voir Fig. 2).

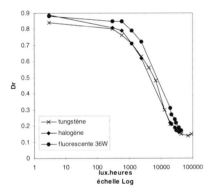

Figure 2. Comparaison de la perte de coloration bleue selon le type de lumière. Sources tungstène, halogène, fluorescente, 300 lux, 55% HR, 23°C (Dr : densité rouge).

Tableau 3. Sources utilisées lors des tests.

source	éclairement	énergie (450–950 nm)	UVa (315–400 nm)
xénon (1500 W)	5000 lux	50 W/m²	0,76 W/m²
tungstène (60W)	300 lux	8 W/m²	0,15 W/m²
halogène basse tension	300 lux	9 W/m²	0,12 W/m²
	100 lux	3 W/m²	
	50 lux	1 W/m²	
fluorescente 36W Mazdafluor blanc industrie TF 40	300 lux	0,980 W/m²	0,03 W/m²
fluorescente 18W Mazdafluor prestilux confort 827	7400 lux	25 W/m²	0,051W/m²

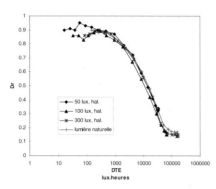

Figure 3. Comparaison de la perte de coloration bleue selon l'éclairement et comparaison avec la lumière naturelle (Dr : densité rouge).

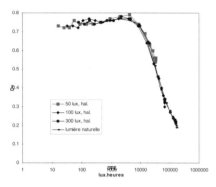

Figure 4. Comparaison de la perte de coloration rose selon l'éclairement et comparaison avec la lumière naturelle (Dv : densité verte).

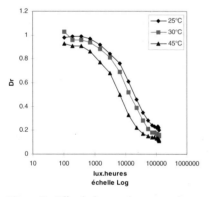

Figure 5. Effet de la température sur la perte de coloration bleue, lampe xénon, 60% HR (Dr : densité rouge).

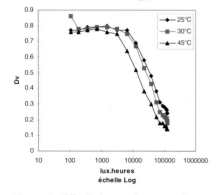

Figure 6. Effet de la température sur la perte de coloration rose, lampe xénon, 60% HR (Dv : densité verte).

Effet de l'éclairement et régénération

Des expositions avec la source halogène ont été faites sous des éclairements de 50, 100 et 300 lux. Dans ces conditions l'actinomètre n'a pas présenté d'écart de réciprocité et par exemple 300 heures d'exposition à 50 lux produisent les mêmes effets que 50 heures à 300 lux (voir Figs. 3, 4).

Afin de déterminer s'il y avait une régénération de la couleur, nous avons exposé des échantillons (7400 lux , 220 minutes), puis les avons mesurés régulièrement lors de leur stockage dans l'obscurité (23°C, 50% HR). On observe une régénération partielle de la couleur qui, après deux semaines, correspond à une remontée uniforme de la densité rouge de 0,07 et de la densité verte d'au maximum 0,05. Le même phénomène se produit de façon plus marquée (de l'ordre de 0,1) sous des éclairements intenses d'environ 20 000 lux sous une lampe xénon. Cet aspect doit être examiné en détail, il est possible que la décoloration soit plus rapide par manque momentané d'oxygène. Dans l'obscurité, la présence d'oxygène, permet à la réaction inverse de se produire pour retourner à un état d'équilibre entre la forme oxydée et la forme réduite.

Effet de la température et de l'humidité sur la décoloration

Des expositions sous éclairage xénon ont été réalisées dans des enceintes climatiques afin de faire varier les conditions thermo-hygrométriques. Les conditions retenues étaient les suivantes : 25°, 30° et 45 °C à 60% HR et 43%, 60% et 80% HR à 45 °C. Les courbes (voir Figs. 5, 6) indiquent que la vitesse de décoloration augmente lorsque la température et l'humidité relative croissent. L'effet de la température semble très marqué, une augmentation de vingt degrés multiplie par environ quatre la perte de la coloration.

Conservation dans l'obscurité

Conservé dans l'obscurité sur une durée d'environ un an, l'actinomètre a gardé son aspect et ses propriétés. Sur des périodes plus longues et dans des conditions de température et d'humidité importantes, il est possible que la couleur se modifie. Des essais de vieillissement thermique dans l'obscurité à 70°C et 70% HR indiquent une variation de densité (voir Fig. 7). Des tests complémentaires devraient permettre d'extrapoler la stabilité dans des conditions ambiantes.

Essai dans des conditions incontrôlées

Pendant les mois de septembre et d'octobre, un actinomètre a été placé sur un mur de notre laboratoire et exposé à la lumière naturelle à raison de sept heures par jour dans des conditions de température et d'humidité ambiantes. La lumination était enregistrée à l'aide d'un radiomètre. Pendant ces mois, le temps était relativement gris et l'éclairement dépassait rarement quelques centaines de lux. Dans ces conditions, on n'a constaté que peu de différences entre les effets de la lumière naturelle et ceux de la lumière halogène sur l'actinomètre (voir Figs. 3, 4).

Discussion et conclusion

Cette étude préliminaire a été réalisée à partir de prototypes fabriqués au laboratoire. Les résultats obtenus sont encourageants car ils révèlent une bonne sensibilité à la lumière, même avec des éclairements d'une cinquantaine de lux. Pour des éclairements courants, il n'apparaît pas d'écart de réciprocité.

La vitesse de décoloration est essentiellement liée à l'éclairement, mais la distribution spectrale de la source lumineuse, la température et l'humidité jouent également un rôle. Si l'on souhaite utiliser cet instrument comme un dosimètre, il sera nécessaire de l'étalonner en fonction de ces paramètres.

Cet actinomètre s'avère un outil intéressant. Facile à mettre en œuvre, il peut servir pour le contrôle et le suivi des conditions d'éclairement : le changement de couleur de bleu à rose puis blanc est une indication visuelle facile à repérer et qui

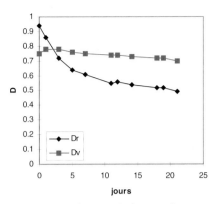

Figure 7. Décoloration de l'actinomètre dans l'obscurité à la chaleur humide, 70°C, 70% HR.

peut servir d'alarme en indiquant que l'on se situe dans la zone des 100 000 lux.heures.

Des contacts sont en cours pour procéder à un couchage industriel plus homogène. Disposer d'un lot suffisant d'échantillons nous permettra de développer un programme d'évaluation du comportement dans des conditions naturelles d'exposition en collaboration avec différentes institutions. Nous pourrons également approfondir les tests présentés et étudier, entre autres, l'effet de la distribution spectrale, des rayonnements ultra-violets, des polluants et des variations climatiques et lumineuses.

Remerciements

Ce projet a pris forme pendant le cours sur les principes scientifiques de la conservation (SPC) de l'Iccrom à Rome en 1996, sous le nom de AMUSE (Actinometer for MUSEums). La recherche a pu être initiée grâce à la collaboration de Lyzanne Gann.

Références

Allen NS, Pratt E, McCormick DM. 1993. Development of a visible light dosimeter film based on crystal violet dye. In : Conservation news (52) : 10–11.

Bergeron A. 1992. L'éclairage dans les institutions muséales. Québec : Musée de la Civilisation; Montréal : Société des musées quebécois : 147.

Brevet 9812825 du 13 octobre 1998 : Dosimètre d'évaluation du degré d'éclairement notamment d'objets dont l'exposition à la lumière doit être limitée.

British Standard 1006 :1971. Methods for the determination of the colour fastness of textiles to light and weathering. International organization for standardization recommendation R105.

Coustet E. 1927. Traité général de photographie en noir et en couleurs. Paris : Librairie Delagrave : 121.

Feller RL, Johnston-Feller RM. 1978. Use of the International Standards Organizations's blue-wool standards for exposure to light. Use as an integrating light monitor for illumination under museum conditions. In : American Institute for Conservation of Historic and Artistic Works. Preprints of papers presented at the sixth annual meeting, Washington : AIC : 73–80.

Garcia I, Costain C, Michalski S, Binnie N. 1995. Évaluation de la sensibilité à la lumière des matériaux colorés dans les collections de musée. In : Résumés, Calgary : 21ème congrès annuel de l'IIC–CG : 16.

Kenjo T. 1986. Certain deterioration factors for works of art and simple devices to monitor them. In : The international journal of museum management and curatorship (5) : 295–300.

Staniforth S, Bullock L. 1997. Surveying light exposure in national trust houses. Museum practice, Issue 6, vol.2, n.3 : 72–74.

Tennent NH, Townsend JH, Davis A. 1982. A simple integrating dosimeter for ultraviolet light. In : Science and technology in the service of conservation, Preprints of the contributions to the Washington Congress, London : IIC : p.32–38.

Tennent NH, Townsend JH, Davis A. 1987. Light dosimeter for museums, galleries and historic houses. In : Preprints of the conference on lighting in museums, galleries and historic houses, Bristol, London : The museums association : 31–35.

Ware JM. 1996. Quantifying the vulnerability of photogenic drawings . In : Mogens Koch, ed. Proceedings of the conference in Copenhagen, Research techniques in photographic conservation, 14–19 May 1995, Copenhagen : 23–30.

Whitmore P, Bailie C, Pan X. 1998. Photochemical kinetics, optics and color change : studies on the origin and prevention of the light fading of paint. In : Art et chimie : la couleur. Résumé, Congrès international sur l'apport de la chimie aux œuvres d'Art, Amphithéâtre Rohan, Ecole du Louvre Palais du Louvre, Paris : 149–150.

Abstract

The rate of the relative humidity response of backboard protected canvas paintings is described as the result of moisture transport through the canvas and of moisture release from the hygroscopic materials enclosed in the system. A mathematical model, which predicts the moisture concentration profiles setting up in the wooden stretcher as a result of sudden external changes, is presented. The internal RH is calculated and tested experimentally from the moisture concentration profiles.

Keywords

canvas paintings, preventive conservation, backboard, relative humidity, moisture diffusion coefficient of wood

The effect of the wooden stretcher on the RH response of backboard protected canvas paintings

Frank J. Ligterink[*]
Instituut Collectie Nederland
Gabriel Metsustraat 8
1071 EA Amsterdam
The Netherlands
Fax: +31.20.3054700
Email: nwo@icn.nl

Giovanna Di Pietro
Abteilung für Wissenschafltiche Photographie
 Klingelbergstrasse 80
4055 Basel
Switzerland
Fax: +41.61.2673855
Email: dipietro@foto.chemie.unibas.ch

Introduction

A current practice in the field of painting conservation is the application of various types of boards and sheeting to the reverse side of the stretcher or the frame of canvas paintings. These backboards are applied to the reverse side of the painting to prevent mechanical damages, to reduce vibrations during transport and to prevent dust penetration on the back side of the canvas. Furthermore backboards reduce the intensity of short time relative humidity (RH) fluctuations on the back of the canvas (Sandner et al. 1993: Di Pietro et al. 1998). Relative humidity fluctuations are expected to induce stresses in the paint layers of canvas paintings. The application of a backboard material will result in a damping of short-term relative humidity fluctuations and might therefore be beneficial as a passive conservation measure.

The change of the RH of the air enclosed between canvas and backboard is indicative of changes in the moisture content of the painting itself. A study of the basic processes underlying this RH response of the painting is fundamental to a discussion of the microclimatic effects of backboards. In order to choose a backboard material from various types available, a physical model that predicts the RH response of the painting to fluctuations in the ambient RH is needed. It was shown in an earlier study (Di Pietro et al. 1998) that the RH response of paintings that contain only thin layers of fibrous hygroscopic materials like canvas or cardboard is characterised by an exponential decay curve that can be predicted simply. In real life the prediction of the RH response of a painting is complicated by the presence of a wooden stretcher. Due to the thickness of the wood, the moisture release of the wood is delayed. In this study a physical model is developed that takes into account the complicated moisture desorption of the wooden stretcher to predict the RH response of a painting to external RH fluctuations.

Theory

Consider an oil-painted canvas attached onto a simple wooden stretcher. This stretcher is closed on the back side with a moisture impermeable Lexan® sheeting. Suppose the whole system (called the backboard system) has been hanging in a room with a constant relative humidity for sufficient time. The equilibrium moisture content of all hygroscopic materials inside the system will have been adjusted to this constant value. Then suppose that suddenly the RH of the room air changes to a new lower value. As a result moisture will diffuse out of both the air and the

hygroscopic materials enclosed in the backboard system until a new equilibrium situation has been established.

The RH change in the backboard system takes place at a certain rate that is determined by two types of moisture transport process within the backboard system. The first type of process is the leakage of moisture out of the backboard system due to the difference of RH between the inside and the outside of the painted canvas. In a general case moisture loss might take place through leakages between canvas and stretcher and through the canvas itself.

For the present situation it is assumed that leakage takes place only through the canvas. The amount of water vapour that diffuses through the canvas surface per unit of time $j(g\ s^{-1}cm^{-2})$ is directly proportional to this difference in RH. The constant of proportionality is called the permeability $P(g\ s^{-1}cm^{-2})$ of the canvas plus paint layers.

$$j = P(RH_{out} - RH_{in})\qquad(1)$$

The second type of moisture transport in the backboard system is related to the moisture release by the enclosed hygroscopic materials in the air volume. In the system two distinct types of hygroscopic materials are present – canvas and wood. The canvas itself is thin and as a result will be able relatively quickly to adjust its moisture content to a new RH value by giving off moisture to the enclosed air. The other hygroscopic material in the backboard system is the wood from the stretcher. The response of the wood is more complicated.

The moisture concentration at the surface of the wood, like the canvas, responds quickly to changes in humidity in the air. Both the canvas and the surface of the wood can be assumed at all times to be in equilibrium with the RH of the enclosed volume. While the surface is drying by giving off moisture in the air, the moisture concentration at the core of the stretcher is still at the initial equilibrium concentration. The difference between the moisture concentration at the surface and at the core drives the diffusion of moisture from the centre to the surface. Diffusion takes place inside the wood until the moisture content of the whole block, the enclosed air and the canvas is in equilibrium with the new RH of the outside air.

The degree to which changes in the RH of the enclosed air will be slowed depends on the counteraction of moisture leakage out of the system by the release of moisture by the hygroscopic materials. If the release of moisture by the wood is slow, the presence of the wood will contribute little to the stability of the RH in the enclosed air.

The time dependence of the moisture concentration profile in the wood is described by the diffusion equation.

$$D_w \frac{\partial^2 c(x,t)}{\partial x^2} = \frac{\partial c(x,t)}{\partial t}\qquad(2)$$

The transport process in the wood is characterised is the diffusion coefficient D_w $(cm^2 s^{-1})$ of moisture for the type of wood. The solution of equation (2) for the case described above can be found with the Laplace transformation method (see Appendix). In order to plot the solution, the values of the physical parameters characterising the backboard system are required. The hygroscopicity factors of both wood and canvas are given by the slopes of moisture isotherms and can be calculated from moisture isotherms reported in the literature (Jeffries 1960). Permeability of the painted canvas was measured with the dry cup method in an earlier study (Di Pietro et al. 1998).

The diffusion constant of moisture in wood can be determined experimentally from the time dependence of the moisture uptake of a block of wood. If a single surface area $A\ (cm^2)$ of a block of wood is exposed to a sudden increase $\Delta\phi\ (-)$ of the ambient RH, moisture will be absorbed at a certain rate. The time dependence of this moisture uptake $M(t)\ (g)$ will depend on the difference in the equilibrium moisture concentration $\Delta c\ (g\ cm^{-3})$ for the two relative humidities. If a linear approximation of the absorption isotherm is made this difference can be expressed as:

$$\Delta c = \alpha_w \rho_w \Delta\phi\qquad(3)$$

Figure 1. Moisture release curves of pinewood blocks. The bold line represents the theoretical curve for the mean diffusion coefficient.

where a_w (-) is the hygroscopicity factor of the wood and ρ_w (g cm$^{-3}$) is the wood density. The moisture release $M(t)$ (g) at time t (s) after a sudden change of relative humidity is given by (Crank 1956):

$$M(t) = 2A\alpha_w\rho_w\Delta\phi\sqrt{\frac{D_w t}{\pi}}$$ (4)

With known surface area and hygroscopicity the diffusion coefficient of the wood can be determined in a straightforward manner from a fit of the mass uptake to equation (4).

Measurements of the diffusion constant of moisture in wood

Experimental set-up

The procedure described above for measuring the diffusion constant of wood was performed with various samples of pinewood. The set consists of eight blocks of pinewood with varying wood structures. Dimensions of all blocks are $14.5 \times 4.4 \times 1.8$cm3. Four of them are sawn in the tangential direction to the trunk axis, the other four in the radial direction. Five faces of the blocks were covered with moisture impermeable tape so that moisture uptake could take place only through the sixth face.

Prior to the start of the experiment the blocks were equilibrated at 55% RH for two weeks. Then they were transferred to a ventilated climate chamber with 30% RH and 21°C and weighed regularly for 10 days. The increase of mass of the blocks was measured with a precision balance (Sartorius RC250S, precision 0.05mg).

The moisture uptake curves were fitted to equation (4) and a mean value of the diffusion constant of moisture D_w was calculated.

Results

Figure 1 represents the moisture release data of seven wooden blocks, three sawn in the radial direction (R1, R2 and R3) and 4 sawn in tangential direction (T1, T2, T3 and T4). One sample (R4) showed a major flaw in its wood structure and was discarded. The experimental data show the expected square root behaviour with time. The bold line is the least square fit of the uptake curves. The resulting mean diffusion constant from the least squares fit is $3.4 \times 10^{-7} \times 0.6 \times 10^{-7}$cm2 s$^{-1}$. The moisture release curves show no correlation for the direction of wood sawing.

Measurements of the RH response of a painting

Experimental set-up

The dummy backboard system is composed of a commercially obtained oil grounded canvas with a single layer of oil paint attached to a pinewood stretcher. The dimensions of the whole system are $50 \times 60 \times 1.5$cm3. The stretcher bars are 4cm wide and 1.5cm thick. The back of the painting is closed with a Lexan® sheet screwed on the stretcher. Lexan® is a non-hygroscopic transparent polycarbonate material with low moisture permeability. Table 1 lists the geometrical and physical properties of the canvas and of the wooden stretcher used in the backboard system.

The painting is positioned on a wall placed in the centre of a climate room and the internal and external RH is measured with capacitive sensors (Vaisala HMM 30D). It is kept in a climate of 55% RH and 20°C for two weeks to let the moisture concentration of the hygroscopic materials reach an equilibrium value. Then the ambient RH value is lowered suddenly from 55% to 30% while the temperature

Table 1.

Material	Surface (cm²)	Density	Permeability (g cm⁻² s⁻¹)	Hygroscopicity Factor
Canvas	A_c = 3000	ρ_c = 0.04 g cm$^{-1}$	P = 7.7×10$^{-8}$[2]	α_c = 0.12
Wooden Stretcher	A_w = 424	ρ_w = 0.6 g cm$^{-3}$	-	α_w = 0.15

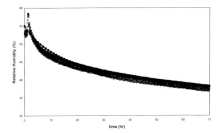

Figure 2. Predicted and measured RH response of a canvas painting on a wooden stretcher with a Lexan® backboard.

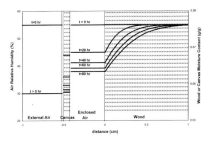

Figure 3. Calculated relative humidities and moisture concentration profiles in a painting with a wooden stretcher.

increases from 20°C to 25°C. The internal RH and T of the backboard system are measured at intervals of five minutes for 72 hours.

Results

Figure 2 shows the measured and predicted RH values of the enclosed air volume in the painting. The solid curve represents the theoretically predicted RH response that follows from the calculated moisture concentration profiles in the wood (See Fig 3).

Discussion and conclusions

The correspondence between theory and experimental results is good. This suggests that the various transport phenomena that take place within the system are well understood. The RH response of canvas paintings with a backboard is the combined result of the different moisture transport processes:

- A release of moisture through the painted canvas that is determined by the canvas permeability
- A fast exchange of moisture between the enclosed air and the surfaces of both wood and canvas
- A slow diffusion of moisture from deeper laying parts of the wooden stretcher to the enclosed air

These factors can effectively be combined into a single model that predicts the RH response of a specific painting.

Acknowledgements

This work is the result of a close collaboration of the working group on backboard protection at the Instituut Collectie Nederland. The authors would like to thank Jørgen Wadum (Mauritshuis, Den Haag), Laurent Suzzani (RijksMuseum, Amsterdam), Wolter Kragt, Ysbrand Hummelen and Ton Jütte (Instituut Collectie Nederland) for their valuable contributions that form the basis of this work.

References

Ambramowitz M and Stegun IA. 1970. Handbook of mathematical functions 9th ed. New York: Dover.

Crank J. 1956, The mathematics of diffusion, 2d ed. Oxford: Clarendon Press, 3.3, equation 3.15.

Di Pietro G. and Ligterink F. Unpublished. Prediction of RH response of backboard protected canvas paintings. (Submitted May 1998 to *Studies in conservation*.)

Jeffries R. 1960. The sorption of water by cellulose and eight other textile polymers. Journal of the Textile Institute 51(9): T339–T374.

Sandner I, Schramm HP and Schaft A. 1993. Reverse side protection of paintings – test results and suggestions for a model. In: Preprints ICOM Committee for Conservation Conference Washington DC, Vol. 1: 157–163.

Materials

Lexan: General Electric Plastics BV., plasticsln 1, 4612 PX Bergen op Zoom, The Netherlands, +31 (164) 292911.

Canvas, Ginkel Kunstenaarsbenodigdheden BV., Bilderdijkstr 99, 1053 KM Amsterdam, The Netherlands, +31 (20) 6189827.

Appendix

The time dependence of moisture concentration profile c(x,t) (g cm$^{-3}$) inside the wood is described by the time–dependent diffusion equation:

$$D_w \frac{\partial^2 c(x,t)}{\partial x^2} = \frac{\partial c(x,t)}{\partial t} \qquad (x>0) \qquad (A1)$$

Prior to the sudden change in the external relative humidity at time $t = 0$ (s) from a value ϕ_0 to a value ϕ_1:

$$\phi(t) = \phi_0 \qquad (t \leq 0) \tag{A2a}$$

$$\phi(t) = \phi_1 \qquad (t > 0) \tag{A2b}$$

the whole system has been exposed sufficiently long to establish an equilibrium situation. Throughout the wood the moisture concentration equals the equilibrium concentration c_0. The initial condition for the wood then is given by:

$$c(x,t) = c_0 \qquad (x > 0, \quad t = 0) \tag{A3}$$

The equilibrium concentration c_0 can be calculated from the hygroscopicity α_w (-) and the density ρ_w (g cm$^{-3}$) of the wood.

$$c_0 = \alpha_w \rho_w \phi_0 \tag{A4}$$

Inside the wood, it is assumed that this concentration attains this constant value for the duration of the experiment.

$$c(x,t) = c_0 \qquad (x \rightarrow \infty, \forall t) \tag{A5}$$

The flux j_w (g cm$^{-2}$ s$^{-1}$) at the wood surface A_w (cm2) that is exposed to the internal air volume must balance the flow through the paint layers plus the uptake m (g) of water by the canvas.

$$A_w j_w(t) = A_c j_c(t) - \frac{d\,m(t)}{dt} \tag{A6}$$

Both fluxes and the mass uptake can be expressed as functions of the moisture concentrations,

$$j_w(t) = -D_w \frac{\partial c(0,t)}{\partial x} \tag{A7}$$

$$j_c(t) = -P(\phi_{in}(t) - \phi_{out}(t)) = -P\left(\frac{c(0,t)}{\alpha_w \rho_w} - \phi_1\right) \tag{A8}$$

$$\frac{\partial m(t)}{\partial t} = \alpha_c M_c \frac{\partial \phi_{in}(t)}{\partial t} = \frac{\alpha_c A_c \rho_c}{\rho_w \alpha_w} \frac{\partial c(0,t)}{\partial t} \tag{A9}$$

where α_c (-) and α_w (-) are the hygrocospicity factors for the canvas and the wood, ρ_w (g cm$^{-3}$) and ρ_c (g cm$^{-2}$) are the volumetric and surface mass densities of the wood and the canvas.

Equations 7, 8 and 9 can be combined to arrive at the boundary condition for the wood surface

$$-A_w D_w \frac{\partial c(0,t)}{\partial x} = -\frac{A_c P}{\rho_w \alpha_w}(c(0,t) - \phi_1) - \frac{\alpha_c A_c \rho_c}{\rho_w \alpha_w} \frac{\partial c(0,t)}{\partial t} \tag{A10}$$

Simplifying notation, this can be rewritten as

$$\frac{\partial c(0,t)}{\partial x} = k_1 c(0,t) - k_2 + k_3 \frac{\partial c(0,t)}{\partial t} \tag{A11a}$$

with

$$k_1 = \frac{A_c P}{A_w D_w \rho_w \alpha_w} \tag{A11b}$$

$$k_2 = \frac{A_c P}{A_w D_w} \phi_1 \tag{A11c}$$

$$k_3 = \frac{\alpha_c A_c \rho_c}{A_w D_w \rho_w \alpha_w} \tag{A11d}$$

Summarising, we arrive at the following set of equations:

$$D_w \frac{\partial^2 c(x,t)}{\partial x^2} = \frac{\partial c(x,t)}{\partial t} \tag{A12a}$$

$$c(x,t) = c_0 \qquad\qquad (x > 0, \quad t = 0) \tag{A12b}$$

$$\frac{\partial c(0,t)}{\partial x} = k_1 c(0,t) - k_2 + k_3 \frac{\partial c(0,t)}{\partial t} \qquad (x = 0, t > 0) \tag{A12c}$$

$$c(x,t) = c_0 \qquad (x \to \infty, \forall t) \tag{A12d}$$

The solution for this set of equations can be found with the method of Laplace transformation. Laplace transformation of the diffusion equation and boundary conditions using initial condition (12b) results in:

$$D_w \frac{\partial^2 \bar{c}(x,s)}{\partial x^2} = s\,\bar{c}(x,s) - c_0 \tag{A13a}$$

$$\frac{\partial \bar{c}(x,s)}{\partial x} = k_1 \bar{c}(x,s) - \frac{k_2}{s} + k_3 s \bar{c}(x,s) - k_3 c_0 \qquad (x = 0) \tag{A13b}$$

$$\bar{c}(x,s) = \frac{c_0}{s} \qquad (x \to \infty) \tag{A13c}$$

With the solution:

$$\bar{c}(x,s) = \frac{c_0}{s} + \frac{k_2 - k_1 c_0}{s\left(k_1 + k_3 s + \sqrt{\dfrac{s}{D_w}}\right)} e^{-x\sqrt{\frac{s}{D_w}}} \tag{A14}$$

The polynomial in the denominator can be factorised into:

$$\bar{c}(x,s) = \frac{c_0}{s} + \frac{A_1}{s\left(\sqrt{s} - \omega_1\right)\left(\sqrt{s} - \omega_2\right)} e^{-x\sqrt{\frac{s}{D_w}}} \tag{A15a}$$

with

$$A_1 = \frac{k_2 - k_1 c_0}{k_3} \tag{A15b}$$

and

$$\omega_{1,2} = \frac{-1 \pm \sqrt{1 - 4 D_w k_1 k_3}}{2 k_3 \sqrt{D_w}} \tag{A15c}$$

After expansion of (15a) into partial fractions

$$\bar{c}(x,s) = \frac{c_0}{s} + A_1 \left(\frac{1}{\omega_1 \omega_2 s} + \frac{\omega_1 + \omega_2}{\omega_1^2 \omega_2^2 \sqrt{s}} + \frac{1}{\omega_1^2 (\omega_1 - \omega_2)(\sqrt{s} - \omega_1)} - \frac{1}{\omega_2^2 (\omega_1 - \omega_2)(\sqrt{s} - \omega_2)} \right) e^{-x\sqrt{\frac{s}{D_w}}} \tag{A16}$$

the inverse Laplace-transformation can be performed separately for each term by consulting tables with functions and their Laplace-transforms (Abramowitz et al. 1970).

$$c(x,t) = c_0 + \frac{A_1}{\omega_1 \omega_2} \, Erfc\left(\frac{x}{2\sqrt{D_w t}}\right) + \frac{A_1(\omega_1 + \omega_2)}{\omega_1^2 \omega_2^2} \frac{e^{-\frac{x^2}{4D_w t}}}{\sqrt{\pi t}} +$$

$$+ \frac{A_1}{\omega_1^2(\omega_1 - \omega_2)}\left(\frac{e^{-\frac{x^2}{4D_w t}}}{\sqrt{\pi t}} + \omega_1 e^{-\frac{\omega_1 x}{\sqrt{D_w}}} e^{\omega_1^2 t} \, Erfc\left(-\omega_1 \sqrt{t} + \frac{x}{2\sqrt{D_w t}}\right)\right) \quad (A17)$$

$$- \frac{A_1}{\omega_2^2(\omega_1 - \omega_2)}\left(\frac{e^{-\frac{x^2}{4D_w t}}}{\sqrt{\pi t}} + \omega_2 e^{-\frac{\omega_2 x}{\sqrt{D_w}}} e^{\omega_2^2 t} \, Erfc\left(-\omega_2 \sqrt{t} + \frac{x}{2\sqrt{D_w t}}\right)\right)$$

The exponential terms cancel and the expression simplifies to:

$$c(x,t) = c_0 + \frac{A_1}{\omega_1 \omega_2} \, Erfc\left(\frac{x}{2\sqrt{D_w t}}\right) + \frac{A_1}{\omega_1(\omega_1 - \omega_2)} e^{-\frac{\omega_1 x}{\sqrt{D_w}}} e^{\omega_1^2 t} \, Erfc\left(-\omega_1 \sqrt{t} + \frac{x}{2\sqrt{D_w t}}\right) \quad (A18)$$

$$- \frac{A_1}{\omega_2(\omega_1 - \omega_2)} e^{-\frac{\omega_2 x}{\sqrt{D_w}}} e^{\omega_2^2 t} \, Erfc\left(-\omega_2 \sqrt{t} + \frac{x}{2\sqrt{D_w t}}\right)$$

The relative humidity of the enclosed air ϕ_{in} is simply found from the moisture concentration at the wood surface $x=0$ with use of equation (4).

$$\phi_{in}(t) = \alpha_w \rho_w c(0,t) \quad (A19)$$

Substituting equation (18) the explicit expression for the RH response simplifies to:

$$\phi_{in}(t) = \alpha_w \rho_w \left(c_0 + \frac{A_1}{\omega_1 \omega_2} + \frac{A_1}{\omega_1(\omega_1 - \omega_2)} e^{\omega_1^2 t} \, Erfc\left(-\omega_1 \sqrt{t}\right) - \frac{A_1}{\omega_2(\omega_1 - \omega_2)} e^{\omega_2^2 t} \, Erfc\left(-\omega_2 \sqrt{t}\right)\right) \quad (A20)$$

Packing and transport of hollow plaster sculpture

Abstract

Protective packaging strategies for the safe shipment of 35 fragile hollow plaster sculptures are described. These include a multi-criteria decision method, based on size, geometry, and surface finishes, that was used to rank-order sculpture vulnerability; double-case designs that simplified the protective packaging for the irregular-shaped sculptures; and several variations of the inner-case component of the double-case design that provided ease of handling and added protection for the fragile plaster works during display installation and removal. Effective material use and other benefits provided by the double-case package designs are discussed, and features that contribute to the optimum performance of a double-case system are presented.

Keywords

preventive conservation, objects, sculpture, package, packaging, shipping, transit, transport

Paul J. Marcon,* Michael Harrington, Paul Heinrichs
Canadian Conservation Institute
1030 Innes Road
Ottawa Ontario K1V OM5
Canada
Fax: +1 613 998-4721
Email: paul_marcon@pch.gc.ca; mike_harrington@pch.gc.ca;
 paul_heinrich@pch.gc.ca

Doris Couture-Rigert
National Gallery of Canada
P.O. Box 427, Station A
Ottawa, Ontario K1N 9N4
Canada
Email: dcrigert@ngc.chin.gc.ca
Fax: +1 613 991-2680

Introduction

The National Gallery of Canada (NGC) recently organized and circulated a retrospective exhibition featuring two Canadian sculptors, Emanuel Hahn and Elizabeth Wyn Wood, including a total of 71 works (Baker 1997). The exhibition travelled by road to five venues between May 1997 and September 1998, covering a distance of more than 6000km. Thirty-five works were made of plaster, the majority being hollow casts reinforced with metal or wood armatures and/or burlap. Nearly all were finished with different coloured paint layers that created the impression of materials such as patinated bronze or stone. The size (height) of the sculptures ranged from 20 to 290cm.

Almost four years were devoted to stabilizing the plaster sculptures structurally and consolidating the endless interlayer cleavage and flaking paint layers. Some works had such problematic surface finishes that after weeks of painstaking consolidation under the microscope the works would keep flaking, losing pin-size paint flakes simply sitting on a shelf. The large plaster sculptures were awkward to manipulate and had extensive losses around the bottom edges. Even after treatment these large plaster sculptures were highly prone to chipped edges, and vulnerable to impacts and abrasion.

The planned shipment of these fragile works caused considerable concern. The Canadian Conservation Institute was contacted to establish a collaborative project aimed at developing crating systems to protect the works from shock and vibration during transit and to reduce the need to handle the actual sculptures during crating and installation. A five-month period was available to develop these crating systems before the deadline for submitting drawings to the NGC Design Department for the requirements to be incorporated into the design of the exhibition, and to have display pedestals and crates built in time.

The works were grouped into three main types, based on shape and construction method: complex hollow casts with delicate elements; compact hollow casts; and reliefs. Representative works for each category appear in Figure 1. Arrangements were also made to have three rough replicas of actual works fabricated, one from each established group type, to be used for performance testing the crating systems and obtaining information on the behaviour of the plasters when subjected to shock and vibration.

Vulnerability of hollow plaster sculptures to physical forces

Detailed information on the shock and vibration fragility of plaster sculptures is not yet available; therefore, to rank-order the works for packaging treatments, evaluations based on the size, geometry, and surface finishes were performed using

Figure 1. Sculpture categories: (a) compact hollow cast, Harvester; (b) relief, Dead Tree Relief, (c) Complex hollow cast with delicate elements. The Bard.

* Author to whom correspondence should be addressed

a multi-criteria decision method (Saaty 1990). The relative vulnerability scores obtained spanned three orders of magnitude. The first category contained *The Bard*, a large complex hollow cast with delicate elements and a fragile surface finish, as the top ranking sculpture. The second category contained many compact hollow casts including two large hollow casts with stable surfaces: *Harvester* and *Recruit*. The third category contained small- to medium-sized compact hollow casts, reliefs with stable surfaces, and some large compact hollow casts with stable surfaces. The application of the decision method in this study was preliminary but the technique proved useful for prioritizing the various works. Packing strategies for sculptures in each category are discussed below.

Shock

Shock damage during shipment usually occurs at cargo transfer points as a result of accidental drops or mishandling of packages. Using qualified art handlers and providing source to destination shipments in air-ride trucks reduced the risk but a finite probability of accidental impact still existed. Considering the fragility and value of the works in this exhibition, protective cushioning using 50–75mm-thick resilient foam was used in most packages. This thickness range provided a reasonable balance between expected hazards, cushion performance, and packaging costs.

Shock is defined as a sudden, severe mechanical disturbance that causes large displacements in the affected object. The two descriptive elements of a shock pulse are magnitude and duration. Magnitude is measured in G's which may be thought of as multiples of the object's weight applied for a brief interval of time. Typical cushioning systems are designed to limit shock levels to a range of 20 G's (for extremely fragile items) to 100 G's (for rugged items). Shock pulse durations associated with this range of protection are 50 ms (20 G's) to 10 ms (100 G's).[1]

The principal shock-related concerns for plaster sculptures are damage to the sculpture body or fragile projections, and surface losses. To achieve reasonably high protection in the absence of detailed shock fragility information, protective cushioning was optimized for the best performance that could be obtained from the cushion thickness used while avoiding undesirable shock response effects. Flexible components subjected to half-sine shock pulses (typical form in protective packaging) may experience up to 1.8 times the shock transmitted through a cushioning system depending on the ratio of critical component equivalent shock pulse frequency Fc/Fs (where Fs = 1/2t, t = shock pulse duration). Component response will be approximately 1.2 times the applied shock magnitude or less for Fc/Fs ratios of 4 or more (See Fig. 2) (Harris 1988, chapter 42, page 13). In practical terms, unnecessary shock magnification in the object/support system, the object, and object components is avoided if these items are relatively stiff compared to the main cushioning system. The main response effects considered here concern large low-frequency projections of *The Bard* and the behaviour of all sculptures on their transit supports.

Shock isolation

The design of protective cushioning begins with an assessment of shock hazards, which are expressed as a drop height above a hard floor surface from which a package may undergo a free-fall drop. Industrial literature provides drop height estimates – based on total package weight – which serve as reasonable guidelines for many applications. When shipping valuable museum items, higher drop heights can be used in anticipation of an extreme hazard such as an accidental drop from a truck tailgate (approximately 75cm). Although this may seem excessive for large, heavy packages, a recent incident involving a valuable fossil specimen falling from the tailgate of a truck illustrates the possibility of such an event and its damage potential.[2]

Protective cushion designs can be optimized for predictable shock isolation using performance data supplied by foam manufacturers and other sources (U.S. Department of Defense 1978). Several design tools based on this information are available to museum practitioners.[3] Both the type of material and the minimum thickness for a given application can be identified when reference is made to cushion performance data.

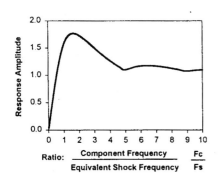

Figure 2. Maximum dynamic response of a simple mechanical system to a half sine shock pulse.

Handling

The two handling concerns during crating and installation that were addressed in this study are accidental impact and strain to vulnerable structures and assemblies during manual handling. Impacts during handling are considered to have short pulse durations and low energy content; as such they do not normally cause an energetic structural response in the affected object. If the surface of the item receiving an impact is durable, the impact may cause no damage and the small amount of energy supplied to the object may be absorbed by its elasticity. If the impact site is not durable, scratches, fractures, abrasion or losses at or near the impact site are likely outcomes. In addition to impact events, static force application while manually handling larger works is also a concern. Therefore, crating designs that minimized or eliminated the need for manual handling of the unprotected works were created, and will be described.

Vibration

Vibration concerns are most relevant to the transport phases of shipment. Dominant vibration frequencies in transport modes range from 1 to 200 Hz. Among common transport modes, trucks have the highest vibration levels and therefore possess the greatest damage potential. Because trucks form an integral part of almost all transportation scenarios and their vibration levels have been studied extensively, a base of information is available for assessing the risk of damage from transit vibration.[4] It is worth noting, however, that even truck vibration is generally considered to be below the damage threshold of many commercial products under non-resonant conditions (Bakker 1986, 655).

Most objects are capable of vibration as indicated by their tendency to vibrate or "ring" at certain frequencies if subjected to a brief impulsive force. In packaging applications, these frequencies are considered "critical frequencies" because any tendency of an object to vibrate makes it vulnerable to the force-multiplying effects of resonance. Resonance effects are illustrated by the curve in Figure 3. This curve depicts a response quantity, such as displacement, plotted as a function of the ratio of the vibration source and critical component frequencies, F_v/F_c, for a simple system having one flexible component. At frequency ratios less than 0.2, the component will vibrate with the same magnitude as the vibration source. For frequency ratios near $F_v/F_c = 1$, resonance effects will cause the component vibration magnitude to exceed the input level. The degree of vibration magnification that occurs will depend on the quantity of damping that is available to dissipate vibration energy. This damping originates from a number of sources such as air resistance and internal friction.[5]

A familiar cause of vibration damage to objects is material fatigue. For previously undamaged materials, the damage process begins with crack initiation followed by crack propagation. Crack development occurs when the stress levels during a number successive oscillation cycles attain a critical threshold. If this threshold is exceeded, fewer cycles are required to initiate crack formation. If the critical stress threshold is not attained during oscillation, an undamaged item can undergo almost indefinite cycling without adverse effects. A detailed understanding of crack development and propagation in plaster sculpture requires further investigation. In the absence of this information, preventive measures were taken to avoid and mitigate vibration effects during the Hahn-Wood exhibition. Sculpture vulnerability was reduced by conservation treatment, the use of well-maintained air-ride trucks that eliminated unnecessary vibration exposure, and protective packages that incorporated effective isolation. In studying the effects of vibration on sculptures for this investigation, emphasis was placed on the response of large sculpture projections, and the behaviour of objects on their supports.

Vibration isolation

The vibration characteristics of an object on a cushioning system can also be described by the curve in Figure 3 if Fc is considered to be the natural frequency of the object on the cushioning system. In the transmission region of the curve

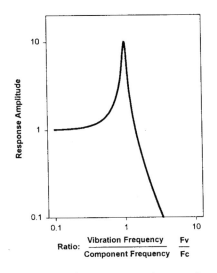

Figure 3. Vibration response for a simple mechanical system with one flexible component.

Figure 4. Installation sequence for The Bard: (a) transport, (b) raising inner shell, (c) removing inner shell covers, (d) applying display panels.

(frequency ratios less than 0.2) external vibrations are transferred to the object with undiminished magnitude. Vibration frequencies in the resonance region (frequency ratios near 1) are amplified and vibration isolation begins at a frequency ratio of 1.4. Effective isolation (e.g., 80%) begins near a frequency ratio of 3.

Resonant frequencies of resilient foam cushioning systems range from 5 to 100 Hz (U.S. Department of Defense 1978, 1591–1814). Vibration isolation is therefore practical for items that have minimum critical frequencies greater than 10 Hz. When vibration isolation using foam materials is not feasible due to low critical component frequencies, it may still be possible to implement control measures if the components are accessible. Disassembling a vibration-prone item may be an option in some cases. Protective wrapping, gentle bracing, or restraint of vulnerable items is another option.

Double-case packages

Virtually all of the plaster works were packed in double-case systems, or some variation of the double-case design. In all of these applications, efforts were made to achieve a reasonable degree of stiffness in the object, the object/support system, and the placement of supports inside the inner case. The objective of these measures was to create a packaging system that dissipated shock and vibration by the oscillation of the inner case on the cushioning system as a rigid unit without packaged item responses that might have magnified the shock and vibration levels transmitted by the cushioning system.

The Bard package design

The crating system for this top-ranking sculpture served both transit and display functions and did not require the fragile sculpture to be handled at any time. The lower portion of the shipping container doubled as a display pedestal and was covered with finished panels during exhibition. Photographs of the uncrating sequence appear in Figure 4. The small hand-operated forklift was transported to each venue to raise and lower the inner case. Only a few gap lines were visible when the package was in display mode including the gap line below the top cover of the pedestal measuring 3mm which is in keeping with pedestal design criteria of the National Gallery of Canada.

The finished display platform on which the sculpture resided formed the bottom panel of the inner case during transit. It was designed for high stiffness as any bending would impose loads on the base rim of the sculpture. Two wooden shells attached to this platform to complete the inner case, which was lowered into the shipping container and floated on 100mm-thick polyurethane cushions for transit.

Because the surface was very fragile, the sculpture was mainly held in place from inside and rigidly attached to the transit/display base using a foam-in-place technique (See Fig. 5). A simple stainless steel armature was fabricated and bolted to the platform to form a mechanical link between the foam and the platform. The hollow space inside the sculpture was lined with aluminum foil, to provide a barrier between the curing foam and the plaster surface. The cured foam relied on a mechanical lock between the surface irregularities of the plaster interior and the foam, providing a positive but removable (through excavation of the cured foam) coupling.

Evaluations of the packaging system and the foam-in-place method were made using a test sculpture (See Fig. 6). Performance testing of the package consisted of bottom rotational and flat drops from heights of 30cm. Additional tests included impact of the short and long faces of the package on moving equipment against a solid barrier at low to moderate velocities. The foam-in-place support remained rigid and intact throughout this test sequence and no damage or losses were apparent along the test sculpture base. This test sequence was considered more severe than the hazards that were expected, and in light of the higher fragility of the model compared the actual sculpture, the performance of the packaging system was rated as satisfactory.[6] Attaining the damage threshold of the test sculpture in the package required very rough handling which included forceful impact of the

Figure 5. Preparing The Bard *for the foam in place restraint system: (a) attaching hardware to the transit/display base, (b) applying foam to the sculpture interior.*

Figure 6. The Bard *test sculpture inside the protective packaging system (outer case and inner shell covers removed).*

Figure 7. Uncrating Harvester *with its dual-purpose platform.*

package on moving equipment against a solid wall and drop heights approaching 75cm. Damage to the test sculpture consisted of cracking near mid-span of the sculpture body and at other locations. The internal foam-in-place system remained fully intact and there was no damage to the sculpture base. Vibration isolation efficiency of the cushioning system near the first critical resonance of the sculpture/base combination was greater than 80% for frequencies of the test sculpture/base assembly and higher.[7]

Large compact hollow casts – *Harvester* and *Recruit*

Two large, compact hollow casts with stable surface finishes were supported on dual-purpose platforms. These platforms formed the base of the inner case and the top cover of display pedestals (See Fig. 7). Installation involved sliding the bases out of the shipping container and lifting them onto display pedestals manually. The stable surfaces of the sculptures enabled polyethylene bracing (with interleave described below) to be used against the sculpture surfaces to hold them firmly in position during shipment. Carved wooden blocks attached to the platform base and covered with polyethylene were used to hold the sculptures in position from inside. A thin interleave of closed cell foam between the sculpture base and hard platform surface conformed to minor surface variations and helped distribute loads.

Small-to medium-sized works

Most small-to medium-sized works were enclosed or braced with supports carved from polyethylene with a thin interleave of knit unbleached cotton jersey, unbleached cotton woven fabric, or acid-free unbuffered tissue paper (CCI 1994). Inner cases were fabricated of triple wall cardboard and contained one or more sculptures depending on the size of the works. These strong lightweight cases were used to move the works to their display locations, thereby protecting them during exhibit installation. The triwall inner cases also enabled an existing inventory of high quality wooden cases to be re-used while providing the exact amount of clearance required for cushioning material between the inner and outer cases (CCI 1997).

In addition to the functional aspects of the packaging system described above, the use of polyethylene enclosures and bracing provided inert long-term storage mounts for the objects. Polyethylene is well suited to this application because it is inert and easy to carve. Polyurethane ester, in contrast, is less stable and not as easily carved. Its use on the external surfaces of the inner case took advantage of its good shock and vibration isolation properties and its external location posed no threat to the packaged object. The straight cuts required to fabricate the cushioning system of polyurethane foam were easily made with a bandsaw.

Conclusion

The plaster works completed their journey with no structural damage; no plaster losses along their edges could be attributed to shipping. The only detectable losses, few and minute on a couple of the most fragile works, were consistent with those mentioned in the Introduction. The adoption of the strategies by the packing staff at the National Gallery of Canada was facilitated by ongoing consultations and demonstrations using sample objects and test equipment.

A final concluding evaluation of the crating systems was carried out after the works were returned to their lenders. The Fabrication Supervisor, the Travelling Exhibition Technician, and the Installation Supervisor were each asked to comment on building the crating systems and how the crates and sculptures could be handled. Although the double-case approach was perceived as more labour-intensive than single crating approaches, it was considered justifiable compared to the anticipated time and cost involved for a conservator to travel to each venue to repair damages to the plaster and inpaint numerous paint losses. The need to handle the actual works was also considered as having been greatly reduced during crating and installation, and virtually eliminated for *Harvester*, *Recruit* and *The Bard*. The

crating system for *The Bard* provided reliable, repeatable operation and functioned consistently well at all of the actual exhibition installations.

Some modifications to the concepts that were used will be considered in future applications but despite the limited duration and rigour of these investigations, the results of this project have added to the knowledge of crating fragile works.

As a result of the investigations and performance tests applied in this study and subsequent applications, a series of guidelines have been developed to help practitioners work toward effective double-case performance.[8]

Acknowledgements

The authors wish to thank the following Technical Services staff of the National Gallery of Canada for their assistance and input: Jean-Francois Castonguay, Marcel Duguay and Laurier Marion. Thanks also to Alan Todd of NGC Design Services for effectively integrating our requirements into the exhibition design. Bill O'Neil's assistance with fabrication of demonstration items and *The Bard* shipping case are also acknowledged with thanks. Photographs courtesy of the Estate of Elizabeth Wyn Wood and Emanuel Hahn.

Notes

1. Half-sine pulse, theoretical free-fall height 75cm, $e = 0.5$ (e is the coefficient of restitution).
2. *The Ottawa Citizen*, September 25, 1997, "75-million-year-old fossil reduced to rubble in freak accident". The package containing the fossil was unrestrained and slid out of the open truck doors when the brakes were suddenly applied while backing down an inclined ramp near the museum.
3. Circular slide rule, Computer software, PadCAD Version 2.0 and PadCAD Version 3.0, Canadian Conservation Institute Publications Department.
4. Marcon (1990) provides a summary of information contained in industrial literature on the shipping environment with references.
5. Amplification in Fig. 2 is for lightly damped engineering structure (i.e., bolted assembly with a fraction of critical damping of 0.05; Harris 1988, chapter 43, page 13). The amplification will not be as severe in sculptures due to greater damping and the random nature of the vehicle vibration.
6. The vulnerability of the actual sculpture to bending forces was further reduced by polyethylene bracing with interleave over a 100cm^2 area of stable surface on the upper portion sculpture.
7. Frequency ratio $= 4.8$ based on cushion resonant frequency of 9 Hz obtained by the U.S. Department of Defense 1978, and a measured frequency of the first bending mode of the sculpture base combination of 44 Hz.
8. To be published by CCI.

References

Baker VA, Hahn E, Wyn-Wood E. 1997. Tradition and innovation in Canadian sculpture. National Gallery of Canada. ISBN 0-88884-670-3.

Bakker M, ed. 1986. The Wiley Encyclopaedia of Packaging Technology. New York: Wiley.

Canadian Conservation Institute. 1994. CCI Technical Bulletin Number #14, Working with polyethylene foam and fluted plastic sheet. Cat No. NM 95-55/14-1994.

Canadian Conservation Institute. 1997. CCI Note 1/4, Making triwall containers. Cat. No. NM95-57/1-5-1997E (ISSN 0714-6221).

Harris CM. 1988. Shock and vibration handbook. 3d. ed. McGraw-Hill Book Co. ISBN 0-07-026801-0.

MacKay A. 1997. Treatment of a painted sculpture, *The Bard*, by Emanuel Hahn. Journal of the Canadian Association for Conservation Vol. 22.

Marcon PJ. 1991. Shock, vibration and the shipping environment in art in transit. In: Mecklenburg MF, ed. Studies on the packing and transport of paintings. Washington: National Gallery of Art.

Saaty TL. 1990. The analytic hierarchy process, planning, priority setting and resource allocation. Pittsburgh: RSW Publications.

US Department of Defense. 1978. U.S. Department of Defense military standardization handbook. MIL-HDBK-304B, 31 October 1978.

Abstract

Hygroscopic walls and ceilings give substantial stability to the indoor relative humidity (RH) in rooms ventilated at less than about one air change per hour. A few centimetres of material are sufficient to buffer the daily RH cycle, about 40cm of wall will buffer the annual cycle of RH in a room with about 0.1 air changes per hour. The factors that define the performance of buffers that must respond to a significant leak rate are the water capacity and the water vapour permeability. The best common buffer materials are wood, cut across the grain, and unfired clay brick. A specially designed light-weight clay made from bentonite mixed with perlite gives an excellent performance. The use of porous materials in walls and ceilings is an unappreciated aid to maintaining constancy of relative humidity indoors and deserves the attention of architects and engineers.

Keywords

Indoor climate, relative humidity, buffering, clay, bentonite, perlite, diffusion

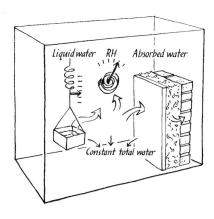

Figure 1. The principle of operation of a climate chamber that defines a flux of water vapour into the interior space. The water vapour distributes itself between the air and the experimental wall, so that the RH is a consequence of the absorptive characteristics of the wall.

On the usefulness of water absorbent materials in museum walls

Tim Padfield
Conservation Department
The National Museum of Denmark
Box 260
Brede
DK-2800 Lyngby
Denmark
Fax: +45 3347 3327
Email: padfield@natmus.dk
Web site: www.natmus.dk/cons/tp/

Introduction

The typical modern museum is built without any deliberate use of materials that will buffer variation of atmospheric humidity, yet the improved airtightness of buildings introduced to give more efficient energy use is precisely the factor that makes feasible the stabilisation of relative humidity by absorbent materials.

The use of absorbent materials to stabilise museum galleries goes back at least to an engineer named MacIntyre who described (MacIntyre 1934) how he stabilised the humidity in the Orangery of Hampton Court Palace near London by stuffing the ventilation channels with discarded cotton fire hose. Recent enquiries revealed no trace of the hose and no records of how well it worked. Whatever the actual performance, MacIntyre's initiative was not imitated. The modern museum is generally a lightly built structure with no natural climatic stability whatsoever.

MacIntyre's cotton hose required air circulation through the ducts. The walls of the gallery were of brick, plaster and wood panelling. None of these materials provides significant buffering. In this paper I explore a bolder concept: walls and ceilings made of absorbent materials will buffer the climate much more effectively. For some purposes this buffering is so effective that mechanical systems are not necessary. It may be that the average RH provided by passive buffers is too high. A relatively small and simple air-conditioning system can gently nudge the climate towards the long-term target while short-term buffering by the material moderates the peak strains on the indoor climate.

The performance of such a passive, or hybrid, system is dependent on the ventilation rate and is in practice only useful for air exchange rates of less than once per hour. A cinema or a disco must therefore use mechanical air-conditioning. On the other hand the quiet, unfrequented halls of an archive or a museum store can be passively buffered even against the yearly cycle of relative humidity (Christoffersen 1995: Padfield and Jensen 1990).

There is no readily available design tool that the architect can use to explore the use of absorbent materials to moderate the indoor climate. All available computer programs for calculating moisture movement within porous walls take the interior relative humidity as a boundary condition, defined by the person sitting at the keyboard. However, when the room has absorbent walls the RH is defined by the interaction of the walls with various sources, and sinks, of water vapour within the room. The RH is a consequence of the behaviour of the walls, not a controlling parameter.

The lack of suitable computer models is matched by a lack of experimental climate chambers that can imitate the situation in a room with buffering walls. Such a chamber should define a flux of moisture into, or out of, the chamber air and measure the resulting RH change, as buffered by the experimental wall within the chamber. This flux chamber is shown in Figure 1 and is described in detail elsewhere (Padfield 1998a).

In this paper I first describe the material properties that are needed to calculate the buffering effect and then give some examples of measured and calculated buffering (See Fig. 1).

The material's capacity for absorbing water vapour

The sorption curve of the material defines how much water will be released or absorbed when the material moves from equilibrium with one RH value to another. The inverse argument is that this same curve also defines the RH change in air that results when the material loses a certain weight of water into a confined space. This is the basis for the buffer effect: when water is withdrawn from the air surrounding the material, it will desorb water to compensate for the loss.

In a museum, where one presumably aims to keep a reasonably even and moderate RH, only that portion of the absorption curve between 40% and 65% RH is relevant. This part is fairly straight for most materials, so the absorption curve can be replaced by a constant: the water capacity shown in Figure 2.

The column at top left in Figure 2 shows the water capacity per unit volume for several building materials. The highest capacity material is clay, in a lightweight mixture described below. Wood comes next and then cellular concrete. Wool insulation, though highly absorbent, has rather poor capacity, because of its low density. The worst materials for buffering RH are the coarsely porous minerals: lime mortar, gypsum plaster and brick. To this list of poor performers mineral insulators such as perlite, glass wool and rock wool can be added.

All the common building materials except wood lie at the inferior end of the scale of buffer capacity. Wood is not, however, a good buffer material, for the reason given in the following section.

The position of a material on this column does not define the buffer performance of the material, because water must be able to penetrate to the surface from the depth of the wall within the natural cycle time of the room RH.

Water vapour permeability

Water vapour permeability is measured by placing the material over a cup containing a saturated salt solution to maintain a constant RH. The surrounding

Figure 2. A progressive description of the comparative performance of various building materials as humidity buffers. The water capacity is shown in the top left column as weight gain per unit volume of dry material when the RH changes from 0% to 100% (the value marked on the column is, however, based on the water absorption between 40% and 65% RH). The column below is the water vapour diffusion coefficient. The middle column is the active depth in which moisture exchange occurs during a daily cycle (on the left) and an annual cycle (on the right). The final column on the right shows the water available to buffer the daily cycle and is an index of the effectiveness of the material in buffering RH change when there is a considerable air exchange in the room. The arrows show how the fundamental material properties are combined to predict the water available for buffering from the various materials. 'Celcon' stands for cellular concrete, wood:: is end grain wood, wood | | is wood planks.

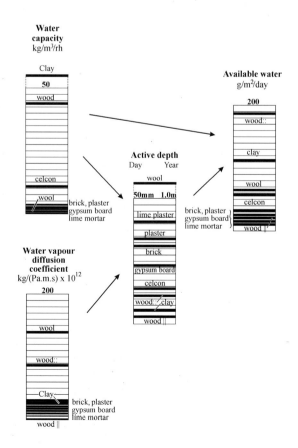

air is held at a different, but also constant, RH. After a short time the material will attain a steady water content gradient through its thickness. After this start-up period the weight of the cup of salt solution will change at a constant rate as water evaporates from the cup or condenses into it. This weight change can be converted into a permeability constant for the material. The values given in the lowest column of Figure 2 were obtained by maintaining 75% RH within the cup and 50% RH outside.

Notice that wood gives two very different values according to its orientation.

The interaction of absorption and permeability in a dynamic situation

A higher permeability makes possible a better performance as a buffer but there is an important complication when the RH is changing: as the water vapour diffuses into the material according to the diffusion coefficient it is being grabbed by the pore walls, according to the absorption coefficient. A material with both a high permeability and a high absorption coefficient will actually show a low permeability to water vapour under dynamic circumstances, because the water is absorbed before it has diffused far.

Calculation of this complex process is aided by defining a unit called the diffusivity, which is the diffusion coefficient divided by the absorption coefficient. If the imposed cycle is approximately sinusoidal the diffusivity can be used to calculate an active depth for moisture exchange by using the expression:

$$d = \sqrt{(Dt/\pi)}$$

where **d** is the active depth for water exchange, **t** is the period of the water flux cycle and **D** is the diffusivity. The active depth marks the distance into the wall at which the variation in RH in the pores has fallen to about one-third of the variation in the room. The mathematical derivation of this expression for the analogous process of heat flow through a material is given by Claesson and Hagentoft (1994).

Unfortunately, the analogy between heat flow and moisture flow is not exact. The active depth described above assumes that equilibrium between the water vapour and the pore wall is instantaneous. There is good evidence that wood does not instantly react with water even on a microscopic scale (Wadsoe 1993, 57–72) and a similar argument may apply to other materials.

The effective depth given in the column in the middle of Figure 2 is therefore just an indication of the order of magnitude of the useful thickness of the material for buffering a daily (reading the left side of the column) and a yearly cycle in relative humidity.

The amount of water available is now given by multiplying the water capacity by this active depth. The result is shown in the column on the right of Figure 2. The most striking revelation in this column is that the good materials are not those used in building. Wood that is cut across the grain is by far the best buffer but is not ideal for museum use because it outgasses various corrosive vapours, notably acetic acid. Clay is the second best buffer. Most clays contain particles of iron sulphide, which can give off hydrogen sulphide in some circumstances but indoors one would expect oxidation to sulphate. Clay walls smell much less than wood, so maybe the danger is not so great. Notice that the active depth of clay is only about 5mm for the daily cycle.

Clay walls as a humidity buffer

I have developed a clay buffer which can be applied to existing walls as a veneer, or used to make a massive wall. A 3cm-thick surface coating of clay is more than enough for daily buffering. A 30cm massive wall provides buffering of the annual cycle, if the air exchange is slow enough.

The clay which buffers best is sodium bentonite, is a very fine-grained montmorillonite. This is a marine deposit formed by the weathering of volcanic ash. This clay needs to be opened up to diffusion before it is of any use as a buffer. I used perlite as the filler. This is an expanded volcanic glass consisting of frothy

Figure 3. SEM image of a broken surface of the lightweight clay mixed from bentonite and perlite. One intact rounded perlite grain is visible. The smashed grains show the foamy internal structure. The bentonite is the fine-grained mass of curved flakes at the bottom of the picture.

Figure 4. The central panel shows a four-day cycle in the experimental chamber with a clay wall under test. The dotted line is the calculated RH in the empty chamber. The shallower curves show the RH measured in the chamber and within the clay wall at 9mm from the surface and at the sealed back of the tile at 34mm. The graph on the left is the same cycle modelled using the measured sorption and permeability coefficients. The graph on the right is made from the model with the coefficients adjusted to give the best fit to the experimental data.

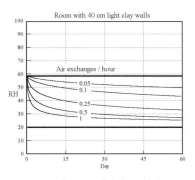

Figure 5. The rate of decline of the RH in a room initially at 58% RH leaking in air at 20% RH. The walls are of the same clay used in the experiments shown in Figure 4. The model uses the adjusted coefficients from the right hand graph in Figure 4.

glassy spheres of up to 2mm diameter. These particles have a high thermal insulation but no absorptive power. Perlite does, however, provide good cohesion to the mixture because the delicate particles are damaged during the mixing. The resulting sharp edges and fragments provide a good bond to each other and to the clay, so that when the mixture dries from its initial plastic state the shrinkage is moderate (8%), the mechanical strength is good (about 2MPa compression strength) and the clay is present in an open structure of shell-like aggregates of the sub-microscopic clay plates. The structure is shown in Figure 3.

These two materials were mixed together in a baker's dough mixer in the ratio of about one part bentonite to 10 parts perlite by volume. Some chopped straw was added at the last moment.

This mix can be cast into tiles for applying as a 4cm-thick buffer layer on existing walls. Laid the other way the tiles can be built up into a massive load-bearing wall, using moist plastic clay as a mortar.

The performance of the buffer wall

A clay wall was built within a climate chamber so that the ratio of wall area to chamber volume was about 0.7 to 1, which is typical of the ratio of wall and ceiling area to room volume in a building. The performance was also calculated by a simulation program which used the absorption and permeability described above to calculate the distribution of water between the wall and the room air. The details of these investigations are described elsewhere (Padfield 1998b).

The 'room' imitated by the climate chamber was subjected to a sinusoidal water vapour flux which would, without buffering, cause the RH to oscillate between 20% and 100% RH in a daily cycle. The maximum rate of drying corresponds with a leak rate of about 0.5 air changes per hour to outside air in winter. The daily cycle hardly reaches the depths of the tile so a four-day cycle, with the same maximum flux rate, is shown in Figure 4 (centre graph). The large amplitude curve (the steep, broken line) is the expected RH variation in the empty chamber. The flux was sufficient to cause condensation for many hours in the empty chamber, whose RH reaches 100% early in the cycle. The heavy, continuous line shows the actual relative humidity in the chamber. Lighter lines show the RH in small holes at two depths within the wall.

The theoretical performance of the clay wall is shown in Figure 4 (left). It is not so good as the measured performance. The values for absorption and diffusion coefficients are then adjusted to give the best fit to the measurements (the graph on the right). This is obtained by using an absorption coefficient which is slightly higher than measured and with a diffusion coefficient three times higher than the measured value. The discrepancy is considerable and not yet explained.

The effect of ventilation rate

The effect of ventilation rate is shown in a model. Air of constant 20% RH is leaked into a room first equilibrated to 58% RH. The subsequent decline in RH is shown in Figure 5. The best fitting constants from the cyclic experiments were used in the theoretical model to predict the drying over two months.

The buffering against one air change per hour is not impressive: the RH has dropped almost halfway to the final value within a day. The half time to equilibrium for a room with a quarter of an air change per hour, which is quite attainable in a modern house, is stretched out to two weeks. The annual cycle calculated for one air change per day is shown in Figure 6.

This slow air change is attainable without particular difficulty in archives and storage vaults where people only enter occasionally. If there is sufficient absorptive material within the building there is no need for absorbent walls, as shown by Christoffersen's analysis of an archive (Christoffersen 1995) and by Padfield and Jensen's modelling of a museum store containing wood (Padfield and Jensen 1990).

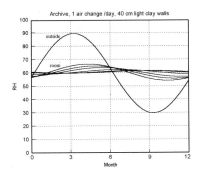

Figure 6. The predicted annual RH cycle in a clay walled building with 0.05 air changes per hour. The flatter curves are the RH at various depths within the wall, which is sealed on the outside.

Practical considerations

There are still some practical details that need to be considered. The surface finish should not dust away and should not be prone to rapid discoloration by accumulated dust. The buffer performance of the clay wall, which is used as an example rather than as a recommendation of the best material, is only slightly reduced by a thin layer of lime or gypsum plaster. Absorbent surfaces above about shoulder level are quite practical, if the dust control is otherwise appropriate for a museum!

Conclusions

Absorbent walls and ceilings will significantly improve the climatic stability of indoor spaces that are ventilated at one air change per hour or less. This ventilation rate is inadequate for popular museums and galleries but is reasonable in less visited museums and in study collections and reading rooms. The message is clear: here is an untapped resource for museum climate control.

Acknowledgements

The work described here was done at the Department of Structural Engineering and Materials, The Technical University of Denmark.

References

Christoffersen LB. 1995. Zephyr, passive climate controlled repositories. Lund University, Department of Building Physics, Report number: TVBH-3028, 1995. ISBN 91-88722-06 6.

Claesson J and Hagentoft C-E. 1994. Basic building physics – mathematical modelling. University of Lund, Department of Building Science.

MacIntyre J. 1934. Air conditioning for Mantegna's cartoons at Hampton Court Palace. Technical studies in the field of the fine arts, 2 (4, April): 171–184.

Padfield T and Jensen P. 1990. Low energy climate control in museum stores. In: International Council of Museums, Committee for Conservation, 9th triennial meeting, Dresden. Paris: ICOM: 596–601.

Padfield T. 1998. A climate chamber that controls water vapour flux. In: Third International Symposium on Humidity and Moisture, National Physical Laboratory (UK), Vol. 2, 57–63. ISBN 0 946754 24 1; CD: ISBN 0 946754 25 X.

Padfield T. 1998. The role of porous building materials in moderating changes of relative humidity. (Ph.D. thesis, Department of Structural Engineering and Materials, The Technical University of Denmark.) Also available (from the author) on CD, with working programs.

Wadsoe L. 1993. Studies of water vapour transport and sorption in wood. (Doctoral Dissertation, Report TVBM-1013, Department of Building Materials, Lund University, Sweden). (See also: Arfvidsson J. 1998. Moisture transport in porous media. Lund University, Department of Building Science, Report TVBH-1010.)

Colour changes of Portland stone in the V&A's facade

Abstract

Selected areas of Portland stone on the V&A's facade have been monitored for colour changes over an eight-year period following building cleaning. The information is used to calculate trend lines for the changes occurring in different areas and to predict future changes.

The most rapid and largest changes, occurring in the most secluded areas, are predicted to reach over 20 CIELAB units in 25 years. Very exposed areas show much smaller and irregular changes. For the majority of the facade, changes are intermediate and predicted to reach 10 CIELAB units in 25 years. In all cases, the largest contribution to overall colour change is the change in lightness, affirming the suitability of reflectance measurements commonly used to monitor soiling rates. The data are also compared to published empirical and theoretical models of rates of soiling. Generally, rates are smaller than those predicted by short-term studies.

Keywords

building, colour monitoring, reflectance, soiling, limestone, model

Boris Pretzel
Science and Information Section
Victoria & Albert Museum
South Kensington
London SW7 2RL
UK
Fax: +44 (0)171 938 8661
E-mail: boris.pretzel@vam.ac.uk
Web site: www.vam.ac.uk

Introduction

The foundation stone of the V&A's main building in London was laid by Queen Victoria in May 1899 and the building was completed in 1906. The facade, made principally from red brick and Portland stone, was designed by Aston Webb and includes some intricate carving and statues. The bright colours of the brick and Portland stone and detail in the carvings had become totally obscured by thick black surface accretions and soiling from airborne pollutants in the 80 years since its completion (See Fig. 1).

In the mid-1980s the V&A started investigating how industrial cleaning processes might be adapted safely to clean the facade. Traditional techniques were considered too damaging, having been developed chiefly to accommodate speed of operation. Both dry sandblasting and wet grit-blasting techniques can cause considerable erosion even at low operating pressure. Wet techniques can also force water to penetrate the stone which may contribute to the rapid re-formation of dark bands often seen in buildings of Portland stone cleaned in this manner. On the other hand, air-abrasive techniques as used by conservators (with very fine aluminium oxide powder, low pressures, and very fine nozzles) were considered too resource intensive for a project of this scale. In the end, in consultation with the contractors who were to carry out the work, two techniques were employed as a compromise between cost and potential damage to the facade. A damp system at a pressure of $1.54 kg/cm^2$, using minimal amounts of water sufficient only to reduce airborne dust, was used for the general areas of stonework and a dry blasting technique, using fine aluminium oxide powder and a 3mm pencil nozzle at $1.4 kg/cm^2$ for the carved areas.

The cleaning of the facade along Cromwell Road started late in 1989, taking over a year to complete and costing £1.5 million (with about as much again for structural repairs and repointing, carried out on the facade in coordination with the cleaning). As expected, the initial results of the cleaning were dramatic (See Fig. 2).

Figure 1. Photograph of the statue of Queen Victoria flanked by St George and St Michael, by Alfred Drury, above the Museum's main entrance, showing the dark soiling obscuring detail. Photo by Paul Robins, V&A Photographic Department.

Figure 2. Photograph of the main facade showing the dramatic effect of the cleaning. Photograph by V&A Photographic Department.

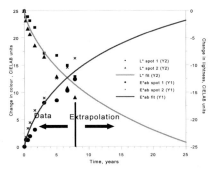

Figure 3. Graph of the colour and lightness changes for the two most secluded areas and regression line extrapolations for the average changes. Measurements were taken between 11 October 1990 and 6 August 1998. Uncertainties are too small to be presented at this scale (the standard deviation around each point is about 0.24 CIELAB units). The best fit regression lines are generated by performing weighted least squares fits to an equation of the form $y = (ab + cx^d)/(b+x^d)$. For ΔL^\star, the regression line has a correlation coefficient of 0.998 and a standard error of 0.377. For $\Delta E^\star ab$, the correlation coefficient is 0.996 and the standard error 0.494.

To assess the success of this major cleaning project and determine the rate of subsequent discolouration, six vertical areas at various heights and locations on the facade were chosen on completion of the cleaning for colour monitoring over the following eight years.

Experimental considerations

Colour measurements were taken with a Minolta CR200 Chroma Meter.[1] This measures tristimulus colour values of areas of approximately 8mm diameter. The meter generates a flash of light from a pulsed xenon tube, diffusely illuminating the measurement surface, and collects the light reflected perpendicularly from the surface (a d/0 spinc geometry). The reflected light is directed to three photocells, each incorporating a filter with characteristics close to one of the three Commission Internationale de l'Éclairage (CIE) colour matching functions for the standard colorimetric observer (ISO/CIE1991). The output from these cells is compared to signals from a further three photocells which receive light from the flash before it is reflected and the results are used to compute tristimulus values of the surface.

Several drawbacks of the Chroma Meter were considered before embarking on the project. Firstly, the meter has limited precision for measuring absolute colour. It was designed principally to measure differences between a target and samples measured at roughly the same time. Extensive experience has shown it therefore to have only limited suitability for measurements over extended periods. However, the reduced precision was considered an acceptable trade-off for the instrument's portability, especially as fairly large colour changes were expected.

A further consideration was the small size of the measurement area. Buildings generally discolour irregularly with large variations in the response of neighbouring regions and this makes the relevance of the changes in small specific areas questionable. The obvious way to overcome this limitation is to choose a large number of measurement sites at each region of interest. For the current project, this approach was considered too resource intensive. Instead, considerable care was taken in the judicious choice of measurement areas. Measurements were also extended to include the lightest and darkest region of each of the stones containing a sampling area. This allowed us to monitor the overall contrast changes in these stones with time without significant extra effort.

Experimental procedure

In consultation with Richard Cook (then Senior Sculpture Conservator, now head of Sculpture Conservation at the V&A), three areas were chosen at roof level (two on part of a balustrade, facing north and relatively secluded, one on the face of the dome, facing south and relatively exposed) and three at ground level (one on the main facade, facing south and relatively exposed, and two on the first column in Exhibition Road, one facing west and one south, both very exposed). For relocation, the areas were marked with a small notch and outlined using a wax pencil. The measurement locations were also recorded photographically at several stages during the project.

Readings on each principal measurement area were taken as a set of 10 independent measurements, using the average and standard deviation of the tristimulus coordinates to represent the best estimate of the true value and the uncertainty associated with the measurement. Data were converted to CIELAB colour space (CIE 1986) to analyse the visual significance of changes. Total colour changes were determined using the simple CIELAB colour difference formula ($\Delta E^\star_{ab} = \sqrt{[(\Delta L^\star)^2 + (\Delta a^\star)^2 + (\Delta a^\star)^2]}$) as well as the more sophisticated CMC adapted colour difference equation (BSI 1988) (this has since been superseded by CIE94 (CIE 1995) and is no longer in common use). In addition to examining changes in the native tristimulus variables (X, Y and Z) and the derived uniform colour space variables (L^\star, a^\star, and b^\star, representing lightness, a red-green coordinate, and a yellow-blue coordinate, respectively), changes in the visual correlates of colour (hue and chroma, in addition to lightness) were investigated.

The contrast of stones containing a measurement site was taken as the colour difference between the average of 15 colour readings in the lightest and 15 in the

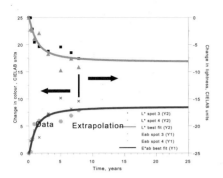

Figure 4. Graph of the colour and lightness changes for the two exposed areas, representing the bulk of the facade, and regression line extrapolations for the average changes. Measurements were taken between 11 October 1990 and 6 August 1998. The resultant uncertainty is too small to be presented at this scale (the standard deviations for spot 3 are 0.35 and 0.27 for DL and DE*ab respectively; for spot 4 they are 0.41 and 0.39). The best fit regression lines are generated by performing weighted least squares fits to an equation of the form $y = (ab + cx^d)/(b+x^d)$. For DL*, the regression line has a correlation coefficient of 0.98 and a standard error of 0.70. For DE*ab, the correlation coefficient is 0.98 and the standard error 0.76.*

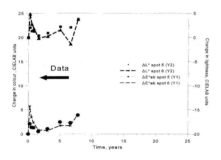

Figure 5. Graph of the colour and lightness changes for the two most exposed areas. The changes are too erratic for any meaningful extrapolations. Measurements were taken between 11 October 1990 and 6 August 1998. The standard deviations for spot 5 are 0.35 and 0.31 for ΔL and ΔE*ab respectively; for spot 6 they are 0.41 and 0.33). The changes are too irregular to allow meaningful extrapolation.*

darkest area of each stone. The contrast measured in this way is not a very precise quantity. The measurement head was deliberately moved between each of the 15 consecutive readings of an area to determine its average colour and variation. Also, the lightest and darkest areas were determined each time by eye and were not in constant locations. Nevertheless, the measurements give useful additional information to the colour monitoring and allow the changes occurring in a measurement site to be interpreted in light of the change in variation of colour across the stone containing it.

Results and discussion

There was considerable variation in the colour changes occurring at the different measurement sites (See Figs. 3–5). The measurement sites can be paired into three groups of two, the two sites in each group having a similar degree of exposure to wind and rain. As expected, the largest and most regular changes occurred in the most secluded areas (See Fig. 3). In exposed areas, the deposition material on the surface of the stone is complicated by wind and water erosion of the surface. Water will also preferentially remove calcium sulphate and calcium nitrate, formed by the reaction of the calcium carbonate stone with corrosive gaseous pollutants in the atmosphere, from the surface. The continuous erosion and leaching causes exposed areas even in very soiled buildings to remain bright and apparently unsoiled.

Substantially the largest contribution to the overall colour change was due to changes in lightness, rather than in hue or chroma. This validates the previous use of simple reflectance measurements to assess soiling in buildings, as reflectance correlates reasonably well with lightness. If the contribution of hue and chroma changes to the soiling were significant, the use of reflectance as a significant variable would need to be reconsidered. Further, for all areas, there was little difference in the behaviour of changes expressed using the simple ΔE^{\star}_{ab} formula or the more complicated CMC formula.

Except for very exposed areas, the Portland stone in the facade is getting darker with time. Secluded areas showed continuous decreases in lightness and increases in colour difference with time (See Fig. 3). The changes for these areas were the largest observed. The stones in these areas also showed greater increases in contrast with time than did those in other areas and developed localised dark and light areas. This indicates that the soiling mechanism is sensitive to small local changes in position, probably due to a combination of the effects of localised wind vortices and preferential tracks for water running down the building in heavy rain. The colour changes between initial and final measurements were 12.4 and 16.2±0.3 units and those in lightness -12.1 and -15.9±0.3 units for spot 1 and spot 2 respectively. The best trend line for the average of the two spots is given by a least squares fit (weighted by uncertainty) to a sigmoidal curve with a monotonic section, a point of inflexion and then an asymptotic approach to a limiting value (a curve with the general formula $y = (ab + cx^d)/(b + x^d)$). This predicts colour changes to increase to over 20 units in 25 years. Fitting the data to a square root relationship gives similar predictions though the line indicates a slightly too rapid initial increase. An exponential fit allows a close fit to the initial changes but then tails off rapidly reaching a value of 16 units after 25 years. The reflectance (the Y tristimulus coordinate) in these areas dropped by 30% in about 4.5 years.

Reasonably exposed areas (regardless of height) darkened systematically with only small accompanying changes in contrast across the stones. Changes were similarly rapid to those for secluded areas for the first two years of monitoring but then showed smaller increases over the next year and only gradual, irregular, changes thereafter (Fig. 4). The darkening was accompanied by a small but noticeable yellowing of the stone. This type of area is the most abundant on the facade and is therefore most representative of the overall changes in appearance. The colour changes between initial and final measurements were 7.9±0.2 and 9.6±0.9 CIELAB units and those in lightness -7.6±0.2 and -9.2±0.2 CIELAB units for spot 3 and spot 4 respectively. The best trend line for the average of the two spots predicts colour changes to increase for the first five years then to show only slow changes thereafter, reaching 8 CIELAB units in 25 years. A square root

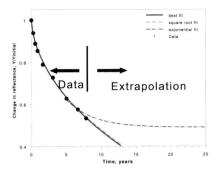

Figure 6. Graph of the change in relative reflectance ($Y/Y_{initial}$) for spot 2, the most secluded area with the largest and smoothest changes. Measurements were taken between 11 October 1990 and 6 August 1998. The standard deviation around each point is about 0.01. The best fit regression line has a correlation coefficient of 0.999 and a standard error of 0.010. Also shown are the weighted least square regression lines assuming a square root relationship (correlation coefficient 0.999, standard error 0.009) and exponential relationship (correlation coefficient 0.991, standard error 0.025). The square root relationship follows the best fit regression line very closely (though the rate of change is a little too steep for the initial few readings). The exponential regression line, although reasonable given the crude assumptions regarding variations in pollution levels, does not fit the data as well for the early measurements (omitted from the figure in the interests of clarity) and diverges sharply from the best fit line after the first six years.

relationship cannot reproduce the rapid decrease in rates of change after the first few years well and would predict a continued increase to 17 CIELAB units after 25 years. An exponential fit gives a similar curve to the best trend line. The reflectance in these areas dropped by 25% after 5 years and varied only slowly thereafter.

The most exposed areas (on the column on Exhibition Road) showed relatively small, irregular commutative changes with both positive and negative lightness changes between consecutive readings (See Fig. 5). Both areas showed increased lightness over the period with one (spot 5, facing south) remaining lighter than the initial value throughout the nearly eight-year monitoring period. The changes in colour between the initial and final measurements were 3.9±0.2 and 4.0±0.3 and those in lightness 3.9±0.2 and 3.8±0.3 for spot 5 and spot 6 respectively. The behaviour of the two spots was quite similar but no meaningful extrapolation can be made from the data. One of the stones (the stone including spot 6) also showed substantial local staining in some regions of one of the stones. These stains appeared over the first two years of monitoring, showing continual but slower changes thereafter. They are significantly different from the soiling occurring in other areas and are probably due to the migration of iron from a contamination source in contact with the stone.

Theoretical models have been proposed to model soiling as a function of time and concentration of suspended particulates by assuming loss in reflectance is due to the coverage of clean surface by opaque matter or alternatively assuming it is proportional to the thickness of the deposited film (Haynie 1986: Lanting 1986). Both models yield an exponential relationship between the reflectance and the product of time and concentration of particulate. Previous short and longer term studies on limestone (Beloin and Haynie 1975: Pio et al. 1998) have found an empirical square root relationship. A square root relationship between colour change and time gives a good correlation for the average behaviour of the most secluded areas monitored but an exponential relationship gives a better fit for the reasonably exposed areas.

The most secluded area (spot 2) showed the largest and smoothest changes. The changes in reflectance for this spot are given in Figure 6, together with the sigmoidal best fit (correlation coefficient 0.9989 and standard error 0.0100), a square root weighted least squares fit (correlation coefficient 0.9986 and standard error 0.0094), and an exponential fit weighted least squares fit (correlation coefficient 0.9911 and standard error 0.0255). For this particular spot, the square root model gives a better fit than an exponential one, in agreement with Pio et al. (1998). However, the exponential fit cannot be dismissed as the implicit assumption that the average level of pollutants remains approximately constant in the vicinity of the facade is very crude.

Taking the square root fit to data for spot 2 would imply concentrations of suspended particulates of the order of 2000 micrograms per cubic meter ($\mu g/m^3$) using the coefficients presented by Beloin and Haynie (1975)! Even the coefficient published by Pio et al. (1998) would imply a concentration of about $100\mu g/m^3$. Even though the V&A is adjacent to two busy streets carrying significant traffic, these estimates of concentration of pollutants are higher than expected. Although no pollution level data were available for the South Kensington roadside site, data for London urban centre sites have average levels of airborne pollutants of about $30\mu g/m^3$ over the period of the monitoring (AEA Technology).

The concentration of pollutants given by fitting the Pio et al. (1998) figures to the average change for the secluded areas (spot 1 and 2) is about $85\mu g/m^3$ and for the reasonably exposed areas (spots 3 and 4) about $40\mu g/m^3$. The Beloin and Haynie (1975) data would give concentrations of $750\mu g/m^3$ even if fitted to the data from reasonably exposed areas.

The rates of soiling found for the monitoring cites indicate that the cleaning for sheltered areas will barely be detectable after 25 years. However, it is the slower and less predictable changes in the partially exposed facade which will determine the appearance of the building and the data for these fluctuate too greatly to be confident in any extrapolation.

Conclusion

The study has reaffirmed the following observations, based on work over shorter time scales and limited to reflectance data only:

- There is considerable variation in response between sites.
- Changes in the most secluded areas are the most predictable (and the largest).
- The largest single contribution to the colour changes are changes in lightness.
- The building is generally getting darker (and slightly more yellow).
- Weathered areas show smallest changes.

In addition, the following new conclusions can be drawn:

- Extending the monitoring duration to greater than 24 months (the longest previously published study) has shown differences in the behaviour of exposed areas not subject to substantial weathering (the bulk of the facade) and secluded areas.
- The empirical relationship to the square root of the exposure, found for short studies, holds for data from secluded areas over the eight-year monitoring period but an exponential fit better describes data from exposed areas.

Acknowledgements

Given the extended duration of the monitoring for this project, many people have been involved in collecting the data. I would like to acknowledge in particular the help of Richard Cook in setting up the project and David Ford for assistance in taking the measurements.

Note

1. Minolta Chroma Meter CR 200 manufactured by Minolta Co., Ltd, 3-13, 2 – Chrome, Azuchi-Machi, Chou-Ku, Osaka 541, Japan.

References

AEA Technology Ltd: www.aeat.co.uk/netcen/airqual/welcome.html.

Beloin NJ and Haynie FH. 1975. Soiling of building surfaces. Journal of Air Pollution Control Association 25(4): 399–403.

BSI 1988. BS 6923:1988. British standard method for calculating small colour difference. British Standards Institution London, United Kingdom.

CIE 1986. Colorimetry. 2d ed. CIE publication 15.2. Commission Internationale de l'Éclairage. Vienna, Austria.

CIE 1995. Industrial colour-difference evaluation. CIE publication 116-1995. Commission Internationale de l'Éclairage. Vienna, Austria.

Haynie FH. 1986. Theoretical model for the soiling of surfaces. In: Lee SD, Schneider T, Grant LD and Verkerk PJ, eds. Aerosols. Michigan: Lewis Pub: 951–959.

ISO CIE 10527. 1991. CIE standard colorimetric observers. International Organization for Standardization. CH - 1211 Genève 20.

Lanting RW. 1986. Black smoke and soiling. In: Lee SD, Schneider T, Grant LD and Verkerk PJ, eds. Aerosols. Michigan: Lewis Pub: 923–932.

Pio CA, Ramos MM, Duarte AC. 1998. Atmospheric aerosol and soiling of external surfaces in an urban environment. Atmospheric environment 36(11): 1979–1989.

ICCROM preventive conservation experiences in Europe

Abstract

Preventive conservation implies a multi-disciplinary approach involving all the staff working in a museum. ICCROM, four European museums and other partners implemented a pilot project called Teamwork for Preventive Conservation. The project produced a change in staff attitude, developing a spirit of cooperation for conservation. The museums developed four to six teams, each with a preventive conservation objective. Results for the collections were positive. Museums joined national partners for activities to develop public and government support. The project will be repeated with museums in additional nations. Better resources will be developed to promote teams that last for a long term and to adapt assessments of preventive conservation to many national cultures. ICCROM has also started a Preventive Conservation Survey of European Museums and Services in order to analyse the situation of museums, and the services in support of preventive conservation in ICCROM's 31 European Member States. The survey will provide data and suggestions for the development of a European strategy on preventive conservation.

Keywords

preventive conservation, teamwork, multi-disciplinary, management, survey, indicators

Neal Putt★ and Cristina Menegazzi
ICCROM
13 via di San Michele
00153 Rome
Italy
Fax: +39 6 588 4265
Email: np@iccrom.org

History

In 1975, ICCROM was among the first organizations in the world to offer courses on preventive conservation. The courses were extremely popular with conservator-restorers, architects and curators. However, by the late 1980s ICCROM had recognized that the individual participants could not implement preventive conservation alone. Results required the joint effort of staff of all kinds – museum directors, tour guides, security staff, architects, registrars, shippers, exhibit builders, curators and administrators – who all contribute to care of collections in myriad ways. Preventive conservation also needed support from administrative authorities outside the museum, professional associations and the public.

To address the need for multi-disciplinary cooperation, ICCROM designed a pilot project called Teamwork for Preventive Conservation, and advertised for participation throughout Europe, eventually selecting four museums as participants and partners.

The pilot project museums were the Stedelijke Musea Leuven (Belgium), the Musée National des Arts et Traditions Populaires (France), the Museu Nacional de Arte Antiga (Portugal), and the Ulster Museum (Northern Ireland).

Structure of the project

1. Directors' meeting

Team participation from senior administration was guaranteed from the outset – the applications required each museum to send their director and one or two senior staff to the first step of the project, a directors' meeting in Rome. The comparisons between nations contributed to morale and creativity. The directors clarified their understanding of preventive conservation and identified the types of staff that might be involved. Each museum identified potential key issues to work on. The directors developed a spirit of teamwork and an understanding of how people with different professional profiles could contribute to and feel a part of the whole.

2. Museum workshops

Following the Rome meeting, the directors returned to their institutions to explain the project to key staff, develop support, and prepare the ground for a workshop of the museum's staff. Advisors from ICCROM and several additional conservation services travelled to each museum to assist in the workshop. As at the directors' meeting, workshop sessions assisted all staff in developing a common understanding of preventive conservation. All staff together reviewed the key issues in this area, and then those with shared interests (for example in storage, handling, public promotion, security, or registration) worked together to define objectives. The result was four to six objectives for the museum, each with a team and a timetable for implementation.

3. Implementation and national networking

Immediately after the workshop, the museum began implementing its objectives, with limited advisory assistance from ICCROM and its partners. As the museums worked, they observed their needs for professional, public and administrative support, at a national or regional level, and began to develop networking agreements with further partners. The Leuven Museum, for example, with support from Institut royal du patrimoine artistique (IRPA) and the Flemish Ministry of Culture, developed a video of "Preservation Through Time", to explain conservation to visitors. The Museu Nacional de Arte Antiga, with the Instituto Portugues de Museus, and the national institute for conservation (the Instituto José di Figueiredo) held a workshop of six leading national museum directors to develop a strategy for preventive conservation. The Musée National des Arts et Traditions Populaires, with the support of the Direction des Musées de France, developed a guide to handling and storing collections, to circulate to other museums with which exhibits are shared.

4. International networking and evaluation

During the project, news passed between the museums and advisors, sometimes via ICCROM. At the close of the project, all museums and advisors completed written evaluations of the pilot project and all were invited to meet in person to recommend future action. The Université Libre de Bruxelles (also representing ICOM-CC), the Direction des Musées de France, the Department of Cultural Heritage of Hungary, and the Netherlands Institute for Cultural Heritage joined the meeting to examine the potential for expanding the project to new nations.

Results and evaluations of the pilot project

Project structure

The original participants were unanimous in approving the structure of the pilot project. A specialist in business management commented that the strength of the Teamwork pilot project was its international shared framework, which remained flexible enough to produce plans for individual situations.

Changing staff attitude

Museums especially cited the initial international meeting of directors in Rome as crucial to staff support and involvement. Directors emphasised the motivating and encouraging aspect of comparisons between museums and nations. The early participation of senior staffs stimulated them to support teams in achieving objectives.

The project also assisted non-conservator/restorer staff to take an active part in conservation. Participants again cited the motivation of the international structure of the project. There was a kind of excitement surrounding the all-staff workshops, and a feeling that the impartiality of visiting advisors could help break down old roles. Staff generally welcomed the chance to work together and succeeded in setting objectives, plans and teams in motion.

An evaluation from the Musée National des Arts et Traditions Populaires (MNATP) commented on team spirit and communications issues:

> At our museum we were always in crisis about conservation. At first we wanted a training course for our top staff, but then we realised we needed that and more. We needed a new tradition of talking to one another. There needed to be a change of habit and mentality.

Directors often welcomed the project as a chance to experiment with "team management" for the entire museum, not just for conservation. The project seemed to open up new channels of communication among all staff, which could help all museum work in general. Some evaluations commented that it was the first time in years that some of the staff had worked face-to-face.

Building lasting teams of professional staff

Museums needed long-lasting teams with clear plans, in addition to better communications. Ulster Museum was especially successful at getting results by creating a core team with representatives from all the main departments. The core team is a compact, effective working group, but still represents all 250 staff. The team had responsibilities and timetables for reporting to the museum director. The core group added further sub-teams to address objectives, again with precise timelines and reporting responsibilities. The schedules took into account staff responsibilities for other programmes.

The core team was made up of the Keeper of Conservation, the Buildings Officer, the Head of Warding and Security, the Keeper of Design and Exhibition Services and representatives from the Departments of History, Sciences, and Fine and Applied Arts. The Finance Officer was included specifically to help with realistic budgeting and funding. The objectives of the core team and the added sub-teams dealt with priorities such as handling and moving objects, environmental monitoring and control, object housings and supports, cleaning, materials testing and case construction, and staff awareness.

Results for collections

Museums were still working on implementing their objectives at the time this paper was written, but they consistently reported results in better preservation, especially in projects for registration, improved storage conditions and staff and public awareness of collections care.

Staff had clearly developed a better understanding of the financial and practical benefits of preventive conservation. Furthermore, staff often corrected a misunderstanding that preventive conservation is only "correct temperature and relative humidity", which only concerns a few. In fact, many of the museums' objectives required multi-disciplinary contributions.

Team-building with "non-professionals"

Some of the museums involved in the project were so large that staff inside the museum did not know where their fellow colleagues' offices were. In comparison, Leuven's city museum, with 35 staff members who see each other daily, had almost a family feeling. Yet the administration, professionals, guides and guards welcomed the museum workshop as an opportunity for communication. There is no conservator-restorer on the staff, and some of the burden for collections care falls on a large group of part-time guides and guards, who were very keen to participate.

Leuven Museum used a risk-assessment system developed by the Canadian Museum of Nature (Waller 1994) to work through understanding conservation and setting objectives. The workshop identified 10 agents of deterioration and three types of risks that threatened the museum collections, and then determined priorities by rating the magnitude of those risks. Following the workshop, professional staff led planning of strategies for risk control.

Evaluations by the guards and guides tended to rate the risk assessment task "difficult", but gave very high overall ratings to the workshop, especially for its promotion of better communications with management and professionals. The workshop seemed to contribute to communications in unexpected ways, as discussions surfaced on new topics connected to conservation, such as security of personnel, and the need for general museum promotion to the public.

Development of national support for preventive conservation

The precision of the risk management workshop helped make Leuven Museum very successful at increasing government support for conservation. The museum sought out newspaper coverage of the workshop, and got the city alderman responsible for the museum to attend. Eventually, the museum took the recommendations and objectives produced by the project to the entire city council and

received funding. This museum also received advisory support from IRPA to implement its objectives, and financial and advisory support from the Flemish Ministry of Culture for a video for the public.

Portugal, because it worked developing on a national strategy, also had very good long-term prospects for support. Six of the most active national museums, the national administration for museums and the national school of conservation agreed on objectives in each museum, a national newsletter and a competition for public awareness projects.

Other national results are listed above under point 3: "Implementation and National Networking".

Repeating the project with a European network

Owing to recommendations from the evaluation, ICCROM will repeat the project as "Teamwork for Preventive Conservation 2" with further European nations, especially in the Mediterranean and the former socialist nations of Central and Eastern Europe. The original museums, national and European partners will stay involved as sources of experience and advice, building towards a European network for preventive conservation.

The network will assist the new participants in obtaining technical support for both teamwork and preventive conservation, and in maintaining their spirit and habits of inter-disciplinary work. How and when will the network communicate? Will the network have a broader role to promote and assist preventive conservation? Answers to these questions depend on the museums and partners working with ICCROM, but networks are already working on several new initiatives.

Improvements in making teams work

The pilot project participants recommended improvements for the new project, which are already underway. Although the project created high initial levels of team spirit and participation, healthy for the entire museum, some problems in team management developed. Some teams never began operation, due to old ingrained failures in communications, or conflicting commitments to traditional work. Others did not achieve the authority and funding necessary to finish their plans. Museums produced surprisingly impressive results, but sometimes by reverting to old administrative and work habits involving a small number of staff.

In Teamwork 2, ICCROM and its partners will work more on assisting museums with training and written resources – resources on issues like how to ensure reporting to management, find funds, recognise commitments to other work and deal with the character and hierarchy of team members. ICCROM will offer experimental resource materials to the network of participants and advisors at the Directors' Meeting of Teamwork 2.

Preventive conservation indicators to suit many cultures

Throughout the pilot project, each museum developed its own "culturally suitable" methods for teamwork and preventive conservation, while still sharing the overall aims of ICCROM's project.

The evaluation of the pilot project reinforced the need for flexibility. One of the surprises was that the museums all refused to fully use any of the numerous published standards, checklists and self-assessment methods for preventive conservation, gathered from Canada, the United States and the United Kingdom (for example Davies 1991: Museum and Galleries Commission 1992: Museums Association of Saskatchewan 1991: Wolf 1991). The participants did look at them as a kind of aide-mémoire, or reminder, but found them too complex and culturally biased for their language and style of administration. (In fact, staff and management placed heavy reliance on their collective experience and judgement to identify the key issues they would address, and this method seemed to contribute substantially to team building). The participants recommended strongly that ICCROM develop a short list of indicators, adaptable to different European nations, for assessing the state of preventive conservation.

The result is a document of some 30 short, simple questions with yes/no answers. The document, called "ICCROM Preventive Conservation Indicators", was designed by taking a collections management approach. It is as simple and comprehensive as possible in order to be adaptable to different ICCROM projects (e.g., Teamwork for Preventive Conservation 2, Preventive Conservation Survey of European Museums and Services, etc.), and to different institutions and cultures.

The document is composed of four sections:

1. An introduction explaining what the document is and how to use it.
2. A definition of preventive conservation.
3. 33 questions divided in seven topics: constitutional framework of the museum; finance/plan; staff/training; collection; building; environment; communication. Each topic has a different number of yes/no questions.
4. A summary table, which helps a museum visualize the state of its entire preventive conservation programme.

One of the most interesting aspects of writing the Indicators is that an international network, as recommended by the pilot project, already did the work. The consultant, supported by the ICCROM staff, worked in collaboration with a network of 11 preventive conservation advisors coming from 10 institutions in nine European countries.[1]

The ICCROM Preventive Conservation Indicators were reviewed several times by the advisors before they were tested. Each advisor gave a different kind of support, whether philosophical or technical. In particular, the advisors of the Museums and Galleries Commission of the United Kingdom helped in refining the form and the content of the document. The document has been tested in 15 museums (Asia, North Africa, sub-Saharan Africa, Europe and South America). The suggestions and the comments received have been taken into consideration for the production of the present version of the Indicators.

ICCROM proposes to distribute the Preventive Conservation Indicators widely in order to receive more feedback and suggestions and refine the document further. It will also serve as the basis for developing a questionnaire for a new project – "Preventive Conservation Survey of European Museums and Services" – and will be the starting point for self-assessment by the new participant museums in the project Teamwork for Preventive Conservation 2.

Preventive conservation survey of European museums and services

During evaluations of the pilot project, museums encouraged more international networking, to support each museum and its partners in their efforts to promote and increase preventive conservation. Lacking concrete information on the needs of museums in various nations, and the services available to them, ICCROM has begun organizing another project named Preventive Conservation Survey of European Museums and Services. The aim is to monitor and analyse the situation of museums and services in support of preventive conservation in ICCROM's 31 European Member States, providing useful data, information and suggestions for the development of a European strategy on preventive conservation.

The results expected by the end of December 1999 are:

- a list of major public and private agencies responsible for services germane to preventive conservation for museum collections;
- reference materials about assessment systems, standards, methodologies, job descriptions, legislation, publications, course curricula, etc., concerning preventive conservation;
- at least 150 European museums where the state of preventive conservation has been assessed by using the ICCROM Preventive Conservation Indicators;
- a document reporting major analysis results and suggestions for the development and improvement of preventive conservation in Europe.

At this moment (November 1998), some of the key national and/or international agencies potentially responsible for services germane to preventive conservation

have already been identified, as well as a number of European museums where the state of preventive conservation will be assessed. The research has been conducted by consulting various sources: the Internet; the ICCROM Scientific Research for Conservation Survey database; the ICCROM library; the ICCROM data bank; and the Teamwork network of professionals and institutions. The draft version of a questionnaire, which will serve to gather information (about what the major public and private agencies are doing in the field of preventive conservation) and to collect reference materials, has been prepared.

ICCROM and its partners will use the results of this survey to develop a European strategy on preventive conservation and to identify new directions in European conservation.

Conclusion

In summary, Teamwork for Preventive Conservation was a successful experiment in creating inter-disciplinary spirit and understanding of preventive conservation. Museums were successful at forming teams and setting objectives, and were obtaining substantial results for the collections by the end of the project. Participant museums were also successful in getting their national services to support preventive conservation, and in getting the message out to the public.

Museums rated ICCROM's international profile as a key contribution to the project's success. But it seems likely that other organizations could succeed in replicating the results, as long as the methods lend excitement and profile to preventive conservation, and a sense of fairness to museum staff communications. For example, projects joining museums in neighbouring nations or large-scale national projects could succeed.

The experience of the pilot project revealed problems in maintaining teams on a permanent basis. Museums also commented that the existing self-assessment methods for preventive conservation reflect their nation of origin, and thus cannot be applied without being adapted to different styles of administration. ICCROM, the pilot project museums, and a growing network of further advisors and museums are working on these problems, starting with developing a short set of "indicators" suitable to different cultures. A new project, Teamwork for Preventive Conservation 2, will include development of better resources and workshops to help teams last for the long term.

Also, by working with its contacts, ICCROM has launched the Preventive Conservation Survey of European Museums and Services. The survey will lead to the development of a strategy to support preventive conservation in Europe.

Acknowledgements

ICCROM thanks the four museums and three advisory service participants in the pilot project who provided so many ideas, so much energy and good-will, and who are even now working on adding further results to the experiment.

The pilot project museums were:

- Stedelijke Musea Leuven (Belgium);
- Musée National des Arts et Traditions Populaires (France);
- Museu Nacional de Arte Antiga (Portugal); and
- Ulster Museum (Northern Ireland).

The advisors who worked with the museum directors and then travelled to each museum were from the Museums and Galleries Commission of the United Kingdom, Canadian Museum of Nature, and International Conservation Services of Australia.

ICCROM also thanks the many partners and sponsors sought out by the museums, who supported truly creative national projects for preventive conservation. The European Commission Raphael Project was an especially significant sponsor.

In developing indicators for preventive conservation, the ICCROM team was supported by advisors from Museums and Galleries Commission (United King-

dom), Museu Nacional d'Art de Catalunya (Spain), Istituto Centrale per il Restauro (Italy), Université Paris 1 Panthéon-Sorbonne (France), Hungarian National Museum (Hungary), National Heritage Board (Sweden), Laboratoire de Recherches des Musées de France (France), International Conservation Services (Australia), Society of Cultural Heritage in South-Holland (Netherlands), Institut Royal du Patrimoine Artistique (Belgium).

References

Davies A. 1991. Standard practices handbook for museums, self-evaluation checklists. Edmonton, Canada: Alberta Museums Association.

Museums and Galleries Commission. 1992. Standards in the museum care of archaeological collections. London: Museums and Galleries Commission.

Museums Association of Saskatchewan. 1991. Standards for Saskatchewan museums. 2d ed. Regina, Saskatchewan, Canada: Museums Association of Saskatchewan.

Waller R. 1994. Conservation risk assessment: a strategy for managing resources for preventive conservation. In: Roy A and Smith P, eds. IIC Preprints of the Contributions to the Ottawa Congress: 12–16.

Wolf S. 1991. The conservation assessment, a tool for planning, implementing, and fundraising. 2d ed. Washington, DC: Getty Conservation Institute and National Institute for the Conservation of Cultural Property.

Abstract

In preparation for the exhibition 'Degas beyond Impressionism' two packing case designs for the transportation of works in pastel were tested. Temperature, relative humidity, shock and vibration were logged within the cases during a journey by road and air. This preliminary trial suggested modifications that might be made to the cases to reduce the levels of shock and vibration. The modified cases were used successfully to transport the exhibition from London to Chicago; the levels of shock and vibration during this journey were also measured.

Keywords

transportation, packing case, shock, vibration, logging, Degas, pastels

Packing case design and testing for the transportation of pastels

David Saunders,★ Mark Slattery, Patricia Goddard
The National Gallery
Trafalgar Square
London WC2N 5DN
UK
Email: david-saunders@ng-london.org.uk

Introduction

In 1996, the National Gallery, London (NG) and the Art Institute of Chicago (AIC) collaborated to stage the exhibition 'Degas beyond Impressionism' (Kendall 1996). During the course of the exhibition, 57 works in pastel and charcoal were gathered in London, transported to Chicago and returned to the lending institutions or private collections, mainly in North America and Europe. As some of these works had rarely travelled on exhibition previously, particular attention was paid to packing techniques and materials. It has long been acknowledged that the transport of pastels is problematic and not without risk. The medium is inherently fragile as it may contain unbound aggregates of pigment, which are often only weakly bound to the paper support. Frequently, works in pastel were the result of experimental techniques that render their structure particularly vulnerable to damage during transportation. Such experimental techniques are evident in Degas' work and have been summarised elsewhere (Norville-Day et al. 1993).

It is generally held that pastels should be transported with the support horizontal, so as to minimise the effect of shock in the vertical axis upon particles adhering loosely to the surface. For the purposes of this exhibition, this assumption was accepted and one design criterion for the cases was that the pastels within should be maintained horizontal rather than vertical. It has been suggested that transportation of pastels at 45° to the horizontal might be an appropriate compromise (Norville-Day et al. 1993). Although this could be an option for transportation by road alone, where space is not a concern, the two venues for this exhibition were on different continents, making a journey by air inevitable. This, combined with the need to minimise the size and mass of the cases to reduce air freight costs and facilitate handling, precluded the possibility of assessing the effects of transporting the pastels at 45° to the horizontal.

The design and construction of suitable containers for this exhibition, which was to run from 22 May to 26 August 1996 at the NG, and then from 28 September 1996 to 5 January 1997 at the AIC, began well in advance to allow the cases to be tested 'in the field' before works by Degas were transported to London for the first phase of the exhibition.

Packing case design

Art Institute of Chicago case

Although the NG has considerable experience in preparing oil paintings on canvas for transportation, the co-organisers of the exhibition at the AIC had much greater recent experience in transporting pastels – including those by Degas. The AIC had also designed a case specifically for transporting pastels. This 'triple case' comprised three separate envelopes. The outer crate was of a conventional wooden construction, but with a side-opening panel secured by captive bolts. Within this rested a secondary case, also of conventional timber construction with a side-opening 'lid'

★ Author to whom correspondence should be addressed

Figure 1. AIC Triple case system, with pastel trays in place within secondary enclosure. Note the temperature/RH logger to the right of the outer case

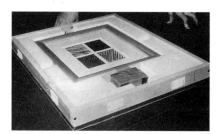

Figure 2. Pastel tray from the AIC system with pastel sample and vibration logger.

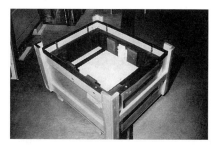

Figure 3. NG prototype case with lower pastel tray in place.

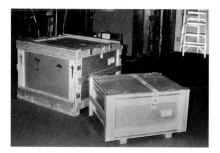

Figure 4. AIC (left) and NG (right) cases packed in preparation for preliminary test.

(See Fig. 1). The secondary case was supported within the outer case by Ethafoam™ (closed-cell polyethylene foam) runners, laid in strips along the sides, top and bottom. The secondary case contained two tertiary boxes, made of lightweight composite materials in which the individual framed pastels travelled flat and face-up. These wooden inner boxes, or trays, slid from the secondary case on Ethafoam runners and had lids secured in place by Velcro® tapes (See Fig. 2). The use of Velcro was intended to minimise vibration when securing and un-securing the lids.

As it was proposed that the specification for the cases to be used in the 'Degas beyond Impressionism' exhibition would be based on this triple case, it seemed wise to assess its performance prior to finalising the packing arrangements. An opportunity to examine one of the cases arose when an exhibition of works by Odilon Redon, organised by the AIC, travelled to the Royal Academy of Arts, London. It was clear that although the pastels to be transported were relatively small, the triple case system was quite large and heavy, raising concerns about the cost of freight shipment and the problems associated with handling bulky crates during transportation. Furthermore, while the casing system seemed likely to offer good thermal buffering, there were some concerns about the cushioning of the contents from shock and vibration offered by the configuration of the three envelopes. In particular, each of the enclosures contained Ethafoam pads that contributed to the overall shock/vibration damping of the pastel in the inner tray. The 'fit' between these pads and the case or tray they supported was not tight, so that the various containers might 'jump' in response to shock input from the outside. In addition, the use of multiple layers of cushioning material can lead to the generation of resonant vibrations if the cushioning is not calculated correctly (Marcon 1991).

National Gallery case

As well as the concerns about the mass, size and performance of the AIC case, some difficulty was experienced in sourcing, outside North America, materials similar to those used in its construction. A ready-made alternative design, developed in London by Wingate and Johnston, which also allowed the paintings within to travel with the support in the horizontal, was delivered in prototype form for evaluation. In contrast to the AIC container, this case was top-loading and relied on a double enclosure to protect the contents from external climatic and mechanical hazards.

Thermal buffering was achieved by a single layer of plastazote™ (closed-cell, cross-linked expanded polyethylene) foam attached to the inner skin of the outer case. Shock/vibration absorption was provided by further plastazote pads which supported the inner trays (See Fig. 3). It was decided to cushion the combined weight of the secondary trays and the works within as a single load. The pastels were held within the inner trays without further cushioning; the lids were again secured with Velcro tapes. The two inner trays were held together in a rigid unit and the combined mass of this unit used to calculate the appropriate surface area for the polyethylene foam. This, along with the early decision to adopt a 'double case' in preference to a 'triple', had the benefit of reducing the amount of space required inside the case and, consequently, reduced the overall size and mass of the container; 840 × 690 × 480mm, 54kg, compared to 990 × 940 × 740mm, 74kg for the AIC case (See Fig. 4).

As supplied by the manufacturers, the case was fitted with cushioning capable of supporting a load of in excess of 180kg. Accordingly, the surface area of the blocks of plastazote was reduced, as the pastels to be transported each had a mass of ca. 10kg.

Preliminary test

To compare the dynamic performance the AIC triple case with the more conventional double case, the NG requested the loan of a triple case from the AIC.

Procedure and equipment

Four pastel samples were prepared, using techniques consistent with those found in works by Degas. These samples were mounted, framed and glazed with either laminated glass or perspex (See Fig. 2). The decision to compare laminated glass

Table 1. *Pastel samples used in the preliminary test.*

Sample No	Glazing	Case	Tray	Logger
I	Acrylic	NG	Lower	Vibration
II	Laminated glass	NG	Upper	Temperature / RH
III	Acrylic	AIC	Upper	Temperature / RH
IV	Laminated glass	AIC	Lower	Vibration

with a polymeric material (perspex) arose from past experience at the AIC, NG and other institutions. Polymeric glazing materials have a tendency to generate static electricity which may cause loosely adhering dry particles to migrate from the surface of the work. Another alternative is to use a single sheet of glass. Single glass layers are usually 'taped' during transit, to prevent shards from damaging the work; it has been suggested that the removal of this tape can also create sufficient static electricity to cause particle transfer to the glass surface (Norville-Day et al. 1993). To reduce the risk of generating static electricity, all four pastel samples were wrapped in anti-static polythene.

To monitor the environmental performance of the cases, an ACR temperature and relative humidity (RH) logger was attached to the inner face of the outer container of the AIC case (See Fig. 1). A second logger was secured inside one of the trays containing the pastel sample. A temperature and RH logger was also located in one of the inner trays in the NG case. *Wanderer* vibration loggers were attached to two of the pastel samples. The location of the pastels within the two cases and the logging devices attached are summarised in Table 1. In all the experiments described, the principal axis of the vibration logger was aligned perpendicular to the surface of the support to respond most strongly to shock and vibration in the vertical direction during transportation. The two cases were then sealed and sent on a journey by road and air to Frankfurt and back.

Results

As temperature loggers were placed in the inner trays of both packing systems, it was possible to assess the thermal buffering effects of the respective packing materials. The external temperature, measured by the sensor attached to the outer skin of the AIC case, fell from 19°C to 12°C during the course of the transportation, rising again to 17°C while the cases were in the cargo shed at Frankfurt. The temperature sensors within the pastel trays showed that the external temperature changes were well buffered by both cases. During the course of the transport the temperature decreased by around 3.5°C in both trays; the thermal half-life of the NG case was slightly longer. The RH within both of the polythene-wrapped pastel samples was maintained in the range 48–51%, indicating good moisture buffering, probably by the wooden frames.

By comparing the data obtained from the two vibration loggers, it was possible to assess the performance of the two casing systems used in this transport; the results are presented in Figure 5 and Table 2. On those occasions when the cases were moved in concert, it was clear that the level of shock and vibration suffered by the pastel sample in the NG case was lower than that suffered by the equivalent sample in the AIC case. This applies both to the journeys to and from the airport by road, characterised by fairly continuous shock/vibration levels of ca. 1.0–1.5*g* for the AIC case and ca. 0.5*g* for the NG case, and to the discrete shocks experienced

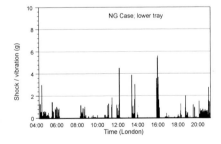

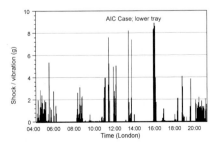

Figure 5. *Shock/vibration measurements during the preliminary test journey from London to Frankfurt; see Table 2 for timings.*

Table 2. *Timings for the transportation between London and Frankfurt.*

04:00		Loading vehicle at NG
04:15		Depart from NG
05:00		Arrive at Heathrow Airport
05:10 – 05:50		Cases unloaded from vehicle and placed on pallets
09:15		Aircraft takes off
10:25		Landing at Frankfurt
10:40 – 11:45		Cases transported to cargo area
13:20 – 14:00		Cases moved within cargo area
15:30 – 16:00		Cases loaded onto aircraft
16:35		Aircraft takes off
17:40		Landing at Heathrow
19:10 – 19:50		Cases loaded onto vehicle
19:55		Depart from Heathrow
20:40		Arrive at NG

during the unloading, palletisation and movement within the cargo sheds in London and Frankfurt. For the AIC case these shocks varied from around $3g$ to $8g$, while for the NG case the corresponding shocks varied from $1g$ to $6g$. Both cases appear to have received particularly 'unsympathetic' handling during the journey from the cargo area to the aircraft at Frankfurt.

Although the levels of shock and vibration experienced by the pastel samples contained in the NG case were lower than those for the AIC case, they are somewhat higher than those normally recorded during transport of this type (Saunders 1998). Two factors may affect these readings. First, the case is quite small and, in the past, it has been observed that small cases are often handled less carefully than larger cases (Saunders 1998). Secondly, in line with recommended practice, the pastel samples travelled horizontally. As many of the shocks and vibrations that affect works in transit derive from vertical movement of the cases, the horizontal work may respond to these inputs to a greater extent than a work travelling vertically. The two factors are, of course, not unrelated; the case shape is determined by the need to house the pastels horizontally.

A comparison of images and photographs of the samples before and after the transportation revealed no significant losses or redistribution of the friable pastel or charcoal. The use of perspex rather than glass had not caused any greater movement of pigment particles from the surface to the underside of the glazing material.

Conclusions from the preliminary test

It was clear that both the NG and AIC cases provided adequate thermal and moisture buffering for pastels transported in the inner trays. The NG case offered better protection from shock and vibration in transit. It was decided that the weight and complexity of the triple case configuration conferred no special benefits over a more conventional container for pastels. Accordingly, the NG decided to refine the lighter and smaller Wingate and Johnston case for use in conjunction with the 'Degas beyond Impressionism' exhibition.

Case design refinements

As a result of the preliminary tests the AIC also made design improvements to their case. To reduce the mass, fluted polypropylene sheet (Correx[a]) was used extensively in the construction of all three enclosures.

As part of the redesign, the inner trays in the NG case were fitted with 'plug' type lids, retained by a thin strip fixed to the inside of the lid preventing it from slipping sideways. This principle was extended to lock the inner trays together in a stack of two or three, depending on the number of pastels to be transported in that case. The bases of the upper tray or trays acted as lids for those below, which further reduced the mass of the overall case. Unlike the prototype case, the final case had a flush-topped lid that prevented water collecting within the outer battens and a stepped seal between the lid and base of the outer container to reduce water ingress. Finally, the area of the cushioning material was recalculated to account for the works that were to be transported during the transfer of the exhibition from London to Chicago.

Tests in transit from NG to AIC

The principal test of the packing systems came with the transfer of the entire 'Degas beyond Impressionism' exhibition from London to Chicago during September 1996. To assess the performance of the redesigned AIC and NG cases, vibration and temperature loggers were attached to four Degas pastels. Two were transported in the top and bottom trays in the new AIC case and the other two in the top and bottom (of three) trays in one of the NG cases. The shipment was made by road from the NG to Heathrow Airport, using a vehicle equipped with air-ride suspension, then by air to Chicago. The final road journey from O'Hare Airport to the AIC was again made in vehicles equipped with air-ride suspension; the timings for the transportation are given in Table 3.

Table 3. Timings for the transportation from London to Chicago.

03:30 – 05:00	Loading vehicle at NG
05:30	Depart from NG
06:15	Arrive at Heathrow Airport
09:15 – 10:00	Cases unloaded from vehicle and placed on pallets
15:45	Aircraft takes off
23:20	Landing at O'Hare Airport, Chicago
23:45	Cases transported to cargo area
01:20	AIC case loaded onto vehicle
02:30	AIC case unloaded at AIC
04:00	NG case loaded onto vehicle
05:00	NG case unloaded at AIC

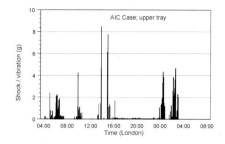

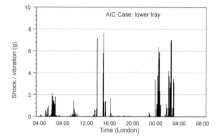

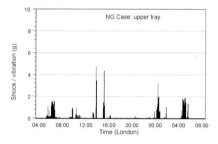

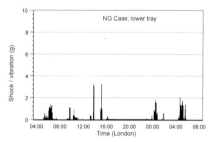

Figure 6. Shock/vibration measurements during the transportation of pastels from London to Chicago; see Table 3 for timings.

The temperature readings from the four loggers indicated that the maximum temperature change in the proximity of any of the pastels was 3°C; all changes in temperature occurred very slowly. From these data it appears that the thermal buffering capacity of both cases is adequate, although the weather was rather mild during this transportation.

Figure 6 shows the shock/vibration traces from the loggers attached to each of the pastels. All four traces show a similar pattern. Fairly low levels of continuous vibration accompanied the road journey to Heathrow Airport. A few discrete shocks during handling in the cargo areas prior to loading were then apparent. Loading was characterised by several short but quite strong shocks (4–9g). Take-off, the flight and landing were, as observed in previous logging exercises (Saunders 1998), periods of low shock/vibration; very small peaks indicated take-off and landing. Although unloading and transportation to the cargo area at O'Hare Airport were characterised by less intense peaks than during the equivalent operations in London, there seem to have been more protracted periods of vibration, at a level of 2–6g: the distance from the aircraft to the cargo area was much greater in Chicago. The road journey to the AIC produced low levels of continuous vibration which were slightly higher than the equivalent journeys in London, perhaps due to different road surfaces or variation in the efficiency of the air-ride suspension systems.

A comparison of the records from the top and bottom trays in the NG case make it clear that there was very little difference between the two. If anything, the shock/vibration from discrete incidents was slightly greater in the top tray, perhaps because these shocks were not always in the vertical direction and could, thus, effect the upper part of the case. A similar pattern was observed in the AIC case. Another explanation for the slightly higher levels in the top tray is that while the cushioning may have been correctly calculated for the bottom tray, it may not have been correct for the top tray, a common fault in double and triple case systems.

Comparisons between the top or bottom trays in the two types of case indicate that during periods of the transportation when the two cases moved together, the levels of shock/vibration were greater in both trays in the AIC case than in either of the trays in the NG case. This seems particularly marked during the unloading from the aircraft and transportation to the cargo area at O'Hare Airport. In addition, the shock/vibration experienced during the final road journey was much higher in the Chicago case. This is probably due to differences in the packaging system; although the two cases were transported to the AIC at different times, the same vehicle and route were used for each journey.

Conclusions

The preliminary trials with the two packing systems allowed their performance to be assessed so that the designs could be refined prior to the 'Degas beyond Impressionism' exhibition. During the course of the exhibition, no change in the condition of any of the pastels was noted, indicating that the cases had protected the works satisfactorily. In both the trial and the final transportation, slightly higher levels of shock/vibration were measured in the AIC case than in the corresponding trays in the NG case.

The effectiveness of the NG case in reducing shock to the pastels over this long and complicated shipment was due to the implementation of many tried and tested principles, which were then adapted to suit the special requirements of the pastel medium. Having first decided which part of the multiple container was to be cushioned, careful attention was given to the selection of appropriate cushioning materials and to the calculation of the surface area for the cushions, taking into account the size and mass of the objects to be transported. The elements of the double case were manufactured to tight tolerances to minimise movement between the various components. Although these appear obvious and simple measures, they are often overlooked by commercial packers.

As noted earlier, the relatively small size of the case and the horizontal orientation of the pastel may explain why the levels of shock and vibration were

somewhat higher than those normally recorded during a road and air transport of this type. While the exhibition was being assembled in London, it proved possible to monitor the transportation of a pastel travelling vertically. The levels of shock and vibration were significantly lower. This prompted a direct comparison between horizontal and vertical transportation of two pastel samples in more or less identical packing cases in the same vehicle. Several trials showed that the levels of shock and vibration were much lower for the pastels travelling vertically. The results from these experiments must, however, be interpreted in the light of the mechanical and physical properties of works in pastel; that is, whether weak shock and vibration parallel to the support – as might be expected when the pastel travels upright – are more damaging than higher levels of shock and vibration perpendicular to the plane of the support – as expected when the pastel travels horizontally.

Acknowledgements

The authors would like to thank June Wallis for preparing the pastel samples.

References

Kendal R. 1996. Degas beyond Impressionism. London : National Gallery Publications.

Marcon PJ. 1991. Shock, vibration and protective package design. In: Mecklenburg MF, ed. Art in transit; Studies in the transportation of paintings. Washington DC: National Gallery of Art: 107–120.

Norville-Day H, Townsend JH, Green T. 1993. Degas pastels: problems with transport and examination and analysis of materials. The conservator 17: 46–55.

Saunders D. 1998. Monitoring shock and vibration during the transportation of paintings. National Gallery Technical Bulletin 19: 64–73.

Abstract

Museums for antiquities are ideal for the application of state-of-the-art environmental design like daylighting and natural ventilation integrated with advanced electromechanical (M/E) systems. By utilising natural resources, improving the environmental conditions in a museum and enhancing the architectural design, the display quality and the conditions for staff and visitors as well as for the exhibits can be improved. The resulting greater influx of visitors and the feasibility of the retrofitting measures are likely to effect a better economic situation for these museums while contributing to the protection of the environment.

Keywords

museums, building, energy conservation, retrofitting, comfort, environmental conditions, lighting, acoustics

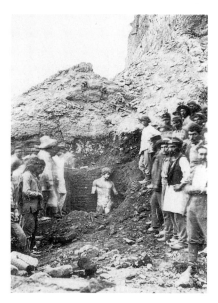

Figure 1. Excavation of Antinoos (EFA).

Guidelines for the design and retrofitting of energy-efficient museums for antiquities in the Mediterranean countries

Alexandros N. Tombazis, Nickos Vratsanos and Stefan A. Preuss★
Meletitiki – Alexandros N. Tombazis and Associates Architects Ltd.
27, Monemvasias str.
GR-151 25 Polydroso – Athens
Greece
Fax: +30 1 6801005
Email: meletitiki@mail.hol.gr

Introduction

Museums for antiquities are the showcases of our cultural roots. Here, the heritage of civilisations from years past is kept alive and knowledge is fostered. This important role needs to find its expression in the actual buildings that house these treasures.

In the past, many archaeological museums in the Mediterranean area have served as mere warehouses of their exhibits. Environmental conditions in these buildings are often visually, thermally and acoustically uncomfortable and unsatisfactory for visitors and staff and in some cases harmful for the exhibits. They often use energy unskilfully and inefficiently and thereby strain our natural environment as well as the finances of the respective museum authorities more than necessary.

The unsatisfactory conditions in many museums have often led designers and authorities to rely entirely on mechanical means to control the whole museum environment, with more or less success. In the case of retrofitting of museums the original design qualities of the buildings were often neglected and obscured.

Undoubtedly, state-of-the-art electromechanical (M/E) installations are of essential importance in the success of a museum building; for the preservation and display of its exhibits as well as for the comfort of its occupants. In fact, their integration into the building design is one of the most important tasks of architects, engineers, conservators and museum authorities.

However, completely rejecting the natural environment and resources means alienating many of the exhibits from their original context, losing out on the beauty of daylight and using much more energy than necessary.

Recent research – to a great extent carried out within the framework of the European Commission – on passive solar heating, passive cooling and daylighting techniques and systems has significantly increased our knowledge basis and contributed to further improve our understanding of the science and engineering of these technologies. Through a JOULE III project and this SAVE II project specifically developed knowledge is now translated into the best architectural and engineering practice in order to reach building design professionals and museum authorities and to awaken their interest in energy-efficient buildings and improved performance of buildings.

The purpose of this research and design project (1 January 1998 until 30 June 1999) was to scientifically investigate the potential of utilising passive means as well as advanced mechanical systems in energy efficient museum retrofitting design in order to optimise performance. The targeted outcomes are guidelines for energy efficient retrofitting based on thorough analyses and simulations of six archaeological museums in five Mediterranean countries. Three of these museums are actual retrofitting projects and the application of the project results will be visible upon their completion.

★ Author to whom correspondence should be addressed

Methodology

This project is subsequent to the already successfully completed JOULE III project of the European Commission DG XII for Science, Research and Development – Retrofitting of Museums for Antiquities in the Mediterranean Countries, Case Study: The Archaeological Museum of Delphi. There, 16 archaeological museums from five different Mediterranean countries were analysed, while the Museum of Delphi served as a case study for an exemplary retrofitting design.

The SAVE II project presented here incorporates the following stages:

1. Preparation, evaluation and proposal of retrofitting scenarios for museum buildings for antiquities in the Mediterranean countries;
2. Definition of the particularities, differences and similarities amongst museums and of the various kinds of exhibits needing conservation;
3. Evaluation of the technical, economical and legislative potential for the application of retrofitting actions;
4. Definition of a common auditing and reporting methodology dealing with the energy characteristics of these buildings;
5. Proposal of certain practical retrofitting strategies and actions for the selected case studies; and
6. Proposal of strategies regarding the conservation techniques of the exhibits.

The following aspects are treated with priority:

- Daylighting
- Passive heating and especially passive cooling
- Natural ventilation
- Use of new energy-saving artificial lighting components
- Use of efficient energy management systems
- Use of environmentally friendly materials
- Acoustic building behaviour and comfort
- Integration of advanced electromechanical systems
- Conservation of exhibits

The study

Out of a total of 16 museums from the aforementioned JOULE project, which represented a wide spectrum of archaeological museums, the following cases were chosen as typical examples for the retrofitting case studies (with the exception of the Archaeological Museum of Heracleion, Crete, which was newly added due to its suitability and a Greek Government programme to actually retrofit this museum in the spirit of this study):

- Portugal – National Archaeological Museum of Lisbon
- Spain – Archaeological Museum of Seville
- France – Archaeological Museum of Nimes
- Italy – National Archaeological Museum of "Pompeo Aria" in Marzabotto
- Greece – Archaeological Museum of Delphi and Archaeological Museum of Heracleion

The criteria for selection were the following:

- Representativeness as building design (on a national level)
- Variety in typological approach (on an international level)
- Technical potential for intervention
- Legislative potential for intervention
- Revenue possibilities
- Possibility for testing and application of novel types of retrofitting design

Present conditions

The majority of the museum buildings in this study consist of older shells transformed to house museums with many problems of obsolescence. A number of the post-war museums are already so old that they almost fall into the same category of need for retrofitting.

There is a vast range in the size of archaeological museum buildings. Many of them have strong qualities in terms of spatial organisation, which forms a good basis for contemporary retrofitting. Many museums however, do not have the spatial capacity to house all the items "checked in" since their construction and are in need of expansion.

Most buildings originally depended on daylighting and natural ventilation. The daylighting and natural ventilation approach of that time however, reflect the lack of in-depth knowledge of the bioclimatic factors and technology, which is available today, and cause great problems of visual and thermal discomfort (glare, reflections, overheating, stuffy air, etc.). The dependence on manually operable devices (windows that can be opened, shades) in combination with a lack of personnel and training also have contributed to bad comfort conditions for occupants, unsatisfactory conditions for exhibits and unnecessary energy consumption.

The majority of buildings have a strong relation to the adjacent environment, either because they are actually part of an archaeological site, or because they are landmarks tied to their historic context. Some of the cases have to deal with pollution from their urban environment. In most cases there is a great need for improvement of the electromechanical systems, including retrofitting, updating and replacement. Acoustic comfort as a design factor has been largely ignored.

There still is a prevailing opinion among museum authorities and designers towards the hermetically sealed museum box that should provide a better control. Even in older shells that used to depend on natural light and ventilation with great potential for contemporary daylighting and ventilation, authorities and designers still tend towards the blocking of the skin apertures. The reason for this is a lack of examples of good practice of well functioning environmental museum design.

For many archaeological museums the energy-running costs of their building like heating, cooling and lighting are important.

Generally there is a strong potential for retrofitting of museums for antiquities, which can bring about substantial benefits in quality, comfort, sustainability and finances.

There is an increasing need for support areas such as storage spaces, laboratories and administration areas as well as 'peripheral' uses such as shopping rooms, lecture rooms, cafeterias etc., which enhance the idea of the modern museum as a multi-functional didactic and research centre (See Fig. 2).

Generally, it can be concluded that there is a great need and 'market' for retrofitting of older museum buildings in order to accommodate the increased needs. The studied museums have shown that there is good potential to fulfil these needs through comprehensive contemporary retrofitting.

Figure 2. Museum of Delphi (MoD), conditions so far in Charioteer room.

Design scenarios

The design scenarios that were developed for each museum generally concentrate on the following aspects:

- Maximising the positive aspects of the existing building
- Decreasing energy consumption for heating, cooling and lighting
- Improving the indoor air quality of the museum
- Providing visual comfort by appropriate daylighting and comprehensive artificial lighting back-up
- Providing thermal comfort (heating, cooling, ventilation) by natural means as much as possible
- Providing appropriate acoustics
- Treating environmentally sensitive exhibits locally for better control and energy savings

Figure 3. Sketch for the Museum of Delphi.

Figure 4. Plan of proposal design for MoD.

Figure 5. Model view of proposal design for MoD.

Figure 6. Lighting proposal for MoD.

Architecture and exhibition layout

The new exhibition layouts incorporate continuous paths where possible (See Fig. 3). The paths tend to be organised along visual axes, areas of movement, areas of stationing and visual and contextual relations between the exhibits as well as between the inside and outside if applicable. Exhibits are rearranged as parts of a whole and as separate parts in independent rooms related to the architecture and lighting design (See Figs. 4, 5).

The retrofitting actions may incorporate:

- New openings in internal partitions for the creation of the new movement and visual axes
- New skylight openings and treatment of the ceiling plane as a light directing and acoustic device
- New exhibit cases and displays like wall niches, podiums, etc.
- Incorporation of new M/E networks and outlets and the proposed light fixtures into the design

General retrofitting measures include:

- Upgrading the construction with thermal insulation, weatherproofing etc.
- Replacing old windows with new double-glazed ones that integrate effective shading devices
- Repairs and maintenance
- Harmonising the use of materials
- Integration of shading/light-redirecting devices into the architecture

Daylighting

Considering the purpose of archaeological museums of displaying artefacts and sometimes parts of buildings of past cultures and sites, it is apparent that light plays an immensely important role. However, light not only determines the quality and authenticity of the display but also affects greatly the visual comfort and endurance of the visitors and affects the thermal energy balance of the museum building.

Different theories and approaches to lighting display prevail in archaeological museums, ranging from completely sealed and artificially lit spaces to predominantly daylighting display with only back-up and/or artificial lighting used to accentuate the exhibits.

In the past, natural lighting designs as in many of the studied cases caused problems of overheating, glare and ungainly light distribution. Therefore, many recent museums have taken on the sealed-box approach. While with such an approach it is easier to control the lighting of the display since it remains constant throughout the day and the seasons, it is questionable whether it pays tribute to the authenticity of the archaeological heritage. After all, the artefacts' original environment was in most cases that of daylight.

Unlike problematic daylighting approaches of the past, contemporary daylighting design can maximise not only the visual benefits of natural light but also the benefits of energy savings, a healthy, natural light colour spectrum and a connection to the surroundings if the museum is e.g. located in an archaeological site. Natural light provides vitality. Its dynamics makes one notice fluctuations, vibrations and emotions. Variation is important in exhibitions because it emphasises the exhibition's experiential character. The light of the day enters the museum through various windows. Even though there may not be many direct visual links to the outside world, the visitor stays informed about the time of day and about weather conditions, and enjoys the changes that natural light brings about.

Where necessary, daylight apertures can be fitted with UV filters to protect the exhibits. Especially sensitive exhibits can be treated in separate spaces with the necessary artificial installations.

The most important aspects of good daylighting in archaeological museums are:

- Light distribution in the exhibition space, emphasising areas of interest, facilitating the visitor's movement through the museum and supporting the architectural qualities of the museum interior
- Avoidance of unwanted direct solar gains
- Avoidance of glare and proper brightness distribution in the field of view (visual comfort)
- Appropriate accentuation and modelling of the exhibits

The main control tools are:

- Windows
- Clerestory windows
- Skylights
- Shading devices
- Devices for glare protection, sunlight protection and guidance of light

Artificial lighting

Within a comprehensive daylight design, artificial lighting plays a very important role in complementing daylight (See Fig. 6). Here again the objectives are light distribution, glare avoidance and accentuation. Additionally, the light fittings should be unobtrusive, have a spectrum with good colour rendering, consume little energy and thereby also minimise unwanted heat gains.

The artificial lighting design should encompass control devices and be integrated with the daylight design in such a way that the transition between daylighting and artificial lighting conditions is gradual, both in light levels and quality.

Crucial for the success of an integrated artificial lighting strategy is the coordination between daylight control, light sensors and luminaire control. The central piece in this control scheme is the Building Management System (BMS) that monitors the lighting situation and controls shading and artificial lighting accordingly. The BMS however, will only be optimised if operated by competent personnel.

Acoustics

Visitors are often led through the exhibition spaces by guides and depend very much on clear and effortless understanding while other visitors may want a rather peaceful atmosphere for their experience of the exhibition. Therefore, acoustics play an essential role in the comfort and overall experiencing of the museum.

The main elements of good acoustics in an archaeological museum are:

- Low background noise levels
- Appropriate reverberation time
- Good clarity of sound

The main acoustic measures apart from modifications of room geometry (not always applicable in a retrofitting design) are treatments of the surfaces through sound absorbing panels, sprayed acoustic plasters or installation of other sound absorbers.

Thermal comfort, energy, electromechanical (M/E) equipment and ventilation

Thermal comfort is very important for the experience of visitors and the conditions for staff. Depending on the kind of exhibit, temperature, relative humidity and the variability of both also play an important role. At the same time thermal behaviour and control of a building influence the energy consumption and consequently the operating costs significantly.

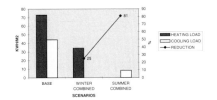

Figure 7. Reduction of heating/cooling loads through retrofitting scenarios.

In order to account for these needs, the interaction of natural and artificial environmental controls is important. This includes a sufficient extent of monitoring equipment like thermometers, hygrometers and CO_2 sensors for determining necessary ventilation rates and expected incidental heat gains (See Fig. 7).

Some basic factors for favourable thermal behaviour are:

- A well insulated skin
- Adequate shading
- Minimising of incidental gains (from artificial lighting, equipment etc.)
- A well functioning ventilation strategy
- Intelligent control preferably through a Building Management System (BMS) and sufficient sensors so as to avoid mishandling
- State-of-the-art electromechanical installations complementary to bioclimatic environmental control

A highly exposed thermal mass inside the building with sufficient insulation outside is preferred as it allows a time lag effect from the day into the night and vice versa. As such, temperature peaks outside are balanced and the feature of night ventilation can be successfully applied. In cases where the actual museum building has a landmark status the interventions on the building envelope can be restricted and the retrofitting design must concentrate on optimisation of the other aspects.

Typical state-of-the-art installations may include, among others:

- Appropriate sizing of all installations
- High efficiency boilers and coolers
- Heat recovery
- An appropriate distribution system
- BMS combined with sensors in the exhibition spaces
- Summer night ventilation for cooling the building mass down at night
- Special low-energy alternatives, such as evaporative cooling, slab cooling, etc.
- Special local treatment of sensitive exhibits
- Demand-dependent ventilation systems.

Strategy integration

An essential factor for the success of these environmental design strategies in practice is the proper integration of strategies. Otherwise certain strategies like daylighting may for example interfere with the ventilation operation.

Only when the strategies work properly together can a synergy be achieved, which results in archaeological museums that provide excellent comfort and display, save energy and protect the environment and enhance the experience and influx of visitors while improving the museum's financial perspectives. An integrated design approach with the various design teams working closely together can ensure the success of the retrofitting strategies (Fig. 8).

Figure 8. Video simulation of design proposal for MoD.

Conclusion

The basis for any intervention on existing archaeological museums must be a thorough analysis of the original building design and its present state. Such an analysis would typically encompass investigations on:

- Climatic conditions
- Nature and history of the building
- General condition of the building
- Museum needs for spaces and facilities
- Conservation needs of exhibits
- Architectural qualities
- Properties of the envelope and structure: walls, roofs, apertures, etc.
- Thermal behaviour of the building
- Electromechanical (M/E) installations and controls

- Exhibition layout and technology
- Lighting conditions and technology
- Acoustic conditions
- Air quality
- Occupation patterns

On this basis design scenarios should be suggested and ideally modelled and/or simulated in order to maximise on the building's good potential and guarantee a sensitive retrofitting that works with the given building rather than against it.
 Typical interventions will be:

- Upgrading of the thermal properties of the building envelope
- Upgrading and often replacing of the electromechanical (M/E) system and providing intelligent controls
- Utilising daylight skilfully through apertures with efficient light redirection systems, shading and filters
- Daylight-responsive high-efficiency artificial lighting systems
- Upgrading or replacing of exhibition technology
- Special treatment of sensitive exhibits locally
- Acoustic improvements through acoustic absorbers, panels or plaster
- New exhibition layout with changes to the inner structure of the building if necessary
- Integration of all aspects into a comprehensive architectural whole

The retrofitting measures have the potential to improve environmental conditions and exhibition quality in museums drastically while reducing energy consumption to about half of typical museum buildings of their type and even less compared to sealed-box museums. The quality of a museum retrofitted in this spirit overall will be improved, which should result in greater appreciation of the exhibits by visitors, higher visitor influx and lower operating costs. This should improve the financial situation of the museum authorities and thereby channel the funds to where they can further the understanding and preservation of past cultures rather than contributing to the strain on our natural environment. More than anything though, such an approach pays more appropriate tribute to our heritage.

Acknowledgements

Project teams

1. *Meletitiki - Alexandros N. Tombazis and Associates Architects Ltd., Greece* (Co-ordinator) Alexandros N. Tombazis, principal; Nickos Vratsanos; Stefan Preuss.
2. *University of Athens, Department of Applied Physics, Greece*: Ass. Prof. Matheos Santamouris; Nick Klitsikas.
3. *University of North London, Low Energy Research Unit, Great Britain*: Professor Mike Wilson; Andre Viljoen.
4. *Bartenbach Lichtlabor, Austria*: Wilfried Pohl.
5. *Instituto de Engenharia Mecanica, Polo FEUP (IDMEC), Portugal*: Professor Eduardo Maldonado.
6. *Seminario de Arquitectura y Medio Ambiente, SAMA S.C., Spain*: Professor Jose Maria Cabeza Lainez; Victor Moreno.
7. *Energie & Architecture, France*: Pierre Diaz Pedregal.
8. *Ricerca & Progetto, Italy*: Angelo Mingozzi, principal; Sergio Bottiglioni.

Research funded in part by the European Commission, D.G. XVII for Energy (Contract XVII/ 4.1031/Z/97-086).

Abstract

The application of a risk assessment framework, using the parameters Fraction Susceptible, Loss in Value, Probability and Extent, to interpret the significance of internal pollutant concentration distribution in a systematic mineral collection, is demonstrated. This interpretation facilitates the application of conservation research findings to setting collection care priorities and strategically identifies the highest priorities for further conservation research.

Keywords

risk assessment, pollutant, mineral, priorities

Internal pollutants, risk assessment and conservation priorities

Robert Waller
Canadian Museum of Nature
Box 3443
Ottawa K1P 6P4 Ontario
Canada
Fax: +1 613 364–4022
Email: rwaller@mus-nature.ca
Web site: www.nature.ca

Introduction

This paper demonstrates the application of a risk assessment framework (Waller 1994) to interpret conservation research results in terms of priorities for collection care and for further research. The exercise employs expert judgements and estimates of probable magnitudes of risk parameters, then reviews the results in the context of other estimated risks.

The concentration level distribution of internal pollutants in mineral collections (Andrew et al. 1993; Waller et al. in press) is considered. The risk evaluated is risk to a mineral collection due to specimen interactions with internal gaseous pollutants. The internal pollutants considered are acidic vapors (characterized as low equilibrium pH (EqpH) and thought to be mostly carboxylic acids), sulfur dioxide, reduced sulfur gasses, and mercury vapor.

Risk assessment parameters

Four parameters are used in the calculation of a Magnitude of Risk (MR). These include Fraction Susceptible (FS), Loss in Value (LV), Probability (P), and Extent (E). Formal definitions of these terms are as follows (Waller and Marcil 1998):

- Extent (E): the measure to which a specific risk will result in Loss in Value to the Fraction Susceptible of a collection over a 100-year period. It reflects the amount of the FS that is affected, the degree to which a potential LV is realized, or both.
- Fraction Susceptible (FS): that part of a collection considered vulnerable to a Loss in Value from exposure to a specific risk.
- Loss in Value (LV): the maximum possible reduction in utility, for known or anticipated uses, of the FS.
- Magnitude of Risk (MR): the estimated Loss in Value to a collection, based on the current situation, over a 100-year period. It is the product of FS × LV × P × E.
- Probability (P): the chance of an event causing damage taking place over a 100-year period.

Interaction of specimens with persistent pollutants is a contaminants type 3 risk, constant in frequency and gradual/mild in intensity. The probability is 1; specimens will be affected by this risk. Consequently, the product FS × LV × E gives the magnitude of risk to a collection due to this specific risk.

Hypothetical collection

The hypothetical collection considered is defined as follows: It contains 10,000 specimens representing 1,000 mineral species contained in 100 cabinets. Each mineral species is represented by 1 to 100 specimens (mean = 10 specimens). The

Table 1. Distribution of mineral specimens among crystal-chemical groupings and relative susceptibility to internal pollutants (*few species highly susceptible or many slightly susceptible; ***many highly susceptible).

Crystal-chemical groups	%	low pH	SO$_2$	H$_2$S	Hg
Elements	4	***	***	***	***
Sulfides/Sulfosalts	10	*	*	***	
Pyrite/Marcasite	3		*		
Oxides	8	*	*		
Chlorides	0.5				
Fluorides	3				
Carbonates	12	***	***		
Borates	0.5	***	***		
Sulfates	4				
Phosphates/Arsenates, etc.	6	*	*		
Tungstates/Molybdates, etc.	1				
Silicates	48				

collection is 50% research- and 50% display-oriented material. It contains a range of mineral species typical of moderate- to large-sized collections that do not focus on a small geographical area, geological provenance, economic activity or so on. Each cabinet contains, on average, 10 species and 100 specimens.

The distribution of mineral specimens among crystal-chemical groupings mimics that of the Canadian Museum of Nature (CMN) collection (See Table 1).

Exposure to low EqpH

Low values of EqpH are thought to be primarily due to carboxylic acid emissions from cabinets, drawers, trays, and other storage materials (Padfield et al. 1982). Exposure to a low EqpH results in surface alteration of minerals that are somewhat soluble salts of weak acids, such as borates and carbonates, and increased corrosion rates of non-noble metallic minerals. A low estimate of FS includes very base metals, such as lead, and certain borates, carbonates, and a few rare, soluble alkaline species (FS ≈ 0.1). A high estimate includes all non-noble metallic minerals, all salts of weak acids, including hydroxides and oxides, and all sulfides and sulfosalts (FS ≈ 0.4). Here, the FS is defined as metallic minerals other than gold, silver and platinum-group minerals (2%), plus all carbonates and borates (12.5%), and a fraction of all other specimens in which susceptible species may contribute significantly to the value of the specimen (3.5%). An example of the latter is a display quartz specimen with associated lustrous calcite. An estimated 1 in 25 specimens contains such associated species. This leads to an estimated FS = 0.18.

Loss in Value is considered complete if the reaction proceeds to completion. For example, complete conversion of a native lead specimen to lead acetate and/or lead carbonate is considered a total LV. Only a few, rare species are so susceptible. They are expected to number fewer than five specimens in our hypothetical 10,000-specimen collection. The reactivity of the bulk of the FS described above is better typified by calcite and aragonite (polymorphs of $CaCO_3$). We currently lack test results of controlled exposure of such mineral specimens to organic acid vapors and must rely on expert judgement of the highest likely Loss in Value due to exposure to low EqpH. Based on observations of specimens stored in wooden cabinetry for up to one century, we anticipate that damage would involve complete loss of luster. However, even at high acid-vapor concentrations, and an exposure duration of several centuries, damage would be limited to surface alteration, to a depth of less than 1 mm. The expected LV for this scenario, estimated by a consensus of experts,[1] is 0.001 for research material and 0.99 for display material. Because the LVs for these two types of material in the collection are so different, the risk is better described by reducing the FS to only the display part of the FS described above. Hence, FS = 0.18/2 = 0.09 and LV = 0.99.

With this FS and LV in mind, the Extent of damage anticipated over one century can be considered. Surface alteration to susceptible mineral specimens has been observed to occur as a result of exposure to low EqpH environments. Unfortunately, we have no well-documented examples of what loss in value might be expected from a given exposure, in terms of time, temperature, relative

humidity and EqpH. Nevertheless, we can estimate probable Extents of damage. Many museums now have material that has been stored in wooden cabinets for one century or more. Consider a collection housed in acidic hardware storage, at relatively high temperatures and relative humidity levels. If E=1, then, by definition, these collections would have realized this full LV to the entire FS. No reports of such extensive damage are in the literature and, probably, it has not occurred. Even for these "worst case" collections, E must be <1.

Let us assume an Extent equal to 0.1 would correspond to damage over one century, progressing to about 10% of the Loss in Value described above. This might correspond to a reduction in luster for calcite specimens of two or three steps. For example, luster may change from adamantine to vitreous or from vitreous to waxy or dull. This Extent is probably somewhat high for collections maintained at moderate temperatures and RH levels. It is considered, however, a reasonable estimate for establishing a probable upper bound to the MR.

Exposure to sulfur dioxide

Sulfur dioxide is expected to cause damage comparable to that caused by the low EqpH described above with the exception that sulfates will be the alteration products.

The fraction susceptible is the same as for low EqpH (0.09). This includes display specimens within the non-noble metallic minerals, carbonates and borates, and a fraction of other specimens in which susceptible species may contribute significantly to the value of the specimen. This fraction susceptible will be reduced, however, by the fact that not all cabinets will contain sulfur dioxide. Only an estimated 10% of cabinets in mineral collections contain significant quantities of sulfur dioxide. Many of these cabinets house the sulfide minerals that are not considered a part of the FS. Neglecting these sulfide cabinets leaves about 5% of cabinets with significant levels of sulfur dioxide. These may or may not also contain susceptible species. Consequently, the FS becomes $0.09 \times 0.05 = 0.0045$.

The rationale and arguments for setting LV and E for damage by sulfur dioxide are the same as those for low EqpH and lead to the same values.

Exposure to reduced sulfur gases

The specific risk considered is reaction with high levels of internally generated reduced sulfur gases (RSG), such as hydrogen sulfide and carbonyl sulfide. The results of the pollutant concentration survey indicated that numerous mineral specimens undergo reactions to either produce or consume RSG. At present, certain mineral specimens are recognized to be producers of reduced sulfur gases. These include native sulfur and specimens containing a mixture of oxidizing disulfide species and acid-soluble monosulfide species. Other specimens are well known for their ability to react with reduced sulfur gases. These include silver, copper, and mercury. Certain sulfide species, such as covellite (CuS) are thought to be susceptible. Based on the survey findings (Waller et al. in press) more species produce and react with reduced sulfur gases than can be identified and listed based on current knowledge.

Survey data indicated that approximately 5% of cabinets surveyed had RSG concentrations considered very high and another 5% had concentrations considered very low. Cabinets with high concentrations must contain at least one mineral species that produces RSG. They may contain 10 such species (the average number of species per cabinet) or even more. However, since RSG emission is a relatively uncommon property of minerals, it is probable that just one or two species per cabinet are RSG producers. Therefore, between 0.5% and 1% of mineral species, or 5 to 10 of the 1,000 species in the hypothetical collection are RSG producing.

By the same reasoning, a similar number of species would be thought to react with RSG. Here, 5 of 1,000 species seems an unreasonably low estimate considering that several, moderately common RSG-reactive species are already known. Consequently, 10 of 1,000 (0.01) species will be used as the estimate of number of species susceptible to damage by reaction with RSG. The FS will be the number of susceptible specimens contained in cabinets that also house RSG-

producing gases. The lower possible bound to this is FS = 0, if all susceptible specimens are in cabinets separate from RSG-producing specimens. The upper possible bound is FS = 0.01 if all susceptible specimens are in cabinets together with RSG-producing specimens. It is possible to calculate a probability of a RSG-reacting species being housed in the same cabinet as a RSG-producing species. These species will not be equally distributed among the 100 cabinets. They will be concentrated among, but not exclusively within, the first 17 cabinets – those containing native elements and sulfides. The midpoint of the possible range of the FS (i.e., FS=0.005) is accepted as a reasonable estimate of the FS.

Loss in Value for this reaction is total if the sulfidation reaction proceeds to completion. For example, complete conversion of a silver specimen to acanthite (Ag_2S) might be considered a total LV if physical form is also lost. Observation of silver specimens exposed to high RSG concentrations for several decades while on exhibit in proximity to RSG-producing specimens indicates that such complete transformation is unlikely even over several centuries. The highest probable LV is thought to be that associated with reaction to a depth of up to one-millimeter producing several millimeters of alteration product.

The expected LV for this scenario, estimated by a consensus of experts,[1] is 0.001 for research material and 0.95 for display material. Because the LVs for these two types of material in the collection are so different, the risk is better described by reducing the FS to only the display part of the FS described above. Hence, FS = 0.01/2 = 0.005 and LV = 0.95.

With this FS and LV in mind, the Extent of damage anticipated over one century can be considered. As with other pollutants, we lack information required to link exposure conditions with loss in value over time. If the full LV was realized to all of the FS described above, then the effect of this risk would be well described in the literature. The Extent is certainly less than one. Assuming an Extent equal to 0.1 would correspond to damage over one century progressing to about 10% of the LV for the whole FS, the whole LV to about 10% of the FS, or some intermediate combination. This is considered a more reasonable estimate of E than the next lower order of magnitude, 0.01, would be.

The MR for damage by reaction with internally generated RSG is 0.00048.

Exposure to mercury vapor

Mercury vapor is present in cabinets housing specimens containing native mercury. It may also be present, to a lesser extent, in other cabinets due to cross contamination by mercury-sorbing specimens or storage materials. For purposes of this paper, mercury vapor is assumed to be present only in the cabinet containing native mercury. This is consistent with findings for the CMN collection. Metallic native elements, except iron, are all capable of forming amalgams (Weaver 1977), although it is not known how many of these might form by exposure of the metal to mercury vapor at room temperature. To estimate the probable upper bound of risk it is assumed that all such specimens will absorb mercury to some extent.

Native mercury is not common as a mineral and most collections are unlikely to contain many specimens. Consequently, it is assumed that all mercury specimens are in a single cabinet. The FS is thus limited to 0.009 (i.e., contents, excluding mercury itself, of one out of 100 cabinets). It may be further limited to the extent that other specimens in the cabinet are not metallic native elements prone to sorption of mercury. There are no literature reports of changes in appearance or chemistry of mineral specimens because of mercury contamination in storage. Visible changes in specimens, such as a lighter color of gold specimens, would probably have been reported if significant in terms of display value. Consequently, the FS is limited to the half of the collection specimens that are primarily of research value (0.009/2 = 0.0045).

Data on the extent of mercury sorption by susceptible mineral species at room temperature does not exist. We can deduce, however, a probable upper bound to the extent of reaction over a period of centuries. If the reaction resulted in sorption of mercury in the range of tens of percent, then changes in size and mass of specimens would have been observed and reported. At most, the reaction is expected to contaminate specimens by a few percent of mercury.

The group of experts[1] did not reach a consensus on the LV due to mercury contamination of research-oriented specimens. For reasons too complex to detail here, opinions ranged from trivial (0.001) to considerable (0.5). The higher value is accepted as the probable upper bound to LV.

The Extent associated with this FS and LV is assumed to be one. The resulting magnitude of risk is 0.002.

Discussion

Risk assessment parameters and calculated MRs for each of the specific risks are given in Table 2. The total risk due to internal pollutants is on the order of 0.01, meaning that 1% of the total collection value is expected to be lost from the hypothetical collection over one century. The significance of this risk depends on the magnitudes of other risks to the collection. For the CMN mineral collection, the risk due to internal pollutants is one of four risks of similar high magnitude. It is considered a significant risk, accounting for about 15% of the total risk to the collection. Other major risks include incorrect relative humidity leading to hydrate transitions, exposure to oxygen leading to pyrite oxidation, and physical forces resulting in damage during handling. Collectively, these four risks account for 75% of the total risk to the collection. Nine additional risks, each on the order of 0.001 account for the remaining risk.

Table 2. Risk assessment parameters.

Specific risk	FS	LV	E	MR
low EqpH	0.09	0.99	0.1	0.009
SO$_2$	0.0045	0.99	0.1	0.00045
Reduced sulfur gases	0.005	0.95	0.1	0.00048
Mercury	0.0045	0.5	1	0.00225

This assessment of risk due to internal pollutants provides guidance on both collection management projects and conservation research priorities. These are discussed below for each of the internal pollutants considered.

Low EqpH

The FS to this risk is more than a magnitude larger than that of each of the other three internal pollutant risks. Consequently, it is difficult to address with minor changes in collection management practices. Mitigating the risk would involve a major project, possibly complete replacement of storage hardware. Such projects are difficult to justify based on this risk assessment due to uncertainty of the estimated MR. Nonetheless, it would seem prudent to surround valuable, susceptible specimens that are in known acidic environments with a layer of buffered tissue.

Of the risk assessment parameters, FS and LV are thought to be relatively accurate for the situation defined. Extent, in contrast, has an uncertainty of at least one magnitude. What is required is a better estimate of E and one that can be related to LV. Further accumulation of anecdotal evidence of damage will be of little benefit, as that will not contribute to quantification of the risk. Controlled exposure, accelerated aging studies are of limited value unless the results can be related to LV. One approach that could give the required information would be to evaluate the condition of sets of near-identical specimens that entered collections at a given time in the past. Collections housed in a range of wooden and metal cabinetry could be included. Determinations would be required of current acid-vapor concentrations, temperature and relative humidity levels and some assurance obtained that current levels are indicative of historical levels. In this way, damage could be quantified and related to environmental conditions. Such a study is a moderate-high priority for mineral preservation research.

Sulfur dioxide

To a limited extent, the risk due to exposure of sensitive specimens to sulfur dioxide might be reduced by relocating specimens to different cabinets. In many cases,

however, this would cause an awkward disruption in the systematic ordering of a collection. It is unlikely to be done without clear evidence of risk to specimens. As for low EqpH, there is a need for information relating Loss in Value due to exposure conditions.

Reduced sulfur gases

A significant portion – perhaps half – of the risk of RSG reactions with specimens can be mitigated by the collection management practice of isolating known emitting specimens from known reacting specimens. For example, isolating sulfur from silver and copper. The estimate of FS includes considerable uncertainty regarding which species generate RSG, which species react with it, and how these species are distributed through a systematic collection. Based on magnitude of risk, these questions deserve only moderate-low research priority.

Mercury

The risk due to mercury contamination is easy to mitigate by a collection management practice of isolating specimens in sealed containers, in a dedicated cabinet, or both. The research questions of which native metal mineral species are susceptible to mercury contamination and to what extent it will occur are interesting but have low priority.

Conclusion

Interpreting the results of conservation research in terms of risk assessment parameters provides a rational perspective for setting collection management and conservation research priorities.

Acknowledgements

I am grateful to colleagues at the Canadian Museum of Nature who contributed judgements regarding Loss in Value.

Note

1. Experts contributing to LV estimates included research curators Drs. J. Grice and T.S. Ercit, research assistant, R. Gault, and collection manager, M. Picard, all at the Canadian Museum of Nature.

References

Andrew K, Waller R, Tétreault J. 1993. A survey of pollutant concentrations in mineral collection cabinets. SSCR Journal 4(1): 13–15.

Padfield, T, Erhardt D, Hopwood W. 1982. Trouble in store. Science and technology, International Institute for Conservation, Pre-prints of Contributions to the Washington Congress. London: IIC: 24–27.

Waller R. 1994. Conservation risk assessment: A strategy for managing resources for preventive conservation. In: Roy A and Smith P, eds.. Preprints of the contributions to the Ottawa Congress, 12–16 September 1994, Preventive conservation: practice, theory and research. London: IIC: 12–16.

Waller, R, Andrew K and Tétreault J. In press. Survey of gaseous pollutant concentration distributions in mineral collections. Collection Forum.

Waller R and Marcil S. 1998. Assessing and managing risks to your collections: glossary. Ottawa: Canadian Museum of Nature.

Weaver E. 1977. Amalgam. In: McGraw-Hill Encyclopedia of science and technology, 4th ed. McGraw-Hill: 334.

Abstract

Humidity control for display cases in museums is important in the control of deterioration processes such as metal corrosion, and generally for the maintenance of high quality conditions for works of art. We have developed a novel device for controlling the humidity in display cases: an electrolytic water removal device using a solid polymer electrolyte (SPE) membrane cell. We applied this water removal device to experimental display cases and confirmed its humidity control abilities. We have found that this water removal device can provide both rapid and precise humidity control.

Keywords

humidity, control, water removal device, absorbent, display case

Figure 1. Structure and principle of the water removal device.

Humidity control for display cases in museums using a solid–state water removal device

Shiro Yamauchi[*]
Mitsubishi Electric Corporation
Transmission & Distribution, Transportation System Center
1-1, Tsukaguchi-Honmachi 8-chome
Amagasaki City, Hyogo 661-8661
Japan
Fax: +81-6-6497-9361
Email: y_yamau@ita.melco.co.jp

Tomiyasu Ohya, Eiko Sakayori and Sayaka Koubayasi
Mitsubishi Electric Corporation
Industrial Design Center
5-1-1, Ofuna
Kamakura City, Kanagawa 247-8501
Japan
Fax: +81 467 41 2390
Email: tommy@idc.melco.co.jp, saka@idc.melco.co.jp,
 kou@idc.melco.co.jp

Yosiharu Takeuchi, Takeaki Hanada
Ryosai Technica Co., Ltd
1-1, Tsukaguchi-Honmachi 8-chome
Amagasaki City, Hyogo 661-0001
Japan
Fax: +81-6-497-9078
Email: takeuti@rtec.ita.melco.co.jp;
hanada@rtec.ita.melco.co.jp

Sadatoshi Miura
Tokyo National Research Institute of Cultural Properties
Conservation Science Department
13–17 Ueno-Park, Taito-ku
Tokyo 110-8713
Japan
Fax: +81 3 3828-2434
Email: miura@tobunken.go.jp

Introduction

Humidity control for display cases in museums is important in the control of deterioration processes such as metal corrosion, and generally for the maintenance of high quality conditions for works of art. Conventionally, a moisture absorbent such as silica gel has been used for dehumidifying and controlling humidity in display cases. In this method the initial dehumidifying effect is good, but hygroscopic performance declines gradually because of the fixed hygroscopic capacity. When a moisture absorbent is used it is difficult to control hygroscopic speed and to maintain long-term reliability.

We have developed a novel device for controlling relative humidity in display cases: a solid state water removal device (WRD) using a solid polymer electrolyte (SPE) membrane cell.

We report here on experiments with the device as applied to display cases and provide a direct comparison with control by a moisture absorbent.

Method

Principle of water removal

Figure 1 shows the structure of the water removal device and the principle of its water removal effect. When direct current voltage is applied between two

[*]Author to whom correspondence should be addressed

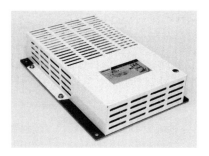

Figure 2. Water removal device (Rosahl RDH-10J1).

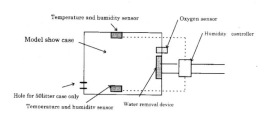

Figure 3. Experimental apparatus for the water removal device.

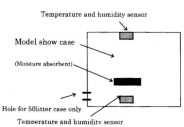

Figure 4. Experimental apparatus for the moisture absorbent.

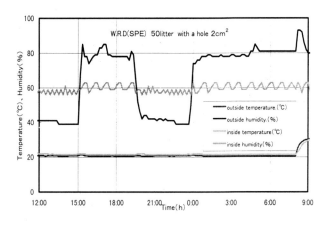

Figure 5. Water removal effect of the water removal device during external RH swings.

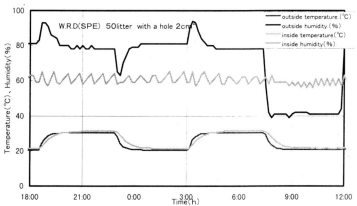

Figure 6. Water removal effect of the water removal device during external temperature swings.

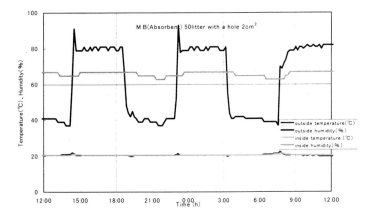

Figure 7. Water removal effect of moisture absorbent during external RH swings.

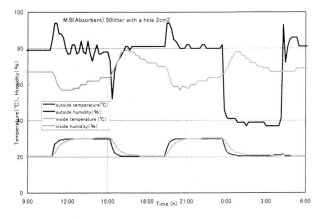

Figure 8. Water removal effect of moisture absorbent during external temperature swings.

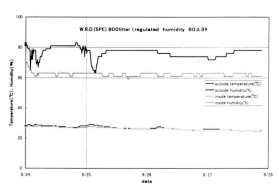

Figure 9. Water removal effect of the water removal device during random laboratory room conditions.

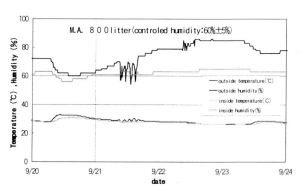

Figure 10. Water removal effect of moisture absorbent device during random laboratory room conditions.

electrodes (cathode and anode), water decomposes into oxygen and hydrogen ions on the anode side. The hydrogen ions transfer to the cathode side through the SPE membrane and generate water by reacting with oxygen in the cathode side. Water in the anode side decreases and water in the cathode side increases. This means that water is removed from the anode side to the cathode side. Figure 2 shows the water removal device (Rosahl RDH-10J1).

Humidity control system

Two display cases were prepared. One was a 50-liter case with a $2cm^2$ hole for ventilation and the other was an 800-liter case without a hole. For the water removal device experiment, each display case was equipped with two sets of devices. One was for humidifying, the other for dehumidifying. For the moisture absorbent experiment, a cassette of moisture absorbent was set in each display case. The experimental apparatus is shown in Figure 3 for the water removal device and in Figure 4 for the moisture absorbent. Experimental conditions are shown in Table 1. The 50-liter display case was placed within a controlled environment chamber. The 800-liter display case was set in a laboratory atmosphere.

Table 1. Summary of experimental results.

Case	Volume	Control Method	Specification	Control Level
1	50 liters	WRD	Reaction Area $2 \times 100cm^2$	60±3%
2	50 liters	MA	Absorbent Weight 1076g	60±5%
3	800 liters	WRD	Reaction Area $2 \times 50cm^2$	60±3%
4	800 liters	MA	Absorbent Weight 1076g	60±5%

WRD = water removal device, MA = moisture absorbent

Results

Humidity control in the environmental chamber studies

We examined the humidity controlling effect of the water removal device and of the moisture absorbent using the 50-liter display case in a controlled atmosphere. Figure 5 shows the humidity control of the water removal device at a stable temperature of 20°C with outside humidity alternating between 80% RH and 40% RH. The device controlled humidity inside the case to a stable 60±3% RH.

Figure 6 shows the humidity control effect of the water removal device at a stable humidity (80% RH) with the outside temperature alternating between 20°C and 30°C. The water removal device controlled humidity inside the case to a stable 60±3% RH.

Figure 7 shows the humidity control effect of the moisture absorbent at a stable temperature of 20°C with outside humidity alternating between 80% RH and 40% RH. The moisture absorbent controlled humidity inside the case to a stable 65±2% RH.

Figure 8 shows the humidity control effect of the moisture absorbent at stable humidity (80% RH) with the outside temperature alternating between 20°C and 30°C. The moisture absorbent controlled humidity inside the display case only within 70±10% RH. The water removal effect of the device was better than that of the absorbent during humidity fluctuations caused by rapid temperature change.

Humidity control in the laboratory room studies

We examined the humidity controlling effect of the water removal device and that of the moisture absorbent using the 800-liter display case under the "real" conditions of the laboratory room.

Figure 9 shows the humidity control effect of the water removal device in the laboratory room. It controlled humidity inside the display case at close to 60% RH. Oxygen concentration in the 800-liter display case was between 20.5% and 22.0% and the current draw was 1A to 2A at an applied voltage of 3V.

Figure 10 shows the humidity control effect of the moisture absorbent in the laboratory. It controlled humidity inside the display case at approximately 60% RH. The water removal effect of the water removal device was as good as that of moisture absorbent.

Conclusion

We have developed a novel device for controlling relative humidity inside display cases, using a solid-state water removal device (WRD) based on a solid polymer electrolyte (SPE) membrane cell.

The following results were obtained:

1 The water removal device controlled humidity in display cases at precisely 60±3% RH during tests in an environmental chamber operated with wide swings in RH or temperature.
2 The humidity controlling ability of the water removal device at the initial stage was comparable to that of the moisture absorbent.
3 The advantage of the water removal device as compared to the moisture absorbent was its much faster response to humidity fluctuations caused by rapid temperature change.

Materials

Water removal device Rosahl RDH-10J1, Ryosai Technica Co., Ltd, 1-1, Tukaguchi-Honmachi 8-chome Amagasaki City, Hyogo 661-0001 Japan. Fax: +81-6-497-9078. Phone: +81-6-497-9082.
Moisture absorbent – Artsorb, Fuji Silisia Chemical Co., Ltd, 2-1846, Kozoji-cho Kasugai City, Aichi 487 Japan. Fax: +81-568-51-2511. Phone: +81-568-51-8557.

Training in conservation and restoration

Formation en conservation–restauration

Training in conservation and restoration

Coordinator: Kathleen Dardes
Assistant Coordinator: Rikhard Hördal

A number of developments this triennium clearly indicate noteworthy trends within the profession. One of the more important meetings during this period took place in Pavia, Italy in October, 1997 when conservation professionals from throughout Europe met to identify the key issues in the preservation of the European cultural heritage and to develop recommendations for future actions. This meeting ended with the adoption of what is now called simply the *Document of Pavia* which contains recommendations for concerted actions on a European-wide level, many directly or indirectly related to conservation education.

One recommendation calls for the development at the European level of the full range of professional competencies required of a conservator. The response to this was a project – Fundamental Level of Competence for Conservators in Europe (FULCO) – to suggest a model for defining competency standards for conservators practicing in Europe. One of the papers contained in these Preprints discusses the results of this project.

Conservation educators have begun to respond to other recommendations since the introduction of the *Document of Pavia*. Thirty-one representatives of 'institutions of conservation/restoration education at a high-level' met in Dresden in November 1997 and agreed to build closer collaboration in teaching through a network of educational institutions, thus establishing the European Network for Conservation/Restoration Education, or ENCoRE. The aim of this network is to support university-level study in conservation by various means, including the exchange of teachers and students and the sharing of educational resources.

The Working Group's Interim Meeting on April 16–18, 1998 at the Espoo-Vantaa Institute of Art and Design drew more than 70 members. The meeting considered the role of evaluation in conservation education. In a future in which conservators may be assessed for competence at various levels of their careers, evaluation protocols are important tools in determining how effective we are in both training and in practice. One of the papers in the present volume continues this theme by examining peer review as a mechanism for assessing training effectiveness. The Proceedings of the Interim Meeting will be published this year.

The Working Group's membership continues to grow and presently exceeds 200 people in the Americas, Asia, and Europe. The most recent Interim Meeting had the largest attendance of all the Working Group's previous meetings. To serve this growing membership, the Working Group publishes an annual Newsletter, which contains updates on training courses, meetings, and other events of interest.

The various developments described above have served as milestones in a profession that is still evolving. The issues being played out in Europe do of course have significance beyond this region and, in fact, are being addressed by members elsewhere. Certification/accreditation and the question of what makes a qualified conservator are being considered by professional bodies in a number of countries. The ideas and experiences presented here by the Working Group members are therefore likely to prove both useful and timely on a broad scale, given their focus on themes of increasing interest to the field. How we define ourselves as a profession must naturally be reflected in the curricula of conservation education programs. It is appropriate for the Working Group on Training to serve as a forum that can allow the various regional perspectives to come together, in order to "internationalize" discussions of vital importance to all of us.

Abstract

The present information is a response to questions raised at the European summit held in Pavia, Italy in October 1997. The author intends to familiarise his colleagues with the grade-granting system for conservator-restorers in Russia, and to describe its history and effect on the quality of preservation of the cultural and historical heritage. In addition, the author proposes this as a basis for creating a similar European qualification system for future conservator-restorers.

Keywords

conservation-restoration, standardization, qualification, international cooperation, examination board

The Russian experience of grading conservator-restorers and its potential contribution to an international system of qualification

Anatoly B. Alyoshin
Academy of Fine Arts
Repin Art Institute
Universitetskaya nab. 17
St. Petersburg 199034
Russia

In April 1998, at the interim meeting of the ICOM-CC Working Group on Training in Conservation and Restoration held in Helsinki, Finland, among the matters discussed were some of the issues that are reflected in the "The Document of Pavia".[1] The current trend towards unification and general professional standards – as articulated at the Pavia meeting – is of great importance for building a new Europe.

Although it is to be expected that standards will be influenced by the ethical, historical and geographical nuances of each member state of the European community, the concept is generally understood and accepted by the field, as evidenced in the signing of the "Document of Pavia". A system of qualifications cannot avoid codifying concepts such as the quality of work required by specialists in conservation, restoration and research. Similarly, it must take into account the grading of qualifications and professional advancement according to an individual's experience and educational level as well as the complexity of work expected of him/her. As with any system of standardization that results in positive or negative decisions, the process can make the majority of people involved feel anxious. Indeed, the elaboration of a standardization system presupposes a kind of ranking similar to that of the military. A rigid qualification system limiting professionals' rights to perform their work and make their individual decisions as well as to receive appropriate compensation for it, at first glance, seems to be completely unacceptable. The European mentality presupposes an inborn sense of individualism, and any European instinctively rejects any attempt to restrict his or her freedom of choice. However, if a law or an act is adopted, the law-abiding European strictly follows it. Sad to say, in Russia laws are passed easily and just as easily ignored. That is probably why the Russian path to the European community is so long and thorny.

At the same time, it should be pointed out that Russia has had much experience in establishing a uniform system of standards. In Russia, requirements for professional qualification have been drawn up to encourage both advancement and better control of the quality of conservation and restoration in the country. However, after the disintegration of the Soviet Union and the rejection of the established system of qualifications, the preservation of works of art fell into rapid decline. The gradual destruction of the uniform system and the loss of general criteria and assessment have allowed doubtful experimentation on works of art, reflecting a lack of true understanding of their artistic and historical value.

A number of colleagues from Western Europe, with whom the author has spoken, have shown great interest in the former Russian system of standards. For this reason, the following discussion describes how the Russian experience may be applied to European conservation-restoration practice.

The Soviet Union was an immense country, incorporating 15 constituent republics, each having its unique historical, cultural, archeological and architectural monuments. In some republics, mostly in the European part of the former USSR, centres for the conservation-restoration of artistic heritage already existed by the middle of this century. However, even more valuable experience had been gained in the heart of Russia.

In St. Petersburg and Moscow – cities possessing unique museum collections – the theoretical and practical basis of the national school for conservation-restoration had begun to form in the 18th century. Unfortunately, the level and quality of work, professional skill and experience, as well as the criteria used for the assessment of restoration work were different all over the country. Therefore, as happened elsewhere in Europe at the beginning of the 1950s, the leading experts in conservation-restoration in Russia were establishing a special body to define common guidelines for grading restorers and maintaining the quality of work, as well as for professional training. In 1954, by a decision of the Council of Ministers of the USSR, the All-Union Examination Board for Conservators-Restorers (now the All-Russian Examination Board) was established under the Ministry of Culture.

The preamble to the document resulting from this decision, stated: "The main purpose of the All-Union Examination Board is to determine the qualification of restorers of historical and cultural monuments. In its activities the Board is guided by the legislation of the USSR and those of the Union Republics on Preservation and Use of historical and cultural monuments."

Staff and structure of the examination board

The examination board was made up of leading conservator-restorers and researchers from institutions concerned with the conservation of cultural and historical works. The Ministry of Culture appointed personnel to the board for a five-year term. The examination board was comprised of the following sections: monumental decorative art, oil paintings, graphic arts, and decorative applied arts (movable property). Over the past 30 years, the members of these sections have included leading experts from Russia, the Ukraine, Georgia, Byelorussia, Latvia, Lithuania, Estonia, Azerbaijan – that is, the republics of the Union where favorable conditions for highly qualified conservators existed. The board's activities were supervised by the Presidium, which includes the chief of the Board of Fine Arts and the Preservation of Monuments under the Ministry of Culture, the chair and his deputies, the secretary, and the chairs of the sections. The Presidium also had scholars from leading centres and the institutions training future conservators.

The work of the examination board

The purpose of the examination board was to determine the grade of qualification of a conservation-restoration professional according to the established standards. In support of this, the following documentation was submitted: a) an application, b) curriculum vitae, c) a testimonial, d) a copy of the protocol of the restoration council of an institution recommending a person for consideration. Separately, restoration certificates were also submitted to the Commission. Their number had to be sufficient to confirm the professional training and experience of an applicant and that professional performance corresponded to accepted standards. In order to accurately determine the correspondence between the quality of actual work performed by restorers with the scholarly and illustrative documentation enclosed, the Commission set up a working group of specialists who visited the applicants to familiarise themselves with their work. The working group then wrote its conclusion, which was consequently considered by the relevant section. Decisions were adopted by not less then two-thirds vote, which were made by secret ballot. The decision came into effect when confirmed by the deputy minister of Culture. The decision adopted by the board to grant a certain grade to a conservation-restoration specialist was obligatory for the salary-grading commissions of all cultural institutions, museums and conservation-restoration organisations. A certificate, valid for 5 years and attesting to the qualification, was issued to the restorer. On its expiration he/she had to apply to the examination board to extend the previous term or get a higher grade.

The examination board was authorized to bestow a higher qualification category if the quality of the applicant's works and the accompanying documentation merited it. The Board could also recommend additional training, or the reduction of a restorer's category, or even to deprive him/her of the right to work due to incompetence or damage done to a work of art. The members of the board

could freely supervise the restoration process at any institution of the Ministry of Culture to make sure that the work conformed to accepted standards.

The following areas of specialization are covered by the qualification system: 1) monumental painting and mosaics on architectural monuments; 2) monumental decorative works of art in museum collections; 3) stone and stucco architectural sculpture; 4) easel paintings in oil; 5) easel painting in tempera; 6) polychrome wooden sculpture and decorative wood-carving; 7) stone and gesso sculpture; 8) furniture; 9) gilding; 10) ceramics and glassware; 11) metalware; 12) leather; 13) textiles; 14) tusk, bone and horn; 15) graphic art; 16) library material and bookbindings.

Four levels of qualification existed for each specialty, reflecting the increasing complexity of the work required of the restorer at each successive level, and the responsibility that goes with it:

- a restorer of the third category should be able to execute simple restoration work, using established methods on works of art of lesser museum and artistic value;
- the restorer of the second category should be able to perform work of intermediate complexity on works of art of the same value;
- the restorer of the first category should be able to perform work of considerable complexity on works of art of high museum and artistic value, direct the work of lower-graded colleagues and share his/her experience with practising students (in this case he/she takes a full responsibility for the execution of the work);
- the restorer of the highest category is authorised to perform independent conservation-restoration work of great complexity on unique works of art, develop new methods, compile training textbooks and aids, direct the work of other restorers and practising students (while taking responsibility for the quality of the work performed), and lecture at schools of higher specialized education.

Restorers in all the above-mentioned categories were required to know and observe the existing methods and protocols for restoration and be able to compile scholarly documentation to accompany their work. A restorer not following these requirements was not graded. In cases where a restorer did not observe the established requirements, he/she could be disqualified.

There are statutes that specify the range of conservation-restoration procedures a restorer must be able to perform, as well as the theoretical knowledge he/she must possess before moving into a higher category. As an example, let's take the conservator-restorer of the lowest or third category within the oil and tempera painting specialty, noting that the professional progress of a restorer within this specialty would be similar to that in other specialties. He/she must be able to identify damage, describe the condition of the painting, clean the canvases, consolidate paint and ground layers, repair minor damage to the support (dents, slackness), make a protective surface coating for temporary storage and shipment, and then remove it, make linings, place a canvas on a stretcher, process ground for restoration, fill in small losses, and coat a picture with vanish. The restorer must also have a basic knowledge of the history of fine arts; know the types and kinds of stretchers, canvases and ground; the techniques used in easel painting; the principles of preventive conservation; the types of damage that occur to painting and their causes; and the characteristics of the basic materials used in the restoration process.

A comparison can be made to the requirements for the restorer of the highest category. He/she must be able to conserve and restore pictures executed in mixed techniques; research painting with up-to-date technical equipment; consolidate a paint layer and ground on such difficult substrates as metal, glass, stone or soft ground, etc.; remove extremely complicated overpainting and vanish coatings; fill in losses on the basis of analogous materials and archival sources; oversee the work of restorers of all categories; do laboratory research in cooperation with physicists and chemists; develop new methods of conservation; understand the historical development of easel painting, the specific characteristics of materials used in creating and restoring paintings and the manner of their preparation, the effects of aging on materials used in the restoration process, and the basic methods of

conservation and restoration of painting (easel and monumental) accepted in Russia and abroad.

Alongside the requirements for restorers that are specific to the different categories, there are also requirements that are obligatory for everyone. These include: sufficient knowledge and strict observance of quality in restoration and in the materials used; storing, packing and shipping procedures; protection of works of art against attack by microbiological organisms and insects; safety measures, including those pertaining to the use and storage of toxic substances; and control over the use of precious metals and stones. The graded conservator-restorer should know the fundamentals of photographic and computer documentation, and scholarly and technical research methods. The most important measure of the graded restorer's work is his/her adherence to the " ICOM Code of Professional Ethics".

At the annual sessions of the examination board, the most skilled and experienced restorers and the members of the board (about 25 people in each section), representing different museums, institutes and restoration centres met in Moscow not only to discuss the question of professional qualification, but also to control restoration activities and discuss improvements to the system.

In the author's opinion a similar system could easily be introduced in Europe and the USA with some variation, such as the establishment of national examination boards capable of making their own qualification categories and then standardizing them internationally under the auspices of ICOM or another international organization. Some difficulties may occur in relation to the different levels of scientific conservation in various countries. The most preferable way would be to establish an international examination board consisting of the leading experts in conservation-restoration, who could work out a system of qualifications and grade-granting procedures for conservator-restorers of all specialties.

However, the establishment of such a system would take a great deal of time and may seem to be too bureaucratic for the free and creative spirit of conservator-restorers, but in time the advantages of the system will be obvious, for the following reasons:

1. It would be a chance to control internationally the level and quality of conservation-restoration, with a positive effect on the state of artistic and historical heritage in many countries.
2. It would raise the scholarly and professional level and skills of conservator-restorers.
3. The board's common decisions, based on the general statutes, would reduce the danger of poor decisions by conservator-restorers, as well as the danger of introducing standardization without proper thought.
4. It would encourage international integration and exchange of experience beyond national boundaries.
5. It would facilitate the introduction of a new system that would allow us to reconsider our view of the old principles of conservation-restoration processes with the aim of developing up-to-date methods (something that seems to the author to be of the utmost importance).

To some extent, this last idea is outside the scope of the present article. Nevertheless, the introduction of new standards would create conditions for a new approach to conservation-restoration processes and would add increased support for the conservator-restorer's professional responsibility to assure the long life of works of art.

Acknowledgement

The author wishes to thank V. L. Dvorkin for translating this article.

Note

1. "The Document of Pavia" was the result of the European summit "Preservation of Cultural Heritage: Towards a European Profile of the Conservator-Restorer", held in Pavia, Italy on October 18–22, 1997, under the auspices of the Associazione Giovanni Secco Suardo.

Abstract

The context and key concepts informing the development of two new taught MAs (MA Textile Conservation and MA Museum Studies: Culture, Collections and Communication) aimed at developing reflective practitioners in conservation and museum practice to be offered by the Textile Conservation Centre, University of Southampton are discussed. The benefits of links to the University's established MA History of Textiles & Dress are explored. The interlinked units and the shared teaching and learning concepts of object-based learning and education methodologies appropriate for post-graduate level programmes with integrated professional practice are described.

Keywords

professional training, conservation education, museum education, reflective practitioners, interdisciplinarity

Interdisciplinary education in action: The context and concepts defining the development of three interlinked conservation and curatorial Masters programmes

Mary M Brooks★, Janey Cronyn and Alison Lister
Textile Conservation Centre
University of Southampton
Apartment 22, Hampton Court Palace
East Molesey Surrey KT8 9AU
UK
Fax: +44 (0)181 977 4081
Email: tccuk@compuserve.com

Introduction

This paper explores the context and concepts that have informed the development of two new interdisciplinary taught Masters courses to be offered by the Textile Conservation Centre, University of Southampton from Autumn 1999. The need for educational programmes in the sector to provide students with the opportunity to develop as reflective practitioners with the appropriate high level of academic, technical and transferable skills, including communication and collaborative abilities, is considered critical. The paper therefore seeks to demonstrate how these new programmes, both in their own design and through interlinking with the University's existing MA History of Textiles and Dress, will seek to deliver these benefits. Some changing aspects of the heritage community are highlighted and implications for the capabilities required by conservation and museum practitioners are discussed. Some key concepts were identified as important in developing programmes which strive to achieve these goals: interlinked museum, conservation and research studies; object-based teaching and learning; teaching methodologies appropriate for post-graduate programmes with integrated professional practice. This suite of Masters programmes will create the opportunity for intending curators, conservators and researchers to study in close co-operation with great potential for exciting high-level cross-disciplinary work and the development of professional links.

The changing context

Several factors led to the recognition that a particular conceptual basis in designing professional education programmes for conservators and curators would be beneficial. The traditional roles and responsibilities of curators and conservators are altering in many English-speaking countries. Possible conceptual and pragmatic reasons for such changes have been explored by Brooks and Javer (1998). Preventive conservation theory and practice has developed alongside a wider view of collection care, such as the increasing importance of collections surveys as strategic management tools. The new role of collection manager may be taken up by professionals with backgrounds in either curatorial or conservation disciplines. These shifting boundaries have been accompanied by changes in employers' expectations. Management skills are seen as being as important as competency in traditional curatorial and conservation areas. The importance of establishing benchmarks for competent professional standards has been reinforced in the UK by the work of the Museum Training Institute (MTI 1996).

The UK has also experienced major changes in higher education. Masters programmes have been encouraged (HEFCE 1996) which impact both students' expectations and academic resources. Conservation education departments have generally been successful in establishing two-year career programmes at Masters rather than Diploma level (Cronyn 1996: Pye 1997: Watkinson and Stevenson 1997). These MAs are benefiting from the development of three-year undergradu-

Table 1. *MA Textile Conservation.*

Rationale and aims
The programme is designed to ensure the continued understanding and preservation of culturally significant textile artifacts by providing a comprehensive, career entry education for graduates intending a professional career in textile conservation. Thus it aims to provide to the field new entrants with a framework of theoretical knowledge and a diversity of practical experience to enable them to meet the heritage sector's need for conservation practitioners who can deal with complex problems and function effectively in a variety of contexts. As the successor to the Postgraduate Diploma in Textile Conservation, run by the Textile Conservation Centre for many years, the MA represents a further development in the formal education of textile conservators.

Educational objectives
The educational objectives of the programme are for students to acquire:

- a general knowledge and understanding of the broad context in which conservation operates;
- an awareness of the historical, cultural and social significance of textile artifacts and the relationship of these to conservation and museological issues;
- a detailed knowledge of the processes of degradation and the factors influencing the successful preservation and interpretation of textile artifacts;
- the necessary knowledge and skills to a) analyse and record the materials, construction and condition of textile artefacts using a variety of techniques; b) propose, implement, record and evaluate appropriate and effective preventive and interventive conservation treatments within current ethical frameworks; and c) identify and undertake advanced independent research (under supervision), and communicate results effectively through oral presentations, written papers and practical work; and
- the range of generic and subject-specific skills required for conservation research and practice.

ate general conservation programmes such as the BA Conservation & Restoration, de Montfort University. The UK's museum studies courses show a similar development towards higher level courses.

There are parallel changes in the profession. In addition to high-level entry qualifications, the need for maintaining knowledge and skills is recognised. Professional bodies such as the United Kingdom for Conservation (UKIC) are setting up accreditation systems requiring Continuing Professional Development (CPD). The UK government's initiative to improve workplace competence has been channelled into the heritage sector by the Museum Training Institute (1996). Their work on standards for competence for both curators and conservators informs much of UKIC's accreditation programme, reinforcing the importance of transferable and management skills.

Professional educational and training programmes must both react to these fundamental developments and be proactive in setting standards. They must balance the academic and professional in order to enable students to become practitioners with the capability to interpret, preserve and conserve the cultural heritage, to take the discipline and profession forward and to commit to their own on-going professional development.

The final change is local. The Textile Conservation Centre merged with the University of Southampton in August 1998 while retaining its unique identity and core activities of conservation education and practice. This development was prompted by the need for a different physical environment where the Centre can realise its objectives in education, research and practice. Having outgrown its Hampton Court Palace apartments, the Centre will occupy a new purpose-designed building on the University's Winchester campus. The University is a research-led institution which has also been recognised for high quality teaching. The arrival of the Centre will create an interdisciplinary focus for the study, research, interpretation, creation and conservation of artefacts.

Concepts

Consideration of the scope and pressures afforded by this context resulted in an enthusiastic response to the development potential of the merger of the Centre with the University. One such development is the creation of a suite of three interdisciplinary Masters programmes characterised by shared underlying concepts. Two of these programmes have been developed *ab initio*: the MA Textile Conservation and the MA Museum Studies: Culture, Collections and Communication (Tables 1 and 2; the MA Textile Conservation is described in Brooks and Javer 1998.) The third programme is the existing MA History of Textiles and Dress. A recent restructuring of this programme enabled a re-assertion of these unifying concepts.

Whilst the provision of suites of MAs in specific areas of 'heritage' studies is not unknown, it is believed that a suite such as that described here which includes programmes for conservators, 'curators'[2] and researchers is unusual. It is also rare to have the opportunity to develop a fair proportion of a suite of MA programmes in this subject area from scratch.

Underpinning all the development work was the belief that conceiving the new programmes as a suite, rather than as discrete courses, could lead to broad range of benefits for the heritage community. Consultation undertaken with active sector practitioners as well as University colleagues during the development process reinforced this perception.

Chief amongst these is the potential for developing individuals with an increased capacity for reflective practice. Such practitioners are able to monitor and evaluate their own thoughts and actions as they occur and to envisage alternative perspectives and approaches (Barnett 1992). They should have more relevant competencies for the current and future needs of the field. This approach also allows a wide range of resources to be optimised thereby enabling programmes to be run and the discipline furthered. In the current context, one of the most crucial resources to be saved is staff time. This will enable both research, the *sine qua non* of a university, to flourish, as well as the now required CPD to take place. The value of adopting an interdisciplinary approach to the education of heritage professionals

Table 1 (cont.)

Structure and content
The programme has been developed following the ICOM and ECCO guidelines on the training and education of conservators/restorers. It also contains the necessary underpinning knowledge and understanding as well as some of the skills and experience necessary for a National Vocational Qualification (NVQ) Level 4 or 5 in Conservation. The on-going growth and evolution of the conservation discipline, and the changing role of practitioners has also been acknowledged. Thus the programme covers a broad spectrum of topics ranging from the interpretation and preservation of collections to the preventive and interventive conservation of individual textile artefacts. The programme also allows students to begin to direct their studies towards a particular area of interest or career path.

YEAR I
Semester I

Meaning and Matter of Cultural Material	Core
Assessment and Care of Cultural Material	Core
Skills for Research and Practice	Research
Fibres and Fabrics: An Introduction to Textile Science and Technology	Core

Semester II

Independent Study Project	Option
Preventive Conservation for Textile Artefacts	Core
Interventive Conservation I: Core Treatment Techniques	Core

Vacation

Placement	Core

YEAR 2
Semester III

The Professional Conservator	Core
Interventive Conservation II: Supplementary Treatment and Analytical Techniques	Core

Semester IV

Interventive Conservation III: Specialism	Option
Conservation Projects Research Skills and Dissertation Preparation	Core

Vacation
Dissertation

through the interlinking of related programmes can be illustrated by examining some of the concepts that underpin these programmes.

The three MAs are united by the aim of developing individuals with an increased capacity for reflective practice and with greater relevant capabilities. Certain intellectual, methodological and professional outcomes flow from the chosen delivery approaches. Embedded in all the programmes is the concept of viewing the object as evidence, the belief that artefact-based study presents a unique resource for the understanding of the past for conservators, 'curators' and researchers. The undoubted postgraduate nature of masters courses leads to the adoption of certain educational methodologies. The final common concept identified here is the commitment to inbuilding professional practice.

Interdisciplinary interaction

One of the key convictions uniting these programmes is that bringing together novitiate practitioners from related fields leads to more satisfying and productive relationships in the future. This accords with the now widely held view (Bergeon 1995: Cordaro 1998: Griffen 1987: MTI 1996: Pearce 1990, 109: Thomson 1989) that only through collaboration, mutual understanding and respect can interpretation and preservation of the heritage be optimised. Whilst this is the case, it is still not common for even those fresh from primary programmes to demonstrate the necessary communication in reality (see *Museums Journal, passim* September 1998 and earlier). This problem is addressed in this suite of Masters by interlinking the programmes at various points. All three student groups will be taught together at the outset of their specialist programmes, allowing time for the development of specialist skills later in each MA. Establishing a common purpose supported by shared values and knowledge at the outset of the students' careers gives them the opportunity to develop the mutual respect and understanding necessary in later professional life. All three cohorts study together during their first Semester in the Units entitled 'Meaning and Matter of Cultural Material', 'Assessment and Care of Cultural Material' and 'Skills in Research and Practice'. The common understanding learnt here is developed later through joint research seminars and a further shared unit on professional practice for conservators and 'curators'. Not only will this enhance communication, as with interlinked study in any subject group, but this synergy will enhance the separate disciplines. It is crucial that the disciplines advance through a knowledge and understanding of associated areas, as well as professional practice as it is the former which effectively underpins the latter. This synergy is also expected to extend beyond this immediate suite of MAs. The vicinity of other programmes in the School of Art such as Fine Art and Textile Design should lead to a greater understanding of creativity, ownership and aesthetics. Further enhancement of the separate disciplines is possible through links with Material Culture Studies, Chemistry, Archaeology, Philosophy, Information Technology and Business Studies.

Common themes

One theme relevant to all those involved in the preservation and interpretation of historic artifacts is the concept of the object as evidence – the belief that artifacts present a unique resource for developing an understanding of the past. The study of objects as evidence of social and artistic life is central to material culture studies as well as being a core activity in curatorial and conservation work:

> Artifacts constitute the only class of historical events that occurred in the past but survive into the present. They can be re-experienced; they are authentic, primary historical material available for firsthand study. Artifacts are historical evidence (Prown 1993).

Close study of the materials, construction, design and patterns of use of cultural artifacts enables sensory and analytical information to be observed, documented and used as the basis for decision-making in terms of interpretation and conservation. Original artifacts provide the foundations for new information for curators,

Table 2. MA Museum Studies: Culture, Collections & Communication

Rationale and aims

The programme is designed to meet certain identifiable needs of the nationally and international heritage sector including the requirement for professionals who are

- appropriately educated;
- trained at a high-level;
- competent, adaptable and resourceful in the areas of both interpretation and preservation of collections.

Educational objectives

The programme aims to enable students to acquire:

- ability to develop independent judgement and critical awareness based on a sound understanding of museological theory and practice;
- sound knowledge and understanding of both the concepts of cultural material, the means by which it has been and can be collected and interpreted in the context of heritage;
- the necessary knowledge, understanding and skills to:

 - identify and document artefacts;
 - propose and implement the means for preserving artefacts in collections;
 - identify and create an appropriate a creative activity, for example, an exhibition, demonstration or a comparable project which interprets artefacts;
 - contribute immediately to the provision of access to cultural material through appropriate collections management
 - identify and undertake research in an appropriate area.
 - develop the necessary range of generic and specific research and practice skills for professional life in the heritage sector.

Structure and content

The design of the programme takes into account the following:

- *Revised ICOM Basic Syllabus for Professional Museum Training* (1998) and *Standards and Ethics for Museum*

conservators and researchers. Buck (1998) recognised the importance of object based-research, particularly when evidence of use remains: 'It is the evidence of the practice of costume that museums hold, and which is needed to give substance to evidence gathered from other sources'.

In this context, what might otherwise be perceived as 'damage', rendering artifacts less valuable, actually has value as evidence: soil and losses become meaningful (Eastop 1999). Objects may also act as triggers for 'material memories', carrying personal significance which curators should, where possible, aim to record (Kirschenblatt-Gimblett 1989). Object-based evidence may also reinforce – or contradict – other documentary sources. Kidwell's (1997) paper exemplifies this approach, demonstrating the value of evidence from object-based study as a means of evaluating evidence from other sources. Curators, conservators and researchers studying together can establish a wider understanding of the meaning of the information inherent in the artefact and its patterns of use. Curators and researchers may focus on contributing an understanding of an artefact's historical and social context and function whilst conservators may contribute a specialist knowledge of materials identification and behaviour; all should be able to work together to enhance interpretation and preservation. Object-based research thus forms an intellectual bridge between curatorial and conservation disciplines to the enrichment of both, with the ultimate benefit of enhanced public intellectual and physical access and interpretation through exhibitions and publications. These Masters programmes therefore integrate object-based study as a common root for careers in conservation, curation and research.

Teaching and learning on post-graduate level programmes

The need for such programmes to be at the post-graduate level is undoubted (Edson 1995, 8). The level of knowledge and understanding required, and the rate at which this must be acquired, demands students who have already undertaken three years post-school education, giving them an appropriate level of self-direction, relevant knowledge and learning skills as well as maturity. Learning in a post-graduate environment also gives students the essential opportunity to rehearse high-level debate regarding their discipline with their peers in other disciplines, something which is not possible where learning is isolated from a graduate teaching institution.

Post-graduate level learning enables certain educational methodologies to be used effectively to develop professional abilities. The three programmes use group-based and experiential teaching and learning methods. For example, a variety of seminar types will be used in the shared Units. Students will examine set texts critically, participate in group debate and then practise verbal argument by giving presentations at which other students are introduced to the role of chair by acting as 'commentators'. Students will also lead workshops which encourages less formal discussion modes. Group working '... forces participants to articulate their thoughts, to listen to others, to modify their own suggestions in the light of peer offerings, and creatively to work together' (Barnett 1992, 192). The programmes also include some form of work-based experience. Whilst this approach to professional skills development is widely advocated in conservation (Bacon 1996: Stoner 1996: Pearson and Ferguson 1996), work attachments are not always well-designed or assessed. A well planned, supported and evaluated work attachment designed in consultation with the profession can benefit both student and host. Formal recognition of the profession's essential role in the development of new professionals is vital. This approach should result in placements being afforded greater support by organisations and proving of greater direct usefulness to the host. For the student, an integrated attachment means a real opportunity to experience and test theory in practice through 'career exploration'. The profession itself ultimately benefits by having access to graduates who are more readily able to apply their newly acquired knowledge and skills appropriately.

Table 2 (cont.)

Training Programs (1991), both drawn up by the Training of Personal Committee of the International Council of Museums (ICOM).
- *Review of Management Training and Development* (1998) published by the Museums Training Institute. It is also contains the necessary underpinning knowledge and understanding as well as some of the skills and experience necessary for a National Vocational Qualification (NVQ) Level (4 or) 5 in Collections Management and Interpretation.

This MA programme falls within the broad definition of museums studies courses but, as the subtitle "Culture, Collections and Communications" indicates, it takes a unique approach. It is distinctive in focusing on:

- The use of objects themselves as evidence, that is an understanding of how direct visual and scientific evidence of the materials, construction and pattern of use of an artefact can equal and corroborate evidence from contextual sources.
- The preservation of objects which enables collections to be studied and displayed as well as maintained.
- Bringing the reality of professional practice into education and training at the postgraduate level.

Semester I
Meaning and Matter of Cultural Material
Assessment and Care of Cultural Material
Skills for Research and Practice
Fibres and Fabrics: An Introduction to Textile Science and Technology

Semesters I & II
Communication Using Objects (Creative activity for example, an exhibition, demonstration or a comparable project)

Easter vacation
Attachment

Semester II
Option Unit
Access to Collections in Organisations

Semester II & Vacation
Research Skills and Dissertation

Conclusions

Barnett notes that interdisciplinary approaches present themselves as obvious strategies in 'a real integration of theory and practice, and a partnership between the academic and professional communities in designing and delivering the curriculum' (1992, 192).

The development of these interdisciplinary MAs was made possible through an unusual set of circumstances. However, it is hoped that the benefits of interdisciplinarity and some of the methods by which these can be achieved are of interest to those working with established programmes as a means of enhancing subject specific skills and knowledge without compromising their integrity or centrality. The long-term goal is to develop professional relationships which will promote the preservation and interpretation of cultural artifacts. Implementation will undoubtedly test these concepts and give rise to further developments. It is hoped that this contribution to the debate on achieving high level academic and professional education will generate further discussion and stimulate new ideas.

Acknowledgements

The authors wish to thank Nell Hoare, Director, Textile Conservation Centre, for permission to publish. Particular thanks are due to all involved in MA development, especially Textile Conservation staff Dinah Eastop, Senior Lecturer, Janet Farnsworth, Conservation Science Advisor and Co-ordinator and Helen Colwell, Photographer. The generous input of other conservation and museum professionals and University colleagues is gratefully acknowledged.

Notes

1. This development is supported by Professor Fernie, Director, Courtauld Institute of Art, University of London which continues to validate the Diploma in Textile Conservation.
2. The term 'curator' is used to cover a wide range of activities specified in recent job advertisements for the following posts: Curator, Assistant Curator, Curatorial Assistant, Temporary Researcher for museum/historic country house, Collection Manager, Collection Service Manager, Collection Developer, Historic Buildings Representative, House Manager, Conservation Advisor and Head of Conservation.
3. Thanks are due to Dr Lesley Miller, Convenor, MA History of Textiles & Dress, University of Southampton, for bringing this paper to our attention.
4. Work experience is a required assessed Unit on the MA Textile Conservation and MA Museums Studies: Culture, Collections & Communication and an option on the MA History of Textiles & Dress.

References

Abbreviations

ICOM CC	International Committee of Museums Conservation Committee
ICOM CC TWG	Training Working Group
MGC	Museums & Galleries Commission

Bacon AF and Brown AJE. 1996. A partnership in learning; the teaching institutions and the profession. In: Cronyn JM and Foley K, eds. A qualified community: towards internationally agreed standards of qualification for conservation. ICOM-CC TWG Interim Meeting. London: English Heritage/MGC: 39–44.

Barnett R. 1992. Improving higher education. Buckingham: Society for Research into Higher Education & Open University Press: 192.

Bergeon S. 1995. La formation des restaurateurs: spécialisation, interdisciplinarité et dangers. Study Series No. 1. ICOM-CC: 20–22.

Brooks MM. Forthcoming. Education & experience: re-evaluating learning in conservation. In: Defining & measuring effectiveness in education & training. Postprints of Interim Meeting of ICOM CC TWG, Finland. Vantaa: EVTEK – Institute of Art and Design.

Brooks MM and Javer A. 1998. Maintaining quality while promoting change: two case examples fostering the integration of theory & practice in textile conservation. In: Postprints of Jubilee Conference. Copenhagen: Danish Royal Academy of Conservation: 41–52.

Buck A. 1998. Foreword. In: Paine C, ed. Standards in the museum care of costume & textile collections. London: MGC: 5.

Cordaro M. 1998. Interdisciplinarity in restoration projects. In: Varoli-Piazza R, ed. Interdisciplinary approach to the study and conservation of medieval textiles. Interim Meeting ICOM CC Textiles Working Group. Rome: Il Mondo 3 Edizione:

Cronyn J. 1996. Future paths for the teaching of textile conservation. (Unpublished Report commissioned by the Textile Conservation Centre.)

Eastop D. 1999. Decision-making in conservation: determining the role of artifacts. In: Timar-Balazsy A and Eastop D, eds. International perspectives in textile conservation 1990–1996. Postprints ICOM CC TWG Interim Meetings. London: Archetype Press.

Edson G. 1995. International directory of museum training. London: Routledge.

Griffen DJJ. 1987. Managing in the museum organisation: I. Leadership and communication International Journal Museum Management and Curatorship 6: 387–98.

Higher Education Funding Council for England. 1996. Review of postgraduate education. Bristol: HEFCE: 96.

Kidwell CB. 1997. Are those clothes real? Transforming the way eighteenth-century portraits are studied. Dress 24: 3–15.

Kirschenblatt-Gimblett B. 1989. Objects of memory: materials culture as life review. In: Oring E, ed. Folk groups & folklore genres: a reader. Logan: Utah State University Press: 329–338.

Pearson C and Ferguson R. 1996. A proposal for guidelines for conservation training. In: Cronyn JM and Foley K, eds. A qualified community: towards internationally agreed standards of qualification for conservation. ICOM-CC TWG Interim Meeting. London: English Heritage/MGC: 63–67.

Museum Training Institute. 1996. Standards of occupational competence for the museums, gallery and heritage sector. Bradford: MTI.

Pearce S. 1990. Archaeological curatorship. Leicester: Leicester University Press: 106–108.

Prown JD 1993. The truth of material culture. In: Lubar S and Kingery WDW, eds. History from things. Essays on material culture. Washington: Smithsonian Institution Press: 3.

Pye E. 1997. A new MSc programme in conservation for archaeology and museums at UCL, Institute of Archaeology. Conservation News 64: 19.

Stoner JH. 1996. The education and training of art conservators: teaching the triptych of practice, history and science. In: Bridgland J, ed. 11th Triennial Meeting ICOM-CC Edinburgh. London: James & James: 134–139.

Thomson SL. 1989. Shared responsibility: in conclusion. In: Ramsay-Jolicoeur B and Wainwright I, eds. Shared responsibility. Seminar, National Gallery Canada. Ottawa: NGC: 79–81.

Watkinson D and Stevenson S 1997. Conservation at Cardiff. Conservation News: 21–22.

Abstract

The advent of the information technology age has led to a heightened awareness of the influence and importance of information, its creation and dissemination. It is apparent that the provision of education and information shape the nature of all future industries and activities. The term "formative conservation" can be used to describe the activities of research, education, training, advocacy and information dissemination which can be seen to form the future of conservation as well as the future generation of conservators. Consequently, all activities in conservation can now be defined as either "interventive conservation", "preventive conservation" or "formative conservation".

Keywords

formative conservation, preventive conservation, interventive conservation, education, training, research, information dissemination, advocacy

Formative conservation

Chris Caple
Department of Archaeology
University of Durham
South Road
Durham DH1 3LE
UK
Fax: +44 191 374 3619
Email: christopher.caple@durham.ac.uk

The development of conservation

Conservation began to develop in the 19th century, initially in the area of activity that is now distinguished by the term "interventive conservation". Objects were saved from decay through cleaning and stabilisation. Often substantive treatments were necessary to prevent objects from totally disintegrating due to forms of decay such as metal corrosion, soluble salt crystallisation or insect infestation. Interventive conservation depended upon the growing subject of chemistry both to identify the causes of decay and to develop solutions. Key texts marking this development have included Rathgen's *Die Konservierung von Altertumsfunden* (written in 1898; translated by G.A. and H.A. Auden and reprinted in English in 1905 as *Preservation of Antiquities: A Handbook for Curators*) and Plenderleith and Werner's *Conservation of Antiquities and Works of Art* (1971, 2nd edition).

Through the late 20th century, and certainly after the publication of Garry Thomson's *The Museum Environment*, the role of preserving objects by controlling their environment and promoting their care became an increasingly important aspect of conservation. The awareness of this area was heightened during the 1990s with the adoption of the term "preventive conservation". This discipline required the development of management techniques which could be applied to museum collections, their buildings and environments, and to the interaction between museum personnel and the objects in the collection. This emphasis on preventive conservation began to be reflected in the ethical codes for conservators developed in the 1980s and 1990s (AIC 1994; UKIC 1996). Key texts during this time included Thomson's *The Museum Environment* (1978), *Preventive Conservation Practice, Theory and Research*, preprints of the IIC Ottawa conference, eds. A. Roy and P. Smith (1994), and most recently Suzanne Keene's *Managing Conservation in Museums* (1996).

Almost all conservation activities could be classified as either interventive or preventive conservation; only areas such as research, education and training seemed to fall into neither category.

The "information age", with its emphasis on communication, has established the importance of knowledge and its transmission in all fields of human endeavour. It can now be appreciated that knowledge creation and dissemination lies at the heart of our ability to enact interventive and preventive conservation and moulds the very future of conservation itself. I would suggest that the creation of knowledge and information (research), the communication of that knowledge (education, training and information dissemination), as well as the efforts to secure support and future resources for conservation (advocacy) are the key activities in developing the conservation of the future and as such can be defined as "formative conservation".

Definition and scope

Various aspects of conservation have as their primary objective the improvement or creation of the future of conservation:

- The creation of information – research – is conducted at many levels, from basic research into the history and composition of a particular object prior to its conservation (the type of research seen in *The Conservator*), through investigations into aspects of materials and their decay (the type of research seen in *Studies in Conservation*), to fully funded research projects with full-time staff and access to substantial funding and equipment.
- All conservation education and training courses. These can be the initial training level courses of several years duration, leading to formal qualification in conservation, through to shorter courses for continuing and professional development of practising conservators. The publications of the ICOM-CC Working Group on Training in Conservation and Restoration illustrate the conscious development of this aspect of "formative conservation" in creating the future generations of conservators.

There is a subtle distinction between education, which can be defined as "primarily the gaining of knowledge and understanding" and training, which can be defined as, "primarily the development of expertise in the application of knowledge and understanding". Though they overlap, it is clear that many of the initial courses in conservation, especially those in higher education institutions, are primarily concerned with education. Internships and other practical courses are primarily concerned with training. Both processes are essential in order to develop good judgement (the intelligent weighting of knowledge) in conservators.

- Conferences and publications form an integral part of continuing and professional development and provide an avenue for the dissemination of the results of research and a forum for ideas. Thus they fundamentally shape the future direction of conservation and examples such as Michalski's work on correct vs. incorrect RH values (Michalski 1993) has had a significant effect on thinking on the stability in the museum environment.
- Information is increasingly available through a wide variety of sources: commercial products, television, video, and the Internet as well as through books, newsletters and journals. The accessibility and accuracy of information are increasingly important concerns for conservators. The future of conservation is determined not only by information that can be readily obtained but also by the quality of that information.
- The future of conservation is fundamentally affected by the resources available to it and by the public support for conservation activities. The term 'advocacy' can be used to describe the various processes of securing support and resources, from speaking to small public groups and arguing with politicians for funds to creating advertising material and answering public enquiries. It is through these methods that we persuade people of the importance and aims of conservation. It is through awareness of the value of preserving the past that people can pursue preventive conservation measures, acting either individually through care of their personal possessions, or collectively for aspects of cultural heritage held in common. Before individuals seek education or information about conservation they must believe that it is an important thing to do. We must have their hearts, before we have their minds. Advocacy is the process of capturing hearts, creating the desire for knowledge and giving people the will to act.

The future of conservation is formed from all these disparate activities. Recognition of their common purpose in forming the future of conservation leads to their inclusion in the collective term of "formative conservation" and an associated definition:

Formative Conservation: The processes of the creation of knowledge and the development of the ability to apply it for the purpose of conserving historic and artistic works.

This can be represented as:

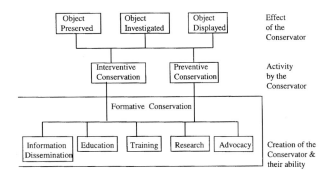

Distance

It can be seen that the scale on which conservation provision is enacted is increasing: "interventive" conservation is practised on a single object, "preventive" conservation is practised on a collection of objects, whilst "formative" conservation deals with all future conservation work. The reason for this trend appears to be the recognition of the more subtle but powerful forces that lie at a distance from the interface between the object and the conservator. The greater the distance from the object, the more one relies on the mechanism one creates to impact on the object and its care. This distance may make research or some aspects of education and advocacy seen rather remote from the objects, but what is being created is increasingly powerful and has the ability to affect an increasingly large number of objects.

Benefits

Gathering together areas of conservation such as publication, education, research, and advocacy under the collective term "formative conservation" now allows any and every aspect of conservation to be described in terms of being "interventive", "preventive" or "formative".

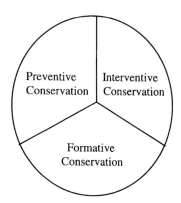

This sub-division of conservation and particularly the creation of the term "formative conservation" may appear either self evident or simply one of an almost endless number of ways of "packaging and labelling" aspects of the discipline of conservation. I would suggest that "formative conservation":

• Accurately describes the reality of what occurs.
• Makes practitioners of research, education, training and advocacy more aware of what they are doing: creating (forming) the ability to conserve in others.
• Emphasises that knowledge created through research is not specific to one object, but has a wider role as "formative conservation" in enabling other conservators to better understand and conserve their objects. Knowledge without dissemination is as immoral as wealth or power not used for the good of mankind.

- Achieves a wider recognition for the role of advocacy and a recognition of its role in defining the future of conservation.
- Allows the overlapping processes of education and training, which are often practised together, to be most usefully seen in terms of their common aim and as aspects of "formative conservation".

The designation of many processes and actions as "preventive conservation" has, through the clarity of this label, made people aware of the importance and distinctiveness of these activities. This has certainly led to increased funding in research and has positively promoted activity in this area. A far greater volume of literature is now published in this area and a far more widespread appreciation of its importance has been established. Specific training courses have been created in this subject and bright, able conservators have been drawn to this area which, ceasing to look so "dull and dutiful", now appears a vibrant area of conservation activity. The recognition of the importance of this area has led to the creation of standards. In the UK these have been established through the Museums and Galleries Commission's "Standards in the Care of Collections" publications and enacted through its Museum Registration scheme. It is to be hoped that by proposing the label of "formative conservation" the importance of the processes, which so fundamentally shape the future of conservation, will be recognised and receive increased emphasis in the future.

Conclusion

It has been the purpose of this paper to present, in brief form, the concept of using the term "formative conservation" to describe those activities whose primary objective is the development of the future of conservation. This objective is achieved through the creation of information and its dissemination through the education, training and resourcing of conservators, in turn leading to the application of that information.

References

AIC (American Institute for Conservation). 1994. Code of ethics and guidelines for practice. AIC News, May 1994: 17–20.

Keene S. 1996. Managing conservation in museums, London: Butterworth Heinemann.

Michalski S. 1993. Relative humidity: A discussion of correct/incorrect values. In: ICOM-CC 10th Triennial Meeting, Washington, DC, USA. Paris: International Council of Museums: 624–629.

Plenderleith H and Werner AEA. 1971. Conservation of antiquities and works of art. Oxford: Oxford University Press.

Rathgen F. 1898. Die Konservierung von Altertumsfunden. Berlin: W. Spemann.

Abstract

The FULCO Project looked at existing systems for defining competence in professional conservation-restoration practice in order to derive from common principles a Framework of Competence that might lead to developed standards, for use in a European context. This paper describes the project methodology, and presents the Framework. It discusses the advantages and shortcomings of a competence-based approach and analyses the possible European contexts in which it could be used.

Keywords

framework, competence, standards, professional

FULCO: A framework of competence for professional conservation-restoration practice: The project discussed

Kate Foley
Wouwermanstraat 22
1071 LZ Amsterdam
The Netherlands
Tel/fax: +31 (20) 6701290

The FULCO Project

The standards through which an emergent profession defines itself and its practice are of great importance. Ethical standards for conservation and profiles outlining the characteristics and practice of the conservator-restorer form a collection of landmark documents in the history of the profession (ICOM 1984; ECCO 1996).[1] However, professional codes and guidelines, which express in narrative form the values of the profession, which act as its conscience and have great moral force, should not be the only tool to be used when more pragmatic tasks involving measurement or assessment must be undertaken.

The issue of finding more precise standards for assessment and measurement as well as for underpinning the ethical practice of conservation-restoration was discussed at Maastricht (Cronyn 1995) and recurred as a theme in many of the papers given at that meeting. It coincided with a worldwide attempt to find measurable standards both in education and for the workplace (Allan 1996: Brennan 1996: Higher Education Quality Council 1996: Human Resources Development Canada 1997).

Thus, the commitment to develop standards of competence for conservator-restorers in Europe, which was first expressed at the European-funded Centres of Excellence Conference in Amsterdam, 1997 (Scholten 1997), was reflecting a concern felt beyond the boundaries of the profession. It was followed by a statement supporting such a development in the Document of Pavia (1997). Seven delegates at the Amsterdam meeting[2] expressed their wish to take the concept further and subsequently became full partners in the European Raphael project, FULCO, funded by DG X.

From the outset it was clear that a difficult task had been undertaken, given the limited timeframe available. Those fully realised standards of competence already existing for conservation-restoration (Arts Training Australia 1994: Museums Training Institute 1996: National Parks Service 1996) had been derived from intensive professional consultation over a very long period of time (over five years in the case of the UK). The fundamental competences described were therefore very robust, growing as they did from an analysis by practising conservator-restorers of their own work. However, the way that they were used geographically and institutionally meant there were differences between them that needed analysis. They could not be used uncritically. There were also drawbacks noted in implementation which should not be repeated in a European context where there was a chance to start afresh.

The so-called "Anglo-Saxon" standards of competence were derived from the "bottom up", by the community itself. A lengthy process of consultation like this, with as its valuable result a real sense of community ownership of the outcome, was impossible to achieve within the Raphael time-scale. The project organisers therefore decided to aim at producing an outline framework of competences, which would take into account work already done and which could be discussed in outline in a European forum before being developed into fully described standards, by the community itself, if it so decided. At a very early stage ECCO representatives were asked to join the partner meetings, as was the Associazione Secco Suardo.

The project aimed to produce a framework of competence for discussion by a meeting of nationally representative European conservator-restorers who could decide whether or not a set of verifiable professional standards should be developed in full and who could begin to consider contexts in which such standards might be useful.

At the meeting to discuss the framework, held in 1998 in Vienna, the delegates agreed that while standards of competence had been found to be of value in some countries, their development in a European context should be firmly linked to the legal recognition of the conservation-restoration profession, and the harmonisation of conservation-restoration education at university level. This organic mode of developing the outline competences into a complete set of standards within the political and academic framework of the conservation-restoration community, could offer a unique opportunity for harmonisation of professional practice throughout Europe.

Competence and occupational standards – a background

A change of climate has overtaken the museum and heritage sector during the past decade, with inevitable consequences for conservation-restoration. Decreasing government support has caused many public institutions to become increasingly self-supporting, leading to a much more business-led environment, often with loss of permanent staff and an increasing use of the private sector.

This has created a more urgent demand on the part of commissioning bodies for assurance of quality for those from whom work is commissioned. As a consequence, conservator-restorers in both public and private practice are called upon to develop and demonstrate new skills and attitudes, and it is no coincidence that the demand for strong supportive professional bodies from conservation-restoration professionals and commissioning bodies has increased with the new pressures.

In this climate, many European governments have sponsored the derivation of occupational standards for other professional fields, with the aim of driving up standards in the workplace but also of influencing higher education providers towards offering more and better-focused vocational education.

However, it is important to note that not all the pressure to develop standards comes from government. Many established professions are finding them a useful tool. For example, in the Netherlands several branches of medicine have defined the competences necessary to practice in their specific fields. The competences have been derived at practitioner level and the work has been recycled into the curriculum of medical schools. This illustrates the way that standards and the educational process may enrich each other but also suggests that even protected professions may find a use for the development of standards based on competence. A more extended bibliography of some competence-based standards for other professions may be found in the Vienna discussion paper (Foley 1998).

Inevitably, the claim that measurable standards for professional practice or educational outcomes are achievable has its critics (Hyland 1994). The new bias of professional education towards the achievement of measurable competences in graduates is seen as militating against the liberal and humane aspects of truly vocational education. Standards themselves are seen as narrow, exclusive and rigid. Indeed, they may be developed to the point where the small print exerts a tyranny over human creativity and common sense.

However, this is to lose sight of one of the most vital aspects of these standards, which is their context. In the debate about verifiable or measurable professional standards it should never be forgotten that such standards are not a platonic absolute from which there can be no deviation; instead, they exist in a very pragmatic context. They come about through the consensus of a professional group that has felt the need to develop them; to be useful at all they need to be regularly updated, so they cannot be seen as fixed; and above all, their purpose is to guide rather than to dictate.

Comparisons

The FULCO Framework was deliberately written with this debate in mind. As a guide the author and research team had fully developed Australian, American and

UK standards and some anecdotal and personal experiences of how these systems work in practice. A detailed and critical comparison of each scheme examined was not possible within the scope of the discussion paper but certain general principles were discernible and needed to be discussed.

Firstly, the core functions or competences – that which is essential for a conservator-restorer to know and do – were comparable in every system considered. The same suite of essential tasks were identified, with of course, variations in presentation and language. If the critical functions that must be carried out in order to practice a profession to a high level are not agreed upon, they cannot be designated as "standards" against which professional behaviour may be measured. It was encouraging that there was a degree of consensus.

Secondly, it was demonstrable that the designated user group had an effect on the way the standards were written. Thus, the same function relating to the initial examination of an object could be written as "describe" or "assess" or "evaluate in context" depending on who was to carry out the task and how that person's expertise rated in the workplace. Thus the perceptions of employers could colour the language of standards, a potent argument for professional bodies to write their own.

The FULCO Framework was therefore deliberately written in language that showed it was aimed at the practicing professional with a high degree of autonomy. Only by drafting an inclusive and high-level framework would it be possible to avoid the mistake of ossifying practice at too great a level of prescription. Also, an outline or framework of taxonomic simplicity, that is the most over-arching level of description, would offer the greatest potential for development by professionals.

Reflective practice

Another innovative aspect of the framework is that in addition to describing the functions of conservation-restoration, it attempts to describe the attributes of "reflective practice", those essential aspects of practice which govern its intelligent and ethical application. Many people think they cannot be easily pinned down and certainly not "tested". However, some interesting work has been done on trying to define and measure professional and reflective attributes (Winter 1992) and it was felt that it was necessary to bring these difficult ethical and cognitive problems into the arena of discussion. Not to do so would be to describe the conservation-restoration profession in too reductive a way. Some of the most interesting work yet to be done in this field may be in the attempt to find a flexible but searching way to teach and assess these attributes.

Conservation-restoration educators have long grappled with the necessity to marry attributes like "intellectual flexibility, rigour and judgment" or "affective awareness" to workshop practice. They are better placed than many other professionals to undertake the task of marrying the attributes of reflective practice to the functions (Bacon 1998).

The framework

For a full discussion of the FULCO framework, in the context of other descriptions of competence-based standards, readers are referred to the Vienna discussion paper (Foley 1998).

The centrepiece of the discussion is the simple framework, as described in Figure 1. This sets out the core tasks or functions of conservation-restoration as they have been derived through functional analysis by groups of conservation-restoration professionals. It is essential to grasp the concept that the functions are concerned with "doing" the task and with "knowing" all that it is necessary to know to carry out the work to an agreed level of quality. In other words, these are not the overarching "standards" for ethical conservation-restoration as described in the professional codes and guidelines. What they offer is another way in to effective care for the heritage by allowing the person who is complying with the standard, or agreed upon, essential function, to compile a whole suite of evidence that s/he is "competent".

The Functions of Conservation-Restoration: Essential Expertise

1. Evaluate conservation-restoration problems in context
Involves examining, researching, identifying, and recording, key features of conservation-restoration problem/s in the context of the object's provenance, significance, history and role in a collection, collaborating with other specialists as appropriate.

Includes research to determine material/s, manufacture/ technology, condition and its cause/s, and consultation to establish future role and its effects.

2. Develop options for solving conservation-restoration problems
Involves evaluation of key problems in context and making decisions based on the development of appropriate solutions.

Includes evaluating solutions in the framework of best professional knowledge and practice, considering health and safety, resource implications, legislative constraints and consulting with other professionals.

3. Develop and implement interventive treatment
Involves researching and developing active treatments to stabilise, support or restore the object/s, in the context of the ethical codes of conservation-restoration and best professional knowledge and practice, in consultation with other professionals.

Includes using the expertise of appropriate specialists, evaluating and recording the use of treatments developed, using the practical and cognitive skills necessary to carry out the work, discussing the implications of interventions, and disseminating the results.

4. Develop and implement preventive procedures
Involves understanding and identifying the causes of degradation and damage to the object/s and developing non-interventive procedures to prevent or minimise it.

Includes the provision and monitoring of suitable environmental conditions for storage, display and transportation, the promotion of good handling, packaging and transportation procedures, disaster preparedness and avoidance, risk assessment, training of relevant staff and dissemination of procedures.

5. Develop strategies for conserving-restoring collections
Involves understanding the strategies to be developed in order to conserve-restore public or private collections within the context of the organisation and the broader heritage field and where appropriate planning for change.

Includes audits of condition, environments, disaster preparedness, assessment of health and safety protocols, deployment and use of electronic and other communications media in the pursuit of conservation-restoration goals, assessment of training provision on conservation-restoration issues for other staff/professionals, and the deployment of resources to achieve these goals.

6. Plan, monitor and manage work
Involves optimising human and physical resources so that planned objectives are met.

Includes setting objectives, devising and where appropriate communicating tasks, responsibilities, timescales, monitoring, reporting and feeding back on progress, fostering team-work, and ensuring the efficient and accountable use of resources.

7. Contribute to the interests of the heritage sector
Involves promoting public knowledge, awareness and enjoyment of the heritage through the practice of conservation-restoration and promoting the growth of knowledge and good practice in the professional field.

Includes promoting the responsible care and use of the object/s, disseminating information in the field, developing working relationships with professionals in conservation-restoration and from the wider heritage field, developing one's own professional interests, and promoting the good of the profession inside the sector and to the wider public.

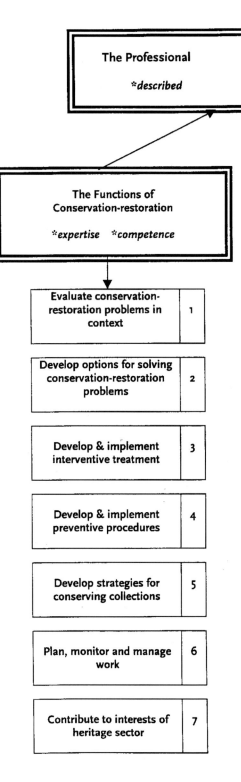

Figure 1. The framework.

A FRAMEWORK OF PRACTICE

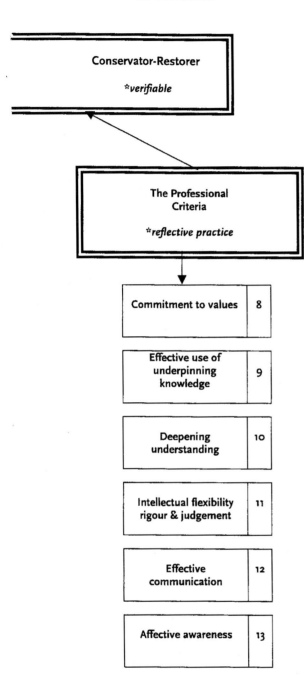

Conservator-Restorer

**verifiable*

The Professional Criteria

**reflective practice*

Commitment to values	8
Effective use of underpinning knowledge	9
Deepening understanding	10
Intellectual flexibility rigour & judgement	11
Effective communication	12
Affective awareness	13

Professional Criteria Underpinning Essential Functions

8. Commitment to professional values
Demonstrates adherence to professional guidelines and codes of conduct and a clear understanding of the underlying ethic of conservation-restoration.

Involves respect for the cultural, religious and ideological views of groups within society, aesthetic awareness and sensitivity to the context of historic/cultural material.

9. Effective understanding
Demonstrates the wide range of professional knowledge as applied in practice within the framework of legislation and professional guidelines.

Involves critical evaluation of research, materials, methods, and general theory and the intelligent use of knowledge in practice.

10. Deepening understanding
Demonstrates reflective practice by critical analysis of one's self and current practice with willingness to change as necessary.

Involves self-evaluation through analysis of strengths and weaknesses, accepting that professional judgements can be questioned, and a verifiable commitment to continuing professional development.

11. Intellectual flexibility, rigour and judgment
Demonstrates flexible thought and rigorous analysis in the resolution of problems requiring judgment between difficult options.

Involves clear analysis of issues and options, prioritisation, decision making and implementation; knowing if a problem is within one's own scope to solve.

12. Effective communication
Demonstrates clear and sensitive communication with others who have an interest in a professional issue or a role in resolving a professional problem .

Involves including all who should be consulted, or to whom information should be disseminated, using the appropriate means of communication, using clear and appropriate language, being receptive to the views of othersand recording the outcomes of communication.

13. Affective awareness (empathy)
Demonstrates sensitivity to the public, to colleagues, and towards cultural material, in carrying out all professional duties.

Involves awareness towards cultural-historical material, ability to manage sensitively and to be managed and empathy with others within the context of a complex professional life.

The concept of evidence

"Competent" as a term applied to a professional cannot simply mean the workmanlike achievement of a set of agreed and prescribed tasks. Rather, it describes a whole range of complex attributes or qualities that bring the performance of the tasks at hand up to the high level of autonomous behaviour required by our peers in the profession.

How do we measure this? If we are concerned about applying agreed standards, the answer must be through developing a rich and flexible concept of the kind of evidence that may be collected by a person wishing to demonstrate competence.

One of the issues raised against the use of "competence" as an assessable standard is that it may lead to rigidity (see Player-Dahnsjo 1997 for a discussion of perceived shortcomings of the MTI standards). In practice, the depth and richness of the evidence supplied by the person aiming to demonstrate competence tends to lead to greater flexibility in the interpretation of the work of conservation-restoration.

This, however, is the source of another problem, namely that the administration of standards depends on the competence of the assessors themselves. In fact, the adoption of competences in the UK as the basis of accreditation (UKIC 1998) has proved to be a very rigorous assault course on the practice of peer review and a potent means of raising the standards of that activity.[3]

How verifiable professional standards could be used

It is important to reiterate that competence and its measurement is a technique which can only be effectively developed by professionals for professionals. The framework as it is shown here (See Fig. 1) is a simple outline. The Vienna discussion paper made it abundantly clear how much work would need to be done to develop detailed standards that addressed the needs of the European community of conservator-restorers. What follows is a brief discussion of how such standards could be used.

As a descriptor

The simplest use of the Framework would be as an additional description of the conservation-restoration professional, in terms of what s/he knows, can do and should be as a professional. Comparatively little would need to be done to modify and prepare a framework like FULCO to the point of consensus. Nothing can replace or reduce in value the more narrative guidelines and codes of ethics. However, an additional descriptor based unequivocally on what a conservator-restorer must know, do and be in order to be competent would, if it attracted a European consensus, have considerable moral force. It would have also have a practical utility when standards are called for, say in the preparation of research grant applications and it could help prepare the ground for legislation pertaining to the profession.

In job descriptions

Given that the profession agrees on what its professionals may reasonably be asked to do, to know and to be, in their practice, it can be helpful for a formula agreed on both sides to be used in job descriptions. Anything that adds to the transparency between commissioning body and conservator-restorer, or employer-employee, will in the long term help to establish the status of the profession.

To assist in the process of registration

In some European countries a register of conservation-restoration practitioners already exists; in others it is in process of compilation. A commonly agreed set of verifiable standards could help to equalise the standards from country to country.

To assist in the process of accreditation

Even where professions manage to establish clear recognition by title, some accreditation procedure, based on an assessment of the candidate's practice as a professional, may be desirable.

It is increasingly common, even among the protected professions, to review graduate candidates for full admission to a professional body only after a period of mentored practice. Here, fully developed verifiable standards commonly held throughout the European Union could be of great value in making the accreditation process easier to administer, fair and transparent. Such standards would complement and strengthen – not supersede – the scrutiny of educational attainment and the use of peer review.

To help educators-trainers focus the vocational/professional outcomes of their courses

Verifiable professional standards are, by definition, focussed on the outcome of courses, on the professional in practice. It is the function of academic education to develop the knowledge base on which standards are founded. However, as we have seen in the example of the Dutch doctors, a fruitful cycle of interaction can take place whereby the trial testing of standards in practice is fed back into the educational process. Because of their professional focus and the fact that they are aimed at the future of the students as practitioners, such standards can be helpful to educational and training institutions, but only as a compass, not a prescription.

To assist in the validation of vocational/professional education

A strong professional body will have an interest in ensuring that the courses through which its members gain entry to the profession, prepare students to meet agreed upon standards. It is the role of professional bodies to focus clearly on the outcome of courses. This leaves the institutions of higher education free to do what they do best and build the discipline while they prepare students to practice it. A clear separation of role and responsibility between the institutions that prepare students for a profession and the professional body is one hallmark of a mature profession. Professional standards that can be verified through the assessment of agreed upon evidence can be used to facilitate this necessary separation and equally necessary dialogue.

Conclusion

Verifiable professional standards based on competence for conservation-restoration are already being used. Their history is chequered. They are capable of generating unwieldy bureaucracies and because they have usually been commissioned by employers or governments their language does not always accurately reflect the value of the core tasks they describe.

However, the analysis of core tasks is very congruent between systems and the method of verification of competence based on evidence is robust and challenging. Within Europe there is every likelihood that professionals will have to cite verifiable standards for a number of political and pragmatic purposes. For the profession to develop such standards in tandem with the push for professional recognition could show political acuity; it might also be wise in the way we place expectations on those entrusted with heritage.

Acknowledgements

I am greatly indebted to Janey Cronyn, with whom I worked on the Framework; to Sue Thomas and Hazelle Page, of De Montfort University, who helped to develop it further and who tested it; and to Rachel Kilgallon, also of De Montfort, whose bibliographic research on accreditation, together with her unpublished research paper on European accreditation issues were a very significant resource.

Endnotes

1. The bibliography of the Vienna discussion document cites an extensive range of conservation-restoration guidelines, codes of ethics, charters, as well as other major sources of discussion on ethics, well known to most readers. For this paper mainly unfamiliar technical literature is cited or that which is specific to standards.

2. The FULCO Partners were:

 Ms. Carole Milner, Museums and Galleries Commission, London, England;

 Mr. René Larsen, Det Kongelige Danske Kunstakademie, Copenhagen, Denmark;

 Dr. Marc Laenen, ICCROM, Rome, Italy;

 Mr. Rikhard Hördal, Vantaa Institute of Art and Design, Vantaa, Finland;

 Prof. Wolfgang Baatz, Akademie der Bildende Künste, Meisterschule für Restaurierung, Vienna, Austria;

 Dr. Erling Skaug, IAKN Dept. for Conservation Studies, Oslo, Norway; and

 Mr. Steph Scholten, co-ordinator, Netherlands Institute for Cultural Heritage, Amsterdam, The Netherlands.

3. It is important not to conflate the UK standards, which were developed by the profession at the invitation of the then MTI with the NVQ system. The standards have their own stand-alone validity and have been reclaimed by the profession, which developed them for use in accreditation. The author of this paper is firmly in favour of high-level academic education as a norm being the precursor of professional practice and does not wish to see a system of qualification based on anything other than this.

References

Allan J. 1996. Learning outcomes in higher education. Studies in Higher Education 21(1).

Arts Training Australia. 1994. National Museums Competencey Standards. Canberra.

Bacon A. forthcoming. Defining and measuring effectiveness in education and training. In: Proceedings of the ICOM-CC Working Group on Education and Training, Finland, 1998.

Brennan J and Little B. 1996. A review of work based learning in higher education. London.

Cronyn J and Foley K. 1995. Standards of qualification in conservation: is commonality either necessary or possible? In: Cronyn J and Foley K, eds. A qualified community: towards internationally agreed standards of qualification for conservation. Proceedings of the interim Meeting of the Working Group on Education and Training in Conservation, Maastricht.

ECCO Official Papers. 1996. The profession, code of ethics, basic requirements for education.

Foley K and Scholten S. 1998. Fulco, a framework of competence for conservator-restorers in Europe. Amsterdam.

Higher Education Quality Council. 1977. Quality, standards and professional accreditation: a mapping exercise. UK.

Human Resources Development, Canada. 1997. The workforce of the future. Canadian Museums Association.

Hyland T. 1994. Competences education and NVQ's: dissenting perspectives. London.

ICOM. 1984. The conservator-restorer: a definition of the profession.

Museums Training Institute. 1996. Standards of occupational competence for the museums, galleries, and heritage Sector. Bradford.

National Parks Service. 1996. Essential competencies for National Parks Service employees. National Parks Service, Training and Development Division.

Pavia. 1997. The document of Pavia, Italy.

Player-Dahnsjo Y. 1997. A report on the Scottish national vocational educational qualifications (S/NVQ's) in the UK heritage sector in ECCO.

Scholten S and Scholte T. 1997. Centres of excellence. Proceedings of the conference, Amsterdam.

UKIC. 1998. Fast track accreditation proposals. London.

Winter R. 1992. The assessment programme – competence-based education at professional/honours degree level. Competence and assessment, no. 20.

Abstract

Assessment of conservation programmes is not straight-forward because of the combination of academic, practical and professional requirements. In this paper normal university and professional assessment methods used in the UK are compared with peer review, and a peer review undertaken at University College London (UCL) Institute of Archaeology is described. Normal methods of assessment are all useful but may not, individually, provide a sufficiently coherent picture; peer review provides the opportunity to examine conservation training in the wider professional context and to achieve a more effective evaluation.

Keywords

Conservation training programmes, assessment methods, peer review

Peer review as a method of assessing effectiveness of conservation training programmes

Elizabeth Pye
Institute of Archaeology
University College London
31–34 Gordon Square
London WC1H 0PY
UK
Fax: + 44 171 383 2572
Email: e.pye@ucl.ac.uk

Introduction

A question which concerns all conservation trainers is how do we assess the quality of the training we provide?

This paper looks at the concept of assessment, discusses the range of different types of assessment currently in use in the UK university system, and whether they are effective for assessment of conservation programmes. The second part of the paper evaluates the use of peer review as an assessment method.

Until relatively recently in the UK, there was no guidance on how to teach in a university, nor on design and content of courses – most of us simply had to learn on the job. Until the early 1980s there was no effective appraisal of university programmes, indeed as recently as 1985, although it was thought possible to assess university research, the quality of teaching was considered impossible to measure. Teaching was a private matter subject to no external scrutiny, even though, as we all know, teaching quality can be varied. Now, however, assessing the quality of what we do is recognised as an important aspect of accountability. We are accountable to our students, to our universities and, ultimately, to our government since it provides much of the funding; and we are also accountable to our profession (Elton 1987: 12, 38). Acknowledgement of this accountability means that today in the UK there is a well-established review system for university research, and a rather newer one for assessment of teaching.

The conservation profession is defined by its objectives, guiding principles and codes of practice to which all conservators must adhere. Professional conservators are also characterised by the specialised knowledge and skill they acquire through training and experience. It is this expertise that is valued by employers and clients. Our programmes must, therefore, provide both academic education and practical training, and prepare students for entry to the profession. Assessment of conservation programmes should take account of this combination of academic, practical and professional requirements.

Basing conservation training in universities offers significant advantages to the discipline and to the students. Through research, universities generate much of the knowledge that informs individual disciplines, and university teaching imparts this knowledge as well as fostering essential academic skills. Basing conservation programmes in universities can mean, however, that there are dangers of isolation from professional practice. Another problem is that universities are traditional and do not readily accommodate vocational programmes, except the well-established ones such as medicine. University procedures may not be easily adaptable to the requirements of new vocational training, and considerable effort may be needed to modify them (Elton 1987: 172).

Assessing the quality of training programmes

There are several reasons for assessing conservation programmes, some administrative, some academic and some professional. One reason is accountability, and this means that the university will be interested in assessment as a tool for making decisions such as whether a programme is worth supporting (this is particularly true of conservation which is expensive in terms of time and resources). Both the

university and the profession will be interested in whether a programme achieves its stated curricular aims, or whether there is need for improvement. Improvement, of course, may mean different things to each (and improvement may mean not just a change within the system, but a change to the system itself) (Elton 1987: 12).

What might we, as teachers, gain from assessment? It can help us to discover whether students' expectations are being met, whether we are approaching the teaching in the most effective and stimulating way, whether the programme is coherent and whether it prepares students for life beyond the university. Through an assessment process we can hope to discover how our graduates are seen by potential employers – which is very important for us as teachers of vocational programmes.

Types of assessment

There are several types of assessment, formal or informal, academic or professional, internal or external. Some deal with individual aspects, some with whole programmes. They are all either formative or summative, or sometimes a combination of the two. In formative assessments the evaluation is undertaken with the aim that it may help to develop or improve whatever is being assessed, whereas summative assessment is a form of judgement and may be followed with rewards or penalties.

Effective assessment should consider the programme in context ie by considering other comparable programmes, the types of students who elect to take the programme, the resources available for teaching and support, the process (the students' experience) and the outcomes (the views of graduates and employers) (Newble and Cannon 1995: 88) (Rowntree 1987: 121–22, 137). Effective assessment should be fair, open, comprehensive, realistic, and practicable in terms of any change proposed (Elton 1987: 14).

Formal assessment procedures

Several assessment procedures affect conservation programmes in UK universities. Internal procedures include: seeking student views; peer review of teaching; course assessment; and internal quality control. External procedures include: the use of external examiners; Teaching Quality Assessment; the Research Assessment Exercise; professional validation of programmes eg by the Museum Training Institute; assessment of conservators' competence in the work-place, and accreditation by their professional body.

Each of these tends to evaluate only part of our activities, rather than giving an overall picture. Thus there are advantages in using several different assessment methods. Triangulation is also an essential check – if similar views are received from different sources, or the same impressions gained from different assessment techniques, this is an indication that the information is probably reliable (O'Neil and Pennington 1992: 9).

Internal procedures

Seeking student views

One means of assessment used widely in training contexts is anonymous questionnaires which seek the views of students. This can provide a valuable comment on the training process as the students experience it, and can be a useful tool for change. Howver, students may not appreciate the benefits of a programme until after its completion, so their views have limitations. Anonymous questionnaires are difficult to interpret, especially with small groups, different educational backgrounds and expectations, and divergent views. Furthermore, students are always concerned about whether the questionnaires are really anonymous and this may temper their views (O'Neil and Pennington 1992: 32).

Peer assessment of teaching

Peer assessment of teaching normally takes the form of one teacher sitting in on another's teaching session(s) and reviewing aspects of the teaching such as content,

clarity, and use of handouts. Although useful, the effectiveness of peer assessment depends very much on the character and experience of the individuals concerned.

Departmental assessment

Department assessment of a programme may involve a whole department or a sub-group. Its effectiveness is limited by the fact that it is normally an internal exercise without the catalyst of external views, so it may be difficult to generate new ideas or to evaluate the course properly in terms of external requirements inside this "closed system".

Internal quality control

Universities have formal internal procedures for assessing proposed changes to programmes, and as external assessment has become established, more internal monitoring and assessment procedures have developed (see Teaching Quality Assessment, below). These normally involve completion of forms and some discussion in committees, but they tend to focus on whether a programme meets the normal academic requirements and do not accommodate the different nature of conservation teaching.

External procedures

External examiners

In the UK each university employs colleagues from other universities to monitor the assessment procedure and marking of examinations. This system is very useful though there may be a tendency to select external examiners for their general sympathy for the programme rather than examiners who will be constructively critical. Conservation departments can select senior conservators working in museums and, in this way gain an invaluable professional view-point.

Teaching Quality Assessment (TQA)

Teaching Quality Assessment is the formal assessment of teaching which has been introduced in UK universities. It assesses the quality of teaching and learning, including factors such as course-design and student achievement (HEFCW: 199). The starting point for the assessment is self-evaluation by the department concerned, and the system uses trained academic assessors following a formalised procedure. The anxiety for conservation programmes is that unless the assessment team includes a conservator, the nature of conservation training may not be fully appreciated.

Research Assessment Exercise (RAE)

The Research Assessment Exercise (RAE) is the companion national assessment scheme to the TQA and measures the quality of university research. It is a judgemental process and the results have a profound effect on status and resources. Unfortunately, as we all know, research in conservation is not well-developed, and this has had repercussions on the growth of the discipline and on training programmes. The RAE presents difficulties for conservators teaching in universities, both because conservation research is undeveloped, and because the intensive nature of conservation teaching reduces the time available to undertake major research. Measured by the criteria used for the RAE, we are not performing well and this affects the status of, and support for, conservation programmes within the university system.

Professional validation of programmes

A further type of course-assessment is professional validation – through which professions validate university programmes as covering part of a professional

qualification. In the UK this form of formal validation is just starting, with programmes being vetted by the Museum Training Institute (MTI). Successful validation, of course, means professional approval of the programme. There may, however, be difficulties with new validation in that professional requirements may not accord with the university requirements, and validators may not understand the constraints within which university programmes operate. Validation may require changes to the syllabus which make it difficult to fit the programme into the normal academic structure, or which are seen as encroaching on the freedom of universities to teach what they choose.

Assessing graduates

Assessing graduates once they have started work gives us some measure of how successful our programmes are at preparing students for professional life. Assessing professional competence is the general approach used. Work-place assessment of competence is well-established in some professions such as medicine and has been adopted for conservators in the UK (Jessup 1991: 51). Competence is measured against agreed upon standards such as those produced by the UK conservation profession for the Museum Training Institute (MTI 1996). The United Kingdom Institute for Conservation in 1998 introduced an accreditation scheme based on measurement of competence.

Competence is not simply being able to do the technical tasks; it is a measure of ability to perform widely and effectively in a job. Competence is not necessarily imparted by a university degree, but assessment in the work-place will give an indication of whether our graduates are given the right kind of fundamental training to enable them to develop competence.

Other useful indicators

Apart from formal assessment systems, there are other ways in which we can gain an impression of how our programmes are seen. There are indicators such as our own attempts at evaluation, how many applications we have each year, how successful our graduates are when applying for jobs, how many graduates now grace the profession, unsolicited feedback from former students along the lines of, "Now I understand why you put so much emphasis on..." or, from both graduates and employers, "You need to include much more on ... in the programme". There is also the demand for staff as speakers or consultants, and there is the winning of awards (by students, staff or institution).

Difficulties with assessment procedures

All these forms of assessment are useful in their own way and added together give us a reasonably clear picture of the health of our programmes. They rarely provide for effective discussion of where we are and where we should be going, just as they do not consider both academic and professional priorities together.

Peer review

Peer review is used in many spheres of activity, in fact both the RAE and TQA are forms of large-scale peer review imposed by the university system. The form of peer review discussed here is set up for the individual activity being reviewed, and involves a team drawn from both inside and outside the institution concerned who review evidence presented about the activity, collect and discuss information derived from interviewing clients and colleagues and present a report at the end of their deliberations. The review team needs a formal structure in which to work, with agreed upon terms of reference, a chairperson, a viable method for collecting evidence, and a timescale. The process needs careful preparation and funding (eg to cover travel expenses) but in other ways it can be set up relatively easily.

Effectiveness of peer review depends on the climate in which it takes place, the interest and commitment of the panel members, how well they have been briefed,

how honest and open the discussion, and "ownership" ie whether everyone feels the report reflects the discussion (O'Neil and Pennington 1992: 60–61).

Peer review offers an all-round assessment of an activity within a wider context. It provides an opportunity to question a range of people and to compare views from different sources (triangulation). It can be either formative or summative, or both. A key advantage of a wide-ranging peer review of a vocational training programme is that it provides an opportunity to measure the character of the programme against professional requirements, ie to test the relevance of the programme's aims to the profession, to decide whether the objectives support the aims, whether the content is up-to-date, whether there are any gaps in the coverage, and so on (Rowntree 1985: 243, 246).

The composition of the panel is important: O'Neil and Pennington (1992: 55) recommend that it should include "broad categories such as providers of resources, deliverers of the programme, direct and indirect 'customers', 'critical friends'" or, as Newble and Cannon put it (1995: 88): students, colleagues, graduates, outside evaluators, professional associates, senior colleagues and administrators. It is important to add that the choice of chairperson is crucial. He or she should not be responsible for delivering the programme and should be fully committed to the review. Involving both graduates and employers in assessment of a training programme gives useful comparative views on how competent students are on graduation, that is on the quality and relevance of their technical skills and how able they are to apply their theoretical knowledge to their day-to-day work (O'Neil and Pennington 1992: 12) (Jarvis 1983: 34).

Peer review at UCL Institute of Archaeology

UCL Institute of Archaeology organised a peer review of the conservation programme in June 1998. A team of people involved in conservation and related fields met for five days and a number of colleagues were invited to come and give their views to the panel.

The review was born out of the realisation that recent changes in the training programmes at the Institute needed further evaluation, that, in spite of these changes, the teaching work-load remained too heavy to allow the development of a productive research programme, and that even more had to be done to integrate conservation effectively with the other museum and heritage activities within the Institute. It was set in the context of re-evaluation of many of the Institute's activities by its new Director, and the requirement by University College that the Institute produce a five-year plan by February 1999.

The aims of the review were to evaluate the composition and delivery of the conservation syllabus and to reduce teaching load. It was not to be judgemental but to be an aid in reaching decisions about the future balance between conservation teaching and research.

The panel consisted of eight people drawn from inside and outside the Institute, and included trainers, administrators, an employer, a research conservator, and an archaeological scientist. Several members of the panel could also bring first-hand knowledge of conservation in other countries or continents. An impressive range of people gave their time and views, including present staff and students, employers or users of conservators, other trainers and conservation consultants; several were graduates of the Institute's programme. My only regret, in retrospect, is that we did not interview any very recent graduates.

One of the potential weaknesses of setting up this form of review, of course, is that panel members and visitors may be consciously or unconsciously chosen from those who are already sympathetic to what is being reviewed. Inevitably, in a small field like conservation, most were friends, but they were "*critical* friends" and the discussion was frank and objective. The Director of the Institute chaired the panel and his informal but searching style of chairing had much to do with the success of the review. It was also useful for us, and for him, that he was exposed to a whole week of debate about conservation.

The key features of the review (which other forms of assessment could not have provided) were the range of relevant professional expertise involved, the lack of rigid structure, and the time to question and deliberate. The discussion was

exceptionally wide-ranging and it was possible to explore issues normally dealt with quite separately such as research and teaching, or the student experience and the employers' views. Through the week, discussion covered the development and structure of the conservation programme at the Institute in the context of issues such as current developments in the practice of conservation; the various ways of delivering conservation training; what employers look for in the conservators they employ; current attempts to define the professional status of conservators both in UK and in Europe; and the reasons for the low level of conservation research. The discussion enabled us to reflect on the effectiveness of our present activities and to test ideas on how we might develop them further. In particular we gained advice and comments on the length and content of our training and on how to provide work experience most effectively within the programme.

In spite of the wide range of professional interests represented, there was a marked coincidence of views and ideas, and this gave us the triangulation we needed to reach our conclusions with confidence. By the end of the week we had a proposal for a reorganised programme structure making the existing one-year theoretical course a prerequisite to the two-year professional training, rather than running them in parallel. The professional training is to consist of one year at the Institute followed by a one-year internship. The theoretical training will provide an introduction to the principles of conservation suitable both as an education for students intending to work in the heritage field, and as and a route into both scientific and theoretical research in conservation.

The process was fascinating and illuminating – particularly the synergy that developed in the group; and the remarkable way in which the individual jigsaw pieces identified during discussion fell into place to create an overall picture by the end of the five days. In retrospect this was a rather intimidating exercise, but the overall experience was thought-provoking, stimulating, and sometimes even fun. This peer review has put the weight of the profession behind our decisions and given us the means to implement change within the university system.

Conclusion

Assessment of conservation programmes is not straight-forward because of the combination of academic, practical and professional requirements. Normal assessment methods are all useful but may neither provide a sufficiently coherent picture nor take account of professional needs. Peer review is a useful method of assessment which provides the opportunity to examine conservation training in the context of current developments within the profession, and to achieve an effective all-round evaluation.

Acknowledgements

I wish to thank Peter Ucko for instigating the peer review, Jo Dullaghan for handling the administration and all the people who gave their time and support to the review. Without them the review would never have happened.

Bibliography

Elton, L. 1987. Teaching in higher education: Appraisal and training. London: Kogan Page.
Higher Education Funding Council for Wales (HEFCW). 1994. The assessment of quality in the higher education sector in Wales: Future directions. Cardiff: HEFCW.
Jarvis, P. 1983. Professional education. London: Croom Helm.
Jessup, G. 1991. Outcomes: NVQs and the emerging model of education and training. London: The Falmer Press.
Museum Training Institute (MTI). 1996. Standards of occupational competence for the museums, galleries and heritage sector. Bradford: MTI.
Newble, D. and Cannon, R. 1995. A handbook for teachers in universities and colleges. London: Kogan Page.
O'Neil, M. and Pennington, G. 1992. Evaluating teaching and courses from an active learning perspective. Effective learning and teaching in higher education module 12. Sheffield: CVCP Universities Staff Development and Training Unit.
Rowntree, D. 1985. Developing courses for students. London: Harper and Row.
Rowntree, D. 1987. Assessing students: How shall we know them? London: Kogan Page.

Theory and history of conservation-restoration

Théorie et histoire de la conservation-restauration

Theory and history of conservation-restoration

Coordinators: Françoise Hanssen-Bauer, Mireille te
Marvelde and Koos Levy-van Helm

78 members

Four Newsletters were published this triennium. The bibliography on ethics begun by former Coordinator Cornelia Weyer has been enlarged and will be improved before the Lyon Meeting. A facsimile of the English version of the *Manual on the conservation of paintings*, originally published in 1940 by the International Museum Office, has been produced by Archetype Publications at the initiative of Michael van der Goltz, in collaboration with Françoise Hanssen-Bauer.

An interim meeting of the working group took place from October 9–11,1998, in Amsterdam. The goal was to invite members to brainstorm on the status of the on-going activity of the group and prepare the Triennial meeting.

The group expressed unease about the actual status and role of the conservator-restorer and about the state of the field's «doctrinal texts». Questions like «What is restored, what is not, how do we prioritise, who is allowed to decide what, should we consider fields to give away and fields we should not» were raised. These questions are not new, but they have developed a character of urgency due to museums' new appointment policies and increased activities to respond to public demand. Many of us have the feeling that research on the history of conservation-restoration is given too low a priority. This part of our work is time consuming and requires involvement from other disciplines. Time and space are needed to focus on the history of conservation-restoration, and to build up our knowledge on the different methods of conservation and their impact on the objects. Many sources have not yet been explored. Reports, and manuals written by or for conservator-restorers still represent a rich heritage to be investigated and inter-preted. Recording of oral accounts, films, and videos should also be intensified. A main concern with all such records is to evaluate their reliability. We need to develop a methodology or criteria in order to judge the authority and sometimes the authenticity of the documents we are consulting. Such an evaluation is relevant for both primary and secondary sources. A related problem is the terminology used in the past and today. Do we for instance have accurate terms to describe ageing?

Regarding the collection of data on conservator-restorers, it was proposed to work with an interview checklist: Who should be interviewed and how? Accessibility of such archives also needs to be defined.

Publishing of source material is of utmost importance: not only our own research and reports, but also student theses, dissertations etc. Old restoration sources should also be re-edited. Meeting participants urged that initiatives such as ICCROM's and Getty's publication of abstracts of theses, books, reports etc. be continued.

Underlying all these questions are an implicit reconsideration of the field's theoretical body and the definition of the values inherent to objects and their authenticity. Values and authenticity of the object are frequently attributed in relation to the object's actual physical context. This is particularly challenging with western collections of ethnographic objects, but also with contemporary art. Measurements of authenticity and values are relative exercises and this notion of relativity should be given more attention before starting any discussion on treatment. Various possibilities are being investigated, such as a joint meeting with the Ethnographic Collections Working Group or Contemporary Art research area, and the collection and historical analysis of documents on ethics produced worldwide over the past 50 years. A question was also raised about how to teach ethics, and concern was expressed about the distance between ethics in theory and ethics in practice.

L'envoi du *Gladiateur Borghèse* au Louvre

Résumé

L'article traite de l'envoi, en 1808, de la célèbre statue en marbre antique dite le *Gladiateur*, de Rome à Paris : comment s'est opéré le transfert du chef-d'œuvre de la collection Borghèse au Louvre ? Quelles mesures ont été prises pour assurer sa conservation durant le transport, et quel a pu être l'impact de cette expédition sur le marbre ? On montre comment le recoupement d'archives et de données techniques inédites fait progresser dans la connaissance du sujet, et permet de formuler quelques hypothèses nouvelles.

Mots-clés

collection Borghèse, Louvre, Gladiateur Borghèse, marbre, sculpture grecque, restauration, moulage, transport

Brigitte Bourgeois
Service de Restauration des Musées de France
Petite Ecurie du Roy
2, avenue Rockefeller
78000 Versailles
France
Fax: +33.1 39.02.75.45
Email: brigitte.bourgeois@culture.fr

Introduction

La collection d'antiques Borghèse et son achat en 1807 par Napoléon Ier

En signant le décret d'achat de la collection Borghèse, le 27 septembre 1807, l'empereur Napoléon réalisait une prise magistrale. Certes, il y mettait le prix : son beau-frère, le prince Camille Borghèse, devait en retirer 13 millions de francs. Mais l'ensemble des marbres antiques qu'abritait la luxueuse Villa Borghèse, sur la colline du Pincio, à Rome, avait une valeur inestimable. Le chef-d'œuvre incontesté de la collection, une grande statue de guerrier combattant traditionnellement appelée le Gladiateur (voir Fig. 1), avait d'ailleurs attiré vers lui, depuis les années 1610, une foule d'artistes, de savants et d'amateurs qui y voyaient « tout ce que l'on connaît de plus beau dans l'Antique ».[1] Le fait que l'effigie fût signée d'un sculpteur grec, Agasias d'Ephèse, fils de Dosithéos, augmentait encore son prestige. Ce maître des années 100 avant J.C. n'avait-il pas réussi à tailler cette figure extraordinairement dynamique dans un seul bloc de marbre ? Et l'un des maîtres de l'âge baroque, sans doute Nicolas Cordier, n'avait-il pas en 1611 restauré avec art l'antique mutilée, en recréant notamment le bras droit manquant ? Aussi n'est-il guère étonnant que les deux experts chargés d'estimer la collection en 1806, Visconti et Vivant-Denon aient jugé cette statue « hors de toute comparaison » et l'aient évaluée au prix astronomique d'un million de francs.

La mission de Pâris et Lorimier : Transférer la collection

Par arrêté du 13 octobre 1807, le gouvernement français nomma deux commissaires chargés « d'ordonner et surveiller le déplacement, l'encaissement et le transport de tous les objets d'antiquités de la Villa ». Le premier, Pierre-Adrien Pâris, était déjà sur place : cet architecte originaire de Besançon résidait à Rome depuis de longues années. L'autre, le peintre Etienne Lorimier, venait de Paris. Du 10 novembre 1807 au 3 août 1808, ces deux hommes allaient accomplir un travail gigantesque dont le détail nous est connu grâce au journal dans lequel Pâris a consigné au jour le jour les heurs et malheurs de leur mission.[2]

Objectif et méthodologie de la recherche

L'objectif est de retracer les modalités de l'envoi du *Gladiateur* et d'essayer d'en évaluer l'impact sur le marbre, grâce à la confrontation de plusieurs sources : archives relatives à l'envoi des marbres Borghèse, et nouvelles données scientifiques et techniques, acquises lors de la toute récente campagne de restauration de la statue.[3]

L'envoi de la collection : principes et méthodes

Quelle stratégie Pâris et Lorimier allaient-ils adopter pour assurer la conservation des marbres Borghèse, aussi précieux que pondéreux, dans leur expédition de Rome à Paris ?

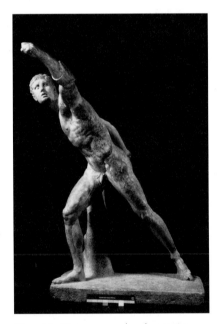

Figure 1. Statue en marbre de guerrier combattant dit Gladiateur Borghèse. *Louvre, Antiquités Grecques, Etrusques et Romaines. Etat actuel.*

Tirer les leçons du passé

Le principe de base fut de faire appel aux compétences de ceux qui s'étaient déjà occupés d'envois d'œuvres d'art, et de s'inspirer de leurs méthodes en les améliorant. Dès leur entrée en fonction, Pâris et Lorimier prirent ainsi le conseil d'experts tels que Valadier, Canova ou bien le sculpteur Joseph-Charles Marin, l'un des commissaires adjoints pour les envois du Directoire. Ils tentèrent aussi de retrouver les ouvriers qui avaient participé aux précédents envois. Les menuisiers existaient toujours, mais les marbriers étaient malheureusement morts ou partis à Paris, tel Mariano, et il fallut en chercher d'autres.

Prévenir les altérations

Bien avant l'heure des manuels modernes de conservation préventive, les commissaires connurent les affres d'avoir à prévenir toutes les altérations susceptibles d'endommager les œuvres. Par exemple, le choix des matériaux d'emballage requit longuement leur attention. Tout fut vérifié, la nature et le degré de siccité du bois, la sciure, la laine, la toile, l'état des clous, les ferrures... Pour les caisses, on prit soin d'employer du peuplier, c'est-à-dire un bois blanc, léger et robuste, et non du pin, dont la résine risquait de tacher le marbre. Même chose pour la sciure qui servit à caler certaines œuvres plus fragiles : on n'employa que de la sciure bien sèche de peuplier, en rejetant la sciure humide ou de pin.

A ce propos, Pâris nous livre une information importante sur l'état de surface de certains marbres. En effet, il observe que « tous les objets encaissés en sciure sont tels qu'il n'y a plus à craindre d'en tacher la matière ; l'Hermaphrodite, le Gladiateur, le Faune à l'enfant, le Centaure, et quelques bas-reliefs pour lesquels on a usé de ce moyen sont d'un marbre si taché et coloré par le temps qu'il est à croire que même la sciure humide n'y ajouterait rien ».[4] Voilà qui confirme l'indication très brève donnée par Visconti, dans sa publication des marbres Borghèse en 1796, sur l'état de surface du *Gladiateur*.[5]

Faire du sur mesure

La fixité des objets dans les caisses était d'une importance capitale. Aussi les planches de calage (en italien *baggiolis*) furent-elles confectionnées par des sculpteurs sur bois, et non par de simples menuisiers afin, dit Pâris, que « les contours des statues soyent suivis avec plus d'exactitude ».[6] Quant au transport par voie de terre, prévu d'emblée pour les œuvres les plus précieuses, il s'effectua tantôt sur des chariots ordinaires, tantôt sur des « chars faits exprès », dotés de suspensions pour amortir les chocs (cas des œuvres classées *sans comparaison* et *de premier ordre* dans l'acte d'acquisition).

L'envoi du Gladiateur

« Ce transport n'est pas une affaire d'épicerie ni de coton », s'écria un jour Pâris, excédé par les obstacles et les déconvenues incessantes.[7] Assurément, quand on se doit de faire parvenir à Napoléon un trophée payé un million, il y a de quoi passer quelques nuits blanches sur les mauvais lits de la Villa Borghèse.

Le constat d'état

L'une des premières tâches des commissaires, aidés par le sculpteur Marin, fut de dresser un tableau général des objets compris dans l'acquisition, en indiquant succinctement leur état de restauration. Le fleuron de la collection y est ainsi décrit : « septième salle, n°10. Le célèbre Gladiateur. S.[tatue] hors de toute comparaison. M.g. [marbre grec]. Le bras gauche antique en quatre morceaux, la jambe droite idem de deux morceaux ainsi que la gauche. Le bras droit moderne et le gros orteil du pied gauche restauré en stuc. Dimensions H.L. : 5.6.[pieds]. Poids en livres de 12 onces : 1800. 1 caisse ».[8]

Pâris, conscient des insuffisances du document, évoquait les circonstances difficiles dans lesquelles il avait travaillé, lors d'un hiver particulièrement rigoureux,

et demandait l'indulgence de ses destinataires. Que ses mânes se rassurent : nous lui sommes si reconnaissants de nous avoir légué un constat d'état du *Gladiateur* en 1807.....

Moulage et désoclage

Une mention du 3 mars 1808 précise que le *Gladiateur* a été, avec le *Faune à l'enfant*, la dernière statue de l'intérieur de la Villa à être désoclée, ou, selon le terme de l'époque, « descendue ».[9] Les commissaires ont donc jugé plus sage de réserver les pièces maîtresses pour la fin, quand le savoir-faire de l'équipe était déjà bien rodé.

Auparavant, ils avaient autorisé Vincenzo Malpini, le mouleur de Canova, à mouler le *Gladiateur* ainsi que d'autres œuvres particulièrement célèbres, comme le *Centaure chevauché par l'Amour* et le *Faune à l'enfant*.[10] Une nouvelle prise d'empreinte eut donc lieu, avec tout l'impact qu'elle pouvait avoir sur le marbre. Dans les années 1780, le prince Marc-Antoine Borghèse, lassé par l'afflux de demandes et soucieux de la conservation du joyau de sa collection, avait mis fin aux moulages du *Gladiateur*. L'interdit n'avait pas tenu longtemps...et le *Gladiateur* exhibe toujours les longues entailles que les couteaux de mouleurs ont creusé dans son épiderme, au cours des siècles.

Emballage

Figure 2. Dessin de la caisse du Gladiateur. *(Besançon, archives Pâris, Ms. 19)*

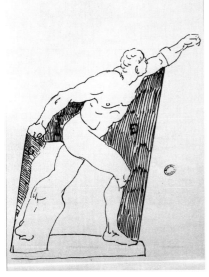

Figure 3. Croquis montrant comment étayer le Gladiateur *avec des tasseaux de pierre. (Besançon, archives Pâris, Ms. 20).*

La mise en caisse posait un sérieux dilemme. En emballant la statue telle quelle, on évitait certes de toucher au chef-d'œuvre mais les anciens assemblages seraient-ils assez solides, et surtout comment le bras gauche résisterait-il au transport, étant donné sa position haut levée et saillante ? Sa fragilité causait de tels soucis qu'on avait interdit d'encaisser des œuvres dans la salle VII (celle du *Gladiateur*), car les coups de marteaux donnés par les ouvriers lui imprimaient des vibrations. De plus, le gabarit énorme de la caisse (voir Fig. 2) allait empêcher l'accès à certaines routes étroites. Alors fallait-il entreprendre de détacher le bras ? Des experts comme Dufourny, à Paris, et le sieur Moglie, à Rome, jugeaient l'opération trop risquée et préconisaient d'envoyer la statue d'une pièce, en liant étroitement les parties entre elles, au moyen d'étais en pierre (voir Fig. 3).[11] Moitte, l'un des anciens commissaires du Directoire, proposait de reprendre la technique qui avait été appliquée à l'*Apollon du Belvédère* : noyer la statue jusqu'à mi-corps dans un lit de plâtre garni de cercles de fer...[12]

Cependant les avantages d'une dépose étaient considérables, et la solution paraissait d'autant plus tentante qu'on venait de la pratiquer, avec un plein succès, sur d'autres statues de la collection (le *Pertinax* et le *Faune flûtiste* par exemple). On s'enhardit donc à la mener sur le *Gladiateur*, le dimanche 13 mars. A deux heures de l'après-midi, un véritable conseil de guerre se réunit autour de la statue. Il y avait là Pâris et Lorimier, les sculpteurs Marin et Fulgoni, le sieur Moglie, Antonio Reali, marbrier, ainsi que le maitre menuisier. « D'après ce qui a été déjà observé, on a reconnu que le bras droit du gladiateur était scellé au plomb et qu'on tenterait inutilement de l'enlever, mais comme le bras gauche n'offre pas la même certitude et que sa situation absolument élevée en l'air faisait craindre qu'il n'y eût du danger s'il n'était pas bien sûrement attaché, on a résolu d'en faire l'épreuve en le chauffant avec toute l'attention et la réserve possible. La mistura [13] qui unit le bras à l'épaule annonçait sa fusion dans tout le pourtour du joint. Cependant le bras n'a pas réussie [*sic*] d'où l'on a conclu qu'il y avait un goujon de fer qui tenant l'avant-bras passait jusqu'à l'épaule scellé en plomb. La main seulement a cédé. Elle n'était attachée qu'en plâtre et on l'a enlevée ».[14]

Le système de calage fut particulièrement étudié, de manière à maintenir et étayer « le bas de la statue, partie faible et qui porte le tout », le torse basculé vers l'avant et les bras : on associa aux classiques *baggiolis* en bois des dalles d'un tuf léger (le *peperino*), découpées sur mesure, reliées entre elles par des agrafes et fixées au marbre par des joints en plâtre. Enfin, par surcroît de précaution, on remplit la caisse de sciure de bois bien comprimée. La main gauche, démontée, fut placée dans la caisse ainsi que deux socles de statues qui servirent à équilibrer la charge. Le piédestal, emballé séparément, ne fut envoyé qu'ultérieurement.

Figure 4. La salle du Gladiateur *au musée Napoléon (Louvre), vers 1815. Aquarelle de Fontaine.*

Figure 5. Gammagraphie du bras gauche.

Figure 6. Vue du bras gauche (avant la restauration de 1996).

Confection du char

Après l'emballage, c'était le second point crucial. Tout fut donc conçu et contrôlé avec soin : les roues, les essieux en bois très fort, le brancard, la qualité du cuir employé pour les suspensions, etc... Une fois assemblé et peint, le char fut testé une première fois le 14 juin sur un trajet Rome-Albano, chargé à titre d'essai d'une caisse et de *bombes* (boulets) pesant au total 7610 livres romaines ; la caisse du *Gladiateur* n'en pesait « que » 6145. L'essai mit en évidence une usure excesssive des suspensions de cuir, par frottement sur les parties en fer du brancard. On améliora donc le système, notamment par l'adjonction de coussinets en cuir de buffle, et on refit un deuxième essai, plus concluant, le 6 juillet (départ à trois heures du matin, les commissaires ne chômaient pas !).

Chargement de la caisse. L'accident du 14 juillet

Une fois pesée et scellée au plomb, la caisse du *Gladiateur* fut emballée dans de la laine à matelasser, de la toile et des cordages. Puis vint la manœuvre délicate du chargement. C'est alors qu'intervint un accident d'une certaine gravité : par la faute d'un des ouvriers, dit le Pontarolo, la caisse fit une chute de plus d'un demi-mètre de haut.

Cet épisode n'a jamais été signalé, car Pâris n'a pas voulu le porter dans son journal où il a simplement consigné, en date du 14 juillet : « le Gladiateur a été placé sur son char ». Il faut fouiller la correspondance qu'il a échangée avec le ministre de l'Intérieur pour en trouver trace, dans une lettre du 17 juillet : « Mais une circonstance qu'il faut que votre Excellence sache, c'est que le jeudi 14 ayant fait élever la caisse du Gladiateur pour la mettre sur son char, le Pontarolo par négligence pour ne rien dire de plus a lâché une corde qui l'a fait tomber de deux pieds de haut.[...] Nous prions votre Excellence de garder pour elle seule ce renseignement que nous ne consignons point dans notre journal et qui la mettra à même de juger des obstacles et souvent de la malveillance que nous avons eu à combattre ».[15]

Pâris se voulait rassurant et disait n'avoir « aucune inquiétude sur les suites de cet accident qui aurait pu tuer deux personnes » ; mais comment le Gladiateur n'aurait-il pas souffert de ce choc violent ? Nous reviendrons plus bas sur ce point.

Transport

Les derniers préparatifs se firent à la hâte, car la saison pressait : si le convoi tardait, il ne pourrait plus franchir les cols des Alpes. Embûches et retards s'additionnèrent jusqu'au dernier jour, mais il en fallait plus pour vaincre la détermination des commissaires qui couraient Rome en tous sens, de l'aube à la nuit, dans une chaleur écrasante.

Un premier convoi par voie de terre avait quitté Rome le 13 juin, chargé d'objets de second ordre voyageant sur des chars ordinaires. Le deuxième convoi (celui du *Gladiateur*), se mit finalement en route le 3 août au soir, sous la conduite de Fulgoni. « Par le plus beau clair de lune du monde », les chars faits exprès quittèrent Rome au pas solennel des bœufs, emportant les trésors de la Villa Borghèse.[16]

L'inspecteur Locangeli, chargé du premier convoi, avait tenu un journal pour consigner les péripéties du voyage : une caisse chargée de travers, un char qui verse, les ornières où les voitures restent prises plusieurs heures, un pont qui s'effondre, un essieu qui casse (et le voiturier par la même occasion qui se casse la jambe)... Fulgoni, quant à lui, écrivit régulièrement aux commissaires pour les tenir informés de la marche du convoi : Bologne, Turin, les Alpes (franchies début septembre), Grenoble, Lyon, Auxerre, ... les étapes se succédèrent avec leur lot d'avaries mais sans accident majeur. L'expédition toucha enfin au but et le convoi se présenta, groupé, « devant le grand Palais du Louvre » dans la matinée du 12 octobre.[17]

Malheureusement, le silence se referme alors, et les archives sont muettes sur cet instant pourtant crucial que dut être l'ouverture des caisses. Pâris, demeuré à Rome, n'était plus là pour relater, de sa fine écriture, les faits et gestes de tout un chacun. Quelque temps après (en 1811), le *Gladiateur* était exposé à nouveau, dans

Figure 7. La cassure de la cheville droite.

Figure 8. La jambe droite (en cours de restauration).

Figure 9. Gammagraphie de la jambe droite.

les salles d'antiques du musée Napoléon : sur les gravures du temps, il apparaît restauré, avec la main gauche remise en place (voir Fig. 4). Mais comment savoir dans quel état il se trouvait, à l'arrivée de ce voyage épique ?

L'impact du transport sur l'œuvre

Puisque l'écrit fait défaut, il convient d'interroger d'autres sources, en l'occurrence la matière même de l'œuvre qui a conservé la trace de l'action du temps et des hommes. On n'évoquera ici, faute de place, que les deux points les plus importants pour lesquels j'avance un certain nombre d'hypothèses, en attendant de reprendre le sujet de manière plus développée.

L'état du bras gauche

C'était, on l'a vu, le principal sujet d'inquiétude, d'autant plus que l'essai de démontage infructueux avait fragilisé encore plus l'assemblage. Il semble pourtant que le bras « en l'air » ait tenu bon et résisté aux cahots du chemin. En effet, la gammagraphie pratiquée en 1996 sur l'ensemble de la statue [18] a montré que la longue barre de fer, scellée au plomb, qui tient lieu d'armature aux fragments du bras gauche est en tous points identique à l'armature du bras droit (voir Fig. 5). Or, on sait que ce bras moderne fut greffé sur l'antique lors de la première restauration de l'effigie en 1611, et qu'il n'a jamais été démonté au cours des siècles. Dans un cas comme dans l'autre, on est donc en présence des armatures du 17ème siècle. Par contre la restauration de la main gauche, effectuée au Louvre entre 1808 et 1811, relève d'une autre technologie (mince tige cylindrique insérée dans la cassure du poignet, sans scellement au plomb).

Inévitablement, le choc subi lors de la chute de la caisse a dû se répercuter dans le bras, surtout si une dalle de pierre avait été placée comme étai jusqu'au niveau du coude, suivant le schéma établi par Dufourny (voir Fig. 3). Ce n'est sans doute pas un hasard si la fracture du coude, telle que nous avons pu l'observer avant la restauration de 1996, était particulièrement marquée, avec des bords très disjoints. Un bouchage en plâtre la comblait (voir Fig. 6); cette technique, différente de celle utilisée lors des restaurations Borghèse,[19] témoigne des travaux de remise en état effectués par l'atelier du Louvre, à l'arrivée de la statue.

La fracture de la cheville droite

Le *Gladiateur* a les deux chevilles cassées. A première vue, il n'y a rien là d'inhabituel. Mais, à y regarder de plus près, la morphologie de la fracture de la cheville droite est assez singulière, avec une ligne de cassure fine et jointive s'accompagnant de fissures et d'éclats, comme si le marbre avait éclaté sous un choc (voir Figs. 7, 8).

Ensuite la gammagraphie montre que, très curieusement, cette zone est la seule partie fracturée de la statue qui ne comporte pas d'armature interne (voir Fig. 9). C'est pourtant une région d'une extrême fragilité, et l'on ne s'explique vraiment pas que, lors du remontage de 1611, le sculpteur-restaurateur ait goujonné toutes les autres fractures des membres et qu'il ait oublié – ou volontairement omis – de renforcer par un insert métallique la cheville droite. Ne faut-il pas en déduire que cet accident n'existait pas lors de la première restauration du *Gladiateur* ?

Si l'on reprend maintenant le constat d'état établi par les commissaires en décembre 1807 et qu'on l'analyse en détail, ne doit-on pas en conclure également que cette fracture n'existait pas avant le transport ? La jambe droite, nous est-il dit, est en deux morceaux : puisque la cuisse constituait indubitablement un morceau (du pli de l'aine jusqu'au dessous du genou), c'est que la jambe proprement dite, avec le pied attenant à la plinthe, formait le deuxième fragment.

Enfin l'examen d'anciennes reproductions du *Gladiateur* montre que cet accident existait déjà au 19ème siècle, notamment avant les désoclages et transports internes au Louvre à l'occasion des guerres de 1914–1918 et de 1939–1945. L'héliogravure qui accompagne la publication d'O. Rayet en 1884 montre ainsi que la cheville droite porte un bouchage destiné à masquer l'accident.[20]

Que conclure de ces remarques ? A mon sens, la seule explication logique qui permette de rendre compte de ces diverses observations est que la fracture de la cheville droite date de l'épisode du transfert de Rome à Paris. C'est une hypothèse, sans doute, mais extrêmement tentante au vu du témoignage des archives : la chute de la caisse lors du chargement du char, le 14 juillet 1808, n'est-elle pas responsable de cet accident ?

Conclusion

Les soins dont Pâris et Lorimier ont entouré le *Gladiateur Borghèse*, lors de son transfert de Rome à Paris en 1808, ont en grande partie porté leur fruit. Le système original de calages (en bois et en pierre) et la qualité du char à suspensions ont assuré une bonne conservation de la statue durant le périlleux voyage par voie de terre, à travers les Alpes.

Seul un accident (ou faut-il parler d'un acte de sabotage ?) a vraisemblablement endommagé le marbre lorsque la caisse est tombée, au moment de son chargement sur le char. Par différents recoupements, on peut penser que de là date la fracture de la cheville droite.

Cet épisode était totalement inconnu ; le voici exhumé du secret d'un lointaine correspondance et confronté à un autre témoignage, celui de la réalité matérielle de l'œuvre. De cette confrontation entre l'écrit et la matière jaillit alors une nouvelle part de lumière sur un passé oublié.

Remerciements

À Anthony Pontabry, restaurateur, à Marie-Claire Waille (Bibliothèque Municipale de Besançon), et à Evelyne Cantarel-Besson (Archives des Musées Nationaux).

Notes et références

1. De Lalande J. 1786. Voyage en Italie. 2ème éd. Paris : tome IV, 478.

2. Journal conservé à la bibliothèque municipale de Besançon, archives Pâris, cote Ms. 13. Voir également Debenedetti E. 1991. Pierre Adrien Pâris e la collezione di antichità della Villa Borghese detta Pinciana. In Collezionismo e ideologia. Mecenati, artisti e teorici dal classico al neoclassico. Roma : 223–248. Et Laugier L. 1995. Dossier préparatoire à la restauration du *Gladiateur Borghèse* (monographie, Ecole du Louvre).

3. Restauration effectuée par Anthony Pontabry, mise en œuvre par le Service de Restauration des Musées de France et commandée par Alain Pasquier, conservateur général chargé du département des Antiquités Grecques, Etrusques et Romaines. Voir Bourgeois B, Pasquier A. 1997. Le *Gladiateur Borghèse* et sa restauration. Musée du Louvre.

4. Journal du 10 mai, p.66.

5. Visconti EQ. 1796. Sculture del Palazzo della Villa Borghese detta Pinciana. Roma : parte II, 59.

6. Journal du 5 janvier : 26.

7. Journal du 8 juin : 78.

8. Archives des Musées Nationaux, A6, antiquités de la Villa Borghèse, dossier du 4 janvier 1811, Tableau général du Museum de la Villa Borghèse à Rome ..., 14.

9. Journal : 42.

10. Journal du 10 février : 34.

11. Journal du 4 février : 33. Et instructions envoyées par Dufourny, avec deux schémas montrant la disposition des dalles de peperino, Besançon, Ms. 21, correspondance échangée entre Pâris et le ministre de l'Intérieur, f.58–59, note pour l'encaissement du *Gladiateur*.

12. Besançon, Ms 21, f. 123–124, lettre du ministre de l'Intérieur du 30 avril 1808

13. Sur la *mixtura*, mélange de colophane, cire d'abeille et poudre de marbre, traditionnellement utilisée en Italie pour la restauration des marbres antiques, voir le traité d'Orfeo Boselli et les commentaires de P. Dent Weil. 1967. Studies in Conservation 12 (13).

14. Journal du 13 mars : 45–46.

15. Ms. 21, n°36, f. 152, lettre de Pâris et Lorimier au ministre du 17 juillet 1808.

16. Journal : 96.

17. Ms.21, f. 195–196, lettre de Fulgoni à Pâris, du 13 octobre 1808.

18. Effectuée par Bernard Rattoni, au Commissariat à l'Energie Atomique (DAMRI/SAR), avec une source au cobalt 60.

19. Avec des bouchages en stuc composé de cire d'abeille et de poudre de marbre.

20. Rayet O. 1884. Hoplitodrome vainqueur, statue en marbre par Agasias d'Ephèse. Monuments de l'art antique. II. Paris.

Abstract

The principle of critical linguistics is that the choice of a way to say something is neither random nor accidental, and carries ideological distinctions. Applying the discipline's analytical tools to three papers selected from the publication *Preventive conservation practice, theory and research* (Roy and Smith 1994) demonstrates profound tensions between the mission of institutions and the professional loyalties of conservators, as well as revealing how restrictive the objective language of science is for conservation. The paper suggests that we look to the arts and humanities to enable us to use language which is unashamedly subjective and can express the passion conservators feel for their work.

Keywords

critical linguistics, conservation publications, language, passion, subjectivity, objectivity

The language of conservation: Applying critical linguistic analysis to three conservation papers

Laura Drysdale
English Heritage
23 Savile Row
London W1X 1AB
UK
Fax: + 44 171 973 3330
Email laura@eng-h.gov.uk

Introduction

The profound relationship between conservators and the objects they treat is rarely explicit. Seeking the status of established professions like medicine or architecture, or declaring an academic allegiance, conservators have expressed their connection with things in the language appropriate to forums such as this conference, or in publications like *Studies in conservation* which are modelled on scientific journals.

Nevertheless the passion conservators feel for objects has to be the driving force for a population whose careers in the cultural heritage sector are proscribed by their perceived service role and whose pay is notoriously low in comparison with their qualifications. Indeed, in the language of marketing, our *unique selling point* is our intimacy with things, our unrivalled knowledge of their construction and behaviour, and our skill in enabling objects to articulate human history by revealing their "true nature". When conservators are gathered together they do speak of their deep pleasure in their work, or of frustration at their inability to prevent preventable damage, but in the quasi-objective language we have adopted in professional publications, overtly subjective expression of feelings would be inappropriate, even ridiculous.

Of course it is obvious that the language of publication must be different to that of verbal presentation, which is why published speeches subvert convention. For example Dr Ashok Roy's lecture published in the *IIC bulletin 1998 No 6* is a rare display of subjectivity:

> To my mind, one of the most enjoyable activities is to gather with colleagues and a picture – best achieved in the conservation studio – as this enables the chance to look closely, and it allows discussion, direct access to other people's knowledge, genuine interdisciplinary communication – and in this sort of get-together, who would want to neglect the importance of joking, irreverence and humour? In other words, pleasure (Roy 1998).

Publication has professional advance as its purpose, so it is preoccupied with information and with the use of complex sentence structure which impresses because it is difficult to read. In functional linguistics this is a specific *register*, where the forms of language encode a socially constructed representation of the world. Critical linguistics allows us to uncover a much more interesting sub-text where in effect the informal solidarity of verbal communication is embedded in the formal authoritative language of professional publication.

Critical linguistics as an analytical tool is described by Roger Fowler in *Language in the News*:

> Each particular form of linguistic expression in a text – wording, syntactic option, etc – has its reason. There are always different ways of saying the same thing, and they are not random accidental alternatives. Differences in expression carry ideological distinctions (and thus differences in represen-

Table 1. Operational and moral differences between decision-makers and workers.

trustee and director level	curator, registrar or conservator level
purely political reasons dogma	scientific logic concern for the welfare of the object discuss reasonable light of logic specific knowledge

Table 2. Negative (decision-makers) and positive (workers) vocabularies.

politics
diplomatic reasons
cynically
subterfuge
national political correctness
purely political reasons
difficult diplomatic situations

dogma
restrictive
mental rigidity
rigidity
rigid adherence
tight
absolute terms
rigidly follow

negotiation
informed negotiation
accommodated
potential
encourage changes
discussion
enabling attitude
willingness to discuss
flexibility
relationship
power to negotiate in the light of local circumstances

scientific logic
real
actual
actual environments
informed
reasonable
ample evidence
specific knowledge
knowledgeable
real needs
scientific observation
probability
evidence

tation). This makes it worth deconstructing texts to reveal their distinctive ideological choice (Fowler 1991).

I have applied the tool to three papers in the volume of conference preprints from the 1994 IIC meeting in Ottawa, *Preventive conservation practice, theory and research* (Roy and Smith 1994). The selected papers address conflicts between the needs of objects and people. They each stem from major but very different national institutions, the Victoria and Albert Museum in London, the National Trust (England, Wales and Northern Ireland) and the National Museum of the American Indian which is part of the Smithsonian Institution in the United States of America. Because the conference subject inherently involves identifying causes of damage in order that they may be prevented, an unsurprising but marked feature of these papers is that they ascribe blame: to directors and trustees, to visitors, and more covertly, to the need to appease an ethnic group, Native American Indians.

Let's be honest: Realistic environmental parameters for loaned objects (Ashley Smith, Ford and Umney 1994)

The authors are all members of the conservation department at the Victoria & Albert Museum, servicing an active international loans and in-house exhibitions programme. The paper's *mission* is to convince workers (curators, registrars and conservators) to change their practice, to become *honest* in identifying environmental requirements for incoming and outgoing loans, despite the machinations of decision-makers (director and trustees). Operational and moral differences between the two groups are explicitly described.

> At trustee and director level, environmental requirements may occasionally be re-negotiated for purely political reasons, without recourse to scientific logic or concern for the welfare of the object. At curator, registrar or conservator level, it should be possible to discuss what is reasonable in the light of logic and specific knowledge, rather than dogma.

The different vocabulary associated with the two groups is apparent in Table 1.

These polarities echo throughout the text, where negative features belonging to or caused by decision-makers are identified by pejorative language relating to politics or dogmatism, and positive ones associated with workers by negotiation and logic/knowledge. Behavioural characteristics are sorted in the same pattern (See Tables 2 and 3).

The deathly rigidity of decision-makers is contrasted with the vitality of objects, which are *organic* and might have a *long life*. One paragraph embodies this polarity:

> Rigid adherence to tight and specific ranges of environment also relates to current aesthetic fashions in conservation and display. Moisture-sensitive materials such as vellum and parchment are now only deemed in good condition if utterly flat. Any sign of cockling is seen as the first stage of complete disintegration. In its pre-museum life, the object probably changed shape quite regularly to avoid internal stress as it accommodated itself to changes in environment.

The negative and positive qualities ascribed to people who are responsible for objects are also attached to objects themselves, the absolutism of *utterly flat* and *complete disintegration* contrasting with the flexibility of *changed shape, accommodated*. Disillusionment with institutions and affection for objects is hardly a subtext in this paper which so richly supports Fowler's assertion that "language is impregnated with ideology" (Fowler 1991). However deconstruction illuminates the transference of feeling to inanimate things that is such a recognisable feature of conservation's profile.

Table 3. Bad behaviour by decision-makers, good behaviour by workers.

Bad behaviour	Good behaviour
dishonest	understanding
incompetence	honestly
ignorance	reliable
failure	accommodated
disappointing	quick to respond
misunderstanding	prevent
ignorance	ease
defensive	positive

Table 4. Grammatical contrast between description of outsiders and insiders.

Outsiders

Exclusion of the definite article
more than 10 million visitors
restrictions on visitor access
desirable capacity for visitors
peak visiting hours
holding visitors back
reduction in visitor entry rate
total visitors per day
limited number of visitors

Over-lexicalisation
overvisiting
visitor-related
visitor figures
visitor pressure
visitor numbers
visitor route
visitor entry rate
visitor management and control
infrared visitor counter
visitor loads
visiting patterns

Insiders

Use of the definite article
the National Trust
the Trust
the most seriously affected houses
the house staff who see the objects daily
the vulnerable furnishings
the original appearance of the rooms

individual words
each room
each house
each individual artefact
the condition of every artefact
the future needs of each collection
damage to elements of particular houses
a house
the house itself

The impact of overvisiting: Methods of assessing the sustainable capacity of historic houses (Lloyd and Mullany 1994)

This paper by the housekeeper of the National Trust and an architectural research student describes damage to historic houses caused by visitors, and suggests how it can be monitored and managed. The paper is less pro-object than anti-people, but again the most elementary analysis reveals a similar transference. The way visitors occupy space is thus described:

> Rooms in the most seriously affected houses develop a battered and tatty appearance, as a result of the cumulative effect of people jostling and kicking furniture, scuffing floors and walls, leaning against vulnerable surfaces, brushing past fragile textiles and touching objects and surfaces against which they find themselves pressed by the surrounding crowds.

Rooms and objects are *seriously affected*, *battered*, *vulnerable* and *fragile* like abused children, while the *crowds* inflict violence as they *jostle*, *kick*, *scuff*, *lean*, *brush past*, *touch* and *press*.

There is a distinct grammatical contrast in the way outsiders (visitors) and insiders (the institution, its possessions and staff) are described. Visitors are depersonalised, by exclusion of the definite article, by corporate mass and by the phenomenon of over-lexicalisation, where insecurity is masked by terminology. Insiders are frequently and contrastingly awarded the definite article or are explicitly individualised (See Table 4).

It is as if by progressively alienated language and by expressions of commitment to the institution, the fascinating tension between preservation and access can be formalised to a simple separation between them and us.

The authors call into play a number of powerful registers to support their case for limiting access. The scientific is used to validate a message to National Trust management and staff with competing demands, such as property managers responsible for access to the sites. Use of abbreviation *(NF, PPV)*, terminology ("*single heel drop*" *technique*) and equipment names (*Nomis portable seismograph*) all contribute to the aura of authority.

> The natural frequency (NF) of a particular floor or staircase can be determined by carrying out simple impact tests using a "single heal drop" technique whilst the rooms are otherwise unoccupied. This technique involves rising up on the toes and then dropping suddenly on the heels near midspan. Impact tests have been carried out on the same floors on which PPV (peak particle velocity) has been measured using the Nomis portable seismograph.

The word *sustainable* in the paper's title employs another register, that of environmentalism. Historical precedent is asserted in a quotation from John Bailey, chairman from 1923 to 1931 ("Preservation may always permit access, while without preservation access becomes forever impossible"), while a last word from the authors uses the familiar language of warning:

> If the Trust continues to allow too many visitors and the damage that they cause, it will create an ever-longer list of repair and remedial conservation work.

Finally the spiritual is invoked in the Acknowledgement at the end of the article:

> Helen Lloyd would like to acknowledge the inspiration given by two National Trust Historic Buildings Representatives, John Chesshyre and Jonathan Marsden, who first addressed the problems of overcrowding at Hardwick Hall and Powis Castle, respectively.

Table 5. Contrast between Native American and Museum values.

Expression
Many, perhaps all, of the sensitive objects in the NMAI collections are considered to be living, breathing, individual members of the Native American cultures.

Rebuttal
This effectively eliminates the possibility of enclosing them in plastic bags as a barrier to discourage insects.

Expression
But within many native cultures there are concerns about whether sacred/ceremonial materials should be handled at all except by designated individuals within the tribe.

Rebuttal
This affects conservation.

Table 6. The Museum Mission and the Authors' Mission.

Museum Mission
..recognize and affirm to Native communities and the non-Native public the historical and contemporary cultures and cultural achievements of the natives of the western hemisphere...recognizing the museum's special responsibility...to protect, support and enhance the development, maintenance and perpetuation of native cultures and communities

Authors' Mission
The museum is trying to incorporate all opinions, both traditional Native viewpoints and current museum standards, for the benefit of the objects.

Inspiration seems a charged response in the management and scientific context of the paper itself, but the word is precisely appropriate to the fervour of heritage protection and the deep loyalty which the National Trust enjoys from staff and members.

Traditional care and conservation, the merging of two disciplines at the National Museum of the American Indian (Drumheller and Kaminits 1994)

This is a paper about trying to do the right thing. The authors are a member of the Onondaga Nation who is a technician in the museum's registration department, and the head of conservation of the National Museum of the American Indian (NMAI). Their paper describes how museum staff and tribal individuals are working together to manage collections within a sub-institution of the Smithsonian. It poses the fundamental dichotomy between access and preservation in an interesting context, and on first reading seems to be taking an admirably correct approach. The vocabulary of co-operation is repeatedly invoked:

> collaboration; cooperation; consultation; interaction; working together; incorporate; worked as a team; accommodate; agreement; consent; working with; shared.

It is accompanied by testimonials of institutional respect for Native American concerns:

> recognise; affirm; acknowledgement; protect; support; enhance.

But on a closer reading, a more ironic tone emerges, especially in the repeated use of dry rebuttals to expressions of Native American values, the soft language of feeling clashing with the hard language of authority (see Table 5).

The balance of power, as expressed in concepts of "common sense" and "normality" is evident in a description of building design:

> The architectural layout and services of the building will respond directly to the input and needs of Native Americans. Native and non-native visitors, including scholars, will be accommodated by supporting traditional Native American care and renewal practices as well as more typical study and research projects.

So *traditional*, with its connotations of past activities eclipsed by present reality is the word applied to Native American practices, while *typical*, i.e. of the moment, is used to describe what some might see as *traditional* museum practices.

This suppressed conflict may be a manifestation of the institutional tensions permeating all three papers. The mission of the museum and the interpretation of it in this paper seem to be in opposition (See Table 6).

The museum's mission is to serve the Native and non-Native public. The authors' mission is to serve the objects. If the conservator's first duty is to the objects but the institution's is to its constituency conflict is inevitable. In truth, the museum is attempting something antithetic to standard practice - it is trying to establish shared rights to museum objects. The placebo of cooperation cannot obscure how difficult this is for NMAI staff who *endeavour, try* and *strive* to negotiate their way through a cultural minefield.

Conclusions

Unlike medics with whom we carers for the cultural heritage are so often compared, conservators tend to be housed not in institutions where our discipline is the core activity (hospitals), but in museums or heritage bodies where conservation is just one of the things that the organisation does. This may lead conservators to reinterpret the purpose of their own institution in a way which is more acceptable to their preservation-focussed vision. They may also to lend their

primary allegiance to the professional bureaucracy rather than the corporate bureaucracy which appears to pay them so little attention. They make, as Fowler suggests, distinctive ideological choices.

There is nothing new in identifying strains in the triangular relationship between owners, conservators and objects. What is interesting is that deconstruction of the three selected texts exposes how professional tensions are mirrored in linguistic ones. To diffuse these tensions we need a professional voice which can talk unashamedly about the subjective pains and pleasures of our work without compromising our credibility. We need vocabulary which can locate us as much in the humanities and arts as in science, whose language is adequate to represent the full breadth of our professional concerns.

References

Ashley Smith J, Ford D, Umney N. 1994. Let's be honest – realistic environmental parameters for loaned objects. In: Roy A, Smith P, ed. Preventive conservation practice, theory and research. Ottawa: International Institute for Conservation of Historic and Artistic Works: 28–31.

Drumheller A, Kaminitz M. 1994. Traditional care and conservation, the merging of two disciplines at the National Museum of the American Indian. In: Roy A, Smith P, ed. Preventive conservation practice, theory and research: 58–60.

Fowler R. 1991. Language in the news. London: Routledge.

Lloyd H, Mullany T. 1994. The impact of overvisiting: methods of assessing the sustainable capacity of historic houses. In Roy A, Smith P (eds). 1994. Preventive conservation practice, theory and research: 132–138.

Roy A. 1998. Forbes Prize Lecture. In: IIC Bulletin 6 (1998): 1–5.

Roy A, Smith P, ed. 1994. Preventive conservation practice, theory and research. Ottawa: International Institute for Conservation of Historic and Artistic Works.

Abstract

In 1992 the World Commission on
Culture and Development was set up
under the auspices of UNESCO.
Three years later the Commission
presented the report *Our Creative
Diversity* (1995). The report breaks
new ground in redefining culture and
development and analyzing their
interactions. In this respect the report
puts into perspective the central
issues of contemporary conservation
theory as reflected in the recent
documents of heritage conservation.
This paper attempts to elucidate the
perception of heritage and heritage
conservation in the late 1990s – the
interpretations of the concepts, and
the importance ascribed to them in
consideration of contemporary
definitions of culture and develop-
ment.

Keywords

history and philosophy of conserva-
tion, cultural diversity, cultural
pluralism, «conservation and develop-
ment»

Our Creative Diversity and contemporary issues in conservation

Beate Federspiel
Royal Danish Academy of Art
School of Conservation
Esplanaden 34
1263 K Copenhagen
Denmark
Fax: + 45 33 74 47 77
Email: bkf@kons.dk

Introduction

In 1988, UNESCO launched the World Decade of Cultural Development,
stressing the importance of the cultural dimension of development and generating
a large number of initiatives, including an international commission whose
purpose was to clarify the relationship between culture and development. By that
time it was clear that development could not only be measured in terms of
economic and material increase. "Building cultural insight into the broader
development strategies, as well as a more effective practical agenda, had to be the
next step in rethinking development."[1] The idea of a commission with this
purpose was inspired by the results achieved by the Brundtland Commission in
rethinking the relationship between the environment and development.[2]

In November 1992 the director-general of UNESCO established the World
Commission on Culture and Development, presided over by the former secretary-
general of the United Nations, Javier Perez de Cuéllar. The result of the
commission's work was the report, *Our Creative Diversity* that appeared in 1995.

From a conservation perspective, the report of the World Commission of
Culture and Development is quite important in that it includes conservation of
heritage on the agenda, and expresses the same ideas that have guided the
achievements and evolution of thinking within the field of cultural heritage
conservation for at least the past decade. It is worth noting that the report is not
specifically related to the protection and conservation of cultural heritage.
Nonetheless it represents an understanding of the concepts of culture and heritage
in very close accordance with the ideas reflected in recent documents in the field
of conservation. However, unlike these documents, the report of the World
Commission will surely reach a broader public and will hopefully influence
decision-makers throughout the world; this is already well underway : The report
has generated a number of important initiatives: the Stockholm "Intergovernmen-
tal Conference on Cultural Policies for Development" (30 March–2 April 1998)
organized by UNESCO, and the publication by UNESCO of the first issue of the
World Culture Report (1998). These two events may well prove to be milestones in
the recognition of the role of culture in human development, contributing greatly
to rethinking these central issues in an increasingly globalized world.

The purpose of this paper is to "read" the evolution of thinking concerning the
concept of cultural heritage as reflected in some of the most central documents since
the Second World War: the World Heritage Convention of 1972, representing the
most universal cultural legislation, and the Nara Document on Authenticity, being
one of the most important conservation documents of the 1990s, reflecting that
cultural diversity and cultural pluralism are determining concepts these days in the
broadened view of culture and heritage values.[3, 4] The Nara Document builds
on the Venice Charter of 1964, which will also be considered here. The focus,
however, will be on the 1990s. In addition to the Nara Document, the ICOM
Policy Statement of 1997 and the 19th General Assembly of ICOM in 1998 as well
as the ICOMOS Declaration of September 1998 reflect significant issues in
contemporary approaches to cultural heritage and conservation.[5, 6]

The point of departure will be *Our Creative Diversity*, the report of the World Commission on Culture and Development, for the reasons mentioned above. It should be noted that the authors of the report had not had the opportunity to read the recent documents relating to conservation as the Nara Document appeared in late in 1994 and thus just "crossed" the Report on Culture and Development. However, this makes the reading of the report that much more interesting from the point of view of conservation. The report of the Intergovernmental Conference in Stockholm and the World Culture Report will also be considered.

Key contemporary issues of culture and development

One of the premises of the work of the World Commission on Culture and Development as outlined in the foreword of the report is the conviction that "culture ... is an essential determinant, if not the essence itself, of sustainable development."[7] The necessity of respecting the pluralism and diversity of cultures is repeatedly emphasized in the report as one of the basic conditions for peace and stability and thus for further human development.

Over the past few decades the attitude towards "development" has changed. From being narrowly connected to economic and material increase, the notion of development has broadened. The eradication of poverty is still the overriding priority of the United Nations Development Program (UNDP), but the ways of reaching this goal have become increasingly focused on the human dimension. [8] Self-respect and respect for others are significant issues. Culture and heritage values play an important part in such a notion of development.[9] Generally speaking it is obvious that concern in the world is growing for the diversity of cultures and heritage values, and the significance of cross-cultural dialogue in the service of development.

The report of the World Commission expresses a concern for cultural resources of all kinds, and rightly complains that responsibility for the cultural inheritance has focused on physical objects: the great historic monuments and objects of art and craft. Further it claims that it is indicative of the situation that the World Heritage Convention clearly reflects that concern for heritage and heritage values applies mainly to the type of heritage that was appreciated in the industrially developed countries. The historical explanation for this lies in the vast destruction of monuments and historic sites during the Second World War. The Hague Convention (1954) and the Venice Charter (1964) reflect a concern for what today would be characterized as a certain and limited kind of heritage.

A wider anthropological approach to cultural heritage is advocated, shifting attention from the tangible to the significance of the intangible heritage. Place names, local traditions and their interactions with cultural landscape, oral traditions, craft traditions – also belong to the cultural heritage.

The authors of the report point out that heritage preservation has been governed by universal principles originating in the West (the main conventions and documents of conservation were formulated in the West). In accordance with this, the report expresses a view that has been current in cultural heritage conservation since the beginning of the 1990s and that is reflected in the following central passage of the report: "... each society needs to assess the nature and precariousness of its heritage resources in its own terms and determine the contemporary uses it wishes to make of them, not in the spirit of nostalgia but in the spirit of development that is promoted throughout this report." [10] Exactly the same approach is expressed in article 11 of the Nara Document.

Museums make a significant contribution in defining the meanings of the concepts of "culture" and "heritage". New schools of museology have developed over the past few decades. Already in 1974, ICOM revised the definition of a museum, stating that a museum is an institution in the service of society and development.[11] Museums are increasingly directed towards multicultural issues and the authors of the report ascribe a particular significance to efforts of this kind which are future looking and involve not only current museum visitors but the entire community, with the aim of addressing key contemporary issues such as cultural diversity in general and indigenous issues in particular. One of the

resolutions of the 19th General Assembly of ICOM in 1998 states ICOM's commitment to "the development of museums as sites for the promotion of heritage values of significance to all peoples through cross-cultural dialogue."[12]

Thus, relating to ICOM's field of operation, the report of the World Commission might be said to reflect what has been going on since at least 1974. The report has not passed unnoticed; the recent ICOM Policy Statement of 1997 refers to it and to the view expressed therein that culture is the very basis of development. Continuing this line of thought the Policy Statement emphasizes ten key issues as central to the continual transformation of museums throughout the world. The first of the issues relates to cultural diversity and cultural pluralism, and states: "The cultural diversity of different nations is a rich inheritance of humanity that will endure as the central pillar for peace, harmony and cultural sustainability of the world. The promotion of this global inheritance through the process of cultural pluralism is the responsibility of all societies ... Museums in different parts of the world are exploring ways of relating to community, cultural and economic development, the sense of place, identity and self-esteem of different people."[13]

Conservation and development

From the conservation perspective, the views advocated by the report of the World Commission are very much in accordance with the way of thinking reflected in particular in the proceedings of the two conferences on authenticity related to the World Heritage Convention, arranged in 1994 with a preparatory workshop in Bergen, Norway, and an international colloquium in Nara, Japan. The result of these conferences was the Nara Document on Authenticity.[14]

It is necessary to take a closer look at the reasons that these two conferences had the common theme of authenticity in relation to the World Heritage Convention. Very simply, perceptions of values relating to protection and maintenance of cultural heritage had changed since the Second World War, and the interpretation of "heritage" had also changed. Specifically, it had become increasingly obvious that the World Heritage List reflected only a very limited range of cultural regions and periods.

As is well known, the World Heritage Convention (The Convention Concerning the Protection of the World Cultural and Natural Heritage), was adopted by UNESCO at its 17th General Assembly in 1972, and ratified by 155 states parties in October 1998.[15] At its 16th session in December 1992 the World Heritage Committee – in operation since 1976 – recommended that "a critical evaluation should ... be made of the criteria governing the cultural heritage and the criteria governing authenticity and integrity, with a view to their possible revision."[16]

The World Heritage Committee has as one of its four essential functions "to identify, on the basis of nominations submitted by States Parties, cultural and natural properties of outstanding universal value which are to be protected under the Convention and to list those properties on the World Heritage List."[17] In other words the Committee defines what is cultural heritage.

The instrument of this definition are the Operational Guidelines for the Implementation of the World Heritage Convention. Two sets of criteria operate concerning cultural and natural heritage: authenticity and integrity, respectively. Paragraph 24 of the Operational Guidelines states that a monument, group of buildings or site nominated for the World Heritage List will be considered when the Committee finds that it meets one or more of the criteria listed in 24a, and further "meet[s] the test of authenticity in design, material, workmanship or setting" (24b, i).

Since the test of authenticity was initiated in 1977, it became increasingly obvious that "authenticity" was a concept originating in Western thought and was not necessarily understood in the same way (if at all) in other parts of the world. The application of universal principles in the field of conservation had been encouraged since the Venice Charter (1964). One of the key issues in this charter is authenticity, which was introduced without debate or a definition, and gained authority by its inclusion in the Operational Guidelines as one of the decisive criteria for nomination for the World Heritage List.[18]

It was also obvious that the perception regarding cultural heritage had changed since the Venice Charter. This was the reason for the joint initiative of the World Heritage Centre, ICCROM and ICOMOS to initiate discussions on criteria for defining cultural heritage with the purpose of broadening the concepts.

After Nara, the understanding of cultural heritage and the criteria of authenticity are determined by the recognition of cultural diversity and cultural pluralism. These concepts do not occur either in the World Heritage Convention or in the Venice Charter, though it might be argued that they are indirectly present as these documents build on the fundamental principle that "the cultural heritage of each is the cultural heritage of all."[19]

The concepts of cultural pluralism and cultural diversity are not new, however. The 18th century German philosopher and historian Johann Gottfried Herder formulated the idea that different societies and cultures have different values. His perception built on the thinking of the Italian Giovanni Battista Vico, who was one of the first to perceive history, not as something given by God, but as a result of man's making.[20]

Around the turn of the century the French philosopher Henri Bergson formulated in his theory of diversification the idea of diversity as a dynamic principle, generating continuity. Diversity is a principle by which complex systems renew themselves, and as such is the condition of development.

From a position dominated by Western concepts, the approach to conservation and protection of cultural heritage has moved to a position of respect for other cultural values, the diversity of cultures being closely linked to development. In this respect the importance ascribed to the application of conservation in the service of development is obvious and may be seen as an implication of perceiving conservation and maintenance of heritage resources as a an issue of sustainability.

The idea of conservation as creating continuity is already expressed in the World Heritage Convention. In article 5 the general aim of ensuring measures for conservation of cultural and natural heritage is described as giving these resources a function in the life of the community and integrating the protection of that heritage into comprehensive planning programmes. It might be concluded that the development-based vision of culture is determining the approach to conservation of cultural heritage in the 1990s.[21]

The very recent ICOMOS Declaration Marking the 50th Anniversary of the Universal Declaration of Human Rights, confirms this view of the close interaction between culture and development, stressing the forward-looking vision for conservation and the importance of diversity.[22] By this declaration ICOMOS wishes in particular to affirm the right to cultural heritage as a fundamental human right.

Conclusion

Three years after the report of the World Commission on Culture and Development it is already obvious that this will stand as one of the important initiatives of UNESCO in the World Decade of Cultural Development.

In 1998 an Intergovernmental Conference on Cultural Policies for Development took place in Stockholm (30 March–2 April), organized by UNESCO as a direct offshoot of the International Agenda proposed in the report of the World Commission. The aim of the Stockholm Conference was – in the words of the post-conference report – to create "a new departure that is likely to chart the course for the development of an internationally agreed conceptual framework that will place culture at the world's centre stage."[23]

To that end an action plan was drafted at the Stockholm Conference, including the recommendation for a World Summit on Culture and Development and identifying a number of measures and actions to be included in the future strategy of UNESCO. One of the four objectives in the action plan specifically addresses conservation and enhancement of the tangible and intangible heritage: Objective 3 in 14 articles treats important aspects of cultural heritage and its protection as part of the fundamental conditions of "sustainable human development"; article 3 emphasizes the need to renew the traditional definition of heritage, acknowledging all the elements through which social groups recognize their identity.[24]

Another important recommendation of the action plan is for UNESCO to pursue the publication of a biennial World Culture Report. The first issue of this report was presented to the press in November 1998. The World Culture Report might be seen as analogous to the UNDP Human Development Report which each year for the past twenty years has attracted great attention; setting the agenda, generating world-wide debate and influencing decision makers and politicians. This may well be the future scope of the World Culture Report.

The World Culture Report is breaking new ground. In the preface Federico Mayor, director-general of UNESCO, describes it as a new tool to provide a worldwide analysis on which new policies can be based. It is worth recalling that the mission of UNESCO is to build a culture of peace, and that "new cultural policies" should therefore promote intercultural dialogue. The World Culture Report pursues the notion of diversity as an issue of human development, discussed in *Our Creative Diversity*, and stresses this as a basis for understanding cultural processes in a world of internationalization and globalization.

Reading the Report of the World Commission on Culture and Development, the report of the Stockholm Conference and the World Culture Report, it is obvious that the emphasis on the crucial importance of integrating the cultural dimension of development in national and international planning strategies is strong these days.

The protection and conservation of heritage and heritage values represent only one aspect of the multipartite relationships between culture and development, though a very important aspect. Conservation of heritage is undeniably on the international agenda.

For the practising conservator these new perspectives of conservation and heritage open up new obligations and possibilities, in particular calling for reconsideration of the central ethical questions of conservation: why do we preserve our heritage, what, how and for whom do we preserve. The scope of conservation has broadened; it is for the whole community and it is for the future in the service of development.

I will conclude this paper with a quotation of Amartya Sen, the Indian economist and philosopher who was awarded the Nobel Prize in economics in 1998. In a few incisive words Amartya Sen has pinpointed the interrelationship between culture and development, putting into perspective the obligation to care for the protection and conservation of the world's inheritance as a basis for human development:

> Culture does not exist independently of material concerns, nor does it stand patiently waiting its turn behind them.[25]

Notes

1. Our Creative Diversity, foreword by Javier Perez de Cuéllar, p.8.
2. The report of the World Commission on Culture and Development is analogous to the report of the Brundtland Commission on Environment and Development, Our Common Future (1987).
3. The Convention Concerning the Protection of the World Cultural and Natural Heritage. Adopted at the 17th session of the general assembly of UNESCO, 1972 (www.unesco.org).
4. The Nara Document on Authenticity was drafted at the Nara Conference on Authenticity in Relation to the World Heritage Convention, 1994. Preprints of the Conference, see references: K.E. Larsen, 1994. The document is available at (www.international.icomos.org).
5. Museums and Cultural Diversity. Draft ICOM Policy Statement, ICOM 1997 (www.icom.org).
6. The ICOMOS Declaration Marking the 50th Anniversary of the Universal Declaration of Human Rights. September 11, 1998 (www.international.icomos.org).
7. Our Creative Diveristy, p. 10.
8. The decade 1997–2006 has been devoted by the UN to the eradication of poverty.
9. UNDP Human Development Report 1997, foreword and chapter 1.
10. Ibid.
11. 11th General Assembly of ICOM, Copenhagen, June 1974. Resolution No.1,7.
12. 19thʰ General Assembly of ICOM. Melbourne, October 1998. Resolution No.1,C.
13. ICOM Draft Policy Statement, 1997. Museums and Cultural Diversity (www.icom.org).
14. Larsen, K.E. and N. Marstein, ed. 1994 and Larsen, K.E., 1995.

15. Convention Homepage. List of States parties, Ratification Status, 26 October 1998 (www.unesco.org).
16. World Heritage Committee, Report of 16th Session, Santa Fe, USA, December 1992, Strategic Orientation, 2.Goal, Recommendation 19. See: World Heritage Centre electronic document repository (www.unesco.org).
17. (www.unesco.org) Homepage. Convention. Operational Guidelines for the Implementation of the World Heritage Convention. Introduction, 3i.
18. For a more detailed explanation of these issues, see in particular the preface to the Nara Conference by Knut Einar Larsen, the foreword by Herb Stovel and the contributions of Bernd von Droste and Ulf Bertilsson.
19. The Nara document on Authenticity, article 8
20. Jukka Jukilehto has brilliantly elucidated the roots of contemporary issues in the perception of history and cultural heritage; particularly in his contribution to the Nara Conference: Authenticity: A general framework for the Concept. (Preprints p. 17–34). See also Jukka Jokilehto: Questions about "Authenticity" Workshop proceedings, Bergen Conference, 1994 and Jukka Jokilehto: Conservation Principles and Their Theoretical Background. Durability of Buildings Materials, 5, 1988, p. 267–277.
21. This notion of conservation and development is particularly clearly expressed in the contributions of Jukka Jokilehto and Marc Laenen to the Bergen and Nara conferences. See also ICCROM Newsletter, 24 September 1998, editorial by Director-General of ICCROM Marc Laenen.
22. The ICOMOS Declaration is accessible at (www.international.icomos.org).
23. Report by the Director-General on the follow-up to the Stockholm Intergovernmental Conference on Cultural Policies for Development. UNESCO, Paris, 10. August 1998 UNESCO Executive Board, 155th Session, Item 3.5.4. of the provisional agenda.
24. Action Plan on Cultural Policies for Development, adopted in Stockholm on 2 April 1998 by the Intergovernmental Conference on Cultural Policies for Development. Annex (155 ex/14) to the report referred to in note 23.
25. World Culture Report 1998, p. 317.

References

ICOM Newsletter 24. September 1998. Editorial by Director-General Marc Laenen

Jokilehto J. 1988. Conservation principles and their theoretical background. Durability of building materials. Amsterdam: Elsevier Science Publications. 5 (1988): 267–277.

Larsen KE, Marstein N, ed. 1994. Conference on authenticity in relation to the World Heritage Convention. Preparatory workshop, Bergen, Norway.

Larsen KE, ed. 1995, The Nara conference on authenticity in relation to the World Heritage Convention, Nara, Japan, 1–6 November 1994. Publ.by UNESCO, ICCROM, ICOMOS and the Agency for Cultural Affairs, Japan.

Our Common Future. 1987. The Report by the World Commission on Environment and Development (The Brundtland Report). UNESCO.

Our Creative Diversity. 1995, 1996. The Report of the World Commission on Culture and Development. UNESCO.

UNDP Human Development Report. 1997. New York Oxford University Press: United Nations Development Programme.

UNESCO, 155th Session, Paris 10 August 1998, Item 3.5.4. of the provisional agenda. Report by the Director General on the Follow-up to the Stockholm Intergovernmental Conference on Cultural Policies for Development.

World Culture Report: Culture, Creativity and Markets. 1998. Paris: UNESCO.

The international documents in the field of conservation referred to in the text are accessible at the following Internet addresses:www.unesco.org, www.international.icomos.org.

Abstract

The Fogg Museum at Harvard University provides a case study of the mutual influences of art history and art conservation when both were present in a single institutional setting. In 1927 the Fogg was explicitly called a «laboratory of the arts.» This paper examines the relationships between technical studies of paintings and contemporary practice of art history between 1900 and 1950. It addresses the reasons why art historians encouraged technical studies in the early twentieth century and how the use of technical information overlapped in conservation and connoisseurship to produce an ahistorical approach to the study of art. The result is a corrective to the view that scientific and aesthetic understanding of artworks necessarily stand in opposition, as well as a call for technical studies that help to re-contextualize the art of the past.

Keywords

connoisseurship, visual evidence, science in conservation, examination techniques, Fogg Museum

Technical studies and visual values: Conservation and connoisseurship at the Fogg Museum 1900–1950

Barbara Whitney Keyser
Art Conservation Program
Department of Art
Queen's University
Kingston, Ontario K7L 3N6
Canada
Fax: +1 613 544-7988
Email: bwk1@post.queensu.ca

Critics of science-based conservation practice have perpetuated the idea that scientific and humanistic values are incompatible; on this view, over-reliance on science produces inappropriate presentations of artworks (Weil 1984: Talley 1983). Recently Talley has shown that conservation in the early twentieth century was intimately related to art history through the practice of connoisseurship, and he calls for a return to the values of direct visual appreciation of artworks as a corrective to over-emphasis on science in conservation (Talley 1996). While valuable, his account does not discuss the close connections between technical studies and art history in the cradle of "scientific" conservation, the Fogg Museum between 1900 and 1950. At the Fogg, both art historians and conservators based their work on observation, rational description, and classification – a "natural history" of paintings that corresponded to contemporary sciences such as botany and mineralogy. In this place and time, both disciplines were based on visual evidence, and they nurtured each other because they occupied complementary positions on common ground. It was the purely visual approach of both fields that produced unsympathetic presentations such as that of the Jarves collection at Yale University. The case of the Fogg shows that returning to purely visual values is not a remedy for inappropriate treatments and presentations; rather, art history and conservation must join forces to move beyond visual values and re-contextualize artworks.

Ron Spronk has outlined the careers of the four Fogg pioneers. Edward Waldo Forbes (1873–1969) was director of the Fogg Museum from 1909 to 1944, and he assembled an outstanding collection of over 1400 western and oriental historical pigments. He also fostered studies of the history of technique by examining original paintings and developing the "egg and plaster" course in which students experienced historical methods in the studio. Alan Burroughs (1897–1965) is best known for his innovative large-scale comparative art historical study using X-radiographs to address issues of attribution. Rutherford J. Gettens (1900–1974) was the Fogg's chemist from 1928 to 1951; he was hired because Forbes had wanted to be the first in the United States to have a chemist on his staff to analyze historical materials, investigate agents of deterioration, and study treatments systematically. Gettens also played a role in advising modern artists on materials and techniques. Finally, George Leslie Stout (1897–1978) came to Harvard as a graduate student and assisted in Forbes's historical techniques course. He became the first conservator of the newly established Department for Technical Studies in 1928 and received his M.A. from Harvard in 1929 (Spronk 1996). Between 1932 and 1942 the work of these pioneers and their contemporaries was published in the first English-language specialist conservation journal, *Technical Studies in the Field of the Fine Arts*.

Gettens himself used the phrase "systematic scientific examination of paintings" to sum up the achievements of the Fogg group (Gettens 1952). This work comprised techniques and methods that are now standard practice in conservation, such as X-radiography, ultraviolet examination, macrography, cross-sections of paint layers, and identification of pigments by X-ray diffraction and microchemical analysis. Note that even the microchemical methods practiced by Gettens, which peaked in the 1930s, relied heavily on operator skill and visual criteria (Laitinen and Ewing 1977). Gettens's emphasis on improvements in description and documentation of condition was an extension of these sciences of observation,

and the Fogg method stressed precise terminology in the writing of condition reports.

George Stout's little classic, *The Care of Pictures*, is still in print and remains worthy of study. It abounds in diagrams of crack morphology and visual classifications of paint structure and condition defects (Stout 1948). Stout was also fascinated by nomenclature, and he devised a scheme for describing the materials and condition of art objects, which had the flavour of Victorian science with its Latinate neologisms such as "abstersion," "interstitial conjugation," and "hiatial insertion." This system never became standard, but Richard Buck's mode of describing condition is still current and remains the basis for rational description of the materials, construction, and condition of paintings.

Thus the Fogg pioneers used technical studies of art to evaluate condition, including prescribing treatments and assessing past treatments. Their ultimate goal was to determine how traditional materials age and to keep them from deteriorating further. Indeed, the aim of the condition survey was to move from remedial treatment to a program of preventive conservation. All these endeavours relied on a forensic, visually-based sense of evidence and its clear communication to other observers. This visual-descriptive approach to conservation can be summarized in the phrase "natural history of paintings."

In this light, it is revealing to see how the Fogg group viewed the relationship of the "technical critic" and the "style critic" or connoisseur. Their approach was surprisingly balanced: while they emphasized objectivity and applied science in technical study, they were well aware of the limitations of technical evidence. As Buck and Stout put it, machines were not the answer but only aids. The facts of examination, they added, are "meshed together in an intricate fabric; each is joined to dozens of others and to images from memory." They regarded the task of the style critic as somewhat more subjective than the technical critic, but the process was similar. The difference was mainly in the nature of the facts that were used, and both types of critic aimed to understand the ideas and intentions of the artist (Buck and Stout 1939).

In the introduction to his classic of 1938, *Art Criticism From a Laboratory*, Alan Burroughs took a similar stance. He regarded the difference between a scientific and an aesthetic approach as one of emphasis, for both required the impersonal and personal points of view. Even the most academic or scientific historian, he wrote, must first of all be intuitive and personal; and while physical evidence bears on the problem of authenticity, it is also subject to interpretation. Thus the two activities proceed in tandem, complementary rather than conflicting. Most revealing, however, is Burroughs's belief that technical examination could lead to "a form of aesthetics practical for those who are interested in *seeing* and not necessarily *theorizing* their way into art [emphasis added]. "My own discovery," he continues, "is that everything which can be said about pictures in general is contained somehow in the physical materials which are the only valid depositories of a painter's feeling about the world." When he offered a Harvard graduate course with the uninviting title "Problems in Attribution in the Light of Recent Developments in the Technical Study of Paintings" (later shortened to "Scientific Study of Paintings"), Burroughs reported that students with no previous experience of art not only solved identification problems but started to understand art deeply. Students "acquired a kinesthetic sense of artists' accomplishments ...They began to appreciate pictures literally from the ground up, as physical symbols of emotional meanings." In sum, Burroughs believed that the physical facts revealed by a tool like the X-ray machine, and described by the semi-scientific vocabulary of the forensic observer, can "move us across miles and centuries into a satisfying relationship" with art of the past (Burroughs 1938).

We might expect that Burroughs's approach would be a threat to connoisseurs who relied on personality and reputation, such as his fellow Bostonian, Bernard Berenson (1865-1959). Rather, a closer look at Berenson's career shows that he vacillated between personal style and objective method, reinforcing the point that in the early twentieth century, American scientists and connoisseurs both embraced the authority of vision over textual study of art. Indeed, "method" and "style" can be contrasted in a way that helps to clarify this issue further. "Method" is a set of rules for practice that enable anyone who follows them to obtain the same results.

Thus method also implies ahistorical, timeless validity as well as objectivity. In its formative period, every discipline searches for an appropriate mode of representing its subject matter, and when that is found, it may seem "style-less" to its practitioners (Van Eck et al. 1995). Buck and Stout's classification schemes now seem transparent to conservators; and until the 1980s, stylistic analysis was equally transparent to art historians. In the early twentieth century, their common roots were still visible.

For, in the late nineteenth and early twentieth centuries, the successes of natural science promoted analogizing from nature to culture; for example, art history was modelled on philology (the study of languages), which in turn was modelled on geology and biology. Heinrich Wölfflin's *Kunstgeschichtliche Grundbegriffe* (Principles of art history, 1915) was translated into English in 1932 and became as canonical for American art historians as Stout's and Gettens's works for conservators. Wölfflin's classificatory method traces to nineteenth-century descriptive science, for his father was a classical scholar and philologist. Thus Wölfflin based his search for principles of art history – that is, laws of stylistic change – on A.H. Sayce's *Principles of Comparative Philology* of 1874. Sayce himself stressed that philology, like biology and geology, was both classificatory and developmental (Hart 1981).

An equally important aim of art history in the late nineteenth and early twentieth centuries was ascertaining accurately which works are truly productions of a given artist or school, for, as in biology, classification schemes are not possible without clear descriptions of the specimens under study. Gibson-Wood has documented how criteria of attribution have changed over time. Until the late nineteenth century, citing an authority such as Vasari would certify a work, but collectors and scholars came to rely more and more on internal, visual criteria – which could either be "objective" or dependent on the sensibility of the connoisseur; possession of such sensibility made the connoisseur akin to the artist (Gibson-Wood 1988). Furthermore, collecting had enormous social and cultural significance in the formative period of the Fogg group, and wealthy collectors needed guidance. They found it in famous connoisseurs such as the Boston-raised Bernard Berenson, adviser to Isabella Stewart Gardiner among others.

Berenson's methods trace to those of Sir Charles Lock Eastlake through J.A. Crowe and G.B. Cavalcaselle and Giovanni Morelli (1816–1891). Eastlake's *How to Observe* of 1835 shows the forensic spirit of the Fogg group (Eastlake 1835), while the monumental *History of Painting in Italy* of 1866 by Crowe and Cavalcaselle employed stylistic profiles of well-authenticated works as touchstones for new attributions based on visual and technical comparison with them. The eye of the art historian had become the authority.

Morelli himself had studied medicine and comparative anatomy in his youth and framed an ideal of factual truth and scientific method above personal prejudice and subjective impressions. He regarded accurate attribution as means to the end of writing a systematic history of Italian painting, although he never wrote such a history himself. Rather, he criticized existing histories as being either aesthetic effusions, simple inventories, or histories of culture – their common error being failure to examine actual works. He embraced a biological analogy of adaptation of work to climate and thus believed Italian art should be studied in terms of regional schools. Attribution was critical for this endeavour because incorrect information would lead to a false pattern of development: for this reason, Morelli held that only a connoisseur could write art history. His influence, Gibson-Wood believes, was not so much his famous method of basing attributions on comparison of details, but rather his emphasis on visual rather than textual evidence – in short, stylistic comparison (Gibson-Wood 1988).

Bernard Berenson was the most influential interpreter of Morelli, and he attempted to raise the status of connoisseurship. In *Nine Pictures in Search of an Attribution* he systematized the "detail method": he set criteria for the usefulness of features as indicators of authorship in inverse proportion to their being vehicles of expression, objects of attention, controlled by fashion, and likelihood of being copied. Thus the most diagnostic were ears, hands, folds of drapery, and landscape backgrounds. In fact, in his books on Italian painting he was writing the histories that Morelli planned but never executed: he was making attributional corrections on the basis of scrutiny of the works alone – including the artist's technique as a

"habit of expression" (Gibson-Wood 1988). It is clear that art history by connoisseurship was compatible with comparative studies based on photographic collections as described by Hamber and technical examination by extensions of vision such as macrography, infrared and ultraviolet, and X-radiography (Hamber 1995).

However, Gibson-Wood stresses the tension between the sensibility of the connoisseur, which dovetailed with late nineteenth century aestheticism, and the use of "objective" evidence in post-Morellian connoisseurship. It is this tension between aesthetics and evidence – or style and method – that is lacking in Talley's account of conservation and connoisseurship. Berenson himself produced both aesthetic meditations of the type Morelli despised and long, quasi-scientific "demonstrations" of visual evidence for his attributions. Visual attributions, then, had a twofold effect: they could claim to be "forensic" evidence like technical examination, but they could also be symptomatic of the personal sensibility of the connoisseur. What is significant is that in either case, appreciation of art did not depend on scholarship about "external" factors such as patronage or the social function of artworks (Gibson-Wood 1988).

Connoisseurship by visual evidence was thoroughly compatible with art history based on stylistic analysis, which also eschewed subjectivity and interpretation. McCorkel has shown how art history in the United States, like other academic fields in the 1930s through the 1950s, had a strong anti-theoretical bias and embraced facts and methods instead. "Soundness," "caution," and freedom from value judgements were considered intellectual virtues. For example, in 1944 Samuel Cauman wrote an article called "The Science of Art History"; there he wrote that students wanted "real answers to real questions" (Cauman 1944). Indeed, one recalls the neophytes in Burroughs's course, who so quickly learned not only to solve identification problems but also – or so Burroughs believed – to understand art profoundly.

This apparent understanding gained by purely visual study dovetails with the transition of art history in American academia from a gentlemanly pastime to an academic discipline based on observation and analysis of visible form. This movement reflects the double nature of Berensonian connoisseurship. Berenson the "stylist" spoke to the elitist epistemology of connoisseurship cultivated by the upper classes, in which the ability to understand art was "the rarified perceptual equivalent of culture." On the other hand, his "detail method" of connoisseurship, like Burroughs's X-rays, led towards the "democratic" idea that knowledge about art was accessible to anyone (McCorkel 1975).

The academic popularity of factual art history, whose principal tool was Wölfflinian stylistic analysis, led to the separation of art history and art criticism, which involved "subjective" value judgements. Stylistic analysis, like the natural history of paintings, is an objective, comparative method that tends to isolate the work of art from feelings, meanings, and values. It was no coincidence that the role of professional conservator and the emphasis on art history as the history of art objects developed simultaneously. For, as McCorkel puts it, on this view "the physical object we have and can observe is our primary subject matter."

Conservators have become used to thinking of artworks as physical objects and may ask how this type of art history could be problematic. However, conservators never work in a cultural vacuum, and it is instructive to look at a now-shocking presentation carried out by the conservator and curator at Yale University in the late 1960s: the Jarves collection of early Italian panels, which were stripped of all later accretions and displayed unrestored. The rationale for this kind of presentation, which was clearly based on pure visual values, was articulated by the art historians Richard Offner and Millard Meiss in a symposium on compensation for loss held at Princeton in 1963. Offner stated that most viewers find loss visually disturbing; as he put it, most people prefer the "illusion of completeness," even though authenticity is sacrificed. But, he added, the work of art suffers more when the missing part is replaced, since the restorer must guess without sufficient knowledge. Furthermore, the work of art is only an organic whole when it is the product of a single personality; any restoration is falsification and tantamount to forgery. In a commentary on Offner's paper, Millard Meiss concurred. He noted that when large losses are evident, the naive viewer is shocked: "Uncultivated beholders, or those who look on the run, do not survive this first shock. For those who do, the original shines far more brightly" (Offner 1963). This view ignores

the original devotional purpose of the images and the need of the original viewers to "read" the religious subject matter.

Throughout the twentieth century, European conservators have attempted to reconcile the historical and aesthetic values of artworks. Their successes and failures are a separate story; here the point is merely to show that between 1900 and 1950, when science-based conservation took shape at the Fogg, both "style critics" or connoisseurs and "technical critics" agreed that the way to appreciate art could be purely visual. The result was a de-contextualizing of works of art in exhibitions and in scholarship. Elsewhere I have outlined ways of using technical studies, textual scholarship, and David Summer's conception of "facture" as an index of all the factors contributing to the creation of artworks to re-contextualize them (Keyser 1994). There is no doubt that Talley has a valid point in calling for conservators to return to visual appreciation and aesthetic sensitivity to artworks. But the answer is neither the denigration of the scientific point of view nor a return to purely visual appreciation. We still need visual classification schemes for condition and conservation experiments that produce valid insights into deterioration processes and treatments. And as conservation professionals we also need to join forces with art historians who are engaged in creating new modes of representation of their subject matter: in recontextualizing works of art in their circumstances of production. Several of the presentations at the 1998 IIC Conference on Technical Studies in Dublin show movement in this direction. The result of these efforts will be not a two-dimensional dichotomy that pits physical facts against aesthetic appreciation, but a three-dimensional conversation amongst facts, aesthetics, and historical understanding.

Acknowledgements

Research for this paper was supported by the Social Sciences and Humanities Research Council of Canada.

References

Buck RD, Stout GL. 1939. Original and later paint in pictures. Technical studies 8: 123–150.
Burroughs A. 1938. Art criticism from a laboratory. Boston: Little, Brown & Co.
Cauman S. 1944. The science of art history. College art journal 4: 23–32.
Eastlake CL. 1870 [1835]. How to observe. In: Contributions to the literature of the fine arts, Series II: 199–300.
Gettens RJ. 1952. A quarter-century of technical research in art at Harvard. Unpublished manuscript. Washington, DC: Gettens archive at Freer Gallery of Art.
Gibson-Wood C. 1988. Studies in the theory of connoisseurship from Vasari to Morelli. New York and London: Garland Publishing.
Hamber E. 1995. The use of photography by nineteenth-century art historians. In: Roberts H, ed. Art history through the camera's lens. London: Gordon and Breach: 89–122.
Hart J. 1981. Heinrich Wölfflin: an intellectual biography. Unpublished dissertation. University of California, Berkeley..
Keyser BW. 1994. Saving the significance. Journal of museum management and curatorship 13(2): 130–159.
Laitinen HA, Ewing GW, eds. 1977. A history of analytical chemistry. Philadelphia: American Chemical Society.
McCorkel C. 1975. Sense and sensibility: an epistemological approach to the philosophy of art history. Journal of aesthetics and art criticism 34: 35–50.
Offner R. 1963. Restoration and conservation. In: Studies in western art 4: Problems of the 19th and 20th centuries. Princeton: Princeton University Press: 152–162.
Spronk R. 1996. The early years of conservation at the Fogg Art Museum: four pioneers. Harvard University art museums review 6(1): 1–12.
Stout GL. 1975 [1948]. The care of pictures. New York: Dover Reprints.
Talley MK. 1983. Humanism, restoration, and sympathetic attention to works of art. International journal of museum management and curatorship 2: 347–353.
Talley MK. 1996. Introduction to part I. In: Price NS, Talley MK, Melucco Vaccaro A, eds. Historical and philosophical issues in the conservation of cultural heritage. Los Angeles: Getty Conservation Institute: 2–40.
Van Eck C, McAllister J, van de Vall R, ed. 1995. The question of style in philosophy and the arts. Cambridge: Cambridge University Press.
Weil PD. 1984. "Visually illiterate" and "historically ignorant": the need to re-examine conservation's humanistic foundations. Preprints of papers presented at the twelfth annual meeting. Washington: American Institute for Conservation: 90–102.

Abstract

Mexico has a long history in the conservation of its cultural heritage, yet there is little written about it and that is not systematic. A review of the development of conservation in Mexico is now fundamental to provide the basis for the future, to understand the ethics prevailing in each period, and their evolution according to the way society conceives its own heritage. This paper shows the general evolution of concepts and ethics in different historical periods and describes some specific characteristics of the conservator's role in Mexico. Special emphasis is made on the conservators' professional training, which started with a strong European influence in concepts and ethics. Later the discipline acquired a character of its own, developing a specific point of view, where the conservator is not only a technician but a professional with extensive knowledge in other areas and able to direct multidisciplinary projects.

Keywords

conservation development, Mexico, ethics, archaeological cultural heritage

Conservation in Mexico

Adriana Cruz Lara
Escuela Nacional de Conservación, Restauración y Museografía
Ex-convento de Churubusco
Xicotencatl y General Anaya S/N
San Diego Churubusco C.P. 04020
México D.F.
Mexico
Fax +525 6 04 51 63
Email: polo97@mexred.net.mx

Valerie Magar★
Coordinación Nacional de Restauración del Patrimonio Cultural
Ex-convento de Churubusco
Xicotencatl y General Anaya S/N
San Diego Churubusco C.P. 04020
México D.F.
Mexico
Fax: +525 688.45.19
Email: vmagar@mexred.net.mx

Introduction

In recent times, conservation has gained importance in the cultural field around the world. From a basically pragmatic activity, conservation has become a professional discipline dedicated to solving all problems related to the permanence of cultural heritage. Its field of action has diversified, it has generated its own methodology and it has acquired an interdisciplinary character.

However, in many countries the study of conservation's historical development is still limited. The review of the criteria that have oriented treatments, as well as the materials and methods used must now be the subject of a deep analysis. The kind of heritage we transmit to future generations depends upon such review.

In the contemporary conservation, Mexico has played a relevant role, although it has been quiet these last years. Its extensive and diverse cultural heritage has generated a special interest in its study and comprehension. Conservation has become a tool that enables this heritage to keep forming part of our culture.

The comprehension of the historical development of this discipline in Mexico is now vital to the process of knowledge and transmission of culture in our country. The different theoretical concepts under which conservation has been confronted are a reflection of the way society conceives itself. Throughout history, many ways of understanding and executing conservation have been generated. The way to treat and face objects is related to the different meanings a society gives to the objects produced by it, or by other human groups, in relation to its political, aesthetic, philosophical, religious or economic ideas. Therefore, societies in different periods have established diverse conservation solutions. Only through an understanding of the development of conservation can we know where to direct our efforts.

The present paper is a first attempt to analyse the development of some theoretical and ethical aspects of conservation in Mexico. Some examples of conservation treatments are used to discuss this evolution. Conservation in Mexico from its beginning until today has been deeply influenced by the criteria developed in Europe. However, as we will see later on, it is also possible to speak of a specific development based, on the one hand on different social and economic conditions, and on the other hand on the very peculiar characteristics of our cultural heritage.

Finally, a general description of current principles used in Mexico is given to show why conservation is and must be a professional discipline where conservators have quite a distinctive profile.

★ Author to whom correspondence should be addressed

Development of conservation in Mexico

In Mexico, the study of conservation's development can be considered almost non-existent. However, it is important to mention some authors who refer to this subject, such as Agustín Espinosa (1981), Carlos Chanfón (1988), Salvador Díaz-Berrio (1990), Laura Filloy (1992) and Julio César Olivé (1995). In the following pages, we will present some general aspects of the development of conservation in Mexico.

Prehispanic period

It is hard to know precisely the concepts prehispanic societies had about conservation. However the importance they attributed to the transmission of their history is obvious, in an oral way, through myths, legends, songs and poems, as well as in a written way, on stone, wood, amate paper or tanned skin (Olivé 1995).

When referring to archaeological objects, there are some cases that have been linked with a specific will of conservation. One example is the doweling or the perforation and tying of ceramic vessels with natural fibers, probably with the goal of extending their use. There is also notice of the use of resins, such as copal (Espinosa 1981), and bitumen as adhesives for bonding broken objects.

Another example is the wilful protection of some architectural elements during the realisation of a new construction period, such as the mural paintings from the archaeological site of Cacaxtla, which were protected by the use of a layer of fine sand before placing the new construction materials.

Finally, the finding of artefacts from other cultures, belonging to older times in some sites, such as the presence of ceramic from Teotihuacan (300 AD) in the archaeological site of Templo Mayor (ca. 1500 AD) shows that importance was given to the conservation of valuable objects.

Although none of these examples can be considered as restorations the way we understand the term today, there was a clear desire to conserve and protect objects and materials that must have had an important value, whether ritual, symbolic, or aesthetic.

Colonial period

What we know of conservation during this period, which extended from the 16th to the 18th century, is extremely limited. This probably is related to the fact that during this time attention was focused much more on the production of artefacts, rather than on their conservation. During the first years of Mexico's Colonial period, objects were not only not preserved, they were actively destroyed in the attempt to impose the new ideology. Juan de Zumárraga, the first bishop in New Spain, described more than 20,000 objects and 500 buildings that had been destroyed by 1531. Bishop Diego de Landa ordered another great act of destruction in the Maya area, especially with the burning of codices, which contained essential information to understand those cultures.

It is however important to mention that after the vehemence of destruction, the Spanish Crown decreed through the emission of the Indies Laws that the ruins of prehispanic buildings and the objects they contained were royal property. This could be considered an initial attempt to protect ruins.

Referring to colonial artefacts, one can find some examples of modifications done to objects linked to religious concepts, with stylistic development and with changes of taste during the different periods. Similar to what was done in Europe during the Medieval and Renaissance eras, these were mostly interventions with no link to the idea of authenticity. One can therefore find easel paintings, mural paintings, polychrome sculptures and altarpieces that were completely modified and renovated. Little is known about the materials and techniques used, but several research projects have begun to identify them.

Meanwhile, the collectors of the time were among the first to conserve and protect the remains from the prehispanic past. Among the main collectors one can find the Mexican Carlos de Singüenza y Góngora in the 17th century, whose collection was acquired and extended by the Italian Lorenzo de Boturini in the 18th century.

During the second half of the 18th century, with the arrival of the Enlightenment, the prehispanic past was revalued and considered a validation of the new ideology. Already from 1743, the Spanish government had confiscated from Boturini his collection with the decree that the colonial government had a right over the manuscripts encompassing indigenous history (Olivé 1995). King Charles III, previously king of Naples, had financed the first explorations of Pompeii. He was also enthusiastic about the ruins found in the New World and therefore encouraged expeditions.

The first explorations of archaeological sites began, and Xochicalco and Palenque were two of the most important. It is important to mention that in the 18th century, the New World was seen as a place that had been inhabited by barbarians before the arrival of Europeans. These travels generated knowledge of the sites, but also favoured looting, since a number of artefacts were removed to be exhibited at the Royal Cabinet of Natural History in Madrid. These expeditions created an interest, particularly within the Creole group, to conserve and diffuse knowledge about the remains found. Nevertheless, such interest was limited to the safekeeping of the objects within buildings expressly dedicated to their protection and exhibition (Filloy 1992). Since then, conservation in Mexico has been mainly directed to conserve its prehispanic heritage.

At the end of the 18th century, A. von Humboldt, tried to change the European vision of America. Part of his study was dedicated to archaeological remains, where he gathered as much information as possible in order to establish analogies between culture and art in the Old and New Worlds.

Independent period

Once independence was achieved in 1810, interest in conservation can be demonstrated in a general way through the legislation of the period and through the work of the Mexican Society of Geography and Statistics. In 1825, another important event was the foundation of the Antiquities Board and of the National Museum as means to encourage knowledge and protection of cultural and natural heritage (Olivé 1995). Many decrees and laws for the protection of remains arose, in accordance with the international standards. These efforts were also linked with a growing nationalist feeling, where there was a search for the cultural identity of Mexican society, including an appreciation of the prehispanic past. In 1831 a Conservation Cabinet was created within the museum.

From that decade on, a series of foreign travellers visited Mexico, essentially attracted by the prehispanic past. These travels included a search for knowledge, but also a treasure hunt to find artefacts that could be moved to "more adequate sites". Many of these gave important scientific contributions to many sites, with the publication of plans, observations, studies and engravings, but in return, in what could be considered "scientific looting", they took large numbers of objects to extend European Museums' collections.

On many occasions, the results of these explorations were almost immediately published in Europe, although their translations into Spanish took several years.

The development of the social sciences around the world gave place to the concept of cultural heritage, which in Mexico acquired a specifically anthropological connotation to which conservation has been linked. The anthropological vision was the result of the impossibility for many countries, among them Mexico, to consider their cultural production using Western concepts of works of art.

Espinosa (1981) mentions some attempts by the Academy of Fine Arts to safeguard part of the church's heritage that had been moved from their original locations in the destruction of the monuments that housed them, during a series of social and political conflicts. In the middle of the 20th century, the Academy of Fine Arts began to concern itself with the conservation of its paintings, creating a small workshop for that purpose, where artists who had received some conservation training in Europe worked.

In the 19th century the newly created National Museum and its Conservation Cabinet began to carry out conservation and restoration of many objects from several prehispanic cultures, among which many examples are found today in the National Museum of Anthropology. At that moment, restoration was performed

by a part of the Museum's staff who lacked, in most cases, specific conservation training.

Many of these treatments, especially at the end of the 19th century and the beginning of the 20th, were executed under the supervision of archaeologists who were, for a long time, the only ones to have access to knowledge of those cultures. The role of the conservator was then limited to the technical solutions of problems. In most cases, a complete restoration was done. Many of these restorations would be judged as falsifications according to current criteria even though they were probably made in an attempt to bring back the original state of the objects. This approach to restoration was related to the recently created National Museum, where objects of these "newly" known civilisations had to be displayed in their complete splendour. During this moment, Mexican society was consolidating its identity and prehispanic cultures were seen as one of the pillars of its origins.

The 20th century

With the turn of the century, archaeological excavations executed by archaeologists began. Batres started the explorations of Templo Mayor in 1900 and in 1905 he launched a long project in Teotihuacan. These works initiated a period of extensive archaeological work throughout Mexico, which extended to the middle of the 1950s. During this period, a great number of architectural reconstructions were carried out, while objects were still transported to museums for their conservation. Little *in situ* conservation was performed on artefacts. Only wall paintings were treated *in situ*, and many received a treatment similar to the one accomplished in Knossos, Crete.

In 1939, conservation was institutionalised by the creation of the National Institute of Anthropology and History (INAH), which had as its main objective the conservation, restoration and diffusion of knowledge about the national cultural heritage. A conservation section was created within the Prehistory Department in order to develop a scientific conservation for archaeological materials. All kinds of objects were restored, although in an improvised way at the beginning.

Conservation was professionalized only in 1967 with the creation of the Latin American Regional Centre of Restoration (Churubusco). Its main goal was to train technicians, essentially from Latin America. Many specialists, such as Paul Philippot, Paul Coremans, Agnes Ballestrem, Paolo and Laura Mora and Charles Hett, among others, designed the courses, which included criteria, treatments and materials in vogue in Europe at that time. For a decade, there was a great development of the discipline and an enormous amount of activity.

An interdisciplinary view of the profession was applied, and emphasis was made of the necessity of collaboration among all areas related to conservation to solve specific problems. Standards such as reversibility, stability and minimum intervention were established according to international codes; important agreements were reached concerning the participation of specialists in archaeological excavations.

Apart from the conservation treatments executed in the workshops, some attempts were made to apply *in situ* conservation treatments on archaeological sites. In the beginning, many European recipes and synthetic materials were applied at many archaeological sites. In most cases, the results were unsatisfactory because the long-term behaviour of the new materials was not as stable as in Europe due to different environmental conditions.

The problems caused by the use of these materials made conservators realise the importance of carrying out a profound analysis of the situation. The materials and sometimes even the methodologies had to be modified to obtain results according to the specific type of objects in particular weather conditions. New concepts and methodologies were designed involving the broadening of conservation towards management plans and intensive studies of cultural heritage included its symbolic, historical and conceptual aspects in a variety of social conditions.

However, it is important to mention that these ideas were applied gradually and it was not homogeneous at a national level. Many of the modern professional criteria have not yet been completely assimilated. In many places, conservation treatments are still done by staff lacking professional training who do not use systematic methodologies involving previous study of the objects and materials

used in treatments and thorough documentation of the process. As a matter of fact, although documentation has been considered an important aspect of conservation since the 1960s, its application has been extremely slow. It is therefore very difficult to date conservation treatments.

The current development of conservation has permitted the definition of ethical criteria and standards and conservation procedures, and it has generated new conservation research areas according to the specific problems of the very diverse cultural heritage in Mexico.

The training of professionals is now focused on an integrated knowledge of cultural heritage which allows the conservator to define the state of conservation of each object, in order to establish the most adequate conservation strategy. This involves an interdisciplinary approach which gathers the scientific, technological and historical knowledge of the cultural objects, necessary for their comprehension and treatment. The experience of different specialists, such as historians, scientists, architects, archaeologists and art historians, among others, converges so that the protection of heritage is the result of a series of studies and research. This methodology allows the fulfilment of complete research on the objects. It is then possible to define conservation strategies according to the conceptualisation of the object and in accordance with current ethical criteria which enable maintenance of the authenticity and integrity of cultural heritage.

Final considerations

In a general way, it is possible to suggest that the evolution of conservation criteria, and therefore of the treatments and materials employed, has developed at a different rate throughout the country. In the last three decades conservation has been directly influenced by criteria, materials and methods used in Europe.

The history of conservation in Mexico is yet to be written and it will have to be researched through oral history and through the analysis of restored objects, since the notion of documentation is extremely recent. This paper is a first step, but there is still a need to analyse a larger number of objects and in a deeper way. This will allow us to make generalisations in order to define in a more precise way the tendencies in the history of conservation in Mexico.

However, it is possible to detect the existence of an evolution of conservation towards professionalisation, through the use of interdisciplinary methodologies. Concepts such as the authenticity and integrity of cultural objects have been incorporated as basic principles. Documentation is also considered essential as a recording device as well as a means of long-term evaluation of the criteria, treatments and materials employed.

Nevertheless, it is necessary to emphasise that the adoption of a methodology that includes thorough documentation is not yet standard practice in Mexico. In many cases the attitude is maintained of keeping the guild's secrets regarding the use of materials. Interventions executed without previous study of the object are frequently found.

It is therefore urgent that a code of conservation ethics based on our own experience, and including principles, guidelines and rules to guide the activities of conservators be created. To achieve this code, it will be necessary to define and limit concepts such as restoration, conservation, ethics and heritage, and to reach a consensus on values or the significance of heritage. We therefore make call for interdisciplinary proposals that will allow the writing of a document executed by conservators.

A code of ethics is necessary for the professional work of the conservator, and it is also useful to inform other related professions, which is, and should be the conduct of the conservators. This code will have to show the change that has occurred, from preserving only the physical integrity of the object, to the preservation of all evidences of a material culture, including its meanings.

In addition to a code of ethics, it is fundamental to emphasise differences in the training and application of the conservation discipline in Mexico. Unlike European conservators, who are eminently specialised technicians, in Mexico the conservator is the one who is in charge of the integration of all research around the objects to be restored. The conservator reaches out to other disciplines to request

help in specific questions but he does not depend on any of them. The conservators do the material research and develop the principles that guide conservation themselves, although unfortunately there is very little written on this latter subject.

Finally, it is important to mention that we must now direct our efforts towards the generalisation of professional conservation, where the exchange of experiences with other countries will be fundamental to protecting our common heritage.

References

Chanfon C. 1988. Fundamentos teóricos de la restauración. México: Facultad de Arquitectura, UNAM.

Díaz-Berrio S. 1990. Conservación del patrimonio cultural en México. México: INAH.

Espinosa A. 1981. La restauración: aspectos teóricos e históricos, (Graduate dissertation, Escuela Nacional de Conservación, Restauración y Museografía, Mexico)

Filloy L. 1992. La Conservación de la madera arqueológica en contextos lacustres: la Cuenca de México. (Graduate dissertation, Escuela Nacional de Conservación, Restauración y Museografía, Mexico)

Olivé Negrete JC. (Coord). 1995. INAH, una historia. México: INAH.

Résumé

L'église de Santa Maria degli Angeli à Lugano abrite trois importantes peintures murales du peintre lombard Bernardino Luini (1480/85–1532): *la Crucifixion* sur le mur diaphragme qui sépare la nef du chœur, *la Madone à l'Enfant, saint Jean-Baptiste et l'Agneau* et *la Cène* (1529–1530). Ces deux dernières proviennent du réfectoire de l'ancien couvent des frères mineurs de l'Observance franciscaine de Lombardie (1499). Supprimé en 1848, il fut mis en vente et remplacé par un grand hôtel, aujourd'hui désaffecté. Décidé de sauvegarder ces fresques, le gouvernement tessinois demanda conseil à des experts lombards. *La Madone à l'Enfant* fut détachée en 1851 avec une partie de son support (*stacco a massello*) par Pietro Tatti. *La Cène*, plus abîmée, subit un arrachage de la couche picturale (*a strappo*) par Gallizioli da Brescia. Cette dernière opération est l'un des exemples les plus précoces en Suisse.

Mots-clés

histoire de la conservation, seconde moitié du XIXe siècle, Lugano (Ti) Suisse, peintures murales, dépose, strappo

La dépose des fresques de l'ancien couvent de Santa Maria degli Angeli à Lugano en 1851: Un exemple important de l'histoire de la conservation en Suisse

Marie-Dominique Sanchez
Glérolles
CH-1813 St-Saphorin
Suisse
Fax: +41 21 946 37 92
Email: marie-dominique.cpif-sa@dial.eunet.ch

L'église de Santa Maria degli Angeli à Lugano (1499) est sans doute l'un des monuments historiques les plus importants du canton du Tessin, voire même de Suisse. Elle abrite trois peintures murales de la Renaissance effectuées, entre 1529–1530, par Bernardino Luini (1480/85–1532) pour l'église et le réfectoire du couvent des frères mineurs de l'Observance franciscaine de Lombardie. Il s'agit de l'imposante représentation de la Crucifixion et des scènes de la Passion et de la Résurrection du Christ qui orne la paroi transversale de l'église, *la Madone à l'Enfant, saint Jean-Baptiste et l'Agneau*, inscrite dans un arc (cf. Fig. 1) brisé qui est exposée dans la première chapelle à droite de l'entrée, ainsi que *la Cène* (cf. Fig. 2) située sur la paroi méridionale de la nef. Ces dernières proviennent de l'ancien couvent adjacent à l'église qui, comme tant d'autres, fut supprimé en 1848 par un décret législatif stipulant l'abolition des biens de l'Eglise. Cette loi fut, entre autres, à l'origine de grandes modifications urbaines que connut la seconde moitié du XIXe siècle. Autrefois fondés à la lisière des villes, ces complexes architecturaux se trouvaient peu à peu intégrés dans le tissu urbain et occupaient des terrains très en vue. Situé face au lac, le couvent de Santa Maria degli Angeli fut mis en vente publique en 1849 après avoir supprimé toutes communications entre les deux bâtiments. Il fut acheté en août de l'année suivante pour faire place à un imposant hôtel qui inaugura l'âge d'or du développement touristique de la ville (Marcionetti 1975). Le sort des fresques de Bernardino Luini, propriété de l'Etat, était au centre des préoccupations. En effet, la mise en vente du couvent sécularisé et le projet élaboré par l'architecte lombard Clerighetti pour transformer celui-ci en grand hôtel suscitèrent une grande inquiétude. Comme tant d'autres, elles pouvaient être vendues à l'étranger ou, laissées à l'abandon, se dégrader et disparaître à tout jamais. La beauté et la grâce de *la Madone*, tout comme la qualité de la version de *la Cène* inspirée de l'œuvre de Léonard, à Santa Maria delle Grazie à Milan, faisaient l'admiration des visiteurs. *La Madone de Lugano*, comme on l'appelait à l'époque, fut notamment louée par Jacob Burckhardt dans le récit de son voyage au Tessin en 1839. Selon lui, la beauté de la Vierge n'avait rien à envier aux peintures de Raphaël. Luini était considéré, avec Léonard de Vinci et Gaudenzio Ferrari, comme l'un des artistes les plus importants de l'école lombarde. L'intérêt très vif pour son oeuvre était alors à son apogée non seulement en Italie, mais

Figure 1. Madone à l'Enfant, saint Jean-Baptiste et l'Agneau, *fresque de Bernardino Luini, état actuel (Ufficio dei Monumenti Storici, Bellinzona).*

Figure 2. Cène, *fresque de Bernardino Luini, état actuel (Ufficio dei Monumenti Storici, Bellinzona).*

également en France et en Angleterre. Du XVIIe siècle à la seconde moitié du XIXe siècle, il était prestigieux pour un amateur d'art de le compter dans sa collection. En 1860, *la Gazette des Beaux-Arts* rapporte que Charles Eastlake offrit, pour le compte de la reine d'Angleterre, la forte somme de huit cent mille lires à la paroisse de SS. Salvatore e Magno à Legnano pour acheter le polyptyque de Bernardino Luini (1522). Mais la vente échoua. Beaucoup d'œuvres furent attribuées à Luini souvent à tort, élevant leur nombre à sept cents pièces (Binaghi 1996). Cette popularité eut des conséquences néfastes pour certaines fresques. Très recherchées sur le marché, elles furent détachées de leur lieu d'origine, fragmentées et dispersées. Ces déposes non seulement isolèrent les représentations de leurs contextes monumental et historique mais en altérèrent souvent la surface. Des panneaux sur bois de l'artiste connurent le même sort. Ce fut notamment le cas de la pala Torriani de Mendrisio, au Tessin (1522) qui fut vendue en 1796, et qui est aujourd'hui dispersée (Dell'Acqua 1975).

Cet engouement pour l'œuvre de Bernardino Luini ne fut sans doute pas étranger à la sauvegarde des peintures de Santa Maria degli Angeli à Lugano. Certainement conscientes de l'impact historique et artistique de ces œuvres, les autorités tessinoises prirent la décision de les détacher. Désirant transformer l'église en pinacothèque cantonale, elles les exposèrent dans l'église où se trouvait déjà la magnifique paroi monumentale (Marcionetti 1975). Réunies sous un même toit, ces œuvres formaient un joyau exceptionnel qui pouvait être admiré de tous.

Le gouvernement tessinois devait agir au plus vite afin que la dépose des peintures de l'ancien réfectoire soit effectuée avant le début des travaux de construction du grand hôtel. Dès le mois de septembre 1850, il contacta des spécialistes de la restauration à Milan, plus particulièrement le directeur de l'Académie de Brera, le comte Ambrogio Nava (1849–1855). A la suite d'événements politiques et militaires, ainsi que des changements économiques, la Lombardie était le centre de nombreuses campagnes de dépose de fresques au début du XIXe siècle. Elle avait notamment connu différentes suppressions de biens ecclésiastiques en 1718, 1783, 1805 et 1811 (Natale 1993). La richesse de son patrimoine artistique séduisit les autorités napoléoniennes, puis autrichiennes qui occupèrent la Lombardie. Souvent dans un état de conservation précaire ou en danger de destruction les objets d'art les plus divers furent amenés à Milan pour constituer la collection de la pinacothèque de la Brera. Les peintures murales à sujets profanes ou sacrés furent détachées de leur lieu d'origine. L'opinion générale d'alors préférait conserver les œuvres d'art dans un musée ou une galerie plutôt que de les voir se délabrer sur place. C'est ainsi qu'entre 1811 et 1821, parallèlement à la promulgation d'une loi sur la tutelle du patrimoine artistique, les plus grands cycles de fresques, de Bernardino Luini notamment, furent détachés. Ce fut le cas des peintures de Santa Maria delle Vetere (c.1505) et Santa Maria della Pace (1514) à Milan, ainsi que de la Villa Pelucca à Monza (1522–1523). Trois types de technique de dépose, effectués par des *estrattisti*, étaient en vigueur à l'époque. La plus ancienne, l'arrachage de la peinture avec tout ou une partie de son support (*stacco a massello*), est décrite par Vitruve dans *De Architectura* et par Pline l'ancien dans *Naturalis Historiae*. Elle avait été notamment utilisée au XVIIIe siècle lors des spoliations napoléoniennes et des découvertes à Pompei. Particulièrement appropriée pour les peintures souffrant de l'humidité, présentant une surface irrégulière ou réalisée directement sur la pierre (Mora et al. 1977), elle avait déjà été employée au début du XVIIe siècle pour détacher une œuvre de Bernardino Luini (1527). Appartenant au cycle peint de la chapelle du couvent des frères mendiants de Barlassina, cette fresque représente la Madone à l'Enfant, saint Jean-Baptiste, saint Antoine l'Abbé, saint Martin et d'autres saints. Très endommagée, elle fut sauvegardée à la demande de l'évêque de Milan, Frédéric Borromée (1564–1631), qui était un grand admirateur de l'artiste lombard. Elle fut déposée et transférée entre 1613 et 1623 dans la chapelle de l'Aiuto à l'église paroissiale San Giulio de Barlassina après avoir été divisée en trois panneaux de 1,60m × 1m pour faciliter le transport (Gatti Perer 1989). La seconde technique (*stacco*) est une dépose de la peinture et des couches de l'enduit sous-jacentes. Le troisième procédé consiste à ne détacher que la pellicule picturale (*strappo*). Il ne peut être appliqué qu'à des œuvres réalisées à bonne fresque (Mora et al. 1977). Cette technique, prônée entre autres par Giovanni Secco-Suardo, avait été développée au XVIIIe siècle par Antonio Contri

Figure 3. Madone à l'Enfant, saint Jean-Baptiste et l'Agneau, *fresque de Bernardino Luini, état après dépose et restauration (Ufficio dei Monumenti Storici, Bellinzona).*

(Conti 1988). Elle suscita des polémiques de la part des partisans du stacco qu'ils trouvaient plus sûr. Elle obtint cependant la préférence car elle avait l'avantage de faire découvrir le dessin sous-jacent (*sinopia*) et de libérer la couche picturale d'un enduit souvent en mauvais état. Les transformations que subit la capitale lombarde et le délabrement de certaines œuvres nécessitèrent le développement d'une technique de dépose rapide et simple comme celui de l'arrachage de la couche picturale (*strappo*). L'un des spécialistes en la matière au début du XIXe siècle, était Stefano Barezzi da Busseto. Voyant l'état critique de *la Cène* de Léonard de Vinci à Milan, il proposa en 1821 d'en entreprendre la dépose. Méfiante, la Commission responsable des biens culturels, lui imposa de faire des essais sur les œuvres de Luini à la Villa Pelucca, à Monza, qui souffrait de l'humidité. Il y a peu d'informations sur la technique et les matériaux utilisés. Toutefois, la dépose de la couche picturale, divisées en plusieurs morceaux, se fit à l'aide d'une fine toile collée à un support de bois avec un mélange de gesso, de colle animale, de lait et de chaux (Autelli 1989). Le résultat final ne fut pas un succès total (Secco-Suardo 1866). Il y eut de nombreuses pertes notamment au cours du lavage à la potasse, effectué avant la dépose, en particulier dans les parties peintes à sec. Ce fut le cas pour la représentation de la Naissance d'Adonis.

Le Comte Ambrogio Nava (1791–1862), peintre et architecte dilettante, remplit de nombreuses charges à Milan et en Italie. En 1830 notamment, il avait été nommé administrateur du dôme de Milan qui faisait l'objet d'importantes restaurations. Enthousiasmé par les peintures murales de Bernardino Luini à Lugano, il conseilla de les faire déposer. Pour ce faire, il proposa, dans une lettre du 31 décembre 1850 adressée aux autorités tessinoises, que le vice-assistant des travaux de restauration du dôme, Pietro Tatti détachât la fresque de *la Madone* avec une partie du support (*a massello*). *La Cène*, quand à elle devait être arrachée avec la couche picturale (*strappo*). Les deux œuvres étaient ensuite transposées sur toile (ACB, 1850–59). Le travail de *strappo* devait être réalisé par Giuseppe Knoller, restaurateur à l'Académie de Brera.

La représentation de la Madone à l'Enfant, inscrite dans un demi-cercle (cf. Fig. 1), se trouvait au-dessus de l'une des portes d'accès au réfectoire. Un procès-verbal de la visite effectuée sur place par Pietro Tatti indique qu'avant son transfert, la lunette était dans l'ensemble semblable au premier jour de sa réalisation à l'exception des deux grandes fissures visibles sur la surface de la fresque (cf. Fig. 3). La première s'étend, de gauche à droite, de la tête de l'Enfant au sommet de la croix de saint Jean-Baptiste, en passant au-dessus des yeux de la Vierge. La seconde, perpendiculaire à la précédente, part du bas de la peinture; elle passe par la poitrine de la Vierge avant de se séparer en deux plus fines craquelures, assez peu perceptibles. L'une d'elles traverse le pouce de la main gauche de la Vierge et se termine vers le bras de saint Jean Baptiste tandis que l'autre s'étend au bas de l'œil gauche de Marie (ACB 1850–59). Tatti effectua avec succès la dépose (*a massello*) de la Madone en mars 1851. Giuseppe Knoller, sans doute peu spécialisé, procéda à quelques essais peu concluant et, craignant d'abîmer *la Cène* qui lui avait été confiée, renonça à l'entreprise. Cette tâche fut attribuée à Bernardo Gallizioli, un restaurateur de Brescia, qui était plus à même de mener la délicate opération. Celle-ci eut lieu en septembre 1851 et dura 10 jours (Martinola 1944). Ce *strappo* marque un moment important pour l'histoire de la restauration et la conservation en Suisse car il s'agit d'un exemple particulièrement précoce de l'utilisation du procédé mis au point à partir du XVIIIe siècle en Italie du Nord. Le célèbre restaurateur de Bergame, Giuseppe Steffanoni, effectua en 1866 celle des peintures recouvrant les voûtes de l'abside de la chapelle des Maccabées de la cathédrale Saint-Pierre à Genève puis, en 1899, celles de la Chiesa rossa d'Arbedo au Tessin et de l'église Saint-Michel de Zoug (el-Wakil et Hermanès 1979). Sa technique consistait à se servir d'une toile de chanvre et une toile de calicot fixées par de la colle pour détacher une fine couche picturale qu'il collait sur un nouveau support composé de deux couches de toile de chanvre imbibées de caséate de chaux. A partir de 1845, Gallizioli, en collaboration avec Ambrogio Nava, procéda au détachement des *Noces de Cana* de Callisto Piazza qui se trouvaient dans le réfectoire cistercien de Sant'Ambrogio. Il réalisa en 1847 avec succès les déposes des fresques de Santa Maria dei Servi, à Milan. Plus tard, en 1860, il effectua celles du cycle franciscain du peintre Scipioni dans la chapelle Casotti Mazzoleni à Santa Maria delle Grazie à Bergame. Il fut également

célèbre pour la transposition de la fresque représentant une Scène de tournoi à Brescia, aujourd'hui conservée au Victoria and Albert Museum, à Londres (Conti 1988).

La fresque de *la Cène* (cf. Fig. 4) était située sur la paroi qui séparait le réfectoire de la cuisine. La partie gauche, de dimensions plus petites que les deux autres, était placée au-dessus de la porte qui communiquait entre le réfectoire et la cuisine. Les dimensions précises nous sont fournies dans une lettre du 7 août 1851 envoyée par l'ingénieur en chef à l'inspecteur des travaux publics du canton (ACB 1850–1859). La longueur totale de la paroi sur laquelle se trouve la représentation de *la Cène* est de 6m. Le premier pan, situé au-dessus de la porte de communication interne, mesure 0,80m × 1,40m, celui du milieu 2,34m × 1,70m et le troisième 1,40m × 1,70m. Le rapport ajoute des renseignements d'importance, à savoir qu'entre les différents panneaux il y a l'espace pour une colonne de 0,34m. De plus, au-dessus des trois arches arrondies d'une hauteur de 1m, se trouvent des peintures considérées sans valeur (ACB, 1850–59). Aucun document ne mentionne avec précisions les différentes étapes des travaux. On peut supposer que Gallizioli procéda à Lugano, de la même manière qu'à Santa Maria dei Servi, en appliquant une toile sur la peinture à l'aide de colles solubles dans l'eau au lieu de substances huileuses comme le faisait Barezzi (Autelli 1989). Toutefois, la composition visible aujourd'hui semble incomplète. Si l'on croit les descriptions de Burckhardt (1839) et le rapport rédigé le 18 septembre 1851 par Gallizioli (Martinola 1944), les scènes de la partie supérieure auraient été supprimées. Il pourrait s'agir des épisodes du Sacrifice d'Isaac et la Prière au Jardin des oliviers, qui sont reproduits dans le fond de *la Cène* de Sant' Ambrogio à Ponte Capriasca (circa 1565). Elles semblent avoir été perdues à jamais, tout comme les éléments architecturaux mentionnés de façon ambiguë. En effet, la phrase – *fra un quadro e l'altro havvi una larghezza ad uso di lesena di M. 0,34* – peut prêter à confusion. Car elle indique que la largeur entre les panneaux est semblable à la largeur de deux colonnes sans en confirmer leur existence. Disparues aujourd'hui, ces éléments de séparation entre les apôtres sont cependant visibles dans une reproduction de l'œuvre (cf. Fig. 5) publiée en 1892 et 1899 (Marazza 1892: Chiesa de Santa Maria degli Angeli 1899). Ces colonnes auraient fait partie d'une loggia analogue à celle de l'œuvre de Andrea del Castagno à Sant'Apollonia à Florence (Di Lorenzo 1994). On ne sait s'il s'agit de repeints ou si elles furent supprimées lors d'une précédente restauration: les trois arches

Figure 4. Cène, *fresque de Bernardino Luini, après dépose et restauration (Ufficio dei Monumenti Storici, Bellinzona).*

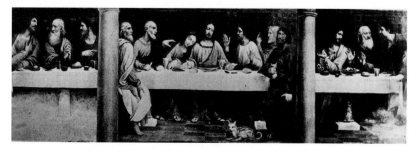

Figure 5. Cène, *fresque de Bernardino Luini, état en 1892 (Ufficio dei Monumenti Storici, Bellinzona).*

composant le haut de l'architecture ayant été considérées sans valeur, ces éléments architecturaux n'avaient plus de raison d'être (cf. Fig. 2). On ignore également le rôle joué par Attilio Steffanoni lors de son intervention sur *la Cène* en 1891. En effet, selon une facture du 21 septembre conservée dans les archives de la famille du restaurateur, il réalisa le rentoilage de la Cène de Bernardino Luini à Santa Maria degli Angeli pour la somme de L.1800.00 (Archives Steffanoni, A. 137).[1] Malheureusement les archives de Bellinzona ou de Berne consultées ne semblent contenir aucun document à ce sujet.

L'épisode de la dépose des peintures murales de Bernardino Luini à Santa Maria degli Angeli en 1851 ne marque pas seulement une étape importante de l'histoire de la conservation en Suisse pour la précocité de l'emploi du *strappo* mais il représente également le début d'une longue série de restaurations qui se dérouleront plus particulièrement de 1858 à 1930. Devenu un véritable emblème historique, artistique et politique, l'église de Santa Maria degli Angeli fut l'objet de grandes interventions visant à préserver, dans la mesure du possible, l'un des plus beaux joyaux de l'art renaissant en Suisse.

Remerciements

Je tiens à remercier le professeur Mauro Natale du département de l'histoire de l'art à l'Université de Genève, Monsieur Théo-Antoine Hermanès, restaurateur, directeur des Ateliers Créphart à Genève et Monsieur Mario Agliati, directeur des Archives cantonales de Bellinzone pour m'avoir aidé à mener à bien cette recherche.

Note

1. Le texte de cette facture m'a aimablement été communiqué par le professeur Mauro Natale.

Références

Archivio Cantonale di Bellinzona 1850–1859. Diversi 861. Incarto relativo alle restauri, ripulitura e trasporto sulla tela degli affreschi del Luini nella chiesa degli Angioli. Lugano.

Archives Steffanoni A. 137. Collection privée. Comptes manuscrits A, 137. Bergamo.

Autelli F. 1989. Rimonizione: notizie storiche e fortuna critica. Pitture murali a Brera. Milano.

Binaghi Olivari MT 1996. Luini Bernardino. Dictionary of Art. London. Vol. 19.

Burckhardt J 1839. Meraviglie del Ticino. Trad. L. Farulli. Locarno 1993.

Conti A. 1988. Storia del restauro e della conservazione delle opere d'arte. 2e edition. Milano.

Dell'Acqua GA 1975. Introduzione al Luini. Sacro e profano nella pittura di Bernardino Luini. Catalogo. Luini 9.VIII–8.X.1975. Milano.

el-Wakil L, Hermanès Th.A. 1979. Restauration de la chapelle Notre-Dame des Macchabées à Genève. Unsere Kunstdenkmäler. Jahrgang XXX.

Gatti Perer ML. 1989. Saggio introduttivo. Pitture murali a Brera. Milano.

Marcionetti I. Chiesa de Santa Maria degli Angeli in Lugano. Lugano.

Marazza A. 1892. Cenacoli di Gaudenzio Ferrari. Archivio storico dell'Arte, V: 145–175.

Martinola G. Distacco e restauro degli affreschi del Luini a Lugano nel secolo scorso. Bollettino storico della Svizzera Italiana.

Mora P. et al. 1977. Conservation des peintures murales. Bologne.

Natale M. 1993. Primato bergamasco: dépose des peintures murales et histoire du goût. Histoire de la Restauration en Europe. Actes du Congrès international. Histoire de la Restauration. Bâle 1991, vol. II. Worms.

Secco-Suardo G. 1866. Manuale ragionato per la parte meccanica dell'arte del ristauratore deu dipinti. Milano.

Abstract

Among the most important written sources in German in the field of conservation science is a small booklet, unfamiliar to many professionals today: *Über Ölfarbe* (Concerning oil colours) written by Max von Pettenkofer in Munich in 1870. This publication will appear in 1999 as a commented reprint by the Enke-Verlag, Stuttgart. Two reasons led to its re-edition: Pettenkofer's publication is difficult to find today, and its relevance to the history of restoration makes it a useful reference for future conservators. As the reprint will also address the younger generation, all technical aspects of the method will be translated into modern terms in the annex. This paper will provide international colleagues with a brief review of the book and a short version of the preface by the author.

Keywords

history of restoration, science, Pettenkofer, regeneration

The reprint of Professor Max von Pettenkofer's 1870 publication *Über Ölfarbe*

Sibylle Schmitt
Nonnenwerthstraße 14
G–50937 Köln
Germany
Email: b1016@mail.dvz.fh-koeln.de

Pettenkofer's publication *Über Ölfarbe* (Concerning oil colours) provoked a long-lasting and widespread use of the process of regeneration. The history of the Pettenkofer process was briefly published by the author earlier (Schmitt 1990). Pettenkofer's discoveries as well as criticism and official acknowledgements therefore will not be repeated in this article; nor will evolving changes in conservation practice be described.

Pettenkofer's fundamental and detailed reflections on the subject involved many technical, ethical and cultural considerations and thus resulted in a highly relevant document for his time. This paper intends to present Max von Pettenkofer as an early scientist of the 19th century, give insight into the background of the historic debate and outline the role of the Pettenkofer process in restoration history.

From the title *Über Ölfarbe* the reader would expect information about oil colours, but this publication must be considered a contemplative reflection: Pettenkofer indeed posed fundamental questions about the artist's materials, oil colours and varnishes, even considering the aesthetic and optical functions of oils. In a few pages he reflected on the composition and technical properties of 'paint substance', but this concern does not lead far. A modern reader may feel puzzled that this technical investigation is not elaborated upon, but basically *Über Ölfarbe* is a retrospective of a kind of 'German cleaning controversy'. The main role of the book is to make quite a personal contribution to a long lasting dispute about a conservation method that Pettenkofer claimed to have invented himself: 'the regeneration process'.[1] Pettenkofer used vapours of *Weingeist* (ethanol with a 20% water content) and copaiba balsam[2] to restore the transparency of 'blanched' paintings. The process was published in 1864 and parts of it were strictly criticised from the start. Besides material quality, technical details and aspects of aging, juridical and economic factors enlarged the discussion. This debate was taken up not only in Germany, but also in Austria, Switzerland, The Netherlands and the United Kingdom, in the daily press and professional journals and via exhibitions in Munich. In the end Pettenkofer received official acknowledgement in and outside of his own country.

Publication

In half of his volume Pettenkofer detailed the entire history of his involvement with regeneration. He divided his text loosely into four chapters. Having introduced the reader to the material proper, he started with 'the process of regeneration and its foundation'. He explained his function, and disclosed his concept and experiments, which he exercised on dummies and originals. Separate steps of his procedure serve to support and illustrate his approach. Pettenkofer concluded the first part with the consideration of preventive measures for climate control. In the second chapter Pettenkofer thoughtfully analysed his critics; quoting whole passages from newspapers and then criticizing their arguments in detail, he confronted them with the superiority of his method. Further chapters are shorter and more focussed. It is illuminating to read his comments in the third chapter, which outlined the practice and ethics of paintings conservation seen through the eyes of an early scientist trained in medicine: diverse purely empirical practice and a low level of

professional (theoretical) understanding. In the end he was his own advocate. In the last chapter he defended the financial benefits he had reaped from patent rights in Germany and Great Britain, finally selling his rights to the Bavarian State. The annex is composed of two earlier complimentary statements and a list of successfully regenerated paintings; together they offered strong and efficient support. The entire report of the Munich Control Committee, reproduced in the annex, acknowledged Pettenkofer as a legitimate expert in the field of paintings conservation.

In 1865 the Pinakothek considered frequent regeneration treatments necessary; treatments were ordered for over 1,000 paintings. As patent fees involved an enormous expense for the museum for over 16 years, the administration finally established a permanent post solely devoted to regeneration.

Über Ölfarbe was edited by the famous Vieweg & Sohn in Braunschweig, in 1870. One year later W. A. Hopman, a Dutch conservator, translated the book which was published in The Netherlands in 1871.[3] This author carried out a precise, almost word-for-word translation, but in contrast to Pettenkofer saw no reason to blame the authorities for improper care of the paintings. Hopman chose tactful additions to explain all details relevant to conservators. In particular, his own successful experiences with the application of copaiba balsam to linings, made him a strong promoter of the Pettenkofer process.

In Germany *Über Ölfarbe* was reprinted in 1872 and the second edition followed in 1902. By the beginning of this century the need for further editions ended because the process was taken up by almost every publication in the field.

The author

Max von Pettenkofer was one of the leading German scientists of the 19th century; his works on typhus and cholera made him famous throughout Europe. Born in 1818, he studied natural science and philosophy in Munich; in 1843 he was approved in pharmacy and simultaneously completed his dissertation in medicine. This training in both fields gave him a decisively superior qualification.[4] In 1865 he became professor of hygiene and established the first German institute on this subject in 1879. In so doing he fulfilled his idea to found a scientifically based public human health care service. His deep reflections on the cholera and typhus epidemics in Munich around 1850 led him to modern insights on public health, involving concerns of clothing, ventilation and heating. Consequently he fought for the creation of a public canal system in Munich and successfully limited the death rate. In about 1860 he investigated assimilation (metabolism) with C.v.Voit (environmental studies) and did biochemical research as well as technical chemistry. For his scientific exchange he travelled throughout Europe and maintained international correspondence. His remarkably innovative knowledge and broad experience resulted in many acknowledgements, not least his being made president of the Academy of Science in Munich. Suffering long lasting bad health Pettenkofer put an end to his life in 1901.

Pettenkofer is considered a predecessor to the establishment of modern natural science as a professional discipline. Colleagues honoured him for his quick thinking faculties. His speciality was revising known procedures with strict methods and simultaneously establishing practical applications.

Paintings conservation and Prof. Max von Pettenkofer

It is striking that the medical doctor Pettenkofer became engaged in a completely different field. To explain this early incursion of a scientist into the field of paintings conservation it is revealing to look back on some aspects of cultural affairs in Munich. In the 19th century, intellectual, technical and economic developments at all levels changed rapidly and provoked a general fight for new values. In Pettenkofer's time King Ludwig I followed the example of his father, Max I, who had strongly promoted the arts and sciences, making several fundamental improvements in Bavarian culture and politics, which contributed to an intellectual renewal. For a long period Munich had persisted as a traditional provincial centre, then was raised to the status of a modern town equal to Berlin and Vienna. The

Academy of Science was given a monopoly as the elite state service; it had significant meaning as an intellectual and social forum and became an important centre for scientific work. Here new disciplines formed, such as the Institute for Hygiene set up by Prof. Pettenkofer. Many other disciplines followed and were gradually established in the academic world. The whole field of science changed dynamically, strongly influenced by its interaction with the beginning industrial revolution.

Judgement of conservation treatments also shifted considerably in the 19th century. Ideas were influenced by manifold art styles and strongly defined by personal convictions, but the harmonic appearance of an artefact prevailed in all discussions. As with debates on painting technique the general orientation was ruled by an aesthetic ideal, making lucidity and brilliance the preeminent category.[5] This judgement dominated the evaluation not only of actual artistic expression but also of all earlier paintings, from renaissance times to the 18th century. Another concern was the state of preservation of antique and medieval artefacts; people praised their painting technique and tried to replicate them in test series. Investigation or analytical approach in the modern sense existed only in very early stages.

The clear interest in conservation of paintings was heightened by a uniform fear about the 'loss of painting technique', which was based on two problems. As the Academy of Fine Art no longer offered training in painting technique, young artists were not schooled in preparing a stable, long-lasting paint structure. In addition, the early industry of oil colours in tubes was not reliable in quality (Wagner 1988). Artists and connoisseurs considered these to be severe and persistent risks because they regarded contemporary art production as an essential contribution to the national artistic heritage.[6]

The care of old paintings was of equal concern; whereas the technical execution of repairs was often considered less important – and therefore left to craftsmen – restoration of the image held very high expectations. In the first half of the century alterations due to ageing and especially losses could not be tolerated and had to be restored in every case (Hampel 1846). Even highly altered and damaged paintings had to be 'cured' completely. The aim was to give them back a fresh appearance, as if they had come straight from the master's hand. Being trained as painters, conservators had no problem fulfilling this task: having copied old masterpieces extensively, they felt prepared for reconstruction.

A case study of the restoration of a Holbein panel shall serve as an example. The famous German conservator from Augsburg, Andreas Eigner, was asked to remove earlier additions from the panel painting. Discovering it to be in a ruined condition he proudly used his visional abilities to recreate the integrity of the damaged painting. Applying vast overpaintings, he believed he had given life to the Renaissance painter and placed himself in the role of Holbein. At the same time he not only denied the ageing processes but also imposed his own identity as an modern artist (Griener 1993). Carrying out recreations of old masterpieces was common practice in this eclectic period. The concept of presenting artefacts in an unaged state resulted quite often in such manipulations. Excessive and often wilful changes contributed to a shift in opinion, and by the middle of this century overpaintings were criticised as window-dressing and the documentary importance of the painting was stressed. When Eigner had to document his treatment, he faced a dilemma and finally used the expression 'only mended' (retouched) to hide his overpainting. In essence no 'restaurator' of that period would have had the means to prove that the ruined condition he found was not a result of his own intervention. The personal conflict between Pettenkofer and his adversary Eigner serves as a good example of the discrepancy in technical equipment, status and cultivation of these representatives of both disciplines and illustrates the lack of organised training in the conservation field.

Pettenkofer entered the field of conservation in 1863, right at the time these convictions were changing. He was asked that spring to join a committee for the inspection of restored paintings, which had been convened by the Bavarian king in 1861 in direct response to critical newspaper reports which had raised the question of improper treatment of national cultural property. It is significant that no 'restaurator' was appointed to the committee. In early 1863 this authoritative

body concluded its inspection with the decision to submit every future conservation treatment to a control.

In May the Committee's duty was to find an explanation for the appearance of the white surfaces on paintings in the Royal Filial Gallery in Schloss Schleißheim near Munich. The objects of concern were a series of delicate Netherlandish 17th century genre paintings, for which traditional conservation treatments were considered to pose too great a risk. The painters, philosophers and art historians on the committee could not solve the problem. Being scientifically skilled and equipped with a high magnification microscope, the scientists were able for the first time in German restoration history to establish clearly the difference between mould and layer separation, today commonly called 'blanching'.

Pettenkofer thought it necessary, however, to understand more completely the underlying principle of cause and effect. Additionally, pushed by criticism, he began experiments to find a practical solution for all blanched paintings. Pettenkofer advertised his invention of a vapour treatment as the promise of an untouched restoration, but secretly made use of traditional means: in the case of persistent layer incoherence, especially blanching of oily compounds in varnish and/or binding media he did not know of a single suitable solvent. He reverted to traditional impregnations with balsam of copaiba and chose a special species from Parà, a solution of 10% leguminosae resin (diterpenoids) in its natural volatile oil (sesquiterpenes). The high content of volatile oil led to Pettenkofer's argument that it was an almost completely evaporating 'solvent' and therefore he need not declare its use. The use of copaiba balsam appeared to Pettenkofer to be a safeguard for old and new paintings suffering from the ravages of time.

Copaiba balsam had traditionally been added to solvent mixtures and was advised for use as an embrocation by Lucanus in 1828. No wonder painter-conservators considered its use for regeneration as a simple variation and did not accept Pettenkofer's claim to patent rights in this respect. Furthermore they had difficulty accepting a pharmacist and scientist who had been acknowledged in their field. Criticism regarding the properties and effects of copaiba balsam was precise and well-founded. The many papers on this topic demonstrate a much greater variety of opinion than appears in contemporary instruction. In spite of all the objections raised against his method as early as 1863, in *Über Ölfarbe* Pettenkofer still recommended complete impregnation even as a precautionary measure. Today the recommendation to impregnate paint structures as a whole appears parallel to the emphasis on mummification, which at that time was considered a guarantee for survival of artefacts.

In his retrospective Pettenkofer enlarged the debate within the framework of his universal knowledge. Apart from his invention of a vapour treatment, he lectured on physical processes – his remarks on the drying process of varnish, paints and alteration due to aging and decay are remarkably modern. In a surprisingly systematic manner he determined the main reasons for paint film defects at the time to be bad climate conditions. His conclusions are based on series of laboratory tests, reconstruction tests on 'dummies' and on real paintings. His arguments clearly show his knowledge not only in the field of early colloid/pigment chemistry but the physical effects of climatology. One hundred years ago he pointed out the principles of preventive conservation, and listed the risks of air pollution and damage due to light and moisture. He reluctantly documented his own regenerations before and after treatment. Possible defects arising from varnish removal are not discussed solely on the basis of individual ability – as most of his contemporaries did – but are focussed on the chemical and physical properties of the material involved. Pettenkofer's contribution to the field of conservation in Germany was that of a pioneer; in the history of conservation he is rightly assumed to mark the beginning involvement of science.

In that period as now, an author would fight for his ideas in a very personal fashion, as Pettenkofer did in his small book. He complicated the development of his ideas with rhetoric which might confuse the modern reader. Nevertheless, promoting his ideas with clever arguments and using an endlessly fascinating style, at once vivid, humorous, proud and convincing, makes *Über Ölfarbe* an illuminating and amusing piece of literature.

Acceptance of the Pettenkofer process in conservation

Instructions for paintings conservation published after *Über Ölfarbe* show that general acceptance of the method followed quickly, spreading widely and in most cases without reservation. Not least it held an attractive promise to prevent damage in old and new paintings by precautionary impregnations with copaiba balsam. The German translation of Bouvier's famous artist's manual in 1875 was published with an appendix on restoration written by Erhardt. With its detailed description of Pettenkofer's process almost verbatim and bestowing it with great praise, this leading publication marked its generally enthusiastic reception in German restoration history. The sixth edition in 1882 noted the one disadvantage of a closed wooden box, which hindered control of the process and often resulted in excessive softening of the colours. Ten years later Ludwig pointed out that success of alcohol treatment often was only provisional and explicated the negative alterations of copaiba balsam on ageing. Keim repeated this criticism in 1903.

Imitation of the process was inevitably accompanied by variations and misunderstandings as well. In 1874 Bezold did not understand the use of alcohol as vapour; Eigner blamed hot alcohol vapours as involving too much risk. Büttner-Pfänner zu Thal published the 'Pettenkofer process' in 1897 with long-lasting success (and therefore with grave consequences). He mixed copaiba balsam with non drying vaseline oil and volatile oils, called it 'Phöbus' and advised the use of chloroform instead of alcohol. This solvent would soften all oil colours to a degree, which allowed the painting process to continue. In 1921 Basch-Bordone gives another drastically exaggerated example; in case of frequent need he imagined highly efficient mass vapour treatment of paintings filling entire closed chambers. The brisk demand for regenerations was obviously not due only to actual need, although the installation of hot air heating in the last decades of the 19th century may have increased climatic problems.

In 1900 the new Minister of Cultural Affairs, Gresser, decided to arrange a series of lessons on the regeneration of paintings, despite the profound reservations of Foltz, the Director of the Pinakothek. In his late eighties Pettenkofer began to teach ambitious pupils of the Academy of Fine Arts. From 1900 on almost every instruction mentioned the process; often they contained a separate chapter for its description and illustration, e.g. Frimmel 1904, Eibner 1908, Berger 1910, Fischer 1911, Goetz 1916, Martin 1918, Schulze-Naumburg 1920, Secco-Suardo 1927, Eibner 1928, Doerner 1936, manual of O.I.M. 1938.

A series of articles by Prof. Dr. Alexander Eibner marked a turning point in the acceptance of the process. In 1908 Eibner gave detailed information about the numerous species of copaiba balsam and their wide range in quality and gave hints that enabled the consumer to evaluate their quality. This was necessary because the trade had not developed any criteria or controls. In the 1920s actual research served Eibner with arguments that had been missing in earlier debates. In 1928 Eibner for the first time related Pettenkofer's activities to past restoration history, carefully discussing the advantages and disadvantages.

Until the late 1940s in Germany copaiba balsam was often used as an unpolar solvent, swelling oily compounds in dull varnishes and colours in order to prevent the risk of contact with alcohol. Its negative properties, often reinforced due to unreliable quality, have been criticized from the start. Today pure balsam has disappeared from the market and is replaced in conservation by an increasing number of other solvents. With technical innovations, the use of solvent vapours became standard procedure in modern conservation practice, not always taking into account known problems of long retention and mostly without the possibility of investigating in detail the reasons for 'blanching'

From about 1990 on, new findings on the ageing process of paint structures in artefacts has led to a reevaluation of conservation methods, allowing an understanding at the molecular level. Actual study by the author proved for the first time that alternating exposure to *Weingeist* and copaiba balsam may spontaneously lead to drastic dislocation of paint particles. Reconstruction in naturally aged paint films provoked the same phenomena, which have been observed in paintings submitted to regeneration in the past (Schmitt and I.van der Werf 1996, 1997, 1998).

Archives show that thousands of paintings were submitted to 'regeneration', but details of treatment have rarely been documented. Thus the probable addition of copaiba balsam or even other additives is hidden for a large range of paintings. For this reason regeneration treatments remain a conservator's concern and interest in their effects is likely to expand. Discussions about regeneration as a means of conservation continue to be controversial. In addition to the historical dimension, *Über Ölfarbe* contributes to critical consideration of the treatments of 'blanching' that remain relevant today.

Notes

1. Later the shortened term 'Pettenkofer Process' was introduced in professional language, in German even the verb 'pettenkofern' is used.
2. Balsam from *Copaifera langsdorfii desfontainer* coming from Pará in Northern Brasil.
3. W.A.Hopman, Over Olieverven en het Conserveren van Schilderijen door de Regeneratie-Behandeling, Amsterdam 1871.
4. Doctors were traditionally educated by philosophers, who at that time used intuitive terms to explain diseases, such as repulsive and attractive forces. In contrast pharmacists used exact measurements and approached problems in a strictly systematic manner.
5. Additions of balsams to oil colours were used in the first half of the century in order to achieve a brilliant appearance. Large publications report on such experiments of reconstruction: Knirim, Die Harzmalerei der Alten, Leipzig 1839, p.371.
6. They consequently supported the foundation of the famous institute and journal of A. Keim, Praktisch- und chemisch-technische Mitteilungen für Malerei und Baumaterialienkunde von A.Keim in München. No.1, 1.Okt.1884.

References

Eibner A von. 1908. Über Kopaivabalsame und Kopaivaöle. Technische Mitteilungen für Malerei 24: 22–24.

Eibner A von. 1928. Entwicklung und Werkstoffe der Tafelmalerei. Munich.

Griener P. 1993. Le 'preconstruit' d'une restauration: le travail de Andreas Eigner (1801–1870) sur la Madone de Soleure de Hans Holbein le Jeune (1522). In: Histoire de la Restauration en Europe, II (Actes Bâle 1991) du Congrès International, Worms.

Hampel JCS. Die Restauration alter und schadhaft gewordener Gemälde, Weimar 1846, preface.

Schmitt S. 1990. Examination of paintings treated by Pettenkofer's process. In: Preprints of IIC congress Brussels.

Schmitt S, van der Werf I. 1996, Copaiba balsam used in the Pettenkofer process and as an additive in 19th century painting techniques: studies of its effect on paint layers. In: Molart research projects and progress report.

Schmitt S. 1998. Progress in research on effects of the Pettenkofer process. Submitted to L.R.M.F. (Laboratoire de recherche des musèes de France) special issue of Techne (congress proceedings of Art & chemie. 1998 Paris).

van der Werf I, van den Berg KJ, Schmitt S. 1997. Molecular characterisation of copaiba balsam as used in painting techniques and restoration procedures. (submitted to Studies in Conservation).

Wagner C. 1988. Gemälderestaurierung um 1800. München.

Abstract

Despite a growing interest in research into the history of conservation-restoration of paintings, there are still big gaps in our knowledge concerning the historical use of materials and methods, which is mainly based on a lack of documentation. In this paper I would like to draw attention to the importance of the paintings themselves as carriers of this kind of historical information as well as the need to analyse the artworks in this respect. Once combined with other pieces of information (documentary and analytical), apparently meaningless facts or observations can become meaningful. An increasing knowledge of the history of conservation-restoration finally contributes to a better understanding of the condition of paintings and consequently to the further development of treatment methods.

Keywords

history of conservation-restoration, paintings, interdisciplinarity, historical treatments, sources, historical research, analytical research

Research into the history of conservation-restoration: Remarks on relevance and method★

Mireille te Marvelde
Weesperzijde 97
1091 EL Amsterdam
The Netherlands
Email: m.te.marvelde@wxs.nl

Introduction

Detailed knowledge of the condition of paintings and the causes of their condition is not only an important prerequisite for any decision about treatment, but is also essential for developing new and better methods of treatment.

Paintings are highly complex objects consisting of many different materials and having different material histories. They have undergone chemical and physical changes, not all of which are visible, as a result of the natural processes of ageing and as a result of – mostly unknown – conservation-restoration treatments that have been carried out in the past. Consequently, the condition of paintings is normally recognizable or intelligible only at a rather general level.

As conservators, we are faced with the problem that even if we had sufficient time to spend on research, it would be impossible to obtain all the information we would need in a specific situation. Our knowledge has to be taken from many different disciplines (art history – and in particular the history of painting techniques, the history of conservation-restoration, fundamental chemical and physical research etc.), which are all in different phases of development.

It is only by combining a close, reciprocal interaction between the different disciplines with the investigation of the paintings themselves that we can make progress in our general understanding of the condition of paintings. This interaction will gradually provide a framework of knowledge and insights out of which more direct answers may be obtained in specific situations. An interdisciplinary approach which takes the paintings as a starting point is at the same time the only way of filling missing gaps in the knowledge of each discipline.

I shall try to justify these claims in a more detailed argument below, in which the discipline of the history of conservation-restoration assumes a central role.

History of conservation-restoration: Status of knowledge and difficulties in developing a research methodology

Since most paintings have been treated many times during their existence, the processes of age and change must have been considerably influenced by previous treatments. To be able to arrive at a clearer idea of these influences – and thus of a painting's original condition and appearance – we need to develop a detailed understanding of historical conservation-restoration techniques and materials.

However, knowledge in this field is still relatively limited. Although a number of investigations have been carried out internationally over the past 30 years or so and increasingly over the last few years, this is still a discipline under development. To date, conservation-restoration historical research from written sources has usually entailed more or less separate case studies and investigations on specific subjects. As a result, our knowledge in this field remains only loosely coherent. The reason for this rather low level of development is that in the past relatively little has

★ This paper deals exclusively with paintings, but in principle the argument is also applicable to other types of works of art. However, since paintings have always been given special attention, there is in general more historical information to be found on them then on most other categories of objects.

been written down concerning the techniques and materials used, and such information as we have, is dispersed among a wide variety of sources. Archival research in this field is enormously time consuming, with relatively few results. Furthermore, such written documentation as exists is mostly vague and unspecific and therefore of little help. What should one do, for example with such items in account books where the occasional reference to a restoration project is limited to «cleaned», «varnished» or «lined»? These terms do not specify the methods and materials involved. Moreover, no systematic search method is usually apparent. Conservators normally have little or no time to conduct archival research on the history of their profession, while few researchers from other disciplines, for example art history, have the necessary interest or the relevant expertise.

However, in addition to the written sources, we also have the paintings themselves as carriers of conservation-restoration historical information. In certain cases (traces of) past treatments can be highly significant, not least for the specification of the otherwise unspecific information provided by archival material.

Paintings as sources of information on past conservation-restoration treatments

Although, as stated above, the historical knowledge of methods and techniques in conservation-restoration is relatively limited compared with other aspects of our profession, the international studies carried out in the last 30 years provide a basis which should now be extended more systematically. The first attempt to give an historical overview of ideas, methods and materials found in written sources was presented by R.H. Marijnissen in his dissertation in 1967.[1] Since then many more contributions have been published on a range of different aspects.[2]

An important step in this development and the collation of results is to use the paintings themselves more systematically as sources of information and to try to link this information to what we know from the written sources. Although most experienced conservators have become «connoisseurs» on old treatments, and are even able to recognize the hand of past colleagues, this kind of knowledge is hardly ever recorded and mostly concerns only clearly visible characteristics.

However, it turns out that even on paintings that have been subjected to many treatments, it is often possible to find traces of earlier treatments that may be of great value once these traces are identified and combined with other relevant information. To find these traces, however, one needs first to be aware of their importance. These sources on the object can be (traces of) old varnish, filling material, retouchings, lining material etc., which not only yield information about the use of materials but also, by analysing where and how they were used, can sometimes provide clues as to the motive for certain methods. Once it has been possible to attribute an old treatment to a particular restorer and to date it (for example, because a clear document is found to correlate with that treatment), other undocumented treatments could be attributed which clearly derive from the same hand and date. In addition, chemical analysis of documented conservation materials could give insight into the materials used by a particular restorer within a particular professional tradition (of course, this is not usually possible with paintings which have circulated on the art market for a long time).

Although it has become a general habit to document our own interventions, it is still not common practice to try to identify and to document what has been done by others before. We document that we have removed materials, but in general we do not try to identify the specific nature or composition of the materials removed, in what context they were used and what might have been the reason for using them. Usually the removed materials are discarded.

We need to become aware of the fact that the removal (and discarding) of materials added during previous treatments without attempting to identify different periods and answering questions about when, why and how they were added, and without documenting the answers to these questions (or even the questions themselves), may well be destroying important sources of our knowledge of the history of conservation-restoration. It is still insufficiently recognized that conservators need to spend more time on research of this kind, for they alone are

in the position to carry it out. At present, it is often only research of direct importance to the planned treatment that is carried out. We need to convince our directors, curators and commissioners that collecting information on the nature of earlier treatments should be a standard part of our work. Conservation-restoration historical research based on the object as well as the written sources, is not only of direct relevance for treatment, but is also indirectly important for intended future treatment. It is a kind of «in depth-investment», since it not only contributes to our knowledge of the condition of paintings but ultimately to their preservation.

The only way to make progress in this field is to advance on different fronts at the same time: continuing to gather general information on different aspects and from different sources in order to clarify the contextual picture, and to investigate paintings in depth together with documentary and analytical research.

The best opportunities for collating different kinds of data on the historical treatment of paintings are usually provided by long-established institutions. Where such institutions have archives containing letters and accounts that deal with the different treatments of paintings that have been in the collection for a very long time, one can relate this information directly to the paintings themselves. As mentioned above, however, the technical information contained in letters and accounts is often vague or unspecific. Brief references in themselves may not at first seem very helpful, but by compiling a large list of such records, patterns begin to emerge carrying implications concerning the way that treatments may have affected the condition of paintings. It is often the less important works, gathering dust in storerooms, which have undergone few treatments, that enable us to connect a specific treatment to an identifiable restorer. Such cases may provide the first clues to our understanding of a treatment vaguely indicated in the documents. Collecting information from various other sources about the restorer and his methods in some cases allows us to reconstruct a context in which the terms used in account books and other documents finally can be interpreted.

Some aspects of conservation-restoration historical research in The Netherlands to illustrate relevance and method

The past decade has witnessed the steady growth of archival research among the long-established collections of the Netherlands. This research has laid the historical basis on which a framework of conservation-restoration knowledge can be constructed and from which conservation projects can profit in the future.

From the information in these documents and from several published and unpublished papers the activities of some of the most prominent 18th to mid 20th century Dutch restorers are gradually being mapped out, although many loose ends still remain: Jan van Dijk (ca. 1695–1769), P.C. Huijbrechts (active ca.1800), Nicolaas Hopman (1794–1870), Willem Antonij Hopman (1828–1910), the German Alois Hauser (1857–1919) who worked for a while in Holland and was an important link between the Hopman and the De Wild «dynasties», Carel Frederik Louis de Wild (1870–1922), Derix de Wild (1869–1932), H. and J. Heydenrijk (active ca. 1900), Agenitus Martinus de Wild (1899–1969) and J.C. Traas (active ca. 1925–1960).[3]

It has become clear that these restorers were given many of the most important commissions for restoring paintings in Dutch collections. Not only do their names turn up regularly in the archives of these collections, but once they had been identified and it became possible to study some of their treatments, the treatments revealed recognizable, individual characteristics. These throw light on their working methods and approaches and provide samples for chemical analysis.

This kind of investigation is the basis of the research project I am involved in: «The application of the wax/resin lining procedure and its effects on paintings», one of the research projects in the Dutch MolArt (Molecular Aspects of ageing in Painted Works of Art) Project. In this particular project, the ageing of wax-resin mixtures and the effects of the treatment at a molecular level of the paint are studied.[4] Although wax-resin lining is no longer applied in the general way it was

in the past, it remains important to know more about its present and future influence at the molecular level. Many paintings have been subjected to this method of lining in the past and will inevitably have to be treated again. Knowing more about the altered properties of the original material and the lining material will help conservator-restorers to interpret damage phenomena (on macro- and microscopical scale) correctly and to make informed remedial and preventive conservation decisions.

On the basis of existing accounts and other documents we were able to obtain a large number of wax-resin samples for which the date of the treatment and the name of the restorer could be established.[5] These samples were used to study the ageing and chemical composition of wax-resin mixtures at a molecular level. Because the characteristics of individual wax-resin linings gradually began to be recognized (e.g. the type of canvas, treatment of the edges, or idiosyncrasies in the application of adhesive), undocumented linings could be attributed to specific restorers, providing further knowledge which was not available from the written records. The results of chemical analyses of the wax-resin mixtures confirmed the assumption that specific materials had been used in particular cases.

Results of chemical analysis further allow us to look both more critically at the reliability of the written sources on the one hand, and at the possibilities and limits of analytical research on the other. To give an example: in a text that survived from W.A. Hopman (1828–1910) he notes that his wax-resin mixture consists of (bees)wax, mastic or «white resin», venetian turpentine and copaiba balsam.[6] Chemical analyses demonstrated that in no sample taken from a lining by Hopman could copaiba balsam be identified.[7] This discrepancy between source and the result of chemical analysis raises such questions as: did Hopman use a material he considered to be copaiba balsam, but which in fact was an adulterated copaiba balsam with some cheaper material? Or was the amount of copaiba balsam he used in his wax-resin mixture so small that it is below the level of detection? The questions that arise from this kind of result may complicate the research on the one hand, but on the other hand it is exactly this generation of new questions that opens up progress in our knowledge: where the results of different disciplines intersect, the impulse is given for further progress in either discipline.

An example of progress in our knowledge of conservation-restoration history by an interdisciplinary approach, concerns the dating of a degradaded wax-resin lining on the painting *The education of Frederick Henry* (1648) by Theodorus van Thulden.[8] This lining, based on the interpretation of archival information, could only have been carried out at two different moments in history; at the beginning of the nineteenth century, or after World War II.[9] Chemical analysis revealed the answer to the question of the date of this lining. A sample of the lining material was added to the range of historical wax-resin samples that had been investigated in the course of research on the influence on paintings of wax-resin linings. The approximately 30 samples were derived from dated linings from each decade since the mid-nineteenth century up to the present (identified by archival research) to investigate the composition and degree of oxidation of the mixtures. The general conclusion of this investigation could be drawn that the degree of oxidation correlates approximately with the dates of the various linings, apparently hardly influenced by such other factors as methods, materials and environmental circumstances.[10]

The result of the analysis of the wax-resin sample from the painting by Van Thulden showed that this wax-resin mixture had undergone the highest degree of oxidation of all the samples analysed. Therefore, we are dealing with a lining from the beginning of the nineteenth century. This means that it is the earliest known use of wax-resin. Until now, it has been accepted that a wax-resin lining by Nicolaas Hopman from 1854 was the earliest lining of this kind to have survived. This «dating» of a lining not only adds to our knowledge of historical linings, since unexpectedly we can now study the characteristics of a wax-resin lining from the beginning of the nineteenth century, it also assumes a further significance. For the age of the sample material is older than any previously known wax lining adhesive, extending the limit of possible future research into ageing and changes in wax-resin mixtures as well as their influence on paintings.

Conclusion

The importance of paintings as sources of information on the history of conservation-restoration is still underestimated. Besides, it is not common to analyse different phases of treatment on the paintings themselves and to try to link this information to archival documents. However, in many cases it turns out to be possible to do this kind of research. In combination with physical and chemical analysis it is even the only fruitful way to expand our existing, fragmentary knowledge of the material history of paintings into something like a more coherent whole.

A close, reciprocal interaction between the investigation of sources, thorough examination of the paintings themselves and scientific research not only helps to develop knowledge in the area of the history of conservation-restoration, but also to develop the various disciplines involved. We need science to identify historical materials, but we also need identified historical material as a basis for fundamental research on the ageing and change of works of art.

Increased knowledge of the history of conservation-restoration, in combination with all these developments, contributes to the gradual growth of a more detailed understanding of the condition of paintings which may finally play an important role in the further development of a sound policy for the conservation of paintings.

Acknowledgements

This paper has been written within the framework of the Dutch MolArt Project. MolArt (Molecular Aspects of Ageing in Painted Works of Art) is a subsidiary of the Dutch Organisation for Scientific Research (NWO).

I wish to acknowledge Klaas Jan van den Berg, Ruth Hoppe and Ernst van de Wetering for comments on the text; Murray Pearson for his part in translating and editing the English text; the conservation studios of the Mauritshuis (The Hague), Rijksmuseum (Amsterdam) and Frans Halsmuseum (Haarlem), The Limburg Conservation Institute (Maastricht) and the State Buildings Department (The Hague) for supporting conservation-restoration historical research in the MolArt Project.

Notes and references

1. Marijnissen R.H. 1967. Dégradation, conservation et restauration de l'œuvre d'art (2 vol.). Brussels.
2. Several important contributions by (among others): H. Althöfer, S. Bergeon, T. Brachert, K. Levy-van Halm, P. Philippot, C. Périer-d'Ieteren, M. Koller, A. Massing, V. Schaible, U. Schiessl, S. Schmitt, C. Wagner.
3. Information about these persons is obtained from the literature, different archival sources and some unpublished investigations. The most important investigations are:
 Broos B, Wadum W. 1998. Under the scalpel twenty-one times. The restoration history of *The Anatomy Lesson of Dr. Nicolaes Tulp*. In: Rembrandt under the scalpel. The Hague/Amsterdam. 39–50.
 Duyn E. van. 1996. Van brood tot alcoholdamp; De ontwikkeling van het restauratieberoep in Nederland in de negentiende eeuw. Master's thesis in the history of art. University of Utrecht (unpublished).
 Heiden P. van der. 1997. Report on the archival research for the history of restoration of the Oranjezaal, Huis ten Bosch, The Hague (unpublished).
 Joosten T. 1989. Report of an internship in the Mauritshuis (unpublished).
 Levy-van Halm K. 1989. Zur Geschichte der Restaurierung in Holland, eine Skizze. In: Geschichte der Restaurierung in Europa. Worms.
 Mandt P. 1995. Alois Hauser d.J. (1857–1919) und sein Manuskript "Über die Restauration von Gemälden". In. Zeitschrift für Kunsttechnologie und Konservierung: 215–231.
 Marvelde M.M. te. 1989. Jan van Dijk, een achttiende kunstschilder en schilderijenresaurator. Master's thesis in the History of Art. University of Amsterdam (unpublished).
 Marvelde MM. te. 1996. Jan van Dijk, an 18th-century restorer of paintings. In: Bridgland J, ed. Preprints of the 11th triennial meeting of the ICOM Committee for Conservation. Paris: International Council of Museums: 182–186.
4. In close collaboration with Klaas Jan van den Berg (FOM- Institute Amsterdam) and René Hoppenbrouwers (Limburg Conservation Institute, Maastricht).
5. Samples were obtained from The Mauritshuis (The Hague), Frans Halsmuseum (Haarlem), Rijksmuseum (Amsterdam), Kasteel-Museum Sypesteyn (Loosdrecht) and Huis ten Bosch (The Hague).

6. Pettenkofer M. von. 1870. Über Ölfarben und Konservierung der Gemälden-Gallerien durch das Regenerations-Verfahren. Braunschweig. Dutch translation by W.A. Hopman. 1871. p. 43.

7. Werf I.D. van der, Berg K.J. van den, Schmitt S., Boon J.J. Molecular characterisation of copaiba balsam as used in painting techniques and restoration procedures. Submitted to Studies in Conservation.

8. This painting is part of a monumental seventeenth century paintings ensemble in the Oranjezaal, Huis ten Bosch, The Hague.

9. Heiden P van der. 1997.

10. Unpublished results of chemical analyses by Klaas Jan van den Berg, using DTMS (Direct Temperature resolved Mass Spectrometry) and PY-TMAH-GCMS (Pyrolysis-Tetramethyl ammonium hydroxide-Gas Chromatography/Mass Spectrometry). Technical assistance by Leo Spetter.

Abstract

In 1928 two different art bulletins discussed the purpose of painting restoration, and one of them published a questionnaire. An unusual spectrum of aesthetic and ethical opinions was presented by Austrian and German art historians, painters, journalists and restorers. Restoration concepts, normally attributed to later decades, and further cultural aspects were discussed. Due to National Socialistic politics these important issues in conservation nearly fell into oblivion, although Austrian and German contributors to this discussion who emigrated to other countries may have influenced the field of restoration elsewhere.

Keywords

history of restoration theory, painting restoration, conceptual issues, aesthetical and ethical aspects

Is it useful to restore paintings? Aspects of a 1928 discussion on restoration in Germany and Austria

Michael von der Goltz
Niedersächsisches Landesmuseum
Willy-Brandt-Allee 5
30169 Hannover
Germany
Fax: + 49 511 9807636

After the First World War there was an active fine art and conservation scene in Germany and Austria which discussed concepts normally attributed to the 1940s to 1960s. National Socialistic politics terminated these fruitful beginnings, forcing important people into emigration or early retirement.

A questionnaire from 1928 reflects early theoretical thoughts on conservation and more general cultural attitudes. It is possible that these survived the emigration of those involved. Early German conservation issues have often been neglected by the English literature and vice versa. This paper could contribute to the excellent work of Nicholas Stanley Price, Mansfield Kirby Talley Jr. and Alessandra Melucco Vaccaro.[1]

Initiated by the German museum council in 1928, the bulletin *Kunst und Künstler* (Art and artist) published fundamental statements by important art historians and museum directors.

Simultaneously the bulletin *Die Kunstauktion* (Art auction) asked "Is it useful to restore paintings?" and many people who were in some way involved in art answered, sometimes turning the inquiry into a controversy.

Usually restoration was not discussed in public, even by restorers, because this was the task of art historians. Restorers were merely the craftsmen charged with carrying out the concepts. So the questionnaire showed an unusual spectrum of opinions, because art historians, painters, journalists, and even a few restorers replied. Though the *Kunstauktion* was an art dealers' magazine, unfortunately statements from this sector were lacking.

The following people were involved:

- Walter Bondy, Bohemian-German painter and writer, editor of the bulletin *Die Kunstauktion*
- Prof. Dr. Alexander Dorner, director of the Provincial Gallery in Hannover
- Dr. Kurt Karl Eberlein, editor of the bulletin *Museumskunde*, Berlin
- Robert Frank, presumably a restorer
- Dr. Max J. Friedländer, then director of the Graphic Department in Berlin
- Dr. Curt Glaser, director of the Art Library, Berlin
- Dr. Gustav Glück, director of the painting gallery in the Museum of History of Art, Vienna
- Prof. Wilhelm Horst, painter and restorer, Darmstadt
- Dr. Franz Kieslinger, Vienna
- Dr. Alfred Kuhn, editor of the bulletin *Kunstchronik und Kunstmarkt*
- Robert Maurer, Austrian painter and restorer, Inquiry office for artworks at the Academy of Art, Vienna
- Max Oppenheimer, called Mopp, Austrian painter, working in Berlin at this time
- Prof. Dr. Gustav Pauli, director of the Museum of Fine Art in Hamburg (*Hamburger Kunsthalle*)
- Dr. Karl Scheffler, art critic, editor of the bulletin *Kunst und Künstler* (Art and artist), Berlin
- Prof. Dr. Hans Tietze, professor in Vienna, responsible for the reorganization of museums in Vienna

- Prof. Dr.Hermann Vob, assistant conservator in the Kaiser-Friedrich-Museum, Berlin
- Prof. Dr. Friedrich Winkler, conservator at the State Museum, Berlin

Common statements

No contributor said it was not useful to restore paintings, but "restoration" was interpreted differently.

There were two common statements, the first one, by Franz Kieslinger, using Ionian nature philosophy to demonstrate that restoration is useful. He tried to explain his point of view by using a metaphor: "Somebody, looking at his father after five or ten years, would not doubt his identity. But is he the same? The Ionian nature philosophy already asks this: Is the river, into which you put your hand, the same? [...] Everything ages. Even artworks, sometimes not as fast as their inventors. The slower aging is part of their value. They are witnesses of former spiritual periods. [...] If over the centuries we replaced the lost stones of a cathedral by unworked stones nothing more than rubble would remain. [...] This image is more impressive than a painting where bare parts destroy the whole composition of form and colour."[2]

The second common contribution, by Alfred Kuhn, compared restoration of paintings with "makeup": "Should a beautiful woman *d'une quarantaine* wear makeup ?" In his opinion the answer was a matter of taste of the – naturally – male spectator. Finally he came to the conclusion: "The museum director or art dealer [...] will always find reasons why their paintings have to *faire la toilette*." Of course they would have a guilty conscience, but be convinced they only did the minimum. Nothing could be done against it, like against the "rouge on the lips of the ladies", and all these other "cute little female arts before going to a party."[3] The banality of this statement provoked a little controversy about social manners, which will not be discussed here.

Beware of restorers

All contributors fundamentally agreed that restorers are bad, consequently that it was great luck to find a good, respectable one. They were called irresponsible, high-handed creators, washers, hacks, overpainters, forgers, scoundrels and so on. So it was proposed to tear restorers out of the state of anonymity: in painting catalogues dates of restorations and the name of the restorer should be published, because later generations had a right to know whom to thank for a masterwork's preservation – or destruction.[4] Even restorers admitted grievances and called for legal measures, perhaps an early demand for protection of the profession. In spite of the profession having reached its 70th anniversary, this demand still has not lost its currentness.

Cleaning and other measures

All German participants were in agreement regarding the cleaning and stripping of paintings. In contrast to Austria, in Germany patina seemed to be so unpopular that it was no longer even discussed. Possible risks of stripping or other measures were seldom mentioned. On the other hand two Austrian contributors, Glück and Kieslinger, pleaded for painting-specific decisions including leaving paintings uncleaned or even overpainted. The German contributors' consensus on stripping paintings should not be misinterpreted. This was not general practice in Germany. As already mentioned, art dealers and collectors did not respond to the inquiry. Their restoration concept was missing, which could be called "done over" – restoration: alterations and signs of aging like patina and overpaint were often retained, while an "old masters look" was attained by retouching and overpainting, by surface-treatment and sometimes coloured varnishes. The fact that some of the art historian contributors may have tried, through their severity, to educate the group of private owners and dealers can't be excluded.

Is it useful to falsify paintings by restoration?

The question of treating losses divided the contributors and led to a controversy. Scheffler was the one who sarcastically wrote, instead of "Is it useful to restore paintings?", the *Kunstauktion* should ask "Is it useful to falsify paintings by restoration?"[5] This question revealed the conceptual borders in the field of restoration. Three different concepts can be extracted from the contributions. These existed during the entire 1920s and can be titled as follows:

1. *Fragmentary restoration*: just conserve the original material: cleaning, stripping, removal of overpaint, retouching, filling and reconstruction, leaving the painting in a possibly fragmentary state.
2. *Documentary restoration*: an alternative compromise for the spectator was carried out, because three-dimensional appearance of losses and holes disturbs the two-dimensional surface of paintings. After cleaning and stripping, losses and holes are filled, but somehow documented or marked by surroundings, deeper fillings or retouchings in a so-called neutral colour, often in "neutral grey".
3. *Complementary restoration*: the guiding principle is the artist's intent. The artwork has to be cleaned, stripped and finally completed. The completion should not be a creative act of the restorer. Based on the latest investigations of art historians and determined by them, it should come as close as possible to what was thought to be the original effect the artist once created.

Most followers of the "fragmentary" and "documentary" restoration concepts, like Friedländer, the future director of Helmut Ruhemann, still stood in the shadow of Alois Hauser's "done over restorations". Hauser, Ruhemann's predecessor, was the third descendant of a famous conservation dynasty, and was dismissed in the year 1928. The Hauser dynasty, which was greatly appreciated and worked for the whole of Prussia, epitomized for the next generation all that was wrong with conservation.

The "complementary" restoration had a few extremely modernist followers. It was based on a mixture of modern ideas on the preservation of historical monuments, constructivism and the Bauhaus. Moreover the artist's intent increasingly became more important than the remaining original.

Background

Most contributions combined restoration concepts with common statements that reflected the actual cultural situation:

- Nearly everybody preferred the "complementary" or "done over" restoration for cult objects still in use.
- The neo-gothic style of the 19th century was condemned unanimously.
- Art dealing, especially the American market, was criticized.

The consensus on these points was quite characteristic of the Weimar Republic. But the contributions also touched on some further aspects:

- Who is able to discuss questions of restoration?
- Who should judge the work of restoration?
- What was the right way to look at artworks and restorations?
- What dangers were implied in completing works of art and how could they be avoided?

It was Gustav Pauli who asked who was capable of discussing restorations. He answered the question in favour of the connoisseur. Friedländer added, the connoisseur would follow the "documentary" concept, after being influenced and convinced by art historians. Scheffler was indignant that the *Kunstauktion* had not restricted the questionnaire to prominent art historians.

The second question – who should judge restorations – was for the ideal visitor: who should come to the museum and look at paintings? It was again Pauli who

favoured the connoisseur: "We install our museums for the really receptive, delicate and respectful lover of fine arts, not for blockheads."[6]

Dorner, on the contrary, stated: "Don't forget the purpose of paintings. Conservation and preservation in museums can't be *l'art pour l'art*, but must have as their aim to instruct and educate the public."[7] This argument underlined a general museum conflict. On the one hand, since the second half of the 19th century, aestheticism and isolation in the field of fine art, here expressed by *l'art pour l'art*, was growing in importance, and on the other hand, increasingly important after the First World War and the German revolution of 1918/1919 was the idea of the museum as an educational establishment. Dorner hoped to achieve the latter through "complementary" restoration. Scheffler angrily criticized this opinion: "To hell with all instruction and education if it can't work without cheating and forgery."[8]

How did the contributors expect the visitors to react to restored artworks? What should happen in the act of looking at paintings ? These questions were implicit in discussing the retouching of paintings in a "documentary" way, in a so called "neutral grey". Grey was said to be neutral and compatible with all other colours because it could be produced by mixing all colours together. This idea, based on the romantic colour-circle or rather colour-ball theories of Philipp Otto Runge and Johann Wolfgang Goethe, was still popular after 1918. In the questionnaire several contributors demanded grey retouchings, expecting the spectator to complete the lacunae using an "active imagination."[9] At the same time this kind of restoration seemed to develop its own aesthetic charm: "The edges of the colour fragments should be clear and clean, as if intention not accident had made them; cracks and losses should be retouched in pure and distinct grey, just as we make clearly visible the tesserae in a destroyed ground, the pieces of glass in a fragmentary church-window, or the edge of a cut off gobelin."[10] This demand was appreciated in part, but some contributors doubted that "neutral grey" really existed.[11]

Again it was Dorner who questioned grey retouchings on principle with regard to the visitor's expectations. He contradicted the idea of completing losses with "active imagination" by turning the argument around: "... the eye joins not only the leftover original parts, but also the grey losses, and everything else except an idea of the original is developed. Often a mental reconstruction is not possible at all. [...] But even when the imagination succeeds in completing a mental picture, it remains in the spirit of the spectator's own time, and it seems to be questionable, if this completion is more correct than that of a restorer."[12] He continued that "complementary" restoration was more objective or correct. Besides, the mental reconstruction required so much effort that enjoyment seemed impossible. In Dorner's opinion even a man with iron nerves could not bear a whole gallery of "fragmentary" or "documentary" restored paintings. Friedländer and Glaser agreed on this point; however, they demanded that the spectator should suffer it.[13] Calling for severity and suffering was a typical and common phenomenon of that time. Tietze was of Dorner's opinion, asking himself if a completed painting could not save more of its intent, than a fragment ever could.[14] Scheffler contradicted Dorner, calling his argumentation "dangerous". He thought enjoyment of art was in the mobility of mental forces and in the re-creation of art.[15] Dorner and Scheffler had radically differing viewpoints: Dorner was largely engaged in education, trying to teach the public about former times and their art, while Scheffler wanted to transform the act of looking into a creative one.

What dangers were implied in the completion of a painting? The "complementary" restoration was called a forgery. This reproach was often caused by fear that not only the museum visitors but also the experts could be deceived. The education of art historians was deficient in art techniques and restoration, leading to critical situations in museums where a rigid hierarchical system existed. Restorers worked under the control and supervision of sometimes ignorant art historians.[16] The danger of deception implied the possibility of falsifying art history: "The mixture of original and forgery is a gloomy fog, which will produce slimy phrases in art-literature."[17]

Dorner and the Austrian restorer Maurer tried to weaken the forgery argument, pleading for better photographic documentation of stripped paintings and the

creation of a photo archive. Furthermore Maurer mentioned a new photographic technique, which he claimed to have developed after years of work. This technique must have been UV photography, because the following year he patented this method.[18] It was again Scheffler who criticized this proposal: "A Viennese man, presumably a restorer, wrote the maddest thing. [...] The proposal of this Viennese expert is, to first take photographs of what is really left, and then, in the name of the lord, restore it. The original state is recorded for eternity. Everybody is content thanks to a genius photographer. – Something like this gets published, and seriously appreciated by people who are said to have an aesthetic sensibility. At this point the discussion becomes a farce."[19] Of course the editor of the *Kunstauktion*, Bondy, as well as the criticized Maurer reacted. Bondy wrote he had not thought of any kind of censorship, while Maurer answered polemically: "Scheffler boasted: We, the Pope of Rome profess by divine right that we have reserved all judgement in the field of fine arts, because we exist." And he continued: "Someone who feels courageous and responsible enough might start cleaning a big public painting collection in the manner of Scheffler, continuing to clean revealing holes even a blind man can't overlook (he will be able to feel them) [...] My opinion remains the same, before endangering public property, first make an optical analysis without touching the painting. Maybe after that we could dare to take responsibility."[20]

Eberlein compared and equated a destroyed, fragmentary artwork with an unfinished one, concluding that any completion should be omitted: "We laugh about everybody who completes an artistic fragment, no matter if it is a work of art, a piece of music or a poem – only the USA has such little taste as to organize this kind of competition for commercial reasons. Although no collector wants the completion of an antique statue, a mosaic ground or a vase, we still hear and hear again of experts raising the incomprehensible argument that losses of paintings should be completed because the situation in this field is different! If we are allowed to complete destroyed pieces, we are allowed to do so with those that are unfinished too, because both are *art-torsoi*."[21] Dorner called this "enjoyment of fragments" and "mental aphorism", which was a "typical phenomenon of romanticism still present in our time. Cultivating a late romanticism is the last thing a serious art historian should try to achieve by restoration."[22]

Eberlein had a further proposal – a collection of copies. Instead of completing original fragments, copies should give an impression of the former appearance: "Here is a new interesting task for the masterly technical ability of restorers. A new totally completed copy would show a painting in its initial state and colour, freed from time and fate, without visible losses and altered parts."[23] Collecting copies should be a task of art historical scholarship, and in future European museums, the preserved and the lost works of art should complement each other.

Dorner was delighted by this proposal. He did not alter his opinion on the field of restoration, but wanted to complement his collection with copies. Neglecting the original material in favour of the artist's intent, Dorner felt good reproductions should become more important than altered original artworks. This led to the next controversy between artist's intent and the original material, transferred to the field of reproduction, dematerialization and the "aura" of artworks, an expression first introduced by Walter Benjamin.

When nine years later, in 1937, Sheldon Keck asked again "Is restoration necessary?" the situation in Germany had already changed dramatically. Many participants in the questionnaire had been forced to retire or emigrate, and conceptual controversy belonged to the past. Maybe it was the temporal or the different social environment, the geographical distance that made Keck's statement nearly incomparable with the former ones. While these had been nearly exclusively aesthetic and ethical, Keck was already a modern restorer and a technical expert writing about different kinds of dangers and damage occurring to paintings and how these could best be treated. Keck's arguments, which pleaded for the use of modern, often synthetic materials, was in many respects comparable to those made today. But his results reflected some of the earlier 1928 opinions. Not as radical as in former days, but comparable to the "documentary" restoration he advocated cleaning, stripping, overpaint removal and then retouching losses "as to make them perfectly evident at close range. At a distance of a few feet the

original paint and the retouching harmonize to give the full effect of the painting"[24].

Conclusion

The questionnaire of 1928 shows early issues of later restoration theories. An engaged fine arts scene discussed ethics, aesthetics, qualities of restorers and mainly the treatment of losses, in combination with questions of display and the expectations of visitors. After 1933, these issues in conservation nearly fell into oblivion, although art experts who had emigrated may have influenced the field of restoration in other countries.

Acknowledgments

I would like to thank Bettina von der Goltz and Helen Smith for their helpful support, and Caroline K. Keck for making Sheldon Keck's article available to me.

Notes and references

1. Stanley Price N., Talley MK Jr, Melucco Vaccaro A. 1996. Historical and philosophical issues in the conservation of cultural heritage. Los Angeles.
2. Kieslinger F. 1928. Ist es zweckmäßig, Gemälde zu restaurieren? Die Kunstauktion 2(25): 8.
3. Kuhn A. 1928. Ist es zweckmäßig, Gemälde zu restaurieren? Die Kunstauktion 2(27): 9.
4. Pauli G. 1928. Über das Restaurieren. Kunst und Künstler 26: 338.
5. Scheffler K. 1928. Polemisches zur Frage der Bilderrestaurierung. Kunst und Künstler 26: 411.
6. Pauli, über das Restaurieren. 338.
7. Dorner A. 1928. Ist es zweckmäßig, Gemälde zu restaurieren? Die Kunstauktion 2(25): 8.
8. Scheffler. Polemisches. 412.
9. Friedländer M.J. 1928. Vom Restaurieren der alten Bilder. Kunst und Künstler 26: 213.
10. Eberlein K.K. 1928. Ist es zweckmäßig, Gemälde zu restaurieren? Die Kunstauktion 2(25): 8.
11. Bondy W. 1928. Soll restauriert werden?-Ein Beitrag zur Frage der Bilderrestaurierung. Die Kunstauktion 2(37): 2.
 Glück G. 1928. Ist es zweckmäßig, Gemälde zu restaurieren? Die Kunstauktion 2(37): 7.
12. Dorner. Ist es zweckmäßig...? 8.
13. Friedländer. Vom Restaurieren der alten Bilder. 213.
 Glaser C. 1928. Die gefälschte Kunst. Kunst und Künstler 26: 292.
14. Tietze H. 1928. Die Frage der Bilderrestaurierung. Kunst und Künstler 26: 340.
15. Scheffler. Polemisches. 412.
16. von der Goltz M. 1996. The state of professionalism in restoration in the 1930s in Germany. In: Bridgland J., ed. Preprints of the 11th triennial meeting of the ICOM committee for conservation. London: 187.
17. Friedländer. Vom Restaurieren der alten Bilder. 212.
18. Türkel S. 1930. Identifizierung von Gemälden. In: Türkel S, ed. Fälschungen. Graz: 91–92 note 9.
19. Scheffler. Polemisches. 413.
20. Maurer R. 1928. Zur Restaurierungsfrage – Polemisches. Die Kunstauktion 2(38): 9.
21. Eberlein. Ist es zweckmäßig...? 8.
22. Dorner. Ist es zweckmäßig...? 8.
23. Eberlein. Ist es zweckmäßig...? 8.
24. Keck S. 1937. Is restoration necessary? Magazine of art 30:345.

Is there an ethical problem after the twenty-third treatment of Rembrandt's *Anatomy Lesson of Dr. Nicolaes Tulp?*

Jørgen Wadum⋆ and Petria Noble
Royal Cabinet of Paintings Mauritshuis
P.O. Box 536
2501 CM The Hague
The Netherlands
Fax: +31 70 365 38 19
Email: Collectie@mauritshuis.nl

Abstract

Rembrandt's *Anatomy Lesson of Dr. Nicolaes Tulp* (1632) has been treated at least twenty-three times. A summary of the known treatments is presented. Before the recent restoration a sheet of paper in the hand of a figure displayed the reconstructed names of the eight surgeons portrayed. Underneath, fragments of an earlier inscription could be seen, and below that, an anatomical drawing. It could be established that the earlier inscription was added after the painting was finished. After removal of the varnish, and the more recent reconstruction, the inscription was found to be very fragmentary. Probably abraded during previous cleanings, former restorers carefully reconstructed the names after each treatment. During the present restoration it was decided not to do so, but to allow Rembrandt's anatomy drawing to remain visible as he intended it. By doing so, part of the history of the painting is now almost invisible.

Keywords

Rembrandt, *The Anatomy Lesson of Dr. Nicolaes Tulp*, restoration history, overpainting, spatial illusion, iconography, cleaning, ethics

Figure 1. Rembrandt, The Anatomy Lesson of Dr. Nicolaes Tulp, *1632. Oil on canvas, 169.5 × 216.5 cm. Mauritshuis, The Hague.*

Introduction

On the last day of January 1632, Adriaan Adriaansz., alias Aris Kint was cut from the rope by which he was hanged in the morning. The corpse was brought to the anatomical theatre in the "Waag" on the "Nieuwmarkt" in Amsterdam and placed on the dissection table. The *praelector*, Dr. Nicolaes Tulp, joined by seven colleagues form the Surgeons' Guild immediately carried out an anatomical lesson. This event, Dr. Tulp's second public dissection, was commemorated by having the renowned twenty-six-year-old Rembrandt create a large group-portrait in oil on canvas.

Shortly after moving from Leiden to Amsterdam in 1631, Rembrandt received the commission from the surgeons to paint *The Anatomy Lesson of Dr. Nicolaes Tulp* (See Fig. 1). In this group portrait Rembrandt created an innovative composition with a diagonally positioned corpse in the foreground. By employing various painting techniques for different parts of the composition he produced a very convincing spatial illusion. In addition he choose to combine aerial perspective with his brilliant *claire-obscure*; no wonder the painting has received much attention throughout its 367 year lifetime.[1]

The first mention of the painting occurred in 1693, when a visitor praised Rembrandt's painting above the other paintings in the guild room.[2] In 1700 the first restoration treatment was recorded when the Amsterdam "painter-restorer" Jurriaan Pool (1665–1745) was asked to clean all the paintings in the Surgeons' Guild room. This treatment was to become the first in a long series of restorations, which until the present day includes twenty-three documented treatments. These were carried out by more than fifteen different "painter-restorers", "picture-restorers", and conservator-restorers. In Appendix 1, their names and treatments are listed in a condensed form. In addition to full-scale restorations, the painting has undergone selective interventions, such as regenerating the varnish layer by rubbing in an aromatic oil. In total, the painting has been lined five times, the first three with glue-paste and the following two with a wax-resin mixture. Five records mention varnish regeneration, one of which refers to the liberal use of copaiba balsam. With the most recent treatment Rembrandt's *Anatomy Lesson of Dr. Nicolaes Tulp* has been cleaned and retouched eleven times.

During the latest treatment in 1997–98, a particular problem warranted careful consideration: alongside each head, light grey numbers, approximately 10 to 13 mm high, correspond with numbered names on a sheet of paper held by Harman Hartmansz., one of the background figures. The names reveal the identity of the surgeons depicted in the painting (See Fig. 2). It was obvious that the names had been reconstructed in the previous restoration with black paint. The remains of an older inscription in grey could be discerned below the reconstruction, and below that an anatomical drawing. A number of questions therefore became relevant before a treatment proposal could be formulated: should the inscription, including the reconstruction remain untouched? Should both inscriptions be removed, or obscured, if the earlier inscription was proven to be a later addition conflicting with the artist's intention? Or, should the later reconstruction be removed in order to

⋆ Author to whom correspondence should be addressed

Figure 2. Detail of Fig 1. Before the 1997–98 restoration. The sheet of paper with the reconstructed names over Rembrandt's original anatomy drawing.

Figure 3. Detail of Fig. 1. No. "2" painted in grey alongside one of the portraits in The Anatomy Lesson of Dr. Nicolaes Tulp.

Figure 4. Thomas de Keyser (?), The Osteology Lesson of Dr. Sebastiaen Egbertsz., *1619. Oil on canvas, 135 × 186 cm. Amsterdams Historisch Museum, Amsterdam. Detail of no. "2" above one of the portraits.*

reveal and preserve the early inscription as historical evidence? The extent to which the earlier inscription would obscure the anatomical drawing could be assessed only after removal of the later reconstruction.

Dating the inscription

It was only during the previous restoration of *The Anatomy Lesson of Dr. Nicolaes Tulp* by J.C. Traas in 1951, that the anatomical drawing below the list of names was observed.[3] In grey paint, Rembrandt had drawn the muscles of an outstretched left arm and above it, that of a bent arm. Alongside, short, narrow parallel lines indicate accompanying text. The question naturally arose, when had the numbers and names been added. Were they added by Rembrandt, or a contemporary, after he had finishing the painting? Were there indications for a much later date?

In the literature it has been noted that these inscriptions were of a later date, probably dating from the early eighteenth century. In *A Corpus of Rembrandt Paintings*, until now the most recent, extensive description of the painting, states that the spelling of the names, Blok instead of Block and Kalkoen instead of Calkoen, ". . . points to an origin no earlier than the last quarter of the 17th century."[4] Yet, it was important to find more certain evidence for dating the inscription. The phenomenon of later added inscriptions is not unusual and is found on many paintings, including Dutch group portraits such as several of the Militia paintings by Frans Hals. A close study of paintings which also hung in the Surgeons' Guild room revealed that *The Osteology Lesson of Dr. Sebastiaen Egbertsz.* (1619), attributed to Thomas de Keyser (1596/97–1667), *The Anatomy Lesson of Dr. Frederik Ruysch* (1683) by Jan van Neck (ca. 1635–1714), *The Anatomy Lesson of Dr. Johan Fonteijn* (1625–26) by Nicolaes Eliasz. (1590/91–1654/56), and Cornelis Troost's (1696–1750) *Anatomy Lesson of Dr. Willem Röell* (1728) were also issued with comparable numbers.[5] Furthermore the style and calligraphy of the numbers on *The Anatomy Lesson of Dr. Nicolaes Tulp* are identical to those on De Keyser's *Osteology Lesson of Dr. Sebastiaen Egbertsz.* (1619) (See Figs. 3, 4). This observation supports the idea that the additions were not only secondary, but also were not intended or approved of by Rembrandt.

In the painting by De Keyser, as well as *The Anatomy Lesson of Dr. Nicolaes Tulp*, the paint used to apply the numbers (and the names) is obviously old, containing extremely large particles of lead white, mixed with a few black, red and yellow particles. This pigment mixture was not found to have been used in *The Anatomy Lesson of Dr. Nicolaes Tulp*.

Study of samples of the paint layer build-up from the numbers of *The Anatomy Lesson of Dr. Nicolaes Tulp* showed that it was possible to substantiate their later application. In the cross-section the presence of a very old varnish layer, between the background paint layer and that of the paint of the numbers proved that they were added long after the painting was completed and varnished.[6] Under long-wave ultraviolet illumination this varnish layer is seen to fluoresce strongly (See Fig. 5).

As the numbers written next to the portraits in De Keyser's *Osteology Lesson of Dr. Sebastiaen Egbertsz.* (1619) and Rembrandt's *Anatomy Lesson of Dr. Nicolaes Tulp* (1632) appear identical in size, calligraphy and pigment constellation (visual examination on De Keyser) it becomes obvious that they were added by another hand. The numbers in Jan van Neck's painting (1683), on the contrary, are executed with greyish, finely ground paint and are much larger, often over 20 mm in height. On Troost's *Anatomy Lesson of Dr. Willem Röell*, however, the numbers are smaller and painted in white, without large pigment particles, as seen in the De Keyser and the Rembrandt. Nevertheless, the handwriting of the number "2" on the Troost painting to some degree does resemble that on the earlier paintings. Number "3", on the contrary, does not, being rounder in form and with a horizontal upper member as in the De Keyser and the Rembrandt.

Earlier it was suggested that the painter-restorer Jan Maurits Quinkhard, who in 1732 restored *The Anatomy Lesson of Dr. Nicolaes Tulp*, the badly damaged *Anatomy Lesson of Dr. Deijman*, and some of the other pictures damaged in the fire nine years earlier, had added the numbers and names on all the paintings in the Surgeons' Guild.[7] In January 1732 the Surgeons' Guild appointed new headmen,

Figure 5. Cross-section of number "7" in The Anatomy Lesson of Dr. Nicolaes Tulp. *Microphotograph in long wave ultraviolet illumination. The lowest layer is the fluorescing grey ground (lower red ground is missing). The dark layer above this is the background paint. The top fluorescing layer is the paint used for the no. "7". At the interface between the light paint of the numbers and that of the dark background is a very thin fluorescing varnish layer.*

who the same year were portrayed by Quinkhard. His group portrait of *The Headmen of the Surgeons' Guild* depicts six elegantly dressed gentlemen, in long wigs seated around a table covered with an oriental carpet. Their profession as surgeons is not directly evident from the picture, as their attributes–books, paper and writing utilities like ink and goose quills–pertain to their management skills. The hanging of this new painting was arranged in such a way that none of the earlier paintings were rearranged. The new headmen reputedly had a great affinity with the past and regarded the early anatomy paintings as important memoranda. However, if the numbers and names were added to all the paintings by Quinkhard, the paint should have the same visual appearance. When exactly the inscriptions were added is difficult to assess; however, as Van Neck's paintings from 1683 has numbers which appear different from both De Keyser's painting and Rembrandt's *Anatomy Lesson of Dr. Nicolaes Tulp*, one could speculate that the inscription on the latter paintings were done before 1683. The first recorded mention of the painting including the names occurs only in 1750.[8]

Result of the recent cleaning

After having excluded the possibility that the inscriptions were either added or approved by Rembrandt himself, the rather awkwardly painted names, applied in 1951 by J.C. Traas, were removed. The black paint used by Traas was easily recognisable as a later paint; flowing over the age cracks in the earlier inscription and the original paint below, it was easily soluble. After removal, the earlier inscription was found to be vague and fragmentary, allowing the anatomical drawing to be seen once more. It was difficult to assess how the original eighteenth century "calligraphy" would have looked and without considerable guesswork the names could not be reconstructed without much subjective interpretation.

Arguments for fragments

As Rembrandt had painted an anatomical drawing it was naturally not his intention for it to be obscured by a later inscription. Besides, the inscription completely disturbed the spatial illusion within the painting. In the lower right corner of the painting, a large open book displays an illegible text. Likewise, in the background of the composition, Rembrandt indicated text on the anatomical drawing with only a few grey lines. This method of rough suggestion, Rembrandt also employed on the scroll hanging on the wall in the far background. In contrast, the clearly readable reconstructed names on top of the anatomical drawing visually protruded into the foreground, confusing the interpretation of illusory depth within the painting. The painting appeared flatter, and the inscription simultaneously distracted the spectator from the splendid tour de force of space in the innovative composition.[9, 1] Rembrandt's group portrait was perhaps in danger of becoming a messenger of history, rather than a work of art. Usually paintings with similar later additions, or inscriptions are not as aesthetically compromised as was *The Anatomy Lesson of Dr. Nicolaes Tulp*.

Rembrandt's anatomical drawing is also essential for the iconographic reading of the painting. It indirectly refers to the theories of the Brussels doctor Andreas Vesalius (1514–1564), a surgeon who had almost eliminated the division between theory and practice. He was the first professor *anatomiae* to carry out dissections himself, instead of by an assistant. In 1555, Vesalius had himself portrayed on the frontispiece of one of his publications, demonstrating the tendons of a lower arm. This image is taken up in Rembrandt's group portrait, possibly suggesting Dr. Tulp to be a new Vesalius, a *Vesalius redivivus*.[1] Dr. Tulp's left hand is not just caught in an expressive gesture but Tulp is actually demonstrating how the retraction of the tendons makes the fingers of the dissected left hand bend. The anatomical drawing of an arm therefore refers to the "theory" that anatomy should be tested against, as does the book in the foreground. Also, the prevailing notion of the righteousness of manual work, where the arm and hand were the visible proof of God's presence in man. The combination of practice and theory is personified in Dr. Tulp depicted performing a dissection while lecturing. The significance of

Figure 6. Detail of Fig 1. The anatomical drawing after the 1997–98 restoration of The Anatomy Lesson of Dr. Nicolaes Tulp.

the situation is further emphasised by having the figure holding the drawing looking directly towards the viewer.

In order to reveal the anatomical drawing, and thereby restore the spatial illusion and iconography within *The Anatomy Lesson of Dr. Nicolaes Tulp* the decision was made not to reconstruct the eighteenth century inscription. On the contrary, the fragments of the names and numbers were slightly subdued with watercolour for the benefit of the overall composition (See Fig. 6). The numbers beside the figures are intact, but not distracting and were therefore left untouched.

Conclusion

We are aware that as a consequence of our decision not to reconstruct the eighteenth century inscription, as restorers before have done, that this part of the painting's history is no longer directly perceptible. However, we believe we have done justice to Rembrandt, and at the same time respected the painting's history: the fragments of names and numbers are preserved as they were after the cleaning in 1951. A coming generation can, if they wish, reconstruct what was added years after Rembrandt painted *The Anatomy Lesson of Dr. Nicolaes Tulp*. Now, for the first time in more than 300 years, we have the opportunity to see the painting closer to Rembrandt's intention, and how the surgeons would have seen it when it was placed on the wall of their guild house in 1632.

Acknowledgements

Thanks are due to Norbert Middelkoop and a large number of individuals who have participated in discussions concerning the fate of the secondary inscription. We are also grateful to Ruth Hoppe for her comments and suggestions on the text.

Notes and references

1. See Middelkoop N, Noble P, Wadum J, Broos B. 1998. Rembrandt under the scalpel. *The Anatomy Lesson of Dr. Nicolaes Tulp* dissected, The Hague/Amsterdam, for a more thorough description of the painting, its history and recent treatment.
2. Commelin C. 1693. Beschryving der stadt Amsterdam, Amsterdam: 651.
3. Hekscher WS. 1958. Rembrandt's *Anatomy of Dr. Nicolaes Tulp*: an iconological study. New York: 67ff.
4. Bruyn J, Haak B, Levie SH, Van Thiel PJJ, and Van de Wetering E. 1986. A corpus of Rembrandt paintings (vol. II), Doordrecht/Boston/Lancaster: 182.
5. The four paintings belong to the Amsterdams Historisch Museum, Amsterdam.
6. Groen, K. 1998. Internal research report for the Mauritshuis: *The Anatomy Lesson of Dr. Nicolaes Tulp*, Dutch institute for cultural heritage (ICN), Amsterdam.
7. Van Eeghen IH. 1969. Rembrandt en de mensenvilders. In Maandblad Amstelodamun (56): 1–11.
8. Monninkhoff, J. 1749. "Na-Reeden", manuscript from after December 18, 1749. Amsterdam, University Library, ms. I C 33.
9. Van de Wetering E. 1997. Rembrandt. The painter at work. Amsterdam: 179–190.
10. Van Biema E. 1896. De verhuizing van 'De anatomische les' naar Den Haag. In De Gids (IVe serie) 14: 560–564.
11. Archive Mauritshuis, 1817 no. 297.
12. Guislain-Wittermann G, Folie J. 1992. Former restorations and preliminary reports from 1627 to 1946. In IRPA/KIK Bulletin (24): 33–54.
13. "Je suis heureux d'apprendre que le tableau de Rembrandt est toujours dans un état satisfaisant". Archive Mauritshuis, 1874 no. 1558.
14. After distilling the volatile pine oil from yellow tar it is mixed with linseed oil and cooked into *harpuis*.
15. Archive Mauritshuis, 1877 no. 59.
16. Nederlandse Spectator (34), 25 August 1877.
17. Archive Mauritshuis 1908 no. 30. For Hauser see Mandt, P. 1995. Alois Hauser d.J. (1857–1919) und sein Manuskript über die Restauration von Gemälden. In Zeitschrift für Kunsttechnologie und Konservierung 2: 215–231.
18. Te Marvelde M. 1998. Verslag van het onderzoek betreffende de bedoeking van Rembrandt's Anatomische les van Dr. Tulp. Internal report, written within the framework of the MolArt project.
19. Annual Report Mauritshuis (1951) 80–81.

20. De Vries AB, Tóth-Ubbens M, Froentjes W. 1978. Rembrandt in the Mauritshuis: an interdisciplinary study. Alphen aan den Rijn.
21. Noble P, Wadum J, Groen K, Heeren R, Van den Berg KJ. 1999. Aspects of 17th century binding medium: inclusions in Rembrandt's *Anatomy Lesson of Dr Nicolaes Tulp*. In TECHNE: Art & chimie. La couleur. Proceedings of the International congress on contribution of chemistry to the works of art, Paris, 16–18 September 1998 (forthcoming 1999).

Appendix 1. Curriculum vitae of *The Anatomy Lesson of Dr. Nicolaes Tulp*. (Freely transcribed into English from the original documents)

1632	Rembrandt, at the age of twenty-six, paints *The Anatomy Lesson of Dr. Nicolaes Tulp*.
1693	The first mention of the painting: ". . . by the famous Rembrandt, which are far better than the others [in the guild room]…"
1700	Jurriaan Pool (1665–1745) an Amsterdam painter-restorer. Cleaned all the paintings in the Surgeons' Guild room.
1709	Pieter Blauwpot (1655–after 1709) an Amsterdam painter-restorer. In July he had 12 paintings to clean by the surgeons.
1723	A fire in the Surgeons' Guild room severely damaged a number of paintings including Rembrandt's *Anatomy Lesson of Dr. Deijman*. (1656). *The The Anatomy Lesson of Dr. Nicolaes Tulp*, hanging across the room, was not recorded damaged in this specific instance.
1732	Jan Maurits Quinkhard (1688–1772) an Amsterdam painter-restorer, repaired the painting and ". . . gave Dr. Tulp a new jacket". The reason was that hot smoke from a hole in the chimney, on which the painting hung, had caused blisters in the area of Tulp's jacket.
1747	The guild records repeatedly mention that the painting could be water damaged if no precautions are taken.
1750	First documented description of the painting including the names of those portrayed.
1752	Jan van Dijk (ca. 1695–1769) an Amsterdam painter who later worked primarily as a restorer. In June, Van Dijk received permission to repair and clean the painting of the ". . . .noble Mr. professor Tulp".
1780	Julius H. Quinkhard (1734–1795) an Amsterdam painter-restorer. Cleans the painting, re-varnishes, fills the holes, and repaints.
1785	A letter from 1817 mentions the following: "Around 1785, when the painter Quinkhard cleaned the work of art, he found it in such pitiful condition, that it could only be preserved by applying a second canvas".[10] This is the first documented lining of the painting.
1808	Jan Spaan (1744–1821) an Amsterdam painter-restorer. It is mentioned that he "repaired" the painting.
1817	J. Hulswit (1766–1822) an Amsterdam painter-restorer. Due to a constant leak that dripped on the canvas, the first canvas was completely disintegrated, and the paint layer had lost its support. The painting was in miserable condition and was seen by everybody as lost. "It was restored by Hulswit in such a manner that it in an extraordinary way was placed on a new canvas without the loss of any original material. A memorable proof of the experience of the painter J. Hulswit from Amsterdam".[11]
1828	The painting is placed in The Royal Cabinet of Paintings Mauritshuis, founded in 1822.
1841	Nicolaas Hopman (1794–1870) an Amsterdam picture-restorer. Cleaned, retouched & varnished.
1845	Cleaned, stretched and twice varnished.
1859	E. Le Roy (1828–after1875) a Brussels' picture-restorer, who then had recently restored Rubens' *The Elevation of the Cross* and *The Descent from the Cross* in the Antwerp cathedral.[12] The painting was brought to Brussels from where it returned one year later.
1866	It was reported that the painting was bulging in places.
1868	Bulging is again reported, as well as white lines appearing mainly in the jacket of Dr Tulp.
1874	Le Roy is confident of his final treatment.[13]
1877	W.A. Hopman (1828–1910) an Amsterdam conservator-restorer. He restores the painting after a thorough examination and evaluation of earlier restoration methods based on three questions: 1). What was the condition before 1860? 2). What was the conservation method used by Le Roy? 3). Which method would he use himself? To 1). Hopman answered, that in the past the painting was impregnated and lined with a material described as *harpuis*[14] which soon becomes brittle. 2). The method used by Le Roy was described as a ".. material dissolved in water, e.g. glue, rye flour mixed with glue and sometimes a mixture of glue and venetian turpentine, two components that will never mix."[15] 3). Hopman's intention was to remove Le Roy's lining, apply a mixture of Venetian turpentine, copaiva balsam, white resin [dammar?], and wax which would adhere the paint layer well. A journal described his result this way: ". . . The dirt is removed, the paint layer is firmly and smoothly adhered to a new canvas, nothing is overpainted. A few scratches and abraded areas have been left untouched. An old work of art is after all not as perfect as a bright new one".[16]
1885	Hopman regenerates the varnish.
1891	Hopman regenerates the varnish.
1906	C.F.L. de Wild Sr. (1870–1922) a Hague conservator-restorer. On 27 September the *Anatomy Lesson* by Rembrandt was regenerated.
1908	De Wild removed the lining and placed a new double lining, as well as removing a thick layer of yellowed varnish. He afterwards used ". . . his own varnish . . ." and not ". . . that of Hauser . . .".[17]
1925	D. de Wild (1869–1932) a Hague conservator-restorer. Removed some darkened overpaintings [retouchings] and did some retouching. The varnish was "repaired".
1925–39?	Unrecorded, but deduced from evidence on the painting it was taken from its stretcher and impregnated from the back with wax-paraffin mixture.[18]
1940	J.C. Traas (1898–after 1963) a Hague picture-restorer. Permission was granted to restore the *Anatomy Lesson*. Due to the outbreak of the Second World War the treatment was postponed.
1942	A minor treatment was carried out on a corner of the painting where the lining had loosened.
1946	On return from its hiding place during the war the top varnish layer and the most disturbing overpaintings were removed.
1951	J.C. Traas cleaned the painting by removing several layers of yellow varnish. Most of the overpaintings were removed and the painting was retouched. ". . . Without exaggerating, one can state that we possess anew the young Rembrandt's masterpiece".[19]
1978	Small holes or craters discovered overall in the paint layer were interpreted as the result of an early exposure to infra-red radiation or treatment, but probably related to the fire in 1723.[20]
1996–98	Petria Noble & Jørgen Wadum, conservator-restorers. Preliminary research was carried out in order to assess the feasibility of carrying out a full restoration treatment. The small holes referred to above, were reinterpreted as the result of the Rembrandt's painting materials.[21] There followed a cleaning, the study of Rembrandt's technique, and an integrated restoration.[1]

Scientific methods of examination of works of art

Méthodes scientifiques d'examen des œuvres d'art

Scientific methods of examination of works of art

Coordinator: Marie-Claude Corbeil

The working group formerly known as Scientific Examination of Works of Art was revived this past triennium after a period of inactivity. The group's programme was expanded to include scientific research in a broader sense. The working group focuses on advanced research on materials analysis and examination of cultural property, and research on technically advanced treatment methods. Advanced research on materials includes systematic study of the composition of original materials found in cultural property as it relates to aging, deterioration, effect of conservation treatment, and general characterization, as well as systematic study of conservation materials. Analysis and examination of cultural property includes research on new methods and techniques, new applications of present methods and techniques, improvements to current methods and techniques, and transfer of existing methods and techniques to the conservation field. Research on technically advanced treatment methods includes development and testing of instrumental methods such as laser cleaning. The name of the group has been changed to Scientific Methods of Examination of Works of Art to reflect the new program.

Conservation scientists play an important role in the preservation of our heritage. Those involved in the examination and analysis of cultural property, as well as those developing technically advanced treatment methods have to stay abreast of technological, instrumental, and analytical developments in order to transfer or apply them to their work in conservation. It is important to disseminate this information to colleagues; our group provides a forum where scientists can discuss the methodology and logistics of their research.

After three years' interruption, the main activity of the group was to rebuild its membership. Newsletters have been published twice, in the fall of 1997 and 1998; the next issue will be published after the 1999 meeting. The newsletter serves as a communication tool, informing members about new publications, web sites, and upcoming meetings of relevance to conservation scientists. It is also a means to promote exchange between members by providing them with a list of members including their fields of activity, research areas, and special interests.

The papers presented at the 12th ICOM-CC triennial meeting bear witness to the contribution of science to conservation. Well-established techniques are used to investigate ancient and modern materials, always adding to the body of knowledge on artistic, historic, and archaeological materials. New, sophisticated techniques are used to characterise traditional materials such as drying oils and dyes, which still retain some of their secrets.

Résumé

Cet article a pour but de caractériser la cire punique après une relecture des recettes antiques. Des échantillons expérimentaux ont été préparés et comparés par spectrométrie infrarouge IRTF au matériel archéologique recueilli sur des portraits du Fayoum à l'encaustique. Des précisions nouvelles sur la technique de fabrication de la cire punique tant au niveau des matériaux utilisables que de l'importance des différentes étapes de la chaîne opératoire sont apportées. Les spectres IRTF révèlent que le matériel archéologique diffère de la cire punique obtenue.

Mots-clés

cire d'abeille, cire punique, portrait du Fayoum, spectrométrie infrarouge, chromatographie en phase gazeuse, natron

La cire punique : Etude critique des recettes antiques et de leur interprétation. Application aux portraits du Fayoum

Sylvie Colinart★ et Sibille Grappin-Wsevolojsky
Laboratoire de recherche des musées de France, UMR 171 du CNRS
6 rue des Pyramides
F-75041 Paris cedex 01
France
Fax : +33 (01) 47 03 32 46
Email : colinart@culture.fr

Chantal Matray
51 rue du Rouet
F-13008 Marseille
France

Introduction

L'étude de la technique picturale à l'encaustique des «portraits du Fayoum», initiée lors de la restauration d'œuvres conservées dans les collections des antiquités égyptiennes du musée du Louvre (Paris) ou du musée des Beaux-Arts de Dijon, a posé le problème de l'identification du liant. La littérature indique qu'il pourrait s'agir de cire d'abeille pure (Pétrie 1889) ou de cire punique. Cette dernière serait le résultat d'un traitement chimique subi par la cire d'abeille selon des recettes antiques rapportées par Pline l'Ancien (1969) et Dioscorides (1907). Celles-ci conduiraient à une cire plus ou moins saponifiée que l'on pourrait travailler, au pinceau, plus facilement que la cire d'abeille (Doxiadis 1995).

Dès la fin du XIXe siècle, de nombreux auteurs, historiens d'art, scientifiques ou restaurateurs se sont intéressés aux portraits du Fayoum, mais peu de textes font référence aux analyses permettant de différencier une cire d'abeille d'une cire punique. Une étude ancienne fait état de remarques sur les points de fusion (Dow 1936). En 1959, Kühn (1960) synthétise, sur la base de la recette de Pline, une cire qu'il qualifie de «punique» et dont il obtient le premier spectre infrarouge publié, mettant en évidence la saponification partielle de la cire d'abeille avec l'apparition d'une bande carboxylate située vers 1570 cm$^{-1}$, mais il n'étudie aucun matériel archéologique. Fromageot (1996), en désaccord avec Kühn, indique que la bande qui caractérise la cire punique est située à 1620 cm$^{-1}$. En 1978, White (1978) et plus récemment Alexopoulou-Agoranou et al. (1997) proposent des identifications de cire punique par chromatographie en phase gazeuse, mais les empreintes chromatographiques présentées ne permettent pas de préciser la nature du liant cireux.

À ce stade de nos connaissances, plusieurs questions se posent pour pouvoir identifier le liant : qu'est-ce que la cire punique des recettes antiques? Que devient la cire d'abeille après saponification? Peut-on la caractériser? Toutes ces interrogations sont à l'origine de la recherche présentée ici.

Ainsi, à partir d'une relecture des recettes antiques et de leurs interprétations contemporaines, des expérimentations ont été effectuées afin de comprendre ce qui se cache sous l'appellation «cire punique». Les échantillons expérimentaux et le matériel archéologique recueilli durant la restauration ont été comparés par spectrométrie IRTF et par chromatographie en phase gazeuse, la cire brute d'abeille servant de référence.

Qu'est-ce que la cire d'abeille?

La cire d'abeille, qui sert de matière première pour l'expérimentation et de référence pour l'analyse, est constituée d'un mélange moléculaire complexe. Elle est principalement composée d'une série d'alcanes linéaires à nombre de carbones impair, de C_{21} à C_{33}, l'hydrocarbure en C_{27} étant majoritaire, et d'une série d'esters de palmitate à nombre de carbones pair allant de C_{40} à C_{52}, le C_{46} étant majoritaire.

★Auteur auquel la correspondance doit être adressée

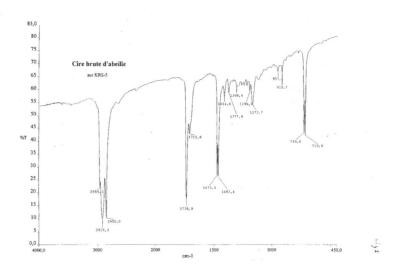

Figure 1. Spectre infrarouge de la cire brute d'abeille.

Sont présents en moindre quantité, des acides gras libres à nombre de carbones pair de C_{16} à C_{44}, le C_{24} étant majoritaire, deux alcènes linéaires en C_{31} et C_{33}, et des alcools à nombre de carbones pair de C_{16} à C_{44} (Kolattukudy 1976). Selon l'origine de la cire, quelques variations de composition peuvent exister mais l'empreinte générale du chromatogramme (Colinart 1996) et celle du spectre infrarouge permettent son identification. Le spectre IRTF se caractérise par une bande ester à 1737 cm$^{-1}$, une bande acide libre à 1712 cm$^{-1}$ et parfois, selon l'origine de la cire, un épaulement ou une bande hydroxyl de faible intensité vers 1630 cm$^{-1}$ (voir Fig. 1).

Qu'est-ce que la cire punique? Etat de la question

Aucun texte égyptien ne nous est parvenu sur la technique picturale à l'encaustique, ni sur la manière d'obtenir la cire punique.

Seuls Pline l'Ancien dans son *Histoire naturelle* en latin (1969) et Dioscorides dans *De materia medica* en grec (1907) font apparaître le terme «cire punique» (*punica*,Ρωματοι) en énonçant les diverses étapes de traitement de la cire d'abeille qui en est à l'origine. La recette de Dioscorides (1907) décrit la fabrication de cire blanche pour la fabrication de pilules à des fins médicales. Cette recette est très proche de celle de Pline qui a été reprise dans la plupart des écrits parus sur la technique picturale des portraits du Fayoum et qui ne sera donc pas présentée ici.[1] Elle peut se résumer en trois étapes : prélavage, réaction au «nitrum», rinçage. Par la suite, quand nous ferons référence aux recettes antiques, nous nous rapporterons de préférence à celle de Pline, plus appliquée à la technique picturale.

Si ces textes antiques exposent clairement les étapes de traitement de la cire d'abeille, ils ne mentionnent pas les proportions des divers ingrédients. D'où la nécessité de reproduire les recettes antiques afin de savoir si elles conduisent à une cire d'abeille totalement saponifiée comme le pense Burdick (1938) ou à une cire partiellement saponifiée (Ramer 1979).

Une autre difficulté se présente : les mots «nitrum» ou «νιτρον» des recettes antiques prennent plusieurs sens selon leur traduction. S'agit-il du natron trouvé en Égypte ou de carbonate de «soude», c'est-à dire de sodium, comme il est écrit dans certaines traductions du texte latin de Pline (1969)? Bailly (1901) définit «νιτρον» comme étant «de la nitre, ou un alcali minéral ou végétal, ou une sorte de soude ou de natron pour lessiver». Pour Berger (1904), il s'agirait également de natron mais il se pourrait que ce soit de la soude. De là naît une grande confusion. L'hypothèse de la nitre est rapidement écartée par Lucas (1962) qui considère que ce produit est très peu utilisé dans l'Égypte antique sauf dans la momification ou dans la fabrication de verre. Il précise la composition du natron à partir de l'analyse d'échantillons archéologiques et géologiques. Ce natron est constitué majoritairement de carbonate de sodium, d'hydrogénocarbonate de sodium, de chlorure de sodium et de sulfate de sodium avec d'autres constituants mineurs (Lucas 1962).

De l'interprétation des termes «nitrum» ou «νιτρον» émergent une série de matériaux dont certains ont été utilisés dans quelques essais de reproduction des

Tableau 1. Interprétation des termes «nitrum» ou «νιτρον»

«nitrum» ou «νιτρον»					
Na_2CO_3	$NaHCO_3$ ou $KHCO_3$	Na_2CO_3 et $NaHCO_3$	Natron : Na_2CO_3, $NaHCO_3$, Na_2SO_4, NaCl	NaOH	Nitre, salpêtre : KNO_3
Dow 1936 Kühn 1960	Dow 1936	Doxiadis 1995	Bailly 1901 Lucas 1962 Dayton 1979	Bailly 1901 Berger 1904	Bailly 1901

recettes antiques dont les nôtres (voir Tableau 1). Ainsi, Kühn emploie du carbonate de sodium seul. L'expérimentation la plus récente est due à Doxiadis, peintre d'icônes qui réalise elle aussi une synthèse de cire punique en se référent aux textes antiques mais en donnant une recette imprécise et sans résultats d'analyse. L'ajout de quelques gouttes de jaune d'œuf et d'huile de lin conduisent à une matière agréable à travailler (Doxiadis 1995). D'autres additifs sont cités par Ramer (1979), tels la résine de pin maritime ou l'huile d'olive.

Expérimentation

Afin d'étudier les modifications possibles de la cire d'abeille et de pouvoir comparer, par l'analyse spectrométrique, les cires obtenues expérimentalement aux cires archéologiques, la recette proposée par Kühn a été reproduite selon le protocole donné par l'auteur ainsi que celle de Doxiadis pour laquelle nous avons fixé les proportions des ingrédients.

Pour la recette antique, dite de Pline, nous avons choisi de prendre un mélange dont la composition correspond à celle du natron trouvé en Égypte. Celle-ci a été définie à partir de la moyenne des données connues tirées de l'analyse de plusieurs gisements égyptiens naturels et de matériel archéologique, soit 30 % de carbonate de sodium, 30 % d'hydrogénocarbonate de sodium, 30 % de chlorure de sodium et 10 % de sulfate de sodium (Lucas 1962). Le rôle des étapes de prélavage et de rinçage à l'eau de mer a été étudié.

Les différents essais sont donnés pour 100 g de cire d'abeille jaune mise dans 300 mL de solvant, avec la proportion des autres ingrédients constituant le «nitrum» (voir Tableau 2).

Chaque mélange réactionnel est porté à reflux pendant une heure, pour pouvoir comparer les résultats et ne pas avoir d'évaporation. C'est peut-être pour cela que nous n'avons observé dans aucun mode opératoire la «fleur blanche» mentionnée sans plus de précisions par Pline. L'eau de mer a été prise au large des Calanques de Marseille. Les essais à l'eau salée ont été entrepris avec la même concentration en chlorure de sodium que celle de la mer Méditerranée (37 $g.L^{-1}$).

Afin d'avoir une référence de cire d'abeille totalement saponifiée, le protocole suivant a été effectué : 15 g de cire d'abeille, 20 mL de soude à 30 %, et 10 mL de méthanol sont portés à reflux sous agitation pendant 1 heure. Un relargage du

Tableau 2. Protocole des différents essais

Protocoles ↓	Prélavage à l'eau de mer	Réactifs	Solvant	Rinçage
Kühn	non	3 g Na_2CO_3	eau distillée	non
Doxiadis	oui	3 g Na_2CO_3 3 g $NaHCO_3$	eau de mer	non
Pline recette n° 1	non	10 % de natron : 3 g Na_2CO_3, 3 g $NaHCO_3$ 3 g NaCl 1 g Na_2SO_4	eau de mer	eau de mer
recette n° 2	non	20 % de natron	eau de mer	eau de mer
recette n° 3	oui	10 % de natron	eau de mer	eau de mer
recette n° 4	oui	5 % de natron	eau de mer	eau de mer
recette n° 5	oui	2,5 % de natron	eau de mer	eau de mer

produit est pratiqué dans 300 mL d'eau distillée contenant 90 g de chlorure de sodium. Le mélange est neutralisé à l'acide chlorhydrique jusqu'à un pH ~ 7-8. La masse est filtrée sur Büchner et lavée trois fois avec 20 mL d'eau distillée, puis séchée.

Mesures

Les échantillons expérimentaux ont été analysés par spectrométrie infrarouge IRTF sur un appareil Perkin-Elmer, spectrum 2000, après pastillage de 13 mm dans du bromure de potassium ou après application sur des fenêtres de KrS_5.

Le matériel archéologique a été sélectionné sous loupe binoculaire. Les spectres ont été réalisés par micropastille de 2 ou 1 mm de diamètre dans le bromure de potassium, après extraction de la matière cireuse par du chloroforme.

La chromatographie en phase gazeuse a été réalisée avec un appareil Hewlett Packard 6890 sur une colonne en silice fondue (J&W Scientific, L = 15 m, d. int. = 0,32 mm, phase stationnaire DB1, e = 0,1 μm). La matière cireuse extraite au chloroforme a été injectée directement dans la colonne (injecteur *on-column*), sans dérivatisation préalable. Programmation de température : 1 min à 50 °C, de 50 à 350 °C à 10 °C/min.

Résultats et discussion

Le matériel archéologique

L'analyse par spectrométrie infrarouge révèle des empreintes différentes selon le prélèvement étudié. Les spectres ont tous conservé la bande ester à 1737 cm⁻¹ mais il apparaît une bande d'intensité variable dont le maximum est situé entre 1632 et 1637 cm⁻¹, bande supposée associée à la fonction carboxylate de la cire punique (Fromageot 1996). Sur certains spectres, la bande acide à 1712 cm⁻¹ a complètement disparu. En revanche, sur d'autres, la fonction acide apparaît sous la forme d'un léger épaulement sur le pic de la fonction ester et une bande de faible intensité, non assignée pour l'instant, est visible entre 1541 et 1545 cm⁻¹ (voir Fig. 2). Les spectres peuvent ainsi être classés en trois groupes (voir Tableau 3).

Les matériaux issus de l'expérimentation

La saponification de la cire d'abeille conduit à un matériau différent de la cire d'abeille brute (voir Fig. 3). Les bandes ester et acide ont disparu du spectre IRTF au profit d'une bande carboxylate à 1559 cm⁻¹, correspondant à la formation du palmitate de sodium. On la retrouve très légèrement décalée à 1560 cm⁻¹ dans la cire de la recette de Kühn.

Celle-ci permet de fabriquer une cire partiellement saponifiée dans le spectre de laquelle la bande acide a disparu. Il faut remarquer que le spectre publié en 1960 est moins bien résolu et que la fonction carboxylate y apparaît à 1570 cm⁻¹. Notons que la matière cireuse forme, en fin de manipulation, une émulsion qui se sépare

Tableau 3. *Classification du matériel archéologique d'après les spectres IRTF*

Classification	Absorptions principales du spectre IRTF (cm⁻¹)	Portrait : titre, musée, n° d'inventaire
Groupe I	1737 ester 1712 acide 1632-1638 (?) 1541-1545 (?), bande absente	Femme, Louvre, MND 2047
Groupe II	1737 ester 1712 acide, bande absente 1632-1638(?) 1541-1545 (?), bande absente	Homme, Dijon, GA2 Femme, Dijon, GA5 Femme, Dijon, GA9 Homme, Louvre , AF6887
Groupe III	1737 ester 1712 acide, bande faible ou absente 1632-1638 (?) 1541-1545 (?)	Homme, Dijon, GA3 Femme, Dijon, GA1 Femme, Dijon, GA6
Cire d'abeille brute	1737 ester 1712 acide	

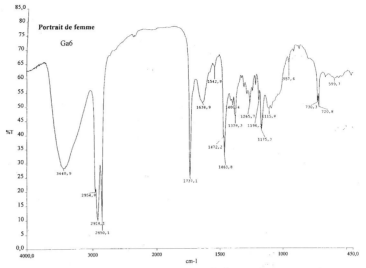

Figure 2. Spectre d'une cire d'un portrait de femme (Ga-6, Dijon).

difficilement de la phase aqueuse réactionnelle à base d'eau distillée. Après un séchage difficile, la matière est toute craquelée.

La cire obtenue en quantifiant la recette de Doxiadis est également partiellement saponifiée et son spectre présente aussi une bande de faible intensité à 1630 cm⁻¹ alors que sur celui de la cire de Kühn, il s'agit d'un épaulement.

Nos essais sur la recette antique révèle que l'emploi de plus de 10 % de natron, avec prélavage et rinçage à l'eau de mer ou sans ces étapes, conduit à une matière très colorée à la consistance granuleuse et peu cohésive, matière qui paraît difficilement employable en tant que liant. En dessous de 5 % de natron et avec l'utilisation d'eau de mer dans toutes les étapes de traitement de la cire (recettes nᵒˢ 4 et 5 de Pline), on obtient une cire partiellement saponifiée à la texture «crémeuse». En séchant, elle se rétracte, se fissure et reprend un aspect proche de celui d'une cire d'abeille. Elle a une zone de fusion légèrement supérieure à celle de la cire d'abeille pure, 71–104 °C.[2]

Le prélavage de la cire brute à l'eau de mer chaude permet la dissolution d'impuretés, non analysées. Les eaux de filtration recueillies après refroidissement se sont colorées. La cire s'est éclaircie. Son spectre montre une bande large et peu intense à 1630 cm⁻¹, la fonction acide est toujours visible (voir Fig. 4). Plusieurs hypothèses sont proposées quant à l'origine de cette bande : on peut supposer qu'elle est le résultat d'un piégeage d'eau dans la cire ou d'une hydrolyse partielle de certains esters au moment du chauffage (Charters et al. 1995). Elle pourrait aussi être due à la formation d'un complexe avec le chlorure de sodium détecté en microscopie électronique à balayage sous forme de micrograins dans la matière cireuse. Notons que dans certains échantillons frais de cire d'abeille, cette bande

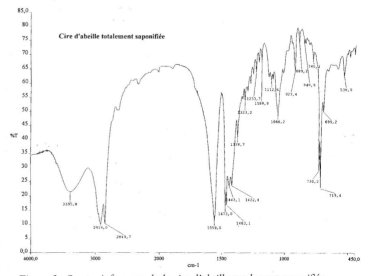

Figure 3. Spectre infrarouge de la cire d'abeille totalement saponifiée.

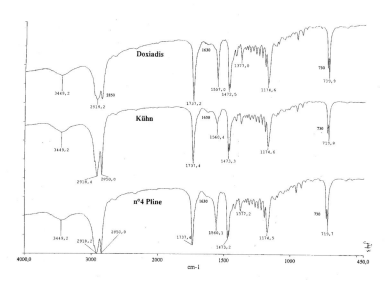

Figure 4. Spectres des trois essais de fabrication de cire punique selon les recettes de Kühn, Doxiadis et Pline.

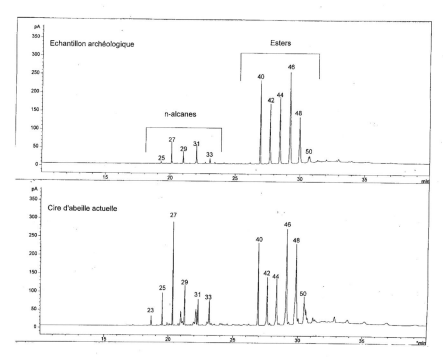

Figure 5. Chromatogrammes d'une cire d'abeille fraîche et d'un échantillon archéologique d'un portrait de femme, Louvre MND 2047.

existe déjà et est attribuable à la présence d'alcool. Elle est légèrement renforcée par le prélavage.

Le rinçage du matériau cireux par l'eau de mer est également important. Le chlorure de sodium gêne la formation de l'émulsion qui apparaît au cours de la saponification. Le rinçage facilite la récupération de la matière cireuse contrairement à ce qui se passe dans le mode opératoire proposé par Kühn et par Doxiadis.

Les essais menés montrent qu'il est possible d'obtenir une cire d'abeille partiellement saponifiée. Le matériau obtenu se caractérise par un spectre IRTF possédant une bande carboxylate autour de 1560 cm$^{-1}$. Son absence sur les spectres des prélèvements archéologiques indique que nous n'avons pas affaire à une cire saponifiée. La bande aux alentours de 1630 cm$^{-1}$ ne semble pas provenir d'un lavage à l'eau de mer car nous n'avons pas décelé de chlorure de sodium dans ces prélèvements. Elle pourrait s'expliquer par le vieillissement de la cire qui donnerait naissance à des alcools et à de l'acide palmitique par altération des esters. Certains produits en faible quantité n'étant pas décelés par spectrométrie, pourraient l'être par chromatographie en phase gazeuse. Dans les conditions opératoires choisies,

cette technique est inadaptée à la mise en évidence du palmitate, mais elle révèle un chromatogramme inattendu pour les échantillons archéologiques : les esters restent majoritaires alors que les hydrocarbures «s'effondrent» (voir Fig. 5). La poursuite de notre recherche devrait permettre de préciser le processus de vieillissement de tous ces matériaux cireux.

Conclusion

Les travaux menés sur les recettes antiques ont permis de synthétiser une matière cireuse partiellement saponifiée, dite «cire punique».

Ils ont apporté des précisions nouvelles sur sa technique de fabrication tant au niveau des matériaux utilisables que de l'importance des différentes étapes de la chaîne opératoire. Les analyses par spectrométrie IRTF ont révélé que le matériel archéologique était différent de la cire punique obtenue.

Il paraît maintenant nécessaire d'entreprendre l'étude du vieillissement de la cire d'abeille et de la cire punique, avec ou sans pigment, afin d'en connaître le processus qui paraît plus compliqué que la simple dégradation des esters; en particulier, il faudrait voir si les hydrocarbures sont détruits par attaque microbactériologique comme on l'observe pour les hydrocarbures des pétroles. Ainsi, nous pourrons peut-être savoir si l'emploi de cire punique dans les portrait du Fayoum est un mythe ou une réalité.

Notes

1. Traduction du texte de Discorides, *De materia medica*, II, 83–84, par Chantal Matray, professeur agrégée de Lettres classiques :

 Très bonne est la cire blonde, plutôt onctueuse, odorante, et avec un léger parfum de miel, et pure en plus; d'origine crétoise ou pontique; alors que la cire très blanche naturellement et plus épaisse est moins bonne.
 Il faut blanchir la cire, voici comment : bien écraser le blanc de la cire, puis verser dans un récipient propre de la cire onctueuse, bien nettoyer les impuretés. Recouvrir d'eau de mer prise au large en quantité suffisante, et porter rapidement à ébullition en y versant en pluie du natron. Quand elle a bouilli deux ou trois fois, retirer le récipient et laisser refroidir. Enlever alors la rondelle obtenue et racler les impuretés s'il y en a. Faire bouillir à nouveau en ajoutant encore de l'eau de mer. Lorsque la cire a recommencé à bouillir, bien clairement, retirer le récipient du feu. Utiliser alors le fond d'un petit pot propre, l'humidifier avec de l'eau bien froide, l'appliquer doucement sur la cire, en l'enfonçant délicatement pour que le minimum de cire y adhère et durcisse de lui-même. Prélever alors la première pastille ainsi obtenue, la réserver. En appliquant à nouveau le fond du pot refroidi à l'eau, répéter la même opération jusqu'à épuisement de la cire. Il ne reste plus alors qu'à passer un fil à travers les pastilles, à les suspendre en les séparant bien les unes des autres, puis à les exposer au soleil pendant la journée, en les humidifiant bien régulièrement, et la nuit à la lumière de la lune, jusqu'à ce qu'elles deviennent blanches. Toutefois, si on veut obtenir une blancheur parfaite, procéder, pour l'ensemble, de la même façon mais multiplier les cuissons. Certains remplacent l'eau de mer par une solution salée très concentrée, portent à ébullition comme indiqué plus haut mais une seule fois, ou deux; ils forment les pastilles en faisant prendre la cire sur une petite fiole qu'ils font tourner sur elle-même, puis ils les dispersent sur l'herbe humide et drue, et les laissent au soleil jusqu'à ce qu'elles soient très blanches. Pour éviter qu'elles ne mollissent, ils recommandent de procéder à cela au printemps lorsque le soleil est doux et fait naître de la rosée.
 Toute cire a des vertus thermogènes, adoucissantes et légèrement cicatrisantes; mélangée avec de la bouillie, elle est bonne contre la dysenterie; bue en doses équivalant à dix grains de millet, elle empêche le lait de cailler pour les nourrices.
2. Mesures effectuées sur banc Köfler.

Références

Alexopoulou-Agoranou A, Kalliga AE, Kanakari U, Pashalis V. 1997. Pigment analysis and documentation of two funerary portraits which belong to the collection of the Benaki Museum. Dans : Portraits and masks, burial customs in Roman Egypt. Sous la direction de ML Bierbrier. Londres : British Museum Press : 88–96.

Bailly A. 1901. Dictionnaire grec-français. Paris : Editions Hachette.

Berger E. 1904. Beiträge zur Entwicklungsgeschichte des Maltechnick, I-II. Die Maltechnik des Altertums. Munich : Callwey : 185–238.

Burdick CL. Janvier 1938. The ancient wax medium. Technical studies in the field of the fine arts 6(3) : 183–185.

Charters S, Evershed RP, Blinkhorn PW, Denham V. 1995. Evidence for the mixing of fats and waxes in archaelogical ceramics. Archaeometry 37(1) : 113–127.

Colinart S. 1996. Analyse des cires dans les oeuvres d'art par chromatographie en phase gazeuse. Analusis Magazine 24(7) : 31–34.

Dayton J. 1983. Minerals, metals, glazing and man or who was Sesostris I. Londres : Harrap.

Dioscorides P. 1907. De materia medica, Livre V, Ed. Max Wellman1, II 83-84 : 166–169.

Dow E. 1936. The medium of encaustic painting. Technical studies in the field of the fine arts 5(1) : 3–17.

Doxiadis E. 1995. Portraits du Fayoum. Paris : Editions Gallimard : 95–97.

Fromageot D. 1996. CNEP, URA 433 du CNRS. Rapport interne n° DF NP 96.154.

Kolattukudy PE. 1976. Chemistry and biochemistry of natural waxes. Amsterdam : Elsevier.

Kühn H. 1960. Detection and identification of waxes, including punic wax, by infra-red spectrography. Studies in conservation 5(2) : 77–81.

Lucas A. 1962. Ancient Egyptian materials and industries. 4e édition. Londres : E. Arnold Ltd.

Pétrie A. 1889. Hawara, Biahmu and Arsinoe. Londres : Field & Tuer : 18.

Pline l'Ancien. 1969. Histoire naturelle, livre XXI, 84. Paris : Les belles lettres : 56–57.

Ramer R. 1979. The technology, examination and conservation of the Fayum portraits in the Petrie Museum. Studies in conservation 24 : 1–13.

White R. 1978. The application of gas-chromatography to the identification of waxes. Studies in conservation 23 : 57–68.

Abstract

In a previous study new compounds were detected from light-aged natural yellow (flavonoid) dyes on alum-mordanted wool. We have now developed a novel analytical technique – negative ion electrospray ionisation quadrupole ion trap tandem mass spectrometry (ESI QIT MS) – for further study and identification of characteristic flavonoid photodegradation products in light-aged historical textiles. The comparison between atmospheric pressure chemical ionisation (APCI) and electrospray ionisation (ESI) both in negative and positive ion mode showed that negative ion electrospray ionisation is the better ionisation method for the analysis of flavones and flavonols, specifically apigenin, quercetin, kaempferol, morin, fisetin and luteolin. Furthermore, the analysis of acid-hydrolysis extracts from dyed wool by negative ion electrospray mass spectrometry (ESI MS) provided complementary data to those obtained by photodiode array high performance liquid chromatography (PDA HPLC). The study of flavonoids by negative ion ESI QIT MS showed fingerprint patterns of breakdown peaks specific to each flavonoid. An example of the analysis of these breakdown patterns to provide structural information is also discussed.

Keywords

flavonoid, textile, photodegradation, photodiode array high performance liquid chromatography (PDA HPLC), negative ion electrospray ionisation quadrupole ion trap tandem mass spectrometry (ESI QIT MS)

The analytical characterisation of flavonoid photodegradation products: A novel approach to identifying natural yellow dyes in ancient textiles

Ester S.B. Ferreira
The University of Edinburgh
Joseph Black Chemistry Building
King's Buildings, West Mains Road
Edinburgh EH9 3JJ
UK
Email: ef@nms.ac.uk

Anita Quye
National Museums of Scotland
Chambers Street
Edinburgh, EH1 1JF
Scotland
Email: aq@nms.ac.uk

Hamish McNab,★ Alison N. Hulme
The University of Edinburgh, Joseph Black Chemistry Building
Fax: +44 131 650 4743
Email: H.McNab@ed.ac.uk, Alison.Hulme@ed.ac.uk

Jan Wouters
Royal Institute for Cultural Heritage
Jubelpark 1
B-1040 Brussels
Belgium
Email: Jan_W@kikirpa.be

Jaap J. Boon
FOM Institute for Atomic & Molecular Physics
Kruislaan 407
1098 SJ Amsterdam
The Netherlands
Email: Boon@amolf.nl

Introduction

Light-vulnerable dyestuffs can be identified by chemical analysis, an important factor in the conservation and preservation of archaeological and historical textiles. Such analysis also enables plant or insect dye sources to be established which, when combined with historical evidence on dyeing practices and trade routes, can assist in elucidating how, where or when a textile was dyed. A variety of micro-analytical techniques are used in a museum context to analyse dyes on ancient textiles, principally thin layer chromatography (TLC) (Schweppe 1986), and high performance liquid chromatography (HPLC) coupled to either a monochromatic UV-visible detector (Walker and Needles 1986) or multi-wavelength photo-diode array detector (PDA HPLC) (Wouters and Rosario-Chirinos 1992: Quye and Wouters 1993: Halpine 1996: Nowik 1996). Although these techniques are successful in the identification of many natural dyes, yellow dyes can prove difficult. One main reason is suspected to be photodegradation by light-ageing, which chemically alters the structure of the dye molecule, changing its chromatographic and spectral behaviour (Quye et al. 1996). Analytical data for photodegraded unknown dyes would therefore differ significantly from unaged references or standard results, impeding identification by spectral and chromatographic comparison.

The majority of natural yellow dyestuffs are flavonoid-containing plants, of which weld (*Reseda luteola* L.), dyer's greenweed (*Genista tinctoria* L.), old fustic (*Chlorophora tinctoria* Gaud.), and onion skins (*Allium cepa* L.) are historically important examples. The flavonoid compounds in these dyes are principally flavones (e.g. 1 & 2, Fig. 1), (2-phenyl-4*H*-chromen-4-ones) and flavonols (e.g. 3 & 4, Fig. 1), (3-hydroxy flavones) as well as their *O*-glycosides (e.g. 5 & 6, Fig.

★ Author to whom correspondence should be addressed

Apigenin (1) *Luteolin (2)*

Quercetin (3) *Kaempferol (4)*

Luteolin
7-O-glucoside (5) *Quercetin*
3-O-glucoside (6)

Figure 1. Molecular structure of the main flavonoids of weld and onion skins.

1). In a recent study to investigate photodegradation products from light-aged alum-mordanted wool dyed with flavonoid dyes after artificial ageing, unidentified chromophoric and non-chromophoric compounds were detectable by PDA HPLC (Quye et al. 1997). As these products are potentially uniquely characteristic of the original flavonoid, and hence dye source, they could prove to be important markers in historical textile analysis. Furthermore, by establishing the degradation mechanism and intermediate compounds of flavonoid degradation, information about influential factors like wavelength and relative humidity would usefully add to conservation considerations for displaying flavonoid-dyed ancient textiles.

Although flavonoid photodegradation has been studied in solution (e.g. Matsuura et al. 1970: Yokoe et al. 1981), very little published information exists on the degradation products of flavonoid mordant dyes in textiles. As PDA HPLC is limited for chemical structure elucidation of unknown compounds, supplementary analytical techniques need to be developed to identify the flavonoid photodegradation products at the very low concentration levels typically extracted from historical textile samples (in the order of 0.01%, i.e. 10–50ng of flavonoid per mg of textile sample).

This paper reports the novel development and application of modern methods of electrospray ionisation mass spectrometry (ESI MS) to identify pure flavonoid standards and acid-hydrolysed extracts from unaged, alum-mordanted wool, dyed with weld or onion skins. The aim of this work was to apply these mass spectrometric techniques to interpret PDA-HPLC results for light-aged flavonoid photodegradation products in the next stage of the project. ESI MS was developed initially for the study of large molecules (proteins and other polymers), but has proved very useful for the identification of flavonoids and other polyphenolic compounds (He et al. 1996: Nawwar et al. 1997: Watson and Pitt 1998). This study reports the application of ESI MS techniques to low flavonoid concentration levels such as found in historical samples and uses ion trap technology to provide structural information based upon the observed fragmentation patterns.

Experimental

Preparation of dyed wool references

Dyeing with natural flavonoid sources involves the aqueous extraction of the coloured compounds from the plant subtract to make a dye bath. Scoured and mordanted wool is then immersed in the dye bath and the formation of a flavonoid-mordant complex is responsible for the colouring of the fibres.

Scouring

For 15g of wool, a scouring solution of 160mL deionised water containing 0.75g of Synperonic N surfactant (final concentration 0.5% w/w) was prepared. The wool was immersed in the solution and gently heated on a hot plate from ambient to 40°C over 25 minutes, maintaining the final temperature for 10 minutes. The wool was then rinsed several times in deionised water until the water was clear.

Mordanting

Alum (3.6g, potassium aluminium sulphate, $KAl(SO_4)_2$) was dissolved in 30mL of deionised water, heated gently until it dissolved, then the solution was added to 720 mL of deionised water containing 0.9g of potassium hydrogen tartrate. Wool (15.0g) was added and this mordanting solution was heated to boiling point on a hot plate and simmered for 30 minutes. Following cooling overnight in the solution, the wool skeins were rinsed and left to dry in a dark place.

Dyeing

The dyeing procedures were adapted from those described by Fraser (1983).

Weld (*Reseda luteola* L.) (principle flavonoids: luteolin, luteolin 7-O-glucoside and apigenin [Cardon 1994]): dried weld (7.0 g) was soaked in 50 mL of deionised

water overnight. The solution was decanted off and the weld further extracted with 2 × 50mL of deionised water; the three fractions were combined to form the dyebath. Wetted alum mordanted wool (1.2g dry weight) was immersed in the dyebath, heated and left at 90°C for 30 minutes. The dyebath was allowed to cool for 30 minutes before removing the wool skeins, which were rinsed in deionised water and dried under tin foil to exclude light.

Onions skins (*Allium cepa* L.) (principle flavonoids: quercetin, quercetin 3-*O*-glucoside and kaempferol. More detailed composition including minor flavonoids can be found in several phytochemistry studies [Bilyk et al. 1984: Cardon and Chatenet 1990: Price et al. 1997: Fossen et al. 1998]): the dried outer skins from commercially-available onions (1.65g) were cut into small pieces and immersed in 150mL of deionised water. The dyebath was heated to boiling point and allowed to simmer at 90°C for 1 hour. The onion skins were removed by filtration and the dyebath cooled to 35–40°C before adding wet mordanted wool skeins (1.2g dry weight) which were immersed and left for 30 minutes and occasionally stirred with no further heat being applied. The skeins were rinsed and dried as for weld.

Extraction of flavonoids from wool references for analysis

The dyed wool references (1.0 mg) described above were extracted by acid hydrolysis (Quye et al. 1996) and the residues reconstituted in 400μL of MeOH:H_2O [1:1(v/v)]. The extracts were kept at −20°C until analysed by PDA HPLC and ESI MS.

Standard solution preparation

Standard solutions of quercetin dihydrate, morin hydrate, fisetin, kaempferol, and apigenin were prepared by dissolving a known amount of the flavonoid in HPLC-grade methanol and successively diluting it in methanol until the required concentration (1–500 μM) was obtained.

PDA-HPLC

PDA-HPLC was performed as described in the preliminary study (Quye et al. 1996).

Atmospheric pressure ionisation mass spectometry

Initially the samples were run on a Micromass 8376E platform atmospheric pressure ionisation mass spectrometer both in negative and positive electrospray ionisation (ESI) and atmospheric pressure chemical ionisation (APCI) mode, in order to assess the sensitivity of the different methods. The samples were injected by an automatic sampler (HP 1050 series) and the data processed by OpenLynx 2.0 software.

Once the method was selected, samples were run on a Micromass 8370E platform electrospray ionisation mass spectrometer in the negative ion mode using the following parameters: sample injection flow rate 10 μl/min; capillary voltage –3.5kV, HV lens 0.54; IE 0.7-1; LM res 13.3; HM res 15.3; cone voltage -25 to –80V. Data were collected and processed by MassLynx 2.0 software.

Electrospray quadrupole ion trap mass spectrometry and tandem mass spectrometry

Mass spectrometry and tandem mass spectrometry (MS-MS) analyses of the flavonoid solutions were performed on a LCQ™ electrospray quadrupole ion trap mass spectrometer with the following parameters: spray voltage -5kV; capillary temperature 175°C; capillary voltage −17V; sheath gas (N_2) flow rate 80 units; auxiliary gas (N_2) flow rate 10 units; tube lens offset −10V; first octapole offset 2.5V; second octapole offset 5.5V; lens voltage 28V; relative collision energy 20.1%; helium collision gas; sample injection flow rate 8 μL/min. Data were collected and processed by LCQ™ software.

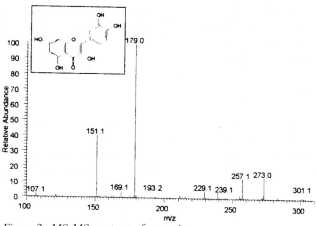

Figure 2. MS-MS spectrum of quercetin.

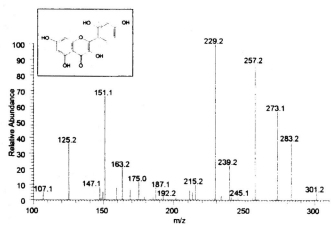

Figure 3. MS-MS spectrum of morin.

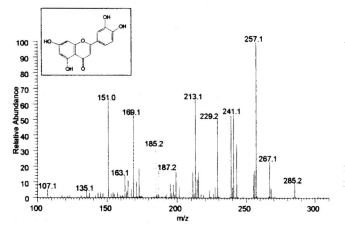

Figure 4. MS-MS spectrum of luteolin.

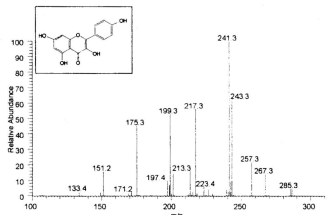

Figure 5. MS-MS spectrum of kaempferol.

Results and discussion

Atmospheric pressure ionisation mass spectrometry: ESI vs APCI

Atmospheric pressure ionisation mass spectrometry offers two ionisation methods: atmospheric pressure chemical ionisation (APCI) and electrospray ionisation (ESI). For low molecular weight, polar molecules like the flavonoids under study, both techniques should produce deprotonated singly charged ions in negative ion mode (Ashcroft 1997). Using pure standard solutions of typical hydroxyflavones quercetin, apigenin and kaempferol (See Fig. 1), comparison between these two ionisation methods showed that ESI was a milder, more sensitive technique, with detection levels in the 5μM range. (For comparison, detection levels in APCI mode were in the 20μM range). Positive ion mode for both methods gave poor sensitivity results with ESI giving no detectable signal for any of the samples. This is understandable since this method requires the analyte to form positive ions in solution and there are no protonation sites in such flavonoids.

PDA HPLC and ESI MS analysis of dye extracts from mordanted wool

After optimising the parameters for ESI MS for pure compounds, this technique was tested on acid-hydrolysed extracts from alum-mordanted wool samples (1mg),

Table 1. PDA HPLC and ESI MS results for the major flavonoids extracted from wool samples dyed with onion skins and weld.

Flavonoid	λ_{max} (nm)	Retention time (min)	[M-H]⁻
Quercetin	256,372	18.2	301
Apigenin	270,340	22.8	269
Luteolin	255,350	20.9	285

dyed with onion skins and weld, and the results compared with the PDA HPLC data. The flavonoids shown in Table 1 were not significantly affected by the acid hydrolysis conditions. Hence, these techniques provide three independent means of characterising the flavonoid, by its λ_{max}, retention time, and molecular ion.

Use of ESI QIT MS-MS for the analysis of natural yellow dyes

The advantage of a quadrupole ion trap mass analyser over a single quadrupole is that ions of a particular mass can be isolated and, by gas collision, fragmentation can be induced and structural information obtained. In addition, ESI QIT MS was found to be more sensitive than ESI MS by a factor of 5, with the flavonoids being detectable in the 1 μM range. In principle, this should allow the analysis of flavonoid dye components from a 0.1 mg dyed wool sample.

Initial studies of gas collision-induced fragmentation were performed on the following selected flavonoid standard solutions, using methanol (CH_3OH) as the solvent: quercetin (3,5,7,3',4'-pentahydroxyflavone), morin (3,5,7,2',4'-pentahydroxyflavone), luteolin (5,7,3',4'-tetrahydroxyflavone) and kaempferol (3,5,7,4'-tetrahydroxyflavone). Results are shown in Figures 2–5.

At an empirical level, the fragmentation patterns produced in this way provide a means of distinguishing the isomers quercetin and morin ($[M-H]^- = 301$), and luteolin and kaempferol ($[M-H]^- = 285$). As can be seen from Figures 2 and 3, quercetin shows an intense peak at 179, whereas morin shows intense peaks at 257 and 229 due to loss of CO_2 and $CO + CO_2$ respectively. Correspondingly in Figures 4 and 5, luteolin shows an intense peak at 241 due to loss of CO_2, whereas kaempferol shows an intense peak at 257 due to loss of CO. At an even more empirical level, the spectra provide a simple fingerprint for each flavonoid dye component.

The loss of small neutral molecules of mass 28 (CO or C_2H_4), 18 (H_2O) and 44 (CO_2), produced by gas collision-induced fragmentation, was common to all the compounds analysed contributing to the fingerprint, but provided little relevant structural information e.g. location of hydroxyl groups. However, we have also identified peaks which appear to be characteristic of particular flavonoid structures. Our studies of this aspect of the fragmentation pattern are still in their early stages, but our approach can be illustrated with reference to the spectrum of quercetin in Figure 2. In order to understand these fragmentation patterns more fully we must first consider the preferred ionisation sites in the flavonoid molecule. According to Georgievskii (1980), the most acidic hydroxyl group in the flavonoid structure is the 7-OH followed by the 4'-OH and the 3-OH. Therefore the fragmentation pattern is likely to contain principal ions derived, at least in part, from the A-ring of quercetin. In practice, its spectrum is dominated by loss of a fragment of mass 122, which cannot be explained by the loss of CO, CO_2, etc. We have proposed the mechanism shown in Figure 6 to account for this fragmentation and a similar breakdown pattern has also been observed for fisetin (3,7,3',4'-tetrahydroxyflavone). This result suggests that this breakdown mechanism is common to flavonols with additional OH groups in the 3'- and 4'- position.

Further evidence for the mechanism shown in Figure 6 has been obtained by recording the spectra using CH_3OD. Under these conditions, all the non-ionised

Flavonol		CH_3OH			CH_3OD	
	$[M-H]^-$	fragment ion	neutral	$[M-D]^-$	fragment ion	neutral
quercetin R = OH/OD	301	179	122	305	180	125
fisetin R = H	285	163	122	288	163	125

Figure 6. Fragmentation of flanonols with an OH group in the 3' position.

hydroxyl groups will exchange H atoms for D atoms, with the corresponding effect on the peaks in the mass spectrum. In agreement with the mechanism presented in Figure 6, the major quercetin breakdown fragment in CH_3OD appeared at m/z 180, consistent with the presence of one non-ionised hydroxyl group in the fragment ion. In the case of fisetin, where the only hydroxyl group in the A-ring is ionised, the fragment ion is the same whether the spectrum is recorded in CH_3OH or CH_3OD.

Conclusions

Comparison between the two mass spectrometry ionisation methods, APCI MS and ESI MS, for the analysis of flavonols and flavones in natural yellow dyes revealed that ESI MS in negative mode was the more sensitive method. Although ESI MS provides important information concerning the mass of the compounds present in the dye extracts and complements information provided by PDA HPLC, it reveals no structural information. A better technique was found to be ESI QIT MS-MS for low concentrations of the flavonoids of interest, enabling not only their identification by breakdown pattern matching, but also providing structural information. It is anticipated that this technique may also be applied to the identification of unknown compounds.

Acknowledgements

We are grateful to the Ministério para a Ciência e Tecnologia, Portugal, for the award of a studentship (PRAXIS XXI BD 13451/97) to Ms Ferreira, the EPSRC for the provision of the ESI QIT MS (Grant No. GR/L53618) and the National Museums of Scotland Charitable Trust for financial assistance. We are also grateful to Mr Alan T. Taylor for technical assistance.

References

Ashcroft AE. 1997. Ionization methods in organic mass spectrometry. Analytical spectroscopy monographs. Cambridge: Royal Society of Chemistry.

Bilyk A, Cooper PL, Sapers GM. 1984. Varietal differences in distribution of quercetin and kaempferol in onion (*Allium cepa* L.) tissue. Journal of agriculture and food chemistry 32: 274–276.

Cardon D. 1994. Yellow dyes of historical importance: beginnings of a long-term multidisciplinary study. In: Dyes in history and archaeology including papers presented at the 13th annual meeting, Edinburgh, 1994. York: Textile Research Associates: 59–73.

Cardon D, du Chatenet G. 1990. Guide des teintures naturelles: plantes, lichens, champignons, mollusques et insectes. Lausanne: Delachaux et Niestlé.

Fossen T, Pedersen AT, Andersen OM. 1998. Flavonoids from red onion (*Allium cepa*). Phytochemistry 47(2): 281–285.

Fraser J. 1983. Traditional Scottish dyes and how to use them. Edinburgh: Cannongate Publishers.

Georgievskii VP. 1980. Acidic properties of flavonoid compounds and the choice of solvent for performing potenciometric analysis. Chemistry of natural compounds (Eng. trans.) 16(2): 136–14.

Halpine SM. 1996. An improved dye and lake pigment analysis method for high performance liquid chromatography and diode-array detector. Studies in conservation 41(2): 76–94.

He X, Lin L, Lian L. 1996. Analysis of flavonoids from red clover by liquid chromatography electrospray mass spectrometry. Journal of chromatography A 755: 127–132.

Nawwar MAM, Marzouk MS, Nigge W, Linscheid M. 1997. High performance liquid chromatography/electrospray ionization mass spectrometric screening of polyphenolic compounds in *Epilobium hirsutum* – The structure of a unique Ellagitannin Epilobamide A. Journal of mass spectrometry 32: 645–654.

Nowik W. 1996. Application de la chromatographie en phase liquide a l'identification des colorants naturels des textiles anciens. Analusis Magazine 24(7): M37–M40.

Price KR, Rhodes MJC. 1997. Analysis of the major flavonol glycosides present in four varieties of onion (*Allium cepa*) and changes in composition resulting from autolysis. Journal of science of food and agriculture 74: 331–339.

Quye A, Wouters J. 1993. An application of HPLC to the identification of natural dyes. In: Dyes in history and archaeology: papers presented at the 10th annual meeting, National Gallery, London, 1991. York: Textile Research Associates: 48–54.

Quye A, Wouter J, Boon JJ. 1996. A preliminary study of light-ageing effects on the analysis of natural flavonoid-dyed wools by photodiode array HPLC and by direct temperature mass spectrometry. In: Bridgland J, ed. Preprints of the 11th triennial meeting of the ICOM committee for conservation. London: James and James (Science) Publishers: 704–713.

Quye A, Wouter J, Boon JJ. 1997. Fading hopes for flavonoid dye analysis? In: Dyes in history and archaeology: papers presented at the 15th annual meeting, Manchester, 1996: 56–69.

Schweppe H. 1986. Identification of dyes in historic textile materials. In: Needles HL, Zeronian HS, eds. Historic textiles and paper materials: conservation and characterization. Washington, DC: American Chemical Society: 153–174.

Walker C, Needles HL. 1986. Analysis of natural dyes on wool substrates using reverse-phase high performance liquid chromatography. In: Needles HL, Zeronian HS, eds. Historic textiles and paper materials: conservation and characterization. Washington, DC: American Chemical Society: 175–185.

Watson DG, Pitt AR. 1998. Analysis of flavonoids in tablets and urine by gas chromatography/mass spectrometry and liquid chromatography/mass spectrometry. Rapid communications in mass spectrometry 12: 153–156.

Wouters J, Rosario-Chirinos N. 1992. Dye analysis of pre-Columbian Peruvian textiles with high-performance liquid chromatography and diode-array detection. Journal of the American Institute for Conservation 31(2): 237–255.

Yokoe I, Higuchi K, Shirataki Y, Komatsu M. 1981. Photochemistry of flavonoids. III. Photoarrangement of flavonols. Chemical and pharmaceutical bulletin 29(3): 894–898.

Materials

Weld, Fibercrafts, Style Cottage, Lower Eashing, Godalming, Surrey GU7 2QD, England.

Methanol, Romil Super Purity, Anderson Gibb & Wilson, Gorgie Road, Edinburgh, Scotland.

Quercetin dihydrate (purity > 99%) and morin hydrate (purity > 95 %), ACROS Chemicals, Geel West Zone 2, Janseen Pharmaceuticalaan 3a, 2440 Geel, Belgium.

Fisetin, Aldrich Chemicals, The Old Brickyard, New Road, Gillingham, Dorset SP8 4XT,England.

Kaempferol (purity > 96%) and apigenin (purity > 98%), Fluka Biochemika, The Old Brickyard, New Road, Gillingham, Dorset SP8 4XT, England.

Luteolin, Extrasynthese S.A., Impasse Jacquard, B.P.62, 69730 Genay, France.

Abstract

Novel chemical imaging techniques provide new insight in the organic chemistry of embedded paint cross-sections. FTIR imaging microscopy delivers a two-dimensional image of the functional group distribution, revealing chemical aspects of the binding medium in each individual paint layer. Secondary ion mass spectrometric imaging of the paint cross-section surface provides the molecular identity of chemical compounds in the layer. The integrated application of FTIR and SIMS imaging reveals the presence, spatial distribution and molecular identity of various organic and inorganic compounds. The strength of these chemical imaging techniques is demonstrated in the characterization of the organic constituents found in microscopic inclusions in the surface of Rembrandt's *Anatomy Lesson of Dr. Nicolaes Tulp*. These techniques provide experimental evidence on the combined presence, distribution and identity of various lead soaps and lead hydroxychloride in these inclusions.

Keywords

binding media, FTIR imaging, mass spectrometry, cross-section analysis, lead chloride, Rembrandt, lead soaps, inclusions

Integrating imaging FTIR and secondary ion mass spectrometry for the analysis of embedded paint cross-sections

Ron M.A. Heeren* and Jaap J. Boon
The MOLART-project, FOM-Institute for Atomic and Molecular Physics
Kruislaan 407
1098 SJ Amsterdam
The Netherlands
Fax: +31 (20) 6684106
Email: heeren@amolf.nl

Petria Noble and Jørgen Wadum
The Royal Cabinet of Paintings
Mauritshuis
The Hague
The Netherlands

Introduction

In the last decades, Fourier transform infrared spectroscopy (FTIR) and mass spectrometry (MS) gained importance as tools for the scientific examination of works of art (Mills and White 1994). As both techniques require only minute amounts of sample to perform analysis at the molecular level, they are well suited for the analysis of microscopic samples removed from art objects. More particularly, they offer the possibility to examine the organic chemistry of surfaces.

During scientific examination of paintings, it is common procedure to study embedded and cross-sectioned samples to gain a better understanding of technique and materials used. Visible and UV-fluorescence microscopic images of these embedded cross-sections are used to evaluate the layer structure and distribution of pigments used in a painting. The identification and interpretation of pigments and binding medium present in such a cross-section generally strongly depend on the experience of the microscopist and on simple physical and chemical spot tests. Scanning electron microscopy combined with energy dispersive X-ray analysis (SEM-EDX) (Elzinga-Ter Haar 1971) is frequently employed to identify the inorganic compounds in individual layers. Fourier transform infrared (FTIR) spectroscopy (Feller 1954: Meilunas and Steinberg 1990: Derrick et al. 1994: Pilc and White 1995) yields information about the infrared-active functional groups present at the surface of the cross-section and as such can be used to identify the type of binding medium used in a particular layer. Secondary ion mass spectrometry (SIMS) provides information on specific inorganic and organic molecules present in the cross-section (van den Berg et al. 1998) but is rarely used in cross-section studies.

Recent instrumental developments in the latter two techniques (FTIR and SIMS) allow their use in a chemical imaging manner. Combined and applied in the scientific examination of embedded paint cross-sections, they reveal the presence, spatial distribution and molecular identity of various organic and inorganic compounds. In this paper we will show how these chemical imaging techniques provide new insight into the chemistry contained in a paint cross-section.

Chemical imaging techniques

FTIR imaging

Characterization of materials using infrared functional group mapping microscopy was developed approximately one decade ago (Harthcock and Atkin 1988). The infrared spectrum yields a set of absorption and/or reflection bands related to the chemical functional groups. Non spatially resolved FTIR microscopy has been used as an analytical technique in conservation science since the early 70s. It has demonstrated its use in material identification of minute paint samples and

* Author to whom correspondence should be addressed

reference materials (Feller 1954: Derrick et al. 1994: Derrick 1995: Pilc and White 1995). Functional group mapping combines spatial and spectral information, identifying and localizing various components of the sample surface. Mapping larger surface areas with sufficient spatial resolution is extremely slow, especially if a reasonable spectral resolution and signal-to-noise ratio are required. A slit or diaphragm in one of the intermediate focal planes of the FTIR microscope defines the spatial resolution of a single measurement. The introduction of a small (in the order of the wavelength) aperture in the optical path potentially creates various instrumental artifacts such as interference and scattering. These effects tend to blur the functional group maps created in this manner. These considerations hamper the routine use of FTIR microspectroscopy in conservation science.

Here, we used a non-dispersive infrared imaging microspectrometer to examine the infrared radiation absorbed by an embedded paint cross-section without the need for elaborate mapping experiments. The experimental setup consists of a Michelson-Morley type interferometer equipped with a step-scan mirror, a FTIR microscope and a 64×64 pixel mercury-cadmium-telluride IR array camera. In step-scan operation, the moving mirror moves in discrete steps, and the mirror surface stays in a fixed position for a variable period of time. An interferogram is built up from detector signals at incremental optical path differences (or mirror displacement). After acquisition of the interferogram, the signal is Fourier transformed to yield the infrared absorption spectrum. This mode of operation opens up new possibilities for FTIR imaging (Treado et al. 1992: Treado et al. 1994: Lewis et al. 1996) which can be employed in the examination of paint cross-sections. Briefly, at each individual "step" of the moving mirror, an IR camera acquires and stores an image. After completion of the full scan (900–3900 cm^{-1}) a dataset is created consisting of a stack of images, which is sometimes referred to as a hyperspectral data-cube. Each pixel stack in this data-cube represents an interferogram, which is subsequently Fourier transformed to yield the corresponding IR spectrum. Each of the pixels of the IR camera is an individual detector. Hence, it is possible to perform a full multi-channel FTIR analysis of the image created by the microscope on the camera. Note that the IR radiation coming through the interferometer illuminates the sample, and characteristic absorptions can be determined in transmission as well as in reflection mode.

All reported results in the literature to date have been obtained in transmission mode, in which a soap/water/lipid film or biological tissue sections were examined. No such measurements seem to have been performed in microscopical reflection mode. The analysis of paint cross-sections in conservation science is one of the potential applications of reflective microscopical FTIR imaging. In this way, an instantaneous correlation of high-resolution spatial and spectral information of the embedded paint samples is achieved. The resulting functional group maps can be readily correlated with the regular microscopic image. Collecting images in the fingerprinting region of the infrared spectrum (2000–900 cm^{-1}) visualises varnish layers, binding media and certain pigments as well as the interaction between the various compounds.

Mass spectrometric imaging

Mass spectrometric imaging can be implemented in a number of ways (van Vaeck et al. 1994). Time-of-flight secondary ion mass spectrometry (TOF-SIMS) (Niehuis et al. 1987) combines a high spatial resolution with a high analytical sensitivity. We have employed an ion imaging variety of this technique in the mass spectrometric imaging studies of some of the cross-sections discussed in this paper. This system, the THRIFT II (Physical Electronics, Eden Prairie, MN), is described in detail elsewhere (Schueler et al. 1990). Briefly, a pulsed, charge-compensated 25 keV primary indium ion beam is used to locally emit both positive and negative secondary ions. These ions are imaged through a time-of-flight system onto a position sensitive detector. One feature of particular importance is the remedy for surface charging of the insulating surfaces. Electrons are pulsed onto the surface in between primary ion beam pulses, to compensate any positive charge build up caused by the primary ion beam. Because of this procedure, the surface of the cross-section does *not* need to be covered with conducting material.

Sample preparation

The samples discussed in this paper were mounted on a custom-built sample holder for polishing unless otherwise indicated. The sample holder enables the adjustment of the surface of the section precisely parallel to the polishing wheel. The vertical position of the resin block can also be regulated in order to apply a minimal and uniform pressure during polishing. A block is first ground with a series of fixed-abrasive cloths. The grain size is decreased to grit 1200 (grain size 14 μm). To ensure an omnidirectional cutting, the sample holder is engaged in a three-branched pathway. The turning of the wheel induces a slow-rotational self-motion of the sample holder in the pathway. After this rough preliminary polishing, the cross-section is repolished on rolling alumina. Alumina with a 0.05 μm grain size suspended in water is dripped over a rotating thin cloth. For comparison, a 4000-grit abrasive cloth has a grain size of 5 μm. The resulting improvements in surface quality and the imperative removal of the smearing layers on the surface of the cross-sections have been described in detail elsewhere (Wyplosz et al. 1998).

Case study: *The Anatomy Lesson of Dr. Nicolaes Tulp*

During the period of examination and investigation that preceded the recently completed restoration of Rembrandt's *Anatomy Lesson of Dr. Nicolaes Tulp*, 1632, in the Mauritshuis, it was observed that the entire surface of the painting was covered with small, crater-like holes, with a diameter ranging from 100 to 200 micrometers.[1] Many of the holes corresponded to the crack pattern, indicating that they were formed very early in the painting's history. The phenomenon was not color dependent, but was most pronounced in the thinner, dark areas. Generally the holes were completely round and regular, although due to abrasion some had a flatter profile and a more irregular contour. Some were filled with darkened secondary material, but most contained a whitish substance which protruded through the paint (Middelkoop et al. 1998: Noble et al. 1998). The analytical approach consisted first of studying cross-sections of the inclusions from different areas of the painting with light microscopy. This demonstrated that all inclusions had the same morphology: an essentially whitish, partially transparent sphere between 100–200 micrometers in diameter, and that they originated in the second ground layer. This ground layer, which is composed of lead white particles of widely varying size, a small amount of yellow ochre, and lamp black, is unusually transparent given that only a trace amount of chalk was detected by elemental analysis (EDX). Red particles (possibly red lead) were observed within numerous inclusions, possibly added as a drying agent. Both the ground layer and the inclusion fluoresced strongly in long wave ultraviolet illumination: the inclusion more whitish than the ground layer. From the cross-sections, it appears that specific areas in the particulate ground layer have transformed into a transparent layered structure with new mineralization. Plastic deformation of the surrounding ground and paint layers suggests extensive swelling which led to the subsequent eruption of the inclusion through the paint surface.

Cross-sections of numerous holes and "inclusions" were subjected to FTIR imaging and mass spectrometric imaging. FTIR chemical imaging showed a distinct spectral difference in the chemical constituents of the inclusion compared to that of the surrounding ground layer. The main organic functional groups identified in the inclusions were carboxylates with absorbances in the range around 1500 cm^{-1} and 1700 cm^{-1} as well as a strong C-H absorbance around 2900 cm^{-1}. In the inclusion, the transparent material is probably a metal ion bridged oil network substance. In this polymeric network, the fatty acid groups in the oil network polymer have cross-bridged with the metal ions from the dryer or pigment, i.e. Pb^{2+}.

The FTIR images also confirmed the presence of carbonates (basic lead white) throughout the ground layer. In holes filled with brownish material, a strong absorbance around 1113 cm^{-1} indicates that this hole is filled with oxidized varnish. This is interpreted as filling of a hole caused by a previously erupted inclusion.

The samples were also subjected to spatially resolved secondary ion time-of-flight mass spectrometric imaging in order to obtain information on the metal ion

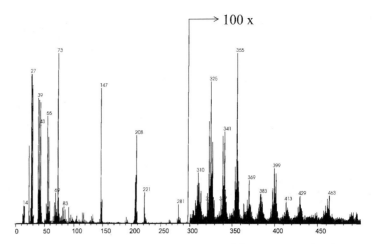

Figure 1a. TOF-SIMS summation spectrum of the positive ion distributions obtained from the cross-section displayed in Figure 2.

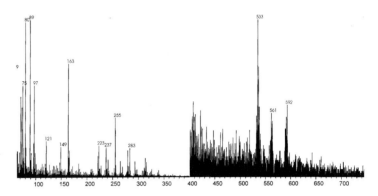

Figure 1b. TOF-SIMS summation spectrum of the negative ion distributions obtained from the cross-section displayed in Figure 2.

distribution and the organic fractions. Figure 1 gives a summation spectrum of the positive (1a) and negative (1b) ion distributions obtained from the cross-section. High intensity ions are observed in the positive mode for various elements: lead with its isotopes at m/z 206, 207, 208, potassium at m/z 39, sodium at m/z 23, and aluminum at m/z 27. Relatively strong peaks are observed for silicones m/z 73, 147, 281, presumably originating from handling of the sample. More complex series of ions are seen at much lower abundance in the mass range from 300–500. The complexity of these ions suggests that they may be lead organic compounds. The ion multiplet at m/z 455–465 matches the elemental composition of a lead palmitoyl acylium ion (Pb-O-CO-$(CH_2)_{15}$-CH_3^+). The isotopic distribution coincides exactly and the pattern is exactly the same in a lead palmitate salt reference sample.

The negative ion distribution shown in Figure 1b gives a different cross sections of ions that can be generated from the surface. The ions in high abundance are from chloride at m/z 35 and 37 (not shown). Strong ions are seen at m/z 59, 73, 75, 80, 89, and 97. Their aspecific spatial distribution indicates that these ions originate from low level contaminants, presumably from sample handling. Series of organic ions derived from fatty acids (FA) appear at m/z 223 (C14 FA), m/z 255 (C16 FA), and m/z 283 (C18 FA). These ions are M-H ions. At high mass we observe [M-OH]⁻ ions indicative of di-acyl-glyceryl ions around m/z 533 (C16, C16), m/z 561 (C16, C18), and 592 (C18, C18).

Because SIMS with the TRIFT instrument detects not only the mass of the ion but also the position where it originates, the resulting spatially resolved mass analysis of these secondary ions can provide evidence whether they originate in specific areas in the cross-sections or are non specific ions. For example, silicones are contaminating substances, so they show an aspecific distribution.

The area of the inclusion reveals the strong presence of lead (measured as positive ion), chloride and fatty acid moieties (measured as negative ions), apart from the expected lead carboxylates in the inclusion. The images displayed in Figure 2 show

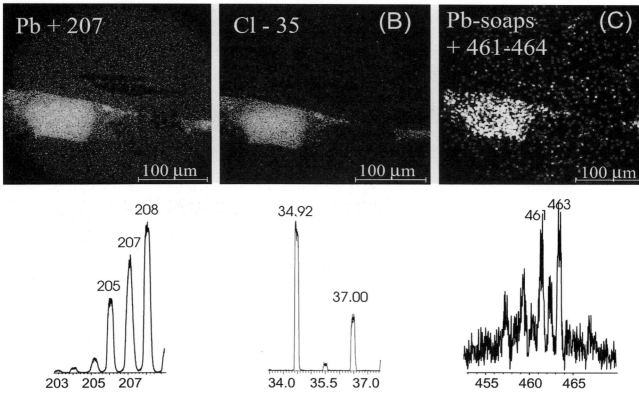

Figure 2. TOF-SIMS chemical images of characteristic ions found in the inclusions in cross-sections from The Anatomy Lesson of Dr. Nicolaes Tulp: *a) positive ion secondary ion image of lead; b) negative ion secondary ion image of Cl⁻; c) positive ion image of the lead palmitoyl acylium ion distribution.*

the lead (A), chloride (B) and lead carboxylate (C) distributions. The mass peaks used to create these images are displayed below each of the chemical images. These peaks are extracted from the overall spectrum, i.e. the spectrum integrated over all image elements. The combination of these findings demonstrates for the first time that lead chloride is present in the inclusions and provides the molecular evidence of the carboxylates found with FTIR imaging. The lead carboxylates reflect the metal ion cross-bridging between fatty acid groups of the oil network polymer and non-cross-linked fractions such as saturated fatty acids. Only the fatty acids and their salts can be released effectively by SIMS. Lead dicarboxylates were not found. The lead chloride is present in the form of lead hydroxychloride, which was identified by XRD (Noble et al. 1998). Its presence in narrow bands in the translucent oil network polymer inclusion as observed by light microscopy suggests that they it has precipitated as a new mineralisation.

The following scenario for the formation of the inclusions presents itself: the original, relatively oil-rich lead-white-containing ground seems to have contained local areas where the oil paint was chemically unstable. We do not yet understand what triggered the process of chemical change that dissolved the mineral phase (lead white) nor do we understand the source of the chlorine (although a poor quality lead white could contain lead hydroxychloride). After dissolution of the mineral phase the remaining cross-linked oil network polymer appears as a translucent material. We suspect that the metal ion cross-bridging in this oil network is significantly reduced because the chloride anions compete with the anionic carboxylic acid groups in the polymeric network for coordinating Pb^{2+} ions. This process could lead to a considerable increase in polymer volume and could be the main driving force for the eruptions. New mineralisation in the form of lead hydroxychloride precipitation starts off another competing reaction for lead. Consequently, the original tight ionomeric structure of the polymer system in the ground loosens up and becomes a chemical sponge for small organic compounds.

Conclusions

In this article, we have described a novel chemical imaging approach for the analysis of paint cross-sections. From the results, it can be concluded that a single

chemical imaging technique, however powerful it may be, usually only provides part of the chemical information embedded in the cross-section. A careful approach, considering several analytical techniques, is imperative to unravel the complex picture of organic and inorganic surface chemistry of paint cross-sections. The success of this approach using FTIR imaging and mass spectrometric imaging is demonstrated on a painting by Rembrandt van Rijn. The results demonstrate the strength of a chemical imaging approach that provides a direct link between surface molecules and their spatial organization in individual paint layers.

Acknowledgements

The authors are indebted to A. de Snaaijer, I. Stavenuiter, J van der Weerd, M. Geldof, G.J. van Rooij, and N. Wyplosz for their assistance in the various stages of these experiments. This work is part of the research program of MOLART (Molecular Aspects of Ageing in Painted Art) and of FOM (Foundation for Fundamental Research on Matter), which is a subsidiary of the Dutch Organization for Scientific Research (NWO). The Priority program MOLART is funded directly by NWO.

Note

1. In France, the phenomenon of small inclusions protruding from the paint has been observed for a long time, and is referred to as *lithargeage* (Bergeon 1980).

References

Bergeon S. 1980. Restauration des peintures. Série Les dossiers du département des peintures 21. Paris: Editions de la Réunion des Musées nationaux: 21.

Derrick MR, Doehne EF, Parker AE, Stulik DC. 1994. Some new analytical techniques for use in conservation. Journal of the American Institute for Conservation 33(2): 171–184.

Derrick MR. 1995. Infrared microspectroscopy in the analysis of cultural artifacts. In: Humecki HJ ed. Practical guide to infrared microspectroscopy. Practical spectroscopy series 19. New York: Marcel Dekker, Inc.: 287–322.

Elzinga-Ter Haar G. 1971. On the use of the electron microprobe in analysis of cross-sections of paint samples. Studies in conservation 16(2): 41–55.

Feller RL. 1954. Dammar and mastic infrared analysis. Science 120(3130): 1069–1070.

Harthcock MA, Atkin SC. 1988. Imaging with functional group maps using infrared microspectroscopy. Applied spectroscopy 42: 449–455.

Lewis EN, Gorbach AM, Marcott C, Levin IW. 1996. High-fidelity Fourier transform infrared spectroscopic imaging of primate brain tissue. Applied spectroscopy 50: 263–269.

Meilunas RJ, Bentsen JG, Steinberg A. 1990. Analysis of aged paint binders by FTIR spectroscopy. Studies in conservation 35(1): 33–51.

Middelkoop N, Noble P, Wadum J, Broos B. 1998. Rembrandt under the scalpel, *The Anatomy Lesson of Dr Nicolaes Tulp* dissected. Exhibition catalogue. Mauritshuis. The Hague/Six Art Promotion bv. Amsterdam.

Mills JS, White R. 1994. The organic chemistry of museum objects. Second edition. Oxford: Butterworth-Heinemann.

Niehuis E, Heller T, Feld H, Benninghoven A. 1987. A TOF-SIMS reflectron. Journal of vacuum science and technology. A 5: 1243–1246.

Noble P, Wadum J, Groen K, Heeren R, van den Berg KJ. 1998. Aspects of 17th century binding medium: Rembrandt's *Anatomy Lesson of Dr Nicolaes Tulp* examined. Submitted for publication.

Pilc J, White R. 1995. The application of FTIR-microscopy to the analysis of paint binders in easel paintings. National Gallery technical bulletin 16: 73–84.

Schueler B, Sander P, Reed D. 1990. Time-of-flight secondary ion microscopy. Vacuum 41: 1661.

Treado PJ, Levin IW, Lewis EN. 1992. High-fidelity Raman imaging spectrometry: a rapid method using an acousto optic tunable filter. Applied spectroscopy 46: 1211.

Treado PJ, Levin IW, Lewis EN. 1994. Indium antimonide (InSb) focal plane array (FPA) detection for near-infrared imaging microscopy. Applied spectroscopy 48: 607.

van den Berg KJ, Huigen R, Boon JJ, van der Spek C, Koot W, Smith G. 1998. Investigation of paint samples with SIMS. Submitted for publication.

van Vaeck L, Struyf H, van Roy W, Adams F. 1994. Organic and inorganic analysis with laser microprobe mass spectrometry. Mass spectrometry reviews 13: 189–232.

Wyplosz N, Koper R, van der Weerd J, Heeren R, Boon J. 1998. Improvements in surface preparation of paint cross-sections necessary for advanced imaging techniques. Submitted for publication.

Abstract

This paper describes the interpretation of FTIR spectra obtained from in situ analysis of layered paint samples prepared as thin sections, including samples from 20th-century paintings by Mark Rothko, Patrick Caulfield, Torie Begg, and Ellsworth Kelly. The advantages and practical limitations of FTIR microscopy for the characterisation of organic and inorganic materials from thin sections containing mixtures of materials applied in thin layers is discussed, with special regard to spatial resolution and interpretation of spectra. Light microscopy and EDX spectroscopy were used as complementary techniques.

Keywords

FTIR microscopy, EDX spectroscopy, modern paintings, acrylics, silver chloride, thin sections, paint media, pigments

The analysis of layered paint samples from modern paintings using FTIR microscopy

Allison Langley and Aviva Burnstock★
Courtauld Institute of Art
Somerset House
London WC2R 0RN
UK
Fax: +44 (171) 8732878
Email: aviva.burnstock@courtauld.ac.uk

Introduction

Fourier transform infrared spectroscopy (FTIR) analysis of materials from paintings is well established. Many of the organic and inorganic painting materials show characteristic absorptions in the mid-IR range (600–4000cm$^{-1}$), and using FTIR spectroscopy it is possible to characterise a range of materials in small paint samples. FTIR microscopy is currently the only method widely available in conservation science laboratories which offers the opportunity to characterise organic materials layered in paintings *in situ* in samples prepared as thin sections. The potential of FTIR microscopy for enhancing spatial resolution of analysis of paint layers has been recognised by many authors (Baker et al. 1988; Tsang and Cunningham 1991; Pilc and White 1995). The characterisation of paint media is most problematic where several thin layers were superimposed in a painting, and where mixtures of organic materials were used as binding medium. The difficulty is particularly pertinent to the analysis of samples from 19th- and 20th-century paintings, where artists employed mixed media and a wide range of natural and synthetic materials.

A variety of methods for sample preparation have been established for use with the FTIR microscope, including examination of paint chips and scrapings, extracted components, and thin sections (Baker et al. 1988; Tsang and Cunningham 1991; Pilc and White 1995). Difficulties in the preparation of layered samples were reported, including the choice of embedding material, which must fulfil criteria such as transparency to IR in the analytical range, non-interference with the paint structure (specifically the binding medium of the paint), and sufficient flexibility for microtome sectioning.

The wavelength range employed intrinsically limits the resolution of FTIR microscopy. Derrick et al. (1991) estimated the practical limitation to be 10 μm, which is within the thickness range of a thin to average paint layer in a traditional painting. Problems implicit in the analysis of layered paint using FTIR include isolation of specific layers for analysis and interpretation of spectra that may contain absorption bands from adjacent layers.

Interpretation of FTIR spectra from layered samples is facilitated by comparison with published spectra of standard materials gathered using a range of IR analytical techniques. With respect to the materials in the present study, Learner (1997) prepared a set of standard spectra characterising a range of artists' materials used in modern paintings using a diamond cell FTIR technique.

The aim of present study was to investigate the potential of FTIR microscopy of thin sections analysed in transmission mode for the characterisation of materials in layered samples from 20th-century paintings. Simulations of the layered systems found in modern paintings were used to establish experimental procedure, create a set of standards and compare with spectra of the same materials obtained by Learner (1997). The practical limitations of resolution relative to the thickness and consistency of layers were investigated. Samples from four 20th-century paintings were examined using the same sample preparation and analytical parameters.

★ Author to whom correspondence should be addressed

Table 1. Composition of manufacturers' reference paints.

PAINT BRAND	POLYMER TYPE	PIGMENTS	ELEMENTAL COMPOSITION[3]
Winsor and Newton Finity Artists Acrylic Colours	poly(n-butyl acrylate/ methyl methacrylate)[1] p(nBA/MMA)[4]	phthato blue PB 15:1 cadmium red PR 108 yellow ochre PY 43 titanium white PW 6 azo yellow PY 74 cobalt blue PB 28	Cu, Ba, S (Si) Cd, Se, S, Ba (Si) Fe, Ca, Si Ti, Si Cl, Si Co, Al (Si, Cl, Zn)
Liquitex Acrylic Artist Colours	poly(ethyl acrylate/ methyl methacrylate)[1] p(EA/MMA)[4]	phthalo blue PB 15 cadmium red PR 108 raw sienna PBr 7 titanium white PW 6 azo yellow PY 83 cobalt blue PB 28	Cu, Si (Ba, S) Cd, S, Se, Si, Ba Fe, Si, Al, K, Mg (Ti, Ca, Cl) Ti, Ca (Si) Cl, Ca, Si Co, Al, Si
Maimeri Brera Acrylics	poly(n-butyl methacrylate/ styrene/2-EHA)[1] p(nBMA/sty/2-EHA)[4]	phthato blue PB 15 cadmium red PR 108 yellow ochre PY 43	Cu, Cl, Si Si, Cd, S, Se Fe, Si, Cl, Ca
Winsor and Newton Griffin Alkyd for Artists	alkyd[2]	phthalo blue PB 15 cadmium red PR 108 yellow ochre PY 43	Ca, Cu, Si Cd, S, Ba, Si, Se Fe, Ca, Si, Al, Mg
Lefranc and Bourgeois Flashe Vinyl Colours	poly(vinyl acetate/VeoVa)[1] PVA[4]	phthalo blue PB 15 cadmium red PR 108 yellow ochre PY 43	Ca, S, Si, Cu Ca , Cd, S, Si, Se Fe, Ca, Si
Winsor and Newton Oil Colours	safflower/linseed oil[2]	cadmium red PR 108 yellow ochre PY 43 titanium white PW 6 French ultramarine blue	Cd, Ca, S, Se, Si Ca, Fe, Si, Mg, K (S, Cl) Ti, Ba, S, Zn, Al (Si) Al, Si, S, Na, Fe (K, Ca)

1. Learner (1997).
2. Manufacturer's Data Sheet.
3. As analysed using by EDX in the present study.
4. Abbreviation for polymer type.

Elemental analysis by energy dispersive X-ray spectroscopy (EDX) was carried out as a complementary technique to characterise inorganic materials.

Experimental methods

Sample preparation of reference paints

Manufacturer's prepared paints from the collection of the Tate Gallery previously characterised by Learner (1997) were selected for analysis by FTIR microscopy (Table 1). The paints were prepared in systematically applied layers and as separate films on Daler-Rowney pre-primed canvas board using a brush, to simulate the layer structures in modern paintings. The results of elemental analysis of the reference materials is included in Table 1, given in order of peak size, with trace amounts given in brackets.

Sampling and preparation for FTIR

Cross sections were taken using a scalpel from the prepared reference materials and from the following paintings:

- *Black Square with Blue* (1970), by Ellsworth Kelly, Tate Gallery, London, TO 7016;
- *Second Glass of Whiskey* (1992), by Patrick Caulfield, Tate Gallery, London, TO 6727;
- *Untitled* (1958), by Mark Rothko, National Gallery of Art, Washington DC, 5124.58;
- *Untitled* (1997), by Torie Begg, in the studio of the artist, London.

Suitable samples (where many layers were evident) were prepared as silver chloride discs, as described by Pilc and White (1995). The silver chloride discs were kept in the dark due to the photosensitivity of the material. Darkening of the embedding medium in some cases obscured the location of the sample. The discs were sliced into thin sections of an average thickness of 10 µm using a Reichart-Jung glass knife microtome. Each thin section was placed on a sodium chloride disc and manually flattened with a stainless steel roller or blunt metal instrument.

Characterisation of samples from dry films of the reference paint types was carried out on chips of paint, cut as thinly as possible using a scalpel, employing the same procedure as for the thin sections.

FTIR analysis: parameters and procedures

Characterisation of the separate materials was carried out in transmittance mode using a Bruker IFS FTIR microscope, sensitive in the range 650-4000cm⁻¹. Each sample was scanned 100 times at an aperture of 80 μm, with a spectral resolution of 8cm⁻¹.

The thin sections were examined with transmitted light in the FTIR microscope to ascertain the width, density, and relative orientation of the layers. An area of each layer was chosen for analysis and isolated using the adjustable aperture of the FTIR microscope.

EDX analysis and light microscopy

Elemental analysis was carried out on samples of dry paint or cross sections embedded in polyester resin using standard procedures (Burnstock 1992), using a Link AN10-85 analyser with the light element detector attached to a JEOL S100 scanning electron microscope.

Cross sections were examined under incident light and UV illumination prior to microtoming using a Leica Arisotmet microscope. Pigment dispersion was characterised by polarised light microscopy.

Results

FTIR spectra of reference materials

The identification of characteristic absorption bands associated with the medium, pigments and extenders in the spectra obtained by FTIR microscopy followed the guidelines given by Learner (1997) in his study of the same materials using a diamond cell. Each paint exhibited characteristic peak wavenumbers and profiles in the regions of the C-H stretch (2800–3100cm⁻¹) and the C=O stretch (1640–1750cm⁻¹) which were key for characterisation and differentiation of the organic binding media (Table 2). Peaks below 1500cm⁻¹ associated with the binding media were often less clearly resolved than those at higher wavenumbers, due to overlap with absorption bands from pigments and extenders. Some differences between the infrared spectra of these materials gathered using microscopy and the diamond cell were observed, as described below.

Table 2. Characteristic absorption peak maxima (cm⁻¹) of the organic binding media of reference paints.

Liquitex Acrylic Artist Colours p(EA/MMA)	Winsor and Newton Finity Artists Colours p(nBA/MMA)	Maimeri Brera Acrylics p(nBMA/sty/2-EHA)	Lefranc and Bourgeois Flashe Vinyl Colours PVA/VeoVa	Winsor and Newton Griffin Alkyd for Artists Alkyd	Winsor and Newton Oil Colours Safflower-Linseed oil	VIBRATION
2981 2948-52 2875 (shoulder)	2952-6 2935-7 (shoulder) 2873-5	3082-4 3060 3028 2954-8 2931 2873	2960-2 2925-35 2873	2923-5 2852-4	2925-9 2856	C-H STRETCH (2800-3100)
1728-31	1728-33	1728-30	1739-41	1733-5	1741	C=O STRETCH (1640-1750)
		1558 1541				AROMATIC RING BREATHING (1450-1650)
1446-50 1380-4	1450-4 1386	1456 1382	1433-4 1375	1448 1379	1483-5 1421-3	C-H BEND (1300-1500)
1236-38 1176 1160 1112-18 1028	1238-40 1166 1067 992 963	1166 1116-18 968	1240-2 1118 1024-6 945	1269-72 1072-4 977		C-O STRETCH C-C STRETCH (900-1250)
852	844 756	761 700-2	875	881 729 705		C-H ROCK (650-900)

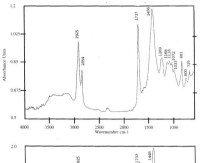

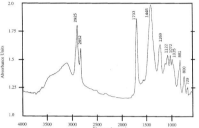

Figure 1a (top). Winsor & Newton yellow ochre alkyd layer.
Figure 1b (bottom). Winsor & Newton yellow ochre alkyd reference spectra.

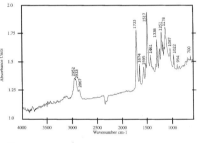

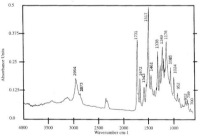

Figure 2a (top). Winsor & Newton azo yellow layer.
Figure 2b (bottom). Winsor & Newton azo yellow reference spectra.

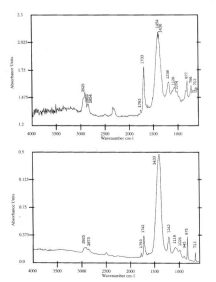

Figure 3a (top). Lefranc & Bourgeois cadmium red PVA layer.
Figure 3b (bottom). Lefranc & Bourgeois cadmium red PVA reference spectra.

Layered samples of reference materials

Layered samples of reference materials prepared as thin sections comprised layers of varying thickness and composition. Layers less than 20 μm thick were difficult to isolate and produced less well defined spectra. Layers of greater thickness produced spectra identical to those taken from the individual materials. Interference from adjacent layers was evident in spectra from thinner layers; several spectra exhibited small peaks characteristic of pigments in adjacent layers. In these instances, characterisation of the bands was relatively straightforward. Other spectra included peaks in the lower wavenumbers region, which remained unassigned.

Absorption bands of the organic media in some of the spectra of the layered samples exhibited shifts in peak maxima and changes in peak profiles compared with data compiled by Learner (1997). In the yellow ochre alkyd paint layer, the C=O peak maxima shifted from 1733cm⁻¹ to 1737cm⁻¹, although the peaks below 1500cm⁻¹ remained unchanged (Figs. 1a and 1b). Acrylics exhibited changes in the shape of the absorption peak in the region of the C-H stretch: spectra obtained from a sample of azo yellow acrylic p(nBA/MMA) which exhibited a C-H stretch profile closely similar to that of p(EA/MMA), however the characteristic absorption wavenumbers (2952cm⁻¹, 2933cm⁻¹, 2867cm⁻¹) were typical for p(nBA/MMA) (Figs. 2a and 2b).

Characterisation of a thin layer (approximately 10 μm) of PVA between two layers was made more difficult because of interference from adjacent layers (Figs. 3a and 3b). Shifts in PVA peak wavenumbers occurred, for example, a C=O peak shift from 1741cm⁻¹ to 1733cm⁻¹, and the shape of these absorption bands was also altered compared with spectra obtained by Learner (1997).

Samples from paintings

BLACK SQUARE WITH BLUE (1970), ELLSWORTH KELLY

Examination of a sample using light microscopy revealed the presence of a thin blue paint layer (layer thickness not measured) over a thicker white ground layer. A spectrum from the ground (Fig. 4a) included absorption bands characteristic of the acrylic p(EA/MMA), aluminium silicate, calcium carbonate, and titanium white (Table 3). The binding medium of the blue paint layer was identified as oil, and the pigment as ultramarine blue (Fig. 4b). The identification of synthetic ultramarine was confirmed by polarised light microscopy.

SECOND GLASS OF WHISKEY (1992), PATRICK CAULFIELD

Examination by light microscopy showed the presence of two layers, brown over white, of equivalent thickness (approximately 30 μm); the brown layer seemed to be made of a mixture of fine yellow and black particles. FTIR spectra suggested that both layers were bound in the same acrylic medium, p(nBA/MMA) (Figs. 5a and 5b). Barium sulphate and titanium dioxide were identified in the spectrum of

Figure 4a. Ellsworth Kelly Black Square with Blue (1970), white ground layer.
Figure 4b. Ellsworth Kelly Black Square with Blue (1970), blue layer.

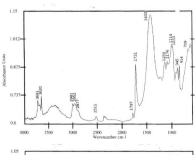

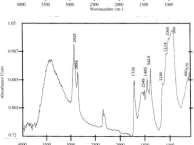

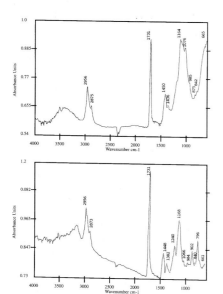

Table 3. FTIR and EDX results for samples from paintings.

Sample description	Components identified by FTIR and peak maxima (cm⁻¹)	Elements identified by EDX	Pigments and fillers deduced from EDX analysis
Ellsworth Kelly			
Blue layer	oil (2925, 2854, 1739, 1485, 1419), ultramarine blue (broad peak centred between 1186-999, two small peaks at 690 and 667)	Si, Al, Na, S	(French) ultramarine
White layer	p(EA/MMA) (2981, 2952, 1731, 1176), aluminium silicate (3691, 3652, 3620, 1114, 1033, 945, 914), calcium carbonate (2511, 1797, 1433, 709), titanium white (large peak near 650)	Ca, Ti, O	titanium white, calcium carbonate
Patrick Caulfield			
Brown layer	p(nBA/MMA) (2956, 2873-5, 1731, 1448-50, 1164-8), synthetic iron oxide (902, 796)	Fe, C, Ca, Si, O (Cl)	carbon black, yellow earth
White layer	p(nBA/MMA) (2956, 2873-5, 1731, 1448-50, 1164-8), barium sulphate (1076, 985), titanium white (strong peak at 665)	Ti, Ba, S, Ca	titanium white, barium sulphate
Mark Rothko			
Red layer: Light red area	oil (2927, 2856), animal glue (1650, 1541, 1456, large broad peak in the O–H stretch at 3298), barium sulphate (1172, 1087, 983)	Ti, Fe, Ba, Ca, S, O, (Cl, Si)	red lake, titanium white, barium sulphate
Dark red area	oil (2929, 2850), egg protein (1658, 1544, broad stretch at 3301), barium sulphate (1168, 1118, 985)		
White layer	oil (2920, 2850), barium sulphate (1182, 1122, 1078, 985), titanium white (broad peak at 667)	Ti, Ba, S	titanium white, barium sulphate
Torie Begg			
Blue layer		Co, Al (Ba, S, Zn Cl)	cobalt blue, little lithopone
Red layer	p(nBA/MMA) (2956, 2875, 1731, 1450, 1386, 1240, 1164, 1068, 989, 962, 756)	Cd, Se, S, Si	cadmium red
Yellow layer		Cd, S, Si	cadmium yellow
White layer		Zn, O, Si	zinc white
Black layer		C, Si	carbon black

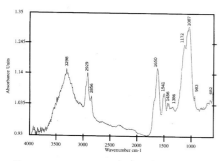

Figure 5a (top). Patrick Caulfield Second Glass of Whiskey (1992), white ground layer.

Figure 5b (bottom). Patrick Caulfield Second Glass of Whiskey (1992), brown layer.

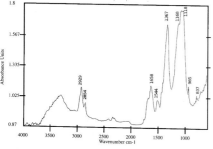

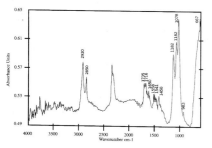

the white layer (Fig. 5a). Spectrum from the brown layer included peaks characteristic of synthetic iron oxide (Fig. 5b). Elemental analysis confirmed these findings.

UNTITLED (1958), MARK ROTHKO

Examination by light microscopy revealed the presence of two medium-rich red layers over a more leanly bound white layer. All three layers were thinly applied, with an estimated average thickness of 10 μm, which is characteristic of Rothko's later painting style. It was not possible to resolve the upper two red layers in the thin sections prepared from the sample. However, on the basis of transparency, two areas for analysis could be defined; a lighter and a darker red area. The lighter red area corresponded to the upper red layer.

Spectra from the lighter red area (Fig. 6a) included peaks indicative of oil and peaks characteristic of animal glue. The presence of barium sulphate indicated by characteristic peaks was confirmed by EDX analysis. The chemical composition of the red pigments was not deduced from the FTIR spectra, but the presence of calcium in the EDX spectra suggested that calcium carbonate was used as an inorganic substrate for an organic red. Iron, silica and chlorine were also present, which could suggest the admixture of an earth pigment. Spectra from the darker red layer (Fig. 6b) included bands characteristic of an oil binding media and peaks indicative of an egg protein. The characteristic absorptions of barium sulphate were also evident. A strong peak at 1367cm⁻¹ was not assigned. The white paint layer (Fig. 6c) included bands indicative of oil; however, the overall profile of the spectrum was similar to that of beeswax, including a number of small peaks between 1735–1458cm⁻¹. Barium sulphate and titanium white were also identified.

Figure 6a (top). Mark Rothko Untitled (1958), red layer (lighter area).
Figure 6b (middle). Mark Rothko Untitled (1958), red layer (darker area).
Figure 6c (bottom). Mark Rothko Untitled (1958), white layer.

UNTITLED (1997), TORIE BEGG

Examination under the microscope revealed at least 21 layers of alternating colours blue, black, red, white, grey, and opalescent white, which varied in thickness from approximately 15 to 50 μm. Prepared as thin sections, the paint appeared translucent. The sample was noticeably more flexible than the more densely pigmented paints, and FTIR analysis was done without having to flatten the thin

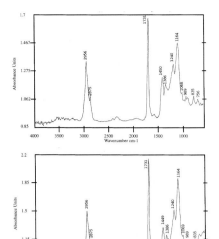

Figure 7a (top). Torie Begg Untitled *(1997), white layer.*
Figure 7b (bottom). Torie Begg Untitled *(1997), blue layer.*

section. Five differently coloured layers were analysed; all were bound in the same acrylic medium p(nBA/MMA) (Figs. 7a and 7b). In this case the FTIR spectra provided no information about the pigments present in any of the layers, but elements indicative of cobalt blue, cadmium red, cadmium yellow, zinc white, and carbon black were found by EDX. All the paints were extended with silica.

Discussion

The spectra collected in this study from reference paints using FTIR microscopy were comparable to Learner's spectra compiled from the same materials using the diamond cell technique, with the following differences: peak maxima in spectra collected using the FTIR microscope were generally 1–9 wavenumbers lower across the spectra, the exceptions being the carbonyl peaks for PVA and alkyd which had similar peak wavenumbers than those reported by Learner. The absorption band for the C=O stretch indicative of oil was consistently higher in wavenumber in the present study compared to that reported by Learner (1997). This may support Learner's suggestion that the diamond cell can exert pressure on the sample during analysis and thus alter its transmission characteristics.

In the present study, embedding and microtoming of the layered samples could not be carried out in dim light as recommended by Pilc and White (1995). The light sensitivity of silver chloride caused the material to darken quickly, limiting the visibility of the sample and the potential accuracy of microtoming the layers.

The primary drawback of the technique used in this study was the limitation in resolution: the smallest aperture was 20 μm in diameter. This is double the practical resolution suggested by Derrick et al. (1991). The difficulty in obtaining spectra for individual layers of lesser thickness, which were typically present in several of the samples from the paintings, could be circumvented to some degree by stretching the layered samples. The prepared thin sections permitted a degree of manipulation, including stretching, thinning, and separation of layers to present ideal regions for FTIR microscopy. Oblique microtome sectioning of thin-layered samples may compensate to some extent for actual thickness of the layer by presenting a wider surface for analysis. Layers containing alkyd or oil paint were less flexible, and it would be reasonable to predict that paints in aged and embrittled media may present problems for analysis using this technique.

The interpretation of spectra from layers less than 20 μm in thickness was contingent upon the characterisation of adjacent layers. Complex paint layers containing several materials which absorb in the mid-IR range were predictably more difficult to identify than simpler paint systems. The importance of close study of the spectra, for both peak wavenumbers and profiles, was highlighted because although the peak shapes of different acrylic emulsion types are similar, each polymer can be characterised by specific wavenumbers.

Examination of each sample using light microscopy before FTIR analysis was an important step to establish the layer order and thickness, and to identify as far as possible the coloured pigments therein. This provided important clues for interpretation of spectral features indicative of specific inorganic materials. Once the sample was placed on the FTIR microscope stage it could only be viewed in transmitted light which precluded optical characterisation of coloured opaque pigments or densely pigmented layers. Locating sites for analysis of specific layers was done using a colour photograph of the cross section taken in incident light as a reference.

Elemental analysis using EDX spectroscopy proved to be a useful complementary technique as it allows characterisation of elements in single layers or particles, from which the inorganic composition of most artists' materials can be deduced. This was particularly evident in samples which contained pigments with few or no characteristic absorptions in the IR range, or where mixtures of materials were present with similar or overlapping spectral features.

Characterisation of samples from the painting by Patrick Caulfield using FTIR microscopy illustrated some of the limitations described above. Though the spectra indicated the presence of a synthetic iron oxide, initial visual examination had revealed that two pigments, a yellow and a black, were present. Whether iron oxide was present in one or both pigments could not be determined. An additional analytical technique was required to characterise the pigments.

Results for samples from the painting by Torie Begg demonstrated the need for further investigation into the IR sensitivity of pigments and the effects of pigment volume concentration on FTIR analysis of paints. The sensitivity of the technique of FTIR microscopy used here was not determined. As the data obtained in a spectrum is quantitative as well as qualitative, the absence of peaks indicative of some pigments may be attributed simply to their low concentration. No published studies were found by the authors which assessed the sensitivity of this analytical method for the wide range of modern pigments and paints available to artists in the 20th century. The absence of peaks indicative of pigment in the denser layers of the Begg sample, such as those containing white inorganic material, may alternatively be due to lack of absorption by the pigments in mid IR range.

Analysis of the sample from Mark Rothko's *Untitled* proved challenging for the technique of FTIR microscopy for several reasons: Rothko's superimposition of thin layers, bound in a variety of media and mixtures of media within layers, and his use of red pigments which did not exhibit characteristic absorptions in the infrared. The identification of barium sulphate and calcium carbonate in the red layers could indicate their use as either an extender or a base for an organic red lake pigment.

Reliable interpretation of FTIR spectra of samples from paintings may depend on several other factors, such as previous conservation treatments involving cleaning, consolidation or coatings, which might add or remove materials from the composite layered system under study. Information about artists' painting techniques may greatly facilitate the interpretation of spectra from samples of their paintings.

Conclusion

The practical spatial resolution of FTIR microscope used in this study was 20 μm; reliable interpretation of data from spectra gathered from thin layers required interpretation using information in spectra from adjacent layers. The spectra obtained using FTIR microscopy in this study differed in some cases from the spectra obtained of the same materials by Learner using a diamond cell technique. The nature of the difference was a shift in wavenumbers for characteristic absorptions of some components. This highlights the problem of calibration for individual instruments and different techniques, and should be considered when interpretation of data is made using published standards. Ageing of the materials may also affect characteristic spectral absorption profiles, and this needs further study.

The use of light microscopy in conjunction with FTIR was found to be essential for location of analytical sites in layered systems. A complimentary technique for elemental analysis (such as EDX used here) increased the level of confidence for the identification of inorganic materials indicated in FTIR spectra, and in several cases, provided information not available using FTIR spectroscopy, where spectra were complex or materials did not absorb in the IR range employed.

Acknowledgements

Tom Learner, Tate Gallery Conservation Department, Judith Millidge, Peter Woods, UCL Dept. of Geology and Earth Sciences, Clifford Price, Sandra Bond, UCL Institute of Archaeology, Jennifer Pilc, National Gallery Scientific Department, London, William Luckhurst, Physics Dept, Kings College, London.

References

Baker M, Von Endt D, Hopwood W, Erhardt D. 1988. FTIR microspectrometry: A powerful conservation analysis tool. In: Rosenberg SZ, ed. Preprints of papers presented at the 16th annual meeting of the AIC. Washington, DC: The American Institute for Conservation of Historic and Artistic Works: 1–13.

Burnstock A. 1992. Chemistry beneath the surface of Old Master paintings. Chemistry & Industry 18: 692–695.

Derrick MR, Landry JM, Stulik DC. 1991. Methods in scientific examination of works of art: Infrared microspectrometry. Los Angeles: Getty Conservation Institute.

Learner TJS. 1997. The characterisation of acrylic painting materials and implications for their use, conservation, and stability (Ph.D. Thesis, University of London, Department of Chemistry, United Kingdom).

Pilc J, White R. 1995. The application of FTIR-microscopy to the analysis of paint binders in easel paintings. National Gallery Technical Bulletin 16: 73–84.

Tsang J, Cunningham R. 1991. Some improvements in the study of cross sections. Journal of the American Institute for Conservation 30(2): 163–177.

Materials

Winsor & Newton Finity Acrylic Paints, Oil Colours, Griffin Alkyd for Artists, Lefranc & Bourgeois Flashe Vinyl Colours, Daler-Rowney pre-primed canvas board, ColArt Fine Art and Graphics Ltd., Winsor & Newton, Whitefriars Avenue, Wealdstone, Harrow Middlesex 8A3 5RT, UK, tel + 44 (0181) 427-4343.

Maimeri Brera Acrylic Paints, Osborne and Butler Ltd., Hartlebury Trading Estate, Hartlebury, nr. Kidderminster, Worcestershire DY10 4JB, UK, tel +44 (01299) 250654.

Liquitex Acrylic Artists Colours (this product has since been reformulated), Binney and Smith Inc., 1100 Church Lane, PO Box 431, Easton PA 18044, USA, tel (+1 215) 253-6271.

Silver chloride, Sigma Aldrich Ltd., New Road, Gillingham, Dorset XP8 3ST, UK, tel +44 (0800) 717181.

Sodium chloride discs, Spectra-Tec Inc., 2 Research Drive, Shelton CT , USA, tel (+1 203) 926-8998.

Abstract

A study was undertaken to understand the formation and composition of so-called "ghost images," which are hazy films that may appear on the inside surface of protective glasses over framed oil paintings. Thermogravimetric analysis demonstrated that evaporation of free fatty acids is one mechanism responsible for ghost image formation. Evaporation rates, expressed on the basis of half-time, were calculated from the thermogravimetry data. It was discovered that palmitic acid evaporates approximately twice as rapidly as azelaic acid, and four times faster than stearic acid. Ghost images generated by oil test paints were subsequently analyzed by gas chromatography-mass spectrometry. A number of fatty acids were detected in the images, and the proportions of each were consistent with the predictions from the half-time data.

Keywords

gas chromatography, ghost images, drying oils, fatty acids, glycerol, lipids, oil paints

Gas chromatographic determination of the fatty acid and glycerol content of lipids. IV. Evaporation of fatty acids and the formation of ghost images by framed oil paintings

Michael R. Schilling,* David M. Carson, and Herant P. Khanjian
The Getty Conservation Institute
1200 Getty Center Drive, Suite 700
Los Angeles, CA 90049-1684
USA
Fax: +1 310 440 7711
Email: mschilling@getty.edu

Introduction

On occasion, oil paintings are framed with a protective glass layer to prevent damage from vandalism and accidental causes. Over time, a hazy film may appear on the inside surface of the protective glass that, ultimately, impairs proper viewing of the painting. To enhance visibility, museum preparators periodically use glass cleaners to remove these so-called "ghost images."

Studies by Williams using infrared spectroscopy revealed that ghost images consist largely of palmitic acid (Williams 1989). To explain his findings, Williams speculated that volatile ketones are released by the paint, some of which undergoes oxidation on the glass surface to form palmitic acid.

Michalski postulated another explanation for Williams's findings. He reasoned that free fatty acids may simply evaporate from the painting and condense on the glass, and enrichment of the image in palmitic acid occurs because the boiling point of palmitic acid is much lower than that of stearic acid (Michalski 1990). However, these ideas were never subjected to experimental verification.

A study was undertaken at the Getty Conservation Institute to further elucidate the composition of ghost images, and to determine whether evaporation may, indeed, play a role in the loss of fatty acids from oil paints. Thermogravimetry (TG) was used to determine the evaporation rates of palmitic, stearic, and azelaic acids in an inert gas atmosphere. Additionally, gas chromatography-mass spectrometry (GC-MS) was used to analyze ghost images that evolved from various test paints in order to identify the materials that were present in the images, and to determine which paints were most likely to produce ghost images.

Experimental process

In thermogravimetry, sample weight (expressed as percent of original weight) is recorded as a function of temperature. Reactions that lead to weight loss (such as evaporation, oxidation, and depolymerization) will give rise to steps on the TG curve. The rate of these reactions can be determined from TG data. The information presented below is a general introduction to the subject of reaction kinetics (for further details see Wendlandt 1974).

Most thermal analysis software can calculate reaction kinetics from the TG results, using equation 1 to find the reaction rate:

$$d\alpha/dt = k(1-a)^n \qquad (1)$$

where $d\alpha/dt$ is the rate of reaction (s⁻¹), α is the fraction reacted, k is the reaction rate constant (s⁻¹), and n is the order of the reaction. TG kinetics software use the Arrhenius equation (equation 2) to find the temperature dependence on the rate constant:

$$k = k_o \exp(-E_A/RT) \qquad (2)$$

* Author to whom correspondence should be addressed

where k_o is the preexponential factor, E_A is the activation energy (J/mole), R is the gas constant (8.31 J/mole.K), and T is the temperature (K). TG thermal analysis software programs provide the user with k_o and E_A results directly from the TG data, and this information is quite useful for predicting reaction rates at various temperatures. A convenient way to express reaction rate data is half-time, which is defined as the amount of time required for one half of a reaction to occur (equation 3):

$$t_{1/2} = \ln(0.5)/31536000k_T \qquad (3)$$

where $t_{1/2}$ is the half-time of the reaction (years) calculated for a given temperature T, k_T is the reaction rate that was calculated for the same temperature T, and 31536000 is the number of seconds in a year. In the present study, it was possible to estimate the half-time of the evaporation rate of a number of fatty acids at various temperatures from the Arrhenius data.

Thermogravimetric analyses were conducted using a Mettler TG50 thermobalance and TC10A controller. Samples of free fatty acid (approximately 2 mg) were analyzed in uncovered 70 μL alumina crucibles, and the furnace was purged with nitrogen at a flow rate of 100 mL/minute. Samples were heated from 25°C to 300°C using several heating rates: 10°, 5°, and 2°C/minute. For each of the three fatty acids tested (palmitic, stearic, and azelaic), duplicate samples were analyzed and kinetic parameters were calculated.

In addition, ghost images were generated from test paint samples and analyzed by GC-MS, in order to identify the various components that were present. To produce ghost images artificially, oil paint samples were placed onto single-depression microscope slides, a second slide placed onto the first with the depressions facing together, and the two slides clamped together. Duplicate samples of each paint formulation tested were placed in separate slide assemblies. One sample was kept on a sand bath set to 80°C for a six-week period, and the second sample was exposed to light in a Heraeus Suntest chamber for four weeks, followed by sand bath heating for one week. The test paints used in this study had been stored in the laboratory for up to five years prior to testing (Schilling et al. 1997).

Ghost images which developed on the upper slide well were rinsed with diethyl ether into sample vials, the ether was evaporated, and the samples were derivatized using N,N–dimethylformamide dimethyl acetal in pyridine (Methyl-8), in order to convert the free fatty acids to the corresponding methyl esters. The solutions were analyzed on a Hewlett Packard 6890 gas chromatograph equipped with a 5972 mass selective detector, split/splitless inlet, autosampler.

Fatty acid methyl esters (FAMEs) were separated on a 30m × 0.25mm fused silica capillary column coated with a 0.25μm film of HP-5MS stationary phase. Helium carrier gas was set to a constant linear velocity of 40 cm/s, which is equivalent to 1.1mL/min of column flow. The split inlet was set to 260°C, the vent flow rate was 50mL/min, and the septum purge flow rate was 1 mL/min. The mass spectrometer transfer line was set to 300°C. The oven temperature program was: 105°C for 1 minute, then 10°C/min to 260°C. Ions selected for quantification were the molecular peaks of the methyl esters.

Standards of FAMEs were used without further purification. Calibration standards were prepared by dilution of a FAME stock solution; nominal concentrations ranged from 2 ppm to 100 ppm. Hexachlorobenzene was added as an internal standard at a concentration of 100 ppm.

An additional test was performed to determine the effect of molecular weight on the extent of fatty acid evaporation. A standard mixture of free monocarboxylic fatty acids (with 12, 14, 16, 17, 18, and 20 carbons) and dicarboxylic fatty acids (with 7, 8, 9, and 10 carbons) was placed in a glass slide assembly and heated on the sand bath in order to form a ghost image. Ghost images were derivatized using a mixture of hexamethyldisilazane and trimethylchlorosilane in pyridine (Tri Sil reagent). For comparison, the residual fatty acids that remained in the lower slide well were also derivatized.

Fatty acid trimethylsilyl esters were separated on a 30m × 0.25mm fused silica capillary column coated with a 0.25μm film of HP-5MS stationary phase. Helium carrier gas was set to a constant linear velocity of 46cm/s. The splitless inlet was

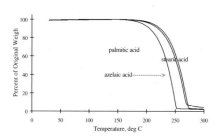

Figure 1. Overlay of thermogravimetry curves for palmitic, stearic, and azelaic acids, acquired at a heating rate of 5°C/ minute.

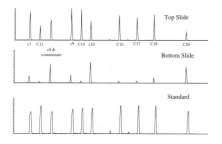

Figure 2. Overlay of gas chromatography-mass spectrometry chromatograms of silylated extracts from a standard mixture of monocarboxylic and dicarboxylic fatty acids, after heating on sand bath to produce a ghost image, and from an untreated standard tested for comparison.

set to 320°C, the vent flow rate was 50mL/min, the septum purge flow rate was 1 mL/min, and the splitless purge delay was 60 sec. The mass spectrometer transfer line was set to 300°C. The oven temperature program was: 80°C for one minute, then 20°C/min to 320°C, followed by a 15-minute isothermal period. Molecular ion peaks of the trimethylsilyl esters were selected for quantification.

Standards of saturated free fatty acids and free dicarboxylic fatty acids were also derivatized and tested to permit quantitative analysis. Nominal concentrations ranged from 2 ppm to 100 ppm. Hexachlorobenzene was added as an internal standard at a concentration of 100 ppm.

Results

Figure 1, showing representative TG curves for palmitic, stearic, and azelaic acids, illustrates that all three fatty acids are capable of evaporating readily. Moreover, obvious differences between the shapes of the three weight-loss curves are evidence that each fatty acid will possess a unique rate of evaporation. It should be noted that evaporation proceeds over a single weight-loss step with no evidence of weight-loss steps caused by competing side-reactions. This fact improves the likelihood that the ensuing kinetic evaluation will yield meaningful results (Widmann 1982). Also, it was observed that the onset of evaporation shifts progressively to lower temperatures as the heating rate is reduced. This behavior is typical for nearly all thermoanalytic studies of physicochemical processes.

Mean activation energy and rate constant data were derived from the set of TG curves (Table 1). The mean and standard deviations for the entire data set are within typical limits for thermoanalytic determinations of reaction kinetics (Widmann 1982), thus estimates of the half-time for evaporation should be acceptable. Reaction rate and half-time data for the evaporation of the three fatty acids were calculated at four reference temperatures (Table 2). Based on kinetic evaluation of the TG data, the estimated half-time for the rate of evaporation at 25°C is approximately 40 years for palmitic acid, 140 years for stearic acid, and 80 years for azelaic acid.

Table 1. Mean activation energy and rate constant estimates, derived from thermogravimetry test results for palmitic, stearic, and azelaic acids.

	EA (kJ/mol)	ln Ko	rate (sec⁻¹)
palmitic acid	88.7 +/- 3.1	14.6 +/- 0.7	(6.87 +/- 3.62) E-10
stearic acid	93.6 +/- 5.1	15.3 +/- 1.1	(2.23 +/- 1.74) E-10
azelaic acid	90.3 +/- 2.6	14.4 +/- 0.8	(2.76 +/- 7.10) E-10

Table 2. Reaction rate and half-time data calculated at four reference temperatures, for the evaporation of palmitic, stearic, and azelaic acids.

T (°C)	palmitic acid rate (sec⁻¹)	$t_{1/2}$	stearic acid rate (sec⁻¹)	$t_{1/2}$	azelaic acid rate (sec⁻¹)	$t_{1/2}$
25	6.1E-10	36 years	1.6E-10	136 years	2.7E-10	82 years
50	9.7E-09	2.3 years	3.0E-09	7.3 years	4.5E-09	4.9 years
80	1.6E-07	50 days	5.8E-08	137 days	7.9E-08	102 days
100	8.1E-07	9.9 days	3.2E-07	25 days	4.1E-07	20 days

Upon examining the slide assembly that contained the mixture of monocarboxylic and dicarboxylic fatty acid standards after it was heated on the sand bath, a pronounced white ghost image was visible on the upper slide well, and a much smaller amount of residue remained in the lower slide well. Figure 2 is an overlay of GC-MS chromatograms of the silylated extracts from the upper slide well, the lower slide well, and an untreated fatty acid standard. It is clear each of the fatty acids present in the standard, both monocarboxylic or dicarboxylic in nature, were detected in the ghost image.

Furthermore, this ghost image is significantly enriched in the lower molecular weight fatty acids, whereas the residue in the lower slide well is depleted in the lower molecular weight fatty acids. Area ratios of the peaks in the ghost image versus the residue in the lower slide reveal a 5:1 enrichment for both azelaic acid

Table 3. Fatty acid molar ratios for ghost images generated by test paints, determined by gas chromatography-mass spectrometry. For entries with a dash, one or both of the fatty acids in the appropriate ratio could not be detected.

Medium	Pigment	Sandbath A/P	Sandbath P/S	Sandbath A/D	Suntest A/P	Suntest P/S	Suntest A/D
Blown linseed	Lead White	0.0	11.9	–	1.3	2.3	0.5
(P/S = 1.8)	Vine Black	0.2	6.4	2.0	1.5	1.9	0.4
	Yellow Ochre	0.4	4.5	1.3	0.4	2.5	0.7
Cold-pressed	Lead White	0.0	2.8	–	0.0	0.9	0.0
linseed (P/S = 1.7)	Vine Black	2.1	–	1.7	3.1	1.8	0.9
	Verdigris	–	–	–	0.2	0.9	–
	Yellow Ochre	–	–	2.4	5.1	1.9	1.0
Egg yolk	Lead White	0.0	5.2	–	0.0	4.1	1.0
(P/S = 3.3)	Yellow Ochre	0.0	5.6	–	0.0	1.8	–
Stand Linseed	Lead White	–	–	–	0.2	1.1	0.7
(P/S = 1.8)	Vine Black	0.0	–	–	0.9	2.1	0.8
	Verdigris	–	–	–	0.0	1.3	–
	Yellow Ochre	–	–	–	0.3	2.3	2.0
Walnut	Lead White	0.1	4.0	–	0.1	2.2	2.4
(P/S = 3.3)	Vine Black	0.2	–	0.9	0.4	1.9	1.6
	Yellow Ochre	6.4	2.3	1.8	0.9	3.5	1.1

and stearic acid in the ghost image, and a 16:1 enrichment for palmitic acid in the ghost image. It should be noted that a contaminant appears with a retention time of 7.4 minutes that overlaps with suberic acid (C8 dicarboxylic) which makes comparison difficult.

Concerning the test paints, ghost images were formed by a majority of the paints, but the intensity varied with the type of exposure and the paint formulation. For the sand bath samples, cold-pressed linseed and stand linseed oil paints produced no visible images, and the others tended to produce images with variable intensity. On the other hand, much less intense images were formed by the Suntest exposure, but nearly all of the paints formed some visible residue. Table 3 lists the fatty acid molar ratios for the ghost images formed by the test paints. Although the GC–MS results revealed that high levels of palmitic acid were indeed present in the images, other fatty acids were also detected, such as stearic acid, azelaic acid, and short-chain dicarboxylic fatty acids.

In general, the chromatograms for the sand bath samples were dominated by high levels of saturated fatty acids. The fatty acid compositions in the sand bath ghosts were proportional to the levels of free fatty acids present in the paint samples, but in every instance the ghosts were enriched in the more volatile, lower-boiling species. Accordingly, the P/S ratios of the sand bath ghost images were higher than that of the corresponding paints. On the contrary, paints exposed in the Suntest chamber often formed images that were enriched in dicarboxylic fatty acids, thus providing evidence for the role of light in oxidative breakdown of oil paint media.

Discussion

In analytical studies of aged oil paints conducted a number of years ago at the Getty Conservation Institute, it was discovered that the saturated fatty acid content of drying oil paints may be reduced by exposure to heat and light (Schilling et al. 1997). The largest overall reductions in saturated fatty acid content were observed for heat-aged paints made from yellow ochre mixed with walnut or poppy oil, but many of the other slow-drying paint formulations exhibited moderate reductions. At the time, these findings were somewhat surprising because saturated fatty acids were believed to be relatively stable marker compounds in drying oil media. In fact, the relative amounts of palmitic and stearic acids are the basis for a method of identification of drying oil media that has been in practice for more than 30 years (Mills 1966).

However, in light of the present study, it is clear that evaporation does play a role in the reduction of saturated fatty acids from the test paints. The TG results demonstrate that saturated and dicarboxylic fatty acids evaporate readily, even when extremely low heating rates are employed. Interestingly, on close examination of glass sample vials that contain oil paint samples we have also observed hazy films on the inner wall of the vials, especially near the samples.

The TG data are in broad agreement with the observed high levels of palmitic acid in ghost images, although strict comparison between half-time estimates and the composition of ghost images from the test paints is not possible due to a number of factors. Because nitrogen gas was used to purge the TG instrument during measurement, evaporation rates were somewhat enhanced. It was, however, necessary to use nitrogen purge to minimize oxidation when employing lower heating rates. The fact that the kinetic data were consistent over two orders of magnitude in heating rate suggests that oxidation effects were, indeed, quite minimal.

Another inherent limitation of the sand bath tests was the imperfect way that fatty acid vapors were condensed onto the upper slide. Condensation of fatty acids occurred as a result of the temperature difference between the lower slide that was heated by the sand, and the upper slide that was cooled by the ambient air. Other, more exotic methods could have been employed to trap the volatiles more effectively, such as a condenser apparatus attached to leak-free sample chambers, but these were rejected for the sake of simplicity. Certainly, a glass-covered frame would have been the ideal sample holder, but we rejected this straightaway due to the risks of contamination.

One other deficiency in the test protocol was the fact that fatty acids may evaporate much more slowly from oil paint than when tested by TG as pure compounds in alumina crucible, primarily because strong interactions with the triglyceride matrix and/or pigments in the oil paint will greatly inhibit the rate of diffusion.

Williams (1989) observed that ghost images were most intense over dark colors and less intense over light colors, which gave rise to a "negative" ghost image of the painted subject. Based on the results from the present study, we may offer an explanation for this phenomenon. In general, slow-drying paint formulations tend to produce intense ghost images enriched in saturated fatty acids; this is consistent with the mechanism of partial hydrolytic decomposition of the triglyceride oil matrix (Schilling et al. 1998). Paints that were slow to dry include those pigmented with ochre or vine black, or made from walnut or poppy oil media. In addition, ghost image formation was greatly reduced over paints made with lead white and verdigris, presumably due to the formation of pigment soaps (Koller and Burmester 1990). Thus, variation in ghost image intensity may be due strictly to the quantity of free fatty acids in paints, which in turn is affected by the specific combination of pigment and medium.

In published studies of crystalline bloom on contemporary art pieces (Koller and Burmester 1990), it has been observed that oil-rich paints made with pigments that do not promote cross-linking (such as alizarin, titanium dioxide, and ochres) are particularly susceptible to the formation of whitish surface deposits of fatty acids. Presumably, the fatty acids were released either from the oil matrix through hydrolysis of the glyceride ester backbone or from decomposition of pigment extenders (such as stearates) and, once liberated, were able to migrate through the paint and deposit on the surface. Therefore, these works should be extremely likely to lose fatty acids through evaporation and, if framed behind glass, form ghost images.

It must be stated that Methyl-8 did not perform as well as we had expected in our derivatization procedure. Yields of methyl esters from dicarboxylic fatty acids were quite low when following the procedure given by the manufacturer (60°C for 15 minutes). Even after changing the conditions to 95°C for three hours, yields of dimethyl esters were less than those of monomethyl esters, and transesterification of glycerides occurred. After most of the study was completed, we switched to using Tri Sil for derivatization of free fatty acids. Tri Sil gave higher, more consistent, yields for all fatty acids at moderate derivatization temperatures, and did not transesterify glycerides to any significant extent. We are quite satisfied with the performance of Tri Sil, but do not recommend using Methyl-8 for routine paint analysis.

Conclusions

Using thermogravimetry and gas chromatography-mass spectrometry, free fatty acids were shown to evaporate readily to form ghost images over oil paints. By expressing evaporation rates as half-times, palmitic acid was found to evaporate

approximately four times more rapidly than stearic acid, and twice as fast as azelaic acid at room temperature.

Ghost images were found to consist of mixtures of free fatty acids, with higher levels of the more volatile species predominating in both homologous series of fatty acids. Images formed by the heating of test paint samples tended to consist largely of saturated fatty acids, whereas the composition of images formed by exposure of paint to light generally were more enriched in dicarboxylic fatty acids.

Free fatty acids are liberated by hydrolysis of oil triglycerides, migrate through the paint, and subsequently evaporate to form ghost images. In general, slow-drying paints yielded more intense ghost images than did fast-drying paints, presumably because of variation in the degree of hydrolysis of oil triglycerides.

Acknowledgments

The authors wish to thank the following members of The Getty Conservation Institute's Scientific Discipline Group: Dr. Alberto Tagle, Director, for enthusiastically supporting and encouraging our research in organic materials; James R. Druzik, Senior Scientist, and Narayan Khandekar, Associate Scientist, for many interesting discussions about our findings.

References

Koller J and Burmester A. 1990. Blanching of unvarnished modern paintings: a case study on a painting by Serge Poliakoff. In: Mills JS, Smith P, eds. Cleaning, retouching and coatings: technology and practice for easel paintings and polychrome sculpture: preprints of the contributions to the Brussels Congress. London: The International Institute for Conservation of Historic and Artistic Works: 138–143.

Michalski S. 1990. A physical model for the cleaning of oil paint. In: Mills JS, Smith P, eds. Cleaning, retouching and coatings: technology and practice for easel paintings and polychrome sculpture: preprints of the contributions to the Brussels Congress. London: The International Institute for Conservation of Historic and Artistic Works: 85–92.

Mills JS. 1966. The gas chromatographic examination of paint media. Part I. Fatty acid composition and identification of dried oil films. Studies in conservation 11(2): 92–107.

Schilling MR, Khanjian HP, Carson DM. 1997. Fatty acid and glycerol content of lipids; effects of ageing and solvent extraction on the composition of oil paints. Techne 5: 71–78.

Schilling MR, Carson DM, Khanjian HP. 1998. The composition of solvent extracts from oil paints. Submitted for publication.

Wendlandt WW. 1974. Thermal methods of analysis. Second edition. In: Elving PJ, Kolthoff IM, eds. Chemical analysis, volume 19. New York: Wiley and Sons: 45–61.

Widmann G. 1982. Kinetic measurements on polymers – applications and limits. Journal of thermal analysis 25: 45–55.

Williams SR. 1989. Blooms, blushes, transferred images and mouldy surfaces: what are these distracting accretions on art works? In: Wellheiser JG, ed. Proceedings of the 14th annual IIC-CG conference. Ottawa: The International Institute for Conservation – Canadian Group: 65–84.

Materials

Fatty acids, fatty acid methyl esters, and dicarboxylic fatty acids standards, Sigma-Aldrich Chemical Co. Inc., P.O. Box 2060, Milwaukee, WI 53201 USA

Tri-Sil and Methyl-8, Pierce Chemical Co., 3747 N. Meridian Road, Rockford, IL 61105-0117 USA

Abstract

A chemical and physical description is given of different processes in the development of an oil paint film: curing, maturing, and degradation. A transition from the initial polyester to an ionomeric system during the maturation process as a result of hydrolysis and metal carboxylate formation is proposed. Analytical results describe to what extent the transition from a polyester to a polyanionic ionomer has occurred for a number of aged paint samples. High degrees of hydrolysis (> 65%) are found in samples from 100–250-year-old paintings.

Keywords

oil paint, curing, maturation, polymer, ionomer, fatty acid, gas chromatography

Chemical changes in curing and ageing oil paints

Jorrit D. J. van den Berg,★ Klaas Jan van den Berg
and Jaap J. Boon
FOM Institute AMOLF
Kruislaan 407
1098 SJ Amsterdam
The Netherlands
Fax: +31 (20) 6684106
Email: jdjvdb@amolf.nl.

Introduction

Since the 15th century, drying oils like linseed, walnut, and poppy seed have been used as binding media for paintings. When fresh, these viscous oils consist of relatively apolar mixtures of triglycerides with different fatty acid profiles. Only a small percentage of these fatty acids (FAs) is fully saturated (7–12%), whereas most of the other FAs are polyunsaturated (65–80%) (Karleskind et al. 1996). This high amount of unsaturated FAs makes it possible for the oil to form a dried film. In this case drying is not the evaporation of a solvent but chemical drying which involves cross-linking of triglycerides to high molecular weight substances. Due to the chemical environment in paintings, these "binding" substances are not stable end products. Further chemical changes in the oil paint film involve hydrolysis of the ester bonds, formation of new oxygen-containing functional groups, oxidative cleavage of the fatty acid hydrocarbon chains, and metal ion co-ordination of the fatty acid group of the cross-linked material and non-cross-linked fractions. A first description of these processes and preliminary chemical data have been reported by Boon et al. (1996) and van den Berg et al. (1998a). It is likely that the different processes partly overlap in time.

Detailed chemical studies of alkyd paint provided a relatively good understanding of the process of curing (Muizenbelt et al.1994; Muizenbelt et al.1996; Hubert et al. 1997). The transition of the initial "polyester" to other forms of polymeric systems in ageing traditional oil paint is less well understood.

In this paper the model describing the processes of curing, maturation, and degradation of oil paint films is detailed further and both chemical and physical aspects are summarised. The analytical chemical challenge to quantitatively determine the progression of each process in oil paint is taken up and supportive evidence from analytical chemical studies on cured as well as aged paint samples is presented.

Chemical and physical aspects of the curing process

Oil paint consists of a viscous mixture of pigment and oil in a ratio mainly depending on the pigment, its oil absorption, and the desired properties of the paint. Evidence for initial chemical reactions involved in fresh oil paint curing after application can be derived from studies on the oxidative changes and cross-linking of unsaturated FAs (Hubert et al. 1997). This very rapid process involves formation of hydroperoxide substituted fatty acids (see also Porter et al. 1995), breakdown of the hydroperoxides giving rise to highly reactive radicals, and subsequent cross-linking. The breakdown process is accelerated (catalysed) by the presence of (transition) metals from pigments or driers. The resulting cross-links formed are covalent ethers, peroxides and carbon-carbon bonds (Muizenbelt et al. 1994). In solidifying paint a three-dimensional network is formed because there is more than one reactive site on the unsaturated FAs, hence more than one point for cross-linking. This is shown in Figure 1. Figure 1A presents a spatial distribution of reactive oil molecules, which forms a three-dimensional network by cross-linking (Fig. 1B). The resulting network is a polyester.

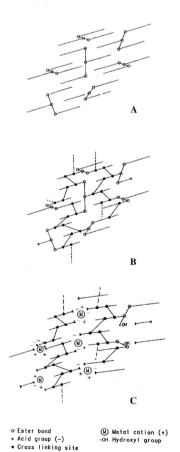

o Ester bond Ⓜ Metal cation (+)
► Acid group (-) -OH Hydroxyl group
● Cross linking site

Figure 1. Schematic model depicting different stages in the development of oil paints: A) fresh; B) after curing; and C) after maturation.

★ Author to whom correspondence should be addressed

Apart from cross-linking reactions, degradation reactions occur which transform the triglyceride radicals into low molecular weight (un)saturated aldehydes, ketones, alcohols, acids, and hydrocarbons responsible for the typical smell of drying oil paints. Most of these smaller volatile molecules arise from the hydrocarbon chain of highly unsaturated fatty acid moieties and will generally leave the paint film by evaporation, although short chain FAs may be trapped within the paint film for a longer period of time. Typical oxidative degradation products remaining in oil paint films are the so-called fatty diacids.

The type of metal ions in the paint film clearly has an influence on the volatile compounds formed and their relative amounts, as shown by Hancock et al. (1989). We infer that the nature of the metal ions dissolving from pigments traditionally used in the oil paint technique will also affect the composition of the organic fraction in aged paints.

Before the oil is used as binding medium, it may have changed chemically, especially due to manufacturing processes used in previous centuries. Modifications are to be expected in the (warm) pressing stage, in refining (e.g. degumming, acid and alkaline washing steps) and manipulation of the viscosity by heat bodying. Depending on the method(s) used, this leads to increased amounts of free, oxidised, cyclic, and isomerised FAs, and partially oxidised polymeric material.

Since oxygen diffuses in from the surface, the top layer will become solid first. If this process is happening very quickly due to the presence of driers or if the paint film is too thick, the underlying layers will dry more slowly. Due to incorporation of oxygen, the paint film's weight increases and it becomes more polar. At this stage, the paint is very sensitive to organic solvents due to the open structure of the network, the high amount of extractable material and the flexibility of the paint system.

Chemical and physical aspects of the maturation process

After the paint film has become a solid but elastic film, oxidation does not stop but proceeds, leading to an increasing relative amount of acidic oxidation products. As a result, the hydrophobic character of the paint film is decreased. More water molecules can be incorporated through H-bonding, thus increasing the moisture content. As a result, hydrolysis of the initial triglyceride ester bonds occurs, leaving a residual cross-linked fraction with free carboxylic acid groups, free FAs and diacids, and glycerol. Glycerol and some of the lower molecular weight FAs will evaporate. The liberated acid groups of both the polymer network and free FAs are immobilised by the reaction with metal ions to metal carboxylates, leading to a so-called ionomer (Holliday 1975). Metal ions at the surface of pigment particles as well as dissolved ions (from pigments or driers) can act as anchor points for the carboxylic acid groups. Multivalent interactions lead to complex linkages between different parts of the polymer network. The physical properties of the resulting ionomer will largely depend on the quantity of anionic groups, the amount and types of metals present, and the degree of neutralisation of the anionic groups. Figure 1C summarises the result of the maturation process of the polyester to the polyanionic ionomer stage of the oil paint.

The physical changes caused by the transition from cured to mature oil paint are very drastic. The paint film loses weight because more volatile compounds evaporate from the paint than oxygen is incorporated. As a result the paint contracts. Again, this process will start at the surface and crack formation can result due to uneven contraction of the top and underlying layers. It is known (Holliday 1975) that metal carboxylate formation in polymers (to ionomers) leads to a large increase in hardness and stiffness of the paint film. As a result of the increased compactness by electrostatic forces, the swelling probability is strongly decreased and the paint becomes somewhat brittle.

The solvent sensitivity in a truly ionomeric oil paint film will be strongly decreased because non-cross-linked FAs in the paint film are chemically trapped in the form of solvent-stable salt. On the other hand the sensitivity to acid, base, and ionogenic detergents is greater because they affect the co-ordination chemistry of the ionomer.

Without stabilisation of the hydrolysed paint by metal ions, the paint film will be more vulnerable to swelling. In this case liberated FAs can appear at the surface (blooming), evaporate (precipitation on the protective glass) or become extracted.

Table 1. Identified non-cross-linked compounds. Numbers correspond to Figs. 2–5.

Label	Compound
*	dimethyl siloxanes
A	hexadecane (internal standard)
1	heptanoic acid, TMS ester
2	glycerol, 1,3-bis[(TMS)oxy]
3	glycerol, 1,2,3-tris[(TMS)oxy]
4	octanoic acid, TMS ester
5	nonanoic acid, TMS ester
6	decanoic acid, TMS ester
7	hexanedioic acid, ethyl TMS ester
8	heptanedioic acid, ethyl TMS ester
9	heptanedioic acid, di-TMS ester
10	octanedioic acid, ethyl TMS ester
11	octanedioic acid, di-TMS ester
12	nonanedioic acid, ethyl TMS ester
13	nonanedioic acid, di-TMS ester
14	nonanoic acid, 2,3-bis(TMS)oxy, propyl ester
15	decanedioic acid, ethyl TMS ester
16	tetranoic acid, TMS ester
17	decanedioic acid, di-TMS ester
18	pentadecanoic acid, TMS ester
19	hexadecanoic acid, ethyl ester
20	hexadecanoic acid, TMS ester
21	octadecenoic acid, ethyl ester
22	octadecanoic acid, ethyl ester
23	octadecenoic acid, TMS ester
24	octanedioic mono-TMS ester, 2,3-bis(TMS)oxy propyl ester
25	octadecanoic acid, TMS ester
26	nonanedioic mono-TMS ester, 2,3-bis(TMS)oxy propyl ester
27	8-octadecenoic acid, 8-TMS ether, ethyl ester
28	10-octadecenoic acid, 11-TMS ether, ethyl ester
29	9-octadecenoic acid, 9-TMS ether, ethyl ester 9-octadecenoic acid, 10-TMS ether, ethyl ester
30	8-octadecenoic acid, 8-TMS ether, TMS ester
31	10-octadecenoic acid, 11-TMS ether, TMS ester
32	9-octadecenoic acid, 9-TMS ether, TMS ester 9-octadecenoic acid, 10-TMS ether, TMS ester
33	icosanoic acid, ethyl ester
34	icosanoic acid, TMS ester
35	octadecanoic acid, 9,10-bis[(TMS)oxy], ethyl ester
36	octadecanoic acid, 9,10-bis[(TMS)oxy], TMS ester
37	hexadecanoic acid, 1,3-bis(TMS)oxy propyl ester
38	hexadecanoic acid, 2,3-bis(TMS)oxy propyl ester
39	octadecenoic acid, 2,3-bis(TMS)oxy propyl ester
40	octadecanoic acid, 2,3-bis(TMS)oxy propyl ester
41	octadecanoic acid, 9,10-bis[(TMS)oxy], 2,3-bis(TMS)oxy propyl ester

Chemical and physical aspects of the degradation process

Due to the continuous exposure of the paint system to air, (UV) light and humidity, the (oxidative) degradation of the polymer system proceeds and the amount of organic material will decrease. Certain pigments like lead white or lithophone, which are activated by light with wavelengths in the 290–350nm band, will enhance the photochemical degradation of the binder (Hess et al. 1979). Due to this phenomenon, small breakdown products like formic acid will be formed. These can interfere with the metal carboxylates already present and the paint may lose its binding capacity leading to an increased extractability of organic fractions. Consequently, release of pigment (chalking) may take place.

In the degradation stage, the paint film is expected to become more brittle and therefore increasingly sensitive to mechanical stress.

Determination of the chemical condition of the paint film

It is clear from the above description of the paint film development that the number of relevant variables is very large. Furthermore, the synergistic effects are not known. Therefore, it is impossible to predict how far the processes that occur within a paint film have proceeded. However, using chemical analysis it is possible to obtain more information on the condition of the paint and the degree of hydrolysis of the polyester. Unfortunately, at the moment there is no single analytical method capable of showing the chemical structure of the polymeric network after ageing. Techniques like nuclear magnetic resonance (Marshall et al. 1985) or infrared spectroscopy (Meilanus et al. 1990) give only information on specific chemical groups present in the sample. Other methods used for polymer analysis like size exclusion chromatography and thermal analyses provide information on the size of the soluble paint network and the compactness (Tg) and other mechanical properties, respectively.

Useful information can be obtained by gas chromatographic examination of the non-cross-linked fraction as reported by Koller et al. (1995) and Schilling et al. (1996). For information on the transformation of the polyester, a two-step derivatisation method has been developed which can chemically distinguish FAs, esterified or liberated from the glycerol backbone. The degree of de-esterification or hydrolysis was determined for samples from paintings and reconstructions.

Analytical results on the transformation of the oil paint polyester

Previous analyses using on-line (trans)methylation with tetramethylammonium hydroxide in combination with Curie–point pyrolysis gas chromatography/mass spectrometry (GC/MS), as described by van den Berg et al. (1998b), already identified most of the non-cross-linked components present in an oil paint system. With the derivatisation procedures presented in this paper, other information on this fraction can be obtained. A four-year old flexible stand oil film, supposed to be in transition between curing and maturation stages, was extracted and the extract analysed with GC/MS after silylation of all free hydroxy and carboxylic groups. Compounds identified include short chain FAs, (oxidised) saturated FAs, and diacids (see Fig. 2 and Table 1). The amount of short chain FAs (compounds 4–6) is relatively high. Their acid group was formed upon autoxidation and not

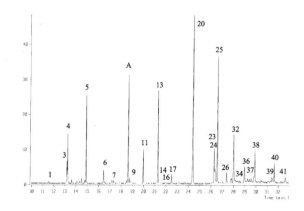

Figure 2. Total ion chromatogram of silylated extract of a four-year-old stand oil film. Numbers correspond to Table 1. The GC oven was at 50°C for two minutes, then ramped with 8°C/minute to an end temperature of 314°C (50(2)-8-314).

Figure 3. Total ion chromatogram of transethylated and silylated sample of a four-year-old stand oil film. Numbers correspond to Table 1. GC temperature program: 50(5)-6-320.

Figure 4. Total ion chromatogram of transethylated and silylated sample of a 25-year-old ivory black pigmented oil paint. Numbers correspond to Table 1. GC temperature program: 50(2)-6-320.

Figure 5. Total ion chromatogram of transethylated and silylated sample of an approximately 150-year-old paint layer on a wooden crucifix. Numbers correspond to Table 1. GC temperature program: 50(5)-6-320.

Table 2. Degree of hydrolysis of a range of paint samples.

Sample	Age (Years)	Free C9Di (%)	Free C18 (%)
Stand oil	4	14	10
Linseed/lead white CCI	25	44	44
Linseed/ivory black CCI	25	48	48
Linseed/iron oxide CCI	25	49	72
Linseed/vermilion CCI	25	50	61
Sargent, paint	95	71	85
Landseer, priming	135	64	91
Crucifix, paint	±150	79	83
Turner, light paint	±190	90	95
Turner, dark paint	±190	81	90
Brown paint	±250	77	96

esterified. Furthermore, the C18 mono-unsaturated FA is still detectable. This compound reacts slowest upon autoxidation and can be found in higher amounts for young or insufficiently dried films. Apart from the previously identified free (oxidised) FAs and diacids, silylated monoglycerides of these acids were detected as hydrolysis products of the non-cross-linked part of the triglycerides. These monoglycerides are no longer detected in samples from an aged painting, indicating that further hydrolysis of the ester bonds has occurred and that most of the FAs are released from their glycerol backbone.

When the total stand oil paint is analysed using two-step derivatisation (see van den Berg et al. 1998c), a more precise picture is obtained on the degree of de-esterification. Tests on combinations of reference compounds like triglycerides, free FAs, lead carboxylates, and sodium carboxylates have shown the validity of this method. A set of two peaks (ethyl ester or silyl ester) is found for most of the compounds in the chromatogram (see Fig. 3 and Table 1). The first peak originates from ethylated FAs that were esterified to the glycerol backbone prior to analysis, and the second from silyl derivatives of FAs that were liberated and present either as free FAs or as metal salts. For the fatty diacids one of the acid groups is always present as a silyl group because this free acid group is formed upon autoxidation. By comparing the ratio of these two peak areas, quantitative information is obtained on the degree of hydrolysis. Most of the FAs and diacids in Figure 3 are present as ethylated derivatives. This indicates that most of the original ester bonds are still intact, as expected for a young unpigmented film. The degree of hydrolysis is 14% for the C9 fatty diacid and 10% for the C18 fatty acid. These two FAs were used for the calculation because they show similar degrees of hydrolysis in most of the analysed samples (Table 2). Surprisingly, the C8 diacid (Figs. 3, 4, and 5) shows a higher degree of hydrolysis. This suggests that of a fraction of the C8 diacids both acid groups have been formed upon autoxidation. Liberated and completely silylated glycerol (compound 3, Table 1) and disilylated glycerol derivatives (compound 2, Table 1) are found in high quantities. The short chain FAs (compounds 4–6) are present as silylated derivatives, which confirms that the acid groups are formed upon autoxidation.

A set of 25-year-old reconstructions made with linseed oil paint and different pigments at the Canadian Conservation Institute was analysed with the same methodology (Table 2). A typical chromatogram of an ivory black pigmented film is shown in Figure 4. It is clear that the degree of hydrolysis is higher for these samples compared to the four-year-old stand oil. Short chain FAs were not observed in this case. The presence of high amounts of mono-unsaturated C18 FAs (compounds 21 and 23) should be noted. It is indicative for the known drying problems of ivory black pigmented paint films (Carlyle 1991).

Samples from paintings by Turner and Sargent, a primed canvas by Landseer, an unidentified brown 18th-century paint sample and samples from a late 15th-century painted crucifix were analysed in the same way. The crucifix was covered with about 17 paint layers, which could be removed mechanically. Figure 5 (see also Table 1) depicts the chromatogram of one of the flesh tone oil paint layers of the crucifix which is about 150 years old. From the ratio of the two ethyl and silyl derivatives, it is clear that this sample has undergone extensive hydrolysis: 79% for C9 diacids and 78% for C18 FAs. The ratio of free versus esterified C9 diacid and

C18 FAs in other (old) paint samples is listed in Table 2. The degree of hydrolysis varies from 64–96%. We expect some sample spot-related variation in paintings due to the heterogeneity in chemical composition of the paints.

In general, we can conclude that the degree of hydrolysis increases with increasing age. However, due to different pigmentation, PVC, storage conditions, etc., it is impossible to relate the exact calendar age to a percentage hydrolysis. The implication of these numbers is that FAs and fatty acid carboxylic groups in the cross-linked fractions are no longer part of a polyester form of the oil network in the binding medium. We infer from the data presented here that the paints are mostly in an ionomeric form. Further studies will be devoted to the ratio of free versus metal co-ordinated carboxylic acid groups.

Implications of the oil paint model for restoration practice

The concept that oil paint is inherently unstable has its implications for restoration practice. There is a strong fear that organic solvents used for cleaning have a major impact on the chemical composition of the paint layers. Are the FAs really extractable? Recent results by White and Roy (1998) suggest that the extractability of the FAs may be limited. Our model suggests that FAs in a well-designed oil paint film should be chemically fixed. Defects and imbalance in the chemical consistency of the oil paint network however may change the degree of metal ion co-ordination and thus the sensitivity of the oil paint film to solvent extraction. Problems in paint consistency seem to be common in 19th-century paintings (Carlyle 1991). More attention should be devoted to the effects of manufacturing methods on the alkalinity of the resulting oil paint and to the ways that artists modified paints, unaware of the subsequent chemical consequences.

Conclusions

The analytical results confirm the idea that the paint develops from a cured stage to a mature stage in which most of the initial ester bonds have been broken. It is supposed that metal ions will stabilise the free carboxylic acid groups that are formed. The transition from a flexible to a hard and somewhat brittle film is evidence for this phenomenon.

Acknowledgements

This research is part of the research program of the NWO priority program of MOLART – a project on the ageing of painted art – and FOM (Foundation for Fundamental Research on Matter), a subsidiary of the Dutch Organisation for Scientific Research (NWO). The authors thank Hans-Christoff von Imhoff and the Canadian Conservation Institute (Ottawa) for supplying samples from a large set of 25-year-old reconstructions; Arnold Truyen (SRAL, Maastricht) for providing the Crucifix sample (Bonnefantenmuseum, 677 BM); Alan Phenix (Courtauld Institute, London) for 18th-century brown paint; Joyce Townsend (Tate Gallery, London) for samples from *Dolbadern Castle* (J.M.W. Turner; first exhibited 1800) and from *Ena and Betty Wertheimer* (J.S. Sargent; 1902); M. Odlyha (Tate Gallery, London) for a sample of E.H. Landseers' primed canvas, taken from *A Study of a Lion* (1862).

References

Boon JJ, Peulvé SL, van den Brink OF, Duursma MC, Rainford D. 1997. Molecular aspects of mobile and stationary phases in ageing tempera and oil paint films. In: Bakkenist T, Hoppenbrouwers R, Dubois H, eds. Early Italian paintings – Techniques and analysis. Maastricht: Limburg Conservation Institute: 35–56.

Carlyle LA. 1991. A critical analysis of artists' handbooks, manuals and treatises on oil painting published in Britain between 1800–1900: with reference to selected eighteenth century sources. (Ph.D. dissertation, Courtauld Institute of Art, University of London).

Hancock RA and Leeves NJ. 1989. Studies in autoxidation. Part I. The volatile by-products resulting from the autoxidation of unsaturated fatty acids. Progress in organic coatings 17: 321–336.

Hess M, Hamburg HR, Morgans, WM. 1979. Hess's paint film defects, their causes and cures. 3d and revised edition. London: Chapman and Hall.

Holliday L. 1975. Classification and general properties of ionic polymers. In: Holliday L, ed. Ionic polymers. London: Applied Science Publishers Ltd.: 1–68.

Hubert JC, Venderbosch RAM, Muizebelt WJ, Klaasen RP, Zabel KH. 1997. Mechanistic study of drying of alkyd resins using (Z,Z)- and (E,E)-3,6-nonadiene as model substance. Progress in organic coatings 31: 331–340.

Karleskind A. 1996. Oils and fats manual. A comprehensive treatise: Properties – production – applications. Volume 1. Andover: Intercept Ltd.

Koller J, Baumer U. 1995. Das Cismarer Hochaltarretabel; Teil II Die Untersuchung der Bindemittel auf Ölbasis. Zeitschrift für Kunsttechnologie und Konservierung 9(2): 286–295.

Marshall GL, Lander JA. 1985. Characterisation of cured alkyd paint binders using swollen state 13C-NMR. European polymer journal 21(11): 959–966.

Meilunas J, Bentsen JG, Steinberg A. 1990. Analysis of aged paint binders by FTIR spectroscopy. Studies in conservation 35(1): 33–51.

Muizenbelt WJ, Hubert JC, Venderbosch RAM. 1994. Mechanistic study of drying of alkyd resins using ethyl linoleate as a model substance. Progress in organic coatings 24: 263–279.

Muizenbelt WJ, Nielen MWF. 1996. Oxidative crosslinking of unsaturated fatty acids studied with mass spectrometry. Journal of mass spectrometry 31: 545–554.

Porter NA, Caldwell SE, Mills KA. 1995. Mechanisms of free radical oxidation of unsaturated lipids. Lipids 30(4): 277–290.

Schilling MR and Khanjian HP. 1996. Gas chromatographic determination of the fatty acid and glycerol content of lipids. I. The effects of pigments and aging on the composition of oil paints. In: Bridgland J, ed. Preprints of the 11th triennial meeting of the ICOM Committee for Conservation. London: James and James (Science Publishers) Inc.: 220–227.

van den Berg JDJ, Boon JJ, Phenix A. 1998a. Analytical chemistry of oil paint: a revised chemical model of aged oil paint relevant to the cleaning of paintings. Proceedings of the Symposium Beobachtungen zur Gemäldeoberfläche und Möglichkeiten ihrer Behandlung. Bern: Höhere Fachklassen für Konservierung und Restaurierung HFG, SFGB.

van den Berg JDJ, van den Berg KJ, Boon JJ, Fiedler I, Miller MA. 1998b. Identification of an original non-terpenoid varnish from the early 20th century oil painting "The White Horse" (1929), by H. Menzel. Analytical Chemistry 70: 1823–1830.

van den Berg JDJ, van den Berg KJ, Boon JJ. 1998c. GC/MS analysis of fractions of cured and aged drying oil paints. Advances in mass spectrometry 14: D05 THPO121.

White R, Roy A. 1998. GC-MS and SEM studies on the effects of solvent cleaning on Old Master paintings from the National Gallery, London. Studies in conservation 43(3): 159–176.

Documentation

Documentation

Abstract

Two report form formats for the examination of canvas and panel paintings were refined during a recent project undertaken by the Istituto Centrale per il Restauro aimed at the surveillance and maintenance of a historical art collection. Described here are the layout of the report forms – with a strong emphasis on artistic techniques and conservation issues – and the methods used for collecting and entering the data, including the employment of specialised terminology and syntax. Practical experience also showed that the project has great potential for conservation training.

Keywords

canvas paintings, panel paintings, database, conservation report forms, collections management

A system for collecting data on canvas and panel paintings for the maintenance and surveillance of a historical art collection in Rome

Anna Maria Marcone, Mariabianca Paris,★ Giancarlo Buzzanca
Istituto Centrale per il Restauro
Piazza San Francesco di Paola 9
00184 Roma
Italy
Fax: +39 6 4815704

Introduction

In 1997 the Istituto Centrale per il Restauro (ICR) in Rome started work on a project aimed at establishing guidelines for the protection and maintenance of museum collections.

For the pilot study it was decided to use the Doria Pamphilj Gallery of Rome.[1] This particular gallery was chosen as it has an extensive and varied collection and is still conserved in its original site (the family palace on Via del Corso). It further retains the characteristics of an eighteenth century private collection as it has not been substantially reorganised since that date.

Two interdisciplinary working groups were set up for the project, working together in close collaboration. The first of these groups was composed of scientific experts – a chemist, a physicist and a biologist – with the responsibility of monitoring and assessing the environment of the exhibition spaces. The second group was composed of technical experts – conservators and information specialists – with the task of studying and reporting on the works as well as combining this information with the local environmental data collected by the other group.

The project also involved the experimental participation of students from the three-year paintings conservation course of the ICR as part of their practical training programme.

For recording the data on environmental factors and on the works of art, the following were developed:

- first and second level environment report forms for the main rooms of the gallery. The first level reports had a series of queries to be filled out using simple visual observation. These observations then determined which environmental measurements were to be carried out. The results of these measurements were then recorded on the second level reports;
- conservation report forms for canvas and panel paintings.

The development and definition of the report forms for the study of the paintings

The design of the conservation report forms drew firstly on pre-existing examples in the literature of the field. Of more importance, however, was the direct experience of the ICR staff, accumulated since the 1970s.

However, all such work in this field derives from the foundation laid down by the Piano Pilota Umbro (Urbani 1976), and some later work based on it, in particular the report forms for the Museo Civico in Pistoia (Angelucci and Martellotti 1982), the Regione Lazio (Cordaro and Mazzi 1993), and the Laboratorio in Viterbo (Olivetti 1988). In this project, we decided also to make direct use of a computer database, choosing File Maker Pro 2.1® due to its ease of use, its versatility and its compatibility with the hardware available in the ICR's conservation studio.[2, 3]

★ Author to whom correspondence should be addressed

Our report form was designed to break down the information on the paintings as much as possible into its component parts while at the same time ensuring it was organised so that it was simple both to enter and recover the data.

To achieve this the data were divided into two levels:

- basic data containing only the most essential information for each entry on the form. This information was entered in some fields on the database using a specially designed code. In other fields it was entered as text using predetermined terminology (Cordaro 1979: Giannini 1992) and rules governing syntax and punctuation;
- detailed data, entered into the computer as free text so as to bring together, explain or document the basic data.

At present, report forms have well over a hundred separate entries (144 for canvases and 104 for panels). These are divided into the following six sections:

1) Reference Data: this collects the material needed to identify the work (location, legal ownership, provenance, type, attribution, chronology, iconography, painting techniques etc.) using a simplified version of the report form "OA" of the Istituto Centrale per il Catalogo e la Documentazione (Papaldo et al. 1985). Given the added requirements of our project, we also included further entries dealing with the *fideicommissum* or inventory number, the location of the work in the gallery, movements of the work when loaned out for exhibitions (documented by catalogues or even labels on the frame or stretcher) and conservation treatments. This section concludes with details on how the painting was examined (e.g. visually, by touch, whether the reverse side could be examined) – information vital for future users of the data in assessing the completeness of the information on the report form.

2) Documentation: lists references to documentary material about the painting, organised into various categories – graphic documentation, photographs and archival and published material. This material is intended to provide information on the history of the painting which is related to its conservation (movements, analyses, treatments, etc.). The section should be compiled both by the conservator and the gallery's curator – particularly in the case of the Doria Pamphilj gallery where the archive is still housed in the family palace together with the collection.

3) Details of location/exhibition of the work: a brief listing of all the movements of the painting within the gallery itself (from archival documents and old catalogues of the collection) as well as its present location. The information should also include the type of wall-mounting and any protective or security methods used. We also included here an entry 'Exhibition risk factors' to list possible risks to the painting from either environmental or human factors, to be assessed on the basis of simple observation. For each painting, the information gathered here should be collated with the more general information about each exhibition space within the gallery previously entered on the first level environmental report forms (the assessment of the environment without precise data from scientific instruments).

4) Technical data and condition report: this includes information about the painting techniques used and the condition of the painting in terms of each of the layers which theoretically make up the painting (in the sequence: supporting/containing structure, e.g. frame, support, auxiliary support, preparation layer, paint layer, varnish). For each layer the information is reported in the following order: materials and techniques used; physical, chemical and biological damage; restoration treatments. A final heading 'Other' allows the recording of any atypical data.

Whenever one of the materials making up the paintings was only identified visually on the basis of the conservator's experience, rather than through scientific analysis (for example, the different types of wood), we always added the letters 'n.a.' (not analysed).

5) Indications for conservation treatment: here the previously collected data were used to propose treatment of the painting and to indicate the relative urgency

of the treatment (emergency treatment, or treatment necessary within a short, medium or long period). The section is divided into headings drawn from several treatments price lists, to be filled out on the basis of estimated working hours required and hence of the costs for the various phases of work.

6) Reference material about the report itself: listing the names and qualifications of the people who compiled the report, the date it was compiled and any dates it was revised.

A guide was prepared so as to facilitate and standardise both entry and recovery of data in the 'text' fields of the report, laying down for each entry the type of information deemed to be essential and the technical terminology to be employed (See Fig. 1). It also included a series of sample reports illustrating the special syntax and punctuation to be adopted.

The collection and recording of the data

Collecting and entering the information in the database was carried out during two ICR work-experience programmes followed by students from all three years of the paintings conservation course. In all, one hundred and twenty works were catalogued. The programmes were experimental in nature, aimed at assessing both

Reference Data - table with example fields

City	Building/Space	Fidelcommissum number	Work	Shape/Size	Subject	Year	Artist	Technique	Type of inspection
Rome	galleria Doria Pamphilj	FC 202	one of a series of two works (see FC 201); painting; with frame	rectangle; height 28.2 cm width 42.5 cm thickness 1.5 cm area 0.12 sq m	View of Rome with the convent of San Pietro in Vincoli	1711	H. Frans van Lint	oil on canvas	visual and touch; back examined

Technical data and condition - table with example fields on *Support structure*

Support structure	Components and materials	Expansion system	Writing/Stamps	Notes
present, unlikely original: stretcher, rectangular, mobile, with manual expansion system	4 battens, wood, with 'T' shaped tenon and mortise corner joins	present, manual expansion, 3 wood keys, pin shaped; non operative (see notes)	present, directly on stretcher, non original: in pink pencil, right batten, "261"; black ink, with stencil, lower batten, "FC 202"	the expansion system is blocked by wooden laths nailed along the outside edge of the stretcher

Technical data and condition - table with example fields on *Support*

Original support	Fibre	Weave	Thread count	Deformation	Losses
present	plant fibre (n.a.)	plain weave	horiz. 16; vert. 20	present (visible from front): impressions of the 4 battens, moderate; stretching creases, slight, upper corner left and right; impact marks, 2 linear, upper and lower left quadrants, 1 point, upper right quadrant	present, 1 loss, slight, lower left quadrant

Technical data and condition - table with example fields on *Paint layer*

Materials	Final protective layer	Surface deposits	Later treatments identifiable	Notes
oil, pigments (n.a.); fluid brush strokes	present, non original, varnish, even layer (see notes)	insect excrement, entire surface	present: cleaning, uneven; retouching (colour change in retouching)	underneath present layer visible residues of an earlier, very yellowed varnish layer

Photographic documentation

 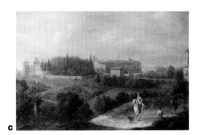

Roma, Galleria Doria Pamphilj: H.F. van Lint, View of Rome with the convent of San Pietro in Vincoli, 1711 (FC 202)
a) front b) back c) front under raked light

Figure 1. A series of examples from the report form for canvas paintings.

Glossary - T shaped tenon and mortise join

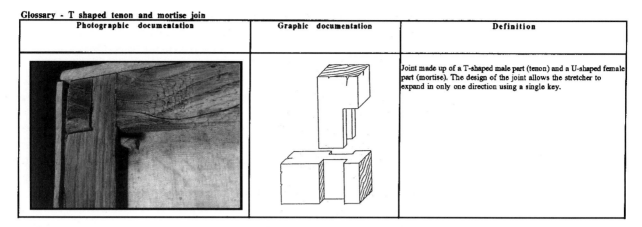

Photographic documentation	Graphic documentation	Definition
		Joint made up of a T-shaped male part (tenon) and a U-shaped female part (mortise). The design of the joint allows the stretcher to expand in only one direction using a single key.

Figure 2. An example of the illustrated glossary.

the practical viability of the reports and their value as a conservation training method.

To allow the information to be gathered, each painting was temporarily moved to an area of the gallery which had been set aside and equipped with tables and computers (one for every two students). Each part of the painting was examined with the aid of a magnifying glass and the information was entered directly into the database. At the same time, each painting was also photographed: the front in black and white (6 × 6 cm), back and front under raking light; and details of technique or deterioration with colour slides (24 × 36 mm). The colour slides of details were taken to illustrate a glossary of technical terms to be attached to the compilation guide (See Fig. 2). When absolutely necessary, emergency conservation treatment was also carried out, in particular the re-adhesion of the preparation and paint layer to the support.

Preliminary results already indicate the utility of the work on two levels: that of understanding aspects of the collection as a whole and of pinpointing future conservation treatment.

In the first case, for example, we found that most of the canvases had been relined in the same way, employing similar stretchers, canvas/stretcher attachments, relining cloth and adhesives. At the same time as this relining, many of the paintings had also been either enlarged or reduced in size. These factors all point to a single extensive restoration programme, probably connected with the reorganisation of the gallery in the eighteenth century, when the paintings were hung symmetrically in terms of their size and shape. It is hoped that research currently being carried out in the archives will confirm this hypothesis.

On the other hand, as far as the conservation and treatment of the paintings were concerned, we were able to set up a priority listing of conservation treatments together with a rough estimate of their cost. For example, one of the most urgent treatments required was the disinfestation of frames under attack by wood-eating insects (fortunately, rarely found in the paintings themselves). Another urgent treatment was the replacement of screwed-on metal plates, nails etc. rigidly binding the paintings to their frames.

Finally, the experience also proved to be valuable in terms of conservation training. The students had the chance to examine and discuss with their teachers a large number of artistic techniques and types of deterioration. They were also able to develop their observation skills so as to extract the maximum amount of relevant information contained in each painting. And finally, with the aid of the systematic procedures provided by the reports, they were able to put this information into a logical framework and to correlate all the various factors involved–the condition of a work with the techniques and the materials used, both original and from restorations.

Concluding this first experimental phase of cataloguing the paintings, those works in urgent need of treatment or with unusual problems were transferred to the ICR where they will be treated in the course of practical training sessions, thus

allowing the students to follow up the treatments they were involved in recommending.

Conclusions

The Istituto Centrale per il Restauro, Rome started this project for the maintenance and checking of museum collections in 1997, using as its pilot study the Galleria Doria Pamphilj in Rome. General information about the paintings' condition and artistic techniques was collected through study of documentary material, and the exhibition spaces were subject to environmental monitoring. Two detailed report forms were drawn up, one for canvases and the other for panel paintings, and these were then transferred to an electronic database. A specialised glossary and series of syntactical rules were established to aid recovery and entry of the data. These report forms were then tested and modified in the context of a work-experience programme using students from the training school of the ICR in which data on one hundred and twenty paintings were entered in the database. Preliminary use of the database confirmed the reports' value in terms of extracting both general observations regarding the whole collection and the relative urgency of particular treatments.

The project will continue with modification of the report forms to meet the needs of other types of paintings in the gallery (the most common examples being paintings on copper and paper) together with their relative technical glossaries. It is also planned to upgrade the software and create a new database based on Access®.[4] Once this experimental phase of the project is finished, the cataloguing of the collection will be completed with the aid of private conservators drawn from ex-students of the ICR who have had experience with the system during their training. It will thus be possible to correlate the data acquired on the paintings with the information from climatic monitoring in order to draw up a programme for the permanent maintenance of the gallery.

Acknowledgements

The authors would like to thank Mark Gittins for his help in translating this report into English.

Notes

1. The collection is made up of a nucleus of works from the Aldobrandini family collection composed of Renaissance art (paintings by Titian, Raphael, Dosso Dossi, Garofalo, Carracci, etc.) which entered into the hands of the Pamphilj family in the mid-seventeenth century. The following century saw the largest increase in the collection, particularly in the genres of still lives and ideal landscapes (Claude Lorrain, Gaspar Dughet, Jan de Momper, etc.) though not to the exclusion of more innovative painters such as Guercino, Caravaggio, and Mattia Preti. The merging of the Doria and Pamphilj families in the second half of the eighteenth century coincided with the reorganisation of the gallery into essentially its present-day layout, where the paintings are mostly organised symmetrically on the basis of their shape and size.
2. File Maker Pro ® Claris Corp., 5201 Patrick Henry Drive, Santa Clara, California 95052.
3. The computerisation and software management of the project was handled by G. Buzzanca.
4. Access® Microsoft Corp.

References

Angelucci S, Martellotti G. 1982. Il rilevamento dello stato di conservazione dei dipinti del Museo Civico di Pistoia. In: Catalogo delle collezioni del Museo Civico di Pistoia. Firenze: La Nuova Italia: 285–300.

Cordaro M. 1979. Sul lessico del restauro. In: Convegno nazionale sui lessici tecnici delle arti e dei mestieri, Cortona, 28–30 maggio. Pisa: Scuola Normale Superiore: 211–219.

Cordaro M, Mazzi MC. 1993. Censimento conservativo dei beni artistici e storici. Guida alla compilazione delle schede. Roma: Centro Regionale per la Documentazione del Lazio.

Giannini C. 1992. Il lessico del restauro. Storia, tecniche, strumenti. Firenze: Nardini Editore.

Olivetti C. 1988. Proposta di una Scheda per la raccolta dei dati nel restauro dei dipinti su tela. Quaderni degli Istituti Culturali della Provincia di Viterbo 1: 25–159.

Papaldo S, Ruggeri Giove M, Gagliardi R, Matteucci DR, Romano GA, Signore O. 1985. Strutturazione dei dati delle schede di catalogo. Beni mobili archeologici e storico artistici. Roma: ICCD.

Urbani G, ed. 1976. Piano pilota per la conservazione programmata dei beni culturali in Umbria. Progetto esecutivo. Roma: ICR: vol.1-3.

Paintings I: Conservation and restoration of paintings

Peinture I: Conservation et restauration des peintures

Paintings I: Conservation and restoration of paintings

Coordinator: Alan Phenix

Paintings I is one of the largest working groups of ICOM-CC, presently comprising nearly 300 members in four specialist research areas: Flexible Supports (essentially paintings on canvas), Rigid Supports, Modern & Contemporary Art, and Icons. I think it is reasonable to say that during the last triennial period there has been considerable activity in virtually all areas of the Working Group, and it continues to provide an important umbrella for research in the diverse fields within the broad subject of the conservation of painted works of art.

By the time of the present conference, the Working Group will have provided members four issues of its Newsletters, published jointly with Paintings II: Scientific Study of Paintings (Methods and Techniques). The partnership with Paintings II remains fruitful and there is clearly a good deal of overlap in the interests of the two groups. With this in mind, the two Working Groups held a joint interim meeting entitled *Image or Object: the influence of conservation treatment on the interpretation of paintings* in Dublin in September 1998. The one-day meeting attracted more than 130 participants. In addition to this overall interim meeting, some of the specialist research areas have held their own interim meetings during the triennium, mostly coinciding with other international conferences. For example, the Modern and Contemporary Art research area held a meeting in Amsterdam in September 1997; and the Icons research area, which continues to have an especially active membership, has held a series of meetings coincident with symposia organised under the Raphael Pilot Programme of the European Commission.

There are, unfortunately, no contributions relating to Icons in these proceedings. This is perhaps a consequence of the fact that there have been so many symposia and publications on the conservation of icons over the last few years.

The selected papers, I hope, honour the stated research programmes of the Working Group. There are several contributions from Rigid Supports, both panel paintings and paintings on more unusual materials. As always, there is strong input from Flexible Supports which includes papers on practical treatments as well as theoretical investigations of canvas paintings as structures. Modern and Contemporary Art is also well covered, within both Paintings I and Paintings II. A particularly interesting feature of the contributions to the Lyon/Paris meeting has been the number of papers (more than a third of those selected) that are relevant to the cleaning of paintings, which is presently covered within the Flexible Supports research area. I think this presents rather a strong case for the establishment of a 'Cleaning of Paintings' research area within Paintings I. I have not yet had time to contact the various researchers in this field to encourage support for this idea, but this is a priority for the period between the time of this writing and the meeting in Lyon.

Abstract

The aim of this study is to investigate the adhesion between artists' canvas and the priming layers in order to gain a better understanding of the mechanisms of flaking. Fresh samples were prepared from linen canvas cut from the warp and weft directions, with applications of warm liquid or cold gel size, and oil or aqueous emulsion grounds. The samples were heat aged and subjected to uniaxial shear and peel tests at 17%, 55%, 75% and 85% RH (20–22°C). Results showed that shear strengths were higher in the weft than in the warp direction, indicating that the woven structure of the canvas may play a prominent role in delamination of the ground from the support. Cohesion within the aqueous emulsion ground was dramatically reduced between 75% and 85% RH. Warm sizing produced more reliable bonds than cold gel applications. Preliminary results suggested that cold sizing may affect adhesion properties at 17% and 85% RH.

Keywords

canvas painting, warp, weft, shear, peel, humidity

The preparation of artists' canvases: Factors that affect adhesion between ground and canvas

Paul Ackroyd*
Conservation Department
National Gallery
Trafalgar Square
London WC2N 5DN
UK
Fax: +44 171 747 2409

Christina Young
Conservation Department
Tate Gallery,
Millbank,
London SW1P 4RG
UK

Introduction

Between 1620 and 1646, de Mayerne compiled a treatise in which one of the principal aims was to improve the preparation of artists' canvases so as to prolong their life expectancy (Van de Graaf 1958). He believed the reasons for deterioration in paintings lay in the priming layers and through empirical observations concluded that sizing with large quantities of animal glue was a prime factor in the cracking of canvas pictures. Consequently, he recommended weak solutions of skin glue, applied either as a cold jelly, to form discrete layers on top of the canvas fibres, or by complete immersion and penetration of the fabric with warm, liquid size. It is likely, however, that both methods would have produced substantial glue layers.

Artists have been continually concerned with the preparation of canvas and a large variety of materials have been advocated for this purpose. By the end of the 18th century artists' colourmen became largely responsible for the process. British 19th century commercial practice favoured cold gel sizing because fewer ground applications were needed to produce a smooth preparation thereby saving labour and materials costs. Nineteenth century machine-woven canvases, commercially prepared with cold size and underbound, absorbent ground, are notoriously problematic when considering conservation treatments at high humidities. Above 75%–80% relative humidity (RH) the canvas tends to shrink, with potential loss of paint and ground. At 85% RH and above, the size reverts to a gel, and is thought to exacerbate the problem by acting as a release layer between ground and canvas. The mechanism of "shrinkers", as such pictures are termed, is now reasonably well studied (Bilson 1996: Hedley 1988).

Only in recent times has there been research pertinent to the mechanical performance of the materials employed in the preparation of artists' canvases. In the early 1980s Mecklenburg, using uniaxial tensile tests, illustrated the mechanical behaviour of the paintings' components in terms of their stress/strain response as a function of humidity (Mecklenburg 1982). In particular, he demonstrated the instability of the glue layer as a function of its moisture content by its ability to carry tension at low humidities and its inability to bear tensile load in a gel state above 85% RH. Mecklenburg, like de Mayerne, proposed that the size layer is largely responsible for the deterioration of canvas paintings. Some practitioners have assumed that the adhesive properties of glue size decline corresponding to its change in modulus around 85% RH. This has given rise to a belief in a "working range" where it may be safe to treat moisture-sensitive paintings – between 75% RH before the likely onset of canvas contraction, and 85% RH when adhesion at the size/ground interface may have weakened considerably.

After age cracks have developed in the paint and ground layers, flaking may be initiated by localised stress concentrations at the edges of age cracks (Colville and

* Author to whom correspondence should be addressed

Table 1. Description of the prepared samples.

Canvas,	Warp direction	Warm size	Emulsion ground
Canvas,	Warp direction	Cold size	Emulsion ground
Canvas,	Warp direction	Warm size	Emulsion ground
Canvas,	Warp direction	Cold size	Emulsion ground
Canvas,	Warp direction	Warm size	Oil ground
Canvas,	Warp direction	Cold size	Oil ground
Canvas,	Warp direction	Warm size	Oil ground
Canvas,	Warp direction	Cold size	Oil ground

Mecklenburg 1978). Cleavage may then be propagated by shear forces exerted at low angles, with some degree of peel action. Uniaxial shear and peel tests on newly prepared samples have been used to investigate some of these factors. In particular, how shear and peel forces act on, and affect adhesion between the priming layers and their support. The aim of this study is to investigate the adhesion between artists' canvas and the priming layers in order to gain a better understanding of the mechanisms of flaking. Fresh samples were prepared from linen canvas cut from the warp and weft directions, with applications of warm liquid or cold gel size, and oil or aqueous emulsion grounds. The samples were heat aged and subjected to uniaxial shear and peel tests at 17%, 55%, 75% and 85% RH (20–22°C).

Sample preparation

Oil and emulsion grounds were applied to cold- and warm-sized canvas (See Table 1). A moderately fine, plain weave canvas (Ulster Weavers) was prestretched and wetted three times in order to redistribute the crimp in the warp threads so providing a more isotropic dimensional response between the weave directions. Sections of canvas were brushed with one coat of warm rabbit skin glue (10% solution – wt./vol.). Other areas were given a coat of the same size but applied by spatula as a cold jelly.

Two types of ground were applied to the sized canvas:

1. an oil ground (Winsor and Newton Foundation White) containing lead and zinc whites in linseed oil.
2. a hygroscopic emulsion ground, titanium white and chalk in a linseed oil/rabbit skin glue emulsion.[1]

Both grounds were applied by spatula in three successive coats. Each coat was made after the previous one had dried. The emulsion ground was administered whilst hot. These grounds were chosen because they produced brittle coatings and to some degree simulated the mechanical properties of aged materials. The samples were heat aged, untensioned and in the dark. Temperature and humidity remained constant at 60°C and 55% RH for 13 weeks. This is estimated to be equivalent to 64 years natural ageing and is based on the working principle that each 5°C increase above ambient (20°C) doubles the reaction rate.[2]

Samples for shear testing were adhered to tinned steel plates, 0.6mm thick, with an inert epoxy adhesive and cut into strips 25mm wide and 180mm long (See Fig. 1). The lap joint between ground and canvas measured 2.5 cm². Peel test specimens were cut into strips 25mm wide, 60–70mm in length, and adhered to aluminium plates (6mm thick) with the epoxy adhesive. The plates were screwed to a sliding linear bearing for testing to ensure a constant peel angle of 90° (See Fig. 2).

Adhesion testing procedure

Peel and shear adhesion tests were performed in a humidity chamber built around the grips of an Instron 4301 tensile testing machine. The crosshead speed was maintained at 1mm/min. throughout. Tests were made under the following conditions: 17%, 55%, 75% and 85% RH at 20–22°C. Humidity was controlled

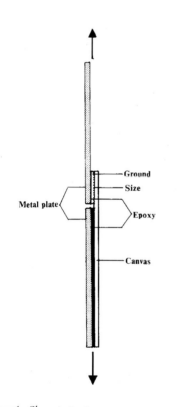

Figure 1. Shear test setup.

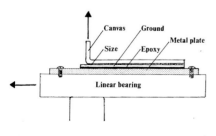

Figure 2. Peel test setup.

17%rh

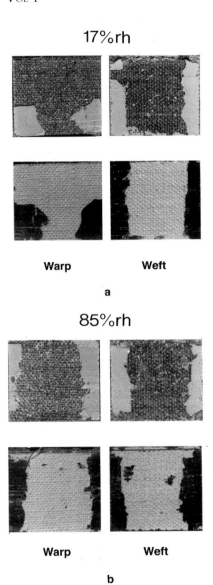

Warp **Weft**

a

85%rh

Warp **Weft**

b

Figure 3. Cold-sized oil ground samples after shear testing.

Figure 4. Shear test results. Emulsion ground samples.

using saturated salt solutions. Temperature was regulated by a thermostatically heating/cooling coil within the chamber.

The samples were preconditioned at each humidity in sealed boxes for at least 24 hours prior to testing. Once inside the testing chamber they were allowed to equilibrate to the prevailing environment for at least 30 minutes. Conditions were monitored by a Vaisala electronic temperature and humidity probe. This was calibrated against a dew point analyser and found to have an accuracy of \pm 2% between 15–85% RH. Temperature, humidity, load and grip displacement were logged for all the tests.

Shear tests

Shear testing was chosen because it is thought to be the main mechanism by which paint and ground flake from the canvas. In principle, the selection of a 180° angle of shear allows only pure shear forces to act on the sample. This type of testing with flexible materials, such as canvas, is problematic because they can deform out of plane under uniaxial tension. In the testing procedure described in this paper the canvas threads in the unrestrained direction were pulled out of plane by the tensioned threads in the opposing weave direction. This caused the fabric to curl from the sides of the join, probably initiating failure through shear and peel forces. Fracture also began across the top of the joint due to the bending moment created by the exposed canvas gap between the metal plates. The remaining central area of the joint was assumed to be subjected to pure shear loading. The edge effects described above mean that in practise the final measurement is of peel and shear. Nevertheless, the testing method does enable a comparative assessment of patterns of behaviour between the samples.

Peel tests

Only the oil ground samples were tested for peel strength at 55, 75 and 85% RH. One peel test was carried out per sample. Tests were carried out at a 90° angle of peel (See Fig. 2). Although the method does not closely resemble the manner in which paintings delaminate it ensures that mostly peel rather than shear forces are acting on the adhesive joint. In practice shear and peel forces probably act together but isolating the two factors may help to identify the prime mechanism which produces delamination in paintings.

Results

Between three and ten shear trials were made on most sample types. Failure was defined as the point at which a load maximum occurred. Results of these tests are shown in Figures 4 and 5. Relative humidity is plotted on the x-axis; mean shear load (Newtons) is plotted on the y-axis. For each sample type, the positive standard deviation values have been connected, as have the negative values, so as to form overlapping bands that enable clear comparisons between sample types.

Photographic records and a microscopic examination were made of the sheared samples after testing to assess the points at which failure occurred and to estimate the proportional surface areas of cleavage at each interface.

Mean peel strengths are shown in Figure 6. These were calculated after the first 3mm of peel in each test and represent 20% of the total peel distance. Standard deviations for the peel results are given in Table 2.

Emulsion ground samples at 17% and 55% RH

There was little difference between the shear strengths of the warm- and cold-sized samples in the weft or the warp, although the cold-sized samples exhibited a greater standard deviation (See Fig. 4). From a visual inspection of the sheared samples at 17% and 75% RH the cold sized, emulsion ground samples displayed larger degrees of ground/size cleavage than their warm sized counterparts.

Figure 5. Shear test results. Oil ground samples.

Emulsion ground samples at 75% and 85% RH

The emulsion grounds, being hygroscopic, were affected by high humidity. At 75% RH the emulsion ground absorbed moisture and softened, exhibiting some cohesive failure within the ground. This was so advanced at 85% RH that 95–100% of failure occurred between the ground layers. At 85% RH sizing methods had little effect on the mode of failure because the behaviour of the emulsion ground predominated. Despite considerable alterations to the mechanical properties of this ground at 75% RH, marked differences in mean shear strengths between warp and weft were retained until 85% RH (See Fig. 4).

Oil ground samples at 55% and 17% RH

At 17% RH the mean shear load of the cold-sized weft samples was lower than at 55% RH, 95N and 121N respectively. This was in contrast to the other oil ground samples. The shear strengths of the warp and weft cold sized samples converged at 17% RH. Visual inspection of the sheared cold-sized specimens showed similar degrees of clean fracture at the size/ground interface with no disruption to the canvas surface. Additionally, the areas of delamination were large and had noticeably increased in area from 55% RH. (See Fig. 3a) These observations reflected the similarity in shear loads between the two sets of samples at 17% RH. This implied that embrittlement in the cold size may have affected adhesion and that the differences in bond performance induced by the weave structure had diminished.

The mean shear strength for the warm-sized weft increased as RH was lowered from 55% to 17%, illustrating a fundamental difference in the nature of the bond between warm and cold sizing. No tests were made with the warm-sized warp specimens due to a lack of sample material.

Oil ground samples at 75% and 85% RH

The mean shear strengths of the cold-sized warp samples increased progressively from 77N to 99N, and 115N with increasing RH from 55%, 75% and 85% respectively (See Fig. 5). Results from the cold-sized weft samples showed negligible changes in shear strength from 55–85%. The mean shear loads of both sets of cold-sized specimens converged at 85% RH, as they had at 17% RH. Microscopic and photographic observations of the samples after testing provided further information. The canvas and the undersides of the oil grounds in these samples were covered in glue and the ground had delaminated from the central area of the join with little sign of cracking, typifying cohesive failure within the glue layer. The area of ground loss was larger at 75% and 85% RH than at 55% RH. There was also little difference in the areas of loss between the warp and weft samples, particularly at 85% RH (See Fig. 3b). Under magnification it was evident that fibres on the canvas surface were disrupted in both the cold-sized warp and weft samples, at 75% and 85% RH. At 85% RH traces of these fibres were visible on the backs of some of the oil grounds. It is possible that increased swelling of the yarns at high humidity may have embedded the fibres further within the softened glue. This could account for the slight increases in adhesion in the warp direction and the vulnerability of the fibres to disruption.

The mean shear strengths of the warm sized, weft samples increased at 85% RH, whereas those values for the warm sized, warp specimens were reduced. Examination of the sheared samples showed that warm sizing produced considerable cracking in the ground. Although the cold sized specimens had exhibited larger areas of ground loss, at both 75% and 85% RH, failure in the warm sized examples caused more disruption in the ground.

Table 2. Mean peel strengths.

	Mean peel strength N 55%RH 75%RH 85%RH			Standard deviation 55%RH 75%RH 85%RH		
Canvas warp, warm size, oil ground	7.3	8.9	9.8	1.4	2.0	1.2
Canvas warp, cold size, oil ground	4.8	5.0	8.3	0.3	1.0	0.8
Canvas weft, cold size, oil ground	4.0	6.3	8.0	0.3	0.6	1.4

Figure 6. Peel strength versus relative humidity, oil ground samples.

Figure 7. Cold-sized warp, oil ground samples. Peel tests.

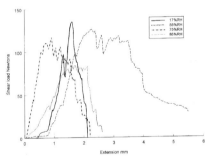

Figure 8. Cold-sized warp, oil ground samples. Shear tests.

Peel tests

Combined results from peel and shear tests on samples with a non–hygroscopic, oil ground provided additional information on the behaviour of the size at high and low RH. In the peel tests the effects of the canvas were diminished and more information could be gained on the adhesive properties of the glue layers. Valid comparisons could not be made from peel tests with the warm sized samples in the weft direction as failure occurred within the ground layers, due to variability deriving from sample preparation. For the remaining three sample types peel tests showed an increase in peel strength with increasing RH in all cases (See Fig. 6). All samples failed within the size layer. An increase in peel strength would be expected in the transition from brittle to ductile fracture of the size with increasing RH. The warm size sample had a higher peel strength throughout the RH range. There was a greater variation in peel strength along the length of peel at 75%/85% RH compared to 55% RH (See Fig. 7).

Discussion of the oil and emulsion ground samples

In both emulsion and oil ground samples, failure occurred at significantly lower loads in the warp than in the weft for all RH values. This was due to the larger degree of crimp in the warp yarns which straightened out under tension. The movement caused by the greater extensibility in the warp was sufficient to reduce the shear strength. Wide horizontal cracks, visible in the warp samples with the emulsion grounds after testing, confirmed the additional dimensional activity in this direction.

At 17% and 55% RH the oil and emulsion ground warp samples failed at similar loads. These loads ranged from 77 to 95N (See Figs. 4, 5). This again confirmed that extension of the warp yarns was an important factor affecting adhesion in this RH region.

At RH values above and below 55% RH the cold-sized, oil and emulsion ground samples produced sharp changes in shear strengths. This was more evident in the warp direction. This is illustrated by a comparison between the results for the cold-sized oil ground samples in the warp from 17% to 85% RH (See Fig.8). The peel results from the oil ground samples had also shown this inconsistent bond performance. Such erratic behaviour may have been due to an uneven glue distribution, a common hazard with cold sizing, coupled with the additional activity in the warp direction.

Conclusions

The dimensional movement of the canvas was one of the most important factors to affect adhesion. Elongation, particularly in the warp, had a pronounced effect on shear strength. However, it should be emphasized that these tests were carried out on new materials. Naturally aged canvas is likely to be less extensible than the fabric used in these tests, especially when under biaxial tension (Young 1996). Nevertheless, uniaxial and biaxial testing have shown that differences in extension between the yarn directions are retained in aged canvas (Young and Hibberd 1999). Therefore, distinctions in adhesion are likely to exist between the warp and weft directions in aged paintings.

The use of absorbent emulsion grounds, found in the 19th century, may have considerable impact on adhesion particularly when considering conservation treatments at high humidity. The exact nature of the bond will depend on the proportions of hygroscopic material used in the ground recipe.

The precise location of the size layer had considerable effect on adhesion. Penetration of the canvas with warm, liquid size provided more reproducible bonds than discrete layers of cold size lying across the canvas yarns. The latter produced inconsistent bonds and enlarged the areas of cleavage at humidities above and below 55% RH. Generally, in the cold-sized specimens there was a greater variation in the bond behaviour of individual samples. This was also true for different samples within identical sample types.

At 17% and 85% RH, cold sizing appeared to affect adhesion, outweighing the distinctions in shear strength between the canvas weave directions. This supported

the view that changes in the glue's modulus, particularly between 75% and 85% RH affected adhesion. Unexpectedly, the glue did not soften to the extent where bonds were dramatically reduced. On the contrary, the evidence suggested that adhesion improved in the warp direction from 55% to 85% RH. This means that in the treatment of 19th century "shrinkers" adhesion may be lower at the size/ground interface at 75%RH. The evidence presented here is not sufficient to discount the existence of a "safe working range" in which to treat moisture-sensitive paintings. These ideal working parameters remain open to investigation. However, it is evident that the dimensional activity in machine woven canvases, together with the inconsistent bond performance of cold gel size at high and low RH, are likely to create problems in humidifying and drying certain 19th century paintings. This situation is likely to be exacerbated by the addition of a hygroscopic emulsion ground.

Most shear loads found in this study, lie within a range of ultimate tensile strengths found for naturally aged, unprimed linings, dating from the 19th century. The range is between 41–218N in the weft, with a mean value of 103N, and 30–121N in the warp with a mean value of 84N (Young and Hibberd 1999). This means that in a painting subjected to external tension, it is likely that shear action may cause failure, probably in the form of interlayer cleavage, before the canvas fails. Restretching of the painting is one situation where this kind of loading might occur.

This research is at a preliminary stage and has highlighted the need for further investigation into the interaction between canvas, size and ground and their effects on adhesion.

Acknowledgements

Thanks are due to David Godkin, Timothy Green, Stephen Hackney, Roger Hibberd and Alan Phenix.

Notes

1. Emulsion ground recipe: 2 parts by vol. rabbit skin glue, (12% solution – wt/vol.), 2 parts by wt. of whiting and 2 parts by wt. of titanium white. Linseed oil, 1 part by wt., added drop by drop.
2. Leverhulme Project F/624/C. Unpublished minutes from the project steering committee meeting 1997. The relevance of artificial ageing to naturally aged material is not clearly understood and is being investigated as part of this project.

References

Bilson T. 1996. Canvas shrinkage: a preliminary investigation into the response of a woven structure. In: Bridgland J, ed. Preprints of the 11th triennial meeting of the ICOM Committee for Conservation, Edinburgh. International Council of Museums: 245–252.

Colville JE, Mecklenburg M. 1976. The application of computer modelling techniques to fabric supported paintings. Internal report. Smithsonian Institution. Washington DC (unpublished).

Hedley G. 1988. Relative humidity and the stress/strain response of canvas paintings: uniaxial measurements of naturally aged samples. In: Studies in conservation 33 (3) 133–148.

Mecklenburg M. 1982. Some aspects of the mechanical behaviour of fabric supported paintings. Internal report. Smithsonian Institution. Washington DC (unpublished).

Van de Graaf J. 1958. Het de Mayerne manuscript als bron voor de schildertechniek van de Barok. Mijdrecht: Venreig.

Young CRT. 1996. Biaxial properties of sized cotton duck. In: Bridgland, J. ed. Preprints of the 11th triennial meeting of the ICOM Committee for Conservation, Edinburgh: International Council of Museums: 322–331.

Young CRT, Hibberd R. 1999. A comparison of the physical properties of 19th century canvas linings with acid aged canvas. In: Preprints of the 12th triennial meeting of the ICOM Committee for Conservation. Lyon. International Council of Museums.

Materials

Linen canvas, Ulster Weavers, 47 Linfield Road, Belfast BT12 5GL. Tel.+44 (0)1232 32494.
Glue size, Roberson and Co., 1a Hercules Street, London N7. Tel. +44 (0)171272 0567.
Foundation White, Winsor and Newton, 51 Rathbone Place, London W1P2BP.
Epoxy adhesive – grade E32A, Permabond UK, Woodside Road, Eastleigh, Hants. SO50 4EX. Tel. +44 (0)1703 62968.
Instron 4301 tensile tester, Instron Ltd., Coronation Road, High Wycombe, Bucks. HP1L 3SY.
Vaisala temperature and humidity probe, Vaisala UK, Suffolk House, Fordham Road, Newmarket, Suffolk CB8 7AA. Tel. +44 (0)1638 674400.

Abstract

An atmospheric atomic oxygen beam has been found to be effective in removing organic materials through oxidation that are typical of graffiti or other contaminant defacements which may occur to the surfaces of paintings. The technique, developed by the National Aeronautics and Space Administration, is portable and was successfully used at the Carnegie Museum of Art to remove a lipstick smudge from the surface of porous paint on the Andy Warhol painting *Bathtub*. This process was also evaluated for suitability to remove felt tip and ball point ink graffiti from paper, gesso on canvas and cotton canvas.

Keywords

atomic oxygen, oxidation, cleaning, painting, graffiti, lipstick

Use of an atmospheric atomic oxygen beam for restoration of defaced paintings

Bruce A. Banks★ and Sharon K. Rutledge
NASA Lewis Research Center
21000 Brookpark Road – Mail Stop 309-2
Cleveland, OH 44135, USA
Fax: +1 216 433-2221
Email: Bruce.A.Banks@lerc.nasa.gov
Web site: http://www.lerc.nasa.gov/WWW/epbranch/ephome.htm

Margaret Karla and Mary Jo Norris
Ohio Aerospace Institute
Brook Park, OH, USA

William A. Real
The Carnegie Museum of Art
Pittsburgh, PA, USA

Christy A. Haytas
Cleveland State University
Cleveland, OH, USA

Introduction

NASA Lewis Research Center has been investigating the effects of atomic oxygen interaction with materials as a result of the interest in understanding materials degradation on spacecraft in low Earth orbit where atomic oxygen is the most predominant specie. Atomic oxygen is formed in low Earth orbit through photo-dissociation of atmospheric diatomic oxygen by means of ultraviolet radiation from the sun. All hydrocarbon materials exposed to atomic oxygen oxidize to form volatile oxidation products, resulting in a gradual loss of thickness of the hydrocarbon material (Banks and Rutledge 1988). As a result of NASA's need to be able to simulate the atomic oxygen found in the low Earth orbital environment, numerous facilities have been constructed which produce atomic oxygen in a low-pressure environment. Exposure of a wide variety of materials to thermal energy atomic oxygen plasmas in these facilities has resulted in an awareness that such atomic oxygen may be useful for removing organic contaminants such as soot or aged varnishes from the surfaces of paintings (Rutledge, Banks and Cales 1994: Rutledge et al. 1998). As a result of several art conservators inquiries as to whether the atomic oxygen cleaning process could be conducted at atmospheric pressure without requiring the use of a vacuum facility, an atmospheric atomic oxygen beam cleaning system was developed (Banks, Rutledge and Norris 1998: Banks and Rutledge 1997).

The atmospheric atomic oxygen source uses an electric arc to dissociate O_2 molecules in an environment that is rich in helium content. The atomic oxygen formed is somewhat inhibited from recombining back into O_2 by the presence of a high concentration of helium (See Fig. 1). The arc forms between an anode needle and a cathode orifice plate in the presence of the helium–oxygen mixture. A cathode orifice plate is negatively biased such that it attracts positive atomic oxygen ions formed in the arc. However, the arc is blown through the orifice, resulting in a stream of oxygen ions and charge exchange oxygen neutrals being propelled downstream for a distance of approximately 1 cm. These atomic oxygen species can then react at atmospheric pressure with organic or polymeric material exposed to the beam.

An Andy Warhol painting (*Bathtub* 1961) was defaced in September of 1997 as a result of someone kissing the painting while wearing lipstick. The lipstick had been handed out during a cosmetics celebration held at the Andy Warhol

Figure 1. Atmospheric atomic oxygen production process.

★ Author to whom correspondence should be addressed

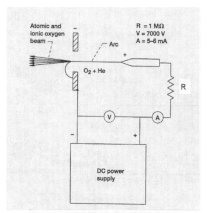

Figure 2. Schematic diagram of atmospheric atomic oxygen beam system.

Figure 3. Close up photograph of atmospheric atomic oxygen beam exiting the cathode orifice.

Figure 4. Photograph of atmospheric atomic oxygen beam system being used at the Carnegie Museum of Art to clean a lipstick smudge on Andy Warhol's painting Bathtub.

Museum, where the painting was located. The red lipstick imprint was highly visible on the painting surface that consisted of a very dry, cream-colored matte-finish oil paint. Conservators at the Carnegie Museum of Art, responsible for the Andy Warhol Museum collection, felt that the porous texture of the painting surface would not allow the satisfactory removal of the lipstick by use of conventional solvent techniques. As a result of their awareness of the atmospheric atomic oxygen beam cleaning technique, collaborative efforts were initiated with the NASA Lewis Research Center to attempt to use the technique to remove the lipstick accretion.

Conservator inquiries about the feasibility of using the atmospheric atomic oxygen beam to remove other types of defacement such as pen marks has also prompted the exploration of its ability to remove felt tip and ball point pen marks on paper, gesso coated canvas and cotton canvas.

Apparatus and procedure

A schematic diagram of the atmospheric atomic oxygen source is shown below in Figure 2. The arc is powered by a 7 kV DC power supply with a 1 Mohm current limiting resistor. These are used to create an arc current of 5.8 mA to produce the atomic oxygen beam. A faint glow indicating the evidence of the atomic oxygen beam can be seen emerging from the cathode orifice plate which is in the shape of a truncated cone (See Fig. 3). The cathode orifice plate is 0.254 mm thick 300 series stainless steel with a 3.175 mm diameter orifice through it for the arc pass through. The anode needle is sharpened tungsten with its tip located 1.6 mm upstream of the anode orifice plate. The painting surface was arranged to be 8 mm downstream of the cathode orifice resulting in an atomic oxygen beam cleaning area 3 to 5 mm in diameter. To ensure adequate overlap of cleaned spots on the lipstick smudge, the atomic oxygen beam was translated only 1.6 mm at a time in both the horizontal and vertical direction until all visible signs of lipstick were removed.

The portable configuration of the atmospheric atomic oxygen beam system including the power supply and load resistor, as configured to clean and remove the lipstick smudge from the Andy Warhol painting *Bathtub*, is shown in Figure 4. Because the atomic oxygen beam does generate a small amount of ozone, the beam system and the painting were located in front of a fume hood (See Fig. 4). The gas feed through arc system consisted of an oxygen flow of 0.1 to 0.2 litres per minute mixed with a helium flow rate of 4.3 litres per minute.

The atomic oxygen cleaning was first conducted on mock-ups using a variety of manufacturers' lipsticks, including the one thought to be the defacement smudge (Eva Szabo Shade 302 Coral, distributed in Pittsburgh, Pa.). Initial tests indicated that the amount of time required to remove the lipstick could be significantly reduced by first removing as much of the lipstick as possible with solvents. The lipstick smudge on the painting was first cleaned using a cotton swab which was dipped in 1 part by volume of acetone and 3 parts by volume mineral spirits (benzine). The swab was then used to wipe off as much of the lipstick as possible. The atomic oxygen beam was then applied in an incrementally rastered manner to oxidize the remaining lipstick smudge. After atomic oxygen cleaning, a portion of the lipstick smudge was then treated with a Groomstick® to see if a total reduction in visibility of lipstick would occur. However, underlying lipstick which was transported through the porous paint, either by mechanical or solvent means caused the visibility actually to increase. As a result of these tests, the procedure was modified such that the atomic oxygen cleaning was not followed by Groomstick® cleaning.

The atmospheric atomic oxygen source was also used to evaluate the effectiveness of using it to remove ball point ink and felt tip pen marks from 25% cotton fiber paper, acrylic gesso on canvas, and cotton canvas. The atomic oxygen beam system configuration and operating conditions used for oxidizing the pen marks was identical to that used for removing the lipstick smudge with the exception that the duration was changed as necessary to attempt to remove the ink marks while minimizing undesirable excess oxidation of the underlying organic substrate material.

Figure 5. Photograph of Andy Warhol's painting Bathtub *with lipstick smudge in central area.*

a

b

Figure 6. Close-up photograph of lipstick smudge on Andy Warhol's painting Bathtub
a Before atomic oxygen beam cleaning
b After atomic oxygen beam cleaning.

Results and discussion

Lipstick removal

Trials were conducted using atomic oxygen beams to clean a variety of lipstick types from gesso surfaces to ensure the cleaning would be satisfactory while not placing a painting at risk due to effects of the beam. All brands of lipstick tested on gesso canvas were found to be adequately cleaned by the atomic oxygen beam. The atmospheric atomic oxygen beam does produce some heating of surfaces exposed to it. As electrically configured in Figure 2, an estimated 1200 volt potential drop in the arc produces 6.96 watts of Joule heating. Some of this heat is carried away through thermal conduction associated with the cathode orifice plate and anode needle. However, a portion of the arc power results in heating the helium and oxygen which is transported to the painting surface. Based on preliminary tests conducted using this configuration, surface temperatures at the painting could range between 77–82°C. Tests were conducted to allow pre-cooling of the gases prior to their passing through the arc site by means of cooling the arc chamber which holds the anode needle and cathode orifice plate. Although no attempt to cool the arc was used for cleaning the Andy Warhol painting, these tests were successful indicating the feasibility of obtaining a room temperature atomic oxygen beam with suitable arc chamber cooling.

After the cleaning procedure was optimized, the atomic oxygen beam apparatus was configured to be portable and transported to the Carnegie Museum of Art in Pittsburgh, Pa. A photograph of Andy Warhol's painting *Bathtub* is shown in Figure 5. The lipstick smudge covered an area approximately 3.5 cm wide × 3.3 cm high. Tests were first done on small amounts of the lipstick applied to the tacking margins of the painting, which exhibited the same white paint substrate as the design surface itself. Since tests on the mock-ups had indicated that preliminary solvent cleaning could significantly reduce time and exposure during the atomic oxygen cleaning phase, the tests on the tacking margins were also done in this way, using a small swab slightly moistened with acetone:mineral spirits (benzine) 1:3. The atomic oxygen test cleaning succeeded in removing the lipstick, and also apparently removed a thin layer of accumulated grime, exposing a significantly whiter substrate than the surrounding paint. Initial tests suggested that the cleaned area could be adjusted with small amounts of watercolor to match the grime-covered surroundings.

The method described above was then applied to the actual lipstick accretion on the front of the painting, starting first with a small area on the lower lip imprint. After a preliminary solvent cleaning, taking care not to drive solubilized lipstick into the porous paint, the lower lip imprint was cleaned by means of incremental atomic oxygen exposure over the entire lower lip imprint until it appeared free of visible red color. The application of Groomstick® to the lower lip imprint after atomic oxygen beam cleaning removed the oxidized surface of the accretion and enabled underlying remnants of the lipstick oils and dyes to faintly reappear. This result was different from previous trials on experiment samples in which the same lipstick had been applied to gesso canvas and removed by the atomic oxygen beam. The difference between the previous experiments and the actual painting may have been the result of a combination of greater porosity associated with the very dry, porous, cream oil paint of the Andy Warhol painting surface as compared with the more dense acrylic gesso on the trial surfaces, or differences in the pressure by which the kiss was applied to the test samples in comparison with the Andy Warhol painting surface. As a result of the slight re-emergence of the lipstick remnant stains upon use of the Groomstick®, it was decided to reclean the area and refrain from further use of the Groomstick® after atomic oxygen cleaning. The lower lip and upper lip imprints were cleaned in an incrementally rastering manner requiring 5 hours and 25 minutes of atomic oxygen cleaning to satisfactorily remove all evidence of the lipstick smudge.

Photographs showing the lipstick imprint on the Andy Warhol painting, *Bathtub* 1961 can be seen in Figure 6a, which shows the smudge prior to atomic oxygen beam cleaning and Figure 6b showing the same location after atomic oxygen beam cleaning. As can be seen in Figure 6, the lipstick smudge was

removed; however, a slight lightening of the entire exposed area resulted. This lightening is thought to be due to a combination of two causes, the first cause being atomic oxygen removal of surface grime as stated above. The second cause of lightening may have been a combination of atomic oxygen bleaching of the paint pigments and oxidation of the organic content of the paint resulting in a more diffusely reflecting surface.

As a result of the atomic oxygen beam cleaning, the painting surface was free of all waxes and oils, thus allowing final color matching restoration to be accomplished. The first step in color matching was to adjust the diffuse reflectance of the cleaned area. After testing several resins on the test cleaned areas on the tacking margins, this was accomplished using a dilute solution of Aquazol® resin in distilled water, matted down with fumed silica. The restoration of the correct color was evaluated on test samples on the perimeter of the painting on the back of the stretcher to identify a suitable color matching technique. The lighter cleaned area was then toned by using a nearly dry watercolor brush to apply a very light gray color to darken the cleaned area and match the rest of the painting. The applied watercolor paint was then smudged slightly with a cotton swab to adjust the texture to match the surrounding area. This inpainting created a surface appearance in keeping with the surrounding paint, all but eliminating any trace of the lipstick defacement and the lightening caused by the atomic oxygen cleaning. The painting has since been returned to display in the Andy Warhol Museum.

Ink Removal

Atomic oxygen beam cleaning of ink marks from paper, acrylic gesso coated canvas and cotton canvas was found to be practical for some inks and impractical for others (See Fig. 7). Atomic oxygen beam exposure durations required to remove ink varied from 4.5 minutes to 12 minutes for those inks that were oxidizable. Black ink from a Sanford Sharpie® permanent marker was the only type of ink that was not removed by atomic oxygen. This is probably a result of some inks having inorganic pigments which would not oxidize readily.

The atomic oxygen beam did cause some oxidative thinning of paper on both sides of the ink marks. A masking technique was evaluated in which a 0.127 mm thick polyimide Kapton® shield was used to prevent oxidation beyond the pen marks to minimize damage to the unmarked substrate materials. The polyimide shield was used on either side of the pen mark lines in much the same way an erasure shield is used. The Kapton® shield was found to be effective to minimize oxidation of the paper beyond the ink marks. Without use of the shield, some thinning of the paper was evident upon holding the paper up to allow light to pass through.

KEY:

SYMBOL	DESCRIPTION OF PEN AND INK COLOR
A	American(Hardpoint, felt tip, black (Eberhard Faber)
B	Waterbury®, felt tip, blue
C	Sanford Sharpie®, Permanent Marker, felt tip, black
D	Paper Mate® Flair®, felt tip, black
E	Bic® Round stic, ballpoint, medium, black
F	Scripto® Stick Pen, ballpoint, medium, blue
G	Paper Mate (Rubberstik, ballpoint, medium, black

Figure 7. Atomic oxygen beam cleaned pen marks (the gap in the pen mark is the cleaned area) and duration of cleaning in minutes for ink marks on 25% cotton fiber paper, acrylic gesso on canvas and cotton canvas.

Conclusions

An atmospheric atomic oxygen beam was used to remove a lipstick smudge from the surface of the Andy Warhol painting *Bathtub*. Because lipstick contains oils and waxes, and the surface of the particular painting was highly porous, conventional solvent removal methods were not thought to be feasible approaches to restoration. The atomic oxygen exposure was found to completely remove all oils and greases from the surface of the painting as well as any visible presence of red color pigment. Restoration of the defaced area approximately 3.5 cm × 3.3 cm high required a total atomic oxygen cleaning duration of 5 hours and 25 minutes. The resulting cleaned area was slightly lighter than the surrounding cream colored paint, thus requiring restoration of the color to match the surrounding area. This was accomplished by the application of a fumed silica filled resin followed by light gray watercolor paint applied with a dry brush and smudging the paint with a cotton swab. The resulting restoration blended well with the surrounding area and the painting was returned to display. Atmospheric atomic oxygen beam cleaning appears useful when no viable alternatives exist. However, consideration should be given to the potential consequences of surface oxidation.

An atmospheric atomic oxygen beam was found useful in removing some types of felt tip pen and ballpoint pen ink marks from paper, gesso and cotton fabric. Cleaning durations of approximately 5–7 minutes were required to remove evidence of ink marks that were amenable to oxidation. The use of a polyimide Kapton® shield on both sides of the ink marks minimized loss of paper thickness due to oxidation.

References

Banks BA, Rutledge SK. 1988. Low Earth orbital atomic oxygen simulation for materials durability evaluation. In: Proceedings of the fourth European symposium on spacecraft materials in space environment. CERT, Toulouse, France, 6–9–98.

Rutledge SK, Banks BA, Cales MR. 1994. Atomic oxygen treatment for non-contact removal of organic protective coatings from painting surfaces. In: Proceedings of the materials issues in art and archaeology, IV. Cancun, Mexico: Materials Research Society.

Rutledge SK, Banks BA, Forkapa MJ, Stueber TJ, Sechkar EA, Malinowski K. 1998. Atomic oxygen treatment as a method for recovering smoke damaged paintings. NASA technical memorandum 1998-208507.

Banks BA, Rutledge SK, Norris MJ. 1998. An atmospheric atomic oxygen source for cleaning smoke damaged art objects. NASA technical memorandum 1998-208506.

Banks BA, Rutledge SK. 1997. U. S. Patent No. 5,693,241, Atmospheric pressure method and apparatus for removal of organic matter with atomic and ionic oxygen.

Materials

Groomstick®, Cutlery Specialties, 22 Morris Ln., Great Neck, NY 11024-1707, USA. Tel. +1 516 829-5899, fax +1 516 773- 8076.
Aquazol®, Conservator's Emporium, 100 Standing Rock Cir., Reno, NV 89511, USA. Tel +1 775 852-0404, fax +1 775 852-3737.
Kapton® polyimide, E.I. duPont de Nemours & Co., Inc., 1007 S. Market Street, Wilmington, DE 19801, USA.

Abstract

Effects of battens on panel paintings were first examined using observations, interviews with specialists and information from conservation records. Battens were then classified into three groups based on degree of restraint: rigid and fixed, rigid and sliding, flexible and sliding. To examine behaviour under changing relative humidity (RH), an example of each type was applied to mock-ups of thinned panel paintings which were conditioned to a moderate RH of 60%, followed by three repeated cycles of low (40%) and high (80%) levels, and finally returned to 60%, all at constant temperature. Surface deformations were measured using digital photogrammetry and illustrated as wire-frame diagrams and raking-light photographs. Deformations were more apparent as restraint was increased, with twist overall and buckling in the less restrained areas. Less restraint in- and out-of-plane allowed movement more like unrestrained panels. Sliding battens caused seizure of panel movement under extreme high RH conditions. Deformations near retainers were caused by wood movement during RH cycling.

Keywords

panel painting, batten reinforcement, digital photogrammetry

Effects of batten reinforcements on paintings on wood panel

Al Brewer
14 rue Maurice Dechy
78120 Rambouillet
France
Tel/fax: +33.1.34.83.86.70
Email: 113305.2351 compuserve.com

Introduction

Batten effects were examined as part of a more comprehensive study of panel reinforcements (Brewer 1998). Observations on panel paintings, interviews with specialists and information from conservation records were combined as a basis for a controlled-environment (CE) study of a representative range of battens applied to mock-ups of thinned panels. Thickness was chosen to represent panels of similar size that have been thinned, flattened and reinforced. Surface deformations were recorded during controlled changes in relative humidity (RH) using digital photogrammetry (Robson et al. 1995: Cooper and Robson 1994) and raking-light photography.

In the following discussion, cited inventory or treatment record numbers are preceded by abbreviated institution names as follows: Ashmolean Museum Oxford (AM), Fitzwilliam Museum (FW) and Hamilton Kerr Institute Cambridge (HKI), Louvre (LV), National Gallery London (NG), National Trust, UK (NT), Royal Collection (RC), Staatsgalerie Stuttgart (SG), Tate Gallery London (TG).

Original battens

Original Florentine and Tuscan reinforcements of the 13th through 16th centuries evolved from rigid battens and/or frame structures affixed to the panel, to battens sliding in grooves in the panel back with the frame separated entirely, then finally to battens shifted to the back surface to slide through retainers which were nailed and/or glued (Castelli and Ciatti 1989). Developments in northern Europe in the 15th century saw the frame, which in many cases served also as a reinforcement, separated from the panel structurally (Verougstraete-Marcq and Van Schoute 1989). In general, the shift throughout Europe was thus away from restraint in all three dimensions and toward restraint of out-of-plane (warp) deformations only.

Battens on most panels were essentially rigid, being of relatively large section and denser wood than the panel, having a dual role of reinforcement and flattening. Sliding battens on 16th-century Italian panels were typically of dovetail cross section and tapered lengthwise to slide in a similarly shaped channel cut into the panel back. Elsewhere, a few panels have been examined where battens appeared to have been purposefully made more flexible. For example, each of two oak panels described as "Dürer school" (Brachert 1992) had two relatively thin original battens. The panels were in good structural condition.

Many fixed-batten panels show concave deformations, twists, compression damage, and fractures. Some panels with rigid sliding battens, mostly smaller examples, have survived intact while others show damage related to batten restraint. A panel painting by Boateri had split toward the middle (See Fig. 1a), suggesting restraint of warp and panel movement along the battens. Splits were more evident at the back in the exposed areas of panel. A large painting by Pesellino with similar battens shows joints, evidently weaker than the wood, that probably broke as a result of similar stresses (See Fig. 1b). Once disjoined, each plank became free to assume the permanent and more or less convex warp which typically results from accumulated compression set toward the panel back.

a)

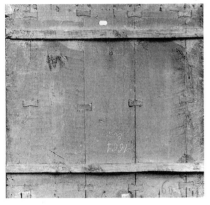

b)

Figure 1. Damages in panels with original sliding battens: a) splits in a panel with original sliding battens, Jacopo Boateri (active Bologna, 1500), Virgin and Child With A Franciscan Saint, 720 × 550 × 25mm thick, Louvre MI.565; b) a large panel with original sliding battens showing disjoins, Pesellino Francesco di Stefano (Florence, 1422– 1457), Virgin and Child With Saint Zanobie(?), Saint John the Baptist, Saint Anthony Abbot, and Saint Francis, 1764 × 1731 × 30–40mm estimated thickness, Louvre MI.504. Photos Laboratoire de Recherche des Musées de France (1971 and 1967, respectively).

In both panels, a sufficient degree of such warp developed to contact the battens after which friction impeded lateral movement. Contact would concentrate bending stress near the panel middle, initiating splits there. Though a gradual increase in such stress might be withstood for many years, compression damage at the front and fracture at the back could result when a sudden drop in RH rapidly increases temporary warp and subsequent stress.

Non-original battens

Much as original reinforcements changed to allow greater panel movement, so non-original reinforcements have evolved from rigid sliding structures to sprung or flexible structures which allow for out-of-plane panel deformations. Developed mostly from an empirical basis, there are several "schools of thought" on appropriate sliding batten designs which, interestingly, have a definite geographic pedigree (Dardes and Rothe 1998). Despite differences, there is some convergence toward allowing greater freedom of both in-plane and warp movement. Such changes reflect a greater understanding of warp behaviour and a greater accept-ance of warp. Still, some practitioners maintain that rigid sliding battens are appropriate reinforcements.

Despite these changes, battens of wood or metal have been glued, nailed or screwed to some panels. In many cases, battens have become partially or completely detached. Some examples and associated effects were noted from treatment records: Hans Memling, *Saint John the Baptist and A Donor*, LV.RF886 (split); Flemish School (end of the 16th century), *Diana and Acteon*, LV.RF1941-9 (disjoined, split); Pinturicchio, *Saint Catherine With a Donor*, NG.693 (splits); Buonconsiglio, *Saint John the Baptist*, NG.3076 (splits); Rembrandt, *Paul in Prison*, SG.INV746 (disjoins, front concave warp), Studio of Joos Van Cleve, *Adoration of the Magi*, FW.1784 (concave warp, disjoins), Frans Floris, *Faith, Hope, and Charity*, NT. Kingston Lacy No. 69 (disjoins), Cornelius Johnson or Janssen, *Penelope Noel*, Corsham Court, HKI.896 (concave warp, bulge between the battens, paint losses), Giovanni Bellini, *Saint Jerome*, AM (splits, saddle-shaped warp).

The small panel by Bellini (266 × 217 × 6mm thick), thinned and with two oak battens glued across the grain, had assumed a saddle-shaped warp which decreased considerably after the battens were removed. Typically, thinned panels with fixed battens warped more convexely as the battens were thinned overall for removal. Immediately after removal, warp decreased and sometimes became convex.

Most non-original sliding battens found on panels are variations on the later Italian style of original batten described above which is intended to slide between retainers (Secco-Suardo 1866). Fractures associated with some designs have been reported, such as for wooden T-shaped battens: Monogrammist of Brunswick (Jan van Amstel?), *The Road to Calvary*, LV.RF773 (disjoins); Garofalo, *Saint Catherine of Alexandria*, NG.3118 (split); Garofalo, *Holy Family*, SG.INV157 (split).

Tubular aluminium battens running through wood or metal retainers have also been used. A few examples dating from the 1960s were found in records. Some specialists disapproved of such battens, recounting panels which had split and had to be treated again (for example, Castelli 1998), and blaming excessive friction between the rigid tubing and retainer holes. The author has seen damages from such battens, applied as late as the mid-1980s. Lack of examples and current usage suggests that this style has not stood the test of time.

Looking at developments since 1950, Carità (1956), working at the Istituto Centrale in Rome, applied rectangular-section stainless steel battens with regularly-spaced slots sliding on roller bearings supported by wooden blocks glued to either side. The batten was oriented with larger faces perpendicular to the panel plane. Though a very low-friction sliding system, warp was not accommodated.

Instead of roller bearings, U-section guides of silver-plated brass were employed on Duccio's *Maestà* (Brandi 1959). It is explicitly stated that the aim of the design was to prevent out-of-plane deformation. Interestingly, the same beam formula used here to design for rigidity was used more recently to design for flexibility to allow for warp (Marchant 1998). These opposite purposes exemplify the change toward accepting warp and allowing for greater panel movement.

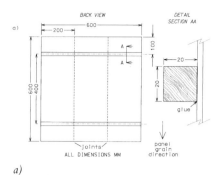

a)

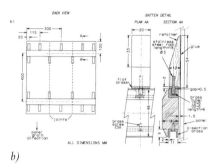

b)

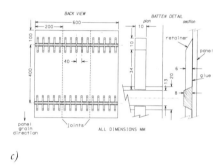

c)

Figure 2. Three batten types applied to panel mock-ups: a) rigid and fixed; b) rigid and sliding; c) flexible and sliding.

In France, Huot adopted Carità's principle of rigid battens sliding on roller bearings, though preferring wooden battens to stainless steel (Bergeon et al. 1998). On both sides of the batten, U-section metal rails (now usually brass) are attached within which roller bearings slide. The wooden retainers are not usually sprung to allow for warp movement. In panels judged to have significant set warp, the battens, while remaining rigid, have been shaped to conform to general panel curvature.

To accommodate warp changes, two basic designs have generally been used: 1) rigid battens with sprung retainers, 2) flexible battens. A variety of sprung batten and lattice designs have been developed during the 1980s and 1990s at the Opificio delle Pietre Dure in Florence (for example, Castelli 1987, Castelli et al. 1989). In many of these, relatively rigid wooden battens slide on polytetrafluoroethylene (PTFE) or nylon retainer surfaces.

At the Vatican Museum, Guidi showed flexible metal battens of small section relative to the panel thickness sliding through low-friction retainers with PTFE contact surfaces (Guidi 1993). For stronger panels, battens are layered double with PTFE spacers between them. Warp movement is accommodated by the flexible battens and is judged empirically according to the apparent strength and rigidity of the panel.

Flexible wooden battens of dovetail section sliding through wooden retainers, similar to rigid structures described by Secco-Suardo (1866), have also been applied (Rothe and Marussich 1998). Panel strength is again judged empirically while battens are made relatively flexible by adjusting the size of their section.

Controlled-environment study

Battens were classified into three basic groups depending on the relative range of in- and out-of-plane panel deformation allowed: rigid and fixed (restrains both types of movement), rigid and sliding (restrains mainly out-of-plane movement), flexible and sliding (allows greater freedom in both directions). An example from each group was applied to panel mock-ups of two wood types. Two battens were applied to each panel with longitudinal centre lines positioned identically to facilitate comparison.

Response of the three battened panel types and an unreinforced panel was compared when exposed to RH cycled between 40% and 80% at 20°C. Construction of a CE-room which could maintain these levels at ±2% is described elsewhere (Brewer 1998). Digital photogrammetry allowed surface deformations to be measured in three dimensions at a resolution of 0.01mm.

Panel mock-up construction

Panels of oak (*Quercus robur* or *Quercus petraea*) and of Scots pine (*Pinus sylvestris*) were constructed, each 600.0mm² × 3.30mm thick and of three planks of equal width: oak radially sawn; pine tangentially sawn with annual ring directions alternated and in the same sequence relative to the front. The planks, air and then kiln-dried, were cut and thinned in stages and equilibrated to about 55% RH, joined with urea formaldehyde resin and sized with two thin spray-coats of animal glue (3.5g/100ml distilled water). A grey oil ground (prepared from black and white artists' oil paints with no solvent, mixed 3:2 by weight) was applied with a scraper-blade.

Rigid and fixed battens (See Fig. 2a) of square-section pine were cut, heated (70°C) on the gluing face with a clothes iron, hot animal glue applied by brush, then pressed onto the panel and weighted to dry for at least 15 hours.

Rigid and sliding battens (See Fig. 2b) were based on a set built to the panel specification by C. Huot, who also supplied retainers. Battens of South American mahogany were sawn, rebated, and chamfered. U-section brass strips were glued (epoxy) and reinforced with countersunk screws. Retainers had been rebated at end-grain, flat brass set-in and glued (epoxy) and a steel rod glued in (epoxy) as a bearing spindle onto which a length of brass tubing was slid. Battens were spaced about 1.5mm from the panel back with card, clamped temporarily, and the retainers glued (polyvinyl acetate) and left to dry at least 15 hours.

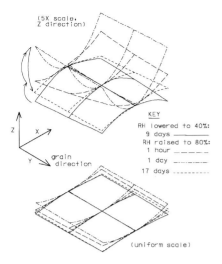

Figure 3. An unreinforced oak panel showing warp changes over the extended high-RH period. Note the reversal of warp direction after the first day of equilibration.

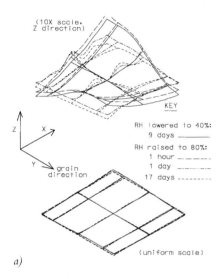

a)

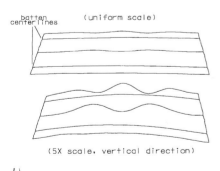

b)

Figure 4. An oak panel with rigid fixed battens: a) isometric view from above showing shape changes from dry to moist conditions. Note the twist, most evident in dry conditions; b) view from above the coated side and from an end-grain edge shows buckling in free areas and convex bending over the battens under moist conditions.

Flexible and sliding battens (See Fig. 2c) of afrormosia wood were cut to a dovetail section and finished with a hand plane. Paraffin wax was rubbed on all surfaces and polished vigorously with cork. Panels were laid face-down, each batten clamped and all retainers along one side glued to the panel. Battens were then set away from the retainers by two paper layers, clamped, and retainers on the other side glued and allowed to dry for at least 15 hours.

For two weeks before and one month after assembly, panels were subjected to a conditioning period at moderate RH (60%), followed by three repeated cycles of low (40%) and high (80%) levels, and finally returned to the initial moderate level, all at constant temperature. Constant RH was reached within one day of each RH change. Previous tests suggested that response of panels would be adequately demonstrated within 10 days at a constant RH. A longer period of high RH was imposed during the third cycle.

Results and discussion

Compared to an unreinforced oak panel (See Fig. 3), the three batten types showed that distortions increased as freedom of panel movement in- and out-of-plane was restrained. Restraint diminished away from the battens so that deformations were more evident at the end-grain edges and over the exposed middle zone (See Figs. 4–6). Expansion in the less restrained regions was affected by restraint so that any initial warp was exaggerated by a buckling reaction which increased until an equilibrium dimension was reached. Twist tended to accompany buckling. Though warp in the longitudinal-grain direction remained similar to unreinforced oak, amplitude was greater for all three batten types. This may have been related to Poisson effects caused by restraint of warp in the transverse-grain direction.

When in-plane panel movement in the transverse-grain direction was restrained in shear on one side by fixed battens, panels deformed out-of-plane (See Fig. 4a). The curvature of this reaction was always opposite to the direction in which the panel would warp were it unrestrained. Under drying conditions, warp of an unrestrained panel was initially convex while a panel with fixed battens bent concavely, and vice versa under moistening conditions (See Fig. 4b). However, while warp of the unrestrained panel diminished as the moisture gradient levelled (See Fig. 3), bending over fixed battens increased toward a limit and persisted until RH change was reversed. The force required to bend the battens must have been sufficient to cause considerable stress in the adjacent panel wood.

Table 1 shows that the maximum range of transverse movement of oak as a proportion of panel width was about half as much over the fixed battens (0.58%) as between them (1.06%), in comparison to other batten types and an unreinforced panel. Though not a statistically valid sample, this large difference surely indicates considerable fixed batten restraint.

Fixed battens caused the greatest twist, especially under drying conditions when panel contraction was restrained. Warp changes in panels like the Bellini, above, can be explained by shear restraint of panel contraction which arises from accumulated compression set and/or wood movement. Therefore, to avoid subjecting panels to unnecessary concave warp and associated compression at the front, it is better to remove fixed battens completely from one end, not thin them gradually overall.

Panels with rigid sliding battens (See Fig. 5a) showed less pronounced distortions. Under raised RH, some twist developed and the free areas between battens showed considerable warp. These areas could also be expected to undergo more rapid moisture exchange and therefore more rapid wood movement than beneath

Table 1. Effect of batten reinforcement on transverse movement of oak panel mock-ups.

Reinforcement	Range of transverse movement between 40% and 80%RH (% initial panel dimension)	
	Between battens	Over battens
Battens:		
Fixed	1.06	0.58
Rigid and sliding	1.19	1.15
Flexible and sliding	1.52	1.41
Unreinforced Panel	Middle	End grain edges
	1.32	1.32

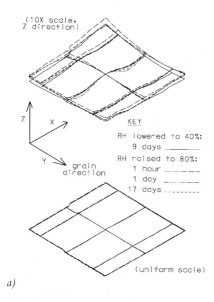

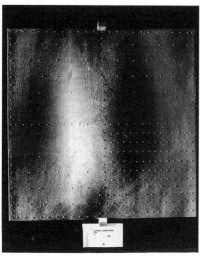

a)

b)

Figure 5. Panels with rigid sliding battens: a) isometric view from above of an oak panel showing changes in shape from dry to moist conditions. Note exaggerated warp in the free area between the battens; b) deformations around retainers across the bottom and top of an oak panel, visible in raking light from the left.

the battens. Resulting shear stresses along the batten edges and between the regions of differing transverse-grain movement would help to initiate splits near the middle where warp restraint is greatest.

Out-of-plane deformations were visible between retainers (See Fig. 5b) due to restraint of warp. The roller-bearing mechanisms did not seize, partly because the thin panels tended to bend under warp restraint. Thicker panels could develop greater pressures, though the danger is offset somewhat by slower response and smaller amplitude of temporary warp. As warp increased, battens contacted the panel back causing friction. Again, this did not cause seizure because the panels simply bent, though seizure could occur with thicker panels.

Flexible sliding battens allowed transverse movement and warp most like unreinforced panels, even over the battens (See Fig. 6). For most of each cycle, panels were not obviously restrained in shear.

However, with both sliding batten types, transverse-grain swelling of the wooden battens caused them to contact the retainers toward the end of the high-RH periods, impeding panel expansion. This in-plane restraint caused twist and localised buckling similar to that of the fixed rigid battens. For the roller-bearing retainers, this fault could be corrected by spacing them further away from the batten edges. For the flexible battens, such seizure was surprising because they were relatively narrow, made from wood classed as having little movement (Anon. 1977), and were wax-polished to reduce friction and rate of movement. Similar recent examples of this type on panel paintings examined by the author were even more tightly retained than those of the test panels. Again, the spacing between batten and retainer might be increased.

Both sliding batten types showed local distortions near retainers as RH-cycling progressed (See Fig. 6b). These may have developed partly from differences in panel wood movement between and over the glued areas.

Conclusions

Using digital photogrammetry and raking-light photographs, effects could be partly explained by mock-up behaviour. Two types of overall deformation were detected in battened mock-ups, one in the most restrained areas over the battens and the other in areas of lesser restraint to either side. These differences became more evident as restraint was increased.

Sliding flexible battens allowed movement both in- and out-of-plane more like unrestrained panels. Their degree of flexibility must be carefully considered in relation to handling and mounting, suggesting use of some sort of perimeter frame. Typically this has been done using lattice support structures where flexibility is given a firmer foundation in basic beam mechanics, principles equally valid for any structure with batten elements (Brewer 1994: Marchant 1998).

Extreme high RH caused seizure of panel movement for both types of sliding batten due to their swelling, indicating that retainers in these designs should be modified to reduce potential friction, perhaps by adequately spacing them away from batten edges.

Deformations near retainers were caused by differences in local wood movement during RH cycling.

Acknowledgements

The author thanks in particular the following for their help in realising this research: Hamilton Kerr Institute, University of Cambridge; Prof. Mike Cooper, Dr Stuart Robson and colleagues, City University, London; National Gallery and Tate Gallery, London; Claude Huot, Paris; Pierre Mohen, Directeur, Laboratoire de Recherche des Musées de France; Nathalie Volle and France Dijoud, Conservateurs en Chef de la Service de Restauration des Musées de France.

References

Anon 1977. A handbook of softwoods. Building Research Establishment (BRE) Report, London: Her Majesty's Stationery Office (HMSO).

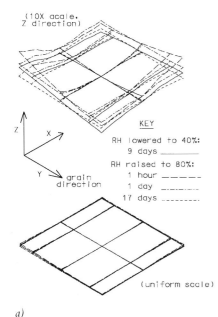

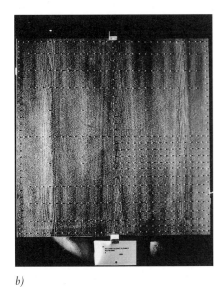

Figure 6. Panels with flexible sliding battens: a) isometric view from above an oak panel showing changes in shape from dry to moist conditions. Note similar curvature over and between battens; b) a pine panel in raking light from the left shows local deformations around the retainers at bottom and top.

Bergeon S, Emile-Mâle G, Huot C, and Baÿ O. 1998. The restoration of wooden painting supports. Two hundred years of history in France. In: Dardes K and Rothe A, eds. The structural conservation of panel paintings. Proceedings of a symposium at the J. Paul Getty Museum, 24–28 April 1995: The Getty Conservation Institute, Los Angeles: 264–288.

Brachert T. 1992. Private communication. Nürnberg: Germanisches Nationalmuseum.

Brandi C. 1959. Il restauro della Maestà di Duccio. Bollettino dell'Istituto Centrale del Restauro 37–40: 29–36.

Brewer JA. 1994. An auxiliary support case history. Hamilton Kerr Institute Bulletin No. 2: 61–68.

Brewer JA. 1998. Effects of reinforcements on the preservation of paintings on wood panel (Ph.D. Dissertation, City University, London).

Carità R. 1956. Pratica della parchettatura. Bollettino dell'Istituto Centrale del Restauro 27–28: 101–131.

Castelli C. 1987. Proposta di un nuovo tipo di traversa per dipinti su tavola. OPD Restauro 2:78–80.

Castelli C and Ciatti M. 1989. I supporti lignei dei dipinti e i sistemi di traversatura: un'analisi storica e alcune proposte operative. In: Tampone G, ed. Il restauro del legno. Ricerche e restauri su architetture e manufatti lignei. Volume II, Florence: Nardini Editore: 141–154.

Castelli C, Ciatti M, Parri M, Santacesaria A. 1989. Alcune nuove proposte per i sistemi di sostegno e controllo dei dipinti su tavola. In: Tampone G, ed. Il restauro del legno. Ricerche e restauri su architetture e manufatti lignei. Volume II, Florence: Nardini Editore: 290–298.

Castelli C. 1998. The restoration of panel painting supports: some case histories. In: Dardes K and Rothe A, eds. The structural conservation of panel paintings. Proceedings of a symposium at the J. Paul Getty Museum, 24–28 April 1995: The Getty Conservation Institute, Los Angeles: 316–340, Figure 11.

Cooper, MAR and Robson S. 1994. Photogrammetric methods for monitoring deformation: Theory, practice and potential. In: Silva Gomes et al., eds. Recent advances in experimental mechanics. Rotterdam: Balkema: 395–400.

Dardes K and Rothe A, eds. 1998. The structural conservation of panel paintings. Proceedings of a symposium at the J. Paul Getty Museum, 24–28 April 1995: The Getty Conservation Institute, Los Angeles.

Guidi E. 1993. Private communication, Vatican City.

Marchant R. 1998. The development of a flexible attached auxiliary support. In: Dardes K and Rothe A, eds. The structural conservation of panel paintings. Proceedings of a symposium at the J. Paul Getty Museum, 24–28 April 1995: The Getty Conservation Institute, Los Angeles: 382–402.

Marette J. 1961. Connaissance des primitifs par l'étude du bois du XIIe au XVIe siècle. Paris: Editions A.& J. Picard & Cie: Plate 56.

Robson S, Brewer A, Cooper MAR, Clarke T, Chen J, Setan HB, Short T. 1995. Seeing the wood for the trees- an example of optimised digital photogrammetric deformation detection. In: From pixels to sequences, ISPRS Intercommission Workshop, Zurich (March 22-24) IAPRS (30) Part 5W1.

Rothe A and Marussich G. 1998. Florentine structural stabilization techniques. In: Dardes K and Rothe A, eds. The structural conservation of panel paintings. Proceedings of a symposium at the J. Paul Getty Museum, 24–28 April 1995: The Getty Conservation Institute, Los Angeles: 306–315.

Secco-Suardo G. 1866. Il restauratore dei dipinti. Milan: Tipografia di Pietro Agnelli.

Verougstraete-Marcq H and Van Schoute R. 1989. Cadres et supports dans la peinture Flamande aux 15e et 16e siècles. Louvain: Heure-le-Roman.

Résumé

Les peintures sous verre sont abordées sous l'angle des problèmes de conservation qu'elles peuvent rencontrer. Des propositions de traitement seront avancées, basées sur des tests de stabilité, de réversibilité, de maniabilité et de rendu effectués par l'auteur.[1] Les problèmes abordés sont le collage du verre, le bouchage des lacunes dans le support, le fixage de la couche picturale, la retouche, et l'encadrement des œuvres. L'auteur conclut en exposant une sélection de matériaux et techniques de restauration-conservation adaptée spécifiquement aux peintures sous verre : pour le collage, il propose le Paraloïd B72 après silanisation des tranches, ou l'HXTAL NYL-1 ; pour le bouchage, l'HXTAL NYL-1 ; pour le fixage, le Paraloïd B72, la Regalrez 1094, la cire microcristalline ou la cire-résine et, pour la retouche, les pigments liés au Paraloïd B72.

Mots-clés

peinture sous verre, collage, bouchage, fixage, retouche, encadrement

Les peintures sous verre : Propositions de matériaux et techniques de restauration

Jessica Coppieters-Mols
Rue de l'Amazone 50
B-1060 Bruxelles
Belgique
Tel/fax : +32.2.537.72.03
Email : arnold.coppieters@skypro.be

Introduction

Les peintures sous verre sont des œuvres réalisées au revers du verre, avec des peintures non vitrifiables, et qui sont destinées à être observées en lumière réfléchie. L'ordre dans lequel sont posées les couches de peinture est inversé par rapport à ce que l'on connaît des peintures traditionnelles : les détails sont placés en premier lieu, viennent ensuite les couches de fond et finalement l'arrière-plan.

Cette forme d'art a suscité notre intérêt lors de l'élaboration de notre travail de fin d'études à La Cambre, Belgique, en 1996, dans lequel nous avons fait une approche de l'histoire de l'art, de la technologie, de la conservation et des techniques de restauration des peintures sous verre (Mols 1996). Cet article est une synthèse des techniques de restauration que nous avons jugées les plus adaptées aux peintures sous verre.

Le collage

La cassure du verre présente, outre une gêne à la lecture de l'image, un danger considérable pour l'œuvre : n'étant plus d'un seul tenant, le verre n'est plus correctement maintenu dans son cadre. Les fragments bougent alors les uns par rapport aux autres, provoquant l'ébréchure des tranches et la formation d'éclats de verre. En se chevauchant, les éléments risquent de causer griffes et lacunes, voire la transposition de certaines zones peintes d'un fragment sur celui qui se trouve derrière. Enfin, séparés depuis trop longtemps et ayant évolué différemment, ils peuvent ne plus être jointifs.

Ces simples faits justifient le collage du support. Nous avons donc confronté les adhésifs utilisés dans le domaine de la restauration-conservation du verre, aux exigences propres à la peinture sous verre, à savoir, stabilité optique, mécanique et chimique ; résistance à la traction, compatibilité avec les matériaux originaux, maniabilité, température de transition vitreuse supérieure à 40/50 °C, compatibilité avec l'indice de réfraction du verre et réversibilité.

C'est ainsi que la shellac, les nitrates de cellulose, les PVC, les polyesters et les polyuréthanes, les polyvinyliques et enfin les silicones, n'ont pas été retenus : les cinq premiers sont instables au vieillissement ; les polyvinyliques ramollissent à une température trop proche de la ambiante (28°C) (Davison 1984) et les silicones n'offrent pas un collage suffisamment fiable, sont peu maniables, ont un indice de réfraction trop différent de celui du verre et leur polymérisation, accompagnée d'un dégagement d'acide acétique, est dangereuse pour la couche picturale.

Il nous restait donc à choisir entre le Paraloïd B72, le Paraloïd B72 précédé d'une application de silane (Dow Corning Z 6040), et les époxy (Araldite 2020, Fyne Bond, HXTAL NYL-1). Nous avons soumis ces adhésifs, applicables en théorie, à des tests de maniabilité, de rendu, de stabilité aux U.V., de résistance au cisaillement et de réversibilité, afin de voir s'ils étaient applicables en pratique.[1]

Nos tests nous ont amené aux conclusions suivantes : le Paraloïd B72 et le Paraloïd B72 + Silane présentent une maniabilité et un rendu médiocres, une mauvaise résistance au cisaillement, et ils ont une T_g (40 à 50 °C) trop proche de la température ambiante. Ces adhésifs ne conviennent donc que pour le collage de

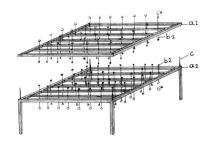

Figure 1. Table de collage.
a1,2. Grilles parallèles, supports des poussoirs.
b1,2. Poussoirs mis en vis-à-vis et équipés d'une tête en caoutchouc.
c. Vis de fixation de la grille a1 à la grille a2.

pièces de petite taille, conservées à l'abri de toute source de chaleur, et pour lesquelles l'invisibilité du joint n'est pas essentielle. A choisir entre les deux, le Paraloïd B72 appliqué après la silanisation des bords est préférable, pour la meilleure résistance du collage au cisaillement. L'Araldite 2020 présente un lèger jaunissement aux U.V. Ce jaunissement, bien qu'imperceptible au sein du joint, nous oblige à l'écarter. La Fyne Bond, extrêmement fluide, migre au sein de la couche picturale et nous oblige à l'éliminer également. L'HXTAL NYL-1 est irréversible et nécessite un long temps de polymérisation, mais présente une bonne maniabilité, un rendu optimal et une très bonne stabilité au vieillissement.

Les adhésifs retenus sont donc le Paraloïd B72 + Silane et l'HXTAL NYL-1, en fonction du cas traité (poids, fragilité et conditions de conservation de l'œuvre). Pour éviter la migration de l'époxy dans la couche picturale, la pose préalable d'une couche d'isolation s'impose, et nous préconisons soit le Paraloïd B72, soit la Regalrez 1094.[2]

Le collage d'une peinture sous verre se fera généralement par infiltration : assemblage à blanc, à l'aide de fines bandelettes adhésives mises en travers de la cassure, et infiltration (coté verre) de l'adhésif par capillarité. Ce collage est jalonné de plusieurs difficultés et comporte des restrictions : les bandelettes adhésives ne peuvent être posées que d'*un* côté du verre (la couche picturale couvrant l'autre côté), et le ressaut est donc plus difficile à régler ; le profil du verre est rarement plat, et le restaurateur est contraint de faire des montages souvent instables pour surélever le verre en positionnant correctement les éclats ; enfin, la polymérisation des époxy est longue, et le risque de déréglage du ressaut avant polymérisation complète de l'adhésif est augmenté.

Ces contraintes ont souvent été résolues en effectuant un premier assemblage à l'aide de points de colle cyanoacrylate, pourtant déconseillée pour son instabilité au vieillissement. C'est pourquoi nous avons mis au point une table de collage, qui permet au restaurateur d'effectuer un réglage précis du joint, tout en assurant à l'œuvre une parfaite stabilité pendant toute la durée de la polymérisation de l'adhésif. La table est composée de deux grilles parallèles positionnées l'une au-dessus de l'autre, et quadrillées de poussoirs réglables en hauteur (Fig.1). Le verre est placé entre les deux grilles et repose sur les poussoirs, réglés de façon à épouser fidèlement la courbure du verre et à ajuster les parties brisées. Immobilisé de la sorte, le verre est prêt à être collé par infiltration.

Le bouchage des manques

Le bouchage de lacunes dans le support peut se faire soit par incrustation d'une pièce en verre, soit par coulage d'une résine. La mise à niveau du bouchage par ponçage représentant un risque considérable pour la couche picturale, nous préférons combler les manques à l'aide d'un morceau de verre taillé selon la forme de la lacune, et collé à l'ensemble. Si l'éclat manquant est trop petit ou de forme trop compliquée, il sera nécessaire de combler le manque à l'aide d'une résine acrylique ou époxy.

Les résines acryliques sont très réversibles, mais présentent l'inconvénient d'une longue mise en œuvre : la résine accuse un retrait important au séchage, et doit donc être posée en une multitude de couches minces et superposées. Les époxy par contre, accusent un retrait négligeable, sont maniables, et leur transparence, leur indice de réfraction et leur brillance leur donnent un aspect similaire au verre.

Nous avons effectué des tests de maniabilité, de rendu, de stabilité aux U.V. et de réversibilité, pour les mêmes résines et dans le même esprit que ceux réalisés pour le collage, pour sélectionner les résines les plus adaptées au bouchage des manques.

Suite à ces tests, nous avons conclu que la Fyne Bond présente un risque important d'imprégnation de la couche picturale. L'Araldite 2020 présente un léger jaunissement, et le Paraloïd B72 est très long à appliquer et a un rendu peu satisfaisant (bulles, aspect plastique et indice de réfraction trop différent de celui du verre). Nous n'avons donc retenu que l'HXTAL NYL-1 comme résine de bouchage, car celle-ci présente une maniabilité relativement bonne, un rendu optimal, une très grande stabilité au vieillissement et une réversibilité difficile, mais possible. Ce choix se fait toutefois à condition d'appliquer une couche d'isolation sur la couche picturale avoisinant la lacune, et d'effectuer un

bouchage légèrement en dessous du niveau de celle-ci, de sorte à éviter la mise à niveau par ponçage et polissage.

Le fixage

Outre la présence de micro-organismes, la perte d'adhérence est la dégradation la plus souvent observée dans le domaine de la peinture sous verre. Les problèmes d'adhérence peuvent apparaître sous deux formes : pulvérulence de la couche picturale ou soulèvements proprement dits.

Les fixatifs à base de collagènes naturels, tels que la gélatine, la colle de peaux, l'amidon et les dérivés cellulosiques ont à maintes reprises été testés et se sont toujours révélés peu convainquants : ils craquellent, ils ont un retrait considérable et, surtout, leur adhésion au verre n'est pas concluante (Bretz 1995). De plus, l'apport en humidité qu'ils impliquent nous pousse à les proscrire, en raison de la très grande sensibilité à l'eau des peintures sous verre.

Les fixatifs qui sont le plus souvent cités sont le Paraloïd B72, la Regalrez 1094, la cire microcristalline, la cire d'abeilles blanchie additionnée d'une résine artificielle et parfois additionnée d'un absorbeur d'U.V. et les acétates de polyvinyle en émulsion. On trouve également des rapports de traitement qui relatent diverses expérimentations, telles que la transposition ou le fixage de la couche picturale par « réactivation » de celle-ci dans un caisson à solvants. Il va de soi que ces méthodes, brutales, peu contrôlables et non respectueuses de l'intégrité de l'œuvre ne peuvent être envisagées.

Le choix du fixatif adéquat a également été fait en fonction de critères de sélection très strictes : stabilité optique, mécanique et chimique ; maniabilité, compatibilité avec les matériaux originaux et avec le type de perte d'adhérence ; neutralité par rapport aux micro-organismes, faible hygroscopicité, T_g superieure à 40–50°C et stabilité dimensionnelle au séchage.

Ayant confronté différents fixatifs à ces critères, nous avons retenu les produits suivants : le Paraloïd B72, la Regalrez 1094, les polyvinyliques, les cires d'abeilles et microcristallines et enfin les mélanges cire-résine.

Suite à des tests de maniabilité, nous avons constaté que le fixage est généralement plus concluant lorsqu'il est effectué sans évaporation du solvant. En effet, les fixatifs en solution et en émulsion ont tendance à ne pas se répartir de manière uniforme dans le soulèvement, mais s'accumulent aux endroits de contact entre la couche picturale et le support. L'ajout supplémentaire de fixatif, même lorsqu'il est couplé à un apport de chaleur, conduira en général à combler le vide sans pour autant résorber la déformation de la couche picturale due au soulèvement de celle-ci.

Par contre, les cires offrent l'avantage de fixer la couche picturale au support sans nécessiter l'évaporation d'un solvant. Il n'y a donc ni retrait, ni risque de solubilisation de la couche picturale, ni même risque de répartition inégale de la résine. De plus, le film de peinture tend moins à se casser lors de l'aplanissement, probablement grâce au fait que la peinture est lentement ramollie, tout en restant gainée par la cire en fusion. Enfin, le fixage pourra être repris sans apport de résine.

Il arrive que le fixage soit mixte : lorsqu'on traite une zone très soulevée dont les écailles risquent d'être véhiculées par la cire en fusion, un premier fixage sera effectué à l'aide d'un fixatif en solution (par ex. Paraloïd B72 ou Regalrez 1094), et ce fixage sera repris à la cire (Fig. 2). De même, les couches pulvérulentes seront traitées par des fixatifs en solution, pulvérisés dans un solvant à évaporation lente.

Pour ce qui est des cires, différentes cires naturelles et microcristallines, ainsi que des mélanges cire/résine ont été envisagées par Mme S. Bretz, restauratrice à Munich. La cire microcristalline Victory White Wax a été retenue pour sa stabilité à la lumière et sa bonne adhésion au verre, mais lorsqu'aucune contre-indication n'est posée (par ex. la sensibilité de certains alliages en présence dans la composition des feuilles métalliques), sa préférence se tourne vers la cire d'abeille blanchie, pour sa longue tradition en restauration et l'avantage qu'elle présente, de pâlir au soleil (Bretz 1995). Cependant, son adhérence au verre étant médiocre, l'ajout d'une résine s'est imposé, et l'auteur préconise l'utilisation de la Regalrez 1094 de la firme Hercules. Cette résine est préférée pour sa grande stabilité mécanique et chimique, son faible poids moléculaire et sa bonne solubilité (de la Rie et

Figure 2. Trois étapes de fixage:
1. Avant fixage.
2. Après fixage à la Regalrez 1094.
3. Après fixage à la cire d'abeilles blanchie+Regalrez 1094.

McGlinchey 1990). L'auteur propose donc la résine synthétique Regalrez 1094, mélangée à 5–20% dans de la cire d'abeille blanchie.[3]

La retouche

L'éthique d'intervention minimale, la fragilité de la couche picturale des peintures sous verre, et la difficulté technique de la retouche motivent souvent le choix d'une homogénéisation de l'œuvre en colorant un fond, posé derrière le verre, de façon à ce qu'il apparaisse à travers les lacunes. Ce type de réintégration diffère selon les ateliers : certains optent pour la pose d'un papier sur lequel les formes générales de la composition sont tracées, sans se limiter à la seule surface des lacunes ; d'autres partent du même principe, mais ne colorent que la zone qui correspond à la lacune ; d'autres encore collent des découpes en papier coloré sur une feuille de Mélinex posée comme fond, ou les collent à même le verre.

Il est important de souligner deux handicaps majeurs de ce type d'intervention. Le premier, d'ordre esthétique, est que le support sur lequel la « retouche » est effectuée n'atteint jamais un contact suffisamment intime avec l'œuvre, et donne à la lacune un aspect flou et blanchâtre, auquel s'ajoute l'ombre portée du bord de la lacune sur le fond, dessinant sur celui-ci un cerne foncé. Le second handicap concerne la conservation de l'oeuvre : les peintures sous verre résistent peu à l'abrasion et à l'humidité. Aussi, nous pensons que chercher un contact intime entre le fond/support de retouche et le verre risque de favoriser la formation d'un microclimat favorable à la prolifération de micro-organismes et au soulèvement de la couche picturale, et d'être générateur de l'abrasion, de l'arrachage ou de la transposition de la couche picturale.

Cette méthode de réintégration nous semble donc difficilement satisfaisante, tant du point de vue esthétique que du point de vue de la conservation de l'œuvre. Il nous a donc semblé intéressant d'envisager une retouche à même le verre (Figs. 3, 4).

Parce que les peintures sous verre sont souvent encollées et/ou ébauchées avec un liant sensible à l'eau, et parce que les liants de retouche aqueux ont une adhésion au verre médiocre, nous les avons écartés. Les liants acryliques tels que le Paraloïd B72 ont étés retenus pour leur solubilité dans une large gamme de solvants, leur bonne réversibilité et leur compatibilité avec la couche picturale des peintures sous verre.

Le problème majeur, en ce qui concerne la retouche d'une peinture sous verre, est que le restaurateur doit travailler au revers du tableau, alors que le résultat de la retouche sera jugé par la face. Afin de remédier à ce problème technique, nous avons conçu un chevalet de retouche, qui permet au restaurateur de travailler sur le revers, tout en gardant la face visible, dans un miroir placé parallèlement au tableau (Fig. 5).

Outre les problèmes de latéralisation engendrés par ce mode de retouche, le restaurateur sera confronté à des problèmes inhérents à la technique de la peinture sous verre : les détails doivent être posés en premier lieu, leur tonalité doit être choisie en fonction des couches qui les recouvriront et en tenant toujours compte de l'influence de la couleur du verre et du fond sur le résultat final. Et, cela va de soi, la première couche posée est la couche visible à la face du verre, et la retouche ne peut donc plus être corrigée après avoir été posée. A moins de la recommencer !

L'encadrement

Nous avons pu constater, sur les peintures dont l'encadrement était d'origine, qu'un espace est toujours laissé entre la couche picturale et le fond. Or, l'encadrement original a souvent été remplacé par un autre, qui enserre la peinture sous verre entre la batée du cadre et le fond, mettant la couche picturale en contact intime avec le fond.

Ce fond, souvent en carton ou en papier acide, encourage l'attaque chimique, la contamination micro-organique, l'abrasion et la transposition de la couche picturale. Les œuvres réencadrées montrent également des dommages dûs à la manière dont le fond a été fixé au cadre : les couches picturales griffées par les clous de fixation et les verres brisés suite à la contrainte de clous sont nombreux.

Le réencadrement d'une peinture sous verre devra être effectué dans le respect de quelques règles : le fond, de couleur foncée, doit être rigide, fait de matériaux

Figure 3. « Le Diligent d'Anvers », 1846, détail avant retouche.

Figure 4. « Le Diligent d'Anvers », 1846, détail après retouche aux pigments+Paraloïd B72.

Figure 5. Chevalet de retouche.
a. Chevalet de la peinture sous verre, posée couche picturale vers le restaurateur.
b. Chevalet du miroir, posé parallèlement à la peinture sous verre.
c. Rails parallèles, supports des deux chevalets.

Figure 6. Encadrement d'une peinture sous verre :
a1,2. Boutons de silicone neutre appliqués en vis-à-vis, pour compenser le relief du verre et éloigner le fond.
b. Trous d'aération recouverts d'un filtre a poussière.
c. Languettes en métal, vissées au cadre.

Figure 7. « Le Diligent d'Anvers », 1846, après fixage et dégagement des surpeints.

Figure 8. « Le Diligent d'Anvers », 1846, après collage à l'HXTAL NYL-1 et retouche aux pigments+Paraloïd B72.

stables et neutres, éloigné de la couche picturale, aéré, et vissé plutôt que cloué ou agrafé au cadre (Fig. 6).

Conclusions

Suite aux tests de maniabilité, de rendu, de stabilité et de vieillissement que nous avons effectués sur les produits retenus comme étant théoriquement valables, nous avons pu faire un choix de quelques matériaux qui nous paraissent adaptés à la restauration des peintures sous verre (Figs. 7, 8) :

1 Le collage se fera soit au Paraloïd B72 appliqué après silanisation, soit l'HXTAL NYL-1, selon le type d'œuvre et les conditions de conservation de celle-ci. Le collage des peintures sous verre à l'aide d'époxy est irréversible. Il est donc conseillé de le mener sur une table de collage, qui permet la stabilité et la précision nécessaires à un collage réussi ;

2 Le bouchage des lacunes dans le verre se fera de préférence à l'aide d'une pièce en verre, collée au moyen des résines sélectionnées pour le collage. Si la lacune ne peut être comblée en y insérant un morceau de verre, elle le sera en y coulant de l'HXTAL NYL-1 ;

3 Le fixage se fera soit avec un fixatif en solution : le Paraloïd B72 ou la Regalrez 1094 ; ou avec un fixatif sans solvant : cire d'abeilles blanchie + Regalrez 1094 ou cire microcristalline, Cosmolloid 80H ;

4 La retouche se fera au Paraloïd B72, et sera facilitée par l'utilisation d'un chevalet de retouche, qui permettra au restaurateur de choisir entre intervention et non-intervention, en ne confondant pas problème technique et problème éthique ;

5 L'encadrement aura un fond rigide, de couleur foncée, neutre, éloigné de la couche picturale, aéré et vissé plutôt que cloué ou agrafé au cadre.

Remerciements

Nous remercions particulièrement le Dr H. Römich, chef du département de recherches pour la conservation du patrimoine culturel au Fraunhofer Institut für Silicatforschung à Bronnbach ; et Mme S. Bretz, restauratrice de peintures sous verre à Munich ; Mme S. Davison, restauratrice de verres et de céramiques, à Thame, GB ; et M. J. Caen, restaurateur de vitraux et enseignant au Hoge School Antwerpen pour leurs contributions à notre recherche.

Notes

1. Les tests comparatifs et exploratoires que nous avons effectués sont les suivants :

- Pour les adhesifs :
 Maniabilité et rendu : des plaquettes de verre identiques ont été peintes à la gouache, cassées, et recollées à l'aide des différents adhésifs ;
 Stabilité de la lumière : les mêmes plaquettes ont été occulté sur une moiti et mises sous des lampes U.V à lumière, dans une temperature ambiante stable de 21°C pendant un temps qui correspond à six bandes de Blue Wool. Le viellissement a ensuite été contrôlé en comparant la décoloration des standards de vieillissement Blue Wool (Feller 1978).
 Réversibilité : des compresses des solvants (acétone, acétate d'éthyl et dichlorométhane) ont été appliquées sur le joint, avant et après vieillissement accéléré.
 Résistance au cisaillement : pour chaque adhesif, 10 éprouvettes identiques ont été réalisées. Pour chaque série, seules 5 éprouvettes ont été exposées aux U.V. La résistance au cisaillement a été testée sur une machine à traction à vis.

- Pour le bouchage :
 Maniabilité et rendu : les résines ont été coulées dans des trous aménagés dans une plaque de verre épaisse de 3mm.

Stabilité de la lumière et réversibilité ont été testées suivant la même méthode que celle utilisée pour tester les adhésifs.

• Pour le fixage :
Seuls des tests de maniabilité et de rendu ont étés menés, sur une peinture sous verre de petite qualité, qui présentait de graves problèmes de soulèvements. Les autres citères ont étés explorés par Mme S. Bretz (Bretz 1995).

2. Regalrez 1094 : résine hydrocarbonée hydrogénée, qui est très stable, incolore, de faible poids moléculaire et non polaire.

3. Mme S.Bretz préconise l'ajoût de Tinuvin 292 à 1,5–2% du poids de la résine afin de maximiser la résistance de celle-ci à la photodégradation.

Référénces

Bretz S. 1995. Konservierung und Restaurierung von Glas und Hinterglasmalerei (Non publié).

Davison S. 1984. A Review of adhesives and consolidants used on glass antiquities. In: Bromelle, NS, Pye, EM, Smith, P and Thomson, G eds. Adhesives and consolidants. Proceedings of the Paris congress. London: International Institute for Conservation: 191–194.

de la Rie ER and McGlinchey CW. 1990. New synthetic resins for picture varnishes. In: Mills, JS and Smith, P eds.Cleaning, retouching, coatings. Preprints of the Brussels congress. London: International Institute for Conservation: 93–97.

Feller RL. 1978. Standards in the evaluation of thermoplastic resins: Further studies on the international blue wool standards for exposure to light. In: Preprints of the 5th triennial meeting of the ICOM Committee for Conservation, Zagreb : International Council of Museums: 78/16/4.

Mols J. 1996. Problématique de la conservation et techniques de restauration des peintures sous verre. Travail de fin d'études, ENSAV La Cambre (Non publié).

Matériaux

Fyne Bond, Fyne Conservation Services, Airds Cottage, St Catherine's by Loch Fyne, Argyll PA 25 8BA, Ecosse.

HXTAL NYL-1 et Victory White Wax, Conservation Materials, 1275 Kleppe Lane #10, Sparks, NV, USA.

Paraloïd B72 et Cosmolloid 80H, Aloïs K.Diethelm A.G., Lascaux Farbenfabrik, CH-8306 Brütissellen, Suisse.

Regalrez 1094, Hercules BV, Veraartlaan 8, Postbus 5822, NL-2280 HV Rijswijk, Pays Bas.

Silane Z6040, Dow Corning (Europe), Chaussée de la Hulpe 154, B-1170 Bruxelles, Belgique.

Résumé

La restauration des peintures du Parlement de Bretagne, incendié en 1994, vient de s'achever. L'article présente les étapes successives de ce chantier exceptionnel en taille et en rapidité : mesures d'urgence, illustrées par un cas, réflexions sur les choix de restauration, et bilan des expériences acquises lors de ce chantier. Un plan de conservation d'urgence, à préparer par les autorités locales en prévision d'une catastrophe, est suggéré.

Mots-clés

Parlement de Bretagne, incendie, ensemble décoratif, peintures sur toile, traitements d'urgence, plan de conservation d'urgence

Figure 1. Plafond de la Grand'Chambre avant incendie, par Noel Coypel (cliché agence Perrot).

Urgence et restauration : L'incendie du Parlement de Bretagne

Sabine Cotte,★ Marie Noëlle Laurent, Frédéric Pellas
Atelier des Envierges
157 rue du Temple
75003 Paris
France
Fax : + 33 01 42 71 75 68

L'incendie qui a ravagé les étages supérieurs du Palais du Parlement de Bretagne dans la nuit du 4 au 5 février 1994, outre l'émotion qu'il a soulevé, a ouvert un des plus importants chantiers de restauration français de ces dernières années. La restauration des peintures des plafonds est aujourd'hui achevée. Nous présentons ici les étapes successives de ce chantier : mesures d'urgence, illustrées par un cas particulier de traitement de support, réflexions sur les choix de restauration, et en bilan de cette expérience, nous donnons quelques suggestions pour un plan de conservation d'urgence, dans l'éventualité de catastrophes.

Le Parlement de Bretagne, au centre de la ville de Rennes, est un bâtiment du XVIIème siècle, construit sur les plans de l'architecte Salomon de Brosse. Les salles du premier étage constituent l'un des plus importants décors civils conservé en France. Le principe décoratif est celui de lambris muraux et de plafonds plats en bois sculpté et doré, à compartiments dans lesquels viennent s'encastrer des peintures. L'ensemble des peintures de chaque plafond fut confié à un artiste différent pour chaque salle, de 1656 à 1867 (voir Fig. 1).

L'incendie de 1994 a débuté dans les combles du bâtiment. Grâce à un faux plafond en briques, les salles décorées ont pu être préservées des flammes, sans pouvoir éviter cependant que des tonnes d'eau ne s'accumulent dans les décors de plafond. Sous le poids de l'eau, les toiles ont formé des poches énormes, ou parfois éclaté en arrachant leurs bords des chassis. Des conservateurs-restaurateurs furent appelés la nuit même par Christophe Amiot, architecte des Bâtiments de France, et se trouvaient sur les lieux dès le matin.

L'urgence

Les premières mesures se sont déroulées en trois temps : sauvetage des œuvres d'art, constats d'état et sélection d'œuvres, traitements d'urgence. L'effet de surprise d'un tel incendie et l'ampleur des dégâts ne facilitent pas l'organisation d'un plan d'intervention. A l'arrivée sur le lieu de l'incendie les conservateurs-restaurateurs se sont informés auprès des personnes responsables. En coordonnant les opérations de sauvetage des œuvres et en associant les compétences de chaque équipe intervenante, nous avons pu mettre sur pied en quelques heures une série d'interventions simples.

Sauvetage des œuvres

- Evacuation des toiles du bâtiment
 Certaines peintures ont été découpées le long des montants des chassis, d'autres ont pu être démontées du plafond avec leur chassis quand le danger du feu était éloigné. Certaines toiles ont été percées en leur centre ou fendues le long des coutures, pour éviter un éclatement anarchique sous le poids de l'eau. L'évacuation s'est faite par les fenêtres, ou à l'aide d'une grue par les trous créés par l'effondrement des étages. Cette évacuation a été faite par les pompiers, des restaurateurs appelés en urgence et des bénévoles de la DRAC Bretagne (voir

★Auteur auquel la correspondance doit être adressée

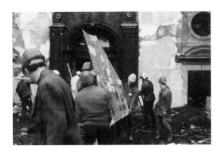

Figure 2. Evacuation d'un tableau.

Fig. 2). Les toiles ont été immédiatement étendues sur le pavé de la rue adjacente. L'excès d'eau a été épongé par des papiers absorbants, et des papiers japon rapidement posés sur les zones en soulèvement ou en début de transposition. Le vent très fort, et la pluie, rendaient ces opérations très difficiles.

- Transport des œuvres à plat dans un lieu de stockage provisoire
- Aménagement du lieu de stockage et de traitement des œuvres
- Désinfection pour arrêter le développement des microorganismes favorisé par le milieu humide : enlèvement des rentoilages anciens, imprégnation au nitrate d'éconazole après étude par le Laboratoire de Recherche des Monuments Historiques
- Jusqu'au traitement de restauration, les œuvres ont été climatisées : retour progressif à un degré d'humidité relative acceptable pour éviter les variations brutales et les altérations qui en découleraient. Le séchage a été contrôlé, d'abord de façon hebdomadaire, puis mensuelle.

Constats d'état

A ce stade, c'est à la suite de réunions entre la maîtrise d'ouvrage, la maîtrise d'œuvre, et les conservateurs-restaurateurs qu'ont été mises en place des mesures conservatoires immédiates et indispensables, en attente du traitement des œuvres. Il fallait prendre en compte les différents types d'altérations, fonction de l'état des œuvres avant l'incendie et de ce qu'elles avaient subi durant le sinistre.

Par ces mesures, il était indispensable de ne pas conditionner le traitement futur. Elles avaient pour unique raison de protéger et stabiliser les œuvres en laissant toutes possibilités ultérieures ouvertes. Sur un ensemble pictural aussi important, il n'existe pas de solution unique mais une adaptation à chaque type d'altération et de support : toiles XIXème, toiles XVIème à préparation argileuse, toiles anciennement rentoilées, etc. La variété des problèmes, pourtant provoqués par la même cause, allaient impliquer une grande variété de traitement, du rentoilage traditionnel à la colle de pâte, à la mise en extension en chambre humide et doublage synthétique en passant par le rentoilage mixte, colle-cire.

L'eau avait provoqué sur l'ensemble des œuvres des dégradations extrêmes de la préparation, des pertes de cohésion et d'adhésion des couches picturales pouvant aller jusqu'à la transposition avec déplacages et déplacements d'écailles, des chancis du vernis à divers degrés de profondeur. Les toiles avaient été découpées ou arrachées des châssis, certains d'entre eux étaient brisés. Les coutures ont parfois explosé, les toiles se sont déchirées sous le poids de l'eau. Certaines ont été retrouvées sous les gravats. L'eau s'est accumulée en poches provoquant des fluages exceptionnels de la toile, compliqués de retrait. Certaines toiles se sont en partie désentoilées.

Chaque œuvre a été soigneusement démontée et rassemblée sur un plan de travail, au moyen d'un maintien solide permettant un stockage rationnel et sur du long terme. Les écailles ont été replacées et les zones en soulèvements protégées. Les déformations ont été soutenues par le revers afin d'éviter tout affaissement préjudiciable de la toile. Une fiche standardisée, accompagnée de photographies, fut établie pour chaque tableau, sous forme d'un constat d'état des altérations et des mesures d'urgence prises pour chacun. Sur cette base, une échelle des priorités a pu être établie. Nous avons procédé à une évaluation des altérations et des moyens à mettre en œuvre pour la restauration. Cette étude a permis de sélectionner douze tableaux considérés comme prioritaires : parmi eux, un tableau présentait une altération de la toile d'une ampleur rarement rencontrée, telle qu'elle nécessitait un traitement urgent du support.

Traitements d'urgence. Un exemple : La Clémence

La Clémence (3.57 × 2.54m) est l'un des écoinçons du plafond du conseil de la Tournelle, peint en 1837 par Nicolas Gosse. Le tableau n'avait pas subi de restaurations antérieures. Son support est une toile de lin, au tissage armure toile. La couche picturale est fine, en superposition de glacis, sur une préparation blanche à l'huile.

Figure 3. La Clémence. *Déformation avant traitement en chambre humide.*

Durant tout l'incendie, ce tableau est resté en place dans les décors du plafond, résistant au poids croissant de l'eau. Une poche d'eau s'est alors formée en son centre. La déformation de la toile atteignait 18cms de haut (voir Fig. 3). Le bord inférieur arraché du chassis a subi un retrait de 13cm sur toute la longueur. La toile s'est finalement déchirée sur 70cm. Mises à part la partie déformée pulvérulente, la couche picturale montrait une bonne cohésion interne. Afin de pouvoir contrôler les facteurs intervenant au cours du traitement, surtout dans le cas d'une toile XIXème réactive, il était essentiel d'en séparer les étapes. Pour agir sur l'humidité, la chaleur et la tension, essentielles dans ce type de traitement, l'intervention a été conduite en chambre d'humidification. Il est connu que même de faibles variations d'humidité peuvent entraîner un accroissement important des tensions au niveau de la toile. Il était donc indispensable d'établir un contrôle rigoureux de l'apport d'humidité et de procéder de manière graduelle afin d'augmenter progressivement la plasticité des différentes couches constituant la peinture.

Les protections ponctuelles mises en place en première urgence ont été conservées, le reste de la peinture n'a pas été protégé. Les bords et la déchirure ont été consolidés et l'œuvre tendue sur un bâti extenseur. L'ensemble a été placé dans une enceinte fermée, l'humidité relative a été amenée au niveau requis et stabilisée par des solutions de sels dissouts dans l'eau. Une fois ce niveau atteint et la toile relaxée, il était possible d'effectuer une reprise de tension par ouverture des angles du bâti (1 à 2mm maximum), et extension à la pince des bords rétractés. Onze cycles d'humidification puis séchage complet ont été nécessaires. Après la 11ème humidification, l'œuvre fut placée hors de la chambre et retournée. Les plis résiduels ont été repris ponctuellement. Une fois la planéité retrouvée, le doublage de la toile a pu être effectué.

Après les traitements d'urgence de supports, la restaurations de tous les tableaux a pu être envisagée. La gestion administrative a été effectuée par le maître d'ouvrage (DRAC Bretagne) et les maîtres d'œuvre (M. Perrot, Architecte en Chef des Monuments Historiques, et Mme. de Maupeou, Inspecteur Général des Monuments Historiques) : mise en place d'appels d'offres restreints, sélection des candidats et suivi des restaurations.

La restauration de la couche picturale

Après le sauvetage des œuvres, la restauration de la couche picturale devait répondre à un double problème : esthétique et historique.

- Esthétique : l'inégalité des altérations dans une même pièce donnait à chaque ensemble un aspect déséquilibré, où les accidents auraient causé un choc visuel.
- Historique : c'est un grand décor, c'est également le symbole du statut particulier de la Bretagne au XVIIème siècle, et de ses relations privilégiées avec la cour de France. Son usage n'a pas varié depuis le XIXème siècle, il abrite toujours le Palais de Justice. Les parlementaires ont fait appel à des peintres renommés : Charles Errard, Noël Coypel, Jean Jouvenet, Ferdinand Elle, Félix Jobbé-Duval. Les allégories mettent en scène la Bretagne, la France, la Justice, l'Innocence, autant d'images clés pour illustrer la forte signification attachée à ce bâtiment.

Le désir de retrouver un bâtiment avec sa fonction d'usage donne une approche différente de la restauration des décors. Les tableaux ne sont pas considérés seulement comme les œuvres d'un peintre et les témoins de son art, mais comme une partie de cette immense célébration de la Justice. Il est dès lors naturel que toutes les parties de ce décor soient à leur place. Il est délicat d'imaginer une réintégration archéologique dans un ensemble destiné à produire du sens et donner une impression de puissance de la Justice : l'état de conservation inégal des œuvres rendrait difficile la lecture de certaines d'entre elles. Il en découlerait une hiérarchie des thèmes qui trahirait le projet initial. Ceci illustre bien le fait que le sens a besoin du support matériel pour exister, et le dépasser. Dans ce cas précis, la perte de l'intégrité matérielle de certaines œuvres aurait oblitéré le sens de tout l'ensemble. L'option choisie fut une réintégration illusionniste, tout en gardant une approche monumentale.

Figure 4. La Piété *de Jean Jouvenet, après restauration.*

Les toiles du Parlement figurent dans des ouvrages sur l'édifice, dans l'état de 1988. La médiatisation qui accompagne cette restauration, dans le sillage du choc causé par l'incendie, donne à ces toiles nouvellement restaurées le statut d'image de référence : cartes postales, catalogues d'exposition, affiches sont désormais diffusées. Il est donc important d'en bien saisir le sens, pour ne pas contribuer à la diffusion d'une image erronée ou inexacte.

La restauration, en donnant aux divers intervenants le temps de la réflexion sur chacune des toiles, a été l'occasion d'en repréciser l'iconographie : ainsi l'allégorie de la Piété, peinte par Jean Jouvenet au plafond du Conseil de la Grand'Chambre en 1696, et dont l'iconographie se superpose avec celle de *l'Abondance*. Cette iconographie fut d'ailleurs comprise comme telle dix ans plus tard par le peintre Louis Ferdinand Elle, qui reprit le même thème pour la Chambre des Enquêtes, en l'intitulant *l'Abondance*. L'examen de la lettre envoyée par Jouvenet aux parlementaires, où il détaille les thèmes choisis, a permis de retrouver le véritable sens de cette allégorie : il s'agit de la Piété, représentée comme « une femme qui répand une corne d'abondance, pour montrer que la justice étant bien rendue dans un esprit de religion et de piété fait naître l'abondance partout » (voir Fig. 4).

Conclusion

Regroupement des conservateurs-restaurateurs

Ce chantier devait être effectué dans des délais très courts, ce qui rendait le travail en équipes indispensable. Chaque équipe, représentée par un mandataire, a assuré la restauration des tableaux d'une salle, pour garantir l'homogénéité des restaurations de chaque ensemble. Les enseignements tirés de ce travail d'équipe sont multiples : d'une part, chaque membre d'une équipe développe considérablement ses talents d'organisation, de communication (tant dans les relations avec la maîtrise d'œuvre que dans les discussions entre membres de l'équipe), et de gestion. D'autre part, il semble que la gestion quotidienne de ce type de chantier incombe de plus en plus aux restaurateurs : la tendance actuelle en France étant de regrouper les restaurations par lots. Il est donc bon de réaliser que ce travail de gestion constitue une partie de notre mission non négligeable, qu'il convient de prendre en compte lors des estimations de travaux. La capacité à répondre à ce type de demande nous semble aller dans le sens du désenclavement de notre profession. Nous avons beaucoup à gagner à perdre notre caractère isolé au profit de regroupements de moyens et de compétences.

Nécessité de plans de conservation d'urgence

Il existe déjà dans tous les bâtiments publics des plans de sécurité et d'évacuation qui constituent une première garantie en cas de sinistre. L'incendie de Rennes nous a fait mesurer à quel point nous étions désemparés après une catastrophe. La réunion d'un grand nombre de bonnes volontés, souvent bénévoles, a contribué en grande partie au succès de cette restauration. Il n'est toutefois pas certain que ces conditions soient réunies à chaque fois. Un plan de conservation d'urgence semble nécessaire ; il pourrait s'axer sur les points suivants :

RAPIDITÉ D'INTERVENTION

Nous avons pu constater que la rapidité et la pertinence des interventions était cruciale : en effet, le temps perdu en recherche des compétences ou du matériel appropriés à chaque type de problème joue en défaveur des œuvres dont les altérations continuent d'évoluer jusqu'à la mise en œuvre des mesures de conservation. Ceci peut causer des dommages irréversibles sur les œuvres traumatisées par une catastrophe. De la même manière, des interventions faites dans la précipitation par des personnes incompétentes, mais animées des meilleures intentions, pourraient se révéler désastreuses.

Il serait donc souhaitable que les régions disposent d'une liste de personnes compétentes à appeler en cas d'urgence : selon le patrimoine local, cette liste devrait comprendre des conservateurs-restaurateurs des spécialités concernées, ainsi que des équipes formées à la manipulation d'œuvres en mauvais état (certaines

compagnies de pompiers ont cette formation spécifique). Il est important que les tâches soient clairement distribuées (qui appelle qui) pour éviter la confusion et favoriser l'efficacité des interventions.

TRANSPORT ET MATÉRIEL

De même que les personnes, le matériel approprié est indispensable et il est aisé de perdre un temps considérable en recherche de fournisseurs. L'établissement de listes de fournitures, avec les adresses et téléphones des fournisseurs, est impérative (où trouver colle, bâtis d'extension, déshumidificateurs, papiers de protection, fongicides...). Certaines fournitures peuvent d'ailleurs se trouver prêtes en permanence (bois, mousses, papiers, bâches plastiques...) et permettre la construction de cadres de maintien provisoires pour le transport. Dans tous les cas, le matériel souhaité doit pouvoir être sur les lieux très rapidement.

Les moyens de transport sont également à prévoir : camions suffisamment larges pour y entrer et transporter les œuvres à plat, et personnel pour la manutention.

LIEUX

Il est indispensable de prévoir un lieu de stockage, de climatisation et d'intervention. Regrouper toutes ces fonctions dans un lieu unique permet d'éviter des transports répétés qui sont autant de traumatismes pour les œuvres sinistrées. Une zone de décontamination est à prévoir pour désinfection, sur le lieu même comme ce fut le cas pour le Parlement, ou sur le lieu de restauration. Ce lieu peut être couplé avec un atelier régional de restauration, qui dans ce cas est équipé pour recevoir des œuvres en mauvais état. Les mesures de prévention ont été les suivantes : chassis autotenseurs, protection des revers par toile ignifugée, moulures amovibles pour une dépose facile.

Toutes ces suggestions ne sont bien entendu pas exhaustives ; cette étude est à faire en collaboration avec des spécialistes de la conservation préventive.

Enfin ce chantier nous a fait réaliser l'importance de la communication : l'urgence largement médiatisée a permis une mobilisation de la population (Association pour le Renouveau du Parlement) ajoutée à celle de l'Etat, pour financer les opérations de restauration. Cette mobilisation a trouvé sa récompense dans l'exposition « Peintures restaurées du Parlement de Bretagne » au musée des Beaux Arts de Rennes.

Remerciements

Nous remercions Christophe Amiot, Dominique Chesneau, Gwenaëlle Le Ricoux, Isabelle Lurton, Catherine de Maupeou, Alain-Charles Perrot, Marie-Line Quéro, le personnel de la DRAC Bretagne et du cabinet Perrot, ainsi que les conservateurs-restaurateurs qui ont participé au sauvetage et à la restauration.

Materiaux

Nitrate d'éconazole, Sigma Aldrich Chimie, 80 rue de Luzias, BP 7701, 38397 St. Quentin Fallavier, France ; aussi France Organo Chimie, 52 rue de Bichat, 75010, Paris, France.

Abstract

Conservation treatment of *Legend of Red Lake Ontario*, a large, contemporary silkscreen on linen by Josh Kakegamic, provided an opportunity to explore stain removal techniques used by paper and textile conservators in the context of paintings on unprimed fabric supports. In collaboration with conservation scientists and conservators specializing in the treatment of textiles, paper, and paintings, a treatment procedure was developed to reduce the dark tide-line caused by water damage to a degree where the silkscreen was considered exhibitable. Sodium borohydride, a mild- to moderate-strength reducing bleach that does not degrade cellulose, was used to decolorize the darkest part of the tide-line and other diffuse areas of staining. Extensive rinsing was undertaken with an airbrush to remove residual bleach and decolorized products as well as visually reduce diffuse areas of staining. In areas where further bleaching was required, fine control was achieved by applying a "mist" of bleach with an ultrasonic mister. This treatment succeeded in reducing the visual impact of the stain to an acceptable degree. It is hoped that these techniques will be of interest to other conservators as they tackle similar problems on unprimed textile supports.

Keywords

water stain, tide-line, treatment, suction, borohydride, bleach, airbrush, ultrasonic mister, linen, painting

A collaborative treatment: Reducing water stains on a silkscreen on linen

Debra Daly Hartin,★ Season Tse, Jan Vuori
Canadian Conservation Institute
1030 Innes Road
Ottawa ON K1A 0M5
Canada
Fax: +1 613-998-4721
Email: debra_daly_hartin@pch.gc.ca

Introduction

Stain removal goes beyond the boundaries of a single discipline in conservation treatment, and therefore provides great potential for collaboration in the development of effective and appropriate treatment procedures. Although stain removal on unprimed fabric supports is a problem encountered periodically by paintings conservators, there is little in the conservation literature on the subject: Mette Bjarnhoff described the removal of water stains from a painting on unprimed cotton using a low pressure table (Bjarnhoff 1984) and Leni Potoff presented an unpublished paper in which he discussed various methods of local stain removal on colour field paintings using poultices and/or suction devices (Potoff 1991).

Water damage to *Legend of Red Lake Ontario*, #8/50, a large, contemporary silkscreen on fabric by Josh Kakegamic, had resulted in a large stain that made the work unexhibitable (See Fig. 1). Conservation treatment provided an excellent opportunity to explore stain removal techniques developed for paper and textiles in the context of unprimed paintings.

This paper describes the approach developed to reduce the visual impact of the tide-line. Devising the treatment was a collaborative process among many professionals at CCI, including myself, a paintings conservator; conservation intern Robin Hanson who performed the initial testing; textile conservators, particularly Jan Vuori; paper conservator Sherry Guild; conservation scientist Season Tse in the development of the sodium borohydride treatment; and senior conservation scientist Stefan Michalski and conservator Paul Heinrichs in the design, fabrication, and modification of the suction disk. It is hoped that our experience will benefit other painting conservators as they deal with similar problems.

Description of the object

Legend of Red Lake Ontario is a seven-colour silkscreen print on linen fabric, approximately 2.75 × 1.28m. The weave is a moderately loose, 1/1 plain weave

Figure 1. Legend of Red Lake Ontario *before treatment.*

★ Author to whom correspondence should be addressed

with a thread count of 11 warps/cm and 11 wefts/cm. The fabric is slightly uneven in colour, similar to fabric sold as "oatmeal" by some distributors. The warp threads (horizontal) are beige and the weft threads are white except in two vertical bands of darker colour in which the weft threads appear similar in colour to the warp. Although the threads in both directions vary in thickness and contain nubs, tufts of loose fibres, and "straw" fibres, the greater unevenness of the white, weft threads imposes a distinct vertical pattern to the fabric.

Dark, unsightly tide-lines extend from the top of the work to its bottom edge, the result of water damage from a ceiling leak at least five years prior to treatment. Water-soluble components in the fabric were mobilized when the canvas was wet and were redeposited at the wet/dry interface, leaving the centre of the affected area lighter in colour and a tide-line of diffuse staining with a sharp dark edge. In addition, it is likely that modification of the cellulose has occurred at the boundary between wet and dry regions which has also contributed to the formation of the tide-line (Hutchins 1983). A large, noticeable "overcleaned" area still stiff with residual cleaning agent remains from a previous, inappropriate cleaning attempt. Rust stains from the staples that secured the print to the auxiliary support are present on the tacking margins, in areas that were exposed to water.

Where the fabric has been exposed to light there has been an overall tonal change; the warp threads are much darker in protected areas along the tacking margin and on the reverse of the fabric.

The printing inks, most likely oil-based, are vibrant in colour and structurally secure. The ink thoroughly covers the fabric surface but does not form a thick layer. Inked nap fibres remain raised above the surface. The ink has flowed into and through the weave such that it is clearly visible on the reverse. The signature appears to have been applied by brush; the ink remains as a surface application and has not flowed through to the back.

Initial testing

The initial approach was to attempt to treat the stain locally. Overall washing was not considered an acceptable option given the uncertainty of how the image area would be affected by the swelling of the linen threads during a wet treatment, in addition to the question of whether or not it would effectively reduce the stain.

Initial tests were undertaken on the tacking margin using a suction disk masked down to a 0.6-cm diameter hole and connected to a 560-W (3/4-horsepower) rotary vane vacuum pump. The water used for solutions preparation and rinsing was purified by reverse osmosis using a Millipore RO-10 unit and polished by Milli-Q Plus cartridges. The specific resistance of the water was 18 MΩ. Using a suction pressure of approximately 64kPa (19" Hg), (maximum vacuum is 101kPa), the following solutions were applied:

- deionized water
- 0.5% (w/v) Canpac 645 (Orvus WA paste)
- 1:1 mixture of ethanol and water
- alkaline water (0.02M solution of magnesium bicarbonate in water with a pH of 8.3)

The solutions were first applied in a continuous stream from the end of a plastic tube of suitable diameter (1.6mm [1/16"] inner diameter Tygon® tube). One end of the tube was placed in a beaker of solvent and the other end was placed on the stain over the disk, under suction. Control was excellent and there was no lateral flow of solvent; however, there was also no effect on the tide-line.

Attention was then directed to the use of sodium borohydride (Sigma–Aldrich), a reducing agent that has been extensively studied and successfully used at CCI as a bleach for stain removal. (Burgess 1988) Although used extensively in paper conservation, it has not been used frequently to bleach textiles (Adler and Avenido). Two preparations were tested:

1 1% (w/v) sodium borohydride in ethanol; and
2 1% (w/v) sodium borohydride in water.

Figure 2. Rinsing with an airbrush after application of the bleach.

Figure 3. Applying the bleach with the ultrasonic mister.

Figure 4. Detail of tide-line before treatment.

Figure 5. Detail of tide-line after treatment.

The solutions were first applied as a continuous stream, with no effect on the tide-line. The solutions were then applied by brush and left without suction for approximately 1 minute. The ethanol solution spread very quickly along the threads, thereby creating a risk to the unstained areas of canvas; the impulse was to rinse it before it had any bleaching effect. The borohydride in water solution remained a droplet on the surface that was slowly absorbed into the fabric; the area was then rinsed with a continuous stream of water. This technique was effective in lightening the tide-line but was impractical because of the small area that could be treated at one time.

In search of a more effective and efficient treatment, the following procedure was developed using a textile suction table manufactured by Museum Services Corporation. It was successful in reducing the visual impact of the tide-line. After one area had been treated the owner was consulted as to whether or not the result was acceptable; with the owner's approval treatment continued.

Treatment

- The textile suction table was covered with Mylar® except for a small area which was covered with fine metal mesh and silkscreen fabric. (These layers provided a continuous open surface behind the object through which to pull the reagents, and created a surface with minimal texture that eliminated the risk of imprinting on the object during treatment under suction.)
- The stain was aligned over the exposed surface and masked down with a latex sheet, from the top, to an area approximately 4 × 6cm, allowing an area of tide-line about 3 × 5cm to be treated at one time. Suction pressure without the object measured approximately 4.98 kPa (20" water column); pressure measured approximately 11.7 kPa (47" water column) with the object.
- Sodium borohydride, 1% (w/v) in water, was applied by brush in a fine line to the darkest edge of the tide-line.
- After one minute, the area was dabbed with blotter paper to remove excess bleach. The suction was turned on and the area was rinsed with water, applied with an airbrush for about three minutes (See Fig. 2).
- Bleaching followed by thorough rinsing was required to lighten the darkest edge of the tide-line effectively; however water rinsing alone, under suction, was sufficient to lighten the diffuse border of the tide-line.
- If the stain was not lightened sufficiently, two or three passes of a "mist" of bleach produced by the ultrasonic mister was applied (See Fig. 3). A gentle jet of "mist" was delivered through a disposable plastic pipette tip, approximately 0.5 cm in diameter. This technique resulted in some additional lightening of the tide-line without affecting the "natural" colour of the linen adjacent to it and was also very useful in further lightening the darker areas of diffuse staining that had not been lightened to an acceptable degree by rinsing. The misted area was rinsed with the airbrush as previously described.

This treatment greatly reduced the visual impact of the tide-line (See Figs. 4, 5, 6, 7). However, there was a slight change in tone after water rinsing alone or bleaching followed by water rinsing. In contrast to the light, warm tone of the linen in the image area, the treated area was more grey and cooler in tone, similar to the colour of the tacking margins. Colleagues have noted similar tonal differences on textiles and papers that have undergone stain removal treatment using borohydride. However, this colour difference was much less disfiguring than the untreated tide-line.

Further notes

Suction disk vs. textile suction table

The design and use of suction tables for local treatments has long been a focus of CCI, primarily through the work of Stefan Michalski (1984). In the latest modification of his textile suction disk, Michalski has incorporated a light to facilitate alignment of the stained area over the small workspace. Paul Heinrichs and Jan Vuori have continued to improve the disk, incorporating different pumps

Figure 6. Detail of diffuse area of staining partially treated.

Figure 7. Detail of diffuse area of staining after treatment.

to achieve higher suction pressures and altering the design to make it more convenient for specific treatments.

The formation of new tide-lines is always a risk when using liquids to treat stains on fabric. Suction treatments on textiles differ from those on paper in that more powerful pumps are required. It is necessary to pull more air through the open weave structure of a textile to achieve the pressures required to reduce lateral flow along yarns when moving liquids vertically through textiles. Michalski (1984) advises using a suction pressure of at least 50.8 kPa (203.9" water column, 15" Hg). Michalski also states that the average pore diameter in textiles, of tight and loose twists, is known to range between 2 and 4 microns. In Figure 3 of the 1984 paper, capillary pressures of 33.9kPa–67.7kPa (136"–272" water column) (20"–10" Hg) correspond to pore diameters of 2–4 microns, the higher pressures corresponding to the more tightly woven textiles. Thus, suction pressures of at least this magnitude are required to counteract the capillary pressures travelling along the yarns.

The recommended suction pressure can be achieved using the suction disk and it has proven extremely useful in treating smaller stains on a thin, tightly woven fabric which is very susceptible to tide-line formation (Vuori et al 1998). For some stains, the small working area of the suction disk is impractical and it is difficult to remove the stain evenly. Fortunately good results can be achieved on some fabrics with lower suction pressures. The loose weave and original size in the linen of *Legend of Red Lake Ontario* allowed us to use a slightly lower suction pressure, which was achievable on the textile table with a larger working area, without creating a new tide-line.

Bleaching using sodium borohydride

Bleaching is considered to be one of the most interventive chemical treatments in conservation, and it is used only as a last resort. It involves decolorizing unwanted coloured materials by chemically changing the stains from a coloured to a colourless state, and solubilizing and removing the staining material (Burgess 1988). In her article "Practical considerations for conservation bleaching," Helen Burgess provided some very practical guidelines on how to carry out conservation bleaching.

Most common bleaches are oxidizing agents and they have a tendency to damage organic materials, such as cellulose, to various degrees. However, in recent years reducing agents such as borohydrides have been found to be effective as bleaches for certain types of stains, especially those formed as a result of oxidation. Borohydrides are best known for their effectiveness in reducing aldehydes and ketones to alcohols. When used on cellulosic substrates (Block and Kim 1986), borohydride reduces the ketone and aldehyde groups (which are responsible for the yellow appearance of oxidized cellulose) back to alcohol groups. It stabilizes cellulose by reversing the 'ageing' effects as a result of oxidation. This protecting effect, together with its ability to remove stains, made borohydride an excellent choice as a conservation bleach. In comparison to other bleaches, sodium borohydride is considered "mild to moderate" in its bleaching efficiency (Burgess 1988).

With any localized treatment, there is always the danger that the treated and untreated areas may behave differently over time as the artifact ages. Other concerns are the risk to fugitive colorants and colour reversion. The suction technique allows us to localize the bleaching action so that the pigment layers are not affected, but it is very important that the residual bleach and decolorized materials be removed from the fabric. Thorough rinsing with water is imperative to prevent over-bleaching and reduce the potential for future colour reversion.

The duration of bleach application must be determined by testing. Lightening can continue during the rinsing stage as soluble coloured products are removed in addition to products that have been decolorized or made more soluble by the bleach. In our experience, frequent rinsing between bleach applications can help to avoid over-bleaching.

Rinsing with airbrush

To determine that rinsing was complete we relied on the fact that sodium borohydride forms a highly alkaline solution (~pH 10) in water. The pH of the

treated areas was a good indicator of borohydride residue. To obtain a pH estimate, non-bleeding narrow-range pH strips (ColorpHast®) were pre-wetted with water and pressed onto the treated area. Rinsing continued until the pH of the treated area was less than 8.

Currently, because of the risk of forming new tide-lines, pH testing is possible only along the tacking margins. Jan Vuori is working on a technique that allows pH measurement using the suction disk within the image area.

During initial testing, large amounts of water delivered in a stream or droplets from a Nalgene squeeze bottle failed to rinse the bleach from the linen; pH readings of treated areas remained at 8.9, indicating there was still residual bleach in the fabric. (The pH of the fabric was 6.5 before treatment.) Therefore, an alternative method of rinsing using an airbrush was tried. It was possible to apply the spray very accurately so that it did not extend beyond the sharp edge of the tide-line. With the suction on, approximately one minute of rinsing in 10s bursts was successful in obtaining a neutral pH, indicating that most of the bleach had been removed. The effectiveness of this method was attributed to the fact that the fine spray of water from the airbrush succeeded in penetrating into the threads and fibres of the fabric, whereas the continuous stream of water or droplets were pulled through the interstices of the weave.

Ultrasonic mister

During the first application of bleach, the natural water resistance of the fabric that was not exposed to water helps to minimize lateral flow of the bleach into the area beyond the water damage. Following rinsing, this "edge" becomes much more vulnerable to lateral flow and a light halo can develop when the area is bleached for a second time. The ultrasonic mister (Michalski and Dignard 1997; Dignard et al. 1997), with or without suction, offers excellent control and precision for bleach application. The use of the ultrasonic mister for bleach application was developed during a concurrent treatment in the textile lab at CCI.

Conclusions

Treatment of the tide-line on *Legend of Red Lake Ontario* is nearing completion; further treatment will include removing the rust stains from the tacking margin and the residual cleaning agent from the area of "overcleaning," reintegrating the light colour of the affected area with the overall tone of the aged linen, and re-stretching the work on a new auxiliary support.

The small areas available for testing (i.e. on the tacking margins) make devising a treatment for this type of stain very difficult. It is expected that improvements to the technique will be made as treatment progresses. Treatment of other objects should also provide new insight and possibilities. It is hoped that the techniques described in this paper will be useful to other conservators.

Acknowledgements

Photography was undertaken by Jeremy Powell, CCI.

References

Adler SA, Avenido MJ. Advantages of borohydride over hydrogen peroxide for the bleaching of cellulosic textiles. Unpublished paper.

Bjarnhoff M. 1984. Removal of damp blotches by the aid of low pressure table. In: de Froment D, ed. Preprints of the ICOM 7th triennial meeting of the ICOM Committee for Conservation. Copenhagen. International Council of Museums: 84.2.10–11.

Block I, Kim HH. 1986. Accelerated aging of cellulosic textiles at different temperatures: The effect of tetrahydridoborate reduction: Needles HL, Zeronian SH, Ed. Advances in chemistry series No. 212. Washington DC: American Chemical Society: 411–425.

Burgess HD. 1988. Practical considerations for conservation bleaching. Journal of the International Institute of Conservation - Canadian Group (J. IIC-CG) 13:11–26.

Dignard C, Douglas R, Guild S, Maheux A, McWilliams W. 1997: Ultrasonic misting, Part 2, Treatment applications. Journal of the American Institute for Conservation 36: 127–141.

Hutchins, JK. 1983. Water-stained cellulosics: a literature review. Journal of the American Institute for Conservation 22:57–61.

Michalski S. 1984. The suction table, II: a physical model. Preprints of papers presented at the twelfth annual meeting of the American Institute of Conservation of historic and artistic works, Los Angeles, California 15-20 May 1984: 102–111.

Michalski S, Dignard C. 1997: Ultrasonic misting. Part 1, Experiments on appearance, change and improvement in bonding. Journal of the American Institute for Conservation 36:109–126.

Potoff L. 1991. Spills, splatters, and leaks: Taking the stain out of the stain painting. (Abstract) Postprints of the joint session of the paintings and textiles specialty groups, Albuquerque meeting of the American Institute for Conservation of Historic and Artistic Works: 18.

Vuori J, Daly Hartin D, Tse S, Maheux A. 1998. Local stain removal from "Océanie, la Mer" by Matisse: The development of a reducing bleach technique using a textile suction disk, ultrasonic mister, and airbrush, Abstract submitted for publication describing work in progress.

Materials

Orvus WA Paste: (anionic detergent containing sodium dodecylsulphate) Sold as Canpac 645, International Gilders' Supplies, 12-1541 Startop Road, Ottawa ON K1B 5P2 Canada, Tel: 613-744-4248.

Sodium borohydride: Sigma-Aldrich; powder 98%, Sigma, 3050 Spruce Street, St. Louis, MO 63103 USA, Mail: P. O. Box 14508, St. Louis, MO 63178 USA, Tel: (314) 771-5765, Fax: (314) 771-5757,Order: 800-325-3010; Fax 800-325-5052; Sigma-Aldrich Canada Ltd., 2149 Winston Park Drive, Oakville, Ontario L6H 6J8 Canada, Tel: (905) 829-9500, Fax: (905) 829-9292.

ColorpHast® Indicator Strips pH 5-10, Canadawide Scientific Ltd., 2300 Walkley Road, Ottawa ON K1G 6B1 Canada, Tel: 1-800-267-2362.

Abstract

Recently, the use of lasers has become important within the field of paintings conservation. Previously used either as an analytical technique or for the cleaning of sculpture, lasers now appear as a potential alternative to the removal of discoloured and unwanted varnish layers by chemical solvents or mechanical action. While investigating the potential use of ultra-violet lasers (excimer lasers) to clean easel paintings, we found that the age of paintings strongly influenced the light absorption length of coatings, one of the most important parameters affecting varnish removal. This paper gives a description of the work undertaken and also the usefulness of pulsed laser ablation as an efficient and safe cleaning technique. Results are given for different artificially aged varnishes – dammar, copal oil, mastic and Ketone N – and these will also be compared with freshly deposited dammar varnish.

Keywords

cleaning, easel painting, UV laser, varnish, absorption length

Measurement of the light absorption length of 308nm pulsed laser light in artificially aged varnishes

Arthur E.Hill,★ Thierry Fourrier, Jason Anderson,
Athanassia Athanassiou, Colin Whitehead
Joule Physics Laboratory
Department of Physics, University of Salford,
Salford M5 4WT
UK
Fax: +44 0161 295 4761
Email: A.E.Hill@physics.salford.ac.uk

Introduction

Scientists, conservators and conservation scientists (Asmus 1986: Dickman 1994: Fotakis et al. 1995: Larson 1996: Cooper 1998: Young 1998) have shown considerable interest in the use of laser techniques for the removal of unwanted layers from various artefacts such as icons, sculptures, stained glass, etc. When removing crust or pollutants from sculpture there is frequent reliance on the somewhat misleadingly named 'self limiting process' (Cooper 1998) – an expression which implies that, once a layer is totally removed from its substrate, no further damage occurs to the underlying, original layer. This may be justified by a difference in the ablation threshold (i.e. minimum energy required for ablation) of the top layer relative to the bottom layer. When applying a similar laser technique to paintings, it has been demonstrated (Hill et al. 1998) that one cannot rely on a self-limiting effect. Both paint and varnishes are made from oleoresinous materials. Once light has 'ablated' the coating layer, it will, if not prevented by a suitable control system, penetrate to the paint layer, resulting initially in discolouration of some pigments and subsequently in ablation of the paint. To overcome this problem it was proposed (Whitehead et al. 1996) that the laser action should be stopped before it reaches the paint film, thereby leaving a thin film of varnish on the paint. This layer should have a thickness of the order of, or greater than, the exponential light absorption length (α^{-1}) of the coating at the specific wavelength employed. This crucial parameter governing any pulsed laser ablation system is the reciprocal of α, the absorption coefficient and determines how far into the material the light can penetrate. It is generally an intrinsic property of the material and is strongly dependent on the wavelength of the incident laser light (Hecht 1987).

If α^{-1} is large, the energy is deposited through a deep region, the mean energy density is low and ablation processes are limited. If α^{-1} is small, the energy is deposited through a small depth, the energy density is higher and ablation occurs more readily. In the limit of very small values of α^{-1}, the ablation efficiency reduces because material can only be removed to the shallow depth penetrated by the pulsed laser light. Therefore, it follows that there is an optimum value of α for efficient pulsed laser ablation to take place.

When removing varnish from a painting with ultra violet laser light at 308nm, it is essential to minimise thermal effects which could discolour pigments (Whitehead et al. 1996) and/or change the nature of the pigment layers. Under the ablation regime commonly used (fluence ~ 500-600mJ/cm$^{-2}$), the light and thermal absorption lengths are assumed to be comparable (Pettit 1993). Consequently, by leaving a coating thickness of the order of, or greater than, α^{-1}, almost no energy penetrates to the pigment, virtually eliminating all risks of discolouration due to a thermal process. Furthermore, α^{-1} has a very strong effect on the rate of ablation of a material and a knowledge of its value is of great importance for experimental ablation work, cleaning of works of art and also for computational modelling of the interaction of laser light with different materials. There is very little information

★ Author to whom correspondence should be addressed

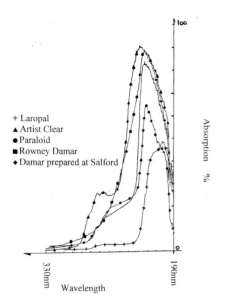

Figure 1. 'Cold' UV absorption characteristics of a number of varnishes.

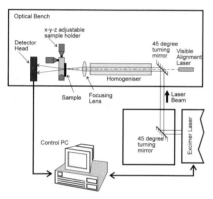

Figure 2. The experimental arrangement of the apparatus used to measure the laser light absorption length in the different varnish materials.

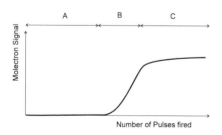

Figure 3. Showing schematically how the Molectron signal varies with the number of applied pulses.

available about the physical properties of artist's materials and no mention of absorption length was found in the literature. It is, thus, very important to measure or estimate the absorption length of some common varnishes in order to construct a useful database for future reference.

Figure 1 shows the UV absorption characteristics of several different varnishes. Care needs to be taken when interpreting these data. It cannot necessarily be assumed that these data are valid for the laser ablation process because the spectra were taken using a spectrometer and a 'cold' UV light source. When a laser source is used for ablation the surface may be modified, such as a change in surface roughness and hence reflectivity. This can easily affect the absorption characteristics of the varnish. Similar effects in metals were reported by Basov et al. (1969) who noticed that, despite its high reflectivity coefficient (close to 99.9%), aluminium was one of the easiest materials to ablate with UV light. Once heated, aluminium showed a reflectivity of only 5%, which increased coupling and hence ablation.

For the reasons highlighted above, knowledge of the laser light absorption length under actual ablation conditions is very important. This paper details some experiments performed to measure the light absorption length in different modern and artificially aged varnishes using pulsed UV excimer laser light of wavelength 308nm.

Experimental work

Figure 2 shows the experimental arrangement of the apparatus used to measure the absorption length of laser light in different varnish materials. These experiments were performed using an automated laser control system. Pulses of light 20ns long and of wavelength 308nm from a (XeCl) Lambda Physik EMG 102 MSC laser were directed through a laser beam homogeniser mounted with coated optics (Excitech Ex-Hs-700D) and focused onto the sample holder. The laser beam size was 1.5mm by 1.5mm. A varnish sample on a glass microscope slide substrate was placed on the holder in the laser beam path. The Molectron beam energy meter head (J25 HR max. responsivity at 337nm) was mounted behind the sample with its output signal feeding an analogue-to-digital computer interface unit. In this unit, the signal was digitised and fed into the laser control system for monitoring and recording.

The laser was set to fire at 1 shot per second at a specified power level. For each laser pulse the signal from the energy meter was recorded. This continued for a fixed number of pulses: the number of pulses was chosen so that, at the specified power level, all the varnish would be removed. Care was taken not to change the Molectron calibration control for the duration of the experiment.

As the varnish was ablated, the energy transmitted by the sample increased. This rise continued until all the varnish was removed and only the glass substrate remained to attenuate the beam. From these graphs, the laser light absorption length in the varnishes was determined.

Theory

The results obtained for the experiments described above are summarised here. The general form of the curves can be seen in Figure 3. In this figure, in the first region, 'A', the trace is flat. This corresponds to a thick layer of varnish: all the laser light is absorbed by the varnish and very little is transmitted. As further shots are applied the varnish is progressively removed. This layer transmits the laser light and the transmitted energy begins to rise (region 'B'). In region 'C' no varnish remains. The final value of transmitted energy depends on both the incident laser fluence and the absorption characteristics of the glass microscope slides. [Note that, for these experiments, slides with differing transmission characteristics were of necessity used for the sample preparation, owing to the difference in age and source of the samples.]

In region B the slope of the curve depends both on the absorption coefficient and on the ablation per pulse. At the laser fluences used for this work (400–500mJ/cm2) the rate of ablation per pulse is essentially constant within the accuracy of

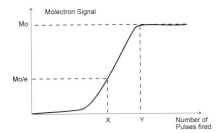

Figure 4. Detail of how the Molectron signal varies with the number of applied pulses.

measurement (about 10%) through the whole thickness of up to 100 μm of varnish (See Fig. 4). If this rate of ablation, a, and the absorption coefficient, α, are constant throughout the varnish thickness then the form of the curve in section B is given by:

$$I(t) = Io \exp(-\alpha (L - Na))$$

Where Io is the incident light intensity, I(t) is the light intensity energy after a thickness t has been ablated, L is the original thickness of the varnish and N is the number of pulses used to ablate the thickness t. From the shapes of section B, measurement of α, and hence α^{-1}, can be determined for different varnishes and for different fluences as detailed below.

Results

The first experiments were carried out on dammar varnish. In order to characterise the measurements, their reproducibility and their legitimacy, dammar varnish was brushed onto two different substrates: a quartz slide and a borosilicate glass slide. [Note: Quartz is very transparent to UV light, unlike borosilicate glass.]

These preliminary experiments helped to determine whether the measurements of the light absorption lengths of the varnishes were dependent on the nature of the substrate used. The first samples under investigation were made using freshly deposited dammar varnish. These samples were prepared at the University of Salford, following preparation instructions from the Tate Gallery collaborators who also supplied the dammar resin. The solvent used was a 4:1 White Spirit:xylene mixture, and 20% by weight resin was added and thoroughly dissolved. All varnishes were brushed onto microscope slide substrates which had reasonable transmission (about 30%) at 308nm. The freshly prepared dammar was applied both to a 30% transmission slide and to a quartz, UV-transparent substrate.

The fresh dammar samples were air-dried for up to 14 days. The artificially aged samples of dammar, Copal Oil, Ketone-N and Mastic had been prepared by the Tate Gallery in the following ways:

Dammar	kept in dark for 2 years
Copal Oil	96 days in a box on roof of Tate Gallery in summer and then heat-aged for 4 days in a climate-controlled oven at 60 degrees C and 52% RH at the Tate.
Ketone-N	As for Copal Oil
Mastic	As for dammar

In all the samples, the varnish thickness was determined by totally ablating all the varnish over a 1.5 by 1.5mm area and then measuring the depth of this hole with a surface profiler (depth variation 1 micron). These measurements were repeated a number of times and showed about 10% reproducibility. The thicknesses are given in Table 1.

The difference in the absorption coefficient of quartz and borosilicate glass did not result in any apparent difference in the measured value of light absorption length of freshly deposited dammar varnish.

Table 1. Summary the values of thickness for the different kind of varnishes.

Varnish	Average Thickness in μm	Ablation rate in μm per pulse (at 0.97J/cm²)	Absorption Length, in α^{-1} in μm
Freshly deposited dammar on Quartz slide	104	2.97	42 ± 5
Freshly deposited dammar on Borosilicate glass slide	106.8	3.16	44 ± 5
Artificially aged dammar	34.7	2.31	11.1± 3.0
Artificially aged Copal oil	29.1	0.96	6.0 ± 3.0
Artificially aged Ketone	9.2	0.92	7.2 ± 3.0
Artificially aged Mastic	25.7	1.28	14 ± 3.0

Figure 5a. Energy transmitted through the varnish as a function of number of pulses for modern dammar varnish.

Figure 5b. Energy transmitted through the varnish as a function of number of pulses for modern dammar varnish painted onto a UV transmissive cuvette.

Figure 6. Energy transmitted through Copal oil varnish as a function of number of pulses.

Figure 7. Ablation comparison between freshly deposited and artificially aged dammar varnish.

Figure 5b shows transmission versus number of shots for the freshly prepared dammar sample on quartz for different laser fluences. Analysis of these curves yields an absorption length α^{-1} of 42 ± 5 mm. Very similar results giving $\alpha^{-1} = 44 \pm 5$ mm for the sample on a microscope slide show (See Fig. 5a) that, at least to the first order, the substrate does not affect the measured absorption length. In the case of the quartz substrates, two of the curves were unsuitable for measurements because the transmitted signal was much larger than that for the glass slides and the Pyroelectric detector saturated.

Figure 6 shows the transmission for the artificially aged Copal oil sample, and gives an absorption length of 6.0 ± 3 µm. Measurements were then taken for the remaining samples and the results are summarised in Table 1.

Figure 7 shows the effect of age on ablation of freshly deposited dammar and aged dammar under ultra violet light (conducted at 248nm).

Summary and conclusions

The absorption length for modern freshly prepared dammar is much greater than for the other artificially aged materials, implying that the fresh varnish is much more transparent to UV light than the older samples. This suggests that, in this respect, older materials should, in practice, be easier to clean by mean of laser techniques than more modern ones, because of the possibility of a greater degree of control offered by the lower ablation rate. It can be seen from the first part of the curves of Figures 5a, 5b and 6 that the transmitted energy oscillates between two values. We suggest that the effect is as if the first shot causes some surface modification and changes the absorption properties of the varnish. The next shot

is more strongly absorbed as a result and material is removed efficiently. The next shot is then incident on 'fresh', unmodified varnish and the cycle repeats. Sometimes two or more shots are required to 'clear away' the modified surface layer. This effect is possibly due here to the presence of solvents left behind in the resin matrix as a result of insufficient drying time.

The results for 6 samples of varnish show a level of repeatability as indicated by the ± uncertainties. These uncertainties arise mostly from systematic errors associated with material surface and bulk uniformity. There is approximately a factor of 2 variation in absorption length between the different artificially aged varnishes which probably arises from the difference in chemical composition.

The value of α^{-1} depends on the material under investigation and so is a fixed property at a fixed wavelength. However, it does vary with the wavelength of the incident laser light and so, by using different laser wavelengths, the user can have some control over its value. For general polymer materials, as the wavelength is reduced through the UV part of the spectrum, the light absorption length also decreases and the material becomes less transparent.

It has been shown that, although the use of freshly prepared varnish samples can be useful in developing techniques and optical systems, the ablation/absorption behaviour is not representative of artificially aged varnishes nor, probably, of naturally aged varnishes.

This work is the first step towards the building up of a database of some useful physical properties of varnishes. This should help future progress in the field of paintings restoration.

Acknowledgements

This research was a two year project supported by BNFL. The authors would also like to thank S. Hackney & Dr J. Townsend from the Tate Gallery London, P.E. Bowes from North West Conservation services in Blackburn and A. Phenix from the Courtauld Institute of Art for their constant help and advice towards the project, as members of its Steering Committee.

References

Asmus JF. 1986. More light for art conservation. IEEE Circuits and Devices Magazine, 2 (2) March: 6–15.

Basov NG et al. 1969. Reduction of reflection coefficient for intense laser radiation on solid surfaces. Soviet Physics-Technical Physics, 13 (1).

Cooper M. 1998. Laser cleaning in conservation, Butterworth-Heinemann: 54–56.

Dickmann K. 1994. Reinigung von Glasoberflachen an kulturhistorischen Gutern mit Excimer-laser-strahlung. Laser Magazin, June: 10–13.

Fotakis C et al. 1995. Laser applications in painting conservation. Optical Society of America TOPS on laser and optics for manufacturing 6: 99–104.

Hecht. E.1987. Optics. 2nd Edition, World student Series. London: Adisson-Wesley.

Hill AE et al. 1998. Progress in the use of Excimer Laser to clean easel paintings. In: Proceedings of the 5th International Conference on Optics with Life Sciences, Aghia Pelagia,Crete, Greece.

Larson JH, Cooper M. 1996. The use of laser energy for cleaning architectural terracotta decoration. In: Architectural Ceramics: their history, manufacture and conservation. Joint symposium of English Heritage and UKIC, September 1994. London: James & James: 92–100.

Pettit GH. 1993. Pulsed ultraviolet laser ablation, Applied Physics A, 56: 51–63.

Whitehead C et al. 1996. Potential use for Excimer Laser to clean easel paintings. In: Proceedings of the Lacona II Conference, Liverpool. (To be published by Verlag Mayer, Vienna, June 1999).

Young CRT. 1998. A preliminary study into the suitability of Femtosecond lasers in the cleaning applications for canvas paintings, In: Proceedings of the 5th International Conference on Optics with Life Sciences, Aghia Pelagia,Crete, Greece.

Abstract

Fourteen methods of local treatment for cupped cracks were applied to model paintings. Profiles of the painting surface were monitored with a mechanical scanner over the course of several months. The model paintings follow a combination often used by contemporary artists: oil paint on acrylic ground on cotton duck fabric. Nine identical cracks were made in each of nine paintings. Local crack treatments included relaxation and flattening alone, adhesion of a solid plate for reference purposes, various sizing methods, and eight variations on the application of small strips of stiff material across the crack. Of the latter, three variations gave good results in terms of maintaining flatness and not surfacing. All methods show measurable stress relaxation, i.e., return of cupping, but the rate varies from hours to weeks to centuries, depending on the visco-elastic properties of the materials. Results are given for slack painting conditions only. Taut painting conditions will be reported later.

Keywords

paintings, cracks, cupping, local treatment, stress relaxation

Preliminary results of a research project exploring local treatments of cupped cracks in contemporary paintings

Mary Piper Hough★
Queen's University and Canadian Conservation Institute
PO Box 2162
Kingston, Ontario
Canada K7L 5J9
Email: marypiperhough@hotmail.com

Stefan Michalski
Canadian Conservation Institute
Email: stefan_michalski@pch.gc.ca

Introduction

A common problem in contemporary paintings is local cracking of the paint and ground layers. Due to their cupping, these cracks become particularly disturbing in areas of flat color. Although cupping may be removed by moisture, solvent vapors and/or heat, maintaining flatness may require reinforcements, which in turn, may "surface". Cracks are often localized, so one attempts to treat them locally, rather than submit the entire painting to the hazards of an overall treatment, such as lining or marouflage. This study examines several methods of local treatment in terms of profile measurements and visual assessment.

During this project, extensive data on the rate of development of cupping after cracking, and their response to RH change were collected. These data and their interpretation in terms of visco-elastic mechanics will be the subject of a later paper.

Treatment types and their mechanical modelling

Causes of cupping and surfacing (Figure 1)

Traditionally, cupping of cracks and surfacing of patches were explained as differential shrinkage of various layers, a mechanism we call "curl". The more modern explanation is "stress alignment" (Mecklenburg 1982). Both explanations are true. Stress alignment cannot produce cupping or surfacing beyond half the thickness of the painting, and it cannot explain cupping in slack paintings. Curl explains cupping and surfacing in slack paintings. Tautening a slack painting will reduce severe cupping or surfacing due to curl, but flattening reaches a limit set by the stress alignment conformation. In this experiment, two stages have been planned for testing treatments: slack for one year, then taut for one year. Here we report the slack stage driven by curl. During our monitoring of the cracked model paintings prior to treatment, cupping increased after we released the tension in the paintings, exceeding the painting half-thickness, thus confirming curl as the dominant driving force.

Treatments with adhesive/size only (Figure 2)

In treatments where an adhesive is flowed into the crack to bond the two fracture faces, the net result depends entirely on whether or not the fracture faces are bonded. We will refer to it as a "butt joint". The process of applying adhesive or

Figure 1. Cupping mechanisms in slack and taut paintings. (Top) Slack painting. Cupping is caused by curl: greater shrinkage in the upper layers than the lower layers. Curl in localized cracks is limited by the resistance of the perimeter of intact painting (P) to moving towards the crack. This movement can cause puckering at the crack tips. Cupping is highest at the middle of a local crack, and increases with increasing crack length.
(Bottom) Taut painting. Cupping due to 'stress alignment': CP (centre of tension of intact painting far from crack) aligns with CF (center of tension of the fabric hinge). Height h cannot exceed the difference between CP and CF when flat.

Figure 2. A butt joint. Excess adhesive or size in the fabric can lead to curl in either direction (not shown), depending on whether the fabric/adhesive composite shrinks (surfacing) or expands (moating).

★ Author to whom correspondence should be addressed

Figure 3. Surfacing mechanisms in slack and taut paintings after adhesion of reinforcements. (Top) Slack, stable painting. Stiff, dimensionally stable reinforcement. (Middle) Slack or taut painting. Shrinking reinforcement such as an old glue patch causes surfacing due to curl. Since the perimeter (P) of intact painting is drawn in by the curl, puckers may form around the patch. (Bottom) Taut painting. Stiff reinforcement. Surfacing due to alignment of CP (the center of tension of intact painting) and CR (center of tension of the hinge with reinforcement).

Figure 4. Model painting, back (top) and front (bottom) views.

Figure 5. Crack apparatus. Cross-section (top) and side view showing the blade arm partially raised (bottom).

size to the fabric under the crack may or may not result in a butt joint. It is, unfortunately, extremely difficult in practice to make a continuous and neat butt joint.

Treatments with reinforcement plus adhesive/size (Figure 3)

Cupping height immediately after treatment will depend on the elastic balance between cupping forces and bending stiffness of the reinforcement. Behaviour over time will depend on the visco-elastic components of these forces. In order to maintain flatness, a reinforcement must stress relax more slowly than the paint layers. This suggests either inorganic materials (metal, glass) or highly crosslinked, filled polymers.

Experimental method

Preparation of model paintings (Figure 4)

A widely used contemporary artist's technique that can exhibit problem cupping is oil paint on acrylic ground on cotton duck fabric. Eighteen such paintings were prepared. Commercial keyed stretchers (24" × 66", 61cm × 168cm) were modified by the addition of two cross bars, placed so as not to interfere with later crack treatments. These crossbars ensured that the tension in the paintings could be released in the long axis without disturbing the short axis. To allow later slackening, the stretcher was expanded 6mm in each direction and fixed. Heavyweight #10 cotton duck was attached. The fabric perimeter was masked with tape to create a 7.5cm border of resilient fabric around the painted area. Liquitex Acrylic Gesso was brush applied undiluted in three coats (3 hours between coats, 15+ days before oil paint). Winsor & Newton Foundation White Oil paint (lead white/zinc white) was applied with the addition of 5% mineral spirits (to increase workability and to exacerbate shrinkage). Six coats were brush applied, one per day. The final coat dried 12–14 days before cracks were made. The ground and paint were weight monitored for uniform application.

Cracking of model paintings (Figures 4, 5)

A cracking apparatus was made for the project. Nine vertical cracks were made in each painting, 15cm long, spaced 15cm apart. The apparatus and paintings were kept in a cold room at −5°C (±2°C) to ensure brittle glassy behavior during impact. The painting was held face down over a narrow trench. The sides of the trench were parabolic curves to prevent collateral cracking. A sheet metal straight edge, held by a heavy hinged arm, was dropped on the painting. It was adjusted to strike the painting precisely parallel. An adjustable bumper stopped the edge after it had travelled 2mm past the point of contact. Thus the edge hit with high velocity, but stopped before it stretched the fabric bridging the crack. Two metal plates held the painting 7cm from either side of the crack, to prevent the shock from affecting adjacent cracks. The cracks showed crisp fracture surfaces, and closed completely when the cupping was held flat.

Heat aging of model paintings

Eighteen model paintings were cracked. Nine of the paintings were set aside for future treatments. The remaining nine model paintings (81 cracks) were used for the local treatments reported here. Prior to heating, these nine paintings were slackened in the direction perpendicular to the cracks in order to facilitate curl. The paintings were then heated to enhance curing, and to speed any visco-elastic forces driving curl. Heating took place in an environmental chamber for 19 days at 41°C±2°C and 10%RH ±2%RH. The paintings and cracks were oriented vertically, in order to eliminate any tension from gravity across the cracks.

Figure 6. Suction table design. Cross-section (top) and top view (bottom). The entire table was 76cm × 61cm (30" × 24"), work area was 25cm × 18cm (10" × 7").

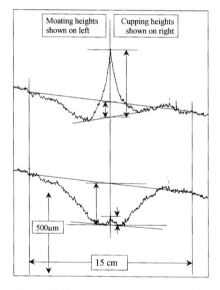

Figure 7. Sample scans across one crack before treatment and after treatment 70 days later (one of #11). Lines as shown were drawn to extract the measurements. The small oscillations in the graphs are the impasto. The scans were always made along the same line, allowing the impasto signature to be used for alignment and identification if necessary.

Randomization of samples

Treatments were randomized across the paintings such that each replicate of a treatment was performed on a different painting and different crack location. Each painting was divided into three sections, two ends and a middle. Triplicates were chosen so that at least one middle and one end were present. Other elements were also randomized: order of treatments; time within project; time of day; treatment equipment (different suction tables).

Suction tables (Figure 6)

During treatment, cracked areas of the painting were held flat by purpose-built suction tables. Eight tables and four vacuum cleaner type pumps (blowers) were used, so that concurrent paintings could be treated and left under suction for the extended curing period. After testing a variety of materials, the following structure emerged: (from the bottom up) a sheet of glass; heavy, open weave, polyester monofilament fabric to distribute airflow; 3.2mm sintered polyethylene sheet taped to the glass; Whatman filter paper to provide additional cushioning and to separate the paint surface from the polyethylene; Mylar® sheet; and Hollytex. A 50mm hole through the Mylar at one end was attached to 50mm diameter pipes connected to vacuum pumps 15m distant. The Mylar sheet had a central rectangular opening onto which the cracked area of the painting was placed paint side down. Upstream from the suction source were two small tubes, one for attachment to a suction gauge, the other for an adjustable air bleed.

Profile measurement (Figure 7)

A mechanical profile scanner was developed for this project. A cast iron optical bench was used as a precise track, 2m long, supported above the painting. A "trolley" was made to slide on the track, and driven by the same XY plotter used to record the scan. Hanging from the trolley was a counter-balanced arm linked to a linear displacement transducer which provided the Y signal. The end of the arm held a 0.5mm diameter plastic stylus that tracked at less than 1g force, small enough to follow impasto without leaving any marks but large enough to cross over the cracks without becoming stuck. Sensitivity was about 1μm height. Over 2,000 scans were recorded during this project.

Experimental treatments

Pre-treatment with moisture and heat relaxation

Moisture was applied to the crack area at the face of the painting for 24 hours (using damp felted Gore-Tex, separated from the paint surface by Hollytex). This was followed by heat from the reverse plus suction from the face of the painting. Heat was applied by a 13mm aluminum plate, 59°C ±4°C, placed on the crack reverse until cool (3.5hours). The paint layer reaches 50°C ±6°C. Suction was maintained for 30 hours. This was sufficient to allow the slowest drying/curing treatment that followed pre-treatment to set up, as well as to allow the moisture to leave the paint films. Weight loss studies had been made to establish moisture equilibration times. The air bleed on the upstream side of the suction tables facilitated drying.

Mechanical treatments

For most treatments (#2–#11), the reinforcement was applied while the painting was held flat, face down, under suction of 17.4kPa ±1.5kPa (4.7–5.6 in.Hg). This pressure is neither recommended nor condemned for normal practice: it was the pressure supplied by the weakest of the four vacuum cleaners, and it was sufficient to hold the cupped paint film flat as the treatments cured. All the strips of material used in treatments #4–#11 were fabricated so that their thickness was the same (0.50mm ±0.05mm). This thickness was fixed by the stainless steel strips of treatment #4 (0.48mm). Width varied between 0.64mm (stainless steel strips) and

Table 1. Summary of treatment results (numbers in center columns are 5minute/70day heights in micrometers).

Group	#	Reinforcement	Adhering Layer	Size	Cupping µm	Moating µm	Surfacing	Comments — Visual appearance in raking light at 70 days	Promising
	1	No reinforcement, no size, just heat, moisture and flattening.			x x 235/380	✓	✓	Initially, crack appears 1/2 height. In a few days it reaches before treatment height, but with more gradual slope. In two months, the original slope reappears.	
Plate	2	Acrylic, 6mm	Epoxy		✓✓ 25/25	✓	x	Crack appears very flat. Plate perimeter has surfaced.	
Plate	3	Epoxy/ Al. Foil	BEVA® film		✓✓ 15/25	✓	x	Crack appears very flat. Plate perimeter has surfaced.	
Strips	4	Stainless steel strips	BEVA® film		✓✓ 35/45	✓	✓	Crack appears slightly raised.	✓
Strips	5	Epoxy/ Glass filaments Heat cure	BEVA® film		✓✓ 40/60	✓	✓	Crack appears slightly raised.	✓
Strips	6	Epoxy/ PE threads Heat cure	BEVA® film		✓ 70/90	✓	✓	Crack appears slightly to moderately raised. Epoxy heat curing appears significant. In one sample, crack ends are slightly raised, middle appears flat.	✓
Strips	7	Epoxy/ PE threads NO heat cure	BEVA® film		x 70/125	✓	✓	Crack appears moderately raised. In one treatment, ends are a bit more raised than the middle.	
Strips	8	Epoxy/ PE threads NO heat cure	threads applied wet		✓ 45/55	✓	✓	Crack appears slightly raised. Suction pulled epoxy through to the surface in several spots in 3 of the 4 cracks, despite time allowance for initial epoxy set. In the 4th crack, epoxy did not come through; as a result the height control is not as good.	
Strips	9	Jade 403/ PE threads	threads applied wet		x x 190/385	✓	✓	Initially, crack appears partly lowered. In a few days reaches before treatment height, but with more gradual slope. By 70 days, the original slope has reappeared.	
Strips	10	Epoxy/ PE threads Heat cure	BEVA® film	BEVA® 371 Heat	✓ 105/70	x 30/10		Crack appears slightly raised. Slight improvement due to size compared to #6. Swelling from size diminished in one week. Sized area slightly moated.	
Strips	11	Epoxy/ PE threads Heat cure	BEVA® film	B-72 Heat	✓ 80/60	x x 10/140		Crack appears moderately raised. Swelling from size diminished in one week. Sized area strongly moated.	
No reinforcement	12			BEVA® 371 heat	✓ 60/60	x 110/70	✓	Crack slightly to moderately raised. Variable crack height - middles tend to be more closed than the ends. Initial swelling from the size diminishes after one week. Sized area moderately moated.	
No reinforcement	13			B-72 heat	x 150/200	x x 55/145	✓	Crack appears about 1/2 the height of before treatment. Initial swelling from the size diminishes after one week. Sized area severely moated.	
No reinforcement	14		Epoxy butt joint		x 60/115	✓	✓	Crack appears moderately raised. There is a slight yellowing of the paint from contact with the epoxy, and/or epoxy residues present on the paint surface.	

2mm. Various casting and moulding techniques were employed, and a micrometer used to check all strip thicknesses, except strips #8 and #9 (wet treatments) which were moulded in situ. All strip treatments #4 – #11 were spaced at 3.2mm (1/8") intervals, with alternating lengths of 25mm and 12.5mm (1", 1/2"), except #8:

#1 No reinforcement. Pre-treatment only (see Pre-treatment section above).

#2 Acrylic plate, 6mm thick, applied over a wide area with 5 minute epoxy. This was a benchmark for experimental purpose, not a suggested treatment for paintings.

#3 Epoxy/aluminium foil plate 50mm wide attached with BEVA film (2 layers). The plate was made with three layers of aluminum foil (100µm) adhered by 5 minute epoxy, each layer 12mm narrower than the next in an attempt to "feather" the edges and reduce surfacing. This was an exploratory treatment designed to test the behaviour of very thin aluminum composites, and continuous patches. It was many times faster to complete than the strip techniques below. Only one replicate.

#4 Individual stainless steel strips (0.48mm × 0.64mm rectangular dental "wire") attached to the fabric with two layers of BEVA film.

#5 Strips of epoxy (Epoweld 3672) filled with full-length glass filaments (50µm diameter), oven heated to improve curing of the epoxy. Attached to the painting with two layers of BEVA film.

#6 Strips of epoxy (Epoweld 3672) coated polyester threads, oven heated to improve curing of the epoxy. Attached to the painting with two layers of BEVA film.

#7 Strips of epoxy (Epoweld 3672) coated polyester threads, allowed to cure at room temperature. Attached to the painting with two layers of BEVA film.

#8 Strips of epoxy (Epoweld 3672) coated polyester threads applied wet to the painting. Four variations on thread arrangement: a) threads alternating lengths of 25mm and 12.5mm spaced at 3.2mm (1/8") intervals; b) same lengths, 6.4mm (1/4") intervals; c) double lengths, 3.2mm intervals;

d) double lengths, 6.4mm intervals. Because of the use of suction during the application of the threads, the epoxy came through the crack to the painting face in a few spots.

#9 Strips of Jade 403 coated polyester threads, applied wet to the painting.

#10 BEVA 371 size (1:1 naphtha) applied to reverse of crack area, 12.5mm on each side of the crack, dried 2 days, then hot aluminum plate (13mm, 73.5°C–80°C) applied, left to cool. Strips of epoxy (Epoweld 3672) coated polyester threads oven heated to improve curing of the epoxy. Attached to the painting with two layers of BEVA film.

#11 Acryloid B72 size (20% in xylene) applied to reverse of crack area, 12.5mm on each side of the crack, dried 2 days, then hot aluminum plate (13mm, 73.5°C–80°C) applied, left to cool. Strips of epoxy (Epoweld 3672) coated polyester threads oven heated to improve curing of the epoxy. Attached to the painting with two layers of BEVA film.

#12 BEVA 371 size (1:1 naphtha) applied to reverse of crack area, 12.5mm on each side of the crack, dried 2 days, then hot aluminum plate (13mm, 73.5°C–80°C) applied, left to cool.

#13 Acryloid B72 size (20% in xylene) applied to reverse of crack area, 12.5mm on each side of the crack, dried 2 days then hot aluminium plate (13mm, 73.5°C–80°C) applied, left to cool.

#14 Epoxy (Epo-tek 301) flowed into the crack from face, to adhere the two fracture faces in a butt joint. Unlike all the above, suction applied by Mitka table, painting face up. Excess epoxy cleaned from face, flat weighted surface applied 24 hours.

Results and discussion

Yellowing and bloom problems

Early results made it clear that the pre-treatment was yellowing and blooming the oil paint. Although these effects were surprising, and were perhaps a peculiarity of this particular paint, or its newness, it seemed pointless to establish a treatment for cupping if there was any risk of such side-effects on contemporary paintings. Results of a trial treatment without pre-treatment were very promising, so it was decided to abandon pre-treatment on the second and third set of treatment replicates.

Separate experiments on spare materials established that moisture, not heat, caused the yellowing. With exposure to the fluorescent lights in the lab, this yellowing was noticeably reduced by three days, and was invisible by two months. However, bloom remains.

Practical results and discussion (Table 1, Figure 7)

Table 1 compiles all the practical results and comments *for the "slack painting" condition only*. An overall qualitative assessment of each treatment's ability to control cupping, avoid moating, and avoid surfacing during the "slack painting" phase has been indicated by checks (good) and crosses (bad). Cupping appearance is not perfectly consistent with the measured cupping height. This reflects the complex interplay of cupping and moating on the visual assessment. Three treatments show promise for further study: #4, #5, #6.

Mechanical results and discussion (Figures 7, 8)

Cupping height and moating height are defined in Figure 7, and plotted in Figure 8. The logarithm of time was chosen for all plots because it often gives straight lines for stress relaxation, i.e., visco-elastic behaviour. All error bars in figure 8 represent one standard deviation about the mean of three replicates, except #8, which averages four samples.

Pre-treatment only, #1, for flattening without reinforcement, shows about half the cupping returns elastically, i.e., as soon as we release the suction, and the remaining half returns visco-elastically over the next 20 hours. The 45µm difference between the before treatment value (425µm) and the 70 day plateau

Figure 8. Cupping height (absolute, solid lines) and moating height (change from before treatment, dashed lines) over time for each treatment. The large data point in the top left of each graph is the before treatment cupping height. Data for #2,#3 from single samples only. All others show means and standard deviation error bars of multiple samples. For #8, four replicates, for #1, #4-#7, #9-#14, three replicates.

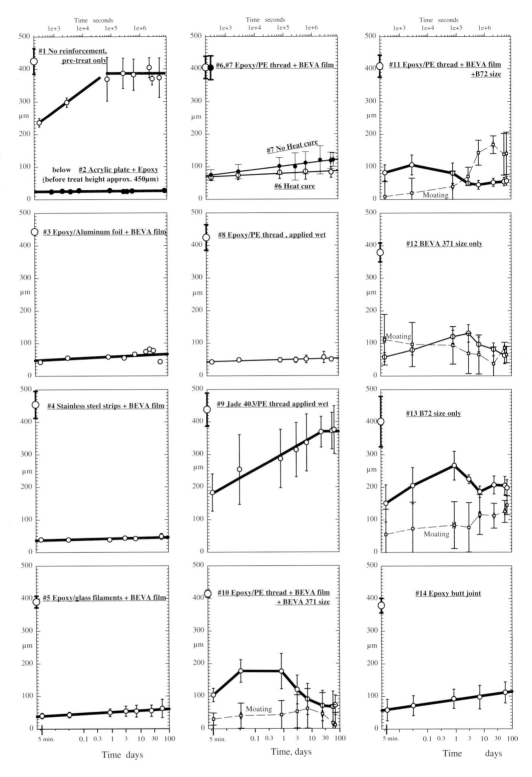

value (380μm) is either genuinely plastic flattening, or a visco-elastic component with a very long time period.

Plate treatments #2, #3 establish that the suction table can hold the cupping flat to within 15μm–25μm. With #2, there is no measurable relaxation after 200 days. The acrylic plate is massive, and the adhesive is crosslinked. With #3, some relaxation takes place, probably due to the BEVA adhesive.

Strip treatments #4–#8 all give 5 minute values approaching the 25μm benchmark of the plates. The 5 minute (elastic) values show the expected order of stiffness: metal, then glass, then polymer. All show very slow relaxation, extrapolation gives many centuries for full return of cupping. With steel #4, relaxation must be due entirely to slow shear movement of the BEVA. Glass and polyester in epoxy, #5, #6, attached with BEVA give identical relaxation rates, which are faster than the steel #4. Since glass does not relax, the epoxy matrix itself relaxes

(by shear between filaments). The difference between #6 and #7 show the benefits of heat curing the epoxy to decrease its relaxation. Treatment #8 gave better results than #7, although both are non-heat cured epoxy. This shows the benefit of a partial (inadvertent) butt joint.

Treatment # 9 shows the relaxation of a non-crosslinked polymer with a low glass transition (Jade 403). The five minute cupping is little better than pre-treatment alone (#1), and all cupping returns within about 100 days.

Treatments #10–#13 show the complex results of size. Moating has been plotted as well, since it dominates the appearance of these treatments. Several explanations are possible for the curl driving this moating, but these will be published elsewhere, along with further data.

Treatment #14 was not a fully effective butt joint because the removal of excess epoxy from the face also removed some epoxy from the joint (probably inevitable in practice).

Conclusion

These treatments are being investigated to provide options for local treatment of cupped cracks, so as to avoid overall lining or marouflage. From these preliminary results, three of the treatments with strips appear promising: #4 stainless steel, #5 epoxy coated glass filaments, and #6 epoxy coated polyester threads. It is clear from the results that for very thin strips, only very stiff materials such as metal, glass, and well-cured epoxy are effective at combating the curl tendency of lead white oil paint. What is unknown at this time is whether these strips will eventually cause surfacing or corrugating even in slack paintings. This will be monitored over time. Of course, any reinforcement will cause some surfacing in taut paintings. The purpose of the next phase of the project is to measure surfacing and its mitigation during the taut painting condition.

The neatest theoretical solution to both cupping and surfacing would be to adhere the fracture faces in a butt joint. Treatment #14 showed moderately good control of cupping during this slack painting stage of the project. This treatment may eventually fail, but at least it will never surface. For this reason alone, more study of this option is warranted.

The only mechanical treatment without side-effects is no treatment. Our preliminary data show that avoidance of low RH will substantially reduce curl forces that drive cupping, given the usual painting structure of rich (paint) over lean (ground). The role of low RH in driving cupping and surfacing due to stress alignment is well known (Figures 1, 2, 3). It is also well known that careful lighting can reduce the annoyance of cupping. These tactics remain important, though limited.

The yellowing and blooming of the oil paint due to moisture treatment were a surprise. Fortunately, it became clear that this pre-treatment was not necessary. It is noted here as a caution to those using moisture treatments on modern oil paintings.

Acknowledgements

The first author wishes to thank the Trustees of the Gerry Hedley Research Scholarship for financial support and the Canadian Conservation Institute for facilities and expertise.

References

Mecklenburg MF. 1982. Some aspects of the mechanical behavior of fabric-supported paintings. (Unpublished report, Feb. 1982. Washington DC: Smithsonian Institution).

Materials

Painting Materials

Stretchers: Conservator's Stretcher™, pine, Wingrill Limited, Brighton Industrial Park, Bag 2220, Brighton, Ontario K0K 1H0, Canada, tel. 613-475-4500.

Fabric: #10, heavyweight cotton duck (500g/m2), Light-Fast Artist Pigment Inc. 107 Kearney Drive, Ajax, Ontario, L1T 2V4, Canada, tel. 905-427-6486.

Ground: Liquitex® Acrylic Gesso, no. 5336, Binney & Smith Inc., Easton, PA 18044-0431, USA.

Paint: Winsor & Newton Artists' Oil Colour Foundation White, (Basic lead carbonate, zinc oxide in linseed oil).

Suction table and pre-treatment materials

Gore-Tex® membrane/polyester felt laminate, W. L. Gore & Associates, Inc. 100 Airport Road, P.O. Box 1550, Elkton, MD 21921, USA, tel. 301-392-4440.

Hollytex #3221 (non-woven polyester fabric, 41g/m2, 64μm thick), Mylar® (38μm thick), Talas, 568 Broadway, New York, NY 10012-9989, USA, tel. 212-219-0770.

Polyester monofilament fabric, Scapex 456, Scapa Inc., P.O.Box 1949, Waycross, GA 31502-1949, USA, tel. 800-841-5132.

Sintered polyethylene slab, 3.2mm thick, pores approximately 50μm. (Ex CCI store).

Whatman® filter paper, cat. no. 1001-917.

Treatment materials

Acryloid® (Paraloid) B-72, Rohm & Haas, Philadelphia, PA 19105, USA.

Aluminum foil cut from E-Z FOIL® baking tray, thickness: 100μm, local grocery.

BEVA® 371 Solution; BEVA® 371 Original Formula Film, Conservator's Products Company of Canada, Toronto, Ontario, Canada, tel. 201-927-4855.

Epo-tek® 301 epoxy, Epoxy Technology, Inc., 14 Fortune Drive, Billerica, MA 01821-3972, USA,tel. 508-667-3805.

Epoweld® 3672 epoxy, Hardman Inc., 600 Cortlandt St, Belleville, N.J. 07109, USA, tel. 201-751-3000.

Glass filaments, diameter 50μm, snapped in required lengths from glass fiber eraser (drafting supplies).

Jade 403 (polyvinyl acetate emulsion), Talas address above.

LePageÔ 5 Minute Epoxy, LePage, Brampton, Ontario L6T 2J4, Canada.

Stainless steel strips (dental wire 0.48mm × 0.64mm, cat. #100-52), Cerum Ortho

Organizers, 115–17th Avenue S.W., Calgary, Alberta T2S 0A1 Canada, tel: 403-228-5199, 800-661-9567.

Polyester threads from Terytex® #39 fabric (Dacron, 542g/m²), Scapa Filter Media

Jordan Road, Skaneateles Falls, N.Y. 13153, USA, tel. 315-685-3466.

Abstract

Museums of modern and contemporary art often lack the necessary information on materials and techniques used by artists. Information of this kind is crucial to the conservation of modern and contemporary art works. This conclusion of the symposium Modern Art: Who Cares? (1997) has prompted the Netherlands Institute for Cultural Heritage to start the research project 'Artist's interviews.' The project aims to offer conservator/restorers and curators a method for conducting artist's interviews in such a way that they yield the information required for the conservation of contemporary art works. Interdisciplinary collaboration between conservator/restorers and curators is a major precondition of the project. The point of departure is to collect information on materials and methods used, their meaning to the artist, and his or her attitude towards ageing and conservation or restoration. The assumption is that once an artist's oeuvre can be 'understood' in this way, questions surrounding conservation can be answered–now and in the future.

Keywords

contemporary art, artist's interview, documentation, modern materials, working methods, meaning of material (material iconology), interdisciplinary collaboration

Towards a method for artists' interviews related to conservation problems of modern and contemporary art

Ysbrand Hummelen,* Nathalie Menke, Daniela Petovic, Dionne Sillé, Tatja Scholte
Netherlands Institute for Cultural Heritage
P.O. Box 76709
1070 KA Amsterdam
The Netherlands
Fax: +31 20 305-4700
Email: modart@icn.nl

Introduction

Museums of modern and contemporary art have insufficient data on the materials and methods used by artists, and as a result issues regarding the conservation of art works cannot be addressed properly. [1] Sometimes the most basic information is missing, so that, for instance, the original appearance of an art work can no longer be reconstructed. In many cases details related to the materials and techniques used are largely unavailable, let alone information shedding light on the artist's intentions. The awareness that these information gaps need to be filled has now been brought home even to politicians. When Barnett Newman's *Cathedra* had been seriously damaged in 1997, Rudi Fuchs, director of the Amsterdam Stedelijk Museum, raised the alarm: 'If we fail to properly research our collections, we neglect our cultural heritage. When looking up the details we had on *Cathedra*, I found that the painting was made of oil paint and "Magna". No one in our museum knew exactly what Magna was. We will have to inquire about that in America. It may be a brand name of acrylic paint, but if you do not inquire in time, there is no one left who knows what it is.'[2]

One of the conclusions of the symposium Modern Art: Who Cares? (Amsterdam, September 1997) was the necessity of museums investing heavily in such matters, and that artist's interviews are a major instrument in gathering data. Several museums are already active in this area – either by written questionnaires about the use of material, or by oral interviews.[3] However, as yet no transmittable method has been developed with regard to the collection, documentation and communication of data.

The Netherlands Institute for Cultural Heritage and the Foundation for the Conservation of Modern Art intend to start the ball rolling towards the development of such a method by instigating the research project 'Artists' interviews'. We hope this first project, which runs from January 1998 to April 1999, culminates in a model which will enable conservator/restorers and curators to interview artists and exchange the data. The method will first be tested by means of ten pilot interviews with Dutch artists. On the basis of the results, conservator/restorers and curators of modern art will assess the method as to its usefulness for their collections.

The need for information

One of the art works analysed by the Foundation for the Conservation of Modern Art in 1995 was Pino Pascali's *Campi arati e canali d'irrigazione* (1967). The work presented an insoluble conservation problem. The artist could not be consulted as he had died in 1968, aged 32.

Campi arati e canali d'irrigazione is a large object installed on the ground, consisting of five shallow metal trays (*canali*) and four 'fields' (*campi*) in between. The trays should be filled to the brim with blue water. To exhibit the work, a blue colouring agent must be added to the water. The colouring agent, however, is not

* Author to whom correspondence should be addressed

among the original materials of the work. There is no documentation on precisely which substance was used by Pascali, and whether this colour lends the work a specific significance. The only clue to be found was 'aniline', a colouring agent mentioned in various museum catalogues. But this was not confirmed by analysis of the blue particles deposited on the inside of the trays.[4]

It is obvious much time and money would have been saved if the artist had supplied this information during his lifetime. Apart from the lack of data, there is the problem of retrospective interpretation. Even if research were to confirm that the colouring agent is indeed aniline blue, essential information – in this case on the intensity of the colour or its meaning to the art work – could still no longer be traced.

The main conclusion reached by the ten pilot projects carried out by the Foundation for the Conservation of Modern Art in 1995 was that the meanings attached by artists to their materials and methods are essential data. This conclusion was further developed in the 'Decision-making model regarding the conservation of modern and contemporary art' and the 'Registration and documentation model'. The method for conducting artist's interviews that is now being developed, is based on these two models.[5]

Collecting data in written form

When studying and comparing the various systems used by museums to gather relevant information on artists, four systems turned out to produce the kind of information that is useful to our research. These were therefore incorporated in our project.

Museums asking artists about their materials and working methods usually opt for the written questionnaire. Erich Ganzert-Castrillo, conservator/restorer at the Museum für Moderne Kunst in Frankfurt, pioneered this approach. In 1979 he published his *Archiv für Techniken und Arbeitsmaterialien zeitgenössischer Künstler* which contains information on materials used by 138 artists from German-speaking countries.[6] For each medium he used a separate form with questions concerning: 1) materials and techniques, 2) origins of the materials (such as manufacturers, retailers, installation firms). Thanks to Ganzert-Castrillo's initiative artists and conservator/retorers became aware of the importance of these data. What is more, Ganzert-Castrillo, a conservator/restorer himself, attached much value to building a relationship with the artist based on trust. The questionnaire is also used by the Museum of Modern Art in New York. Whereas Frankfurt posed two basic questions, New York produced a list in three parts (biographical details, collection data per object and technical information) which contains highly specific questions (about 45 in all). Two questions in the biographical section stand out as they probe into the artist's personal background and the context of the oeuvre. But these are open questions giving the artist every opportunity to evade the issues.[7]

A third questionnaire was developed by London's Tate Gallery. This questionnaire focuses on sculptures, with special emphasis on the installation of the object and the artist's ideas about its conservation.[8]

An advantage of the written questionnaire is that it offers the artist the opportunity of careful deliberation. In our view, however, too little attention is paid to the meaning of the material. In most cases the data are merely focused on specific objects and the information is seldom, or only in very general terms, put within the broader context of material meaning(s).[9] Another objection to written questionnaires is the absence of dialogue between interviewer and artist, which would allow for a more intensive treatment of the subject.[10]

The oral artist's interview

Oral interviews, on the other hand, give rise to dialogue and offer wider opportunities for relating materials and working methods to the significance thereof. Carol Mancusi-Ungaro, chief conservator/restorer of The Menil Collection in Houston, has been interviewing artists since 1990. The interviews are recorded on video. 'It is my task to gain insight into the physical life of paintings.

Obviously, the best source is the painter himself. That is why I started interviewing artists, first the older artists whose work we have in our collection, such as Jasper Johns, Robert Rauschenberg, James Rosenquist. I talk to them while they are looking at their work in our museum, I ask them to describe the work, why it looks that way, how they feel about ageing, and how we will approach restoration in the future. How does an artist make his work sing? When modern artists talk about their materials, they talk about their art.' [11]

In a number of ways we have taken Carol Mancusi-Ungaro's approach as point of departure for our project:

1. She attaches much importance to the visual record of the conversation that takes place in the artist's studio, because this is a documentation of the state of the work at that point in time. Moreover, the visual record provides information on the works and tools present in the studio, and it is also a record of non-verbal interaction between the artist and the interviewer.
2. The idea behind the interview is to gain insight into the artist's attitude towards damage and the natural ageing process. This requires an understanding of the conceptual meaning of the use of materials within the context of the artist's oeuvre as a whole. Mancusi-Ungaro emphasises questions on meaning and tries 'to establish a sense of the artist's viewpoint towards the preservation of his art'.[12] From this information conclusions can be drawn that may provide answers to future questions regarding conservation. The information makes it possible to act 'in the spirit of the artist', in case of unforeseen conservation or restoration problems in the future.
3. No questionnaires are sent to the artist prior to the interview. Carol Mancusi-Ungaro's interviews are characterised by open questions, allowing the artist to elaborate on the content of his work. Moreover, by enquiring further and further, the required factual (material-technical) information emerges.
4. She often starts the interview by asking the artist to describe a work. A seemingly simple question like 'What do you see?' often leads to unexpected viewpoints. The artist is invited to present a personal view on a work, which can give strong impetus to the interview.

Objectives

The project aims to develop an instrument that will enable conservator/restorers and curators to conduct interviews that will benefit the conservation of modern and contemporary art by providing museums with the information they need. Based on the outcome of Carol Mancusi-Ungaro's work, our assumption is that an understanding of the meaning of the material and how it is used, as well as insight into the artist's ideas about the conservation of the work, will provide answers to current and future questions regarding conservation.

The point of departure is to gather information with regard to the artist's entire oeuvre. Asking artists to describe specific works, specific problems or material-technical details must be part of the overall framework of the interview. At first the questions are relatively 'open'; in the course of the interview increasingly specific questions are asked regarding material-technical matters.

The ten pilot interviews will be evaluated by conservator/restorers and curators. We presume their findings will enable us to ascertain whether the method that has been developed can be applied in practice.

Preconditions

One of the first preconditions is that interviewers are knowledgeable about the content of the work (both where the use of materials and its meaning are concerned). Interviewers must also have the skills to conduct the interview according to the scenario that has been developed.

For the interview to succeed it is of major importance that it takes place in a relaxed atmosphere. The artist should not feel as if he or she is interrogated or visited by the 'restoration police'. At no time should the artist feel criticised, and called upon to justify his or her methods.

We have made a definite choice in favour of the oral interview, which, preferably, is to be recorded on videotape.

Interdisciplinary collaboration

One of our project's major points of departure is the interdisciplinary collaboration between conservator/retorers and curators, during the preparations as well as at the time of the interview itself and during the evaluation afterwards. The two disciplines are complementary: the material-technical expertise of the conservator/restorer and the curator's art-historical and theoretical knowledge are the foundation upon which to base an understanding of the art work in this context.

For practical reasons the division of the tasks during the interview can be as follows: one of the interviewers functions as chairperson or first interviewer, while the second interviewer mainly monitors the procedure (keeping an eye on the time, on the topics discussed, possibly using a checklist).

Preparations

Part of the project is to make a script that is to be used as a guideline during the preliminary stages and during the interview itself. The scenario, as we call it, includes a chronological outline of the interview, a basic structure which can be altered depending on the specific circumstances of each interview. Sometimes an interview may take an unexpected course. It is therefore up to the interviewers not to adhere too strictly to the scenario, to allow for unexpected developments during the course of the interview.

The interviewers prepare themselves by studying the artist's oeuvre, and the available data and condition registrations and by going through the literature. One of the points at which the information gaps will come to light is when the aforementioned 'Registration and documentation model' is completed. The specific questions are put on a checklist, which may also include questions on presentation, details of the materials, brand names etc.

The questions are listed according to the chronology indicated in the outline. The literature is also incorporated in the scenario, by putting quotations under the proper headings. The checklist remains separate, even though certain questions will be used in the scenario.

Scenario structure

Questions can be asked at several levels, which can be divided roughly into: opening question, questions about origins, meaning of material, context, transference, ageing and conservation and restoration (see outline). The ideal interview would provide answers to all these questions in such a way as to reveal an overall picture of the artist's works and views. The chronology need not be followed too closely, but it is important that questions be asked at all levels.

After an introduction the general chronology of the interview is as follows:

Opening

Preferably standing before a work in the artist's studio, the interview can be started by asking about the artist's perception of the work. This can be followed by a description of the object, but other reactions (associations) are also possible. The question triggers a primary reaction, which is exactly what the interviewer wants: the artist will point out what he or she finds important.

Origin, creative process

At this stage the interview focuses on this particular object, and the artist is asked how it came into being. At a later stage the questions may also include other works by the artist. What the interviewer aims to achieve is that slowly a picture emerges of how the artist works, from conception to construction. Issues addressed are: working method, techniques, selection of materials (no reference is to be made as

yet to brand names and other small details, as this would disrupt the flow of the conversation).

Meaning of material

A very important category of questions centres on what the material means to the artist. Interviewers are emphatically advised not to bring up this subject until the artist has talked in detail about the origins of the work, the creative process (as this kind of information will probably not come up again in later stages of the interview). At this level, the questions focus on the properties of materials and material iconology.

Context

After this first part it may be time to ask how the artist relates to members of his or her generation, and to artists using the same stylistic methods. At the contextual level, such issues as reception, cultural-historical roots as well as training and biographical details will be discussed. Based on the study of the literature, control questions can be asked, such as: 'You are seen as an artist whose selection of materials is based on their symbolic meaning. Is that correct?' The reply might shed new light on assumptions made in the literature.

Transference

The outline of the scenario reflects the 'life story' of a work of art. The interview progresses chronologically from open to closed questions, more or less parallel to the development from questions about the meaning of the material to, ultimately, questions about the artist's views on ageing and conservation. A major advantage of this approach is that the interview does not focus on specific conservation problems at too early a stage.

Initially, the scenario focuses on the life of the art work as it is still in the artist's studio. At a certain point, however, the work has left the studio. Function and care are taken over by others. The object is exhibited. Within the scenario's chronology we now move to another level, the level of transference of the work to the outside world.

Matters such as presentation, perception, perceivable appearance (both visually and where other senses are concerned) begin to play a part. One of the central questions is whether the material is to meet certain specific optical requirements, or whether these are secondary to the illusion. It is important to know if the artist believes the illusion could be disturbed by intervening in the material. Questions on material and authenticity are also relevant in this context: Is the original material essential to the meaning of the work? The artist can also be asked about the conditions for exhibiting an installation.

It is also important to find out if in the artist's view a discrepancy has occurred between the original and present state of the art work.

Ageing

As of this point the scenario becomes increasingly specific and concrete, dealing with issues regarding 'ageing' and, finally, 'conservation and restoration problems'. Here the artist can be probed about the meanings originally associated with the work and its materials, and how he/she feels about the work's present state. If the artist feels the meaning of the work has been altered by the ageing process, this may be further pursued.

Conservation and restoration

Obviously, the next step is to confront the artist with specific conservation problems and damage and to ask his opinion. In our view, open questions such as 'How do you think your work should be treated?' do not lead to useful answers. At this point another control question can be asked, for instance by confronting the

artist with a conservation proposal. The questions are now 'closed' and directly linked to specific situations.

To conclude the interview further questions can be asked regarding factual data on materials, such as brand names, a plan containing directions for installation of a work, the composition of materials etc.

It is, of course, no problem if this kind of information comes up spontaneously at other points during the interview. The checklist is meant to ensure that these sort of questions are not left out.

Conclusion

The interview scenario and the various question levels have now been outlined. The final result of the interview depends on a variety of factors related to the interviewers as well as the artist. As for the method used, evaluation from within the museum field will indicate whether this approach works and what adjustments may be necessary.

Simultaneously with this empirical study and within the same project, attention is paid to theoretical aspects. This is because certain categories of questions need to be defined. Categories may include for instance, appearance, material iconology and authenticity. This part of the project is carried out in collaboration with art historians and art theorists, and will presumably be continued in a follow-up project.

The current project is a first attempt to systematically bridge the information gap regarding modern and contemporary art. After the pilot interviews have been completed and the results analysed, it will have to be considered whether to have similar interviews conducted on a larger scale.

Notes

1. This is one of the conclusions reached at the symposium in 1997 see: Hummelen Y, Sillé D, Zijlmans M. 1999. (eds.) Modern Art: Who Cares?, Foundation for the conservation of modern art, Amsterdam.
2. Rudi Fuchs in an interview by NRC-Handelsblad, 19 December 1997.
3. Questionnaires have been developed by, among others: Erich Ganzert-Castrillo (Museum für Moderne Kunst, Frankfurt), Archiv für Technik und Arbeitsmaterialien zeitgenössischer Künstler, Ferdinand Enke Verlag, Stuttgart 1979 ; Artist's biography, collection of paintings and sculpture, Museum of Modern Art; Sculptor questionnaire, Tate Gallery, London. Further literature: Giraudy D. 1972. Proposition pour une méthode de documentation sur les techniques des artistes actuels. ICOM-CC 3rd Triennal Meeting, Madrid, October 1972; R. Guislain-Witterman. 1977. Zusammenarbeit zwischen Künstler und Restauratoren, Düsseldorfer Symposium Restaurierung Moderner Kunst, Restaurierungszentrum & Firma Henkel; Von Weise S. 1977. Kunst zum Verscheid? Das Problem der Konservierung moderner Kunst in den Augen ihrer Produzenten. (Düsseldorfer Symposion,); Stoner JH. 1984. A datafile on artist's techniques cogent to conservation, ICOM-CC 7th Triennal Meeting, Copenhagen, 84.4.7–8; Stebler W. 1985. Technische Auskünfte vor Künstlern. Fragen zur Praktibilität und Brauchbarkeit von Künstlerinterviews durch Restauratoren und Kunsttechnologen in bezug auf die Probleme der Material Erhaltung in der Zeitgenössische Kunst. In: Maltechnik-Restauro, 1985 (1): 19–35.
4. Research report Campi arati e canali d'irrigazione by Pino Pascali, Foundation for the conservation of modern art, Amsterdam, March 1997. The blue colouring agent was analysed by P. Keune and T. van Oosten. See also the chapter on Pascali in: Modern Art: Who Cares? (see note 1).
5. Both models are published in: Modern Art: Who Cares? (see note 1).
6. See Ganzert-Castrillo (note 3).
7. We are indebted to Jim Coddington for sending us the questionnaire (see note 3).
8. See note 3.
9. See also: Stoner JH. 1985. Ascertaining the artist's intent through discussion, documentation and careful observation. In: The international journal of museum management and curatorship,1985 (4): 87–92.
10. See also: Quint Platt A.1984. Documenting twentieth century American art under the jurisdiction of the General Service Administration. In:ICOM-CC 7th Triennial Meeting Preprints, Copenhagen. Vol.I, pp.84.4.3–6.
11. Carol Mancusi-Ungaro, interviewed by NRC-Handelsblad, 19-12-1997.
12. Letter by Carol Ungaro-Mancusi to the Foundation for the conservation of modern art, dated 5 August 1997.

Abstract

'Megilp' was a gelled medium widely recommended and used during the late 18th and 19th centuries. It is a mixture of lead-treated drying oil and mastic varnish and was used by artists for both impasto and glazing. These media are associated with a tendency to darken and with particular vulnerability to solvents during cleaning. Megilp samples, naturally aged, light exposed, and thermally aged, were immersed for 24 hours in each of the series of solvents: iso-octane, xylene, dichloromethane, acetone, ethanol and water. The substances extracted from the megilps were analysed by direct temperature-resolved mass spectrometry (DTMS) and gas chromatography/mass spectrometry (GCMS). Their high sensitivity to the various solvents has been demonstrated. The extracted materials consisted mainly of fatty acids, diacids, oxidised triterpenoid compounds, triterpenoids, diglycerides, lead, polymerised resin-oil networks. The chemical constituents and their distribution in the leached megilp samples varied according to the solvents used, the relative proportions of oil and mastic in megilp mixtures, the manner of ageing and the lead compound included as drier.

Keywords

Oleo-resinous paint, solvent leaching effects, direct temperature-resolved mass spectrometry (DTMS), principal component analysis (PCA), gas chromatography/mass spectrometry (GCMS), fatty acids, triterpenoids, de-esterification

Solvent extraction of organic compounds from oleo-resinous 'megilp' paint media

Maria Kokkori★ and Alan Phenix
Courtauld Institute of Art
Department of Conservation and Technology
Somerset House
The Strand
London WC2R 0RN
UK
Fax: +44 171-873 2878
Email: marie.kokkori@courtauld.ac.uk

Jaap J. Boon
FOM Institute for Atomic and Molecular Physics
Kruislaan 407
1098 Amsterdam
The Netherlands

Introduction

It is known from both practical experience and the findings of scientific studies that human intervention by cleaning can be a significant contributor to the deterioration of paintings. There is always a certain degree of risk to the original materials of the painting. Two phenomena are strongly related to deterioration as a result of cleaning: swelling and leaching. Leaching might be considered as a secondary process, to some degree dependent on the magnitude of swelling caused by solvent sorption. The effect of solvents on paint films and, especially, investigation of their leaching action and its consequences has been the subject of several studies, but none has investigated oil/resin paints even though these might be expected to exhibit a particular vulnerability to solvents during cleaning.

The overall objectives of this research were to investigate the leaching phenomenon due to the use of different solvents on megilp paint media; through chemical characterisation and analysis of the soluble components extracted from the megilps.

The work was also intended to support and extend earlier studies and analyses concerned with megilp paint media and to develop further our understanding of both physical and chemical properties of these gelled, thixotropic media, widely recommended and used during the late 18th and 19th centuries.

Mass spectrometric analytical techniques have been used to identify the solvent-extractable components of megilp media and to evaluate the degree of hydrolysis of glyceride component of the binder phase.

A selection of megilp samples were immersed for 24 hours in different solvents to extract substantially all the soluble components. The solvent extracts were analysed by direct temperature-resolved mass spectrometry (DTMS) and gas chromatography/mass spectrometry (GCMS). Different factors influencing the leaching phenomenon were further investigated by analysing the DTMS data using the principal component analysis (PCA) statistical technique.

DTMS is a very powerful tool among the analytical methods used for complex organic substances. It has been developed within the MOLART project (FOM Institute for Atomic and Molecular Physics) for fast analysis of minute paint samples (Boon 1992: Boon et al. 1994).

It is a qualitative and semi-quantitative spectrometric technique that provides broad-band information at the molecular level and enables the characterisation of both volatile materials and immobile polymeric phases in one analytical run. It maximizes the molecular information that can be gathered by a single analytical technique where sample size is a critical constraint. It also requires little or no sample work-up and the analysis time is two seconds. It therefore, allows the rapid analysis of large sample sets, thus providing a statistically significant framework in

★ Author to whom correspondence should be addressed

which to place more detailed molecular level studies (Boon et al. 1995: Boon and Och 1996: van der Doelen et al. 1998).

Principal component analysis was additionally used here in order to process the complex body of DTMS data and to identify important patterns from the results obtained. It is a technique for reducing the dimensionality of a data set by creating linear combinations of the measured variables (Hoogerbrugge et al. 1983: Windig et al. 1994).

GCMS is an established technique for the analysis of complex mixtures (Mills and White 1994). It combines sensitivity with versatility and range of applicability. Recently, more derivatisation techniques for GCMS analysis of paint binders have been explored (White and Pilc 1996). One such development, the double derivatisation transethylation-silylation GCMS has been studied by J. van den Berg on a variety of paint samples and this has revealed important features of both the mobile and stationary phases (Van den Berg et al. 1998). This method can also give information on the fatty acids which are still bound to their glycerol backbone and are not cross-linked. A combination of this transethylation method with a silylation derivatisation makes it possible to discriminate between the free and bound fatty acids in one GCMS analytical run. In this way, the degree of hydrolysis of the glycerides can be monitored.

All non-cross-linked compounds can be identified this way. Glycerol-esterified fatty acids are converted into ethyl esters whereas free fatty acids are silylated. It has been postulated that the degree of de-esterification (hydrolysis) can be determined by measuring the relative abundances of the free and esterified C9 fatty diacid and C18 fatty acids.

Experimental procedures

Megilp samples were provided by the Tate Gallery. The samples were prepared in 1993, following recipes compiled by L. Carlyle from her research into 19th-century artists' manuals, using typical proportions for the ingredients, and were both exposed to natural light and thermally aged (Ara 1990: Carlyle 1991).

A certain amount of scientific information on these formulations has already been gathered; they have been analysed by thermoanalytical techniques (DSC) and by FTIR, and their surface morphology on drying and after ageing has been characterised by SEM (Townsend et al. 1998).

The source material for the present solvent extraction studies were unpigmented mastic megilps containing three different proportions of linseed oil to mastic varnish (1:1, 1:3 and 3:1) mixed with two different driers (litharge and lead acetate). These had been prepared on Melinex® supports. Different sets of the same source samples had been exposed to different conditions after preparation: one set was exposed to daylight in the painting conservation studios of the Tate Gallery (UV-filtered and air-conditioned) and another set was thermally aged in an oven for 35 days at 70°C and 50% RH.

Small samples taken from the various megilps were immersed for 24 hours in six different solvents. The solvents studied were iso-octane, xylene, dichloromethane, acetone, ethanol and water representing a range of polarities, hydrogen bonding capabilities and different effects on megilps. Although the immersion tests carried out here are not fully representative of a typical cleaning procedure, they do, however, indicate the ultimate capacity of solvents to act on the various components of megilps and they reflect the magnitude of response of these samples to each solvent.

Direct temperature-resolved mass spectrometry (DTMS)

Megilp samples ranging in size from 0.01 to 2mg were immersed in an excess of each of the six different solvents for 24 hours. Both the soluble compounds which, were extracted into the liquid solvent phase, and the insoluble residues were analysed by DTMS. Megilp leached extractables of approximately 1.5 to 2μl were mixed with 1.5μl of the internal standard (perylene in ethanol) and the residues were homogenized in ethanol using a miniature glass glass mortar. Aliquots of the suspensions obtained were applied on the analytical filament (Rh/Pt) of the DTMS

and dried in vacuum. The analyses were performed on a Jeol SX-102 double focusing mass spectrometer using a direct insertion probe equipped with a Rh/Pt filament (100 micron diameter). The probe filament was temperature-programmed at a rate of 0.5 A/min to an end temperature of 800°C.

Fragmentation of compounds was effected using the electron impact method. Ions were generated by electron impact at 16eV in an ionization chamber kept at 180°C, accelerated to 8kV and mass analyzed over the range of m/z 20–1000 with one cycle time. Data were processed using a Jeol MP-7000 data system. Principal component analysis of the DTMS spectra was performed using the self-developed interfacing software Chemometriks interfaced to Matlab® 5.2 (1997 version).

Gas chromatography mass spectrometry (GCMS)

Megilp samples of 1–2 mg were immersed in an excess of each of the six solvents for 24 hours. Both the soluble compounds extracted into liquid solvent phase and the insoluble residues were subjected the transethylation/silylation pretreatment and were analysed by GCMS. To a weighed sample, in a vial, 250μl 0.01 ethanolic sodium ethoxide per mg of sample was added. The vial was flushed with N_2, sealed and placed in an oven at 70°C for 90 minutes. After cooling 30μl ethanolic NH_4Cl solution was added. After 20 minutes the ethanol was evaporated under a N_2 stream. The residue was dissolved in 250μl hexane/hexadecane (100mg/ml) and treated with 13μl Bis-(trimethylsilyl)-trifluoracetamide (BSTFA). The vial was sealed and returned to the oven for another 60 minutes. The solvents were evaporated under a gentle steam of N_2 and the residue was dissolved in dichloromethane. 2μl of the derivitised sample was injected into a SGE BPX5 column (25m, 0.32mm i.d., 0.25mm film thickness) using an AS-800 on-column auto-injector. Helium was used as a carrier gas at a flow rate of approximately 26cm/s. The temperature of the gas chromatograph was 50°C, maintained for two minutes and the oven temperature was programmed at a rate of 6°C per minute to an end temperature of 320°C which was maintained for 10 minutes. The analysis was performed on a Carlo Erba HRGC Mega 2 gas chromatograph coupled directly to the ion source of a Jeol DX-303 double focusing (E/B) mass spectrometer. Ions were generated by electron impact at 70eV in an ionization chamber and accelerated to 10kV. The mass was analysed over the range of m/z 40–700 with one second cycle time. Data was processed using a Jeol MP-7000 data system.

Results

Gravimetric analyses were considered necessary before and after the solvent exposure. The largest changes occurred with acetone and ethanol where complete dissolution was observed after 24-hour immersion. Xylene extracted compounds up to 56% of the soluble compounds and dichloromethane up to 77%. The percentages after water and iso-octane extraction were lower and especially for the light exposed samples: water caused 15–17% reduction in weight of samples and iso-octane 12–20%.

Direct temperature-resolved mass spectrometry (DTMS)

Naturally aged, light-exposed and thermally-aged samples were immersed for 24 hours in six different solvents as mentioned before and the samples before immersion, the leached extractables and the residues were analysed by DTMS.

The main materials found after solvent treatment were polymerised oil networks, resins, fatty acids, diacids, diglycerides, oxidised triterpenoid compounds and lead (See Fig. 1). Characteristic peaks for m/z 28 and 44 correspond to CO_2 mainly evolved from the polymerised oil network by decarboxylation of the many carboxylic organic acid groups and to a large extent by decarboxylation of the mineral phase. Lead released at high temperatures, either from the basic lead acetate or from the litharge, appears with an isotopic multiplet at m/z 206, 207 and 208. Peaks indicative of the two most nonreactive constituents of the oils, palmitic (C16:0) and stearic (C18:0) fatty acids, appear at m/z 256 and m/z 284 respectively. Complete oxidation of the double bonds in unsaturated C18 fatty

Figure 1. DTMS spectrum of a resin-rich (1:3) megilp including lead acetate.

Figure 2. DTMS spectra of ethanol extractables from light-exposed 1:1 oil to mastic megilps, including: a) litharge; and b) lead acetate.

acids during oxidative polymerisation, leads to different diacids. Azelaic acid (C9 diacid) is indicated by ions at m/z 152, 98, 111, 84 and 83 while C8 diacid shows peaks at m/z 171, 138 and 84. Peaks indicative of diglycerides showed at m/z 550 (C16/C16), 576 (C18/C18:1) as well as at m/z 578 (C16/C18), m/z 604 (C18/C18:1), m/z 606 (C18/C18). The ions in mass range from m/z 390 to 450 are indicative of mastic varnish. Ions appearing at m/z 143 and 125 are indicative of oxidised hydroxyisopropylidene side chains on the triterpenoid skeleton. The m/z 189, 203 and 205 are characteristic fragment ions indicative of the oleanenone skeleton in mastic. At higher temperatures in the DTMS run mass peaks indicative of the oil:mastic polymeric network were observed.

1:1 OIL TO RESIN MEGILPS

The MS data on the ethanol-extractable fraction of two light-exposed megilp samples is shown in Figures 2a and 2b. The largest peak at m/z 252 is from perylene the internal standard. The spectra are further characterised by high intensity peaks for free palmitic (m/z 256) and stearic acid (m/z 284), for C8 (m/z 171, 138, 84) and C9 (m/z 185, 152, 98) diacids, and also peaks corresponding to lead (m/z 208, 207, 206) and triterpenoid compounds (m/z 390–490). The resemblance of the DTMS of the solvent extracted fraction and the spectra corresponding to the same samples before immersion treatment, indicates the high degree of dissolution. The MS data on the acetone-extractable fraction of the same samples is quite similar to that for ethanol, as well as that corresponding to dichloromethane extraction. When the water and iso-octane extracts of the same samples were analysed by DTMS, it was clear from the total ion current that the degree of extraction was very low, whereas the MS data on the xylene extracts showed mainly peak characteristics for triterpenoid compounds.

The data obtained after the analysis of the solvent extractables of the equivalent thermally aged megilps were qualitatively quite similar regarding the extraction of diacids, palmitic and stearic acids, lead and triterpenoid compounds, but different in the degree of extraction. For example, dichloromethane extraction was less dramatic for the thermally-aged 1:1 megilp, than for the equivalent light-exposed samples, the reason for which remains unclear at present.

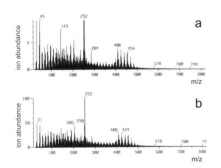

Figure 3. DTMS spectra of two thermally-aged, resin-rich megilps including: a) litharge; and b) lead acetate.

RESIN-RICH MEGILPS

Figures 3a and 3b show the MS data of two resin-rich thermally-aged megilp samples. The signals from the triterpenoid compounds (m/z 390–490) are higher than those arising from the palmitic (m/z 256) and stearic (m/z 284) acids. Fragment ions of C8 and C9 diacids and oxidation products exhibit high signals as well. Solvent extraction by acetone and ethanol gave essentially the same results whereas dichloromethane removed the bulk of the fatty acids and diacids and a small amount of the mastic triterpenoids. Xylene extraction removed most of the triterpenoids and a small amount of the fatty acids. Solvent extraction by iso-octane and also by water selectively removed only a very small amount of the triterpenoids.

The MS data of the resin-rich light-exposed megilps indicate the presence of the same type of material extracted as from the thermally aged samples, but in different ratios and, in addition, the presence of quite low signals arising from mono- and diglycerides.

OIL-RICH MEGILPS

Figures 4a and 4b present the summation mass spectrum of two oil-rich light-exposed megilp samples. Both samples are characterised by high intensity peaks corresponding to C8 (m/z 171, 138, 84) and C9 (m/z 185, 152, 98) diacids, those due to the presence of palmitic (m/z 256) and stearic (m/z 284) acids, characteristic peaks for triterpenoid compounds (m/z 390-490) and those for diglycerides (m/z 578, 604, 606). The ion at m/z 252 is perylene the internal standard, and the peaks at m/z 206, 207, 208 are indicative of lead. The material desorbing at higher temperatures shows a mass spectrum characteristic for polymeric materials, also evident in the spectra from the solvent extractable fractions.

The DTMS data of the acetone extracts shows a large number of characteristic ions over a wide mass range including diacids, free fatty acids and polar high

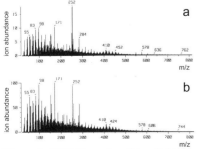

Figure 4. DTMS spectra of two light-exposed, oil-rich megilps, including: a) litharge; and b) lead acetate.

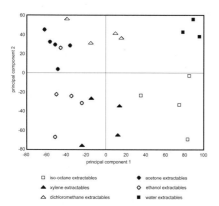

Figure 5. Score plot of principal component 1 vs. principal component 2 showing the relative distribution of leached 1:1 oil to mastic megilps, light-exposed and thermally-aged.

PCA projects the original data from its multidimensional representation down to two dimensions and the resulting score plots indicate the relationships among m/z values of the mass spectra responsible for the chemical relationships among the samples. Thus, by the position of the samples on the plot, similarities and dissimilarities among them can more easily be examined and illustrated. The geometrical distances between the samples in the map correspond to differences in the mass peaks distribution in the DTMS spectra, which in turn are related with differences in chemical composition.

molecular weight compounds such as triterpenoid compounds and diglycerides. Lead was extracted at a high temperature deriving from the decomposition of the driers. The ethanol extraction experiments gave essentially the same results. Solvent extraction by dichloromethane removed diacids, a large amount of the fatty acids, diglycerides and some of the mastic triterpenoid compounds. Xylene removed mainly mastic triterpenoids whereas iso-octane and to a lesser extent water, removed a small amount of diacids and diglycerides. The solvent extraction fractions of the equivalent thermally aged samples were analysed by DTMS as well, where similar type of materials were present but in different ratios.

PCA analysis

The MS data of 141 naturally aged, light-exposed and thermally-aged megilps immersed to six different solvents, showed that the chemical constituents and their distribution in the leached megilp samples as identified by DTMS vary according to different factors such as the influence of the different solvents used, the proportion between oil and mastic, the manner of ageing (light exposed or thermally aged) and the drier (litharge or lead acetate).

In order to systematise the previous observations and understand on a molecular level the variations among the megilp samples as measured by DTMS, the data obtained was further analysed by using principal component analysis.

The more chemically similar the solvent extracts, the more closely they plot on the score map (See Fig. 5). Thus, the acetone and ethanol extracts of oil/resin (1:1) megilps were grouped in the same area and characterised by peaks corresponding to fatty acids, diacids, lead and a molecular ion region between approximately m/z 390 and 490; whereas, xylene extracts were characterised only by low peaks corresponding to triterpenoids. The limited degree of extraction became evident, comparable to that of octane and water-immersed megilps.

The geometric distances between light-exposed and thermally-aged samples in the score plot could be explained by the limited concentration of fatty acids and diacids in the latter group.

The relative distribution of the components of solvent extracts from resin-rich megilp samples (oil: resin 1:3) was dependent not only on the solvent used, but also on the manner of ageing and the presence of a drier (lead acetate or litharge). The mass peaks responsible for the position of the light-exposed samples were respectively m/z 143, 125 corresponding to side-chain oxidised dammarane-type triterpenoid compounds. Oleanane-type skeletons characterised by mass peaks 189, 203, 205 became more prominent in the litharge samples.

The solvent extracts of oil-rich megilps (oil:resin 3:1) were characterised by high peaks corresponding to fatty acids, diacids and the presence of diglycerides.

Table 1. List of compounds identified by GCMS. The free fatty acids can be seen as silyl esters and the ester linked fatty acids as ethyl acids.

Internal Standard		Hexadecane
C8 EE/TMS		Octanedioic acid, ethyl TMS ester
C8 TMS/TMS		Octanedioic acid, di-TMS ester
C9 EE/TMS		Nonanedioic acid, ethyl TMS ester
C9 TMS/TMS		Nonanedioic acid, di-TMS ester
C16 EE		Hexadecanoic acid, ethyl ester
C16 TMS		Hexadecanoid acid, TMS ester
C18 EE		Octadecanoid acid, ethyl ester
C18 TMS		Octadecanoic acid, TMS ester
9=10	9=10	9- TMS ether, 9-octadecenoid acid, ethyl ester
C18 OTMS	OTMS	10-TMS ether, 9-octadecenoid acid, ethyl ester
C18:1 EE		Octadecenoid acid, ethyl ester
C18:1 TMS		Octadecenoid acid, TMS ester
8=9	10=11	8-TMS ether, 8-octadecenoid acid, ethyl ester
C18 OTMS	OTMS	11-TMS ether, 10-octadecenoid acid, ethyl ester
C18		Octadecanoid acid
C16		Hexadecanoid acid

Table 2. Identification of the degree of de-esterification of several megilp samples.

Sample	C9 %	C18 %
LMISI Ethanol Extracts	21.62	19.79
LMISI Acetone Extracts	26.31	16.46
LMISI DCM Extracts	15.76	17.50
LMISI Xylene Extracts	11.63	12.12
LMIS2 Ethanol Extracts	22.37	29.85
LMIS2 Acetone Extracts	27.82	20.00
LMIS2 DCM Extracts	18.79	19.67
LMIS2 Xylene Extracts	15.18	16.42
AMISI Ethanol Extracts	18.10	12.82
AMISI Acetone Extracts	20.76	15.33
AMISI DCM Extracts	13.28	10.94
AMISI Xylene Extracts	9.37	8.56

Gas chromatography mass spectrometry (GCMS)

The degree of de-esterification (hydrolysis) was monitored using on-column GCMS analysis with the samples derivatised by transethylation followed by silylation.

Fractions obtained by solvent extraction of the megilp samples contained free (oxidised) (un)saturated fatty acids, autoxidation breakdown products, glycerol, (oxidised) mono- , di- and triglycerides and oligomeric material. All non-cross-linked ester-bound fatty acids were detected using GCMS with a transalkylation derivatisation of the extract, giving alkyl esters of (oxidised) fatty acids. After silylation GCMS analysis gave the (oxidised) fatty acids and breakdown products that were not ester-bound.

Table 1 shows the main compounds identified by GCMS analysis. The free fatty acids can be seen as silyl esters, whereas the ester-linked fatty acids appeared as ethyl esters. The diacids were identified either as ethyl silyl diester or silyl diester. Saturated and unsaturated fatty acids were also present as well as triterpenoid compounds.

Acetone, ethanol and dichroromethane extracts of both light-exposed and thermally-aged megilp samples exhibited characteristic peaks for ethylated and silylated diacids and fatty acids but in quite different amounts depending on the extracting power of the solvent. Xylene, iso-octane and water extracts were characterised by the presence of low peaks corresponding to these compounds.

Thermally-aged megilps exhibited a higher degree of de-esterification in comparison with the naturally aged and light-exposed ones as well as samples where litharge was used as a drier instead of lead acetate. Table 2 shows characteristic examples of the degree of de-esterification of 1:1 oil to resin, resin-rich (1:3) and oil-rich (3:1) megilps which were light exposed and thermally aged.

Conclusions

DTMS and PCA were used to screen for variations at the molecular level among a selection of megilp paint media – naturally-aged, light-exposed and thermally-aged – each of which was immersed in a series of six different solvents. GCMS was used to determine the degree of de-esterification of the binding media.

The present work has demonstrated that the extraction of soluble components from megilp paint media is strongly affected by numerous factors including the type of solvent used, the relative proportions of oil and mastic in megilp mixtures, the manner of ageing and the lead component included as drier. The complex relationship between all these factors was evident.

The presence of the drier influenced the degree of extraction; lead acetate acts as a catalyst to oxidation whereas litharge provides a more alkaline environment, thus promoting de-esterification. Thermally-aged samples exhibited a higher degree of de-esterification than naturally-aged and light-exposed samples.

The type of solvent used strongly affected the amount and the nature of the extracted components. Iso-octane and water exhibited a limited degree of extraction in comparison with the solvents with intermediate polarity values like xylene, dichloromethane, acetone and ethanol.

These last two solvents were particularly active in extracting soluble components from the megilp media. This might imply that controlling the risk of leaching during cleaning of megilp paints can be best achieved by using the least polar solvent possible to remove an unwanted varnish or coating.

Acknowledgements

The analytical part of this research was carried out at the FOM Institute of Atomic and Molecular Physics. Jerre van der Horst (FOM Institute AMOLF) and Leo Spetter (MOLART) provided technical assistance, and K.J. van den Berg (MOLART) assisted in the interpretation of mass spectrometric data. This research was supported by MOLART, a Priority program of the Nederlandse Organisatie voor Wetenschappelijk Onderzoek (NWO, The Hague), the Gerry Hedley Research Scholarship and the Courtauld Institute of Art.

References

Ara K. 1990. An investigation of late C18 and C19 thixotropic paint media: megilps and gumptions, based on the investigations carried out by Leslie Carlyle from documentary sources. Unpublished, Hamilton Kerr Institute, University of Cambridge.

van den Berg JDJ, van den Berg KJ, Boon JJ. 1998. GC/MS analysis of fractions of cured and aged drying oil paint. In Karjalainen EJ, Hesso AE, Jalonen JE, Karjalainen UP, eds. Advances in mass spectrometry 14, CD version poster paper D05 THPO121, Elsevier, Amsterdam.

Boon JJ. 1992. Analytical pyrolysis mass spectrometry: New vistas opened by temperature resolved in-source PYMS. International journal of mass spectrometry and ion processes 118/119: 755–787.

Boon JJ and Och J. 1996. A mass spectrometric study of the effect of varnish removal from a 19th century solvent sensitive wax oil painting. In: Bridgland J, ed. Preprints of the 11th triennial meeting of the ICOM Committee for Conservation. Edinburgh: International Council of Museums: 197–205.

Boon JJ, Pureveen J, Rainford D, Groen K. 1994. Direct temperature resolved mass spectrometry of the mobile and chemically bound organic constituents in Rembrandt's Jewish Bride. Restauratie Jaarboek, vol.1, de Acht Rembrandts. At press.

Boon JJ, Pureveen J, Rainford D, Townsend JH. 1995. The opening of the Walhalla, 1842: studies on the molecular signature of Turner's paint by direct temperature resolved mass spectrometry (DTMS). In: Townsend JH, ed. Turner's painting techniques in context. London: UKIC: 21–29.

Carlyle L. 1991. A critical analysis of artists' handbooks, manuals and treatises on oil painting published in Britain from 1800–1900: with reference to selected eighteenth century sources. Doctoral thesis, Courtauld Institute of Art, University of London.

van der Doelen GA, van den Berg KJ, Boon JJ. 1998. Comparative chromatographic and mass spectrometric studies of triterpenoid varnishes: fresh material and aged samples from paintings. Studies in Conservation 43: 249–264.

Hoogerbrugge R et al. 1983. Discriminant analysis by double stage principal component analysis. Analytical Chemistry 55 (11):1711–1712.

Mills JS, White R. 1994. The chemistry of museum objects. 2d ed. Butterworth-Heinemann: Oxford.

Townsend J, Carlyle L, Burnstock A, Odlyha M, Boon JJ. 1998. Nineteenth century paint media part I: the formulations and properties of megilps. In: Painting techniques history, materials and studio practice. Roy A, Smith P, eds. Preprints to the IIC Congress. Dublin: International Institute for Conservation: 205–210.

White R and Pilc J. 1996. Analyses of paint media. National Gallery technical bulletin 17: 91–95.

Windig W et al. 1983. Interpretation of sets of pyrolysis mass spectra by discriminant analysis and graphical rotation. Analytical chemistry 55 (11): 81–88.

Résumé

Avant de réencadrer une miniature à la fin d'un traitement de conservation-restauration, il est conseillé de réaliser un empaquetage. Celui-ci permet de maintenir l'assemblage du verre, de la miniature et du dos en carton, d'établir une distance entre le verre et la couche picturale, d'assurer une position correcte et sans contraintes dans le cadre et de ralentir les effets d'un changement de climat extérieur sur la miniature. Les différentes manières de réaliser cet empaquetage en utilisant, entre autres, du carton non acide, du papier japon, du polycarbonate et de la baudruche sont décrites. Les avantages de la baudruche, fabriquée d'après des recettes traditionnelles, sont énoncés.

Mots-clés

baudruche, conservation préventive, empaquetage, miniature, polycarbonate, portrait miniature

L'empaquetage avec de la baudruche pour réassembler les portraits miniatures après traitement

Carmen Krisai-Chizzola
Linzerstr.18
A-5280 Braunau am Inn
Autriche
Fax: +43-(0)7722-6311119
Email: di.krisai@alumni.netway.at

Les portraits en miniature et les miniatures de cabinet sont des chefs d'œuvre de petites dimensions peintes à l'aquarelle et en gouache sur du vélin ou de l'ivoire. Dès l'origine, ces supports très vulnérables ont été renforcés par des supports secondaires collés au revers et la couche picturale a été protégée par un verre. Le cadre met en valeur le charme du portrait. La dernière étape après le traitement de conservation-restauration du support et de la couche picturale est l'encadrement. En tout cas, il est déconseillé de poser simplement le verre bombé sur la miniature et de remettre tous les éléments dans leur ancien cadre, le réassemblage à l'aide d'un empaquetage sera préférable.

Le terme « empaquetage » définit l'ensemble formé par le verre protecteur, la miniature et les supports secondaires collés ou apposés au revers de la miniature.[1] Ces éléments sont maintenus ensemble par une fine bande (de baudruche) collé le long des bords à la circonférence de la miniature (Mercenier 1998).

L'intérêt de cette fermeture est de protéger la couche picturale contre la poussière et de ralentir les effets des changements de climat extérieur sur la miniature. Les traités anciens spécialisés dans la peinture en miniature décrivent comment il faut peindre les portraits en miniature, mais rarement ils indiquent comment il faut protéger les chefs d'œuvre achevés.[2] L'expérience dans la conservation confirme que la plupart des miniatures ont eu à l'origine un empaquetage. Dans un encadrement qui n'a encore jamais été ouvert, on peut observer que le matériau situé au revers du support secondaire de la miniature est replié vers la face et collé sur les extrêmes bords du verre. Si cet empaquetage, réalisé dans la plupart des cas avec de la baudruche, quelques fois avec du papier ou du cuir, a été percé ou déchiré lors de différentes manipulations, les témoins de cette méthode de fermeture originale se trouvent sur les bords du support secondaire (morceaux de baudruche enroulés ou chiffonnés) ou sur les bords du verre (voir Fig. 1).

Puisque quelques difficultés nous sont posés par le verre et par le peu de place disponible dans le cadre, certaines modifications par rapport à l'empaquetage original seront nécessaires. Lorsque le verre original est plat, il faudra le surélever pour assurer qu'il ne repose pas sur la couche picturale. Cela est important, car la dégradation du verre qui se présente sous forme de gouttelettes alcalines, de dépôts cristallins ou de réseau de craquelures sur ses surfaces peut, en contact avec la couche picturale, produire des taches ou des dissolutions locales de l'aquarelle (Banik et al. 1989: Mercenier 1998). Si un verre est gravement attaqué par ces dégradations (maladie du verre), il faudra toujours l'isoler et le conserver à part, comme document, car il a perdu sa fonction de protection et de mise en valeur du portrait. Le nouveau verre à placer sur la miniature sera fabriqué sur mesure.[3] Le fait d'insérer des pièces créant une distance est une mesure importante du point de vue de la conservation préventive : il est difficile de prévoir une dégradation éventuelle du verre qui dépend essentiellement de sa composition chimique (Newton et al. 1989). Dans le cas d'un verre bombé, seul les bords reposent sur la couche picturale et il ne faudra agrandir la distance entre le verre et la miniature que dans certains cas.

Généralement le cadre est formé d'un profil métallique qui contourne directement le verre protecteur et maintient la miniature et les supports secondaires par des petites dents métalliques repliées sur le dos. Cet ensemble peut être inséré dans un cadre en bois, une petite boîte, un étui. Une telle fermeture est assez simple à ouvrir

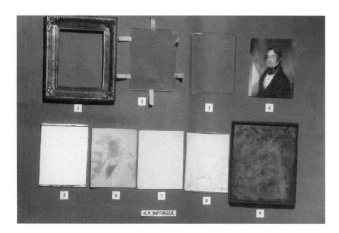

Figure 1. Assemblage d'une miniature après traitement, collection particulière, Autriche. L'empaquetage contient les éléments 2, 3, 4, et 5.

1. Cadre en métal doré (original).
2. Verre plat, (ancien), avec languettes de papier japon (nouvelles).
3. Passe-partout en polycarbonate 0,5 mm (nouveau).
4. Miniature peinte par M.M. Daffinger (Autriche) vers 1830, 97 × 79 mm, aquarelle sur ivoire (original).
5. Dos en carton d'épaisseur 1,4 mm (nouveau).
6. Ancien support secondaire jauni irrégulièrement (original). Il a dû être séparé de l'ivoire pour pouvoir traiter les déformations et fissures de la miniature.
7 et 8. Deux feuilles de papier apposées (originales).
9. Plaque métallique formant le revers du cadre (original).

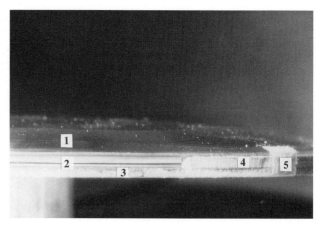

Figure 2. Détail d'un empaquetage vu par le côté, travail en cours.
1. Verre bombé (original).
2. Miniature, aquarelle sur ivoire (original) avec support secondaire en papier (original).
3. Dos en carton (nouveau), les bords sont teintés à l'aquarelle.
4. Pièce d'espacement en carton (nouvelle).
5. Languette de maintien en papier japon (nouvelle) collée à l'amidon.

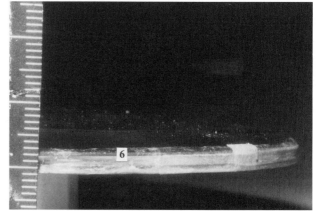

Figure 3. Même détail que Figure 2, empaquetage terminé.
6. Bande de baudruche (nouvelle) collée le long des bords à la colle de peau.

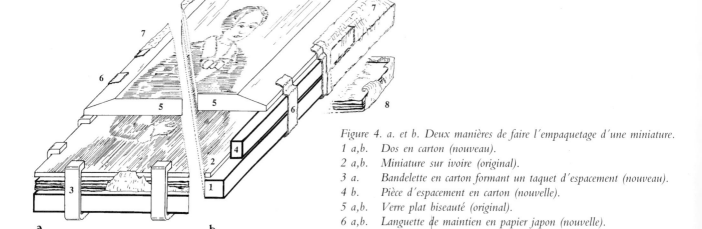

Figure 4. a. et b. Deux manières de faire l'empaquetage d'une miniature.
1 a,b. Dos en carton (nouveau).
2 a,b. Miniature sur ivoire (original).
3 a. Bandelette en carton formant un taquet d'espacement (nouveau).
4 b. Pièce d'espacement en carton (nouvelle).
5 a,b. Verre plat biseauté (original).
6 a,b. Languette de maintien en papier japon (nouvelle).
7 a,b. Baudruche (nouvelle).
8 a,b. Ancien support secondaire (papiers, baudruche) (originaux).

et à fermer et on a un peu d'espace pour améliorer le montage en agrandissant la distance entre le verre et la couche picturale de la miniature et en réalisant l'empaquetage. Un portrait en miniature porté comme bijou, pendentif, ou bracelet possède souvent un cadre serti, bien étanche. Ces cadres sont très difficiles à ouvrir, il faut utiliser des outils de joaillier (Pappe 1995). La miniature se trouve sous un verre bombé, et, manque de place, il n'y a pas moyen de changer quoi que ce soit. La miniature de cabinet fait partie de toute une série de miniatures qui sont encadrées de la meme manière, avec des cadres décoratifs assez grands, où on a des moyens aisés pour réaliser l'empaquetage.

Un nouvel empaquetage sera donc réalisé en deux étapes : 1. assurer une distance entre le verre et la miniature et éliminer toute contrainte sur le support, 2. coller/sceller les bords avec une bande étroite. Parmi les nombreux matériaux disponibles aujourd'hui, seront choisis ceux qui répondent aux critères de stabilité : cartons et papiers non acides, colles stables et facilement réversibles, membranes permettant le passage de vapeurs d'eau. La visibilité de cet empaquetage à l'intérieur du cadre devra rester minimale, l'esthétique de la miniature ne devra pas être génée par les nouveaux éléments introduits dans un but de conservation préventive. Les anciens matériaux comme les supports secondaires en carton acide qui doivent parfois être séparés de la miniature au cours du traitement seront à conserver sans être intégrés dans l'empaquetage nouveau, posés simplement derrière celui-ci avant de fermer le cadre (voir Figs. 1 et 4 b).

La manière de réaliser cet empaquetage dépend essentiellement de la place disponible dans l'encadrement. La base est formée par un carton non acide rigide (voir Figs. 1 – 4 : dos en carton nouveau) sur lequel seront appliqués les pièces d'espacement qui ne seront de préférence pas collés sur le verre (original). Ensuite il y a plusieurs possibilités pour cette première étape de l'empaquetage :

- S'il y a beaucoup de place dans le cadre, s'il s'agit d'une miniature non encadrée conservée en réserve de musée, ou bien s'il faut créer un nouveau cadre (copie d'un cadre original), on construit en carton non acide un passe-partout, avec un enfoncement dans lequel la miniature peut reposer librement, sans contraintes (CCI 1992).
- Lorsque quelques millimètres sont disponibles sur les côtés, cela permet de coller avec de l'amidon des pièces ou des filets de carton non acide noir ou teinté à l'aquarelle, selon la couleur environnante, sur les bords du dos de l'empaquetage (voir Figs. 2 et 4b).
- S'il y a très peu de place (environ 1 mm), on colle 6 à 10 bandelettes de carton non acide (d'épaissseur 0,5 mm) sur le revers du carton qui protège la miniature par l'arrière. Ces bandelettes (environ 3 mm de large) sont repliées vers devant. Les petits taquets ainsi formés écartent le verre de la couche picturale et sont d'autant plus discrets s'ils sont teintés à l'aquarelle (voir Fig. 4a).
- Quand la taille de la miniature et du verre sont identiques et que le cadre est très étroit (recouvrant que très peu les bords du verre), il n'est pas possible d'utiliser du carton, qui se cliverait en son épaisseur, s'il est coupé trop finement. La nouvelle solution est de découper un passe-partout dans une feuille de polycarbonate (PC, épaisseur 0,5 mm). Cette matière transparente et stable (Tétreault 1992) peut être facilement coupée aux ciseaux, poncée et polie, et on obtient un passe-partout très fin (environ 1 mm de large), quasiment invisible (voir Fig.1).
- Dans le cas où une miniature sur ivoire légèrement déformée sera encadrée, la forme du dos en carton placé derrière la miniature sera adapté pour ne pas créer des tensions, qui risqueraient de fissurer le support.

La deuxième étape de l'empaquetage consiste à assurer le maintien de ces éléments en scellant les bords. Les matériaux utilisés qui ne prennent pratiquement pas de place sur les côtés de la miniature se distinguent essentiellement par leur degré d'étanchéité.

Dans la pratique, une méthode utilisant des languettes de papier japon pour maintenir l'ensemble, puis des bandes de baudruche préencollées pour le scellage, s'est montrée la plus efficace. Cette méthode utilisant les matériaux traditionnels donne un empaquetage esthétique et fonctionnel, permettant les échanges d'air et des vapeurs d'eau (Wouters et al. 1992). Ainsi les problèmes issus d'un microclimat

formé dans l'interstice entre le verre et la miniature sont réduits. Pour pouvoir tenir le verre par l'extérieur, on place une ventouse en son centre. Puis 6 à 10 languettes de papier japon (épaisseur 0,1 mm, longueur 5 cm, largeur 0,5 cm) sont collés à l'amidon sur ses tranchants (voir Fig. 1). Après séchage, on pose le verre sur la miniature et on tire la longue partie du papier japon vers le carton du dos, où on fait un collage ponctuel à l'amidon près du bord (voir Fig. 2). Ensuite la baudruche préencollée (voir dernier paragraphe) est coupée en bandes de 7 à 15 mm de large. On colle d'abord le bout de la bande sur le bord du verre en veillant à la positionner correctement dès le départ. Pour réactiver le préencollage, on humidifie la baudruche au fur et à mesure qu'on l'applique, en contournant le verre, puis elle est repliée vers le revers (voir Figs. 3 et 4). L'humidification se fait, puisqu'on a besoin d'une main pour tenir la miniature et de l'autre pour tirer sur la baudruche, avec la langue. Le faible apport d'humidité est négligeable.

Si le support secondaire inclus dans l'empaquetage doit rester visible (lorsque le nom de la personne représentée y est inscrite) il faudra, pour sceller les bords de l'empaquetage, coller directement une bande de baudruche dessus, ou bien prévoir un passe-partout pour le revers, sur lequel ce collage sera réalisé.

Un empaquetage entier recouvrant toute la surface du carton au revers de la miniature peut être réalisé avec du papier japon ou de la baudruche. Ces derniers sont découpés plus grands, les bords se rabattent vers la face pour être collés sur le bord du verre. Pour éviter un grand apport d'humidité avec les colles acqueuses, on utilise des adhésifs acryliques réactivés par des solvants, malgré que les membranes épousent ainsi moins bien les formes arrondies.[4]

Les rubans autocollants de qualité archive paraissent pratiques s'il faut vite terminer le travail.[5] Cependant ils n'épousent pas suffisamment la forme ovale et ne permettent pas les échanges d'humidité. Étant donné qu'on ne connaît jamais la composition des adhésifs de ces rubans, ils sont à éviter.

L'application d'un ruban téflon (PTFE) se prête surtout pour des scellages temporaires (protection de miniatures en cours de traitement).[6] Il s'étire facilement et se moule très bien aux formes arrondies et adhère sans adhésif, ce qui est un avantage du point de vue de la réversibilité. Une telle fermeture est complètement étanche.

Étant donné qu'il est actuellement difficile d'acheter de la baudruche, qui est d'ailleurs très chère, et par manque de vieux stocks, il a fallu la fabriquer à l'atelier d'après des recettes traditionnelles. La baudruche est utilisée comme séparation lors du battement dans la production de l'or en feuille. Elle est fabriquée à partir de l'appendice de bœuf qui est bien lavé, ensuite clivé dans son épaisseur. La partie extérieure, très fine (épaisseur 0,02 mm), est rincée, dégraissée et séchée sous tension. Selon les recettes il faut la tremper dans l'eau de chaux, dans une solution de potasse, dans une succession de solvants (méthanol, puis méthanol + chloroforme 3+1 puis éthanol) (Wouters et al. 1992), ensuite la tendre sur un chassis à l'aide de ficelles. Quelques traités indiquent un traitement de surface avec de l'alun, de la colle d'esturgeon, de blanc d'œuf et le collage de deux baudruches pour plus de solidité (de Groot 1991). L'appendice de bœuf donne une surface d'environ 30 cm sur 80 cm de baudruche. Puisqu'il n'est pas évident de l'obtenir (frais dans l'abattoir), on peut aussi utiliser de la peau de saucisse disponible chez le traiteur, de préférence l'intestin grêle de bœuf (se laisse aussi cliver, 12 cm de large) qui donne des surfaces suffisamment grandes pour l'empaquetage de miniatures. Après séchage de la baudruche, l'encollage est appliqué au pinceau lorsqu'elle est encore tendue : avec de la colle d'esturgeon, colle de peau ou gélatine (à chaud, solution aqueuse à 10 %).

Conclusion

Le réassemblage d'une miniature en formant un empaquetage de manière traditionnelle en utilisant de la baudruche est une étape importante faisant partie de la conservation préventive. C'est à ce moment-là qu'il est possible d'offrir à la miniature un environnement exempt de tension afin de limiter les risques dans le futur. En effet, d'autres conservateurs-restaurateurs spécialisés en miniatures confirment que l'emploi de la baudruche permet de réaliser des empaquetages esthétiques et fonctionnels.[7]

Notes

1. Le terme « empaquetage » a été crée pour désigner cet assemblage. Anglais: sealing, allemand: Randverklebung.

2. Pappe (1993) cite les sources suivantes: Perrot (1693); Diderot D´Alembert (1765); Constant-Viguier (1828); Edinburgh Encyc. (1830); Debillemont-Chardon (1909) parmi une quarantaine d´anciens traités analysés.

 Debillemont-Chardon (1909) décrit ainsi (p. 152–153) :

 « Chacun sait que les miniatures doivent nécessairement être mises à l´abri sous un verre qui les protège et qui a, en outre, disons-le en passant, le réel et précieux avantage de donner au coloris plus de moelleux et de fondu. Beaucoup de miniaturistes du temps passé se contentaient de poser simplement la glace sur l´ivoire auquel celle-ci ne se trouvait ainsi appliquée et fixée que par la seule pression du cadre. Ce procédé sommaire de fermeture avait de graves inconvénients, car l´air, la poussière et l´humidité pénétraient facilement entre le verre et l´ivoire et faisaient bientôt de sérieux ravages.

 « D´autres, plus soigneux, montaient leurs miniatures en collant à l´envers de l´ivoire de la peau de gant très fine dont les bords, débordant sur la glace, fixaient très hermétiquement cette dernière à l´ivoire. Cette méthode est excellente, la plus parfaite peut-être, mais elle est d´une pratique toujours difficile et qui devient presque impossible pour des miniatures plus grandes. Pour moi voici comment je procède. Je me procure dans une pharmacie un petit rouleau de taffetas français ou de baudruche gommée ; j´en coupe une petite bande large d´un centimètre environ et de longueur suffisante pour faire le tour de la miniature ; puis, tout en l´humectant peu à peu en la passant sur le bord des lèvres (ce qui est sans danger, puisqu´elle est antiseptique), j´en borde rapidement le verre et l´ivoire. Il faut prendre soin que la partie appliquée sur le verre soit moins large que celle appliquée sur le carton, et faire, pendant tout le cours de l´opération, une pression légère sur le verre et l´ivoire de façon que la baudruche soit collée bien régulièrement. Si ce petit travail, d´ailleurs très facile, est habilement exécuté, votre miniature n´aura plus rien à craindre de la poussière et de l´humidité. »

3. On a intérêt à concevoir un verre nouveau un peu plus grand que la miniature pour avoir plus de facilités de placer les pièces d´espacement (fournisseur voir Matériaux).

4. Méthode appliquée par Catherine Delayre, Paris, France (communication personnelle).

5. Épaisseur 0,02 mm (fournisseur voir Matériaux).

6. Épaisseur 0,05 mm, (communication personnelle de Carol Aiken, Baltimore MD, USA; fournisseur voir Matériaux).

7. Alan Derbyshire et Cecilia Rönnerstam, Victoria and Albert Museum, London, UK; Carol Aiken, Baltimore MD, USA; Catherine Mercenier, Bruxelles, Belgique.

Références

Banik G, Chizzola C, Thobois E, Weber J. 1989. Formation de dépôts cristallins sur la paroi interne des verres d´encadrement de miniatures sur ivoire. Journées sur la conservation, traitement des supports, travaux interdisciplinaires. Paris: AARAFU: 177–183.

CCI. 1993. Care of paintings on ivory, metal and glass. CCI notes 10/14. Ottawa: Canadian Conservation Institute.

Debillemont-Chardon G. 1909. La miniature sur ivoire. Paris.

De Groot ZH. 1991. Die Herstellung von Goldschlägerhaut, transparentem und gespaltenem Pergament. In: Rück P, ed. Pergament, Geschichte, Struktur, Restaurierung, Herstellung, Sigmaringen.

Mercenier C. 1998. Analyse de la miniature sur ivoire (mémoire, ENSAV La Cambre, Bruxelles).

Newton R, Davison S. 1989. Chapter 4. In: Conservation of glass. London: Butterworth: 135–164.

Pappe B. 1993. Werkstoffe und Techniken der Miniaturmalerei auf Elfenbein. Porträtminiaturen auf Elfenbein. Zeitschrift für Kunsttechnologie und Konservierung 7 (2): 261–310.

Pappe B.1995. Porträtminiaturen auf Elfenbein, Bewahrung und Aufbewahrung. Zeitschrift für Kunsttechnologie und Konservierung 9 (1): 18–48.

Tétreault J. 1992. Matériaux de construction, matériaux de destruction. La conservation préventive. Paris: AARAFU.

Wouters J, Gancedo C, Peckstadt A, Watteeuw L. 1992. The conservation of Codex Eykensis: The evolution of the project and the assessment of materials and adhesives for the repair of parchment. The paper conservator 16 : 67–77.

Matériaux

Verres bombés, Ste. A. Laurencot, 19 Rue des Gravilliers, F - 75003 Paris, France.

Feuille de polycarbonate (PC) « makrolon », 0,5 mm, Wettlinger Kunststoffe, Neulerchenfelderstr 6–8, A - 1160 Wien, Autriche.

Ruban téflon « PTFE thread seal tape », disponible dans chaque magasin d´installation (plumbing store) aux USA.

Ruban autocollant qualité archive : « document repair tape », Archival Aids, PO Box 5, Spondon, Derby DE2 7BP, GB.

Carton non-acide noir, Pappen Römer, Bothmerstr. 11/13, D-80634 München, Allemagne.

Abstract

A non-contact method is described which uses atomic oxygen to remove soot and char from the surface of a painting. The atomic oxygen was generated by the dissociation of oxygen in low pressure air using radio frequency energy. The treatment, which is an oxidation process, allows control of the amount of material to be removed. The effectiveness of char removal from half of a fire-damaged oil painting was studied using reflected light measurements from selected areas of the painting and by visual and photographic observation. The atomic oxygen was able to effectively remove char and soot from the treated half of the painting. The remaining loosely-bound pigment was lightly sprayed with a mist to replace the binder and then varnish was reapplied. Caution should be used when treating an untested paint medium using atomic oxygen. A representative edge or corner should be tested first in order to determine if the process would be safe for the pigments present. As more testing occurs, a greater knowledge base will be developed as to what types of paints and varnishes can or cannot be treated using this technique. With the proper precautions, atomic oxygen treatment does appear to be a technique with great potential for allowing very charred, previously unrestorable art to be salvaged.

Keywords

atomic oxygen, char, paintings, fire damage, treatment

Recovery of a charred painting using atomic oxygen treatment

Sharon K. Rutledge★ and Bruce A. Banks
NASA Lewis Research Center
21000 Brookpark Rd. MS 309-2
Cleveland, OH 44138
USA
Fax: 1 (216) 433-2221
Email: sharon.k.rutledge@lerc.nasa.gov
Web site: www.lerc.nasa.gov/www/epbranch/ephome.htm

Virgil A. Chichernea
Cleveland State University
Cleveland, OH 44115
USA

Introduction

Fire in any structure housing an art collection can result in great cultural loss if the art is unrecoverable by conventional methods due to extensive charring of the surface. Paintings in particular are challenging to restore because the carbonaceous char of the varnish and binder is usually intermixed with the paint pigments. It is difficult to remove the char without removing or moving the pigment. A non-contact treatment technique using atomic oxygen, however, is able to distinguish many paint pigments from char and allow the char to be selectively removed, leaving the pigment on the surface.

Research into using atomic oxygen as a treatment technique started through inquiries made by the Conservation Department of the Cleveland Museum of Art as to available NASA technologies that could be used to remove urethane varnish. Presentation of these results and discussion with conservators from other organizations led to investigating the technique for removing soot and char from the surface of paintings and other fine art. Fire damage was believed by conservators to be a problem area that required some additional restorative tools.

Although NASA's focus is on research involving improvements in civil aviation and the peaceful exploration of space, an important function of the agency is to take technologies developed for these programs and make them available for applications on Earth that benefit everyone. That is why techniques to investigate the effects of atomic oxygen on various spacecraft materials are being studied for potential benefit to the art conservation community.

Atomic oxygen is present in the atmosphere surrounding the Earth at altitudes where satellites typically orbit. It has been shown to react chemically with surface coatings or deposits that contain carbon (Banks et al. 1988). In the reaction, the carbon is converted to carbon monoxide and some carbon dioxide. Water vapor can also be a byproduct if hydrocarbons are present. This process can be harmful to a satellite if enough carbon-containing materials that are critical to its operation are removed. Due to the importance of understanding the reaction and the need to test potential solutions for protecting surfaces from reaction, facilities have been developed for producing atomic oxygen on Earth (Banks et al. 1989). Radio frequency, microwave, or electron bombardment has been used to dissociate molecular oxygen into atomic oxygen. These atoms can be either directed at the surface as a gentle flow of gas or the surface can be immersed in the gaseous atomic oxygen. Large area exposure is typically performed in a vacuum chamber where pressures range from 0.001 to 100 millitorr depending on the technique used. Smaller areas can be treated at atmospheric pressure using a DC arc device which is described elsewhere (Banks et al. 1998). Because the process is dry and the reaction is confined to the surface, there is less risk of damaging the underlying paint or canvas.

The atomic oxygen cleaning technique has been demonstrated to be effective at removing soot from canvas, acrylic gesso, unvarnished oil paint, and varnished

★ Author to whom correspondence should be addressed

oil paint (Rutledge and Banks 1996: Rutledge et al. 1998). This paper investigates its usefulness in removing char from a varnished oil painting. The process, which has been patented by NASA, is not intended to be a replacement for conventional techniques, but to be an additional tool for use where conventional techniques may not be effective (US Patent #5560781, 1996).

Procedure

Description of the painting

The Cleveland Museum of Art donated the charred varnished oil varnish painting used for testing of the treatment process. It was originally displayed in St. Alban's Episcopal Church in Cleveland until an arson fire destroyed the church in June of 1989. The museum received a pair of paintings from the church for restoration. The subject of this testing was a painting depicting a female saint with upraised head and eyes. The painting was heavily soot covered with extensive charring and blistering of the full thickness of the paint. Charring was evident as a very black and brittle layer. The other painting of the pair, which depicted the Madonna, infant, and an additional figure which is probably John the Baptist, experienced much less blistering and charring. Restoration attempts were made on the latter painting at the Cleveland Museum of Art using acetone. Methylene chloride was also tried. These processes removed some of the soot and varnish, however, the surface was still very dark and features were difficult to distinguish. Both paintings were considered to be unsalvageable and were donated to NASA for testing of the atomic oxygen treatment process. Because there was less surface charring, the painting depicting the Madonna and infant was treated first (Rutledge et al. 1998). Success with this painting led to the attempt to try to remove the much more extensive charring from the surface of the second painting, which we named the "Saint Painting."

Atomic oxygen cleaning

Cleaning of the painting was performed inside a large vacuum chamber that can accommodate a painting of approximately 1.5 m × 2.1 m in size. The vacuum in the chamber is provided by conventional vacuum pumps with pressures during treatment which range from 1 to 5 millitorr. Two large aluminum parallel plates inside the chamber produce the atomic oxygen. One plate is connected to a radio frequency power supply operating at 400W, while the other plate is at ground potential. The ground plate has several bolts attached to it from which works of art to be cleaned can be suspended in a vertical position either by attachment of fine wire or by acting as a support for a painting stretcher. Canvases too large to fit in the chamber in one dimension, which can be rolled, could be treated in sections by use of a roll and take-up reel inside the vacuum chamber. Paintings to be cleaned are suspended so that the ground plate is as close as possible to shield the backside from atomic oxygen exposure during treatment. Figure 1 shows a painting mounted inside the chamber. A controlled entry of air into the chamber at rates between approximately 130 and 280 standard cubic centimeters per minute provides the source of the oxygen. Radio frequency oscillation of electrons between the two aluminum plates produces dissociation of the oxygen in the air into atomic oxygen. The radio frequency was generated by a power supply manufactured by RF Power Products Inc. The dissociation of the air into atomic species creates a pink-colored glow between the plates. The nitrogen in the air has been found not to have an effect on the removal of carbon and behaves as an inert gas for the treatment exposure. An automated timer and controller on the system allows the cleaning to proceed over a desired timeframe unattended and will turn off the system if a loss in vacuum, water cooling to the pumps and power supply, or drop in plasma intensity is detected.

Analysis

A quartz halogen microscope light set at full intensity, with a color temperature of 3200 K (Blackbody peak wavelength of 900 nm), was mounted on an aluminum

Figure 1. Photograph of the inside of the vacuum chamber showing the two vertical aluminum plate electrodes and a painting hanging on the ground plate (to the right).

Figure 2. The St. Alban's Church "Saint Painting" as received from the Cleveland Museum of Art.

Figure 4. The "Saint Painting" with a polymer mask covering the right half for comparison purposes to prevent this side from being treated.

Figure 3. Close up of the "Saint Painting" showing blistering.

beam so that the light could fall on the surface of the painting at roughly a 45 degree angle. Quartz halogen was selected as the light source because its spectrum is closer to that of daylight, giving a more balanced source of light across the entire color spectrum than conventional incandescent or fluorescent light. This configuration was used to monitor diffuse reflectance from selected portions of the painting at various intervals during the cleaning process. The detector was placed near the light source. The painting was removed from vacuum for these measurements and then returned for further exposure. The reflectance from a magnesium-oxide-coated glass slide was used to correct the data from the detector to eliminate drifts in the intensity of the light source between measurements. The area that could be illuminated was approximately 1.91cm in diameter, so it was necessary to select areas from the painting that were both uniform over this size range and had potential for changing the most (largest contrast) during the cleaning process. In this way, the end point of the cleaning process could be determined by looking for a leveling off of the reflected light signal, indicating that no further change is taking place.

Results and discussion

The "Saint Painting" was approximately 0.733m × 0.58m in size. Figure 2 shows this oil painting as it was received for treatment. A close-up photograph showing the blistering around the face is contained in Figure 3. Because it is sometimes difficult to get an accurate color match in before-and-after photographs, it was decided to restore only half of the painting so that a direct comparison would be available. Two sheets of 0.0127cm thick polyimide Kapton® manufactured by DuPont were used to mask the right half of the painting. Any type of non-metallic covering could be used such as cardboard, paper, or some other plastic sheeting. Kapton® was used because of its availability and its ability to lie in close contact with the surface (stiff but pliable) without putting excessive pressure on the blisters. These sheets were positioned so that a portion of the face and the right side of the central figure would not undergo atomic oxygen treatment. The sheets were wrapped to the reverse of the painting and then stapled to the stretcher to hold them in place. Close contact with the surface was needed to produce a crisp boundary

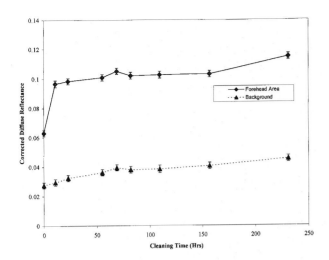

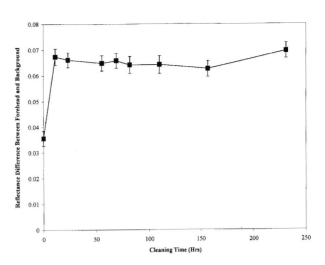

Figure 5. Plot of the diffuse reflectance of light as a function of cleaning time for the forehead and background areas of the painting.

Figure 6. Plot of the difference in diffuse reflectance of light between the background and forehead as a function of cleaning time (contrast).

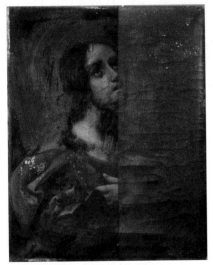

Figure 7. Photograph of the "Saint Painting" after treatment of the left half with atomic oxygen for 10.9 hours (mask has been removed for comparison).

between the treated and untreated areas of the painting. The polymer mask covering half of the painting is shown in Figure 4.

Prior to treatment, two areas were selected to receive reflected light monitoring at intervals in the treatment process. The center of the forehead was chosen because it should represent a broad area of a light color. The background next to the halo was chosen because it was believed that this area should remain dark. It was desired to find two areas that would have the greatest contrast at the conclusion of the treatment and then use the measure of the contrast as an indicator of the completeness of the treatment. Lacking initial photographs of the painting, making a determination of the lightness or darkness of particular areas on the painting was extremely difficult. The soot deposits and char were also not uniform on the surface. This resulted in the cleaning of some areas more quickly than other areas. Unfortunately, this was the case for the two areas that were initially selected. Figure 5 contains the reflectance as a function of cleaning time for the forehead and background areas. Figure 6 contains a plot of the contrast data, which is the difference in reflectance between the forehead and background areas. The background did remain dark during the cleaning process as expected, but the forehead area quickly lightened and then remained fairly constant in reflectance. Other areas of the painting lightened at different rates. This made it difficult to determine the endpoint through the use of reflected light from the selected locations. The authors are in the process of testing an alternative technique that scans the reflected light signal over the entire surface and determines the standard deviation of the signal in order to give a better indication of the contrast change for the entire painting. For this painting, we had to resort to judging the endpoint visually.

Figure 7 shows the painting with the polymer mask lifted off of the surface after treating the left half of the painting for 10.9 hours with atomic oxygen. At this point, many surface details became much more visible such as the detail pattern on the sleeve of the robe, the brooch, and the white lace. Further cleaning removed more of the discolored varnish that appears in the photograph as streaks on the surface of the painting. Although there were areas where the varnish appeared to have been removed down to the paint after 10.9 hours, further cleaning did not appear to change the appearance or coloration. At the conclusion of the cleaning, the paint pigment was loosely bound on the surface. Because the atomic oxygen reaction is confined to the surface, it will remove binder that is in between and on top of pigment particles but will leave a small amount underneath that loosely attaches the particle to the surface. This has been observed with early scanning electron microscope studies of oil paint exposed to atomic oxygen (Rutledge et al. 1994). Because the attachment point is small, it would be possible to remove pigment by mechanical contact with the surface such as brushing. Therefore, with the guidance of conservators from the Cleveland Museum of Art, a fine spray mist of a Grumbacher non-yellowing resin based varnish for oils was applied to fix the

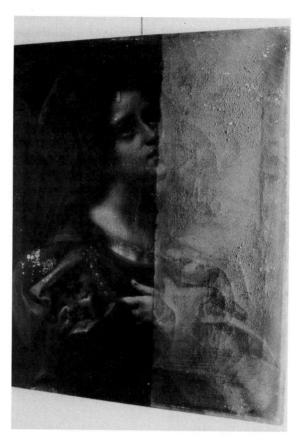

Figure 8. Photograph of the "Saint Painting" after atomic oxygen treatment was completed on the left half and varnish reapplied; the right half was not treated.

pigment on the surface. After this step was complete, an Acryloid® F-10 based picture varnish (Grumbacher) was applied by brush to the treated half of the painting. This varnish was selected because the conservators could remove it if at some future date they desired to complete the restoration by consolidation and inpainting. Figure 8 shows the painting after treatment and re-varnishing of the left half. Details on this side are clearly shown and the blistering is much less noticeable although it is still present on the surface.

There is a potential for dehydration shrinkage to occur during the treatment process due to the fact that it is performed under a partial vacuum. For this painting, there was no deformation observed during treatment. It appeared that if shrinkage did occur, the canvas, paint, and stretcher shrank at approximately the same rate because no additional cracking beyond that originally present on the painting was observed after treatment. This may not be the case for every material combination.

The authors were unable to obtain a photograph of the painting before the fire damage occurred so it was difficult to determine if there were any shifts in paint coloration due to the treatment process. There did not appear to be any yellowing of the surface. The white lace, whites of the eyes, and pearls in the brooch were white after treatment. There have been a number of oil paints tested for changes in coloration using reflectance spectroscopy prior to and after exposure to atomic oxygen (Rutledge et al. 1994). Changes in coloration were not observed for these materials; however, they were for more modern paint formulations. Caution must be used when treating an untested paint medium using atomic oxygen if the cleaning will progress into the paint pigment. A representative edge or corner of the painting which contains most of the paint colors present should be treated using atomic oxygen with the remainder masked off so that a determination can be made if this process will be safe for the pigments present. Organic paint pigments will experience oxidation and removal so care must be taken during cleaning to minimize the loss of organic pigment. As more testing occurs, a greater knowledge base will be developed as to what types of paints and varnishes can or cannot be treated using this technique. With the proper precautions, atomic oxygen

treatment does appear to be a technique with great potential for allowing very charred, previously unrestorable art to be salvaged.

Conclusions

Atomic oxygen treatment has been shown to be able to effectively remove char and soot from a fire damaged, varnished oil painting. In order to remove the charred varnish and paint binder, the paint pigment is exposed. The process leaves the pigment loosely bound on the surface. The pigment can be rebound to the surface using a fine spray mist of a material of the conservator's choice. This can be followed by further treatment by the conservator. Atomic oxygen treatment can be used to perform extensive cleaning, as in this case, or for a light surface cleaning. It is important to first verify that the materials present in the painting are safe for atomic oxygen cleaning by cleaning a small representative edge or corner prior to treatment of the entire painting. This technique appears to have great potential for removing heavy soot and char from the surface of art damaged during a fire and may allow restoration of previously unrestorable works of art. The process is not intended to be a replacement for conventional techniques, but an additional conservation tool in applications where conventional techniques have not been effective.

Acknowledgements

The authors would like to thank Mr. Kenneth Bé of the Cleveland Museum of Art for providing the painting for these tests and for his helpful comments, discussion and advice.

References

Banks BA and Rutledge SK. 1988. Proceedings of the fourth European symposium on spacecraft materials in the space environment, CERT, Toulouse, France, Sept. 6–9, 1988: 371–392.

Banks BA et al. 1989. Proceedings of the 18th annual symposium on applied vacuum science and technology (NASA TM-101971).

Banks BA, Rutledge SK, and Norris MJ. 1998. An atmospheric atomic oxygen source for cleaning smoke damaged art objects. In: Proceedings of the 26th annual AIC meeting, Arlington, Virginia: American Institute for Conservation (NASA TM-1998-208506).

Rutledge SK, Banks BA, and Cales M. 1994. Atomic oxygen treatment for non-contact removal of organic protective coatings from painting surfaces. In: Materials issues in art and archaeology IV. Materials Research Society, Cancun, QR Mexico (NASA TM-106650).

Rutledge SK and Banks BA. 1996. Atomic oxygen treatment technique for removal of smoke damage from paintings. In: Proceedings of the Materials Research Society meeting, Boston, Massachusetts, December 1996 (NASA TM-107403).

Rutledge SK et al. 1998. Atomic oxygen treatment as a method of recovering smoke damaged paintings. In: Proceedings of the 26th annual AIC meeting, Arlington, Virginia (NASA TM-1998-208507).

Banks BA and Rutledge SK. 1996. US Patent #5,560,781. Process for Non-Contact Removal of Organic Coatings from the Surface of Paintings.

Materials

Kapton® polyimide: E.I. DuPont de Nemours & Co. Inc., 1007 S. Market Street, Wilmington, Delaware, 19801 USA. 1-302-774-1000.

Resin-based varnish for oils: n-hexane, turpentine, propane, Stoddard solvent, isobutane, n-butane, M. Grumbacher Inc., Bloomsbury, New Jersey 08804 USA. 1-908-479-4124.

Picture varnish: D-Limonene 5989-27-5, 2-Ethoxyl Acetate (sic) (EEA) 111-15-9, Rohm & Haas Acryloid® F-10, M. Grumbacher Inc., Bloomsbury, New Jersey 08804 USA. 1-908-479-4124.

Abstract

In this investigation glue-paste lining adhesive has been successfully removed from a canvas using an ultraviolet 248nm excimer laser. The main benefits of using a laser are that it is a non-contact technique and it allows for the possibility of automation. The bulk of the glue was removed using a high fluence (1.16J/cm2) scan over the surface. This was then followed by a low fluence (0.35J/cm2) scan which was used to remove the remaining glue. This low fluence scan selectively removes the glue but is not sufficiently high to cause damage to the underlying canvas. Optical and electron microscopy have been used to show that there are significant improvements over the traditional method of glue removal.

Keywords

paintings, canvas, glue, ultraviolet, excimer, laser, ablation, absorption

Canvas glue removal using a 248nm excimer laser

Lee Spencer, Thierry Fourrier, Jason Anderson, Arthur E Hill★
Joule Physics Laboratory
University of Salford
Salford M5 4WT
UK
Fax: +44 (0)161 295 5903
Email: A.E.Hill@physics.salford.ac.uk

Introduction

Glue-paste composed of animal glue and starch is a common adhesive used in the lining of paintings to attach a reinforcing canvas to a degraded original support. The lining may have been performed for a variety of reasons: to reinforce a weakened, torn or otherwise degraded original canvas; to consolidate and to provide additional support to image layers at risk of flaking or delamination; or to help correct surface deformations in paint and/or support. Inevitably, over time such linings deteriorate, often to the point where the painting needs to be re-treated and the lining canvas and lining adhesive removed.

The current method of reversing a glue-paste lining generally involves first removing the (often weakened) lining canvas by slowly peeling it away from the original canvas. This leaves behind a layer of glue which must be removed for there to be no damaging stress applied to the painted canvas, and to ensure any re-lining is properly adhered. Removal of the glue is typically achieved by painstaking mechanical action with a scalpel. Sometimes a small amount of water is applied to the glue to soften it. This process is very time consuming and tedious and it also requires a high level of skill to avoid physical degradation of the original fabric support. The glue-paste joins two very uneven surfaces together hence it is very uneven in thickness. The use of a laser could provide a non-contact method of glue removal which could reduce the risk of damage to the underlying original canvas.

Previous studies of glue removal have been performed using a 830nm Ti:Sapphire laser (Shepard 1998) and a 308nm excimer laser (Whitehead 1997). The study with the ultrashort pulsed Ti:Sapphire laser demonstrated its ability to remove canvas glue. The short nature of the pulse avoids any thermal effects that are normally associated with laser interactions with polymers, although the laser cannot distinguish between canvas and glue. The 308nm excimer laser study showed that the glue could be adequately removed by scanning the pulsed beam across the surface, although there was some damage to the canvas.

Glue-paste lining adhesive is usually a mixture consisting of animal glue and grain starch (from wheat or rye flour), both of which are organic polymers. The ratio of these two components and the presence of other ingredients, such as plasticising substances, are largely dependent on local traditions of conservators where the painting was treated. Animal glue is derived from collagen, the major proteinaceous component of animal and fish skins, as well as tendons and the proteinaceous matrix of bones (Skeist 1990). Wheat starch is a vegetable adhesive that becomes an adhesive substance by the simple addition of water. Starch is a branched chain polysaccharide with the same chemical composition, but different structure, as cellulose, which is the main component of the canvas (McMurray 1996).

In 1982 it was reported that the controlled removal of material from the surface of solid organic polymers using high intensity UV pulses from an excimer laser was possible. This process is commonly known as ablation. Ablation using UV radiation offers a clean and precisely controlled method of removing small quantities of material without causing thermal damage to the etched substrate (Costela 1995).

The ablated area is defined by the size of the light beam and the depth of the hole is defined by the operating conditions of the laser. There is a large body of

★ Author to whom correspondence should be addressed

work involved with the determination of how UV laser light interacts with organic polymers for industrial purposes. This information was useful in developing the experiments to be performed in this study.

Experimental method

To set up a glue removal experiment using a laser it is essential to know the amount of glue that is actually present. The first set of experiments set out to determine the topography of the glue surface and the underlying canvas of the sample. A Surtronic 3P stylus profiler was raster scanned across the surface of the sample to build up a three-dimensional image of the glue surface. This procedure was then repeated with the profiler scanned over an area of canvas that had the glue removed by mechanical scraping. From these images it was then possible to calculate the average depth and the peak-to-peak and trough-to-trough depths of the glue.

The next stage of the experimentation was to determine the etch rate curve for the glue-paste at 248nm. An etch rate curve is the most common way of expressing ablation data. It is a measure of how much material is removed per laser pulse for a given laser fluence. Fluence is the energy density of the laser beam, that is the average laser energy per unit area, measured in J/cm^2. The laser used in the experiments was a 248nm Lambda Physik LPX 205 running on krypton and fluorine with neon as the buffer gas to optimise efficiency. The experimental set up (See Fig. 1) required a beam homogeniser to convert the poor power distribution of the excimer laser output into a far more uniform and usable beam. All experiments were performed in the homogenous plane. A fan was used to blow debris away from the path of the laser beam to reduce attenuation effects and avoid any debris coating the focussing lens. The high voltage setting of the electrode discharge controlled the output power of the laser. The variable aperture was used to control the output fluence. Before the laser was fired, the sample was artificially smoothed using a scalpel so that the surface depth variation was only 10–20μm. This was performed so that the accuracy of measuring the etched holes could be increased. The sample was then mounted on the sample holder. The beam size was set at $(1.85mm)^2$, the pulse repetition rate was set at 4Hz. This low repetition rate was used so that any cumulative thermal effects could be reduced. The fluence was varied from $0.23–1.66J/cm^2$. Preliminary measurements had been made so that the maximum number of shots could be fired at the sample without damage to the underlying canvas This varied from 4000 shots at the lowest fluence down to 100 shots at the highest fluence. Obviously, the greater the number of shots the greater the accuracy in determining the average etch depth per pulse.

Once the thickness of the glue and the etch depth per pulse had been determined it was possible to start some glue removal experiments using a scanning system. These experiments, which involved scanning the laser beam across the sample, were carried out in a similar manner to those performed by Whitehead et al. (1997) with a 308nm excimer laser. Initially, a number of pulses were fired at a target site, the sample was then moved in the X direction by a computer controlled actuator by a distance less than that of the beam width. The same number of pulses were then fired at this new target site. This procedure was repeated moving the target in the X and Y directions to form an overlapped grid (See Fig. 2). The reason for this overlap is that the spatial pulse shape was not exactly "top hat" in that it had sloping edges. By overlapping the target sites a more even coverage of laser light could be achieved. This initial grid was still insufficient in achieving an even removal of glue and, to improve the situation, a second grid was overlaid over the initial grid but offset by half a pulse width in the X and Y directions. Obviously, because two grids were applied to the canvas surface only half the number of shots was required in each grid to achieve the glue removal required. As experimentation continued it was determined that the glue removal procedure needed to be further refined. In the 308nm excimer study (Whitehead et al. 1997) and in earlier parts of this study a fixed fluence was used to remove all of the glue. This allows rapid glue removal but leaves damage to the canvas fibres. To avoid this problem a new system was designed. This involved removing the glue in two stages. For both of these stages the overlapped grid system was to be used.

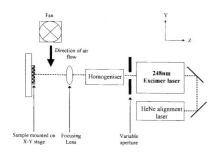

Figure 1. Experimental layout of laser experiments.

Figure 2. Overlapping of target sites on the sample to achieve uniform glue removal: a) Initial grid pattern; b) Repeat grid offset by half a beam width in the X and Y directions.

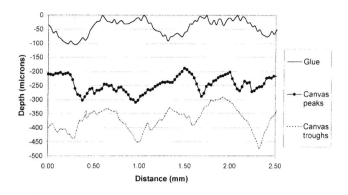

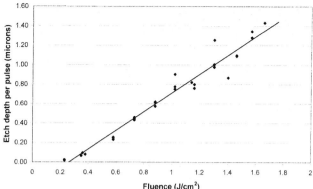

Figure 3. Composite graph showing typical cross section through the canvas sample. Two profiles of the canvas are shown to highlight the large variation in glue thickness and hence the problem of removing all of the glue without damage to the canvas.

Figure 4. Etch rate curve for the glue-paste. Linear regression was used to add the linear fit to the experimental results.

The first stage is to remove the bulk of the glue rapidly using a high fluence regime. This high fluence is used until the canvas has only a thin coating of glue remaining. This thin layer of glue is then removed using a low fluence. The aim here is the selective ablation of the glue-paste but not the underlying canvas. This works on the premise that materials have different effective absorption coefficients and fluence thresholds for ablation. It is this fluence threshold that is of interest because it is possible to remove one material at a given fluence whereas a different material will never be ablated at the same fluence. The experiments were all designed to find the optimum parameters required for glue removal with minimal damage to the underlying canvas using this high/low fluence regime.

An additional experiment was performed to determine the low-level UV absorption of the glue-paste. This was performed by dissolving some of the glue-paste sample in deionised water at 80 °C in an ultrasound bath. The glue did not dissolve in water at room temperature. The sample was then measured in a diode array UV spectrophotometer.

Results and discussion

A plot of a cross-section through the sample can be used to understand the unevenness of the canvas sample being examined (See Fig. 3). This is in fact a compilation of results from a series of profiling measurements. The full line shows a typical two-dimensional surface profile of the glue-paste surface. The average peak-to-trough distance is calculated from the three-dimensional data to be 100μm. This line clearly shows the impression that is made on the glue surface from the lining canvas and highlights the fact that the laser impacts on a highly uneven surface. The dotted line is a scan across the peaks of the canvas. This would be the point where the glue layer is at its thinnest. The dashed line is a scan that passes over the fibre interstices. This is the point where the glue layer would be at its thickest. The average glue thickness for this particular sample was $200 \pm 20\mu$m. Again, there is the problem of a huge variation in the surface of the canvas dependent upon the scan line. From calculations, however, it has been shown that the glue does not penetrate all the way through the weave interstices. This is also shown by the fact that there is less depth variation in the glue surface than in the canvas surface.

The etch rate curve for glue paste has been plotted on linear axes (See Fig. 4). This is somewhat unconventional, as the standard format is to plot the fluence on a logarithmic scale. A logarithmic scale is generally used so that a fit of Beer's Law with experimental data can be made. However an attempt was made to fit the etch rate data to Beer's Law and a more complicated model (Singleton 1990) and neither of these proved particularly successful. The best obtained mathematical fit to the etch rate data was a simple linear plot with the equation: $d = 0.96 (F) - 0.25$, where d is the etch depth per pulse in microns, and F is the fluence in J/cm2. The ablation threshold of the glue-paste is around 0.20Jcm2. That is to say that below this fluence there may still be chemical changes in the glue-paste, but it will not be ablated. Up to the highest fluence measured, 1.66J/cm2, the experimental results compare favourably with the linear fit, within the $\pm 10\%$ error in measuring the fluence.

Figure 5. SEM micrograph, showing minimal damage to the peak of a canvas weave after laser treatment.

Figure 6. SEM micrograph, showing the level of damage to the canvas weave after glue removal with a scalpel.

Table 1. Parameters used in the two glue removal experiments.

Parameter	First glue removal experiment	Second glue removal experiment
Beam size (mm)	1.85 × 1.85	1.85 × 1.85
Pulse repetition rate (Hz)	4	4
Beam separation (mm)	1.3	1.6
Bulk removal: Fluence (J/cm^2)	1.16	1.16
Bulk removal: Number of shots	80 + 80	80 + 80
Fine removal: Fluence (J/cm^2)	0.35	0.35
Fine removal: Number of shots	225 + 225	600 + 600

Now that a relationship between the etch rate and the fluence is known, together with the mean glue depth for a given fluence, an estimate can be made for the number of shots required to remove all of the glue. In all of the glue removal experiments the beam size was maintained at a constant ($1.85mm^2$), the smallest achievable beam size with the 150mm focussing lens used. The pulse repetition rate was also maintained constant at 4Hz. Two series of experiments were pursued. The first involved using a beam separation of 1.3mm when constructing the glue removal grid. After some characterisation of the beams' spatial characteristics it was decided that a separation of 1.6mm would lead to more satisfactory results. A list of the optimum parameters has been given to compare the two regimes (See Table 1). For both experiments the same bulk glue removal regimes were pursued. This involved a fluence of $1.16J/cm^2$ fired 80 times at each target site for the first grid, and then a further 80 times at each target site when the sample was offset by half a beam width in the X and Y directions. If a comparison is made between the number of shots required for the fine glue removal regime for both experiments it can be seen that when the beam separation was much larger, a larger number of shots was required to remove the glue. This is reasonable because there is a larger area of glue removal at 1.6mm than at 1.3mm separation. In terms of comparative glue removal, the 1.6mm beam separation is far superior. It offers excellent glue removal and at the same time there is negligible damage to the underlying fibres.

The samples were examined under both an optical and electron microscope. The results were extremely convincing. The glue had been removed in its entirety from the weave interstices, the area where glue was expected to remain, if anywhere, because the weave interstices were the areas where the glue layer would be at its thickest. At the same time an examination of the peaks of the canvas weave showed that perhaps only two or three layers of fibres at the peak of the weave were severed (See Fig.5). This should be compared with the level of damage seen when the glue is mechanically scraped from the canvas (See Fig. 6). The laser may not even have caused this fibre damage. The greatest tension in the canvas weave is present at the peak of the weave but, when this peak is strongly adhered to the glue, it remains unbroken. When the glue is removed it is possible that the top layers of fibre degrade and are removed with the explosive process of ablation. It is clear from the results that the fine glue removal fluence used, $0.35J/cm^2$, while allowing a slow ablation of the glue-paste is not responsible for anything but minimal damage to the canvas. To confirm this a brief experiment was performed to see the effect of

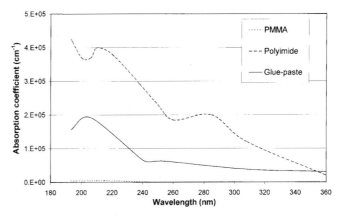

Figure 7. Low-level UV absorption spectra of the glue-paste. Compare this with a strong absorber, polyimide, and a weak absorber, PMMA.

low fluences on a sample of canvas. It was found that at 0.35J/cm2, even after 1600 shots there was no damage to the canvas detectable under an optical microscope, although the colour of the canvas had changed to a darker colour, indicating a possible carbonisation of the surface.

The low-level UV absorption experiments show that the glue-paste is a moderate absorber at 248nm (See Fig. 7). At 248nm the absorption coefficient is 62,000cm$^{-1}$. This should be compared with 240,000cm$^{-1}$ for polyimide, a strong absorber, and 500cm$^{-1}$ for PMMA, a weak absorber (Costela 1995). There is no direct correlation between the low-level absorption coefficient and the effective absorption of the glue-paste with UV laser light. The reason for this is that the light sources for the two experiments are entirely different. The UV laser provides high intensity light that can cause surface heating, photochemical changes and ablation, whereas the UV lamp of the spectrophotometer comparatively does not. There is a good deal of scepticism concerning the use of low-level UV absorption data. However, the trend is that a moderate absorber of low-level UV light will also be a moderate absorber of high intensity UV laser light.

Conclusions

On the sample measured, the impression of the lining canvas gave rise to a mean surface variation of 100mm. The mean variation in canvas depth was more severe at 180mm. The overall glue layer was of the order 200μm thick on average.

A high and low fluence regime was used to remove the glue effectively. The high fluence (1.16J/cm2) was used to remove the bulk of the glue without penetrating far enough to cause damage to the underlying canvas because, if the canvas is subjected to this high fluence, it is readily ablated. The remaining glue is removed by using a low fluence (0.35J/cm2), which has been shown to be high enough to ablate the glue slowly but is too low to cause damage to the underlying canvas. This selectivity is entirely due to the different UV absorption properties of the canvas and the glue-paste. The best achievable results were obtained in experiment 2 (See Table 1). This process is slow but it offers unparalleled glue removal and minimum damage to the canvas. Compared to mechanical scraping of the glue, it offers a vast improvement in the quality of the canvas fibres. It also offers better results than are obtainable with the 308nm excimer laser.

The 248nm excimer laser has been shown to be an effective tool in the removal of canvas glue. The next stages of the process should involve the development of a control and monitoring system in a feedback loop with the laser to prevent any damage to the underlying canvas. This monitoring system could be provided by a mass spectrometer measuring in real time the ablated products, with a response time faster than that of the pulse repetition rate to allow pulse by pulse monitoring. Also, a system needs to be developed that could operate much more rapidly than the laboratory set up. This poses more of an engineering problem than a scientific one.

Acknowledgements

We wish to thank S. Hackney from the Tate Gallery in London, for providing the canvas samples used in the experiments; also C. Faunce, S. Astin, and P. Baugh from the University of Salford for their help throughout the experiments.

References

Costela A et al. 1995. Ablation of poly(methyl methacrylate) and poly(2-hydroxyethyl methacrylate) by 308, 222, and 193nm excimer radiation. Applied Physics A 60: 26–270.
McMurray J. 1996. Organic chemistry. 4th Edition. International Thomson Publishing.
Shepard J. 1998. Investigation into the suitability of ultrashort pulses as a means of glue-paste lining adhesive. Diploma project report. Dept. of Conservation & Technology, Courtauld Institute of Art, University of London. Unpublished.
Singleton D. 1990. Comparison of theoretical models of laser ablation of polyimide with experimental results. Chemical Physics 144: 415–423.
Skeist I. 1990. Handbook of adhesives. 3d edition. Van Nostrand Reinhold Publishing.
Whitehead C et al. 1997. Experiments into canvas glue removal. Tech Note 21. Department of Physics. University of Salford. Unpublished.

Abstract

The solvent-extractable components of dried oil paint films have been studied in the context of the effects of organic solvents used in painting conservation treatments. The soluble fraction has been measured and characterised in a range of pigmented oil films of different ages, as well as in samples from an early 19th century painting. The soluble material consists of a complex mixture of chemical components. In addition to free fatty acids, mono-, di- and triglycerides have been identified in some extracts. The quantity and composition of the extracts vary according to factors such as the time of solvent exposure and the solvent used for extraction. More polar solvents are found to extract a greater proportion of more oxidised, polar paint film components.

Keywords

oil paint film, organic solvent, fatty acid, glyceride, gas chromatography, liquid chromatography mass spectrometry

The components of oil paint films extracted by organic solvents

Ken Sutherland★ and Nobuko Shibayama
Scientific Research Department
National Gallery of Art
Washington DC 20565
USA
Fax: +1 202 842-6886
Email: k-sutherland@nga.gov

Introduction

The risks associated with the use of organic solvents in painting conservation treatments have been demonstrated by a number of studies (Stout 1936: Graham 1953: Jones 1965: Stolow 1985: Erhardt and Tsang 1990). These identified the primary effects of solvents on dried oil paint films as a swelling of the film and the extraction of soluble components of the oil binder. When cleaning a painting, swelling of the paint layers will give the immediate risk of physical damage to the paint layer, whereas leaching has more long term risks, such as an embrittlement of the paint film and a possible change in surface appearance due to disruption of the binding medium.

The extractable fraction in a dried oil film consists of low molecular weight components not incorporated into the polymeric oil matrix. The triglycerides initially present in the oil undergo processes of oxidative scission and hydrolysis in addition to cross-linking, which lead to the production of these smaller, extractable compounds (Mills and White 1994: Boon et al. 1996).

Investigations are being carried out at the National Gallery of Art to give more information on these solvent effects, focusing on the extraction of organic components from the paint film. The studies are intended to give a more detailed understanding of the different factors affecting the leaching process, the chemical nature of the extractable components, and the potential risks associated with the use of different solvents. Areas of investigation include the analysis by gas chromatography (GC) and liquid chromatography mass spectrometry (LCMS) of soluble material from oil paint films of different ages, including 4-year-old and 32-year-old films made with a range of pigments, including umber and lead white. Samples from these paint films have been extracted using different solvents encountered in conservation treatments. Variations in the quantity and chemical composition of the extracted material are being investigated, according to factors such as the age of the paint film, the solvent used for extraction, and the time of solvent exposure. The soluble components of samples from a painting dating from the early 19th century have also been analysed and preliminary experiments have been carried out to determine the quantities of organic material extracted during cleaning treatments.

Materials and methods

Paint samples and paintings

The paint films used in the study include a set of samples prepared in the National Gallery of Art in 1993 and samples prepared by Nathan Stolow between 1953 and 1971. The results described will be from an umber and linseed oil (sun thickened) film from 1993, prepared as 70% oil by weight; and a lead white and linseed oil (alkali refined) film, 15% oil, prepared by Stolow in 1965. None of the samples has undergone accelerated ageing. The painting sampled for analysis was an early 19th century portrait on canvas by an unknown American artist, held by the Scientific Research Department of the National Gallery of Art.

★ Author to whom correspondence should be addressed

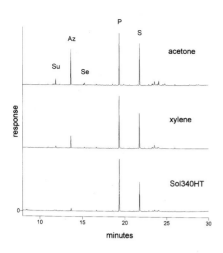

Figure 1. Gas chromatograms of solvent extracts from 32-year-old lead white and linseed oil film. Su = dimethyl suberate, Az = dimethyl azelate, Se = dimethyl sebacate, P = methyl palmitate, S = methyl stearate.

Solvent extraction

Solvent extracts were obtained by immersing paint samples in solvent for 10 minutes or 24 hours, after which the soluble material was analysed by GC or LCMS. Sample sizes varied according to the type of analysis and the paint film: for GC, samples weighing 1–6mg were immersed in 1–2mL solvent. For LCMS, samples weighing 10–40mg were immersed in 1–2mL solvent. Samples from the painting, 0.5–1mm², were immersed in 0.1–0.2mL solvent. Measurements of quantities of fatty acids extracted from paint samples were made using GC with methyl tridecanoate as an internal standard (see Appendix).

The solvents used were Sol340HT (a low aromatic hydrocarbon mineral spirit produced by Shell Chemical, sometimes sold as Stoddard solvent), xylenes (a mixture of ortho, meta and para isomers), methylene chloride (dichloromethane), acetone and ethanol.

Cleaning experiment

Samples were taken from adjacent areas of a painting: one cleaned mechanically, using a scalpel blade; and one using solvent, with cotton swabs as in a typical cleaning treatment. Samples from the mechanically cleaned area had no exposure to solvent and therefore represented the paint film "before treatment". For each paint sample, the proportions of fatty acids extractable by 24-hour immersion in the cleaning solvent were then measured using quantitative GC analysis (see Appendix). Differences in the proportions of extractable material between the samples taken from paint areas cleaned mechanically and from those cleaned using solvent swabs, gave an indication of the quantities of fatty acids which had been extracted by the cleaning treatment. Five samples were taken from each area, to account for inherent variations in paint film composition.

Results and discussion

Gas chromatography

Analysis of solvent extracts from oil paint samples using GC shows the presence of fatty acids derived from the oil medium. Figure 1 shows chromatograms of extracts obtained from samples of a 32-year-old linseed oil film pigmented with lead white, using three solvents: acetone, xylene and Sol340HT.

The main components detected are methyl esters of the saturated fatty acids, palmitic and stearic acid; and dicarboxylic fatty acids, primarily azelaic acid (C9), and also suberic (C8) and sebacic acid (C10). These dicarboxylic acids are produced during the drying process by oxidative scission of the unsaturated C18 acids initially present in the triglycerides of the linseed oil.

The relative proportions of these fatty acids are different in the three solvent extracts, particularly with regard to the shorter chain fatty acids. Acetone extracts the greatest proportion of azelaic, suberic and sebacic acids. A smaller proportion of these compounds is found in the xylene extract and only a trace is detected in the Sol340HT extract.

This demonstrates a correlation between the polarity of the solvent used for extraction and the polarity of the material extracted. Azelaic, suberic and sebacic acid are more polar than palmitic and stearic acid, since they are dibasic, i.e. possessing two carboxylic acid groups, and also because of their smaller size. The proportions of these compounds found in the solvent extracts is consistent with the polarity of the solvents: acetone is a polar, oxygenated solvent; xylene is an aromatic solvent of intermediate polarity; and Sol340HT is a nonpolar hydrocarbon solvent.

Liquid chromatography – mass spectrometry

GC analysis gives information only on the component fatty acids in the solvent extracts. Additional information on the composition of the extracts was obtained using LCMS, which allowed separation and identification of some of the higher molecular weight compounds.

Figure 2. Liquid chromatograms of solvent extracts from 4 year old umber and linseed oil film. mA = monoazelain, Az = azelaic acid, dA = diazelain, tA = triazelain, mP = monopalmitin, mO = monoolein, dPA = diglyceride of palmitic and azelaic acids, dOA = diglyceride of oleic and azelaic acids, mS = monostearin, dSA = diglyceride of stearic and azelaic acids, tAAS = triglyceride with one stearic and two azelaic acid residues.

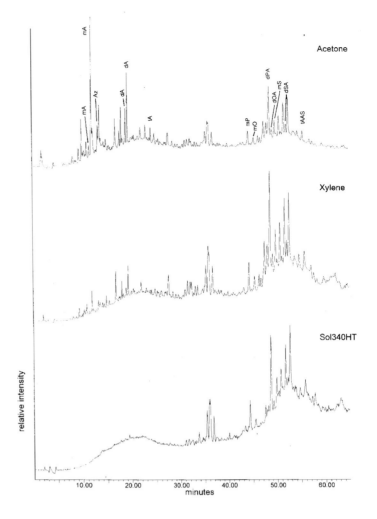

Figure 2 shows chromatograms of solvent extracts, this time from a 4-year-old linseed oil film pigmented with umber, analysed by LCMS. The same three solvents were used for extraction: Sol340HT, xylene and acetone. The solvent gradient system used for the chromatography (see Appendix) gives a separation of compounds on the basis of polarity, with more polar compounds eluting earlier, and less polar compounds later in the chromatogram.

Distinct groups of compounds can be seen in the extract samples. The group eluting between 44 and 55 minutes includes mono-, di- and triglycerides, generally containing at least one saturated or monounsaturated (oleic) fatty acid residue. Species identified by mass spectrometry are labelled in Figure 2 and include monopalmitin, monoolein and monostearin; mixed diglycerides of azelaic acid with palmitic, stearic or oleic acid; and a triglyceride with one stearic and two azelaic acid residues. Some of the compounds show more than one peak, corresponding to isomers with the fatty acids in different positions.

The group of compounds eluting between 8 and 24 minutes includes mono-, di- and triglycerides of oxidised fatty acid residues, such as azelaic acid. Species identified include mono-, di- and triazelain, as well as azelaic acid. Many other peaks were not readily identifiable since appropriate standards were not available, but the mass spectra suggest a number of these are other fatty acid and glyceride species containing oxidised functional groups. The acetone extract contains the greatest proportion of the more polar, oxidised compounds in this region; the xylene extract an intermediate amount; and the Sol340HT extract contains only a trace.

Measurements of soluble fatty acids

GC analysis of solvent extracts was also carried out using methyl tridecanoate as an internal standard, to measure the quantities of fatty acids extracted from paint films, including samples from paintings as well as test paint samples.

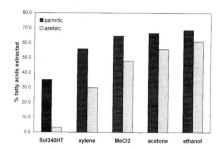

Figure 3. Percentages of palmitic and azelaic acids extracted from umber paint samples after 24-hour immersion in solvent.

Table 1. Percentages of palmitic and azelaic acids extracted from paint samples after immersion in solvent.

	palmitic	azelaic
umber paint samples, 24-hour immersion		
Sol340HT	35.1	3.1
xylene	55.9	29.8
methylene chloride	64.7	47.8
acetone	66.5	55.6
ethanol	68.6	61.0
umber paint samples, 10-minute immersion		
Sol340HT	4.3	-1.1
xylene	47.4	19.6
methylene chloride	63.8	47.9
acetone	55.9	46.3
19thC paint samples, 24-hour immersion		
Sol340HT	2.1	1.4
xylene	13.0	1.3
methylene chloride	60.2	9.9
acetone	23.0	12.3
ethanol	39.3	17.7

Table 2. Hildebrand solubility parameters (δ) for solvents used in study

Solvent	δ
Sol340HT	7.4 [1]
xylene	8.8
methylene chloride	9.7
acetone	10.0
ethanol	12.7

[1] From Shell literature, others from Crowley et al. (1966)

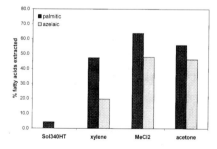

Figure 4. Percentages of palmitic and azelaic acids extracted from umber paint samples after 10 minute immersion in solvent.

The quantities of palmitic and azelaic acids extracted from samples of the 4-year-old umber paint film by a 24-hour immersion in one of five solvents: Sol340HT, xylene, methylene chloride, acetone and ethanol; are plotted in Figure 3. These values are also listed in Table 1. The values are given as percentages of the total fatty acids present in the paint film before extraction (see Appendix for quantification methods). It should be pointed out that despite the high extraction values – almost 70% palmitic acid was extracted in ethanol – the paint samples remained intact and no pigment was lost in any of the solvents.

These results again show a relationship between the polarity of the solvent and the proportion of the more polar compound, azelaic acid, in the extract, with the proportion of azelaic acid in the extracts relative to palmitic acid increasing in the order Sol340HT < xylene < methylene chloride < acetone < ethanol. The solvents in Figure 3 are placed in order of their Hildebrand solubility parameter, d, which is a value related to the polarity of the solvent. These values are listed in Table 2.

There is also a correlation between the polarity of the solvent and the overall quantity of material extracted, with ethanol extracting the greatest proportions of fatty acids and Sol340HT the least. The intermediate effect of methylene chloride is perhaps surprising, considering the high swelling effect which has been demonstrated for chlorinated solvents in this solubility parameter region (Stolow 1985). This suggests that the degree of swelling is not always the most important factor determining the amount of leaching that occurs, and that the solubility parameters of the solvent and extractable compounds play an important role.

Figure 4 shows the data for 10 minute extractions from samples of the same paint film (10-minute values were not available for ethanol). These quantities are also listed in Table 1. A comparison of the 24-hour and 10-minute extraction gives some idea of the relative rates of action of the different solvents. For the more polar solvents, methylene chloride and acetone, a significant proportion of the material soluble by 24-hour immersion is extracted in only 10 minutes. For Sol340HT, only a small proportion of palmitic acid has been extracted in 10 minutes. Methylene chloride can be seen to have a very rapid leaching action in this respect, having the greatest effect in 10 minutes of the four solvents tested.

Solubility measurements on a 19th century painting

Similar solubility measurements have been carried out on samples from paintings. These include an early 19th century portrait on canvas, by an unknown American artist, currently in the Scientific Research Department at the National Gallery of Art. Pigment and medium analysis of this painting showed a fairly traditional use of materials, with pigments bound in pure linseed oil. Residues of a discoloured varnish indicated that the painting had been cleaned and revarnished at least once. Samples were taken from a flesh area, consisting of well bound, lead white based paint, after first removing surface varnish mechanically, using a scalpel blade. Samples were immersed in the same five solvents for 24 hours; the quantities of fatty acids extracted are plotted in Figure 5 and listed in Table 1.

When analysing samples from paintings, there is the complication that solvent-extractable material will include compounds other than those deriving from the original binding medium – such as varnish components and, in some cases, additives to the paint medium. Conservation materials such as wax may also be present. In this case, however, preliminary fatty acid analysis of samples from the same paint area indicated that the medium was pure linseed oil, free of fatty acid contaminants such as wax; it was concluded that the fatty acids detected in the solvent extracts were derived from the binding medium. The ratios of fatty acids in the extracts were consistent with this idea. An additional factor to be taken into account is that previous exposure to solvents in cleaning treatments may have an influence on the quantities of soluble material observed.

Methylene chloride was the most active solvent in this case, in terms of extraction of fatty acids, followed by ethanol, acetone, xylene and Sol340HT. The orders of solubility are lower than in the younger, test paint films, although still significant: 39% palmitic acid was extracted in ethanol, and 60% in methylene chloride. The pronounced effect of this latter solvent on the aged paint samples suggests that swelling action plays a greater role than with the younger paint

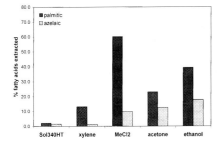

Figure 5. Percentages of palmitic and azelaic acids extracted from 19th century paint samples after 24 hour immersion in solvent.

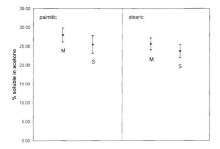

Figure 6. Percentages of palmitic and stearic acids extractable from 19th century paint samples taken from mechanically (M) and solvent (S) cleaned areas.

samples. It is not clear why this should be so, but the results demonstrate that the leaching process is complex and affected by a number of factors, including swelling behaviour and solubility parameters.

Samples were also analysed from two adjacent areas of the same flesh paint area, one which had been cleared of varnish mechanically as before, and the other cleaned using solvent swabs with acetone, as in a cleaning treatment. The swabbing was prolonged, giving a longer exposure to solvent than would generally be used in practice. The quantities of fatty acids extractable from the samples by a 24-hour immersion in acetone were then measured as before. The results are plotted in Figure 6. Five samples were taken from each area; the degree of variation observed within each group of samples is indicated in the figure. The proportion of fatty acids soluble in the paint samples is seen to be reduced in the samples cleaned with acetone, compared to those "before cleaning" (i.e. mechanically cleaned). This indicates that a small percentage of the acetone-extractable fatty acids (approximately 2%, relative to total fatty acids in the paint film) have been removed by exposure to acetone in the form of a simulated cleaning treatment. Values for palmitic and stearic acids only are given, since azelaic acid levels showed too much variation within the two groups of samples to give a meaningful comparison.

Conclusions

The fraction of a dried oil paint film extractable with solvents consists of a complex mixture of compounds, including fatty acids, mono-, di- and triglycerides. The quantities and relative proportions of the components extracted vary according to the time of exposure to solvent and the type of solvent. More polar solvents were generally found to extract the greatest quantities of material in the paint films tested, although the high swelling solvent methylene chloride was found to have the greatest effect on the 19th century paint samples. The more polar solvents are also found to extract a greater proportion of more oxidised, polar components, including azelaic acid, from the paint films. This factor may be significant when considering the effects of solvents on older paint films, which are likely to have become progressively more oxidised and polar in character with age, and this is an area requiring further investigation.

A small, but measurable, proportion of fatty acids was found to be removed from an area of flesh paint in the 19th century painting by exposure to solvent swabs used as in a cleaning treatment. Further experiments of this type are being carried out to compare the relative effects of cleaning procedures using different solvent formulations and methods of application.

Appendix

Gas chromatography

A Perkin Elmer Autosystem GC was used, in splitless mode, with a Restek Rtx-1 column and flame ionisation detector. The temperature was programmed at 50°C for 0.5 minutes, then increasing at 25°/min to 100°C, and then at 6°/min to 280°C, held for 5 minutes. The injector temperature was 300°C, detector temperature 325°C. 1 μl samples were generally injected.

Paint samples and solvent extract residues were derivatised for GC analysis using either diazomethane, by a modification of the method of Mills (1966), or using TMTFTH (3-(trifluoromethyl)phenyltrimethylammonium hydroxide, Chrompack), as described by White and Pilc (1996). Both methods give conversion of fatty acids, in free acid and glyceride ester forms, to their methyl esters.

For quantitative GC, methyl tridecanoate was used as an internal standard. Turbochrom software was used to calculate peak areas. Percentages of soluble fatty acids were calculated in one of two ways. For the laboratory prepared paint films, paint samples were taken from the film before and after immersion in solvent. Samples were 0.3–0.5 mg, weighed using a Mettler balance accurate to 10 μg. After derivatisation and analysis, concentrations of component fatty acids in the samples were calculated with reference to the internal standard. Differences in these concentrations before and after immersion were used to determine the percentages

of fatty acids extracted. Multiple samples were taken before and after immersion – between 3 and 5 – to reduce the likelihood of statistical error.

Samples from the painting were immersed in solvent for 24 hours, after which the solvent was transferred to a separate vial. Both the solvent extract and paint sample residue were derivatised and analysed separately, and the quantities of fatty acids in each were determined. Quantities of fatty acids in the extract were then calculated as percentages of the total fatty acids, i.e. those in the residue plus extract. Duplicate samples were extracted in each case; the results presented are averages.

Liquid chromatography mass spectrometry

A Hewlett Packard HP 1090 liquid chromatograph was used, with an Aquapore RP18 column and an Inertsil ODS3 column in series. A water-acetonitrile system was used, starting with 90% water, with a gradient to 100% acetonitrile over 50 minutes, total run time 65 minutes. Acetic acid was added to both solvents at 0.5%.

The LC was interfaced to a VG-Quattro II mass spectrometer via an APCI source. Data were processed using Masslynx software.

Acknowledgements

This work was carried out at the National Gallery of Art, Washington DC, supported by the Culpeper Foundation, and since 1998 has continued as part of the MOLART research programme, funded by the Dutch Organisation for Scientific Research (NWO). The lead white oil paint film was provided by Nathan Stolow and the umber paint film was prepared at the NGA by Barbara Berrie. The authors are grateful to colleagues in the painting conservation and scientific research departments of the NGA for advice and help with this work.

References

Anon. 1994. Hydrocarbon solvents: Typical properties. Shell Chemical Company brochure SC: 1056–94.

Boon J, Peulvé S, van den Brink O, Duursma M, Rainford D. 1996. Molecular aspects of mobile and stationary phases in ageing tempera and oil paint films. In: Early Italian paintings, techniques and analysis. Maastricht: 35–56.

Crowley J, Teague G, Lowe J. 1966. Three dimensional approach to solubility. Journal of paint technology: 269–280.

Erhardt D, Tsang JS. 1990. The extractable components of oil paint films. In: Mills, JS and Smith, P eds. Cleaning, retouching, coatings. Preprints of the congress of the IIC. Brussels: International Institute for Conservation: 93–97.

Graham I. 1953. The effect of solvents on linoxyn films. Journal of the oil and colour chemists' association 36: 500–506.

Jones PL. 1965. The leaching of linseed oil films in isopropyl alcohol. Studies in conservation 10: 119–128.

Mills JS. 1966. The gas chromatographic examination of paint media. Part I. Fatty acid composition and identification of dried oil films. Studies in conservation 11: 92–107.

Mills JS, White R. 1994. The organic chemistry of museum objects. 2nd ed. London: Butterworths: 35–40.

Stolow N. 1985. Solvent action. On picture varnishes and their solvents, Revised and enlarged ed. Washington DC: National Gallery of Art: 47–116.

Stout G. 1936. A preliminary test of varnish solubility. Technical studies in the field of fine arts 4: 146–161.

White R, Pilc J. 1996. Analyses of paint media. National Gallery technical bulletin 17: 91–95.

Abstract

Oil paint films were exposed to solvents including toluene, acetone, and triethanolamine for varying lengths of time. Weight measurements show that evaporation of the volatile solvents acetone and toluene from paint films is essentially complete within hours. These dried films weigh less due to extraction of components including glycerol, azelaic acid, fatty acids, and mono-, di-, and triglycerides. Stress-strain measurements show measurable changes in stiffness in bulk films after as little as 30 seconds exposure to the volatile solvents. Dried films are stiffer and somewhat more brittle than unexposed films due to the loss of plasticizing compounds. The ability of paint films to safely tolerate moderate (+/- 15%) fluctuations in relative humidity as one layer in a painting is unaffected. In contrast, the nonvolatile solvent triethanolamine (TEA) does not evaporate appreciably even after two weeks. Exposure to TEA results in a permanent decrease in stiffness.

Keywords

paint, solvent, cleaning, physical properties, weight, stiffness, elasticity, plasticity

Effects of solvents on the physical properties of paint films

Charles S. Tumosa, Jennifer Millard, David Erhardt,[*] and Marion F. Mecklenburg
Smithsonian Institution
SCMRE-MSC, MRC 534
4210 Silver Hill Road
Suitland, MD 20746-2863 USA
Fax: 301 238 3709
Email: wde@scmre.si.edu

Introduction

It is standard practice to use solvents to remove coatings and dirt from paintings. Many of the effects of solvents on paint films have been examined in numerous studies (Stolow 1985: Erhardt and Tsang 1990: Phenix 1998: White and Roy 1998). Changes in volume, weight, optical appearance, and bulk composition have been examined, as well as the composition of materials leached from the paint. However, little if any work has been conducted on the effects of solvents on critical mechanical properties such as strength, stiffness, elasticity, and plasticity. Though the optical appearance of a paint film is paramount, other physical properties are critical to the long-term survival of a painting during handling, transport, or environmental changes. The elasticity of a paint film (its ability to be reversibly stretched or compressed within a finite range) is especially critical because of the differential dimensional response to environmental changes of the other layers within a traditional painting. This paper examines the effects of selected volatile and nonvolatile solvents as a function of time of exposure, time after exposure, and amount of residual solvent.

The samples

The tested samples consisted of naturally aged, 0.1 to 0.2mm thick, dried oil paint films ranging in age from 6–20 years old. The newer films were made from custom-prepared paints containing only oil and pigment, the older films were prepared from artists' quality commercial oil paints. The films contained various pigments as noted in the text and figures. The mechanical tests required free paint films of a consistent thickness and suitable size, which excluded the use of samples from paintings. Accelerated aging was not used for several reasons. First, previous tests on the older samples had shown that their bulk physical properties had stabilized and become uniform within three years, indicating that the "drying" process for all of the samples would be complete (Mecklenburg and Tumosa 1991). Any subsequent changes due to degradation processes would be incrementally small rather than fundamental. Second, it has not been shown that any accelerated aging process accurately simulates the natural aging of bulk paint films. Light aging probably simulates accurately many of the changes that occur on the surface of paint, but has no significant effect on the interior of bulk samples. Thermal aging causes changes in the interior of paint, but it is questionable if these changes accurately simulate natural aging. The drying and aging process of paint films includes chemical changes such as polymerization, chain scission, oxidation, and hydrolysis as well as physical changes such as the loss of volatile compounds and the "ordering" of polymer chains in thermodynamically stable, compact, pseudo-crystalline arrangements. It is unlikely that elevated temperatures speed up all of these processes uniformly. This is certainly not true if thermal aging is used before the drying process is complete, since it is known that the thermal polymerization of drying oils occurs through a completely different mechanism than the oxidative polymerization of oil films painted out and exposed to air.

[*] Author to whom correspondence should be addressed

Even if the paint is "dried" before thermal aging, it is unlikely that thermal aging accurately simulates natural aging. For example, natural rubbers form ordered regions ("crystallize") during natural aging. Exposure to elevated temperatures not only prevents the formation of such regions, but can actually reverse the process! It is likely that thermal aging of dried oil paint films would also cause changes in the physical, as well as chemical, aging process. For example, the saturated fatty acids stearic and palmitic, as well as the mono-, di-, and triglycerides containing them, are found in significant quantities even in old paint films (vide infra). The melting points of most of these compounds are in the range 60 to 80° C. Temperatures this high are often used for artificial aging in order to produce changes in a reasonable length of time. However, we have found that changes induced in oil paint films by treatments at such temperatures are quite unlike those seen in naturally aged samples as old as 200 years.

The problems associated with conducting aging experiments above critical phase transitions have been discussed elsewhere (McCormick-Goodhart 1995). It is not a simple matter to demonstrate the equivalence of natural and artificial aging (Erhardt and Mecklenburg 1994), and thus far it has not been done for the thermal aging of paint. We therefore chose to conduct our work on reasonably old naturally aged films.

The experiments

A strip of paint film was dipped in a solvent for a measured length of time, removed, and air dried. A different paint sample was used for each combination of solvent, exposure time, and drying time. The films were weighed before and after exposure, and during drying. Stress-strain measurements were conducted either after one hour or after at least 24 hours (the weights had all stabilized within 5 hours). The methods used for these measurements have been described previously (Mecklenburg and Tumosa 1991).

The interpretation of stress–strain data

A typical stress-strain curve for an untreated paint sample (See Fig. 1) provides a number of types of information. The curve plots the amount of strain (dimensional change) and the corresponding stress (force per unit cross-sectional area). The initial linear section of the curve is the elastic region. In this region, the paint recovers and returns to its original size when the force is removed. The slope of this linear section of the curve is the modulus, or stiffness. The subsequent curved and less steep region of the plot is the plastic region, in which the paint has been irreversibly stretched and will only partially recover if the force is released. Materials with little or no plastic region are considered to be "brittle" and their physical strength is quite sensitive to small defects. A stress-strain curve for a paint more brittle than that in Figure 1 would have a similar curve that simply ended earlier. A stiffer paint would have a steeper slope at the beginning of the curve. The end of the curve is where the sample breaks, and represents the maximum possible stress and stretch the paint can take (ultimate strength and breaking strain, respectively). Oil paints have elastic limits, or yield points, similar to those of many other materials, and typically can be reversibly stretched by about a 0.4% change in dimension. Paint also has a significant plastic region, and can be deformed quite a bit before breaking. With proper care and under reasonable environmental circumstances, paint should never leave the elastic (reversible) region, since either improper handling or quite wide environmental changes are required to produce irreversible strains in paint (See Erhardt et al.1997 and references therein for discussions of calculating allowable relative humidity ranges).

Weight changes

Weight changes resulting from solvent exposure for a six-year-old paint film of malachite in cold-pressed linseed oil are typical of those found (See Fig. 2). Acetone evaporates quickly (at least from and near the surface), and only a weight loss resulting from the extraction of leachable components is seen. The weight

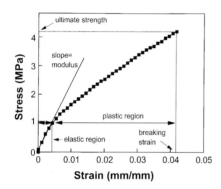

Figure 1. Stress-strain curve for an untreated, eight-year-old paint film prepared from lead white in acid refined linseed oil. The force per cross-sectional area (stress) is plotted as a function of dimensional change (strain). The initial linear portion of the curve defines the elastic (reversible) region, the slope of this area is the modulus, or stiffness. The later portion of the curve represents the plastic region in which permanent deformation occurs. The end of the curve is the breaking point. Measurements conducted at 23°C and 48% RH.

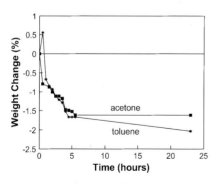

Figure 2. Weight changes over time for samples of a six-year-old paint film prepared from malachite in cold pressed linseed oil after immersion for one minute in toluene or acetone. Measurements conducted at 23°C and 48% RH.

continues to decrease over time as absorbed acetone migrates to the paint surface and evaporates. The weight eventually stabilizes within about five hours. Weight losses for acetone exposure of various paints ranged from about 0.7 to 3%. Toluene produces similar results, although there is a fleeting weight gain that is probably due to the slow evaporation of toluene from and near the surface. Loss of the absorbed acetone and toluene occurs at a similar rate, probably because the rate-controlling step is migration through the paint film and not the volatilization of the solvent. Weight losses for the toluene exposure of various paints ranged from about 0.5 to 4%. (Acetone and toluene have different solvent properties, but are similar in their ability to swell paint films (Phenix 1998). The effect of the nonvolatile solvent triethanolamine (TEA) is quite different. Even though TEA is quite effective in extracting material from paint films (Erhardt and Bischoff 1994), only a weight gain of about 4% was seen. There was no significant change in the weight even after hundreds of hours. TEA is absorbed quickly, and does not evaporate under any reasonable conditions.

Stress-strain measurements: effects of volatile solvents

Results for the treatment with toluene of a paint consisting of lead white in acid-refined linseed oil illustrate the effects of volatile solvents on stress-strain properties (See Fig. 3). All tests except as noted were run more than 24 hours after exposure when the weight had stabilized. The untreated sample has a yield point (elastic limit) of about 0.4%, but does not fail until stretched by over 4%. A 30-second exposure to toluene produces little if any change. Slight differences in breaking length probably are due to sample variation, and are not considered significant. A one-minute exposure does produce a slight increase in the modulus (stiffness). A one-hour exposure produces a significant increase in stiffness and a decrease in elasticity (increase in brittleness) with the breaking strain reduced to about 1.5%. Longer exposure (up to 24 hours) produces only slightly more change. Low-molecular weight components of the paint film act as plasticizers, softening the paint film and extending its plastic region. The extraction of increasing amounts of these materials with longer exposure times results in a stiffer and more brittle paint film. This effect is limited, though, and seems to be essentially complete within an hour. This probably represents the time required to remove completely the leachable components from the tested film. The properties of the completely leached film probably represent the limit that the paint will reach and still remain a viable paint film. It probably also represents a limit for the properties of paint films that have lost volatile components over time. It is significant that even the completely leached film retains most of its elastic region and a significant portion of the plastic region. This leached film is able to safely tolerate quite wide environmental extremes, much as a new paint film. Results for the same paint treated with acetone were quite similar, again emphasizing the similarities in effect of toluene and acetone.

The sample tested one hour after a one-minute exposure is noticeably less stiff. In this case, weight measurements showed that about half of the absorbed toluene was still present, and this residual solvent is evidently enough to have a quite noticeable plasticizing effect. This effect disappears completely after the absorbed toluene has evaporated, and no significant residual effect is seen when the exposure time is short enough.

Results for other paint samples treated with acetone and toluene were similar, though not identical. The degree of stiffening of the paints varied, as did the time it took for them to be affected. A six-year-old film of malachite in cold pressed linseed oil, for example, exhibited significant increases in stiffness with only 30-second exposures (See Fig. 4). A film exposed for one minute to acetone was already stiffer after one hour than the untreated film even though residual acetone was still present. The film stiffened considerably more as the remaining acetone was lost, and eventually was several times stiffer than the untreated film. An 18-year-old paint containing burnt umber in linseed oil behaved similarly. In general, although the specific sensitivity of each paint film varied, the overall effects were similar for all of the samples, as were the effects of acetone and toluene on a specific film.

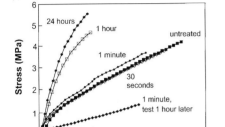

Figure 3. Stress-strain curves before and after immersion in toluene for an eight-year-old paint film prepared from lead white in acid refined linseed oil. Times given are length of immersion. Treated samples were tested at least 24 hours after treatment except as noted. Measurements conducted at 23°C and 48% RH.

Figure 4. Stress-strain curves before and after immersion in toluene for a six-year-old paint film prepared from malachite in cold pressed linseed oil. Times given are length of immersion. Treated samples were tested at least 24 hours after treatment except as noted. Measurements conducted at 23°C and 48% RH.

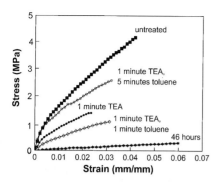

Figure 5. Stress-strain curves for an eight-year-old paint film prepared from lead white in acid refined linseed oil. Treated samples were immersed in triethanolamine (TEA) for the given time, some samples were subsequently also immersed in toluene. Tests were conducted at least 24 hours after treatment. Measurements conducted at 23°C and 48% RH.

The only anomalous results were obtained for an eight-year-old paint consisting of synthetic ultramarine in cold-pressed linseed oil. This paint was relatively unaffected by 30-second and one-minute exposures to toluene (although it was less stiff until the residual toluene was lost), but was stiffened considerably after only thirty seconds exposure to acetone. Long term exposures (one and 24 hours) to acetone also produced more stiffening than the same exposures to toluene. The stiffening effects of acetone had leveled off after one hour. The stiffening effect of toluene was still increasing between one and 24 hours, but appeared to be approaching the same limit as that of acetone. This indicates that the differences are probably due to faster action by acetone, rather than a significant difference in the ultimate sensitivity of the paint to the two solvents.

Stress-strain measurements: effects of a nonvolatile solvent

The effects of TEA on the physical properties of the paint films were drastically different, as would have been predicted by the weight measurements. Treatment with TEA resulted in a softer and more flexible film (as did treatment with toluene and acetone before they evaporated), but the effect was permanent. A white lead paint exposed to TEA lost half its stiffness after only one minute of exposure, a 46-hour exposure left it quite stretchy but extremely weak (See Fig. 5). It is not easy to remove the TEA. A one-minute exposure to TEA followed by a one-minute exposure to toluene removes some of the TEA, but the film is still much less stiff than the untreated film. Even though it is a viscous and slowly diffusing material, TEA was absorbed quickly enough that even a five-minute exposure to toluene was not enough to "clear" the TEA absorbed by the paint film in a one-minute exposure. It is still significantly less stiff than the untreated film. Once TEA is absorbed, it cannot be removed by any technique that would not also significantly alter the paint film.

The nature of the extracted materials

The low molecular weight materials (fatty acids and smaller) extracted from dried oil paint films have been analyzed in previous studies (See, for example, Stolow 1985: Erhardt and Tsang 1990). Predictably, the extracts included free fatty acids, as well as smaller compounds such as oxidation and scission products resulting from the polymerization process. Stolow (1985) used comparisons of the types and amounts of low molecular weight materials in both the original extracts and hydrolyzed extracts to conclude that larger moieties such as triglycerides also were extracted. This is indeed true. A gas chromatographic analysis of the volatile components up to and including triglycerides leached from a six-year-old malachite film by acetone shows that significant amounts of mono-, di- , and triglycerides are extracted, as well as fatty acids and polymerization and degrada-

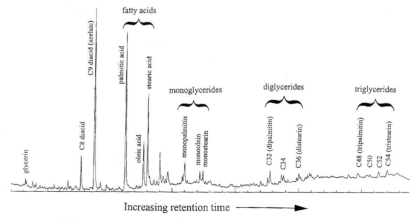

Figure 6. Gas chromatographic analysis of the acetone extract of a six-year-old paint film prepared from malachite in cold pressed linseed oil. Numbers refer to the carbon chain length of acids and diacids, or to the total number of carbons in the fatty acid components of the glycerides. Derivatizable compounds analyzed as the trimethylsilyl derivatives.

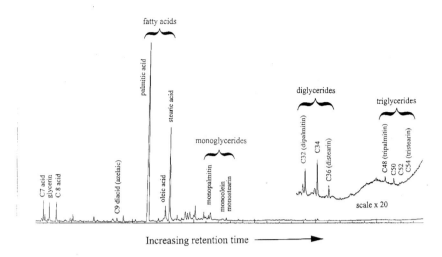

Figure 7. Gas chromatographic analysis of the acetone extract of a paint sample from a fragment of an 18th-century panel painting. Numbers refer to the carbon chain length of acids and diacids, or to the total number of carbons in the fatty acid components of the glycerides. Derivatizable compounds analyzed as the trimethylsilyl derivatives.

tion by-products (See Fig. 6). The amounts of the glycerides decrease in the order mono-, di-, and triglyceride, of course. That is because each successive type is more likely to have contained a polyunsaturated fatty acid that would have been part of the polymerization process and incorporated the glyceride into the polymer matrix. It is primarily the increasingly smaller amounts of mono-, di-, and triglycerides that originally contained only unsaturated fatty acids that can be extracted.

The molecular weight and size also increase in the same order, reducing the extractability. The amounts and composition of such extracts as a function of binder, pigment, solvent, and exposure time will be reported elsewhere. Significantly, such materials also can be extracted from even very old paint films. A sample of oil paint from an 18th-century panel painting still contains extractable glycerides of each type (See Fig. 7). Note also that free glycerol is present in the old paint. Though migration of low molecular weight compounds to the surface of paint films followed by volatilization surely occurs, such results indicate that it is an extremely slow process that would be further inhibited by the presence of a varnish layer.

Summary

Solvents have measurable effects not just on the surface of paint, but also on the physical properties of the bulk film. The initial effect of volatile solvents is softening of the film due to the plasticizing effect of solvent absorbed into the film. This effect lasts until the absorbed solvent has evaporated from the paint film, a process that took a number of hours to complete with the solvents studied. If the exposure was short enough, the paint films recovered within a day and there was no residual effect on the measured properties. Longer exposures ("longer" being as little as 30 seconds depending on the paint and solvent) left the paint films stiffer than untreated films due to the extraction of soluble paint components that had functioned as plasticizers. The loss of plasticizing material could also result in a more brittle film, although the paint films studied retained their elasticity and at least some of their plasticity. A nonvolatile solvent such as TEA permanently softens the paint, and is difficult or impossible to remove completely by subsequent treatment with a volatile solvent. In practice, the presence of cracks and defects in paint film surfaces will magnify the effects of solvents by permitting easier access to the interior of the paint film.

Conclusions

Solvents can affect the bulk physical properties of paint. Short solvent exposure times can temporarily affect a paint film even if there is no permanent change in physical properties. These experiments confirm the obvious, that the temporary presence of absorbed solvent can soften paint layers and make them more

susceptible to mechanical damage during cleaning. Paint films cleaned with volatile solvents should recover within about a day and be at least as stiff as the untreated film after enough solvent is lost. If the solvent exposure is long enough, the resulting extraction of soluble materials leaves the dried film stiffer than before. With short treatment times, the resulting film may be more brittle than an untreated film, but it still retains elasticity and enough plasticity that reasonable handling is safe. Even paint films that have been overcleaned and leached can safely tolerate the same environmental fluctuations as undamaged paint films. This is important, since it is difficult to control solvent exposure times for paintings with cracks and imperfections that absorb and retain liquid solvent. Older paint films that have lost low molecular weight components should also tolerate moderate environmental fluctuations. Nonvolatile solvents should not be used on original paint layers. They permanently soften paint and are not readily removed even with procedures that alone are vigorous enough to alter the paint film.

References

Erhardt D and Bischoff JJ. 1994. The roles of various components of resin soaps, bile acid soaps and gels, and their effects on paint films. Studies in conservation 39(1): 3–27.

Erhardt D and Mecklenburg MF. 1994. Accelerated vs natural aging: Effect of aging conditions on the aging process of cellulose. In: Vandiver PB, Druzik JR, Madrid JLG, Freestone IC, Wheeler GS, eds. Materials Research Society symposium proceedings volume 352: Materials issues in art and archaeology IV. Pittsburgh: Materials Research Society: 247–270.

Erhardt D, Mecklenburg MF, Tumosa CS, McCormick-Goodhart M. 1997. The determination of appropriate museum environments. In: Bradley S, ed. British Museum occasional paper number 116: The interface between science and conservation. London: The British Museum: 153–163.

Erhardt D and Tsang J. 1990. The extractable components of oil paint films. In: Mills JS, Smith P, eds. Cleaning, retouching and coatings: Technology and practice for easel paintings and polychrome sculpture, Preprints of the contributions to the Brussels congress, 3–7 September 1990. London: IIC: 93–97.

Stolow N. 1985. Solvent action. In: Feller RL, Stolow N, Jones EH. On picture varnishes and their solvents. Revised and enlarged ed. Washington, DC: National Gallery of Art: 45–116.

McCormick-Goodhart MH. 1995. Moisture content isolines of gelatin and the implications for accelerated aging tests and long term storage of photographic materials. Journal of imaging science and technology 39(2): 157–162.

Mecklenburg MF, Tumosa CS. 1991. An introduction into the mechanical behavior of paintings under rapid loading conditions. In: Mecklenburg MF, ed. Art in transit: Studies in the transport of paintings. Washington: National Gallery of Art: 137–171.

Phenix A. 1998. Solvent induced swelling of paint films: some preliminary results. WAAC newsletter 20(3): 15–20.

White R, Roy A. 1998. GC-MS and SEM studies on the effects of solvent cleaning on old master paintings from the National Gallery, London. Studies in conservation 43(3): 159–176.

Abstract

Investigation of the deterioration of paintings requires not only the testing of archival samples but also the development and testing of model paintings which accurately represent naturally aged paintings. One aspect of this research is the characterisation of archival linings and the development of an ageing regime for new canvas. Assessments included uniaxial and biaxial tensile tests and the measurement of strain within stretched samples using electronic speckle pattern interferometry. The 19th-century linings tested have a mean strength of 15% that of new linen. Artificially aged linen (using 10% sulphuric acid) could be matched for archival strength and stiffness but further work is needed to achieve equivalent brittleness. Biaxial tests demonstrated that canvas on a stretcher would fail at loads lower than those expected from a simple consideration of the uniaxial strength, indicating the presence of strain concentrations approaching a factor of 10. This was confirmed using ESPI to map the strains.

Keywords

acid ageing, linings, tensile testing, biaxial, ESPI, stress concentration

A comparison of the physical properties of 19th-century canvas linings with acid aged canvas

Christina Young★
Conservation Department
Tate Gallery, Millbank
London SW1P 4RG
UK
Email: christina.young@tate.org.uk

Roger Hibberd
Mechanical Engineering Department
Imperial College (ICSTM)
Exhibition Road
London, SW7 2BX
UK
Email: r.d.hibberd@ic.ac.uk

Introduction

The investigation of the mechanical deterioration and failure of paintings on canvas requires representative paintings to be subjected to invasive and destructive testing. For example, to gain knowledge of the delamination of paint from the canvas support, cracks must be initiated and their growth monitored. There is insufficient archival material for realistic mechanical testing and therefore the only feasible approach is the construction of model paintings which have mechanical characteristics that match, as closely as possible, those of naturally aged paintings.

Archival samples can be used to characterise the changes in material properties as they age. This characterisation should include not only the whole composite but also all the constituent parts of the painting – canvas, size and paint films. If 'model' paintings can be developed it becomes possible to conduct a thorough programme of mechanical testing to establish the mechanisms of failure at both macro- and micro-scales. Such models will also aid the development of non-destructive examination techniques which are applicable to real paintings.

This paper concentrates on one aspect of our work, the characterisation of archival 19th-century linings and the development of an ageing regime for new linen. Although the prime motivation for the research was the development of model paintings the archival results also provide useful data for conservation practice.

Accelerated ageing of canvas

The strength of linen yarns depends primarily on the cellulose fibres within the yarn. As the canvas ages the cellulose degrades principally by chain scission, with a consequential reduction in strength (Krassig 1985). The choice of the accelerated ageing regime is problematical given the variety routes, such as acid hydrolysis, oxidation and photochemical dissociation, which lead to degradation. However, acidic gas pollutants (SO_2 and NO_x) in the atmosphere are generally regarded as playing an important role in the ageing process (Hackney and Hedley 1984: Havermans 1995). Given also the low ultraviolet light levels experienced by most paintings under gallery conditions, the initial route chosen for accelerated ageing has been acid-catalysed hydrolysis of the canvas using (10%) sulphuric acid (H_2SO_4).

Archival materials

The archival materials were linings which had been removed from paintings in the Tate Gallery collection during conservation treatments. They were selected on the criteria that there was sufficient material to perform a series of uniaxial tests on small samples (25 × 140mm) and biaxial tests on large samples (300 × 300mm) and that

★ Author to whom correspondence should be addressed

Table 1. Details of archival linings.

Code	Approx. Date of Lining	Accession No.	Artist	Title of Work from which Lining Originates	Machine Or Hand Woven (based on visual inspection)	Yarn Count/cm ±1/cm Warp/Weft
L001	1840–1845	N020002	Turner	Sunrise, with Boat between Headlands	Machine	18 / 20
L002	1843–1900	T04944	Highmore	Equestrian Portrait of King George II	Machine	13 / 14
L003	1882–1930	N05591	Romney	Lady Hamilton as Circe	Machine	27 / 21
L004	1856–1858	N00615	Frith	The Derby Day	Hand	15 / 16
L005	19th C	T06455	Wright	Portrait of Lady Elizabeth Churchill...	Hand	12 / 14
L006	1820–1870	N04500	Aken	An English Family at Tea	Machine	11 / 10
L007	1843	N00535	Turner	The Sun of Venice Going to Sea	Machine	17 / 17
L023	1840–1845	N05513	Turner	Landscape with Water	Machine	18 / 18
L024	1845	N00543	Turner	Venice, Evening, Going to the Ball	Machine	20 / 20
L025	1840–1845	N01985	Turner	Sunrise, a Castle on a Bay, Solitude	Machine	20 / 17

Table 2. Properties of archival linings.

Code	Loose Lining Or Glued Lining	Glue/ Size Present (no continuous layer was found on linings)	Measured pH ± .02	UTS Ave.. Load to Failure (N) WARP	UTS Ave.. Load to Failure (N) WEFT	No. of Folds to Failure
L001	Loose	Very thin, in interstices on outer face of lining	4.42	102	148	3
L002	Glue	Within interstices and on yarn tops	4.26	120.7	112	10
L003	Glue	Within interstices and on yarn tops	3.75	58.7	40.7	2
L004	Loose	None found	4.99	76.3	-	9
L005	Glue	Within interstices and on yarn tops	4.07	86	-	2
L006	Glue	Impregnated throughout lining	3.56	113	75	1
L007	Loose	Very thin, in interstices on outer face of lining	4.14	72.6	81.4	4
L023	Loose	Very thin, in interstices on outer face of lining	3.76	29.7	-	1
L024	Loose	Very thin, in interstices on outer face of lining	4.02	46.9	60.8	2
L025	Loose	Very thin, in interstices on outer face of lining	4.19	120	218	16

Table 3. Stiffness and extension tests on archival linings.

Sample	Artist	Warp/ Weft	Strain at Failure %	Stiffness At 30N N/mm	Stiffness at 80% UTS N/mm
L001	Turner	Weft	4.7	50	63
L001	Turner	Warp	6.9	29	26
L002	Highmore	Weft	8.1	47	49
L002	Highmore	Warp	9.3	23	38
L003	Romney	Weft		48	
L003	Romney	Warp		28.0	
L004	Frith	Weft		38	
L005	Wright	Warp	6.3		28
L006	Aken	X	1.8		93.7
L006	Aken	Y	1.4		94.3
L007	Turner	Weft	5.9	43	53
L007	Turner	Warp	6.8	35	29
L023	Turner	Warp	6.9		8.6
L024	Turner	Weft	3.75	41	25
L024	Turner	Warp	3.65	46	36
L025	Turner	Weft	5.7	57	89
L025	Turner	Warp	7.6	36	56

Table 4. Results of uniaxial and biaxial tests on acid aged canvas.

	WARP				WEFT			
Acid Hours	Load to failure UTS (N)	Strain at failure %	Stiffness at 30N (N/mm)	Stiffness at 80%UTS (N/mm)	Load to failure UTS (N)	Strain at failure %	Stiffness at 30N (N/mm)	Stiffness at 80% UTS (N/mm)
0*	548	24.9	27.8	81	582	10.7	58	188
0	579	18.5	39.9	85.3	646	10.8	56.5	163
0**	568	33.5	43.9	99.1				
4	551	49.9	33.1	56.5	565	11.9	58.2	172.9
8	511	40.5	25.9	40.3	635	12.0	54.5	175
32	486	37.3	27.5	38.0	556	12.7		166
64	453	40.2	25.6	35.3	478	10.8		165
141	401	40.1		45.3	508	12.9	60.4	176
252	341	39.7	28.9	37.3	406	11.2	67.2	160
525	217	30.7	31.2	31.0	259	8.4	64.0	146
1029	138	27.1	34.1	19.3	152	8.8	69.0	96
3165	20.9	21.5		3.1	39	7.1		10.6
T 501	204	11.3	63.1	81.9	250	12.8	55.0	92
B 480	204	14.8		22.0	219.	2.6		52.6
B 525	321	57.8		71.0	324.	5.7		250.0

*sample direct from roll, not wetted and stretched ** re-wetted and dried unstretched T - acid aged under tension B - biaxial test

there was some knowledge of their origin (See Table 1). The Turner loose linings are well authenticated. The data for the other linings is included for comparison, but as their history is not well documented, their age and treatment history cannot be confirmed.

Further tests to characterise the linings have been carried out. The pH values were measured by placing 0.1mg of macerated sample in 10ml of distilled water for 24 hours. The values are given in Table 2 and show how acidic the linings are compared to new canvas which has a pH of 6.8.

Cross sections of the linings were also made and stained to identify any proteinaceous material such as animal glue. Visual inspection was also used to identify glue. All except the Frith loose lining have some glue present. The Turner loose linings have a very small amount within the interstices of the outer faces of the linings.

An empirical assessment of the brittle nature of the linings was made using a simple fold test. Samples were repeatedly bent back and forwards upon themselves until failure occurred. Table 2 summarises the number of folds to failure for the linings.

Preparation of acid aged samples

Ulster fine linen was stretched onto a loom and wetted and re-stretched three times before being cut into 500mm squares. These were laid flat in a bath containing 10% by volume sulphuric acid in distilled water. The bath was covered to eliminate light and kept at room temperature. Samples remained in the acid solution for periods between 4 and 3165 hours. A number of samples were aged for 501 hours on PVC stretchers to investigate the combined effect of mechanical stressing and acid ageing. After ageing, they were rinsed to remove most of the acid and then washed in distilled water. They were then neutralised in 1.4% ammonium hydroxide in distilled water, followed by rinsing in distilled water. The pH of the final rinse water was checked to ensure that a neutral environment had been reached. The samples were then laid flat to dry in ambient conditions.

Uniaxial testing

Uniaxial testing was performed on an Instron 4301 tensile tester, which had an environmental chamber enclosing the specimen grips. Three to four samples (25mm x 140mm) were tested in warp and weft directions. The samples were held in rubber faced grips to minimise stress concentrations, with a distance between the grips of 80mm. Temperature and humidity were kept constant throughout the tests. Failure (Ultimate Tensile Strength, UTS) was defined as the point at which yarns started to break and the load was first reduced. Two types of tensile load-extension tests were undertaken:

1) Loading to failure.
2) Cyclic loading between 0 and 100N, followed by loading to failure.
(The cyclic range was reduced if the UTS was below 100N).

For the cyclic loading tests, the stiffness (the gradient of the load-extension curve) was calculated by taking the tangent to the curve at 30N on the third tension cycle. This point was chosen because any initial slackness in the system is removed over the initial cycles (Young 1996b). The stiffness at 80% UTS was also calculated. A summary of the results is given in Tables 2, 3 and 4.

Physical properties of 19-century loose linings

The UTS values of all the archival materials are plotted in Figure 1. They range from 41 to 218N for the weft and 30 to 121N for the warp. In most samples the weft is stronger, the mean values being 103N for the weft and 84N for the warp. These are 18% and 15% respectively, of the values for new Ulster linen. This relatively wide range of UTS values indicates the difficulty in defining a typical naturally aged canvas.

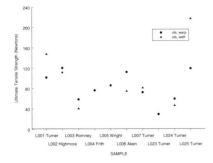

Figure 1. Distribution of UTS for the archival linings.

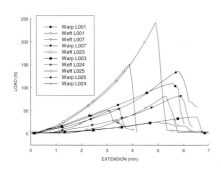

Figure 2. Load-extension UTS curves for Turner linings.

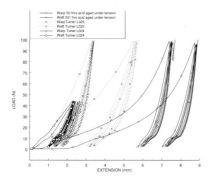

Figure 3. Cyclic loading behaviour of selected Turner linings and acid aged canvas.

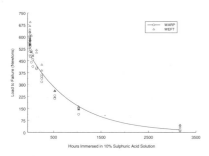

Figure 4. Hours in sulphuric acid versus UTS for Ulster linen.

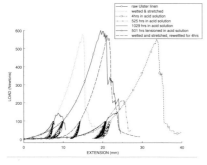

Figure 5. Load-extension characteristics for acid aged canvas.

Load-extension curves for the simple load-to-failure tests are shown for the Turner linings in Figure 2. These suggest there is a wide range in stiffness. However, the results from the cyclic loading tests show a smaller variation in stiffness (Two examples are shown in Fig. 3). This loading condition is more typical of that experienced by a painting. The cyclic values for the Turners range between 41 and 57N/mm in the weft direction and 24–45N/mm in the warp, indicating that archival canvas remains anisotropic (uneven stiffness in the two principal directions) and that the stiffnesses are similar to new Ulster linen which has values of 58N/mm in the weft and 29N/mm in the warp.

The mean strain (percentage change in length) at failure for the Turners are 5% in the weft direction and 6.3% in the warp. These are low compared to new canvas and are related to the absence of the long "decrimping" region, the presence of a small amount of glue in the outer fibres of the samples and to the brittle nature of most failures. The results for cyclic stiffness and strain at failure are typical of those for all the archival linings except the Aken, which fails below 1.8% strain. The Aken, however, differs from the other materials in being completely impregnated with glue.

PROPERTIES OF THE ACID AGED SAMPLES

The effect of the acid ageing is shown in Figure 4 which plots UTS against the number of hours in acid. The strength declines approximately exponentially and reaches an asymptotic point at 3000 hours. These results are consistent with an earlier series of tests on Belgian linen (Zeller 1998).

Figure 5 shows the warp load to failure and cyclic loading curves for:

i. Raw canvas.
ii. New canvas wetted and stretched three times.
iii. As ii. plus wetted without tension for four hours.
iv. As ii. then acid aged 525 hours.
v. As ii. then acid aged 1029 hours.
vi. As ii. then acid aged 501 hours under biaxial tension.

They all exhibit the characteristics found in earlier tests (Young 1996a), with non-linear plots showing increased stiffness as the load increases. Where a canvas is loaded, cycled and then taken to failure, it can be seen that the cycling does not affect the overall slope of the load-extension curve.

The cyclic stiffnesses of the acid aged material do not change significantly with ageing, remaining at about 30N/mm in the warp and 65N/mm in the weft. This is comparable to both new canvas and archival linings. The strain at failure of the 525 and 1029-hour samples was 7% in the weft and 30% in the warp. The warp values are higher than both raw new canvas and new wetted and stretched canvas, and far higher than the archival linings. This is the consequence of crimp induced by swelling of the yarns in the aqueous solution. The same effect is demonstrated by the wetted and stretched sample which was immersed in water for four hours and allowed to dry untensioned. This resulted in an increase in the warp strain to failure from 18.5% to 33.5%.

The high level of crimp in the warp can be reduced by acid ageing under biaxial tension, which results in more even crimp and a lower strain to failure. This is shown by the plot (See Fig. 5) for the sample acid aged under tension. This sample is close in terms of stiffness and extension to the Turner samples in Figure 3. An alternative approach may be the re-wetting and stretching of the acid aged canvas.

The other difference between the acid aged and archival canvas is the nature of the final failure. The archival canvas fails suddenly whilst the acid aged canvas tends to tear more progressively. This is also shown by the fold test where the archival linings fail between 1 and 16 folds (See Table 2) whilst samples acid aged for 1029 hours can withstand over 100. The sample aged 3165 hours fails at 14 folds, but its UTS does not correlate with the lining results. Some of the brittleness is due the presence of a small amount of glue. This could lock the weave, giving higher local strains on folding and hence more rapid failure.

Biaxial testing

Biaxial testing was performed on an improved version of the tensile tester used earlier (Young and Hibberd 1999). The grips have interchangeable faces so that slippery materials such as sailcloth, brittle archival samples and paintings on traditional wooden stretchers can be held. The tester has been integrated with an electronic speckle pattern interferometer (ESPI) for measurement of two-dimensional in-plane strain.

The same UTS tests as for the uniaxial samples were performed. The samples were cut into a cruciform and held so that the warp and weft were in line with the two axes of the biaxial tester. The tests were carried out under load control. In this mode, as the tension is increased or decreased, the grips are moved such that the weft and warp tensions stay within 6N of each other.

Electronic speckle pattern interferometry

ESPI is an optical non-destructive technique which can be used to measure the full-field deformation of an object. It has been demonstrated on a variety of works of art (Accardo et al. 1985: Hinsch 1993: Boone et al. 1995) and has recently been developed to measure the two-dimensional in-plane deformation of paintings on canvas (Young 1999). The results can be displayed as grey-scale images showing the deformation across the surface in the x and the y-directions. The strain can be calculated by differentiating the deformation data and can also be displayed as a grey-scale map. Thus, as the sample undergoes testing the resulting deformation or strain can be recorded and visualised. The biaxial testing was performed in conjunction with the ESPI to ensure uniform tensioning of the sample was occurring under biaxial load and to identify the points of high strain concentration and potential failure sites.

Biaxial testing and ESPI results

As a painting on a stretcher is under biaxial tension, it is important that acid aged linen used as the support for model paintings have biaxial properties comparable to those of naturally aged canvas: similar stiffness over the whole loading range, similar load-to-failure values and similar warp/weft characteristics. Whilst much information can be obtained from uniaxial testing, biaxial restraint of woven material alters its mechanical response. Therefore it is essential to perform biaxial tests. The loading width on the biaxial tester is more than 10 times that of the uniaxial tester (260mm compared to 25mm). One might therefore expect that to cause failure under biaxial loading at the same stress as in the uniaxial samples, the biaxial sample would need to be subject to a 10 times higher load. The mean UTS of the archival materials was 94N; thus failure under biaxial loading would need a tension of approximately 900N. Previous tests on Turner loose linings (Young 1996a) and experience of how real paintings fail indicate that failure occurs at lower loads.

A sample acid aged for 525 hrs was tested to investigate the UTS under biaxial loading. It started to fail at 321N in the warp direction at the corner of one of the cruciform arms. The test was repeated on three other samples that had been aged for 480, 501 and 525 hours. They all failed first in the warp at loads of 217N, 320N and 234N, respectively. These loads are equivalent to the uniaxial UTS linen acid aged for 480 to 525 hours, which implies a stress concentration of a factor of 10 at the point of failure under biaxial loading.

A cruciform only approximates the configuration of a canvas support on a stretcher. To ascertain whether similar stress concentrations were present in the real case, a sample that had been acid aged for 480 hours was stretched onto a 300mm square stretcher with double mitred mortise and tenon joints. Staples were placed at 30mm intervals. The stretcher was then fixed onto the grip plates of the biaxial tester so that the grips controlled the stretcher bar position (the joints were sanded to reduce friction at the corners). The stretcher bars were moved out in pairs to keep the loads even in warp and weft. The strain was measured using the

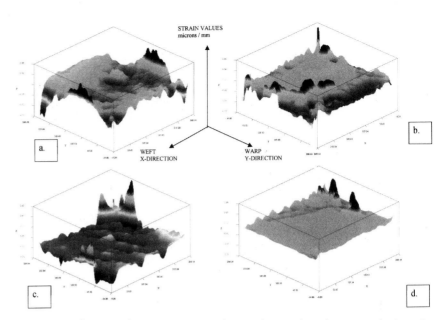

Figure 6. Two-dimensional ESPI strain maps for 525-hour acid aged canvas under biaxial tension.

a) x-component of strain (280N to 290N) b) y-component of strain (280N to 290N)
c) x-component of strain (290N to 300N) d) y-component of strain (290N to 300N)

interferometer as the tension was increased. Figures 6a and 6b show the x and y components of strain for the whole surface, when tensioned from 280N to 290N. The x and y axes are the weft and warp directions of the sample; the z axis plots the strain at each point. The maps show high strain along the stretcher bars, around the staples and at the corners. Negative strain is also present at the corners as parts of the canvas contract because of the Poisson effect. Hedley has demonstrated similar deformation (Hedley 1975). Figures 6c and 6d show the strain maps at the point of failure at 300N as the canvas started to tear at staples in the top left and bottom right corners. This resulted in large strains at the corners, as the canvas surrounding the staples became unconstrained. There was no sign of failure within the body of the canvas.

This test was repeated using a Turner loose lining (L025) carefully stretched onto the wooden stretcher and tensioned in a similar manner. Uniaxial values of mean UTS were 120N and 218N in the two yarn directions. Figures 7a and 7b show the evolution of strain as the lining is biaxially tensioned from 27N to 30N. There are areas of high strain along the stretcher bars in both the warp and weft directions as the lining pulls around the bar and straightens. Figures 7c and 7d show strain induced by increasing the load from 227N to 230N where it starts to fail at the bottom right staple in a similar manner to the acid aged sample above. One can see the change from even loading conditions where the sample is being deformed symmetrically, to an area of high strain in the bottom right hand corner. Failure at this point has caused the loads and hence the strain to redistribute. The correspondence between archival and acid aged tests is encouraging. In practice failures of the support occur at the stretcher joint and thus the role of the stretcher and fixing method is presently under investigation (Young and Hibberd 1999).

Conclusions

The archival linings have UTS values in the range 30N to 218N with a mean value of 94N. The stiffness values are similar to that of new Ulster linen and, even with a varying amount of glue remaining, they still exhibit the characteristics of a woven material; lower stiffness in the warp, hysteresis and a small amount of short-term creep.

Characterisation of the samples using FTIR to examine the fibres both for identification of the material, the degradation products and the change in the crystallinity index are underway. Depolymerisation is also being investigated using thin-film chromatography.

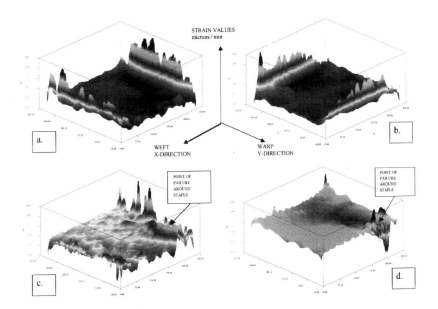

Figure 7. Two-dimensional ESPI strain maps for Turner lining on stretcher under biaxial tension.
a) x-component of strain (27N to 30N) *b) y-component of strain (27N to 30N)*
c) x-component of strain (227N to 230N) *d) y-component of strain (227N to 230N)*

Acid ageing can produce canvas that has the same UTS range as the linings, but with considerably more crimp. This is primarily because of swelling of the fibres in the aqueous solution. After neutralisation and drying, the swelling is reduced but the fabric is left highly crimped and loosely packed. The result is a large extension on initial tensioning as the crimp is taken up. To produce material of equivalent extension to failure the canvas needs to be acid aged under tension or 'decrimped' after acid ageing.

Although acid ageing for 3165 hours produces material which has a brittleness closer to that of the linings, its UTS is below that of the archival material. This suggests that the mechanism by which canvas becomes brittle cannot be triggered solely by acid ageing. Further tests on canvas aged under tension and on-going tests on light and thermally aged samples will help to identify this process.

To match the UTS of the linings using acid alone, the Ulster linen needs to be aged between 1000–2500 hours in 10% sulphuric acid. One aim of this work is to produce model primed canvas that subsequently will be thermally aged. Acid followed by thermal ageing of canvas is likely to accelerate the degradation of the canvas (Hackney and Hedley 1984). Thermal ageing alone at 60°C (the value presently being used for ageing of glue size and paint) has very little effect on the canvas compared to the paint. Thus 500-hours acid aged canvas is being used for the model paintings based on the prediction that, once thermally aged, they will matched the UTS range of 19th-century primed linings.

Biaxial testing in conjunction with ESPI strain measurements has demonstrated that although the uniaxial UTS would suggest that a canvas can withstand high loads, it is the stress concentrations introduced by the loading conditions of a stretcher which determine the loads at which a canvas support fails.

Acknowledgements

The authors would like to thank the Leverhulme Trust, the Commissioners for the Great Exhibition of 1851, the NERC, Paul Ackroyd and Tim Green.

References

Accardo G et al. 1985. The use of speckle interferometry in the study of large works of art. Journal of photo science. 33: 174–176.
Boone PM et al. 1995. Examination of museum objects by means of video holography. Studies in conservation. 40(2): 103–109.

Hackney S and Hedley G. 1984. Linen canvas artificially aged. In: de Froment D, ed. Preprints of the 7th Triennial Meeting ICOM-Committee for Conservation. Copenhagen. International Council of Museums: 2:16–21

Havermans JBG. 1995. Environmental influences on the deterioration of paper. Rotterdam: Barjesteh Meeuwes. ISBN: 90-561-3010-2.

Hedley G. 1975. Some empirical determinations of the strain distribution of stretched canvases. In: Preprints of the 4th Triennial Meeting ICOM-Committee for Conservation. Venice. International Council of Museums: 75/11/4.

Hinsch K. 1993. Optical methods in engineering metrology. D.C. Williams, ed. Chapman Hall: 323–330.

Krassig DH. 1985. Structure of cellulose and its relation to the properties of cellulose fibres. In: Kennedy J, Phillips GO, Wedlock DJ, Williams PA, eds. Cellulose and its derivatives, Ellis-Horwood: 3–23.

Young CRT. 1996a. Measurement of the biaxial tensile properties of paintings on canvas. PhD Thesis, London, Imperial College.

Young CRT. 1996b. Biaxial properties of sized cotton-duck. In: Bridgland J, ed. Preprints of the 11th Triennial Meeting ICOM-Committee for Conservation, Edinburgh. International Council of Museums: 2: 322–331.

Young CRT. 1999. Measurement of the biaxial properties of nineteenth century canvas primings using electronic speckle pattern interferometry. Optics and lasers in engineering Special Edition. In press.

Young CRT and Hibberd R. 1998. Biaxial tensile testing of paintings on canvas. Studies in conservation. In press.

Young CRT and Hibberd R. 1999. Measurement of the two-dimensional strain distribution of paintings on canvas using electronic speckle pattern interferometry. In: Pre-prints to ART '99, 6th Int. conference on non-destructive testing and microanalysis for the diagnostics and conservation of cultural and environmental heritage. Rome, May 1999. AIPnD.

Zeller B. 1998. Artificial ageing internal progress report. ICSTM London.

Materials

Linen (3151), 320g/m², 19 yarns/cm warp, 17 yarns /cm weft, plain weave. Ulster Weaving Company, Belfast.

Paintings II: Scientific study of paintings (methods and techniques)

Peinture II: Etude scientifique des peintures (méthodes et techniques)

Paintings II: Scientific study of paintings (methods and techniques)

Coordinator: Jørgen Wadum
Assistant Coordinator: Anne Rinuy

During the past triennial period many of our Working Group members have been very productive indeed. For example, in 1998 two congresses were held which attracted contributions from our members: The *IIC 17th International Congress on Painting Techniques: History, Materials and Studio Techniques* was held in Dublin in September 1998, where several papers came from colleagues traditionally active within our Working Group. A second gathering where Paintings II members were contributors was the *Art & Chimie, la couleur*, a *Congrès international sur l'apport de la chimie aux œuvres d'art*, held in Paris, also in September 1998. During this same year the publication *Looking Through Paintings. The Study of Painting Techniques and Materials in Support of Art Historical Research* was launched. Again several of the contributions were authored by Paintings II Working Group members.

Notwithstanding, it has been possible yet again to select high quality papers and posters for this *ICOM-CC Triennial Meeting* in Lyon. We were extremely grateful for all the contributions that were sent to us; the number and range emphasized the extraordinarily large amount of material that has been collected and evaluated during conservation and restoration work in studios and laboratories worldwide. This strongly confirms that the *Scientific Study of Paintings (Methods and Techniques)* continues to increase despite some institutions' ever augmenting workload with exhibitions and loan activities. The interdisciplinary interest in techniques and materials is further reflected in the growing number of results being presented in exhibition catalogues and monographs throughout the museum world.

Contrary to previous years, the coordinator and assistant coordinator not only made a preliminary ranking of the incoming papers, but also pre-edited the contributions in discussion with the submittants. This was an interesting challenge, as the often extensive work was intensified by the relatively short time-frame available. However, we hope you will agree that the contributions to this volume, reflecting research areas ranging from Old Master paintings to Modern and Contemporary Art, materials and techniques of paintings on rigid as well as flexible supports, are of an equivalent or improved calibre compared with previous Preprints.

The partnership between Paintings I and Paintings II during the past three years resulted in four co-operatively produced issues of a *Newsletter*, and also manifested itself in a joint interim meeting: *Image or Object? The influence of treatment on the interpretation of paintings* on September 12, 1998 at the National Gallery of Ireland, Dublin. More than 130 colleagues were present, several of whom expressed interest in a comparable meeting during the coming triennial period.

A significant issue that deserves mention is the acknowledgement by ICOM-CC of the importance of the *Document of Pavia*. This document describes the unique role of the conservator-restorer in the protection of the cultural heritage, in: establishing the definition of the profession of the conservator-restorer; defining the level of teaching and training of the conservator-restorer; creating a common profile for conservator-restorers; and describing at a European level the competence and qualifications of a conservator-restorer, based on the ICOM-CC definition and the E.C.C.O. professional guidelines.

The interdisciplinary role of the conservator-restorer in transmitting information, not only within this field but also to policy-makers and society at large, is increasingly emphasized. In Paintings II a high level of Scientific Study of Paintings, Methods and Techniques has resulted in an enhanced understanding of artists' working methods. We are confident that the substantial and important contribution emerging from the 1996–1999 triennial period will be transferred also to a broader public.

Abstract

A mixture of lead sulfate and zinc oxide of fixed composition was found in several oil sketches and paintings by Tom Thomson and the Group of Seven. In the case of the Group of Seven, this mixture was used over a period of some thirty years. Freeman's White, a mixture of lead sulfate and zinc white patented in 1882, may have been used by Thomson and the Group of Seven. The possibility was considered that leaded zinc oxide, which was not intended for artistic purposes, had been used. However, lead sulfate was found by X-ray spectrometry to be the major constituent of the mixture, while leaded zinc oxide, zinc white, normally the main constituent, is mixed in with basic lead sulfate.

Keywords

lead sulfate, leaded zinc oxide, Freeman's White, Tom Thomson, Group of Seven

Figure 1. A.Y. Jackson (Canadian, 1882–1974), Early Spring, Quebec, 1927, oil on canvas, 53.3 × 66.0 cm, Art Gallery of Toronto, Toronto, accession no. 135. Gift of the Canadian National Exhibition Association, Toronto, 1965.

Figure 2. Tom Thomson (Canadian, 1877–1917), The West Wind, 1917, oil on canvas, 120.7 × 137.2cm, Art Gallery of Ontario, Toronto, accession no. 784. Gift of the Canadian Club of Toronto, 1926.

The use of a white pigment patented by Freeman by Tom Thomson and the Group of Seven

Marie-Claude Corbeil,[*] P. Jane Sirois, and Elizabeth A. Moffatt
Analytical Research Laboratory
Canadian Conservation Institute
Department of Canadian Heritage
1030 Innes Road
Ottawa ON K1A 0M5
Canada
Fax: (613)998-4721
Email: marie-claude_corbeil@pch.gc.ca

Introduction

In the early 1910s, a group of artists from the Toronto area founded a new landscape school. The idealistic and nationalistic goal of these young artists was to stop Canadians from acting like a colonized people, at a time when people systematically denigrated Canadian art and revered and imitated British and European art. Among them, Tom Thomson (1877–1917) played a key role in initiating others to the greatness of the Canadian wilderness. His tragic and mysterious death, just before his fortieth birthday, contributed to his fame in Canada. In 1920, Frank Carmichael (1890–1945), Lawren Harris (1885–1970), A.Y. Jackson (1882–1974), Franz Johnston (1888–1949), Arthur Lismer (1885–1969), J.E.H. MacDonald (1873–1932), and Frederick Varley (1881–1969) exhibited together for the first time under the name "The Group of Seven". In 1926, after Johnston's resignation, A.J. Casson joined the Group. The Group disbanded in 1933, and merged with the Canadian Group of Painters (Hill 1995: McKendry 1997).

Thomson and the Group of Seven worked closely together. They made sketching trips together to places such as Algonquin Provincial Park in Ontario, and shared a studio in Toronto. When they began painting in the 1910s and 1920s, Thomson and the Group of Seven were criticized for their crude touch and colours and for their realism in depicting what people considered, at the time, the most hideous aspects of Canadian landscape. Today, they are the most renowned and celebrated artists in Canada, and their work is an essential reference in Canadian landscape painting (See Figs. 1, 2). Their small, colourful oil sketches are often appreciated more than the larger studio paintings.

During the course of the examination of several sketches by Thomson, lead sulfate and zinc white were identified together in almost every sample analyzed. Furthermore, X-ray spectrometry results showed that lead and zinc were always present in the same ratio, indicating that the two compounds were not randomly mixed. A survey was conducted of the use of lead sulfate and zinc white in works by Thomson and the Group of Seven. This article will focus on documentary sources on the use of lead sulfate and zinc white mixtures as artists' pigments and the use of one specific mixture by Thomson and the Group of Seven.

Lead sulfate, leaded zinc oxide, and Freeman's White

A recipe for making lead sulfate was published in 1795 by Bardwell. Although the pigment is not referred to as lead sulfate but identified as "white precipitate of lead" and "vitriol of lead," it is quite clear from the recipe that lead sulfate is the end result: "If a small quantity of strong nitrous acid be poured upon litharge, the acid unites itself to the metal with considerable effervescence and heat. Some water being now poured on, and the glass vessel containing the mixture shaken, a turbid solution of the litharge is made. If a small quantity of acid of vitriol be now added, it throws down a beautiful white precipitate" (Bardwell 1795). Bardwell (1795) mentions an earlier recipe for such a white, which was published by Weben in 1781 in a book entitled *Fabriken und Kunste*.

[*] Author to whom correspondence should be addressed

In 1835 Field reported the use of lead sulfate as an artists' pigment. It was described as follows: "Sulphate of lead is an exceedingly white precipitate from any solution of lead by sulphuric acid, much resembling the blanc d'argent; and has, when well prepared, quite neutral, and thoroughly edulcorated or washed, most of the properties of the best white leads, but is sometimes rather inferior in body and permanence" (Field 1835). Harley (1982) reports that lead sulfate was still available in the 1830s and sold under the name Flemish White. It was still mentioned in treatises at the beginning of the twentieth century (Church 1901).

Lead sulfate has been reported as being used with zinc white in "leaded zinc oxide" (Gettens and Stout 1966). However, most sources refer to leaded zinc oxide as a mixture of zinc white and basic lead sulfate (Painter 1963: The Society of Dyers and Colourists and the American Association of Textile Chemists and Colorists 1971: Stephenson 1973: Dunn 1973: Dunn 1975: Federation of Societies for Coatings Technology 1978). Basic lead sulfate was first manufactured around the mid nineteenth century (Dunn 1973). As described by Dunn, "basic lead sulfate is a broad term that embraces many compounds with varying degrees of basicity above the normal (nonbasic) lead sulfate" (Dunn 1973). However, he adds that the pigment marketed for the pigment industry "may be a mixture of normal and monobasic lead sulfate" (Dunn 1973: Dunn 1975). This may explain why there is so much confusion about the composition of leaded zinc oxide. Authors sometimes use both terms, lead sulfate and basic lead sulfate, in the same article (Grandou 1966: Kühn 1986). The very few results on the analysis of leaded zinc oxide are also quite confusing. Three samples of pigments identified as leaded zinc oxide contained zinc oxide and lead sulfate, zinc oxide being the main constituent (Kühn 1986). We analyzed a sample labelled "basic sulfate white lead," from Eagle-Picher, and found that it contained lead sulfate only.

Contradictory information about the use of basic lead sulfate is found in the literature. Dunn states that basic lead sulfate was not used alone, but always in mixed pigment formulations, primarily with zinc oxide in leaded zinc oxide (Dunn 1973: Dunn 1975). On the other hand, it is reported in *The Colour Index* (The Society of Dyers and Colourists and the American Association of Textile Chemists and Colorists 1982) that basic lead sulfate is used alone or in admixture with zinc oxide or other pigments, and is also used for purposes similar to white lead, the latter statement also being made by Martens (1964). Basic lead sulfate (used alone or in leaded zinc oxide) is mentioned mainly for industrial or commercial applications (Stephenson 1973: Association française de normalisation 1988: Mayer 1991). In 1934 Doerner wrote: "For commercial purposes, especially house painting, basic sulphate of lead . . . is today used. For artistic purposes it has not as yet been tested" (Doerner 1962). Wehlte (1975) states that it is "unsuitable as artists' color."

In 1882, a new white pigment was patented by Joseph Benjamin Freeman in England. Although no specific name was given to this new pigment by Freeman, who referred to it as "an improved pigment," we chose to refer to it as "Freeman's White" for the purpose of the present article. It consisted of a mixture of lead sulfate and zinc white ground under great pressure. Freeman (1882) states: "I find that 1 part by weight of oxide of zinc or zinc white, to 3 parts by weight of sulphate of lead answers well, but these proportions may be varied, and I do not limit myself in this respect, as a greater proportion of either ingredient may be used." In 1885, Freeman obtained a second patent for the improvement of the white pigment previously patented. The improvement consisted in adding barium sulfate to the mixture of lead sulfate and zinc white. Freeman (1885) recommended the following proportions: 5 parts by weight of lead sulfate, 2 parts by weight of zinc white, and 1 part by weight of barium sulfate. Again, Freeman stated that he did not restrict himself to these proportions. Both formulations have been mentioned in artists' manuals (Seward 1889: Laurie 1895: Church 1901: Laurie 1967).

It is often difficult to know if books on artists' materials and pigments refer to lead sulfate or basic lead sulfate, or to their respective mixture with zinc white, since a variety of common names are used in place of chemical names (See Table 1). Furthermore, the same common name sometimes applies to different compounds. For example, Flemish White, which corresponds to lead sulfate according to Harley (1982), is used by Mayer (1991) for lead white; "Sublimed White Lead," a name given by most authors to basic lead sulfate, is described by Mayer (1991) as "a basic

Table 1: Common names used for lead sulfate, basic lead sulfate, and mixtures of lead sulfate and zinc white.

Chemical compound(s)	Names*
PbSO₄ (Lead Sulfate, C.I. Pigment White 3)	Echtweiss[1] Fast White[2] Flemish White[3] Freemans White Lead[2] Lead Bottoms[2] Metallweiss[1] Milk White[2] - Milchweiss[1] Mulhouse White[2] - Mühlauserweiss[1] - Blanc de Mulhouse[4]
PbSO₄.PbO (Basic Lead Sulfate, C.I. Pigment White 2)	Bartlet White Lead[2,5] Basic Sulphate White Lead[2,5,6,7] Lewis White Lead[2,5] Sublimed White Lead[2,5,8] - Blanc de plomb sublimé[4] Super Sublimed White Lead[5] White Lead Sulfate[2]
PbSO₄ + ZnO	Freeman's White[9] Marble White[9] New Flake White or Cambridge White[9] Permanent White Lead[10] White lead, Caledonia Park Works, Glasgow[9]
PbSO₄ + ZnO + BaSO₄	Freeman's White Lead[11]

*References: 1 – Kühn 1975; 2 – The Society of Dyers and Colourists and the American Association of Textile Chemists and Colorists 1982; 3 – Harley 1982; 4 – Painter 1963; 5 – Dunn 1973; 6 – Martens 1964; 7 – Gettens and Stout 1966; 8 – Wehlte 1975; 9 – Laurie 1895; 10 – Seward 1889; 11 – Church 1901.

lead sulphate that contains zinc." The name "Freeman" is part of many versions of a name used indiscriminately for lead sulfate or for mixtures of lead sulfate and zinc white. Keeping in mind that information on pigments that are referred to by common names only should be interpreted with some caution, it seems that the latest reference to Freeman's White is by Doerner in 1934 (Doerner 1962). It is not mentioned in artists' manuals and treatises published after this date.

Identification of Freeman's White in paintings by Thomson and the Group of Seven

Experimental

A survey of several oil sketches and paintings by X-ray spectrometry was conducted on site at the Art Gallery of Ontario (AGO) in Toronto, using a Canberra InSpector portable spectrometer equipped with a Princeton Gamma-Tech LS 15 lithium-drifted X-ray detector and an americium-241 annular radioisotope source. Three sketches were analyzed in our laboratory using a Tracor Northern NS-880 X-ray spectrometer, a Princeton Gamma-Tech IG 25 intrinsic germanium detector, and an iodine-125 source.

X-ray diffraction patterns were obtained with a Rigaku RTP 300 RC generator equipped with a rotating anode and a cobalt target, using a microdiffractometer and a 100 μm collimator. For Fourier transform infrared (FTIR) spectroscopy, a portion of each sample was mounted in a diamond anvil microsample cell. Spectra of most samples were acquired using a Bomem Michelson MB-100 spectrometer in the range 4000–400cm⁻¹. Smaller samples were analyzed using a Spectra-Tech IR-Plan microscope accessory interfaced to a Bomem Michelson MB-120 spectrometer in the range 4000–700cm⁻¹.

Results

The chemical compounds found in leaded zinc oxide and in Freeman's White, namely lead sulfate, basic lead sulfate, and zinc oxide, can be identified unambiguously by X-ray diffraction (XRD) (See Table 2). However, determination of the lead/zinc ratio by X-ray spectrometry provides the only evidence that two pigments were used together in a mixture of fixed composition. The ratio of the lead and zinc peak areas would be fairly constant throughout paintings made using mixtures produced by paint manufacturers such as leaded zinc oxide or Freeman's White. If an artist were to mix lead sulfate or basic lead sulfate with zinc white (or paints containing these pigments) on the palette, this would result in paint mixtures having different lead/zinc ratios.

Table 2: X-ray powder diffraction data for lead sulfate, basic lead sulfate, and zinc white*

Lead Sulfate (PbSO₄) PDF 36-1461		Basic Lead Sulfate (PbSO₄×PbO) PDF 33-1486		Zinc White (ZnO) PDF 36-1451	
d (A)	I	d (A)	I	d (A)	I
		6.362	25		
		6.193	25		
		5.906	16		
		4.428	25		
4.2665	50				
4.2379	51				
3.8106	40				
		3.7029	20		
3.6203	15				
		3.5110	15		
3.4796	22				
3.3345	67	3.3426	100		
3.2190	53				
		3.1811	10		
3.0076	88				
		2.9614	80		
		2.9499	30		
		2.8620	25		
		2.8481	45		
				2.8143	57
2.7650	40				
2.6999	43				
2.6188	10				
				2.6033	44
		2.4729	18	2.4759	100
		2.4308	20		
2.4079	20				
2.2768	20				
		2.2579	25		
2.1637	30				
2.0675	100				
		2.0492	25		
2.0323	58				
2.0272	54				
1.9727	24				
		1.9099	10	1.9111	23
		1.8482	25		
1.7928	19				
		1.7247	18		
1.7041	19				
1.7013	16				
		1.6653	18		
1.6210	22			1.6247	32
1.6113	12				
1.4932	23			1.4771	29
		1.4477	10		
1.4405	12				
1.4020	15				
1.3687	14			1.3782	23
				1.3583	11

*Lines with intensities below 10 were omitted for simplification purposes.

Fifty-five sketches and paintings were surveyed by x-ray spectrometry at the AGO, and three sketches were analyzed in our laboratory. Several areas of each sketch or painting were analyzed. Paint samples from another 15 sketches and paintings were analyzed by X-ray diffraction and FTIR spectroscopy prior to or after the survey. A total of 73 sketches and paintings were included in the study.

In 19 of the 58 sketches and paintings analyzed by X-ray spectrometry, lead and zinc were found in a majority of areas in a constant Pb/Zn ratio, indicative of the use of a mixture of fixed composition.[1] Sixteen of these 19 sketches and paintings were sampled and the presence of lead sulfate and zinc white was established by XRD and FTIR in 15 out of 16. No basic lead sulfate was found in any of the samples analyzed. Furthermore, lead sulfate was found by X-ray spectrometry to be the major constituent of the mixture, while in leaded zinc oxides, zinc white was normally the main constituent (Dunn 1973). In only one instance were lead sulfate and zinc white not found in a painting when X-ray spectrometry indicated that they would be present. This shows that X-ray spectrometry is a reliable method for identifying mixtures such as this one. On the other hand, in the case of a few paintings, X-ray spectrometry did not indicate that lead sulfate and zinc white were present, but the compounds were identified by XRD and FTIR

Figure 3. Diffraction pattern of white paint from A Northern Lake *by Tom Thomson.*

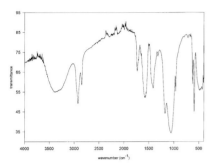

Figure 4. FTIR spectrum of white paint from A Northern Lake *by Tom Thomson.*

in only one or two samples. Therefore X-ray spectrometry is not always useful to detect lead sulfate/zinc white mixture when it has been used in limited areas of the painting.

Samples from 42 sketches and paintings, including the 16 discussed above that were first analyzed by X-ray spectrometry, were analyzed by XRD and FTIR. Lead sulfate and zinc oxide were found together in 29 out of 42 works. The diffraction pattern and IR spectrum of a sample of white paint from *A Northern Lake* by Thomson are presented (See Figs. 3, 4). The infrared spectrum shows absorptions due to lead sulfate and zinc white in the proportions typically found in paint samples analyzed. Absorptions in the infrared spectrum attributable to $PbSO_4$ are found at 1175, 1060, 967, 633, and 598cm$^{-1}$, and the absorption due to ZnO is centered around 484cm$^{-1}$. The remaining absorptions in the spectrum are attributable to the drying oil medium and zinc soaps formed by the reaction of zinc white with components of the drying oil. Overall, if the results of X-ray spectrometry, XRD and FTIR analysis are combined, lead sulfate and zinc white were found in 32 sketches or paintings out of 73. Barium sulfate was never found associated with lead sulfate and zinc white.

Although for some members of the Group of Seven, the number of paintings and sketches examined was limited, some trends were observed. For instance, Freeman's White was not found in works by Carmichael, and Jackson made limited use of it, as it was found in only one sketch. It was found in Harris' and MacDonald's sketches, but not in their paintings, while it was identified in both sketches and paintings by Lismer, Thomson, and Varley. From this, it seems that Freeman's White was perhaps not thought of as an inferior type of paint that was used exclusively for the artists' outdoors sketching activities.

Sketches and paintings included in this study were painted between 1912 and 1943 and, regardless of the artist, Freeman's White was identified throughout this period. Freeman's White was used in large quantities in the works in which it was found, since it made up the bulk of the thickly applied paint, and, in the case of the Group of Seven, it was used over a period of some 30 years. This suggests that Freeman's White was bought on a regular basis. We do not have information from archival documentation about the artists' materials suppliers. Pigment manufacturers and artists' materials producers were contacted; none ever produced or sold Freeman's White. However, a sample of lead white from Wadsworth, Howland and Co. (an artists' materials supplier in Boston), collected by Forbes in 1924, was found to consist of a mixture of lead sulfate, zinc white, and barium sulfate (Carriveau and Omecinsky 1983), which corresponds to the improved formulation of Freeman's White as described in the 1885 patent.

Conclusion

A mixture of lead sulfate and zinc oxide of fixed composition has been found in several oil sketches and paintings by Thomson and the Group of Seven. In the case of the Group of Seven, this mixture was used over a period of some 30 years. It has never been identified in any other work, Canadian or foreign, by our laboratory, and has not been reported by other conservation laboratories.

The possibility was considered that leaded zinc oxide, which was not intended for artistic purposes, had been used. However, lead sulfate was found by X-ray spectrometry to be the major constituent of the mixture, while in leaded zinc oxide, zinc white, normally the main constituent, was mixed in with basic lead sulfate, according to most sources. Nevertheless, since very few analyses of leaded zinc oxide have been reported, the hypothesis cannot be discarded.

On the other hand, Freeman's White, a mixture of lead sulfate and zinc white patented in 1882, may have been used by Thomson and the Group of Seven. There is no indication that Freeman's White was deliberately chosen by the artists as it is quite possible that it was sold under other names. We know of at least one instance where the improved formulation of Freeman's White, containing barium sulfate, was sold as lead white.

Future work will involve obtaining more data on the composition of leaded zinc oxide by instrumental analysis and information on artists who used Freeman's White or artists' materials suppliers who sold it.

Acknowledgements

The authors wish to thank Ms. Elisabeth West FitzHugh, Freer/Sackler Galleries, for providing samples of leaded zinc oxide pigments which were originally analyzed as part of the study on zinc white published by Kühn in 1986. The reference by Seward was drawn to our attention by Leslie Carlyle, CCI. In addition to paintings from the AGO collection, paintings from the McMichael Canadian Art Collection, the National Gallery of Canada (NGC), and the Frederick Horsman Varley Art Gallery of Markham were included in our study. The assistance of Sandra Webster-Cook and Dennis Reid, AGO, and Anne Ruggles and Charles Hill, National Gallery of Canada, is greatly acknowledged.

Note

1. The proportions of lead sulfate and zinc oxide were determined by X-ray spectrometry but are not disclosed here since the information could be used fraudulently. Thomson and the Group of Seven have been widely imitated and copied in Canada.

References

Association française de normalisation. 1988. Dictionnaire des pigments et des matières de charge. Paris: Association française de normalisation: 152.

Bardwell T. 1795. Practical treatise on painting in oil-colours. London: 70–72.

Church AH. 1901. The chemistry of paints and painting. London: Seeley and Co. Limited: 133–134.

Carriveau GW and Omecinsky D. 1983. Pigments: I. Whites. Journal of the American Institute for Conservation 22: 68–81.

Doerner M. 1962. The materials of the artist and their use in painting with notes on the techniques of the Old Masters. First published in 1934. Translated by Eugen Neuhaus. Revised ed. New York: Harcourt, Brace & World Inc: 55.

Dunn EJ Jr. 1973. White hiding lead pigments. In: Patton TC, ed. Pigment handbook. Volume I. New York: John Wiley & Sons: 65–84.

Dunn EJ Jr. 1975. Lead pigments. In: Myers RR and Long JS, ed. Treatise on coatings. Volume 3. New York: Marcel Dekker: 333–427.

Federation of Societies for Coatings Technology. 1978. Paint/coatings dictionary. Philadelphia: Federation of Societies for Coatings Technology.

Field G. 1835. Chromatography; or, A treatise on colours and pigments, and of their powers in painting, etc. London: Charles Tilt: 69.

Freeman, JB. 1882. Patent no. 4879. London.

Freeman, JB. 1885. Patent no. 13,891. London.

Gettens RJ and Stout GL. 1966. Painting materials: A short encyclopaedia. New York: Dover Publications Inc.: 177.

Grandou P, Pastour P. 1966. Peinture et vernis. 1- Les constituants. Paris: Hermann: 757.

Harley RD. 1982. Artists' pigments c. 1600–1835. 2nd ed. London: Butterworth Scientific: 171–172.

Hill CC. 1995. The Group of Seven: Art for a nation. Ottawa: National Gallery of Canada.

Kühn H. 1986. Zinc white. In: Feller RL, ed. Artists' pigments: A handbook of their history and characteristics. Volume 1. Washington, DC: National Gallery of Art: 169–86.

Laurie AP. 1895. Facts about processes, pigments and vehicles. London: Macmillan and Co.: 48–49.

Laurie AP. 1967. The painter's methods and materials. New York: Dover Publications Inc.: 83.

Martens CR. 1964. Emulsion and water-soluble paints and coatings. New York: Reinhold Publishing Corporation: 74.

Mayer R. 1991. The artist's handbook of materials and techniques. 5th ed. Revised and updated by Steven Sheehan. New York: Viking.

McKendry B. 1997. A to Z of Canadian art. Kingston, Ontario: Blake McKendry: 95.

Painter A. 1963. Dictionnaire des pigments. Peintures, pigments, vernis 39(3): 92–93,95.

Seward H. 1889. Manual of colours, showing the composition and properties of artists' colours, with experiments on their permanence. London: George Rowney & Co.: 42.

Stephenson HB. 1973. Zinc oxide and leaded zinc oxide. In: Patton TC, ed. Pigment handbook. Volume I. New York: John Wiley & Sons: 37–51.

The Society of Dyers and Colourists and the American Association of Textile Chemists and Colorists. 1971. The colour index. Volume 3. 3rd ed. Bradford: Society of Dyers and Colourists: 3379.

The Society of Dyers and Colourists and the American Association of Textile Chemists and Colorists. 1982. The colour index. Pigments and solvent dyes. 3rd ed. Bradford: The Society of Dyers and Colourists.

Wehlte K. 1975. The materials and techniques of paintings. New York: Van Nostrand Reinhold Company: 70.

Abstract

This paper presents a survey of red and yellow synthetic organic artists' pigments discovered and produced in the 20th century and used in oil colours. The red pigments are β-naphthols, β-naphthol pigment lakes, BONA pigment lakes, Naphthol AS pigments and benzimidazolones and polycyclic pigments like perylenes, quinacridones and diketopyrrolo-pyrroles. The important yellow pigments are the Hansa yellows and the benzimidazolones. The history and development of these pigments were studied from the (patent) literature. Their use as artists' pigments is mentioned. As good quality organic pigments have been developed, the prejudice against 'coal-tar pigments' and 'aniline colours' has gradually subsided until today it is no longer a concern. The pigment lists of manufacturers producing artists' pigments today show that the new chemical classes, with excellent colourfast pigments in yellow, orange, red, violet, blue and green colours, have a good reputation among modern artists.

Keywords

history, yellow, red, synthetic organic, twentieth century, artists' pigments

A survey of red and yellow modern synthetic organic artists' pigments discovered in the 20th century and used in oil colours

Matthijs de Keijzer
Netherlands Institute for Cultural Heritage (ICN)
P.O. Box 76709
1070 KA Amsterdam
The Netherlands
Fax: +31 20 305 4700
Email: nwo@icn.nl

Introduction

A systematic and comprehensive analysis did not exist of the availability and use of modern synthetic pigments in the field of artists' materials. This is because only a minority of works had been investigated as recently as the 20th century and because of the gradual then rapid increase in the use of modern pigments. The former Central Research Laboratory for Objects of Art and Science was encouraged to undertake an in-depth study of the history of the technology and the development of pigments for a great variety of colours. The data provided by the manufacturers and suppliers of artists' materials concerning the types of paint in which a certain pigment was first used, and the date it was introduced, have been a great help in establishing the pigment chronology.

The pigment lists of the paint manufacturers Royal Talens, Winsor & Newton, Daler-Rowney, Schmincke and Société Lefranc & Bourgeois show that at present half of the quality A artists' paints contain organic and inorganic compounds discovered in the 20th century. For the B quality paints, this proportion is about 70%. At the dawn of the 21st century artists, restorers and conservation scientists are remarkably unaware of developments in the area of modern pigments. In contrast they used to be familiar with dyestuffs and pigments from the 19th century and earlier.

At the 9th triennial meeting of the ICOM Committee for Conservation in 1990 the author published two articles on the history and development of the synthetic inorganic and the blue, green, violet, orange and brown synthetic organic artists' pigments discovered in the 20th century (De Keijzer 1990a, b). This article continues and completes the series.

History and development

The Hansa yellow, β-naphthol, β-naphthol pigment lakes, BONA pigment lakes, Naphthol AS and benzimidazolone pigments are based on the diazo-reaction discovered by Peter Griess in 1859. Further systematic study of diazonium compounds opened the door to the development of a large family of azo dyes and pigments. Since World War II the polycyclic pigments have played an important role in the manufacture of organic pigments.

Red pigments

β-naphthol pigments

β-naphthol was discovered by Schaeffer in 1869. Para Red (PR 1, 12070) was obtained by Gallois and Ullrich in 1885 by coupling β-naphthol with diazotised 4-nitroaniline. This first β-naphthol pigment was manufactured by Farbwerke Meister Lucius & Brüning, Germany, in 1889. It possesses a poor colourfastness and a poor fastness to solvents. Despite the decided bleed, it is still used because of its tinctorial value.

Toluidine Red (PR 3, 12120), diazotised 2-nitro-p-toluidine coupled with alkaline β-naphthol, was invented in 1904 by Lucius & Bruning (British patent 19.100, French patent 357.858 and the German patent ap.F. 20.265, in 1905). In full shades it has good colourfastness (step 7 on the Blue Scale) but mixed with 1:4 TiO$_2$ it only reaches step 4. Therefore it is only used in the full or similarly deep shades. Because Toluidine Red has a good tint, good hiding power and does not react with sulphur compounds, it was suggested as a suitable substitute for Vermilion (*Zinnoberersatz*). In the 1927 catalogue by Talens N.V. Helioechtrot RL (PR 3) is listed. In the 1931 catalogue of Rembrandt Oil Colours by Talens the names *Talens citroen, licht, middel donker, oranje, rood licht, rood donker, rose, bruin, groenblauw, groen licht* and *groen donker* are mentioned. Mostly these names refer to synthetic organic dyes or pigments of which Helioechtrot RL is one. In the Artists' Oil Colour list (A quality) and Winton Oil Colour list (B quality) of Messrs Winsor & Newton Ltd. in the mid-1980s, Toluidine Red was listed in the products Bright Red and Vermilion Hue. Also in the 1988 catalogue of Lukas Künstlerfarben- und Maltuchfabrik, Dr. Fr. Schoenfeld Co., Lukasrot, Karmin, Krapplack hell, Kadmiumrot dunkel and Zinnober dunkel are listed in their A and B quality products. Toluidine Red has been analysed in the wall painting *Miss Blanche* by Huszár (1923) and in two paintings by Dubuffet *Chain de Mémoire III* (1964) and *Le train de pendules* (1965).

In 1906 Herzberg and Spengler discovered Chlorinated Para Red (PR 4, 12085) and Aktien-Gesellschaft für Anilin-Fabrikation (AGFA) patented the manufacture by diazotising 2-chloro-4-nitroaniline and combining it with β-naphthol (German patent 180.301, French patent 368.259 and US patent 865.587). This pigment is often mentioned as Fire Red and Permanentrot R. It has a lighter and yellower tint than Toluidine Red. Its resistance to oil bleed and its colourfastness in full shade are good, but less than PR 3. In the 1988 catalogue of Lukas it is used in the A and B quality of artists' oil colours in the products Helio-Echtorange, Helio-Echtrot, Kadmiumorange, Echtrot and Zinnoberrot hell. This pigment has been analysed in the 1929 pigment collection of the Missiemuseum in Steyl-Tegelen, The Netherlands.

Some time later Badische Anilin und Soda Fabrik (BASF) revealed that the isomer compound of 4-chloro-2-nitroaniline gave a brilliant orange-red pigment with good properties; it was called Parachior Nitroaniline Red (PR 6, 12090). Also in 1906 C. Schraube and E. Schleicher discovered this pigment (German patent 200.263, British patent 6.227 and US patent 860.575). It was also introduced under the trade name Hansarot GG. It is a little bluer and very slightly more lightfast than PR 4, and is appreciated for its transparency.

β-naphthol pigment lakes

The development of the azo pigment lakes started with the invention of Lithol Red (PR 49, 15630) in 1899, discovered by Julius (German patent 112.833, 17 December 1899; British patent 25.511(1899); US patent 650.757, 10 January 1900 and French patent 297.330 (1900)). Lithol Red, which is synthesized from 2-naphthylamine-1-sulfonic acid as a diazonium compound, was initially used in the form of calcium and barium salts, which were precipitated onto inorganic carrier materials. The pigment was used in its pure form after it became apparent that the carriers contribute very little to the application properties of the product. The main use of Lithol Red is for printing inks.

The breakthrough of Lithol Red led to the preparation of a whole family of hard-to-dissolve azo compounds of which Red Lake C (PR 53, 15585), diazotised o-chioro-m-toluidine-p-sulfonic acid coupled with alkaline β-naphthol, became a most important member; it was discovered in 1902 by Schirmacher (Lucius & Brüning: British patent 23.831; German patent 145.908, French patent 328.131 and US patent 733.280). The first commercial production was begun in 1903 by Lucius & Brüning; it is used for the printing ink industry. Its colourfastness is less than that of the Naphthol AS pigments, but it is also used for coloured pencils and watercolours.

BONA pigment lakes

This group of pigments derives its name from 2-hydroxy-3-naphthoic acid, β-oxynaphthoic acid (BONA) used as the coupling component. BONA was discovered by Schmitt and Buckard in 1887. In 1893 Kostanecki used BONA as a coupling component. In 1902 AGFA succeeded in the first dye synthesis with BONA (German patent 145.9 13, 1902). Lithol Rubine B (PR 57, 15850) which was discovered by Gley and Siebert at AGFA in 1903 (German patent 151.205, British patent 11.004, French patent 332.145 and US patent 743.07 1). It has a clear bluish red colour and possesses a high tinctorial strength, a colourfastness of 4–5 on the Blue Scale. When it is mixed the colourfastness drops to step 4 and 3. The BONA pigment lakes in comparison with the β-naphthol pigments are slightly more colourfast. In the 1991 artists' pigment catalogues of Royal Talens it was still used in the products Geraniumiak and Talensrood purper (Rembrandt Oil Colours), Cadmiumrood azo, Vermiljoen and Karmijn (Van Gogh Oil Colours) and Donkerrose (Amsterdam Oil Colours), but it was replaced some years ago.

Another important BONA pigment lake is Permanent Red 2B (PR 48, 15865). The manufacture of Red 2B pigments involves the following basic steps: diazotisation of Red 2B acid, coupling with BONA and precipitation with the appropriate metal salt. In 1928 it appeared in Germany, twenty years after Lithol Rubine B (PR 57), but was unsuccessful at first. Alfred Siegel of E.I. du Pont de Nemours & Company discovered that the presence of trace amounts of unsulfonated Red 2B acid resulted in wide variations in pigment quality. Siegel solved the bleed problem by precipitating the dyestuff with calcium, barium or manganese, creating the products known today as Permanent Red (US patent 1.803.657, 5 May 1931; US patent 2.117.860, 17 May 1938 and US patent 2.225.665, 24 December 1940). The colourfastness in full shade reaches step 4–5 on the Blue Scale. In the 1991 Talens catalogue this pigment appears in Cadmium Red Dark azo (Van Gogh and Amsterdam Oil Colours).

Naphthol AS pigments

Naphthol AS pigments are monoazo compounds with coupling components of arylides of BONA. The chemist Schopf discovered this coupling in 1892 in an attempt to prepare 2-phenylamino-3-naphthoic acid. In 1911 the chemists Winther, Laska and Zitscher working at Oehler (Offenbach/Main), part of the Chemische Fabrik Griesheim-Elektron (now Hoechst AG), discovered azo colorants from diazotised anilines or toluidines and Naphthol AS as a coupling component. This invention led to the fundamental German patent 256.999 on 4 July 1911. One year later this firm replaced the β-naphthol pigments by Naphthol AS for the application of ice-dyeing on textiles (German patent 261.594, 18 May 1912). In a few years there was a rapid development of new Naphthol AS pigments. The German patent 262.294 (17 November 1912) protects the process of dyeing cotton with Naphthol AS, so that the price of the 2-hydroxy-3-naphthoic arylides dropped. Between 1920 and 1930 the development of the Naphthol AS technology in Germany was initiated by IG Farbenindustrie AG and in the 1940s this pigment group began to be developed in the USA. Today there are 40 known Naphthol AS pigments. Only eight Naphthol AS pigments are of interest as artists' pigments: Permanentrot FRR (PR 2, 12310) and Permanentrot F4R (PR 8, 12335) (Griesheim-Elektron: German patent 256.999 (1911), British patent 6.379, French patent 441.333 and US patent 1.034.853 (1912)); Permanentrot F4RH (PR 7, 12420) and Permanentbordeaux FRR (PR 12, 12385), both invented by Wagner at Griesheim-Elektron (German patent 421.205, British patent 199.771 and French patent 549.020 (1921)); Permanentrot FRLL (PR 9, 12460) discovered by Laska and Zitscher, at Griesheim-Elektron, in 1922 (German patent 390.627 and US patent 1.457.114, 1922). Permanentrot FGR (PR 112, 12370) was invented by IG Farbenindustrie AG in 1939. Better pigments were invented using new substituents like the sulfonamide and carbonamide groups. Examples are Permanentcarmin FBB (PR 146, 12485), discovered in 1953 by Hoechst AG and Permanentrot F5RK (PR 170, 12475).

Permanentrot FGR (PR 112) was used as an artists' paint by Talens (1991 catalogue of Rembrandt Oil Colours) in the products Vermiljoen chin, e.g., Talensrood donker and Permanentrood. Permanentrot F4R (PR 8) appear in the 1988 Lukas catalogue in Indischgelb, Geramumlack and Gruner Lack hell (A quality), Geraniumiack and Kobaltviolett dunkel (B quality). Permanentrot FRLL (PR 9) was identified in the 1970 painting *La suite américaine* by Rancillac and Permanentcarmin F5RK (PR 170) was analysed in the 1983 painting *Mire G 131 Kowloon* by Dubuffet.

Perylene pigments

Perylene pigments are diimides of perylene-3,4,9, 10-tetracarboxylic acid; in 1913 a number of these products were used as vat dyes. The first introduction of these compounds as pigments came in 1950 when Harmon Colors did research on vat dyes to bring them to a suitable pigment form. Hoechst AG continued to research the perylene pigments (Hoechst AG: British patent 839.634 (1955); British patent 835.459 (1956); British patent 861.218 (1956); German patent 1.113.773 (1956); BASF AG: Belgian patent 589.209 (1960)). Perylene Vermilion (PR 123, 71145) was discovered by Harmon Colors in 1952. Perylene Scarlet (PR 149, 71137) was patented by Hoechst AG in 1956 (German patent 1.067.157) and Perylene Maroon (PR 179, 71130) is protected by the British patent 923.72 1 (BASF AG). Further research led to new perylenes, such as PR 190, PR 224. The perylenes have high colourfastness and good weatherfastness. The 1996 Talens catalogue shows Perylene Scarlet (PR 149) in their product Scarlet.

Quinacridones

Much of the history of the quinacridones was already treated in De Keijzer (1990b). The pigment industry expanded the spectrum of the quinacridone pigments. These have been marketed since the late 1960s in colours ranging from orange, gold, red, and maroon to magenta and violet. Good examples are Quinacridone Red (PR 192), Pigment Red (PR 206) and Quinacridone Scarlet (PR 207). In 1974 Talens listed Quinacridone Magenta (PR 122) and Quinacridone Violet (PV 19) in its Rembrandt Oil Colours assortment. In the 1991 Talens catalogue of artists' oil colours Quinacridone Magenta is present in the products Rembrandt Rose, Permanent Violet and Permanent Red Violet (Rembrandt Oil Colours); Permanent Rose, Permanent Red Violet and Permanent Blue Violet (Van Gogh Oil Colours) and Violet (Amsterdam Oil Colours). Quinacridone Magenta is often mixed with Carbazole Dioxazine Violet (PV 23).

Benzimidizalone pigments

The development of benzimidizalones was begun in the early 1960s by the chemists Schilling and Dietz at Hoechst AG. The first patent (US patent 3.124.565) was applied in 1960 by Hoechst AG to protect pigments obtained by diazotising aminobenzoic acid amines and coupling with BONA derivatives of 5-aminobenzimidazolone. Systematic research was carried out with a variety of amines to create a range of benzimidazolone pigments covering as broad a palette of shades as possible. In a very short period different processes were developed. German patent 1.215.839 describes that alkoxy substituted aminobenzoic acid amides as the diazo component yield bluish-red pigments. US patent 3.137.686 and the German patent 1.213.552 (Hoechst AG) disclose benzimidazolone pigments with aminobeuzene suifonic acid as the diazo component (PV Carmine HF4C (PR 185, 12516), introduced in August 1967; PV Bordeaux HF3R (PV 32, 12517), introduced February 1965). US patent 3.124.565 mentions that excellent pigments were obtained with simple amines such as nitroamlines and chloronitroamlines after diazotisation and coupling with the BONA derivatives of S-aminobenzimidazolone (PV Fast Red HFT (PR 175, 12513), introduced June 1965); PV Fast Brown HFR (PBr 25, 1251Q), introduced December 1966; PV Carmine HF3C (PR 176, 12515), introduced January 1965 and PV Fast Maroon HFM (PR 171, 12512), introduced August 1964). Belgian patent 723.711

(Hoechst AG) mentions that ester functions in the diazo component yield red benzimidazolone pigments with excellent fastness to migration (PV Red HF2B (PR 208, 12514), introduced May 1970). The coupling component for the red pigments is 5-(2-hydroxy-3-naphthoyl)-aminobenzimidazolone (Patton 1973). Benzimidazolone PV Carmine HF3C (PR 176) is listed in the 1988 catalogue of Lukas in the artists' oil colours in their products Karmin, Krapplack hell, dunkel and dunkelst, Casslerbraun, Sepia, Vandyckbraun and Indigo (Lukas Sorte 1 Feinste Künstler-Ölfarbe) and Karminrot, Krapplack hell, Krapplack dunkel, Casslerbraun and Vandyckbraun (Lukas Studio Feine Künstler-Ölfarbe).

Diketopyrrolo-pyrrole pigments

This pigment group is the latest important discovery. In 1974 an attempt was made to synthesize a 2-acetinone by reacting benzonitrile with bromoacetic acid in the presence of zinc dust. This preparation failed but the result was a small yield of a 1,4 diketopyrrolo(3,4c)-pyrrole. In the early 1980s studies were done by Ciba-Geigy leading to this type of heterocyclic pigment (US Patents 4.415.685 (1983) and 4.585.878 and 4.791.204). The available pigments turned out to be extremely insoluble and the colourfastness reached step 8 of the Blue Scale. They are synthesized by reacting succinic ester with benzonitriles in the presence of sodium methylate in methanol (Herbst and Hunger 1993). Today three reds and one orange DPP pigment are available: Irgazin DPP Red BO (PR 254, 56110), Irgazin DPP Red SG (PR 255), Irgazin DPP Red 4013 (PR 264) and Irgazin DPP Orange 16A (PO 73). These pigments entered the pigment market recently.

Talens was the first to introduce them in its Rembrandt Oil Colour assortment in 1996. Irgazin DPP Orange 16A (PO 73) is listed in its products Vermilion and in Permanent Yellow Medium, Dark and Permanent Orange (mixed with PY 154). Irgazin DPP Red BO (PR 254) is found in the artists' oil colours Permanent Red Deep and in Permanent Red Medium (mixed with PR 255) and Permanent Madder Light (mixed with PR 264 and Quinacridone Violet, PV 19). Irgazin DPP Red SG (PR 255) is put in Permanent Red Light (mixed with PO 73) and Irgazin DPP Red 4013 (PR 264) in the artists' oil colours Permanent Red Purple, Permanent Madder Deep and Permanent Madder Medium (mixed with PV 19), Burnt Carmine (mixed with synthetic Ultramarine Blue, PB 29) and Permanent Madder Brown (mixed with synthetic red iron oxide, PR 101 and PV 19).

Yellow pigments

Hansa yellow pigments

With β-naphthol, BONA and the anilide of BONA as coupling components, one could only produce red and orange pigments. The range of available colours was restricted and it was not possible to manufacture shades of yellow beyond that of Dinitroaniline Orange (PO 5, 12075). The breakthrough came with the invention of acetoaceticarylides reacting with diazo components as coupling compounds. The first patent in this connection was issued in 1897. This led eventually to the German patent 257.488 (17 October 1909; Lucius & Brüning) that deals with the production of azo pigments, made by coupling diazotised nitro- or chloro-aromatie amines with acetoaceticarylides. The first pigment, Hansa Yellow G (PY 1, 11680) discovered by Wagner in 1909, was made by diazotised 2-nitro-p-toluidine coupled with acetoacetanilide. In 1910 the first commercial production was begun by Lucius & Brüning. This pigment group led to a search for other possible combinations using different derivatives. The second famous yellow pigment in this range, Hansa Yellow l0G (PY 3, 11710) made by diazotised 4-chloro-2-nitroaniline coupled with o-chioroacetoacetanilide was discovered by Desamari (US patent 1.059.599) in 1910 and was produced in the same year, followed by Hansa Yellow 5G (PY 5, 11660) and Hansa Yellow 13G (PY 4, 11665).

In 1957 much improved monoazo yellow pigments were discovered, such as Hansa Yellow GX (PY 73, 11738), diazotised 4-chioro-2-nitroaniline with o-acetoacetanisidide, patented by Coating & Speciality Products Department (Imperial), Hercules Inc. (French patent 1.309.211, British patent 938.047 and

DAS 1.231.367; Dalamar Yellow (PY 74, 11741), diazotised 4-nitro-o-anisidine with o-acetoacetanisidide, protected by Du Pont de Nemours in 1958 (US patent 3.032.546 and Canadian patent 6 12.395). Other trade names of Dalamar Yellow are Permansa Yellow GY (Sherwin Williams Company) and Hansa Brilliant Yellow SGX (Hoechst AG). In 1961 Hoechst AG introduced Permanent Yellow FGL (PY 97, 11767), diazotised 4-amino-2,5-dimethoxybenzene-sulfonanilide coupled with 4'-chloro-2' ,5 '-dimethoxyacetoacetanilide, (US patent 2.644.814) and Hansa Brilliant Yellow 1OGX (PY 98, 11727), diazotised 4-chloro-2-nitroaniline coupled with 4-chloro-o-acetoacetotolide, (US patent 3.165.507).

Hansa Yellow G (PY 1) and Hansa Yellow lOG (PY 3) were the first monoazo pigments that were accepted as artists' pigments to replace chrome yellow. An advantage over chrome yellow is that these pigments do not react with sulphur compounds. These pigments are gradually replaced by the much improved monoazo yellows. In the 1996 Talens catalogue (Rembrandt Oil Colours) the Hansa yellows disappear and are replaced principally by the benzimidazolones. The pigment catalogues of Talens show that Hansa Yellow lOG was put on the *Rembrandt Temperaverven* list in 1927 (Talens Groen Licht: a mixture of a green pigment and Hansa Yellow lOG). The 1931 oil colour catalogue of Talens mentions Hansa Yellow lOG, Hansa Yellow GGR (PY 1) and Hansa Yellow GR (PY 3).

Benzimidazolone pigments

In the 1993 list, Standard Specification for Artists' Oil, Resin Oil, and Alkyd Paints, three yellow benzimidazolones are mentioned: Benzimidazolone Yellow H4G (PY 151, 13980), Benzimidazolone Yellow H3G (PY 154, 11781) and Benzimidazolone Yellow H6G (PY 175, 11784). Yellow and orange benzimidazolones containing the coupling component 5-acetoacetylamino-benzimidazolone can use the same amines as are used for the red pigments (US patent 3.109.842 (PV Orange HL (P0 36, 11780, February 1964)). The Belgian patent 723.012 by Hoechst AG protects pigments with 3-aminoisophthalic acid dimethyl ester as the diazo component (PV Fast Yellow H2G (PY 120) November 1969). Benzimidazolone Yellow H4G (PY 151) was introduced in 1971. Benzimidazolone Yellow H3G (PY 154) entered the pigment market in 1975. Benzimidazolone Yellow H6G (PY 175), was introduced after 1980. All these pigments have a greenish yellow shade, excellent colourfastness and weatherfastness. In comparison with the Hansa Yellows the colourfastness is up to 2 steps better. Mixed with the phthalocyanine blues it can give brilliant greens. Benzimidazolone Yellow H3G (PY 154) is the most popular benzimidazolone pigment and is often used by Talens (1996 catalogue: Rembrandt Oil Colours) in their products Permanent Yellow Light, Permanent Yellow Medium and Dark (mixed with P0 73), Permanent Yellowish Green, Permanent Green Light, Medium and Deep (mixed with Copper Phthalocyanine Green, PG 7) and Cinnabar Green Light and Medium (mixed with PG 7 and synthetic hydrated iron oxide, PY 42).

Acknowledgements

Royal Talens B.V. provided the author with data regarding the production of pigments and the marketing of their artists' materials. In addition, the author gratefully acknowledges the use of Royal Talens' archives and library, and thanks Jaap Mosk for his assistance in shortening this article.

References

De Keijzer M. 1990a. A brief survey of the synthetic inorganic artists' pigments discovered in the 20th century. In: Grimstad K. ed. Preprints of the 9th triennial meeting of the ICOM Committee for Conservation. Paris: International Council of Museums: 214–219.

De Keijzer M. 1990b. Microchemical analysis on synthetic organic artists' pigments discovered in the twentieth century. In: Grimstad K. ed. Preprints of the 9th triennial meeting of the ICOM Committee for Conservation. Paris: International Council of Museums: 220–225.

Herbst W, Hunger K. 1993. Industrial organic pigments, production, properties, applications. Weinheim: VCH Verlagsgesellschaft mbH.

Patton TC. 1973. Pigment handbook, properties and economics. Vol. 1. New York: John Wiley & Sons.

Abstract

Eight portraits at the Tate Gallery by Sir Joshua Reynolds (1723–1792) were examined to assess whether the varnishes could be removed safely. Analysis of the paint medium was carried out with DTMS (direct temperature-resolved pyrolysis mass spectrometry), varnish having been removed beforehand in test cleans by a variety of methods. Most samples included mixtures of the following media: linseed and walnut oils (some with lead driers), beeswax, mastic resin, Venice turpentine and on occasion bitumen. Beeswax was a significant component of the paint film in several paintings. An assessment was made of the effects of cleaning methods on areas of paint.

Keywords

Reynolds, Tate Gallery, medium analysis, DTMS, cleaning tests, beeswax, bitumen, mastic, megilp, lead driers, gum, ammonium hydroxide, varnish removal methods

A technical assessment of eight portraits by Reynolds being considered for conservation treatment

Rica Jones and Joyce H. Townsend★
Conservation Department
Tate Gallery, Millbank
London SW1P 4RG
UK
Fax: +44 171 887 8059/8982
Email: rica.jones@tate.org.uk;
joyce.townsend@tate.org.uk

Jaap J. Boon
FOM Institute for Atomic and Molecular Physics
Kruislaan 407
1098 SJ Amsterdam
The Netherlands
Fax: +31 20 668 4106
Email: boon@amolf.nl

Introduction

In 1996 the Tate Gallery Conservation Department was enabled by the Getty Grant Program to carry out a conservation treatment survey of paintings by Sir Joshua Reynolds. The paintings were selected on the basis of their importance to the collection as a whole; all were unfit for display in their current condition. Some of the results are presented below. All paintings are on glue-lined, linen canvas except *George IV when Prince of Wales*, which is on mahogany panel.

Reynolds's experiments with media have become legendary. Within his lifetime some of the paintings faded, cracked or were occasionally returned to him when areas of paint fell off (Talley 1986). Reynolds himself left technical information in the form of ledgers and sitters books, which refer to specific paintings (Cormack 1968–70: Dubois 1992–93). Materials he recorded using include linseed and nut oils with driers such as lead acetate, megilps, resins such as copal and mastic, waxes such as beeswax and spermaceti, Venice turpentine, copaiba balsam, bitumen, egg yolk, egg white, gum tragacanth and gum arabic, and he used them apparently as his fancy dictated.

Methodology

Information was gathered from conservation records, ledgers and sitters books, which however contained no reference to any paintings in this survey. Examination procedure involved detailed surface examination, use of raking light and ultraviolet light, stereo microscopy, X-radiography, making of cross-sections for viewing in visible and ultraviolet light, pigment characterisation by optical and electron microscopy, and thermomicroscopy (Odlyha 1995). Test cleans were done on the varnish with propan-2-ol or dilute ammonium hydroxide, followed by re-sampling of the paint in some instances. All the paintings have received conservation treatment in the past, so we tried to sample away from locally treated areas.

The great variety of paint media used by Reynolds required a suitable analytical approach. Direct temperature-resolved mass spectrometry (DTMS) meets these requirements (Boon 1999). With this method, potentially soluble mobile fractions as well as cross-linked chemically bonded fractions can be discriminated in one analytical run. The mass spectrometric information obtained as a function of temperature makes it possible to analyse simultaneously waxes, di- and triterpenoid resins, bituminous hydrocarbon fractions, free fatty acids and diacids, polysaccharide gums, cross-linked oil paint network polymers, asphaltenes, proteinaceous lining glues and some inorganic materials from the pigments. The materials identified have often undergone extensive ageing. The DTMS information is described in artists' and conservators' terminology.

★ Author to whom correspondence should be addressed

Figure 1. Francis Beckford, *N05798, 1283 × 1016mm. Tate Gallery, London.*

Figure 2. Lord Ligonier, *N00143, 2794 × 2388mm. Tate Gallery, London.*

Figure 3. Self-portrait as a doctor, *N00306, 737 × 610mm. Tate Gallery, London.*

Results

FRANCIS BECKFORD, 1755–56 (FIG. 1)

Paint: A cross-section from the edge of his breeches shows a monochrome underpainting in grey beneath a layer of blue. This was confirmed as a consistent feature of the costume by surface examination and comparison of the original with the X-radiograph, which displays brushwork not visible to the unaided eye. Examination of the cross-section in UV fluorescence suggests that the medium in both layers of the coat is unmodified oil. Samples from the background showed a straightforward single layered, wet-in-wet construction, in opaque tones. Fluorescence suggested unmodified drying oil.

The crimson tablecloth has a more complex construction. Reynolds started off with a thick, very dark red or black opaque underpainting, which, when dry, was glazed thickly with translucent crimson, composed of lake with possible traces of yellow ochre, vermilion, and a substance that appeared to be bituminous but which was not confirmed by DTMS. The medium of the glaze is made from linseed oil with a drier added, mastic resin and an unidentified polysaccharide gum. This mixture is very close to two recipes found in Dossie's *Handmaid to the Arts* (1758), the gum providing body and a less yellowing medium than the equivalent amount of oil. Translucent, oval shapes visible when the glaze is viewed in cross-section may be the gum. Recent research on Rembrandt has revealed a similar composition in glazes (Groen 1997); this may therefore be a more common feature than has been realised.

The face and hands could not be sampled but all display varying degrees of wrinkling in the basic flesh tones, the face being much the worse affected. Too much oil is the conventional explanation for this defect but it may be that Reynolds's recorded method of painting into a white 'couch' for the face (using a variety of materials) is the cause (Talley 1986). There has also been fading of red pigments in the flesh tones.

Varnish and test cleans: The mastic varnish layers are easily soluble in propan-2-ol, in which the paint is safe. In spite of this, however, it was decided that full cleaning was not suitable. The fading and wrinkling in the face made overall thinning of the varnish a preferable option. The varnish is providing a mellowing tone and there is a risk of further wear to the features in trying to remove varnish trapped in the wrinkles. *Suzanna Beckford*, the pair, is very similar.

LORD LIGONIER, 1760 (FIG. 2)

Paint: Cross-sections show a simple one- or two-layered construction. The only complex areas are the thickly pastose saddle cloth, bag and the braid on his coat, where there is much wet-in-wet work. The paint generally is thin and opaque, except for the sketchy plants in the foreground. There is no abrasion or serious paint loss. Large patches of discoloured overpaint in the sky mask minor damages. There has been no visible fading of pigments. Four samples consisted of unmodified linseed oil.

Varnish and test cleans: There are two or more layers of natural resin varnish (probably mastic) which have become very yellow. Both are easily soluble in propan-2-ol, in which the paint is safe. It was decided this painting could be cleaned in the normal manner.

SELF-PORTRAIT AS A DOCTOR, CA. 1775 (FIG. 3)

Paint: Much obscured by several layers of thick, discoloured varnish and glazes of repainting. Cross-sections indicate a very complex construction, possibly incorporating changes to the design, though none was apparent in the X-radiograph.

Several areas were analysed with DTMS. All the samples were infused with glue from the lining and all included traces of residual varnish.

• Top edge, comprising upper layers of brown background paint. The varnish was removed by dry scraping. The paint is a mastic resin rich linseed oil paint with possibly some bitumen. It also contains lead white and chalk. This paint dissolves in 2-propanol. Thermomicroscopy showed that the paint began to soften at 114°C and was melted by 135°C.

- Another sample from an adjacent area to the previous sample, the varnish previously removed with ammonium hydroxide, had the same composition with a measurable reduction in fatty acids.
- Blue-grey underlayer at the same point as the first sample. It is composed of linseed oil, probably with a lead drier, an aged colophony-type diterpenoid, and a triterpenoid mastic-type resin but no wax or bitumen. This is possibly a variety of megilp.
- The red glaze over the jacket, with the varnish previously removed with ammonium hydroxide, is composed of a polysaccharide gum, some oil and some mastic resin which may have soaked in from the varnish. There was no wax or bitumen. Further analysis with GCMS suggested that the gum might be gum arabic or cherry gum, or a mixture of both, possibly with honey or sugar added as plasticisers. A further sample from which the varnish had been removed by dry scraping revealed only triterpenoid resin, highly polymerised and oxidised.

Varnish and test cleans

- The varnish consists of dammar resin, with no evidence for oil.
- Cleaning tests revealed the paint is highly soluble in propan-2-ol.
- Light opaque areas such as the highlights and half-shadows in his white collar are apparently resistant to ammonium hydroxide.
- Ammonium hydroxide eats away at the whole thickness of the varnish using the cracks as access, rather than gradually thinning it.
- There is some evidence that ammonium hydroxide causes leaching in the background paint.
- In the red glaze and the dark background this action leads to etching of the paint at the cracks before the ammonium hydroxide has removed all the varnish.
- In the dark shadows of his robes the paint is more resistant to the ammonium hydroxide, but there is not an adequate margin for control.

The only way to clean this painting would be to find a safe method to reduce the thickness of the varnish, leaving some in place to protect the paint from etching and leaching.

SELF-PORTRAIT AS A DEAF MAN, CA. 1775 (FIG. 4)

Paint: Cross-sections indicate a very complex, varied structure. Serious wrinkling has occurred in all the shadows of the face (Fig. 5), in the ear and in parts of the neckband. A number of samples were analysed after the varnish had been removed with ammonium hydroxide.

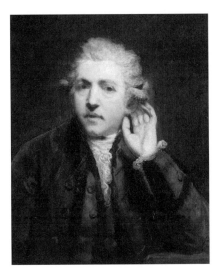

Figure 4. Self-portrait as a deaf man, N04505, 749 × 622mm. Tate Gallery, London

- Green cloth, lower right corner: medium is mainly beeswax with spermaceti wax with a small amount of linseed oil.
- Half-shadow of red jacket: oil probably walnut, which was less thoroughly dried despite the abundant presence of lead white, and a substantial amount of aged polymerised triterpenoid resin.
- White highlight (impasto) on cravat: walnut oil and an unidentified additive.
- Greyish-white, smooth area of cravat; the oil is a mixture of linseed and probably walnut. The oil paint appears less aged than expected, because diglycerides are still present. Some beeswax is present, and large amounts of triterpenoid resin, again perhaps from paint or varnish, and some indication of bitumen.
- Grey-black shadow next to cravat: possibly walnut oil (with unusual ageing characteristics, as above), but no wax. Triterpenoid resin is present and is likely to be dammar varnish.
- Paint in the dark shadow of the waistcoat softened from 125 to 128°C and melted gradually thereafter. Paint from a bright red area of the jacket did not melt before 140°C.

Figure 5. Detail of wrinkling in the face of this self-portrait. Arabella Davies and Marcus Leith.

Varnish and test cleans:

- More than one layer of dammar. Some may have been absorbed by the paint.
- Ammonium hydroxide cleans the varnish with a reasonable degree of control in the light and opaque areas tested in the cravat. Encouraging results were also obtained in the tablecloth.

- Despite these results, however, really extensive testing must be done on thinning rather than removing the varnish, as the wrinkled areas in the face could prove very susceptible to cleaning. It is also likely that the dark background contains potentially vulnerable materials.

LADY CHARLOTTE HILL, COUNTESS TALBOT, 1782 (FIG. 6)

Paint: The paint clearly varies greatly in materials and structure from area to area. Contraction cracks occur in a number of passages; their network and widths vary greatly and it would seem that their origins vary accordingly, some due to artist's alterations, others to mixed media. Other than that, the painting appears in good condition, though badly obscured by a very thick varnish. The face does not appear to have faded.

DTMS showed that:

- The white dress contains a mixed oil, possibly linseed and walnut.
- In the sky the binder is walnut oil alone.
- A sample from a white island of paint in the badly cracked area to the right of the figure showed it was mainly linseed oil but with unusual ageing characteristics. This probably means the presence of an undetectable additive.
- An adjacent sample from a contraction crack included evidence for a diterpenoid resin, perhaps colophony.
- The red lake glazing on top of the curtain is of very complex structure. The cross-section has a three-layer construction using different binding materials, which appear waxy or resinous in UV.

Figure 6. Lady Charlotte Hill, Countess Talbot, *N05640, 2343 × 1460mm. Tate Gallery, London.*

Varnish and test cleans:

- The varnish is probably mastic, beneath which is a thin grey layer. The principal component of the grey layer is aged mastic resin and cross-sections show that it is full of dirt particles.
- Test cleans showed that propan-2-ol removes the whole thickness of the mastic varnish, leaving the grey layer intact. Ammonium hydroxide was controllable in removing the mastic. With further prolonged contact it also removed the grey layer, leaving the paint apparently unaffected. A sample from the white dress, analysed after total varnish removal with ammonium hydroxide, did not appear to have lost any mobile components such as fatty acids as a result of cleaning.
- It will be possible to remove the upper layer of mastic with propan-2-ol or ammonium hydroxide and retain the grey layer. Of the two, propan-2-ol would be the better choice, as the lower layer is very resistant to it. It is desirable to retain the grey-layer permanently, because it will protect potentially vulnerable areas from solvent or reagent attack, and will act as a patina or unifying veil over this painting where different areas have aged disparately.

GEORGE IV WHEN PRINCE OF WALES, 1785 (FIG. 7)

Paint: Whereas all the other paintings appeared to have conventional primings, neither surface microscopy of the painting nor any of the cross-sections revealed a ground in this one. A test clean at the top edge, where the paint thins out before reaching the perimeter of the panel, shows very faint streaks of a whitish material deep in the grain of the wood. It was not possible to get samples of it. In the light of the waxy nature of the paint, this may be a thin scraping of beeswax, perhaps with chalk. The site of an old damage on the edge of his chin, when cleaned out, revealed a slightly thicker white layer immediately on top of the wood. This is probably a couch of white laid in for the face alone. The X-radiograph suggests that the material is not lead white, as the face looks so very much darker than the cravat, which contains lead white.

Being on panel, the pastose texture of the paint is considerably less changed than in the average painting by Reynolds, most of which have been lined. There is a dense, rectilinear crackle pattern over the entire sight area. This is brittle age-cracking. There is no drying crackle. There are a number of very small, retouched losses of paint (pinhead size) on the cheeks. Apart from this the paint is in good condition.

Figure 7. George IV when Prince of Wales, *N00890, 765 × 616mm. Tate Gallery, London.*

There is a complex layered structure, which varies from area to area. All the cross-sections from the landscape and sky reveal multiple layers, and several have air-bubbles in the body of the paint, generally not extending into the top layer. The old damage on the edge of the chin revealed several layers of paint at this point. The whole of the blue jacket was first painted red, not as an underpainting but because Reynolds is recorded to have altered the colour (Hackney, Jones and Townsend 1999, 146–151).

Medium analysis of the uppermost layers only, the varnish having been previously removed with ammonium hydroxide, showed:

- Mainly mastic with some beeswax and possibly a trace of drying oil in the dark background at upper edge
- Mainly mastic resin with some beeswax in the white cravat. A second sample also contained just detectable traces of linseed oil.
- Beeswax and mastic resin in the greyish background paint at the left edge.
- Beeswax and mastic resin in the blue paint at the left edge.
- The paint melts in the temperature range 77 to 95°C, the melting point varying from area to area sampled.

Varnish and cleaning tests: The varnish is thick and considerably yellowed. In cross-section at least two layers can be seen. There is a line of dirt between them. None of the varnish is original, since it runs over the edge of a crack in the panel. An important feature is contraction in the varnish, which is threatening to promote cleavage in the paint layer.

- A varnish sample from the white cravat is aged mastic.
- Most of the varnish is melted by 75°C.
- The paint is immediately soluble in propan-2-ol.
- Ammonium hydroxide dissolves the varnish layers but is not sufficiently controllable as it approaches the paint. This is mainly due to the system of cracks, which provide ready channels for the reagent, which begins to etch into the surface of the paint.

A safe means of thinning the varnish is desirable on two counts – to reduce the discolouration and to reduce the amount of traction on the paint film. Research into alternative methods of cleaning and into the possible long-term effects of ammonia gels would need to be carried out as part of the potential treatment.

THE AGE OF INNOCENCE, CA. 1788 (FIG. 8)
Paint: There is another composition underneath this (Hackney, Jones and Townsend 1999, 60–65). Samples from the upper painting, after the varnish had been removed in each case with ammonium hydroxide, showed:

- The blue sky is bound in a drying oil, which is not linseed.
- The green background foliage, topmost layer of paint, contains beeswax (including its paraffin fraction) and drying oil rather low in fatty acids.
- The layer of grey paint immediately beneath contains mostly beeswax with no evidence for oil.
- The white dress was painted with poppyseed oil, traces of triterpenoid resin, an unidentified component but no wax.
- Apart from these results, it is evident from the UV fluorescence of the cross-sections that beeswax is a considerable component of the picture.

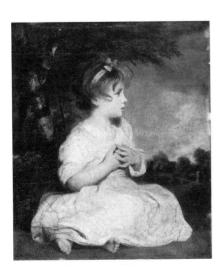

Figure 8. The Age of Innocence, N00307, 762 × 365mm. Tate Gallery, London.

Varnish and test cleans: Many layers of natural resin varnish are present, consisting of triterpenoid resins – mastic and in some instances dammar. The lowest layer is resistant to removal with ammonium hydroxide. In a test on an original area of the sky, all varnishes except the lowest were removed with ammonium hydroxide, and a cross-section taken. There is no disruption in the paint film and the varnish is even. It looks, therefore, as if the painting may be cleanable with ammonium hydroxide, possibly in conjunction with alternative methods,

provided that the lowest layer of existing varnish is left in place to protect vulnerable areas and provide a unifying tone.

Conclusion

- All except one painting proved to be in mixed media. This survey indicates that the cause of the cracking and shrinking in Reynolds's paintings is the mixing of media rather than the extensive use of bitumen, as is traditionally supposed.
- In several cases, lead driers were used with the oil.
- The two red glazes analysed contained a polysaccharide gum and mastic resin, as well as oil.
- Beeswax, mentioned so often in his technical notes, is confirmed as a major ingredient, especially in his later works. Wax, if the principal component and if it can survive early restorations, proves to be relatively stable.
- Several paint samples began to melt at approximately 75°C.
- The predominance of waxy and resinous components means some paintings cannot be cleaned with any solvent. Ammonium hydroxide proved a possibility in some cases, though only if the lowest extant varnish could be left in place to protect vulnerable areas and to provide a 'patina' in compositions where different areas have aged in widely disparate ways. A dark brown paint appeared to be leached by ammonium hydroxide; a white paint appeared to be stable. Much research is needed into dry methods of varnish removal and the use of ammonia gels.
- Early works, even when the majority of the painting is stable, can prove uncleanable because of experimental techniques used in the face alone.

Acknowledgements

We are grateful to the Getty Grant Program for sponsoring this project, and to the MOLART program, a PRIORITY project of NWO (the Dutch Science Organisation), which undertook the DTMS studies. The authors would also like to thank the following people: Arabella Davies, Hélène Dubois, Marcus Leith, Dr Marianne Odlyha, Jos Pureveen and Dr Brian Singer (for GCMS of gums).

References

Boon JJ. 1999. Poster submitted to ICOM-CC: DTMS studies of the painting media of Reynolds. And other references mentioned therein. Cormack M. 1968–70. The ledgers of Sir Joshua Reynolds. Walpole Society, 42: 105–169.

Dossie R. 1758. The handmaid to the arts, I. London: 149.

Dubois H.1992–93. Aspects of Sir Joshua Reynolds' painting technique.(Unpublished dissertation for the Hamilton Kerr Institute: Appendix I). Groen K. 1997. Investigation of the use of the binding medium by Rembrandt: chemical analysis and rheology. Zeitschrift für Kunsttechnologie und Konservierung 11(2): 207–227.

Hackney S, Jones R, Townsend J. 1999. Paint and purpose, a study of technique in British art. London: Tate Gallery Publishing.

Odlyha M. 1995. The role of thermoanalytical techniques in the characterisation of samples from Turner's The Opening of the Wallhalla, 1842. In: Turners Painting Techniques in Context. London: UKIC: 29–34. Talley MK. 1986. 'All good pictures crack'. Sir Joshua Reynolds's practice and studio. In Reynolds, Royal Academy of Arts: 55–70.

A technical investigation of Willem de Kooning's paintings from the 1960s and 1970s

Abstract

A wealth of anecdotal evidence and archival records, in combination with the examination and technical analysis of Willem de Kooning's paintings of the 1960s and 1970s, confirmed the degree to which the artist consciously adopted unorthodox procedures and used unconventional materials in his paintings. A gas chromatographic procedure for the quantitative analysis of selected fatty acids to the glycerol content of the oils was useful for the identification of the oils present, supplementing standard methods of fatty acid analysis. This method also provided a greater understanding of the condition of these paints, some which have remained soft since they were executed. The results of this study demonstrate that de Kooning's conscious use of inert pigments may have been as responsible for the soft paint films as was his choice of medium.

Keywords

Willem de Kooning, oil paint, gas chromatography, castor oil, safflower oil, poppy oil, linseed oil

Susan Lake★
Hirshhorn Museum and Sculpture Garden
Conservation Laboratory
Smithsonian Institution
7th and Independence, SW
Washington, DC USA 20560
USA
Fax: +1 202 786-2682
Email: lakes@hmsg.si.edu

Suzanne Quillen Lomax
National Gallery of Art
Scientific Research Department
Washington, DC 20565
USA

Michael R. Schilling
The Getty Conservation Institute
1200 Getty Center Drive, Suite 700
Los Angeles, CA 90049-1684
USA

Introduction

Willem de Kooning (1904–1997) is one of the great painters of the 20th century.[1] Central to the appreciation of his accomplishments is his highly idiosyncratic use of painting materials. Less recognized is the extent to which the artist consciously employed unconventional materials in his paintings to produce works that evoked his daily environment and randomly observed visual details. During the late 1940s and into the 1950s de Kooning used a range of house paints and sign painters' enamels along with artists' paints, often mixed with sand, charcoal, plaster of Paris, calcite, wax, and ground glass and applied to inexpensive fiberboard and wood pulp paper supports. These paintings have been equated to visual metaphors for the gritty textures of Lower East Side New York (Hess 196: Zilczer 1993). By contrast, de Kooning acknowledged that the art he produced after about 1960, following his move from New York City to a small town on the eastern tip of Long Island, manifests a significant change in style from those produced in the previous decades (Inner Monologue 1959: Rosenberg 1972). As the New York paintings are infused with the feeling of the grime and tawdry details of the city, the East Hampton works convey a sense of the colors, textures, and light of the water-surrounded environment of East Hampton. De Kooning's methods, his choice of materials, and the conservation implications of his technical procedures in the paintings of the 1960s and the 1970s are the subjects of this essay.

Abstract Landscapes: *Untitled*, 1962

Untitled, 1962 (See Fig. 1) typifies the shift in de Kooning's pictorial conception after about 1957. Technical analysis indicates that this work and other abstractions of the early 1960s marked a period of transition for de Kooning in which he developed new techniques and adopted new materials as a means to convey his new environment. In particular, medium analysis indicates that during this period the artist was experimenting with ways to keep his paints fluid for longer periods of time. By 1955, his paintings had begun to sell, and his dealers were thereafter willing to advance him money to buy art materials (Hess 1968). Despite his increased affluence, he continued to use house paints, although to a more limited extent. The gray-brown paint in *Untitled*, 1962, is an oil-modified alkyd, as is a

Figure 1. Untitled, *May 1962, canvas, 202.9 × 179.5, Hirshhorn Museum and Sculpture Garden, Smithsonian Institution, Washington, DC.*

★ Author to whom correspondence should be addressed

Table 1. A Brief Survey of de Kooning's Paint Medium in Works from the 1960s and 1970s.

Door to the River, 1960

Pink, voids, matte	poppy/linseed oil
White, voids, matte, brittle	poppy oil

Spike's Folly II, 1960

Yellow, soft	castor oil
Blue, brittle	poppy/castor oil

Untitled, May 1962

White ground	drying oil
Yellow, voids, brittle	poppy oil
Pink, voids, brittle	poppy oil
Gray-brown, hard	oil-modified alkyd

Rosy-Fingered Dawn at Louse Point

Bright yellow, gooey	castor/linseed oil

Pastorale, 1963

Light blue, voids,	brittle poppy oil
Gray-brown	oil-modified alkyd

Woman, Sag Harbor, 1964

White ground	drying oil
White, brittle	safflower oil
Pink, soft	poppy/linseed oil
Yellow, soft	poppy/linseed oil
Blue-green	linseed/safflower oil
Dark red, sticky	linseed/safflower oil
Red-orange, sticky	linseed oil
Maroon, gooey	linseed/safflower oil

Woman, 1965

Orange, sticky	linseed/safflower oil
Red, soft	linseed/safflower oil
Amber drip, soft	linseed/safflower oil
Dark green, soft	linseed/safflower oil
Light blue, hard	poppy/safflower oil
Pink, brittle	linseed/safflower oil

The Visit, 1966 B67

Orange, gooey	linseed/safflower oil
Gray-green, wrinkled, soft	linseed/safflower oil

Two Figures in a Landscape, 1967

Orange, soft, gooey	linseed/safflower
Pink, wrinkled, soft	safflower oil
Amber medium from pink, wrinkled	safflower oil

Amityville, 1971

Yellow, wrinkled, soft	poppy/linseed oil
White, soft	poppy/linseed oil

...Whose Name was Writ in Water, 1975

Amber drip, gooey	linseed/safflower oil
Red, gooey	safflower oil
Maroon, gooey	poppy/castor oil

Untitled I, 1977

White, wrinkled, soft	linseed oil
Pink-white, wrinkled, soft	linseed oil

Untitled V, 1977

Gray, voids, wrinkled	linseed oil
Black, wrinkled, soft	castor oil
Dark blue, wrinkled, soft	linseed oil

Figure 2. Woman, Sag Harbor, 1964, hollow-core door, 203.1 × 91.2, Hirshhorn Museum and Sculpture Garden, Smithsonian Institution, Washington, DC.

Figure 3. Woman, 1965, hollow-core door, 203.2 × 91.4, Hirshhorn Museum and Sculpture Garden, Smithsonian Institution, Washington, DC.

sample of the gray paint from the lower left corner of *Pastorale* (Learner 1996). As de Kooning continued to use these fast-drying house paints, he simultaneously began to experiment with methods to slow the drying rate of his medium that included the addition of poppy oil to artists' paints. The P/S peak area ratios of samples of the pink and yellow paints of *Untitled* are in accord with this observation.[2] Additionally, P/S, azelate to glycerol (A/G), and palmitate to glycerol (P/G) molar ratios in the light blue paint of *Pastorale*, the white and pink paints of *Door to the River*, 1960, and the blue paint of *Spike's Folly II*, 1960, correlate to pure or admixed poppy oil (See Table 1). [3] These analytical results are supported by a remark de Kooning made to an interviewer in 1969 when he stated that he had once experimented with adding poppy oil to his paints, but eventually gave it up because it was "too oily" (Perreault 1969).

The Door Paintings: *Woman, Sag Harbor*, 1964 and *Woman*, 1965

From 1964 to 1966, de Kooning painted a series of larger-than-life female images on hollow-core-doors. *Woman, Sag Harbor* of 1964 (See Fig. 2), and *Woman*, painted in 1965 (See Fig. 3), confirm a shift in his technical method. The impression of strong light in these works and others of the 1960s and 1970s is due, in part, to de Kooning's careful preparation of his supports and his selection of paints. A smooth white ground or light-colored support became characteristic of his works of the 1960s and 1970s. Additionally, in both these pictures he used the white ground as part of the image, leaving portions fully exposed or visible through areas of more thinly applied paint.

De Kooning told Harold Rosenberg (1972) that during this period he began making his own colors from artists' paints that he called "mineral colors" in order to incorporate the feeling of natural light in his paintings. He also worked out this system because these colors remained wet longer than traditional artists' pigments (Shirey 1967; de Antonio and Tuchman 1984). Identification of the pigments in the paints of *Woman, Sag Harbor* and *Woman*, as well as those in other works of the 1960s, reveals that the artist used a rather restricted palette of single colors and their tints. The intensely colored reds, oranges, and maroons in each of these paintings are usually pure cadmium colors, sometimes mixed with large amounts of an organic pigment or dye of the same color. The paler pinks, oranges and yellows are one of the cadmium colors combined with a mixture of the white pigments titanium dioxide, zinc oxide, and barium sulfate (See Table 2).

Photographs and anecdotal reports suggest that by the time the artist painted these works he had discontinued his use of house paints and poppy oil and had replaced them with safflower cooking oil that he added to artist's oil paints. Visitors to the artist's studio recall that the artist bragged about finding a cheap salad oil that he could use in lieu of more expensive artist's oils (Dickerson 1964). Photographs

Table 2. Elemental composition of the pigments in selected works by de Kooning.

Untitled, 1962

	Zn	Ti	Ba	Cd	Al	Si	Fe	S	Se	Other
White ground	n.d.	16	n.d.	n.d.	19	35	11	8.3	n.d.	Ca 10, Pb 1.4
Yellow	14	14	41	13	1.1	1.1	n.d.	17	n.d.	organic yellow
Pink	13	22	25	n.d.	1.1	13	n.d.	26	n.d.	organic red
gray-brown				not analyzed						

Woman, Sag Harbor, 1964

	Zn	Ti	Ba	Cd	Al	Si	Fe	S	Se	Other
White ground	50	47	n.d.	n.d.	1.7	1.1	n.d.	n.d.	n.d.	
White	18	20	41	n.d.	2.2	2.7	2.2	14	n.d.	
Pink	26	28	27	5.5	n.d.	n.d.	n.d.	13	n.d.	organic red
Maroon	1.0	1.1	4.6	72	n.d.	n.d.	n.d.	14	8.0	organic red
Red	n.d.	n.d.	n.d.	75	n.d.	n.d.	n.d.	14	11	
Yellow	45	1.8	n.d.	34	0.2	1.9	n.d.	17	n.d.	
Blue-green	26	36	15	1.1	2.0	1.7	11	7.0	n.d.	Mg 1.1, organic green, organic blue

Woman, 1965

	Zn	Ti	Ba	Cd	Al	Si	Fe	S	Se	Other
Orange	29	9.7	29	12	2.7	1.8	n.d.	16	n.d.	organic red
Red	n.d.	n.d.	n.d.	75	n.d.	n.d.	n.d.	14	11	organic red
Light blue	21	19	42	0.6	2.2	1.5	n.d.	14	n.d.	ultramarine
Pink	13	n.d.	27	31	7.0	n.d.	n.d.	10	n.d.	Mo 12
Dark green	12	n.d.	39	28	n.d.	1.3	n.d.	14	n.d.	Mo 6.6, organic green, organic blue

of de Kooning's Long Island studio often show bottles of Saff-o-life cooking oil on the artist's work table. John McMahon (1993), de Kooning's studio assistant during this period, recalls that de Kooning first blended a specified number of tubes of artist's paints on a palette according to specific recipes he developed. He next scooped the paint mixture into a bowl and then added safflower oil, water, and a solvent, whipping the ingredients with a brush to a fluffy consistency. According to McMahon, the artist experimented with a number of different vegetable oils before turning to safflower oil. De Kooning told an interviewer (Rodgers 1978) that he used safflower oil because it "stays wet a long time, it doesn't dry like linseed oil, I can work longer."

Medium analysis offers evidence that corroborates many of these reports. The P/S peak area ratios of six paint samples taken from *Woman, Sag Harbor* and five taken from *Woman* all fall between 2.3 and 3.8. Most of these correlate with naturally-aged samples of pigmented and unpigmented safflower oil and with mixtures of linseed oil tube colors combined with large amounts of unpigmented safflower oil analyzed by the authors. Similarly, the P/S, A/G, and P/G molar ratios of selected paint samples from *Woman, Sag Harbor*, *Woman* 1965, *The Visit*, 1966–67, *Two Figures in a Landscape*, 1967, and *...Whose Name was Writ in Water*, 1975, correlate with safflower oil or mixtures of linseed oil and safflower oil (See Table 1). For paints with P/S ratios above 3, it is likely that poppy oil was present along with safflower or linseed oil, indicating that de Kooning may not have completely discontinued his use of poppy oil or that poppy oil was present in the binding medium of the tube paints he was using.

The once widely held perception that de Kooning mixed mayonnaise with his paints was disproved with medium analysis. No cholesterol, a component of egg used in the preparation of this sandwich spread, was detected in any of the samples analyzed. Furthermore, egg yolk can be readily detected in oil paints because its P/G ratio, 1.2, is much higher than that of the typical drying oils. These results confirm de Kooning's statements that he never added mayonnaise to his paints (Rodgers 1978: Cherry 1989). Reports that de Kooning's unusual medium included mayonnaise may be an extrapolation of the vivid descriptions of the artist's temporary emulsion as having the "consistency of heavy sauces" and "a good mayonnaise" (Hess 1972).

De Kooning seems to have used his unorthodox medium in order to experiment with a greater variety of ways to lay on and manipulate his paints. In addition to the complex paint textures the artist produced by the action of his brush, the surfaces of *Woman, Sag Harbor* and *Woman*, 1965 have developed peculiar circular

Figure 4. Woman, 1965, detail showing bubbles in the paint surface that are the result of the artist's addition of water to his medium.

depressions and wrinkles upon drying. The circular crater-like formations in the paint surfaces of many pictures of the 1960s and 1970s were certainly formed as water and air bubbles caught in the temporary mixture of water and oil, popped forming hollow cavities (See Fig. 4). The large round voids in the paint surfaces of these works indicate that de Kooning was experimenting with the intriguing visual effects created by adding larger percentages of water to his oil medium. The artist had apparently begun to mix a few drops of water with his paints as early as the late 1950s (Gaugh 1983). By the late 1960s he often used a particularly wet mixture of equal parts of water and oil (Shiff 1994). It is noteworthy that water had no apparent effect on the extent of hydrolysis in these paints. Wrinkles in the paint surfaces of works of the period are also a common occurrence and they reached an extreme in works of the late 1960s and into the 1970s. They were likely formed from the artist's addition of excess oil to his paints and as a result of his heavy build-up of paint applied to a nonabsorbent support or ground. The oil content in de Kooning's paints was, indeed, found to be quite high.

While the pitted and wrinkled surfaces of these paintings may be seen as a failed and defective paint, they were certainly intended. De Kooning, in fact, developed his own technical procedures to achieve them. This idea is supported by numerous statements made by the artist in which he acknowledged that he was searching for ways to convey the very substance of water and the sensuality of human flesh (de Kooning 1951: Dickerson 1964). In the paintings of the 1960s and 1970s, de Kooning realized the full potential of his statements not only in terms of the images he presented but also by modifying his procedures and his materials to concentrate on the sensory aspects of his medium.

Other observations

During a visit to the Metropolitan Museum of Art in the late 1970s, de Kooning became aware that his techniques might result in long-term instability of his paintings. John Brealey, chairman of the Department of Paintings Conservation, cautioned de Kooning against mixing non- and semi-drying oils into his paints because de Kooning was unaware of the fine distinction between drying oils, such as linseed oil, and semi-drying oils, like safflower oil (Leonard 1998). Concern over the stability of his paintings may have been one factor that contributed to de Kooning's use of more thinly applied paints later in his career.

Table 1 shows an unmistakable evolution in de Kooning's choice of medium. Firstly, the observations that de Kooning began to use tube colors more frequently during the later half of his career is consistent with the oils identified in his paints from this period. Furthermore, in paintings from the early 1960s his paints included linseed oil and castor oil, although during this period he frequently mixed poppy oil into his paints. The earliest evidence for his use of safflower oil comes in paintings from 1964 or 1965, and it seems that safflower oil mixtures became his medium of choice until the middle of the 1970s, when he learned about the dangers posed by semi-drying oils. In the two untitled paintings from 1977, he appears to have abandoned safflower oil entirely and began using tube colors that included mixtures of linseed oil and castor oil.

Could the slow-drying paint formulations that de Kooning preferred actually have a negative effect on the long-term stability of his paintings? Quantitative gas chromatographic analysis of glycerol and fatty acids in de Kooning's paints revealed that the extent of hydrolysis was less severe than was expected. Moreover, the paint samples identified as having linseed or castor oil binders were hydrolyzed to a greater degree than were the paints in which poppy or safflower oil were present. Identification of the pigment composition of de Kooning's paints and a comparison of the individual pigments present with the condition of the paint films strongly suggests that de Kooning's choice of pigments may be as responsible for the soft paint films as is his choice of medium.

Conclusion

Examination and technical analysis of de Kooning's works from the 1960s and 1970s has revealed the degree to which the artist was both a conservative and an

experimentalist. At times he used methods and materials in ways that have been practiced by artists for centuries. At other times, he deliberately misused his materials and disregarded proper procedures of painting as a way to discover a fresh visual statement. While de Kooning's unorthodox materials, namely his mixing of safflower oil and water with his paints, facilitated a working method that produced some of the masterpieces of the postwar period, they simultaneously are credited as the reason why many of the paints in the works of these decades have remained soft and sticky, even 30 years after their execution. While the long-range prognosis for de Kooning's paintings of this period will only be answered with the passage of time, this study shows that the detection of glycerol and fatty acids allows for a more complete understanding of the condition of oil paints and their complex degradation mechanisms.

Acknowledgments

The authors are grateful to the museum curatorial staffs and private owners who permitted us to take paint samples from their pictures. Without their generosity, this project would not have been possible.

Endnotes

1. This essay is a revised excerpt of two articles, "The relationship between style and technical procedure: Willem de Kooning's paintings of the late 1940s and 1960s," by Susan Lake and Jay Krueger and "A study of Willem de Kooning's paintings from the 1960s and 1970s" by Michael Schilling and Suzanne Quillen Lomax, both of which will appear in *Conservation Research 1998/1999*, Studies in the History of Art, National Gallery of Art, Washington, DC.
2. Samples in 1 mL conical vials were heated to 60°C for 4 hours in 20 uL m-(trifluoromethyl) phenyl-trimethyl-ammonium hydroxide in 5% methanol (Meth-Prep II, Alltech). Solutions of fatty acid methyl esters were centrifuged and allowed to sit 8–10 hours before splitless injection (250°C) into a Zab 2SE mass-spectrometer equipped with a HP-5 column (30M × 0.32 ID) and with helium at 1 mL/min. The oven temperature program was 3 min isothermal at 100°C, then 5°C/min to 200°C, 10°C/min to 300°C, and 5 min isothermal.
3. Complete experimental details for gas chromatographic analysis of fatty acids and glycerol appear elsewhere (Schilling et al. 1996), although one modification was made to the published procedure. The quantity of methanolic hydrochloric acid added to the sample vials in order to provide an excess quantity of acid was exactly 150.0 μmoles per ml of reagents.

References

Cherry H. 1989. Willem de Kooning. Art Journal 48: 230.

De Antonio E. and Tuchman, M. 1984. Painters painting. New York : Abbeville Press.

De Kooning W. 1951. The renaissance and order. Trans/formation 1: 85–87.

Dickerson G. 1964. Transcript of an interview with de Kooning. (On file with the Thomas B. Hess Papers, Archives of American Art, Smithsonian Institution, Washington, DC).

Gaugh H. 1983. Willem de Kooning. New York: Abbeville Press.

Hess TB. 1968. Willem de Kooning. Exh. cat. New York: Museum of Modern Art.

Hess TB. 1972. Willem de Kooning: Drawings. Greenwich, CT: New York Graphic Society.

Inner Monologue. 1959. Transcript of a discussion with de Kooning, Michael Sonnabend, and Kenneth Snelson. (Willem de Kooning Office, New York).

Leonard M. 1998. Personal communication with Michael Schilling.

Learner T. 1996. Personal communication with Susan Lake.

McMahon J. 1993. Personal communication with Susan Lake.

Perreault J. 1969. De Kooning at the Springs. New York Magazine, 17 March: 44–47.

Rodgers G. 1978. Willem de Kooning: the artist at 74. LI: Newsdays Magazine for Long Island, 21 May: 18–20, 35–36.

Rosenberg H. 1972. Interview with Willem de Kooning. Art News 71: 54–59.

Schilling MR and Khanjian HP. 1996. Gas chromatographic determination of the fatty acid and glycerol content of lipids I. The effects of pigments and aging on the composition of oil paints. In: Bridgland J. ed. ICOM Committee for Conservation Preprints, 11th triennial meeting, Edinburgh, Scotland. London: 220–227.

Shiff R. 1994. Lipstick and water: de Kooning in transition. In: Willem de Kooning: Paintings. Exh. cat. Washington, DC: National Gallery of Art.

Shirey D. 1967. Don Quixote in Springs. Newsweek, 20 November: 80.

Zilczer J. 1993. Willem de Kooning from the Hirshhorn Museum collection. Exh. cat. Washington, D.C.: Hirshhorn Museum and Sculpture Garden, Smithsonian Institution.

Résumé

Pour l'essentiel, les œuvres exposées dans les manifestations consacrées à Georges de La Tour ont été radiographiées. Certaines présentent des repentirs. L'auteur s'interroge sur la contribution de ces modifications au processus de la création et sur leur interprétation en termes de repères chronologiques et de critères d'attribution. Certains repentirs témoignent d'une recherche de l'artiste pour un prototype, d'autres, d'un souci d'amélioration lors d'une réplique. L'absence de repentir est aussi significative chez un peintre qui a effectué de nombreuses variantes à partir d'un « patron ». Les copistes maîtrisent parfois imparfaitement les procédés de reproduction et de légères modifications peuvent s'en suivre.

Mots-clés

Georges de La Tour, radiographie, copie, réplique, prototype, repentir, atelier

A propos de l'œuvre de La Tour. Les repentirs et leur signification

Elisabeth Martin
Laboratoire de recherche des musées de France
6, rue des Pyramides
75041 Paris, cedex 01
France
Fax: + 33.1.47 03 32 46

L'œuvre du peintre lorrain Georges de La Tour (1593–1652) a été reconstituée, après deux siècles d'oubli, par les historiens d'art et sa redécouverte est à l'actif de cette discipline. Elle a aussi interpellé les scientifiques pour différentes raisons : les lacunes dans les documents d'archives, les nombreuses répliques que le peintre a déclinées tout au long de sa vie, l'époque à laquelle sa carrière s'est déroulée, ont déjà été évoquées pour expliquer cet interêt.

Grâce à la compréhension bienveillante de nombreux musées, le L.R.M.F. dispose d'une documentation très complète sur le peintre et très peu d'artistes ont bénéficié d'une situation aussi favorable en ce qui concerne l'étude du corpus de leurs tableaux par les méthodes scientifiques. Aussi, après les expositions de Washington et Fort Worth aux Etats-Unis, de Paris et d'Orléans en France, il semble important d'engager une réflexion méthodologique à propos des repentirs dont témoigne l'œuvre du peintre. Les faits eux-mêmes ont déjà été publiés dans leur grande majorité, mais leur interprétation en terme de repères chronologiques et de critères d'attribution est controversée. Le propos tentera principalement d'établir la contribution des modifications au processus de la création comme certains auteurs l'ont fait pour d'autres peintres, par exemple pour Caravage (Gregori 1991).

Réutilisation d'un motif

Exemple Saint Joseph charpentier *(Paris, Louvre)*

Publiée dès 1957 (Hours), la radiographie du visage de l'Enfant Jésus indique de façon indubitable qu'un autre visage était peint à l'origine. Mais est-ce bien celui de l'Enfant Jésus ? Rien n'est moins sûr. En effet il semble que les traits du visage caché sont plus mûrs et plus féminins que ceux d'un jeune garçon. Le visage entrevu en radiographie évoque bien davantage celui d'Irène dans la composition *Saint Sébastien soigné par Irène* (en largeur) dont l'original est perdu, mais qui est connu par une dizaine de copies. Il ne s'agirait pas alors d'une recherche sur le thème de l'atelier de saint Joseph, mais d'une composition, à peine commencée et abandonnée au profit d'une autre, avec réutilisation par l'artiste de la toile déjà préparée, certes dans un format en hauteur différent de la composition connue. Si l'on admet que les deux thèmes sont disjoints, il n'y a plus à parler de repentir et l'image ne donne aucune information concernant le processus de la création.

Elaboration d'un prototype

Exemple Le Tricheur à l'as de trèfle

Depuis le catalogue de l'exposition parisienne de 1972, des modifications en cours d'exécution sont mentionnées sur ce tableau, au Kimbell Art Museum à Fort Worth depuis 1981. Les changements observés sont pour la plupart décelables sur la radiographie (Martin 1993: Barry 1996), car les éléments initiaux de la composition ont été peints avec des pigments à base de plomb avant d'être modifiés de façon assez importante. Ainsi, dans un premier temps, le visage de la servante au profil énigmatique a été ébauché dans la position que la réflectographie infrarouge

Figure 1. Madeleine pénitente. *Paris, musée du Louvre.*© *L.R.M.F.*
La manche du tableau de Los Angeles présente le même aspect à l'oeil nu.

Figure 2. Madeleine pénitente. *Los Angeles, County Art Museum. Détail radiographique* © *L.R.M.F.*
Il montre le repentir. L'épaule gauche de la blouse, d'abord large, a été rétrécie ensuite.

révèle à merveille (Barry 1996) avant d'être immobilisé dans une attitude qui renforce la complicité des personnages. Les lignes du visage de la servante et de sa coiffe sont très similaires d'une position à l'autre ce qui incite à penser que l'artiste a pu utiliser un « patron » pour reporter les contours (Barry 1998) ; le second tracé de la nuque en terre d'ombre a d'ailleurs été décelé par autoradiographie (Barry 1996). La radiographie, quant à elle, indique sans ambiguïté que les formes initiales et finales ont été peintes et qu'il ne s'agit pas simplement de changements lors de la mise en place.

Le vêtement de la servante comportait dans un premier temps un large décolleté carré laissant voir la carnation de la gorge, opaque aux rayons X, avant d'être transformé de façon plus pudique. La veste du tricheur, conçue large, a été retrécie le long de la manche extérieure, la ceinture noire a été posée sur la couche picturale représentant la veste, car l'emplacement prévu à l'origine plus bas a été modifié en cours d'exécution, comme en témoigne la radiographie. La position de la main de la courtisane n'a pas été trouvée d'emblée. La manche de la veste du jeune naïf a aussi été légèrement remaniée de même qu'une des cartes à jouer. D'abord jaune, d'après les observations faites lors de sa restauration (Barry 1996), la coiffe de la servante a été peinte en gris par La Tour dans la seconde position.

Cette énumération constitue autant d'indices en faveur d'un prototype où le peintre cherche directement sur la toile une disposition adéquate pour les divers éléments de la composition, même si certains motifs sont guidés par un « patron ». Les objectifs du peintre sont perceptibles et indiquent une véritable recherche qui est rendue manifeste par la radiographie.

Un commentaire en tout point comparable pourrait être fait au sujet de *Saint Sébastien soigné par Irène* (en hauteur) conservé au Louvre.

Amélioration pour une réplique

1. *Exemple des* Saint Jérôme pénitent

L'existence de deux œuvres représentant la même composition avec des variantes, *Saint Jérôme pénitent,* dont l'une est à Grenoble et l'autre à Stockholm, permet de comprendre en quoi les modifications observées sur la radiographie du tableau suédois ont une autre finalité que précédemment.

La composition a peut-être nécessité des recherches dont les témoignages ont disparu, mais l'œuvre grenobloise sans repentir décelable atteint un équilibre qui a satisfait son auteur. Pour *Saint Jérôme* au chapeau cardinalice à Stockholm, La Tour reprend la silhouette à partir sans doute du même « patron » (Martin 1993) et ébauche tel quel le personnage avec du blanc de plomb, comme l'indique la radiographie. Ses exigences formelles sont devenues autres et le peintre a modifié ensuite discrètement quelques zones qui correspondent à l'œil nu à un état « amélioré ». : la malléole apparaît, le poignet est couvert par le drapé, le talon est moins arqué que sur l'autre œuvre. Les changements que la radiographie met en évidence témoignent des améliorations apportées pour une réplique autographe. La prévision des ombres portées sur cet exemplaire est aussi un argument en faveur d'une réplique.

2. *Exemple des* Madeleine pénitente

On peut noter que les deux œuvres représentant la sainte en méditation devant une veilleuse à huile, l'une à Los Angeles au County Art Museum, l'autre à Paris au Louvre (voir Fig. 1) comportent le même léger changement visible en radiographie sur la manche gauche de sa blouse qui a été rétrécie sur les deux versions (voir Figs. 2, 3). Cela suggère que les deux tableaux sont des œuvres faites à partir d'un même modèle et qu'elles ne sont, sans doute, ni l'une ni l'autre une première version. Cette répétition d'un même repentir peut paraître tout à fait surprenante. S'explique-t-elle par les pratiques de l'atelier de La Tour ? Est-ce lui qui a reporté la silhouette des deux Madeleine, ou aurait-il confié ce travail à un intervenant de son atelier qui a ébauché le personnage selon le « patron » avant que le maître ne termine la composition en réajustant entre autre la blouse au dernier moment ? Rappelons que les deux œuvres sont signées, celle avec la flamme bifide G de La Tour, l'autre (?) La Tour.

Figure 3. Madeleine pénitente. *Paris, musée du Louvre. Détail radiographique©* L.R.M.F.

Outre l'accident sur la joue, le détail montre le repentir. L'épaule de la blouse d'abord large, a été retrécie ensuite avec un réseau de craquelures parfaitement cohérent.

Figure 4. Saint Sébastien soigné par Irène. *Orléans, musée des Beaux-Arts.©* L.R.M.F.

3. *Exemple des* Tricheurs

Le *Tricheur à l'as de carreau* se caractérise par un nombre très restreint de repentirs et par la prévision des zones sombres, comme la ceinture noire du tricheur, ce qui suggère que la disposition avait été conçue précédemment. Il comporte cependant quelques modifications en cours d'exécution, tel le changement de couleur du corselet de la servante qui, de rouge comme sur le *Tricheur à l'as de trèfle*, a été peint ensuite en bleu-vert (Rioux 1993), ce qui tend à améliorer la gamme chromatique. Ce tableau témoigne en outre d'hésitations dans l'exécution de la veste du jeune homme berné, différente de celle du même personnage dans l'autre version, car il ne répète pas mais cherche une disposition satisfaisante pour le plissé.

Outre le vêtement de ce personnage, les deux œuvres différent à l'évidence l'une de l'autre par certains détails, mais les positions de la servante et du tricheur sont identiques sur les deux tableaux (Barry 1996). Il n'y a donc pas d'amélioration visible d'une version à l'autre pour cette partie de la composition.

On peut donc déduire de l'étude approfondie des deux *Tricheur* que la grande majorité des indices décelés par les méthodes scientifiques, y compris l'analyse de la matière picturale (Martin 1998, 1) et l'évolution de la touche, sont en faveur d'une date plus tardive pour la version du Louvre, qui répète pour l'essentiel la composition américaine. Certaines constatations semblent en contradiction avec la proposition précédente. Elles n'invalident cependant pas la conclusion car les procédés picturaux en très petit nombre (Gifford et al. 1996)[1] peuvent être interprétés en terme de réminiscence : ainsi le maître a peint en jaune la coiffe de la servante du tableau parisien comme il l'avait, semble-t-il, fait lors de l'ébauche du *Tricheur à l'as de trèfle* avant de modifier la servante et la couleur de son turban, sans qu'il y ait impossibilité à cela. Aucun des indices pris en compte ne peut être érigé en preuve, pas plus la superposition de deux couleurs dont celle de dessous est présente sur l'autre version [2] que la mise en évidence de contours [3] et c'est la convergence d'un grand nombre d'informations qui oriente la déduction avec une pondération des critères qui tient d'autant plus compte des arguments invoqués qu'ils se déroulent lors des premières phases de l'élaboration de l'œuvre, comme les « repentirs de recherche » pour le *Tricheur à l'as de trèfle*.

Cet exemple témoigne de la complexité du processus créatif même pour une réplique, où recherche, amélioration et réminiscence interfèrent. Il n'en demeure pas moins que les repentirs mis en évidence sur *Saint Jérôme pénitent*, les deux *Madeleine pénitente* et le *Tricheur à l'as de carreau* sont moindres que ceux nécessaires à l'établissement d'un prototype.

Maîtrise imparfaite des procédés de reproduction

Huit tableaux représentant le même original perdu de Georges de La Tour ont été étudiés par les méthodes scientifiques à l'occasion d'une exposi-

Figure 5. Saint Sébastien soigné par
Irène. *Fort Worth, Kimbell Art Museum.*
Détail radiographique avec calque
superposé. ©*L.R.M.F.*
Il montre les repentirs pour le visage
d'Irène. Le contour noir sur calque a été
établi d'après la version d'Orléans. La
superposition de la radiographie et du
calque met en évidence les écarts entre les
éléments de référence des deux tableaux.

Figure 6. La Découverte du corps de
saint Alexis. *Nancy, musée historique*
lorrain. ©*L.R.M.F.*

tion sur le thème de *Saint Sébastien soigné par Irène* à la lanterne (voir Fig.
4) (Martin 1998, 2).

La superposition des calques des radiographies (voir Fig. 5) permet de mesurer
les écarts des éléments de référence d'une version à l'autre, les dimensions des
toiles étant très proches. Ces différences atteignent dix pour cent pour certains
repères. Ce chiffre est à rapprocher des modifications révélées sur la radiographie
d'un des exemplaires, celui conservé à Fort Worth. Sur ce tableau l'artiste a fait
subir de petites translations à la lanterne, 0,5 cm pour la porte qui mesure 5 cm de
large (Barry 1996). De même le visage d'Irène a été légèrement rehaussé ce qui
se traduit par un double regard et un double menton. Il n'y a cependant guère de
changement dans la position ou l'expression du personnage autre que le déplacement,
ce qui ne permet pas d'y voir un « repentir d'amélioration », dans le sens admis
précédemment. En effet l'objectif n'est pas une différenciation par rapport au
modèle, mais tend vers une plus grande ressemblance, car on constate qu'après
modification les distances entre les différentes parties de l'exemplaire de Fort
Worth sont plus proches qu'à l'origine de la moyenne mesurée sur les autres
copies. Les autres critères[4] n'étant pas dans leur ensemble en faveur de
l'originalité de l'œuvre (Martin 1998, 2), il y a tout lieu de penser que ces
déplacements sont le résultat d'une maîtrise imparfaite des procédés de reproduc-
tion. Ces changements sont caractérisés par un réajustement de faible ampleur sans
invention ni interprétation. Une légère hésitation se discerne d'ailleurs aussi sur
deux autres copies du célèbre tableau peint pour le duc de Lorraine ou le roi de
France. La présence d'hésitations de ce type doit inciter à la prudence et ne peut
constituer à lui seul un critère d'attribution, encore qu'une version originale puisse
éventuellement comprendre aussi des déplacements de peu d'envergure.

Absence de repentirs de contours et œuvres de l'atelier

Au contraire des cas précédents, les études fines effectuées sur deux exemplaires
d'une même composition tendent à montrer la superposition très exacte des
contours jointe à l'absence de repentirs sur l'une ou l'autre des toiles. Cela constitue
un argument pour proposer qu'elles soient des oeuvres faites dans l'atelier du maître
qui détenait le modèle. La présence de « patron » a déjà été évoquée comme procédé
de production pour deux versions du *Tricheur* ou du *Saint Jérôme pénitent*, les quatre
œuvres étant unanimement attribuées à Georges de La Tour lui même. Il s'agit ici
d'aborder le problème de la signification de ce fait en tant que critère d'attribution.
Ainsi les deux scènes représentant *La Découverte du corps de saint Alexis*, l'une à mi-
mollet à Nancy (voir Fig. 6), l'autre en pied à Dublin, qui sont souvent considérées
comme des copies, sont superposables de façon très satisfaisante avec un écart
inférieur à un pour cent (voir Figs. 7, 8). Cela suggère qu'elles ont été exécutées
à partir d'un « patron » dans un seul atelier, celui qui possédait le modèle. Il semble
logique de proposer celui de La Tour quand on sait de plus que la préparation du
tableau nancéen présente les mêmes constituants que celle des œuvres nocturnes
dont l'attribution au maître lorrain n'est pas douteuse (Martin 1998, 3).

Une argumentation du même type peut être développée en ce qui concerne
Saint Sébastien soigné par Irène du Louvre, unanimement salué comme un des chefs
d'œuvre de Georges de la Tour, et le tableau très proche conservé à Berlin,
beaucoup plus controversé. La radiographie d'Irène tenant le flambeau de ce
dernier tableau se superpose de façon très exacte à l'image aux rayons X obtenue
à partir du tableau du Louvre. Le mode de fabrication du support, identique pour
les deux tableaux (Martin 1993), joint à la superposition des silhouettes suggèrent
fortement que les deux *Saint Sébastien* ont été faits dans un même atelier, celui de
Georges de la Tour, d'après un patron peut-être en plusieurs morceaux..

C'est dire tout l'intérêt de ce mode d'investigation qui permet de cerner la
production de Georges de la Tour et de son atelier par des critères matériels : largeur
des lés, mode d'assemblage des lés, couleur et constituants de la préparation, usage
de « patron ». Ces guides, qui permettent de reporter les silhouettes d'une réplique
à l'autre, ont pu être utilisés par Georges mais aussi très probablement par Etienne,
son fils, dont l'activité a sans doute duré une vingtaine d'années (Reinbold 1998).
D'autres critères sont alors nécessaires pour préciser la main, mais les établir
dépasse les limites de cet article.

Figure 7. La Découverte du corps de saint Alexis. *Nancy, musée historique lorrain. Détail radiographique avec le contour blanc sur calque établi à partir de la radiographie.* © *L.R.M.F.*

Figure 8. La Découverte du corps de saint Alexis. *Dublin, Gallery National d'Ireland. Détail radiographique avec en superposition le contour blanc sur calque établi à partir de la radiographie du tableau de Nancy.* ©*L.R.M.F.*
Cela met en évidence la très grande proximité de contours des tableaux de Nancy et de Dublin.

Conclusion

Selon une pratique que n'ignorait ni Caravage ni Champaigne, mais d'une manière beaucoup plus systématique, Georges de La Tour s'affirme au XVIIème siècle comme le peintre des séries. Beaucoup d'éléments de ces séries ont disparu mais la mise en évidence des procédés de production et de reproduction par les investigations scientifiques permet d'émettre des hypothèses fructueuses. Certains repentirs témoignent d'une recherche lors d'un prototype, d'autres du souci d'amélioration pour une réplique. L'absence de repentirs jointe à la superposition des contours de deux exemplaires sur le même thème est aussi significative de la production : les tableaux proviendraient alors d'un même atelier au contraire des œuvres de différents copistes extérieurs à l'atelier où est produit l'original, et donc sans l'aide d'un patron. Ces copistes maîtrisent parfois imparfaitement les procédés de reproduction et de légères modifications peuvent s'ensuivre.

Notes

1. Les nuances rougeâtres décelées dans le col du *Tricheur à l'as de trèfle* ne signifient pas que La Tour ait peint d'abord le col à motifs blancs visibles sur l'autre version car les losanges en blanc de plomb seraient perceptibles sur la radiographie, ce qui n'est pas le cas.
2. La logique interdit que cet argument soit érigé en preuve puisqu'il aboutit à des conclusions qui s'excluent : ainsi le jaune sous le gris de la coiffe de la servante du *Tricheur à l'as de trèfle* entraînerait l'antériorité du *Tricheur à l'as de carreau* alors que le rouge sous le vert du corselet du même personnage du *Tricheur à l'as de carreau* entraînerait l'antériorité du *Tricheur à l'as de trèfle*.
3. Si le contour de la nuque est bien sous-jacent à la peinture, le trait du rabas de la veste du tricheur ne semble pas un dessin sous-jacent de mise en place, car, exécuté probablement sur la peinture il ne se manifeste que sur la photographie en lumière directe (catalogue de Washington, p 295, ainsi que sur les documents du L.R.M.F. de 1972). Est-ce une facétie ?
4. La mise en évidence d'un tracé en terre d'ombre sur *Le Tricheur à l'as de trèfle* et sur *Saint Sébastien soigné par Irène* (Fort Worth) ne permet pas d'en faire un critère d'attribution dans la mesure où seulement ces deux tableaux ont été soumis aux investigations par autoradiographie.

Références

Barry C.1996. Appendix: La Tour and autoradiography. Catalogue de l'exposition Georges de La Tour and his world, Washington, 6 octobre 1996–5 janvier 1997: 287–301. Traduction française dans le Catalogue de l'exposition d'Orléans, 1998.

Barry C. 1998. Georges de La Tour's use of cartoons. Painting techniques, history, materials and studio practice. Communication au congrés de l'IIC, Dublin, 1998.

Gifford M, Barry C, Berrie B, Palmer M. 1996. Some observations on Georges de La Tour's painting practice. Catalogue, Washington, 1996 op. cit. 240–257.

Gregori, M. 1991.Catalogue de l'exposition Michel-Angelo Merisi da Caravaggio. Electa, Milano.

Hours-Median M. 1957. A la découverte de la peinture par les méthodes physiques. Paris: Arts et métiers graphiques.

Martin E. 1993. Un autre regard. Catalogue de l'exposition Georges de La Tour ou les chefs d'œuvre révélés, Vic-sur-Seille 3 septembre–14 novembre 1993: 45–57.

Martin E, Duval A. 1998. Laveissière S. Le tricheur à l'as de carreau. Techne 7: 115–116.

Martin E. 1998. Images de saint Sébastien. Catalogue de l'exposition *Le Saint Sébastien soigné par Irène* de Georges de La Tour, Orléans, musée des Beaux-Arts, 9 mars, 26 avril 1998: 47–57.

Martin E, Duval A, Reinbold A. Georges de La Tour, copies and studio practice. Communication, Congrès IIC, Dublin, 1998.

Reinbold A. 1998. L'atelier d'Etienne de La Tour. Le pays lorrain (à paraître).

Rioux JP. 1993. *Le Tricheur à l'as de carreau*. Etude technique des matériaux de l'oeuvre. Catalogue, Vic-sur-Seille: 34–47.

Résumé

La connaissance de l'essence de bois d'un panneau peint permet de préciser sa provenance géographique. Cette identification est basée sur une étude microscopique à partir d'un prélèvement invasif. L'évaluation de la radiographie pour la caractérisation de l'essence d'un bois a été testée car il s'agit d'un examen d'une totale inocuité, de réalisation facile. Les résultats sont encourageants et permettront de réduire significativement les indications d'un prélèvement.

Mots-clés

bois, radiographie, essence, identification

Evaluation de la méthode radiographique dans l'identification des essences de bois des panneaux peints

Elisabeth Ravaud
Centre de Recherche et de Restauration des Musées de France
Laboratoire de Recherche des Musées de France
Palais du Louvre
6 rue des Pyramides
75041 Paris Cedex 01
France
Fax: +33 01 47 03 32 46

Introduction

L'intérêt de la connaissance de l'essence de bois des panneaux peints a été démontré magistralement dans l'ouvrage de J. Marette, *Connaissance des primitifs par l'étude du bois*, dès 1961. En postulant que les essences employées sont le plus généralement d'origine locale jusqu'au XVIe siècle, cette étude montre que la détermination de l'essence contribue à la connaissance de la provenance d'une œuvre. L'observation du revers fournit d'intéressants renseignements mais l'identification microscopique de l'essence est nécessaire. Cette étude nécessite la réalisation de prélèvements du support, toujours réalisés avec réticence car invasifs. Par ailleurs dans certains cas de tels prélèvements ne peuvent être obtenus en raison de l'absence d'accès direct au support. La radiographie, technique non invasive, de pratique courante dans l'exploration des peintures, donne une image par transmission de la répartition des atténuations des rayons X après traversée d'une peinture et apporte ainsi d'importants renseignements sur le support. C'est parfois le seul moyen de visualisation de celui-ci quand les revers sont masqués ou peints. Il a semblé donc intéressant d'évaluer l'apport diagnostique de cette technique dans l'identification des bois.

Généralités sur les bois et les images radiographiques obtenues

Structure

Le bois croît de façon concentrique discontinue à partir d'une couche de cellules génératrices située sous l'écorce. Chaque accroissement ou cerne annuel comporte le bois initial ou bois de printemps, de faible densité tissulaire, et le bois final ou bois d'été, de plus forte densité. La croissance s'arrête dès la fin de l'été marquant la limite du cerne. On distingue deux grandes familles d'essences, les résineux essentiellement constitués d'un seul type d'éléments verticaux, les fibres trachéides, assurant soutien et conduction, et les feuillus caractérisés par la présence de vaisseaux ou pores parallèles à l'axe du tronc, spécialisés dans la conduction de la sève brute. Dans tous les bois existent les rayons dirigés horizontalement, du centre vers la périphérie du tronc.

Débit

Les planches constituant les panneaux peuvent présenter plusieurs types de débit longitudinaux . Le débit radial correspond à un plan de coupe passant par le coeur de l'arbre. Le débit tangentiel est un plan de coupe tangent à la surface de la grume. Les plans intermédiaires entre les deux premiers sont dits sur faux-quartier. L'image radiographique va varier en fonction du type de débit des planches.
L'image radiographique enregistre des variations de densité. Deux types d'images de la trame du bois sont possibles. Dans un cas, la radiographie restitue simplement la variation de densité cellulaire dans les cernes avec une proportion variable de bois initial peu dense, radiotransparent et de bois final plus dense ou opaque. La couche de préparation surperposée tend à amplifier le contraste existant spontanément. Un

deuxième type de contraste est obtenu par imprégnation des structures creuses du bois c'est-à-dire les pores par cette préparation à base de calcium ou parfois de blanc de plomb donc de densité importante. Ce moulage des vaisseaux donne des images de stries ou de lignes denses caractéristiques des feuillus.

Méthodologie

Dans une première partie, nous avons défini une sémiologie des signes radiologiques des principales essences retrouvées dans les panneaux peints d'Europe occidentale. Cette sémiologie a été obtenue en étudiant systématiquement les radiographies d'un premier échantillonnage de 50 tableaux incluant les essences suivantes: chêne, peuplier, noyer, tilleul, hêtre, érable, saule, sapin, épicéa, pin sylvestre et pin maritime. Nous en rappellerons les résultats en présentant parallèlement les données macroscopiques et microscopiques des différents bois contribuant à la compréhension des images.

Dans une seconde partie, nous avons étudié un second échantillonnage de 275 panneaux correspondant à des tableaux de la peinture européenne occidentale pour lesquels nous disposions à la fois d'une identification microscopique de l'essence et d'une radiographie. Cet échantillon comprenait 74 panneaux de chêne, 137 de peuplier, 18 de noyer, 10 de tilleul, 2 de hêtre, 4 de saule, un d'érable, 11 de sapin, 9 d'épicéa, 6 de pin sylvestre et 3 de pin maritime. La répartition des essences reflète la nature des collections françaises. Les analyses microscopiques ont été réalisées par l'Office du Bois et le Centre Technique du Bois, de façon indépendante de la réalisation des documents radiologiques. Selon la taille du panneau, le nombre de radiographie variait de 1 à 24 clichés (taille d'un cliché: 35 × 43 cm). Pour chaque panneau, un cliché a été sélectionné par tirage au sort. Ce cliché a été lu en aveugle c'est-à-dire sans connaissance du titre et de l'auteur, donc de la provenance présumée et également en aveugle des résultats de l'examen microscopique. L'identification proposée a été choisie dans la liste des essences étudiées. Sur chaque document radiologique, les signes recherchés ont été:

- débit de la planche.
- visibilité ou non des cernes.
- aspect du fil du bois.
- largeur des cernes en situation radiale (plan perpendiculaire aux cernes).
- proportion de bois initial et de bois final dans le cerne en situation radiale.
- caractère de la transition entre bois initial et bois final en situation radiale.
- présence de stries ou de lignes denses par imprégnation et leur répartition dans le cerne.
- stries denses présentes de façon indépendante de la préparation.
- examen de la trame du bois à la loupe: recherche d'un aspect microstrié.
- caractéristiques secondaires du bois:
 - fréquence des fentes et leur situation sur la planche
 - fréquence des nœuds et leur aspect
 - fréquence et importance de l'atteinte xylophage reflétant la durabilité d'un bois.[1]

Nous avons étudié le taux de concordance entre la détermination des essences réalisées par examen microscopique et par examen radiologique. Puis pour chaque essence ou groupes d'essences (chêne, peuplier, noyer, autres feuillus, résineux) nous avons calculé la sensibilité, la spécificité et le rapport de vraisemblance en prenant pour référence l'examen microscopique. La sensibilité d'un signe radiographique S dans l'essence E est la fréquence ou la vraisemblance de la présence du signe S parmi les panneaux de l'essence E. La spécificité est la fréquence ou vraisemblance de l'absence du signe S parmi les essences différentes de E. Le rapport de vraisemblance est la vraisemblance qu'un signe radiographique S soit retrouvé dans l'essence étudiée comparé à la vraisemblance pour que le même signe soit retrouvé dans une autre essence. Il est égal au rapport: sensibilité/ (1- spécificité).

Sémiologie des principales essences étudiées (sur le premier échantillonnage)

Feuillus

Figure 1. Radiographie de bois de chêne en débit radial (Déploration du Christ, Petrus Christus, musée du Louvre). L'alternance très régulière de raies sombres et claires est l'une des images évocatrices de chêne.

CHÊNE: *QUERCUS PEDUNCULATA, QUERCUS SESSILIFLORA ET QUERCUS PUBESCENS*
* caractéristiques macro et microscopiques:
 Le chêne est un bois de structure hétérogène, au fil très droit, assez fissile, durable. Microcopiquement, il présente de gros vaisseaux de 300 à 500 micromètres de diamètre disposées en deux ou trois rangées dans le bois initial puis on observe une décroissance brutale de leur diamètre à 20 micromètres. Les rayons sont larges (environ 15 cellules) et très hauts (plusieurs centimètres).
* sémiolologie radiologique (voir Figs. 1, 2):
 Dans le plan radial, on observe une alternance régulière de raies étroites de 1 à 2 mm, radiotransparentes (sombres) et opaques (claires). A la loupe, un aspect microstrié net est visible. En cas d'imprégnation par la préparation, l'étude à la loupe montre que dans les parties sombres, on peut identifier une à trois lignes nettes et denses, correspondant aux gros vaisseaux du bois initial. Dans le plan tangentiel, les vaisseaux apparaissent comme de courtes stries qui ne sont visibles que dans la partie initiale du cerne. Parfois, les gros rayons observés strictement tangentiellement sont repérables comme des images lenticulaires très denses. Les fentes partant du bord des panneaux sont fréquentes, l'atteinte parasitaire est rare. Les nœuds sont généralement absents.

Figure 2. Radiographie de bois de chêne en débit radial (Vierge aux palmiers, école francoflamande, musée de Picardie, Amiens). La préparation très dense a imprégné les gros vaisseaux du bois initial, souvent regroupés par deux.

PEUPLIER: *POPULUS TREMULA, POPULUS NIGRA ET POPULUS ALBA*
* caractéristiques macro et microscopiques:
 C'est un bois de structure homogène, au fil droit à légèrement ondulé. Les accroissements sont souvent larges témoignant d'une croissance rapide. Le peuplier est peu fissile et non durable. En microscopie, les vaisseaux sont petits, de 50 à 100 micromètres de diamètre, souvent accolés en files radiales, les rayons très fins unisériés (une cellule de large). Les taches médullaires, fréquentes dans certaines régions, peuvent atteindre plusieurs décimètres de longueur.[2]
* sémiologie radiologique (voir Fig. 3):
 Dans le plan radial, les cernes sont assez larges, 5 à 10 millimètres, peu contrastées. L'observation à la loupe donne une structure microstriée nette dense et homogène. On observe des images de stries denses, indépendantes de l'existence ou de la nature de la préparation, regroupées en bandes assez larges et très hautes (plusieurs dizaines de centimètres), situées toujours parallèlement aux cernes, indifféremment dans le bois initial ou final. Ces stries pourraient correspondre à des taches médullaires. L'atteinte xylophage est très fréquente, les nœuds sont souvent présents. Des largeurs de planche allant jusqu'à 70 centimètres ont été observées. Les fentes en milieu de planche fréquemment observées sont liées au débit sur dosse.

Figure 3. Radiographie de bois de peuplier en débit tangentiel (Portait de Dante Alighieri par Juste de Gand et Berruguète, musée du Louvre). Ce détail nous montre une bande de stries spontanément dense au centre de l'illustration.

NOYER: *JUGLANS REGIA*
* caractéristiques macro et microscopiques:
 Le noyer est un bois à struture homogène à semi-homogène, à fil souvent ondulé. Il est résistant à la fente, peu durable. Microscopiquement, il est caractérisé par des pores assez gros (200 à 100 micromètres), généralement isolés, décroissant régulièrement dans le cerne. Les rayons ont 3 à 5 cellules de large.
* sémiologie radiologique (Voir Fig. 4):
 Lorsque les pores ne sont pas imprégnés, la texture du bois est caractérisée sous la loupe par un aspect ondulé filandreux où l'on discerne des stries radiotransparentes ou sombres. En cas d'imprégnation par la préparation, les vaisseaux forment des lignes denses. Dans le plan radial, on observe de multiples stries denses sans pouvoir différencier nettement les parties du cerne. Dans le plan tangentiel, les lignes décroissent régulièrement d'épaisseur jusqu'au bois final.

Figure 4. Radiographie d'un bois de noyer en débit tangentiel (La Belle Ferronnière de Léonard de Vinci, musée du Louvre). L'imprégnation des pores par la préparation permet de visualiser les vaisseaux bien individualisés et de taille régulièrement décroissante dans le cerne.

Figure 5. Radiographie de bois de tilleul en débit tangentiel (Le Vieillard et la jeune femme, école allemande, musée de Cognac). Le cerne débute par une ligne continue de très fins vaisseaux imprégnés par la préparation, puis une faible décroissance est observée avec une zone finale très radiotransparente.

Autres feuillus

TILLEUL: *TILIA PARVIFOLIA ET TILIA PLATYPHYLLOS*

- caractéristiques micro et macroscopiques:
 C'est un bois de structure homogène, à fil droit. Il est de durabilité faible, moyennement fissile. Au microscope, les vaisseaux sont de petites tailles, 40 à 75 micromètres, isolés ou groupés, de répartition homogène avec une ligne continue de vaisseaux en début de cerne. Les rayons ont 3 à 5 cellules de large, soit environ 40 micromètres de large et haut de 2 à 4 millimètres.
- sémiologie radiologique (voir Fig. 5):
 En coupe tangentielle, une imprégnation des vaisseaux par la préparation donne des stries extrêmement fines dans le cerne débutant par une première rangée apparaissant continue et dense. Une légère décroissance de la taille des stries peut être notée. En l'absence d'imprégnation, la loupe peut révéler un aspect microstrié très fin homogène. Parfois des images de stries spontanément denses regroupées en fuseau sont observées.

HÊTRE: *FAGUS SILVATICA*

- aspects micro et macroscopiques:
 Le hêtre est un bois de structure homogène parfois semi-poreuse. Son fil est droit, il est très peu durable, moyennement fissile. Microscopiquement, ses vaisseaux sont de diamètre assez fin, 50 à 75 micromètres, extrêmement nombreux avec une décroissance régulière jusqu'au bois final. Les rayons peuvent être larges (25 éléments soit 500 micromètres) et haut (3 à 5 millimètres). Les cernes sont soulignés par une zone de fibres aplaties, à parois épaisses, sur le bord extérieur de la zone finale.
- sémiologie radiologique:
 En coupe radiale, le hêtre présente des cernes souvent très étroits, très rectilignes, cernés d'une ligne radiotransparente dans le bois final. A la loupe, on distingue un aspect microstrié très fin. En cas d'imprégnation, les vaisseaux apparaissent comme de très fines stries plus fréquentes dans le bois initial. En coupe tangentielle, ses rayons donnent des petites images lenticulaires denses.

ERABLE: *ACER PSEUDOPLATANUS, ACER PLATANOÏDES*
- caractéristiques macro et microscopiques:
 C'est un bois de structure homogène à fil assez irrégulier, ondulé. Il est non durable, peu fissile. Microscopiquement, les pores isolés assez peu nombreux, de répartition uniforme ont un diamètre variant entre 50 et 100 micromètres. En fin de cerne, existe une fine ligne de fibres épaisses. Les rayons sont assez fins (4 à 5 cellules de large) et d'une hauteur parfois supérieure au millimètre.
- sémiologie radiologique:
 L'examen à la loupe montre une texture spontanément finement microstriée. En cas d'imprégnation des pores, on observe de très fines lignes très régulièrement réparties sans identification des cernes. On peut aussi rarement retrouver des bandes de stries spontanément denses.

SAULE: *SALIX ALBA*
- caractéristiques micro et macroscopiques:
 Ce bois a une structure homogène, il est très peu durable. Microscopiquement, les pores mesurent 50 à 100 micromètres, les rayons sont unisériés. Le plan ligneux ne se distingue de celui du peuplier que par le caractère hétérocellulaire des rayons.
- sémiologie radiologique:
 Les cernes sont peu contrastés, de petites bandes de stries spontanément denses sont possibles. L'atteinte xylophage est généralement extrêmement marquée.

Résineux

SAPIN: *ABIES ALBA*
- caractéristiques macro et microscopiques:

Figure 6. Radiographie de bois de pin sylvestre en coupe radiale (Consécration de Saint Augustin par le Maitre d'Alfajarin, musée des Beaux-Arts de Dijon). Le pin sylvestre, comme tous les résineux se caractérise par une bonne visibilité des cernes sur l'ensemble des panneaux. Le rapport bois initial sur bois final est égal ou supérieur à 1.

Ce résineux a un fil droit, il est très fissible et très peu durable. Au microscope, le sapin est caractérisé par une absence de canaux résinifères. Le passage est rapide du bois initial au bois final.
- sémiologie radiologique:
 Les cernes sont visibles sur une grande partie des panneaux, mais souvent peu contrastés et assez larges. Le rapport bois initial sur bois final est proche de 1. On note la fréquence de fentes, de nœuds et d'une atteinte xylophage. L'examen à la loupe montre une trame parfaitement homogène.

EPICEA: *PICEA EXCELSA*
- caractéristiques macro et microscopiques:
 Ce bois présente des cernes qui peuvent être très étroits, inférieurs au millimètre, si le bois provient de haute montagne. Il est très peu durable, fissile. Le fil est droit. Microscopiquement, les canaux résineux sont de très petites tailles, peu nombreux. Le passage du bois initial au bois final est continu.
- sémiologie radiologique:
 Les cernes visibles sur la totalité du panneau, souvent peu contrastés, parfois très étroits en coupe radiale. Le rapport bois initial sur bois final est proche de 1. L'atteinte xylophage est assez fréquente et marquée. Les fentes sont assez rares. La trame est homogène sous la loupe.

PIN SYLVESTRE: *PINUS SYLVESTRIS*
- caractéristiques macro et microscopiques:
 Ce résineux a un fil généralement droit, des cernes nettement visibles. Il est assez résistant aux attaques de vrillettes. Au microscope, on observe un passage soudain du bois initial au bois final. Les canaux résinifères à cellules sécrétrices sont assez gros et assez nombreux.
- sémiologique radiologique (voir Fig. 6):
 Les cernes sont visibles sur la plus grande partie du panneau. Ils sont bien contrastés. Le rapport bois initial sur bois final est égal à 2 ou 3. Le fil est droit à légèrement sinueux. Les attaques xylophages sont rares et limitées, les fentes sont rares. L'examen à la loupe montre quelques stries irrégulièrement réparties et peu nombreuses.

PIN MARITIME: *PINUS PINASTER*
- caractères macro et microscopiques:
 Ce conifère a un fil assez sinueux. Il est durable. Les accroissements sont généralement assez larges. Les hauteurs de planches sont limitées par la configuration de l'arbre. Au microscope, les canaux résinifères sont nombreux et gros. Les nœuds sont nombreux.
- sémiologie radiologique:
 Les cernes sont bien visibles sur l'ensemble du panneau, le fil est sinueux. Le rapport bois initial sur bois final est égal à 2 ou 3. L'atteinte xylophage est très rare et peu marquée. Les nœuds et les fentes sont fréquents.

Résultats de l'analyse radiologique du deuxième échantillonnage

Pour 13 tableaux, le type d'essence n'a pu être déterminé radiologiquement car la trame du bois n'était pas accessible en radiographie. Cela est survenu le plus souvent en raison d'une toile marouflée ou incluse ou d'un enduit opaque au revers.

Dans 16 cas, aucun signe radiologique évocateur de la trame du bois n'était retrouvé. Il est intéressant de noter que dans 93% des cas il s'agissait d'essences feuillus et dans 66% cas de peuplier.

L'évaluation a donc porté sur 246 panneaux. Pour ces panneaux le taux de concordance entre le diagnostic microscopique et le diagnostic radiologique est de 85,7%. (voir Tableau 1)

Parmi les feuillus, nous avons individualisé les trois essences les plus fréquentes (chêne, peuplier, noyer) par rapport aux autres essences. Par ailleurs, l'analyse radiologique a rapidement montré le défaut de discrimination entre les espèces résineuses.

Finalement le choix de l'essence proposé au terme de l'étude radiographique a été fait entre 5 classes: chêne, peuplier, noyer, autres feuillus, résineux.

Tableau 1. Comparaison des essences diagnostiquées par l'analyse radiologique et par l'analyse microscopique.

Radio Micro	chêne	peuplier	noyer	autres feuillus	résineux
chêne	71		1		
peuplier		120		2	3
noyer		6	9		1
autres feuillus		3		5	1
résineux	2	3		1	19

Tableau 2. Sensibilité, spécificité et rapport de vraisemblance du diagnostic radiologique.

essences	sensibilité	spécificité	rapport de vraisemblance
chêne	98%	97%	33
peuplier	96%	90%	9,6
noyer	56%	90%	5,6
résineux	76%	79%	3,6
autres feuillus	50%	55%	1,1

Interprétation des résultats

La radiographie est un examen très sensible et très spécifique dans le cas du chêne et à un moindre degré pour le peuplier. Son diagnostic radiologique est en effet basé sur la présence de bandes de stries spontanément denses, images particulièrement fréquentes dans cette essence mais qui ne sont pas caractéristiques. On retrouve en effet des images très proches dans le tilleul, l'érable et le saule. La forme prise par le regroupement de ces stries doit être précisément relevée car dans le peuplier il s'agit de bandes à bords parallèles très longues (plusieurs dizaines de centimètres) et souvent multiples tandis que dans les autres cas, l'anomalie est rare et courte en forme de fuseau, notamment dans le tilleul.

Le noyer est identifié de façon peu sensible mais lorsque les signes sont présents, le diagnostic radiographique est spécifique. Ce diagnostic est essentiellement basé sur la visualisation des pores bien individualisés par imprégnation avec une décroissance régulière de leur épaisseur jusque dans le bois final. Les cas de faux-négatifs correspondent généralement à une répartition des stries non évocatrice et conduit à un diagnostic abusif de peuplier.

Le diagnostic de résineux par la radiographie n'est ni très sensible ni très spécifique mais il apporte toutefois une orientation importante du diagnostic dans près de trois cas sur quatre.

Pour les autres essences de feuillus, les résultats ne sont actuellement pas convaincants. On peut se demander s'ils sont liés à la nature même du plan ligneux de ces essences, qui se prête mal à une interprétation radiographique ou plutôt à la rareté des cas qui ne permet pas de définir une sémiologie fiable.

Limites de l'étude

La radiographie n'est pas une technique d'identification parfaite, elle n'est contributive que dans le cadre de la reconnaissance d'un nombre limité d'essences connues. Cette dernière nécessite un entraînement sur un échantillonnage d'apprentissage avec une comparaison de la lecture radiologique et des coupes microscopiques. Par ailleurs, l'échantillonnage disponible dans cette étude est représentatif des tableaux de nos collections et comprend majoritairement du chêne et du peuplier. Les résultats observés avec les autres essences sont peut-être liés à notre manque d'entraînement concernant ces essences.

Conclusions

Cette évaluation de la méthode radiographique dans la détermination des essences de bois employées dans les panneaux peints européens a montré des résultats encourageants. Les essences les plus fréquentes comme le chêne et le peuplier sont identifiées de façon très sensible et très spécifique. Le noyer est identifié de façon certes moins sensible mais toutefois très spécifique. Les résineux sont identifiables

comme famille, sans que la radiographie soit discriminative sur l'espèce. Dans les autres essences feuillus ou dans le cas des résineux, une analyse microscopique peut être envisagée en deuxième intention. On limite ainsi de façon importante les indications de prélèvements sur l'œuvre. Nous pensons par ailleurs qu'une pratique assidue de cette méthode permettra d'améliorer ces premiers résultats.

Remerciements

Nous remercions vivement madame Dupéron, du Laboratoire de Paléobotanique de l'Université Paris VI, pour ses précieux conseils et madame D. Mahaud de la documentation du L.R.M.F. qui a bien voulu sélectionner les dossiers et les préparer pour une lecture en aveugle.

Notes

1. La durabilité est l'aptitude d'une essence à résister à l'attaque des agents biologiques d'altération: champignons lignivores et insectes xylophages.
2. La tache médullaire est une anomalie occasionnelle du bois de la texture du bois. Elle est formée généralement de tissu parenchymateux anormal et coloré, s'étendant longitudinalement et parallèlement aux cernes.

Références

Carlquist S. 1988. Comparative wood anatomy. Berlin: Springer-Verlag.

Collardet J, Besset J. 1988. Les résineux (conifères). H.Vial et Centre technique du bois et de l'ameublement.

Collardet J, Besset J. 1992. Feuillus des zones tempérées. H. Vial et Centre Technique du bois et de l'ameublement.

Jacquiot C, Trenard Y, Dirol D. 1973. Atlas d'anatomie des bois des angiospermes. Tomes 1 et 2. Paris: Centre technique du bois.

Schweingruber FH.1982. Anatomie microscopique du bois. Teufen: F. Flück-Wirth.

Venet J. 1986. Identification et classement des bois français. 2e édition. Nancy: ENGREF.

Easel painting on lapidary surfaces in 16th-century Italy

Abstract

The techniques for creating easel painting on lapidary surfaces in Italy from the 1500s to 1600s is traced. The Italian, and specifically Medici, taste for objects in *pietra dura* using lapidary surfaces comprised of marble, alabaster, lapis lazuli and *pietra paesina* was not limited to the Florentine artistic stone inlay technique; these stones were also used as easel painting surfaces from the mid 1500s through the first quarter of the following century. These surfaces, as well as the more traditional slate, are examined from an historical as well as methodological point of view through reference to various treatises and manuals.

Keywords

slate, easel painting, Sebastiano del Piombo, stone, oil priming

Joan Marie Reifsnyder

via dell'Eremo 4
Bagno a Ripoli (FI) 50012
Italy
Fax: +39/055630436
Email: jmreif@dada.it

Introduction

In his introduction to *The Lives of the Most Excellent Painters, Sculptors and Architects*, first published in Florence in 1550, Giorgio Vasari comments: "The courage of our pictorial artists has gone on increasing, so that colouring in oil, besides the use made of it on the wall, can when they desire be employed also for painting on stone" (Maclehose 1960). Whether oil painting on lapidary surfaces in 16th-century Italy was truly an act of courage, may be more an example of Vasari's poetic license than artistic heroics. What is true, however, is that the pictorial decoration of stone surfaces is more commonly known, in historical terms, as those polychrome layers applied to stone sculpture and architectural structures rather than to the creation of flat-surfaced, moveable painted images referred to as "easel paintings". The practice of using lapidary supports for easel paintings is a phenomenon which seems to evolve in Europe during the 16th and early 17th centuries, and quite specifically, northern and central Italy.

Stone panels as painting support

From the various literary sources, treatises and the actual stone-support paintings known to us today, flat lapidary supports made from slate, marble, touchstone (paragon), alabaster, limestone (*pietra paesina*) as well as other types of stones and minerals appear to have been used as oil painting supports in two ways:

1. The stone slab was treated and prepared in a way very similar to that of a wall painting, painted stone sculpture or even the traditional wood panel. The surface of the stone was completely covered with a ground preparation or priming and subsequently the pictorial film. The use of the colour or tonalities of the stone surface itself was not employed in the image.

2. The second principle use of stone as a painted support was to incorporate the colour or patterned characteristics of the stone into the pictorial image. The dark, tenebrous tonality of stones such as slate, touchstone or black marble were used to create a suggestive, atmospheric pictorial image and to develop the deep shadowing typical of night or candlelight scenes with chiaroscuro effects. Similar to the use of stones for their dark tonality, various coloured or "patterned" stones were used for their "fantastical" or landscape effects. The

Figure 1. Florentine School 17th century, Episode from 'Orlando innamorato', oil on pietra paesina, 20 × 95cm. Museum of the Opificio delle Pietre Dure, Florence.

Figure 2. Filippo Napoletano, The vision of St. Augustine, *oil on lineato d'Arno, 43 × 93cm. Museum of the Opificio delle Pietre Dure, Florence.*

painted images were placed in "settings" created by the natural grain, pattern and colour of the stones. Most often stones such as marble, alabaster, *pietra paesina*, jasper, agate and even lapis lazuli and amethyst were used as pictorial supports. The stone surface was in large part unpainted and the portion of the stone left in view constituted an integral part of the aesthetic image (See Figs. 1, 2).

Literary sources

Relatively few sources exist which describe or explain the technical execution of easel painting on stone surfaces. Often the mention of the use of stone as a painting surface is tied to the descriptions found in historical artists' treatises for the preparation of a wall or stone sculpture to receive oil-based pigments.

Among the most important traditional writings mentioning oil painting is the Paris transcription of the treatise by Eraclius made in 1431 by Jean Le Begue, *De Coloribus et Artibus Romanorun*. Merrifield (1849) provides us with the specific passage in this treatise where the use of oil painting on a stone surface is described: "If you wish to paint on a column, or a slab of stone, first let it dry very perfectly in the sun, or before a fire. Then take white [lead], and grind it very finely with oil on a marble slab. Afterwards ... lay on it two or three coats of that white, with a broad paint brush. Then rub very stiff white over it with your hand or with a brush, and let it remain a short time. When tolerably dry, press your hand strongly over the white surface, drawing your hand toward you. Continue to do this until it is a smooth as glass. You will then be able to paint upon it with all colours mixed with oil".

Variations on this procedure are also documented. An initial treatment to the dry wall surface itself was done with size, and Cennini instructs us: "... And work on iron in the same way, and on stone... " (Thompson 1960). The use of size was to avoid the "sinking in" of the colours and Eastlake elaborates on Cennini's instructions: "...The surface of stone, after being dried in the same way, or by means of fire, was sometimes covered with size, to intercept all internal causes of alteration in the superimposed shining liniment" (Eastlake 1960).

In 1550, Giorgio Vasari provided invaluable insight into the method of preparing and working on stone surfaces, again, by making reference to the technique of mural painting in oil. He mentions two possible methods for the preparation of the wall surface, both employing the use of boiled linseed oil or linseed oil followed by a thick rosin/mastic varnish (Maclehose 1960). Vasari refers the reader to this wall-preparation method in his instructions for the preparation of stone surfaces. When the surface of the stone itself was meant to be left in view and not covered completely by paint film, a drying oil alone was used. The preparation of the oils used as mordents for gilding can help in understanding the characteristics of the materials used to prepare the stone surface for oil painting.[1]

The most widely used lapidary support for oil paintings in the 16th century was slate and in his introductory section on Painting, Vasari provides us with some insight as to the reasons this stone was used as a painting support: "...they have found a suitable kind [of stone] on the sea-coast of Genoa, in those flagstones we have spoken of in connection with Architecture, which are very well fitted for this purpose, for the reason that they are compact and of fine grain, and take an even polish. In modern times an almost unlimited number of artists have painted on these slabs and have found the true method of working upon them" (Maclehose 1960).

Vasari attributes the first uses of stone as a surface for easel painting to Sebastiano del Piombo. Probably overly generous in his attribution of this "invention" Vasari states: "This painter has begun a new way of colouring on stone, which has been quite pleasing to the general public. It seems that with this method the paintings become eternal and neither fire nor worms can harm them" (Bettarini and Barocchi s.d.). In his introductory section Vasari reiterates this characteristic: "and it is impervious to worms, which cannot be said for wooden panels" (Maclehose 1960). In fact, it seems that the principal type of damage – related to the excessive weight of the stone slab – was that painted lapidary supports were easily breakable and therefore difficult to transport, as was especially the case with slate (Hirst 1972). In addition to this defect, there is also mention that slate dissolves in potassium nitrate, as was seen for "... those works on slate painted by Zuccheri in the Orvieto Cathedral" (Milanesi 1878: Bazzi 1976). The comment published in 1550 by

Vasari on the genius of Sebastiano was already "old news" when it came out. As early as 1530, in a letter dated 8 June written by Vittorio Soranzo and directed to Pietro Bembo, Sebastiano's use of stone supports for easel paintings is the object of praise: "Our Venetian, Sebastianello had found a secret for painting beautifully in oil on marble in such a way that the painting becomes almost eternal. As soon as the colours are dry they bind to the marble in such a way that they seem to almost petrify. Every type of test has been made and it is long-lasting" (Hirst 1981).

Vasari finishes the instructions for painting on stone with his own personal reflections. "Later they have tried the finer stones, such as marble *breccias*, serpentines, porphyries and the like, which being smooth and polished admit of the colour attaching itself to them. But in truth when the stone is rough and dry it imbibes and takes the boiled oil and the colour much better. Therefore it is not necessary to begin by spreading size on all these stones, but only a coat of priming oil colour ... and when this is dry the work may be begun at will.... These, [the paintings] provided they are worked with great diligence and care, endure forever. They may or may not be varnished, just as you like, because the stone does not suck up, that is, absorb as much as does the panel or canvas" (Maclehose 1960).

Two types of surface priming

"Fully primed" surfaces

The use of slate or marble as supports with a white or toned drying-oil imprimatura seems to have been the earliest type of support and preparation for lapidary easel paintings. Among the earlier uses of marble or slate supports are two works by Titian, both in the Prado, one on slate, *Ecce Homo* (1547), and the other on marble, *La Dolorosa* (1554). Hirst (1981) cites at least eight works by Sebastiano del Piombo either on slate or marble surfaces, the earliest dating from approximately 1530. Among the most important examples of paintings on slate supports are the 14 individual paintings comprising the upper row of panels in the Studiolo of Francesco I de' Medici in the Palazzo Vecchio in Florence. A common thread for all these works seems to be the general rationale behind the use of the stone; that is, to create a permanent or "eternal" image. These are works where the entire stone surface is prepared with a white lead and/or coloured earth oil-based priming. Neither the tonality of the dark stone, nor its surface design is part the pictorial representation.

The use of the "easel" size stone slabs in the construction of larger stone support works composed of multiple pieces also occurred (Rotondi Terminiello and Semino 1985). Vasari was quite familiar with this large-scale use of stone surfaces. While he directed the work on the reconstruction of the Palazzo Vecchio for Cosimo I de' Medici in the middle of the 1500s, four large paintings, each composed from series of square slate slabs, were executed by Jacopo Ligozzi, *Il Cigoli* and *Il Passignano* for the Hall of the 500. The advice given by Vasari for painting on slate surfaces is actually demonstrated by the technique these artists used in preparing their modularly-constructed slate supports: "He who desires to paint a picture in oil on stone can take some of those Genoese flagstones (slate) and have them cut square and fixed in the wall with clamps over a layer of stucco, spreading the [oil-based fill] composition well over the joining so as to make a flat surface of the size the artist needs" (Maclehose 1960).

The most famous use of multiple slate slabs used to create a single painting is the altarpiece of the Madonna of Vallicella by Pieter Paul Rubens in the Chiesa Nuova in Rome. Rubens resorted to the use of slate slabs only as a second choice support. His first work, which was painted on canvas, created difficulties with the glare of light on its surface. Rubens himself requested that the "Oratorian" order should give him a second opportunity to execute the work more successfully; he chose slate slabs mounted on the wall with clamps and filled the joins with an oil-stucco priming as described by Vasari. In this case the stone was chosen as a material "... which would absorb the colours so that they [would] not suffer from reflections by contrasting lighting" (Jaffé 1977).

There are indications that for this type of fully-covering imprimatura application, the stone surface was not polished, but instead as Vasari stated: "...when the stone is rough and dry it imbibes and takes the boiled oil and the colour much better".[2]

Not only do the some of the works by Sebastiano seem to confirm one of the possible working methodologies described in the traditional literature, but the series of works on slate in the Studiolo of Francesco I de' Medici (executed under Vasari's direction, himself the author of one of the paintings on slate: *Perseus and Andromeda*) confirm the preparatory technique of using a fairly consistent white lead priming applied with a brush. In fact, the white lead in oil is applied in such a way as to perceive the horizontal brushstrokes of the imprimatura through the pictorial layers.[3]

Toned surfaces

The dark-toned surfaces of slate, the use of touchstone (paragon) and black marbles, seems to be a way of using the stone which is most directly associated with northern Italian artists in and around both Verona and Genoa.[4]

Verona seems to provide a fertile ambience for the use of black "touchstone" or marble as painting supports, as Genoa does for slate, because of the natural deposits of these stones in the area. In addition, the tradition of the "night or candlelight" scenes, seen in the works of both Jacopo and Francesco Bassano, are easily transferred by artists within this sphere of influence to a support with a naturally dark surface (Ottani Cavina 1971). Because the stone's dark ground is itself used as a tonal element, the stone surface is not left "rough", but brought to a high polish.

In the conservation treatment of a specific work on a "dark stone", Stout and Pease (1938) comment that the lapidary surface in question did not have a generally distributed ground film: "Paint was used for the foreground and for the separate figures, but the dark background was furnished by the stone itself and it had apparently been polished with an oil". Although the traditional method of polishing does not include oil, the reference here may be to the application of a drying oil or oil-resin as a preparation for the oil colours.

Recently, two unedited works of this dark-ground type have been examined. One, on marble or touchstone, and the other on slate, have a surface which is simply polished; there is no oil film coating covering the entirety of the stone's surface. However, there is evidence in both works of a transparent oil or oil-resin underpainting, delineating and priming the area over which the figures and image are painted.[5]

The use of stones with distinctive markings and colourings to create the background or "setting" for a painted scene is closely tied to the Granducal court in Florence at the end of the 16th and the beginning of the 17th centuries. A cultivated and elite art form during the 1500s at the Medici court was that of semi-precious stone inlay using *pietre dure* – marble, lapis lazuli, porphyry, agate, jasper, amethyst, malachite. The technique consists of creating geometric patterns or "pictures" with carefully chosen pieces of stones, cut and fit together to form a pictorial "image"; a sort of "painting with stone". Many of these same *pietre dure* were used, along with "softer" stones such as alabaster and *pietra paesina* or *lineato d'Arno*, a limestone containing markings reminiscent of land or seascapes, for the almost fanciful evolution to "painting on stone"(Giusti et al 1978). Like the dark-toned stones, the patterned stones were polished and then received a very thin, transparent oil or oil-resin underpainting only in those areas where the figures and images would then be painted. These types of painted caprices have been described as being "made by nature and helped along by the brush" (Chiarini 1970) (See Figs. 1, 2). Interestingly enough, many of these works are found in natural history or decorative arts collections rather than in painting galleries.

Conclusion

The various types and uses of stone as supports for easel paintings, even though requiring different types of preparation based on the final aesthetic purpose have a surface preparation, be it by the use of size, oil-pigment priming, oil or oil-resin film, or mechanical polishing, which prevents the stone from excessively absorbing the oil binder in the pigments.

The fashion of the use of lapidary supports for easel paintings did not endure. The most negative aspect in this type of painting seems to have been the weight and fragility of this support and the subsequent difficulty in safely and easily moving the work. In the evolution of easel paintings the advantages of the lapidary support with

respect to panels, i.e., does not deform or buckle and is not subject to worm or fire damage – its "eternal" characteristic – obviously did not outweigh these difficulties. Easel painting on stone in Italy during the 1500s and 1600s seems to have fulfilled a certain intellectual taste for the *cosa rara*, the unusual and uncommon object, which was both unique and precious. In the enormous historical production of easel paintings, lapidary supports continue to evoke a fascination and curiosity which is only now beginning to be addressed. Continued investigation, experimentation and simulation will be needed in order to understand more fully and appreciate this uniqueness.

Notes

1. "Take linseed oil boiled in the usual way and take giallolino and verdigris and tow in equal parts; grind these things dry, then mix them with oil and lay the first coat on the marble or stone . . . Also when you wish to lay a mordant on polished iron or marble, or any other polished surface, you must first lay on a coat of glue neither too thin or too thick and let this dry; then lay on the mordant . . . , because without the glue, the mordant would not adhere firmly." (Maclehose. 1960. Segreti diversi, Marciana Manuscript: 620–622).
2. Upon visual examination, the unfinished work by Sebastiano del Piombo of *Paolo III Farnese* in Parma, seems to be prepared with a very slight, but exact "scratched grid-structure" on the slate surface–almost imitating the weave pattern of a canvas–in order to provide the "roughness" Vasari speaks of. Then the surface of the work receiving colour appears to be covered with a very thin cold-greyish coloured oil priming. Personal communication: Roberto Bellucci, paintings conservator, Opificio delle Pietre Dure, Florence.

 This same type of surface preparation seems to exist in at least two other works by Sebastiano, both currently in the Capodimente Museum in Naples. The unfinished portrait of *Clemente VIII* and the *Sacra Famiglia* are painted on slabs of slate spread over with a grey/white-lead colour. These slabs are not completely smooth, but have a rough or uneven surface. The longitudinal marks from the cutting of the slabs is evident. Could these be some of the elements alluded to in the literary references as Sebastiano's "secret" for painting on stone?
3. A passage in the treatment report for the *Pietà* by Sebastiano del Piombo in the Prado confirms: "La pintura revela una imprimaciòn muy ligéra, dada con brochazos muy regulares, en sentido horizontal, sobre la que està pintada la obra directamente" (Luzòn Nogué 1995).
4. For an exhaustive listing of approximately 135 specific works on lapidary supports, types of stone and artists, see Rinaldi (1990).
5. The first is by Rubens depicting the *Adoration of the Shepherds* and is the property of a private Florentine collector; the second, presumably by a northern Italian artist, in the collection at the Pitti Palace Florence and depicting the *Rape of Proserpine*, is currently under study. My thanks to Dr. Marco Chiarini, Director of the Palatine Gallery, for allowing me to view and examine this work.

References

Bazzi M. 1976. Abecedario pittorico. Milan: Longanesi: 28.
Callois R. 1963. D'étranges délires de marbre. In: Connaissance des Arts (139).
Chiarini M. 1970a. Pittura su pietra. In: Antichità Viva, IX.
Chiarini M, comp. 1970b. Pittura su pietra. Exhibition catalogue, Centro Di, Florence.
Eastlake CL. 1960. Methods and materials of painting of the great schools and masters, vol. I & II. New York: Dover Publications.
Giusti AM, Mazzoni P, Pampaloni Martelli A. 1978. Il museo dell'opificio delle pietre dure di Firenze. Milan: Electa: 367–388.
Hirst M. 1981. Sebastiano del Piombo. Oxford: Clarendon Press (24). Delle lettere da diverse Re et Principi et Cardinali at altri huomini dotti a Mons. Pietro Bembo scritte, originally written in Venice 1560: 110.
Jaffé M. 1977. Rubens and Italy. Oxford: Phaidon: 91.
Luzòn Nogué JM. 1995. (:compiled by) Sebastiano del Piombo y España. Exhibition catalogue, Museo del Prado.
Maclehose LS. 1960. Vasari on technique. New York: Dover Publications.
Merrifield MP. 1849. Ancient practice of painting, vol. I, II. London: 230.
Ottani Cavina A. 1971. I dipinti su lavagna. Bolaffi arte (6).
Rinaldi S. 1990. Supporti lapidei e vitrei, I supporti nelle arti pittorici (:compiled by Maltese C.). Milan : Mursia ed.
Rotondi Terminiello G, Semino A. 1985. La pittura su ardesia (complied by Boccardo P.) Del dipingere e scolpire in pietra. Exhibition catalogue. Genova.
Stout GL, Pease M. 1938. A case of paint cleavage. In: Technical studies in the field of the fine arts. Fogg Museum, Harvard University, VII (July): 33–45.
Thompson DV. 1960. The craftsman's handbook (Il libro dell'arte), by Cennino d'Andrea Cennini. New York: Dover Publications.
Vasari G. 1878–1885. Le vite de' più eccellenti pittori scultori e architettori, edited by G. Milanesi, Florence.

Résumé

La décoloration de roses et de pourpres dans six tableaux de Van Gogh peints en mai et juin 1890 est mise en évidence par l'examen des œuvres et par comparaison avec des copies. L'analyse a identifié deux types de pigments organiques rouges responsables de ces altérations : un carmin laqué à l'aluminium et à l'étain et une éosine laquée à l'aluminium. On expose brièvement quelques aspects relatifs au choix de ces pigments et aux conséquences de leur décoloration.

Mots-clés

carmin, décoloration, éosine, pigments laqués, Van Gogh

Figure 1. Les deux fillettes.

Figure 2. L'église d'Auvers.

Caractérisation de pigments décolorés dans des tableaux de Van Gogh peints à Auvers-sur-Oise

Jean-Paul Rioux

Laboratoire de recherche des musées de France
6, rue des Pyramides
75041, Paris Cedex 01
France
Fax : +33 (0)1 47 03 32 46
Email : rioux@culture.fr

Le docteur Gachet qui avait aidé Van Gogh pendant son séjour à Auvers en mai et juin 1890, possédait plusieurs toiles peintes pendant cette brève et ultime période de production de l'artiste. Ces œuvres qui ont été données ou vendues au musée du Louvre par le fils du docteur dans les années 1950, font maintenant partie des collections du musée d'Orsay. Elles ont été récemment réexaminées, et cette étude a mis en évidence des décolorations pigmentaires semblables dans plusieurs œuvres (Rioux 1999).

Des roses disparus et des pourpres pâlis

Sur les bords de trois tableaux, *Les deux fillettes* (voir Fig. 1), *L'église d'Auvers* (voir Fig. 2) et *Dans le jardin du docteur Gachet* (voir Fig. 3), on observe des traces roses qui sont absentes du reste de la peinture. Peu étendues, elles ne sont visibles que quand les tableaux sont désencadrés car elles sont toujours situées dans des parties soustraites à la lumière ambiante par la feuillure du cadre. Ce ne sont pas des retouches désaccordées car, à la loupe, on constate qu'un même coup de brosse change de couleur s'il est en partie exposé à la lumière. Le phénomène est donc dû à la décoloration d'un pigment photodégradable.

En 1901, Blanche Derousse a peint à l'aquarelle des copies d'une partie des Van Gogh du docteur Gachet. Ces aquarelles sont parvenues jusqu'à nous en très bon état de conservation.[1] Quand on les compare avec leurs modèles, on constate une bonne similitude des couleurs, témoignage de fidélité du copiste, à l'exception des pourpres et des roses qui sont absents des modèles. Les traces roses observées sur les bords des trois tableaux déjà mentionnés, sont donc des témoins résiduels de couleurs originelles beaucoup plus étendues qui ont pâli ou disparu. On a découvert le même type de décoloration en comparant avec leurs copies deux tableaux apparemment inaltérés *Mademoiselle Gachet au jardin* (voir Fig. 4) et *Le Portrait du docteur Gachet* (voir Fig. 5). En l'absence de copie ou de document de référence, on peut aussi se demander si les couleurs bizarrement ternes de *Nature morte dit Roses et anémones* (voir Fig. 6) ne seraient pas la conséquence du même phénomène.

Van Gogh a donc utilisé des pigment fugaces qui se sont lentement décolorés : les roses, où le pigment est très peu concentré, ont blanchi ou sont devenus invisibles tandis que les rouges et les pourpres peints directement avec la peinture issue du tube, ont pris une couleur beige terne. Ces décolorations ont modifié l'harmonie chromatique de l'œuvre originale et ont parfois fait disparaître certains détails (Rioux 1999).

Des décolorations de roses ou de rouges ont déjà été signalées dans d'autres tableaux. Lors de la restauration d'une autre version des *Deux fillettes* par Van Gogh,[2] une couleur rose résiduelle sur les bords de ce tableau était expliquée par une décoloration semblable à celle de la version du musée d'Orsay et un phénomène comparable était aussi observé dans un tableau de Gauguin (Cadorin et al. 1987 : Cadorin 1991). Des décolorations ont également été étudiées dans un triptyque peint par Van Gogh à Arles en 1888 : *Le verger rose*, *Pêchers en fleurs* et *Le verger blanc* (Bang 1991 : Hofenk de Graaff et al. 1991).[3] Les pigments rouges instables, identifiés au cours de ces études, sont de deux types : différents carmins ou des pigments à base d'éosine. Tous sont des pigments laqués obtenus en rendant

Figure 3. Dans le jardin du docteur Gachet.

Figure 4. Mademoiselle Gachet au jardin.

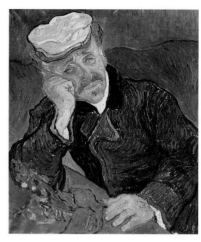

Figure 5. Portrait du docteur Gachet.

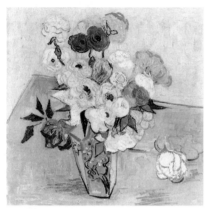

Figure 6. Nature morte dit Roses et anémones.

insoluble un colorant organique préalablement dissout. La précipitation est obtenue par l'ajout de sels minéraux, l'alun étant le plus habituel, à une solution aqueuse du colorant.

Les carmins contiennent un même principe colorant, l'acide carminique, extrait de cochenilles (Schweppe et Roosen-Runge 1986). Le fabricant du pigment peut modifier l'intensité de la coloration et la nuance du pigment laqué selon la nature des minéraux ajoutés. Ceux qui contiennent de l'étain produisent une couleur écarlate particulièrement intense mais cette qualité pigmentaire a malheureusement pour contrepartie une grande instabilité à la lumière. Celle des carmins à l'étain est plus accentuée que celle des carmins à l'aluminium, lesquels sont moins solides que les laques de garance ou d'alizarine qui, parmi les pigments laqués, ont généralement la meilleure stabilité (Saunders et Kirby 1994).

En 1871, Caro synthétise pour la première fois un colorant rouge qu'il appelle éosine en référence aux premiers rayons de l'aurore, divinisée sous le nom d'Eos dans l'Antiquité. L'éosine est obtenue par fixation de quatre atomes de brome sur la fluorescéine qui avait été découverte un an auparavant (Langstroth 1973).

Ce nouveau produit peu onéreux et de fort pouvoir colorant était intéressant pour compléter la gamme des colorants naturels qui, à l'époque, étaient la seule source de pigments laqués. De nouvelles laques à base de colorants de synthèse apparaissent alors sous divers noms commerciaux (Coffignier 1924). La « laque géranium » est une éosine laquée qui a été proposée aux artistes peu après la synthèse de ce colorant et on sait que Van Gogh, d'après les commandes de peintures qu'il transmet à son frère, en a utilisé mais, comme les carmins, ce nouveau rouge était aussi très instable à la lumière.[4] Les artistes de l'époque étaient pourtant prévenus contre les risques de décoloration de certains rouges comme les carmins de cochenille dans la peinture à l'huile (Mérimée 1830) ou les pigments rouges de synthèse (Vibert 1892). L'évolution a été assez rapide pour que ceux qui ont vécu jusqu'à un âge avancé, puissent constater l'altération par eux-mêmes. On raconte que Renoir, retrouvant son « Bal du Moulin de la Galette » au Louvre après la Première Guerre mondiale, a déclaré en plaisantant : « Le tableau n'est pas de moi : je l'avais peint rose; il est bleu ».[5]

Analyses

Pour caractériser les pigments responsables des décolorations, il faut analyser la matière des résidus inaltérés quand ils existent ou celle des zones supposées décolorées. Il faut aussi disposer de techniques d'analyse sensibles puisque le pigment rouge est souvent très peu concentré. L'observation au microscope de

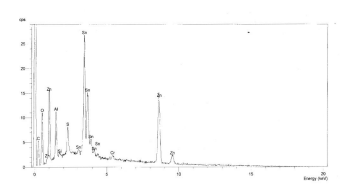

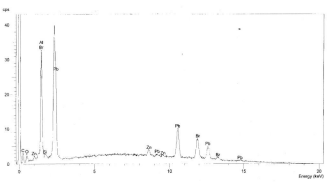

Figure 7. L'église d'Auvers, *touche rose peinte dans le chemin au premier plan, microanalyse d'un grain de pigment rouge.*

Figure 8. Le Portrait du docteur Gachet, *fleurs bleues de la digitale peinte sur la manche, microanalyse du pigment rouge sous-jacent.*

prélèvements ponctuels permet d'établir la stratigraphie des couches de peinture et d'étudier leur aspect coloré. Ces prélèvements, en nombre très limité, ont été effectués de préférence sur les bords de la partie peinte et, dans quelques cas, dans une partie plus centrale lorsque cela était nécessaire et possible. Dans un deuxième temps, les mêmes prélèvements font l'objet d'une analyse chimique. La microscopie électronique à balayage avec analyseur (SEM/EDX) n'est pas, en principe, une technique adaptée à l'étude de matériaux organiques. Cependant, elle a l'avantage de pouvoir identifier les éléments chimiques d'une couche ou d'un grain de pigment, éléments qui pourraient ne pas être détectés par une analyse globale. La détection d'étain, d'aluminium et parfois de soufre signale les carmins de cochenille laqués à l'étain et à l'aluminium car l'étain est normalement absent des autres rouges laqués (voir Fig. 7). La détection de brome est un indice de la présence d'éosine car le brome n'entre pas dans la composition d'autres pigments usuels. Toutefois, cet élément n'est clairement décelé que si l'éosine est suffisamment concentrée. En effet, la raie L_α du brome, la plus intense, a la même énergie (1,48 keV) que la raie K_α de l'aluminium, élément abondant dans la partie minérale de la laque. Cette ambiguïté peut être levée par la détection des raies K_α du brome (11,88 et 11,92 keV) ou K_β (13,28 keV) mais ces raies sont relativement peu intenses parce qu'elles sont moins excitées (voir Fig. 8). Dans le cas de roses très clairs où le brome

Tableau 1. Résultats des analyses.

oeuvre	localisation et couleur	fluo res cen ce	analyse élémentaire d'un grain rouge	pigments rouges	pigments blancs et charges environnants	autres pigments dans la même couche
Deux fillettes RF1954-16	bord supérieur dextre, toit gris rosé	–	Pb, Sn, Al, Zn, O un peu de Cr Ba, S	carmin laqué sur Al et Sn	blanc de plomb, blanc de zinc, sulfate de baryum	bleu de cobalt (Al, Co, O), noir
L'église d'Auvers RF 1951-42	chemin au premier plan, touche rose	–	Zn, Al, Sn, S, O un peu de Cr	carmin laqué sur Al et Sn	blanc de zinc	
L'église d'Auvers	chemin au premier plan, partie décolorée en blanc de la même touche rose	–	Zn, Al, Sn, S, O un peu de Cr	carmin laqué sur Al et Sn	blanc de zinc	
Le jardin du docteur Gachet RF 1954-15	traces roses sur le bord dextre	–	Zn, Al, Sn, S, O un peu de Cr	carmin laqué sur Al et Sn	blanc de zinc	
Le jardin du docteur Gachet	traces roses sur le bord senestre	–	Zn, Al, Sn, S, O un peu de Cr	carmin laqué sur Al et Sn	blanc de zinc	
Melle Gachet au jardin RF 1954-13	rose très pâle, buisson de fleurs sur le bord dextre	+	Zn, Pb, Ba, S, O	probablement éosine laquée	blanc de zinc, blanc de plomb, sulfate de baryum	ocre (Si, Al, Fe, O), vert émeraude (Cr, O), outremer (Si, Al, S, Na, O)
Nature morte dit Roses et anémones RF 1954-12	table, couleur blanche en surface (rose décoloré)	+	Pb, Ba, S, O	probablement éosine laquée	blanc de plomb, sulfate de baryum	
Nature morte dit Roses et anémones	cerne grenat de la table, bord dextre	+	Zn, Pb, Hg, S, O	vermillon et probablement éosine laquée	blanc de zinc, blanc de plomb, sulfate de baryum	
Nature morte dit Roses et anémones	beige clair de la rose aux pétales cernés de bleu au sommet du bouquet	+	Pb, Ba, S, Hg, O	vermillon et probablement éosine laquée	blanc de plomb, sulfate de baryum	
Nature morte dit Roses et anémones	grisâtre du fond	+	Pb, Ba, Hg, S, O	vermillon et probablement éosine laquée,	blanc de plomb, sulfate de baryum	outremer (Si, Al, Na, S, O), vert émeraude (Cr, O)
Portrait du docteur Gachet RF 1949-16	digitale bleue sur la manche, rouge sous-jacent	+	Pb, Al, Br, O, un peu de Zn	éosine laquée sur Al	blanc de plomb,	outremer (Si, Al, Na, S, O), sulfate de baryum(Ba, S, O)
Portrait du docteur Gachet	rouge grenat des ombres sur la table orangée (minium)		Pb, Hg, Ba, S, O	vermillon, minium,	blanc de plomb, sulfate de baryum	
palette utilisée par Van Gogh en 1890		–	Zn, Al, Sn, S, O un peu de Cr	carmin laqué sur Al et Sn	blanc de zinc	
tube de « laque géranium » (1890)		+	Pb, Al, Br, Na, Ca, Ba, S, O	éosine laquée sur Al, charge au Pb		

n'est pas détecté, on peut avoir recours à une analyse microchimique simple et très sensible.[6] Après extraction de l'échantillon, l'éosine en solution présente une fluorescence caractéristique sous un éclairement ultraviolet (Cadorin et al. 1987). Les carmins ne peuvent être confondus avec l'éosine car, dans les mêmes conditions, ils ne fluorescent pas.

Ces analyses ont été menées sur les six Van Gogh de la collection Gachet dont il a été question plus haut ainsi que sur une palette et sur le contenu d'un tube de peinture.

La palette qui était demeurée intacte depuis la mort de l'artiste, lui avait été prêtée par le docteur Gachet pour terminer le portrait *Mademoiselle Gachet au piano* (Gachet 1994).[7] Sur le tube, on peut lire le nom de la couleur « laque géranium » et celui de « Tasset et Lhôte », un des fournisseurs de Van Gogh. Le contenu desséché et à peine entamé a conservé une couleur rouge intense. Van Gogh avait souvent chargé son frère de l'achat de peinture ayant cette dénomination et il semble qu'il en avait un usage assez régulier.[4, 8]

Résultats

Les analyses dont les résultats sont rassemblés dans le Tableau 1 ont identifié deux types de rouges organiques dans la peinture de Van Gogh à Auvers :

- un carmin laqué à l'aluminium et à l'étain
- une éosine laquée à l'aluminium

Ces deux pigments qui ont une couleur très saturée à l'état pur, sont souvent dilués dans une grande quantité de blanc pour former des roses plus ou moins clairs. Le carmin est préférentiellement éclairci par du blanc de zinc tandis que la laque d'éosine est mélangée de blanc de plomb chargé au sulfate de baryum.

L'observation au microscope optique de coupes transversales des prélèvements permet de distinguer les parties superficielles entièrement décolorées et les parties plus profondes décolorées entièrement ou partiellement (Rioux 1999). D'après les analyses faites sur deux prélèvements effectués sur *L'église d'Auvers*, les résultats ne sont pas influencés par l'état d'altération de la couleur. Dans les roses à base de carmin, le pigment se présente sous la forme de grains très fins, pourpre foncé, individuellement discernables. Dans les roses à l'éosine, la coloration, moins violacée que dans le cas précédent, est plus diffuse et il est plus difficile de repérer des grains rouges isolés.

Le rose de la palette[9] est un carmin laqué à l'aluminium et à l'étain qui contient un peu de chrome, particularité qu'on retrouve dans les carmins de tous les tableaux. Le pigment décoloré des *Deux fillettes* du musée d'Orsay est différent de celui de l'autre version[2] qui est une laque rouge à l'éosine (Cadorin et al. 1987). Malgré l'identité du sujet et la proximité temporelle d'exécution, les deux versions se distinguent par la nature du pigment rouge.

La peinture du tube de « laque géranium » est une éosine laquée à l'aluminium.[10] L'image en électrons rétrodiffusés (mode composition) obtenue au microscope électronique à balayage permet de distinguer une matrice continue contenant la laque d'éosine (Br et Al) et des grains abondants très riches en plomb qui, d'après la couleur orangée observée après extraction du colorant, semblent être du minium. C'est probablement une « laque géranium » de composition semblable qui colore *Mademoiselle Gachet au jardin, Nature morte dit Roses et anémones* et le *Portrait du docteur Gachet*, œuvres qui sont toutes peintes dans les premiers jours de juin 1890.

On remarque que le carmin et l'éosine laquée ne coexistent pas sur un même tableau : chaque fois, l'artiste a choisi l'une ou l'autre couleur. Il ne s'agit pas d'une règle générale car un carmin laqué à l'aluminium et une éosine laquée ont été trouvés sur un même tableau de la période d'Arles : *Pêchers en fleurs* (Hofenk de Graaff et al. 1991). Dans cette même œuvre, l'analyse avait identifié du vermillon associé à l'éosine laquée. On retrouve un tel mélange dans *Nature morte dit Roses et anémones*. Van Gogh l'a peut être réalisé lui-même sur la palette mais il aurait pu utiliser un mélange déjà préparé. L'aspect homogène de la peinture rouge et l'absence de vermillon pur dans les tableaux étudiés incitent à favoriser cette seconde hypothèse.

Un carmin laqué à l'aluminium et à l'étain et une éosine laquée mélangée de vermillon ont été utilisés dans le triptyque : *Le verger rose*, *Pêchers en fleurs* et *Le verger blanc* (Hofenk de Graaff et al. 1991) comme dans les tableaux de la collection Gachet. On note cependant deux différences : un carmin laqué à l'aluminium seul et des charges au carbonate de calcium ou à la dolomite décelés dans les tableaux d'Amsterdam sont absents de ceux de la collection Gachet.

Conclusions

Le carmin et le rouge d'éosine sont l'un et l'autre des pigments fragiles puisque, dans tous les tableaux étudiés, ils ont entièrement perdu leur couleur sous l'action de la lumière. D'après sa correspondance,[11] on sait que Van Gogh était averti du risque, mais il semble qu'il l'ait mal mesuré : il imaginait qu'en accentuant la force des couleurs, il compenserait leur adoucissement ultérieur. Cette prévention était illusoire puisque, dans le cas du carmin et du rouge laqués qu'il a utilisés, l'altération ne se limite pas à une diminution de l'intensité colorée mais peut se poursuivre jusqu'à une décoloration totale.

Cependant, tous les pourpres et roses de Van Gogh ne sont pas systématiquement instables. Des couleurs roses en bon état apparent de conservation subsistent dans des tableaux peints à Auvers comme *Les roses*,[12] ou dans des tableaux d'époques plus anciennes. Bien qu'aucun exemple de rouge laqué réputé plus stable, garance ou alizarine, n'ait été trouvé dans ces six tableaux de la collection Gachet, l'artiste a probablement peint aussi avec ces pigments. Un plus grand nombre d'œuvres doit évidemment être analysé avant qu'on puisse avoir une idée plus précise de la fréquence d'usage de ces divers rouges organiques en rapport avec les sujets représentés et les périodes de création.

En déséquilibrant partiellement l'harmonie initiale des couleurs, la décoloration des roses et des pourpres entraîne une perte de qualité esthétique qui a pu influencer le jugement de critiques d'art non prévenus du phénomène. Celui-ci devra désormais être pris en compte puisqu'il présente un caractère assez général : dix tableaux au moins, six de la collection Gachet et quatre précédemment étudiés, en sont affectés. Il est très vraisemblable que d'autres cas devraient pouvoir être trouvés en particulier dans des œuvres peintes au cours des dernières années de la vie de Van Gogh mais aussi dans des tableaux de ses contemporains.

Notes

1. Paris, Musée d'Orsay.
2. Collection particulière, catalogue La Faille n° 784.
3. Amsterdam, Rijksmuseum Vincent Van Gogh (Fondation Vincent Van Gogh), catalogue La Faille n° 555, 404 et 403.
4. Lettres 475, 541a, 551, 584, 629, 638.
5. Paris, Musée d'Orsay, RF 2739.
6. Ce test caractérise les colorants dérivés de la fluorescéine mais n'est pas spécifique de l'éosine.
7. Bâle, Kunstsammlung, catalogue La Faille n° 772.
8. « Puis (mais chez Tasset) deux laques géranium, tube moyen format », lettre 629.
9. Analyse au microscope électronique à balayage par A. Duval.
10. La présence d'éosine avait déjà été décelée dans le contenu de ce tube quand, en 1967, une première analyse avait été faite au LRMF sous le contrôle de S. Delbourgo.
11. Lettre 476.
12. Copenhague, Ny Carlsberg Glyptotek, catalogue La Faille n° 595.

Références

Bang MM. 1991. Van Gogh's palette. In: A closer look, technical studies on works by Van Gogh and Gauguin. Cahier Vincent 3. Waanders Publishers, Zwolle: 57–60.

Cadorin P, Veillon M, Mühlethaler B.1987. Décoloration dans la couche picturale de certains tableaux de Vincent Van Gogh et de Paul Gauguin, 8e réunion triennale du comité de conservation de l'ICOM, Sydney : 267–273.

Cadorin P. 1991 Colour fading in Van Gogh and Gauguin. In: A closer look, technical studies on works by Van Gogh and Gauguin. Cahier Vincent 3. Waanders Publishers, Zwolle : 10–19.

Coffignier C. 1924. Couleurs et peintures, Paris, JB Baillière : 316–321.

Correspondance complète de Vincent Van Gogh. 1960. Paris.

Gachet P. 1994. Les 70 jours de Van Gogh à Auvers : 166.

Hofenk de Graaff JH, Karreman MFS, de Keijzer M, Roelofs WGT. 1991. Scientific investigation. In: A closer look, technical studies on works by Van Gogh and Gauguin. Cahier Vincent 3. Waanders Publishers, Zwolle :75–85.

Langstroth TA. 1973. Phloxine. In: Patton TC ed. Pigments handbook, volume 1, 1st edition : 629–633.

Mérimée JFL. 1830. De la peinture à l'huile.

Rioux JP. 1999. La décoloration de couleurs roses et pourpres dans des tableaux de Van Gogh peints à Auvers-sur-Oise, catalogue de l'exposition « Les collections du docteur Paul Gachet » (Musée d'Orsay), RMN, Paris.

Saunders D, Kirby J. 1994. Light induced colour changes in red and yellow lake pigments. National Gallery technical bulletin 15 : 79–97.

Schweppe H, Roosen-Runge H. 1986. Carmine, cochineal carmine and kermes carmine. In: Feller RL ed. Artists' pigments, volume 1 : 255–283.

Vibert JG. 1892. La science de la peinture.

Abstract

The author has interviewed contemporary American artists Andrew Wyeth and Jamie Wyeth and discusses issues connected with conservators advising artists. Conservation concerns include efflorescence and stability of the egg tempera medium, surface gloss, and localized application of varnishes.

Keywords

egg tempera, efflorescence, stearic acid, palmitic acid, Andrew Wyeth, Jamie Wyeth, artists' intent, varnish

Collaborations with living artists: The Wyeths (a.k.a. the Pennsylvania Bruegels)

Joyce Hill Stoner
Winterthur/UD Program in Art Conservation
Winterthur Museum,
Winterthur, DE 19735
USA
Fax: +1 302 888 4838
Email: joyce.stoner@mvs.udel.edu

Introduction

Since attending a conference on the conservation of contemporary art in Ottawa in 1980, I had been hoping to follow in the tradition of a number of the speakers and help to advise living artists about their materials and techniques. With the current enhanced emphasis on preventive conservation, this also seemed to be a timely pursuit. Discussions among the 1980 conference participants emphasized some of the challenges and pitfalls of such collaborations. Do conservators really know enough at this time to provide authoritative answers about materials on the market and their use? Artists listened to the conservators disagree on various points and wondered if there was any consensus among professionals on a number of issues. How much is it appropriate for conservators to interfere with creativity? I think of the "prime directive" of the "Star Trek" series – if you arrange the occasion to observe and study other civilizations, you must not change the course of their history. David Bomford has brought the "Heisenberg Uncertainty Principle" into his discussions of conservation issues; it is again appropriate when working with living artists. Will the act of observing a phenomenon change the phenomenon?

Background

In connection with a 1998–99 exhibition at the Farnsworth Museum in Maine and the Delaware Art Museum in Wilmington Delaware, USA, I was asked to prepare a catalogue supplement about the techniques of four generations of American artists, "A Closer Look" at:

- Howard Pyle (1853–1911), the Delaware artist and book illustrator praised by European artists William Morris, Joseph Pennell, and Vincent Van Gogh, who taught more than 100 students. N. C. Wyeth was recognized as his most successful student.
- N. C. Wyeth (1882–1945), successful American illustrator and artist who created powerful oil paintings reproduced as illustrations for classic editions of "Treasure Island," "Robin Hood," "Kidnapped," etc.
- Andrew Wyeth (born 1917), son and pupil of N. C., sometimes known as the most famous or most popular living American artist. His first one-man show in New York at the age of 20 sold out during the first day. He creates works of metaphoric and altered realism expressed largely in egg tempera on panels, watercolor, or drybrush.
- Jamie Wyeth (born 1946), son of Andrew, student of his father's sister Carolyn Wyeth, also had his first one-man exhibition in New York at the age of 20. Jamie's works remain popular with numerous collectors; he has painted animals, portraits, and eerie dreamscapes in oil over a career of 30 years and counting.

All four of the artists listed above, in writings or interviews, have denied the importance of "technique." Artists' resistance to discussing the "mechanics of art" mentioned by Leslie Carlyle in her study of nineteenth-century British instruction

manuals [1] and still prevalent today, presents an additional challenge for the well intentioned conservator. During the course of my studies and interviews, I have also carried out a number of treatments for the Wyeths. I was told by Betsy Wyeth (Andrew's wife, curator, and sometimes model) that "artists do not like to hear what is wrong with their paintings"; this of course complicates the writing of condition reports. At some point, a noted US conservator chided Andrew Wyeth directly about his techniques; this did not aid future open dialogues between the artist and the conservator.

Andrew Wyeth's tempera paintings on panel often present at least three issues for conservators: he pushes the tempera medium beyond traditional boundaries, and this sometimes causes insecurities in the paint film; he has asked that varnish be removed from some egg tempera paintings but be retained on others; and a white efflorescence exudes periodically from the egg medium. Jamie Wyeth generally uses traditional oil painting techniques but sometimes enhances the surfaces of paintings or frames with unusual materials, ranging from ground-up essence of pearl to seashells, and often intentionally varnishes only a portion of the overall painting.

Conservation concerns and the artists' intent

Andrew Wyeth learned the tempera on panel technique from his brother-in-law Peter Hurd (1904–1984), another of N. C. Wyeth's pupils. Hurd was from the southwestern US and for a 1932 mural commissioned for a Wilmington home, began using egg tempera on gessoed Masonite panels in pursuit of a dry fresco-like surface cousin to that of the Mexican muralists. Hurd interested Andrew and N. C. in the tempera technique, and by the end of the 1930s, all three artists were adept with this material. All three also scratched into the surface of their temperas, creating a unique surface texture I have not found in tempera works by other artists. Betsy Wyeth has watched all three artists paint and refers to their action as "fencing."

In my first interview with Andrew Wyeth, August, 1997, I learned that direct questioning was unlikely to be successful. I started talking about the "marvellous topography" of his temperas, but he stopped me immediately with "all good tempera painting should be completely smooth." Wyeth told me that he used the full traditional Cennino Cennini egg tempera technique complete with green underpainting for a 1938 portrait of his friend Walt Anderson. (This is a meticulous painting of a forceful single male face in a landscape, with discrete lines of tempera brushwork, and pure, bright, and true fresco- or tempera-typical earth colors.) He had given me a handout describing the Hurd version of Cennino Cennini's method, and I knew that several earlier interviewers had received the same paper and had assumed this was accurate. However, I said "you don't really do this now, do you." He smiled and said, "No, not anymore." Repeatedly burned by the press over the last 35 years, Wyeth has no reason to coddle interviewers and enjoys being elusive. His paintings reflect elements of himself – seemingly straightforward yet incorporating hidden messages which can be playful or lethal. A recent review in the New York Times called the family style "the weirdly cryptic" combined with "the excessively plain spoken."[2]

Wyeth works in both watercolor and tempera. He has said that watercolor "perfectly expresses the free side of my nature. . . . Watercolor shouldn't behave, it simply shouldn't."[3] Watercolor would be hard pressed to "behave" during the following scenario described by his biographer, Richard Meryman:

> Every watercolor has been like a battle, the outcome constantly in doubt. His breath fast, talking to himself, the glasses he wears paint-spattered with color, he attacks the paper with a frenzy, scratching it with the end of his brush, scraping it with a razor blade, dabbing at it with Kleenex. In 1993 Wyeth painted his artist son Jamie, who describes the process: It's absolute control that looks like a mess. Chaos. But he has absolute knowledge of what's going to happen without thinking about it. He was using like a two-quart saucepan filled with water. He had a wide brush with a long handle and he dipped in it and splashed it into the color and dragged it down across the paper in an absolutely straight line. As he pulled it away, there'd be just this tiny, tiny hairline.[4]

Figure 1. Tenant Farmer *by Andreu Wyeth, 1961. Tempera on panel, Delaware Art Museum, Wilmington.*

Figure 2. Detail of Figure 1. Note flaking where the edge of the roof was relocated.

His watercolors often contain straw or grass, gouges from the assertiveness of his touch, splashes from temperas carried out nearby, or dog paw prints; he throws many works on the floor while he is working.

Andrew Wyeth sees a danger and deadliness in "technical perfection" and uses his tempera medium in nontraditional ways. He told Thomas Hoving, former Director of the Metropolitan Museum, "now and then I have to take something and push it just as hard as I possibly can."[5] He sometimes builds his tempera paintings layer by layer, comparing them to tapestries or his wife Betsy's knitting. This multiple layering, sometimes caused by changing the location of a compositional element, can result in tiny flake losses in the tempera. (See Figs. 1, 2, *Tenant Farmer* by A. Wyeth, overall, after treatment, and detail, before treatment, of the change of the roof gable with attendant flaking.)

Another cause for paint insecurity may be the relative thirstiness of the preparatory gesso on the Masonite panels. He originally purchased "Renaissance Panels" made by the Weber company and still has a number of those stockpiled (often subject to unmonitored storage conditions), and has also used "Anjac" panels (which have shown cracks in the gesso) and panels made to order by various craftspeople. Variations in these panels are to be expected. In *Groundhog Day* at the Philadelphia Museum of Art, he changed the location of a cup and saucer on the breakfast table, scraping away the gesso in the pattern of a crater. The paint is secure within the scraped crater, but demonstrates cleavage around the edge of the crater; this may indicate that the thirsty gesso had robbed the paint of some of its necessary binding material. I discussed this with the artist who immediately asked if he should size future panels before painting on them. My best guess was "yes, I think so" but I felt the rather frightening realization that the answer was still an educated guess, especially considering the variations among the panels.

I can tell the artist and his family without hesitation what they already know— the importance of good storage and exhibition conditions. While in storage, some completed temperas on gessoed panels have got wet around the edges with predictable results. Because these are living artists with an extended family dedicated to the arts, the works are appreciated freely in varying locations in the renovated historic buildings where they live, with fluctuating climate control. A conservator's advice will not change this. Should it?

When the flaking is consolidated and losses inpainted, the dryness of the tempera surface must be maintained – usually. The surface mattness or gloss can also have significance as I will explain below. Andrew Wyeth was taught oil painting by his father. He abandoned oil painting after working in oil extensively in his teenage years. The process of painting in oil did not suit Andrew and could have placed him into direct competition with his father's peak period of his "Treasure Island" illustrations. Andrew told himself, "Andy, you can't compete with a man with his talents. You can't!"[6] He told his biographer Richard Meryman:

> Oil is hot and fiery, almost like a summer night, where tempera is a cool breeze, dry, crackling like winter branches blowing in the wind. I'm a dry person, really. I'm not a juicy painter. There's no fight in oil. It doesn't have the austere in it. The difference is like the difference between Beethoven and Bach.[7]

Tempera as a medium is associated with dryness in the mind of Andrew Wyeth. He compares its quality to "a cocoon-like feeling of dry lostness – almost a lonely feeling," "an Egyptian mummy, a marvellous beehive, or hornet's nest." The artist calls the dry, gray clapboards of the Olson house in Maine (setting for his work *Christina's World*, 1948, an icon of American painting) "a tinderbox, that crackling-dry, ancient, bones type of thing." A visit to the Olson house deepens the surrealistic, dry, dusty lonely feel. The house has been preserved with distressed surfaces of torn faded wallpaper, cracked grainy plaster, dog claw marks, and worn wood grain floors on which sharp geometric boxes of sunlight and shadow are projected through the windows. Reproductions of the Wyeth paintings related to each room are on display; this also provides a clear lesson in how Andrew Wyeth reconstructs and simplifies what might be considered reality.

Both Andrew Wyeth and his father N. C. saw Botticelli's *Birth of Venus* in 1940 when it visited the Museum of Modern Art. Andrew Wyeth refers to seeing that painting as a pivotal moment for him – that he had been impressed by how "dusty"

Figure 3. Oil Lamp *by Andrew Wyeth, 1945. Tempera on panel, private collection.*

it seemed, but that it had taken a number of years before this understanding of the quality of tempera truly "sank in."

Before his real assimilation of the dryness of tempera, Wyeth mentioned that he had varnished paintings such as *Night Hauling* of 1944 and *Oil Lamp* of 1945 (See Fig. 3). (This would have concurred with the practices of his father at the same time.) *Toll Rope* (1951) had also been varnished, but apparently by a dealer. Wyeth requested that the golden, shiny wax coating from the velvet black scene of *Night Hauling* be removed and approved my removal of varnish from *Toll Rope* (See Fig. 4, detail with varnish removed). With varnish removal, the facture of *Toll Rope* changed from a slick surface resembling an art book color plate to an essay in dust catching sunlight and abstract topography of wood grain and rope fibers. In the case of *Toll Rope*, Wyeth's signature had become embedded in the dealer-applied varnish; I had carefully cleaned around the signature, leaving it as a slightly shiny plateau. Andrew's son Jamie visited the studio and noted that it ought to be removed entirely and replaced. My next adventure (carried out after consultation with the museum director) then involved the actual removal of this signature while the artist stood by and carefully replaced it. Of course, now a 1951 painting has a 1998 signature.

In contrast, Andrew Wyeth has requested that *Oil Lamp* (an indoor portrait of Alvaro Olson, See Fig. 3) remain varnished. This works well because the varnish provides a golden mellowing tone suiting the lamplight in contrast to the bright clear sky of *Toll Rope*. There may be an additional significance to the varnish on *Oil Lamp*. This painting was in progress when Andrew's father N. C. was killed on a train crossing in 1945. N. C. Wyeth always varnished his own tempera paintings on panel and *Oil Lamp* retains an N. C.-like surface which may have a conscious or unconscious homage involved. This also reminds conservators who work with living artists never to generalize about their preferences and to proceed only painting by painting.

The third concern with Andrew Wyeth's works involves the periodic appearance of a powdery white efflorescence (See Fig. 5, detail of Fig. 1). Egg tempera paintings by Andrew Wyeth, Mark Rothko (1903–70), and the British tempera revival painters such as Joseph Southall (1861–1944) or Edward Wadsworth (1889–1949) all may occasionally exhibit this efflorescence on the surface of the paint.[8] The white powder has been analyzed by Lucy B McCrone of the McCrone Research Institute 1986, Beth Price of the Philadelphia Museum of Art 1994, and Janice Carlson of Winterthur Museum in 1997 to be a stearic or palmitic acid exuded as the egg medium matures and ages. There are variations in the form of the efflorescence, ranging from a powdery snow-like dust to a crystalline latticework. The efflorescence can be brushed away or removed with Shell solv and silk, but it seems to return. Wyeth paintings in various locations and museums have been waxed, varnished, or placed in a climate control boxes, but may continue to effloresce. One painting completed in fall of 1997 shows new efflorescence

Figure 4. Detail, raking light, of Toll Rope *by Andrew Wyeth, 1951. Tempera on panel, Delaware Art Museum, Wilmington. After removal of varnish.*

Figure 5. Detail of Figure 1 showing powdery white efflorescence of stearic and palmitic acid from the egg yolk medium, especially on the right side of the photograph.

biweekly. Wyeth had previously been told this efflorescence was mold and unfortunately had some of his works needlessly and possibly excessively fumigated. (Other works have actually shown mold due to damp storage conditions, complicating the dialogue.)

Jamie Wyeth uses oil paint on canvas or panel, charcoal, pen-and-ink or watercolor illustrations, and mixed media on toned boards. His choices of vehicles and subjects are distinctly different from those of his father; this is perhaps part of the reason they have remained close friends and artistic colleagues. He left school in the 6th grade to be tutored at home in the morning and studied painting with his artist aunt, Carolyn Wyeth in the afternoons. Jamie Wyeth's love of the medium of oil dates from oil paint tubes left in Carolyn Wyeth's studio (which had formerly been occupied by his grandfather N. C. Wyeth). He noted:

> It would have been very abnormal for me not to be in a room that did not have paint lying around. I do remember oil as my first interest. I have an Aunt Carolyn who painted and I suppose my real interest started in oil just because I loved the way she squeezed it out – it looked so edible, you know. When I was six or something I would walk in and see it squirt – burnt sienna and raw umber, and I swear that is the only reason I got interested in oil. Just the consistency looked so wonderful. And then I tried them. My father works in tempera which I did try. All the properties he likes I dislike and vice versa. I like the moistest ones. He likes the dryness of tempera. I think these choices are purely personal.[9]

To paint accurate humans and animals, Jamie Wyeth has dissected corpses in a NY morgue, collected taxidermy specimens, kept a wolf in his living room, studied sharks in a specially built tank, constructed a studio in his barn, and raised an abandoned vulture. He has recently devoted hours of study to ravens and gulls, luring them with carcasses to his island home. He has noted that when he paints outdoors insects are often entombed in the paint.

In the 1960s and '70s he painted a number of paintings featuring the textures of lattice work or wicker; these surfaces reveal copious scrapings and rubbings. The artist explained his "subtractive" methods for both oil and watercolor in 1982:

> To take it right down to either the canvas or to the paper, you lift off when it is wet, either with your finger nail or with a knife or with whatever tool you have at the time. And then of course it leaves some residue of color but it creates a sort of void that has been left.

[He noted that restorers have sometimes retouched such intentional voids in his father's paintings – highlights in a metal stove.][10]

Accents in texture and variation in surface gloss are another unique attribute of Jamie Wyeth's work. For at least three paintings Jamie painted accents composed of essence of pearl; he has ordered a mixture of ground-up pearl in an oil medium

Figure 6. Comet by Jamie Wyeth, 1997. Oil on panel, private collection.

Figure 7. Detail of Figure 6 showing enhanced varnish on the top of the lighthouse.

Figure 8. Sunset, Southern Island *by Jamie Wyeth, 1995. Oil on panel, private collection.*

which creates a pearly opalescence in the final surface. This unusual effect is visible in the stars and comet in "Comet" (1997) (See Fig. 6). He has also occasionally decorated frames with incised lettering or attached seashells. For mixed media works on paper in the late 1970s and early '80s; he would varnish only the eye of a goose noting "in the actual goose that was the liquid area among the flats and tones."

On some of his recent works, the artist has added extra varnish to selected areas of the paintings, causing conservation concerns analogous to works by Kasimir Malevich (1878–1935) or Juan Gris (1887–1927). The top of the lighthouse of *Comet* has enhanced varnish (See Fig. 7, detail of Fig. 6). Two paintings of the same troubled looking young woman of the 1990s, *Sunset: Southern Island*, 1995 (See Fig. 8), and *If Once You Have Slept on an Island*, 1996, have intentionally glossy surfaces on the face of the sitter or the pane of glass over her face. Such special effects are often changed by conservation treatments; a conservator might misunderstand the artist's intent and apply an overall varnish to homogenize the surface. Several earlier works by Jamie Wyeth that he had varnished only locally were later varnished overall; he described one looking like an "ice skating rink" or a "bug in ambergris."

Conclusion and dialogues continue . . .

It is important but constantly challenging to work with living artists. Both Jamie Wyeth and Andrew Wyeth are reclusive and elusive and generally will not answer direct questions. (Both have lived, at different times, in the lighthouse in Maine depicted in *Comet*, Fig. 6). Both are artists who have attained commercial success, but both continue to get up before 6:00 a.m. and spend most of every day painting. As one might intuit from their dedication, they do seem to be concerned about the longevity of their works, even if they are reluctant to discuss this directly. Jamie has now begun following leads I provided for a paper maker who can make archivally sound brown cardboard for his mixed media works, and both Andrew and Jamie have given us panels to test for them at the Winterthur/UD Program in Art Conservation. Andrew has previewed my 60-minute slide lecture about his own work and the work of his father and his son. I have been privileged to be among the first viewers to see new works, a moment when one is acutely aware of the artists' antennae – finely tuned for the smallest reactions. Will the act of observing the phenomenon change the phenomenon? Possibly. This reminds us all: "be careful what you wish for."

Acknowledgements

Thanks to Herbert L. Crossan for his help with the photographs and to the artists, their families, and their staff for gracious assistance.

Notes

1. Carlyle L. 1998. Design, technique and execution: the dichotomy between theory and craft in nineteenth century British instruction manuals on oil painting. In: Hermans E. Looking through paintings. London: Archetype Publications: 19–28.
2. Gopnik A. 1998. 'Pictures great,' his publisher told him. New York Times Book Review 15 November, 15–16.
3. Hoving T. 1978. Two worlds of Andrew Wyeth: a conversation with Andrew Wyeth. Boston: Houghton Mifflin: 33.
4. Meryman R. 1996. Andrew Wyeth: a secret life. New York: Harper Collins: 111.
5. Hoving, 28.
6. Wyeth A. 1987. N. C. Wyeth. In: An American vision: Three generations of Wyeth art. New York: Little, Brown and Co.: 85.
7. Meryman, 118.
8. See also Mancusi-Ungaro C. 1981. Preliminary studies for the conservation of the Rothko Chapel paintings: an investigative approach." In: AIC preprints. Philadelphia, 109–113, and Dunkerton J. 1980. Joseph Southall's tempera paintings. In: Joseph Southall 1861–1944. Birmingham: Birmingham Museums and Art Gallery: 22.
9. Jamie Wyeth, interview with the author 15 June 1982 and 29 December 1997.
10. Andrew Wyeth elaborated on this event in an interview in August 1997; the painting was a watercolor where he had used the end of the brush to score away the black pigment to create the stove pipe vent switch. This accent was retouched when the painting was reframed.

Abstract

On the basis of Raphael's *Transfiguration of Christ* (c. 1520), it is demonstrated that to properly interpret the use of colour in paintings a distinction must be made between those aspects of colour that were intended by the painter and those caused by ageing. In the literature, it has been assumed that the deep black shadows and the abrupt transitions between light and dark as they now can be observed in the bottom half of the *Transfiguration* were deliberately conceived by Raphael. Comparison with preliminary studies and copies, and investigation of the paint surface, however, has shown that these areas of shadow have darkened considerably. Through this discolouration, the contrast between light and dark was enhanced, thereby generating the suggestion of a theatrical, dramatic illumination. This effect, in the literature considered as an essential feature of the painting, does not appear to have been intended by Raphael.

Keywords

Raphael, *Transfiguration of Christ*, light and shadow, discolouration, original appearance, drying cracks, lampblack, Vasari

Chiaroscuro or discolouration? The interpretation of dark areas in Raphael's *Transfiguration*

Margriet van Eikema Hommes
MOLART (Molecular Aspects of Ageing of Painted Art)
Kunsthistorisch Instituut der Universiteit van Amsterdam
Herengracht 286
1016 BX Amsterdam
The Netherlands
Fax: + 31 20-5253023
Email: eikema@amolf.nl

Raphael's *Transfiguration of Christ*

The *Transfiguration* (panel, 405 × 278cm) was commissioned by Cardinal Giulio de'Medici for the Cathedral in Narbonne probably around 1515 (See Fig. 1). At about the same time, the Cardinal also commissioned Sebastiano del Piombo to paint a *Raising of Lazarus*, possibly with the aim of creating a competitive situation and spur both painters to excel. After Raphael's sudden death in 1520, it was decided to leave the *Transfiguration* in Rome, and in 1523 the work was placed in S. Pietro in Montorio, where it hung until the end of the eighteenth century. The painting is presently in the Pinacoteca of the Vatican (Drussler 1971).

The top half of the painting shows the Transfiguration of Christ on Mount Tabor between Moses and Elijah, as was witnessed by the apostles Peter, James and John. Raphael enriched the scene with an episode that takes place after the Transfiguration in the biblical account. When Christ descended from Mount Tabor, he heard that the other nine apostles had attempted to heal a youth possessed by demons, to no avail. Depicting the Transfiguration and the failed healing in a single scene is Raphael's new invention (Oberhuber 1962).

The interpretation of the dark areas in the art historical literature

The use of colour in Raphael's last painting has interested art connoisseurs and later on art historians since the sixteenth century. As of the eighteenth century, the question of why the depiction of light and shadow in the *Transfiguration* deviates so greatly from that in Raphael's other paintings has been an ongoing subject of discussion. Only in the top half of the painting with the Transfiguration scene, does the treatment of light display similarities with Raphael's earlier work. Transitions in the modelling of the figures are gradually indicated. The shadows are not very dark and thus still have an identifiable colour and the forms in shadow are easily read. The bottom half with the healing scene contrasts greatly. The very dark shadows partly flow into a black background. These black shadows and abrupt transitions that have so little to do with Raphael's manner of painting puzzled art historians in the past, including Burckhardt, Dollmayr, Von Rumohr, and Wölfflin and even today are a topical subject.[1] The shadows have been variously interpreted throughout the centuries. Already in the middle of the eighteenth century it was thought that Raphael was not solely responsible for the painting's execution. After his sudden death, the bottom half of the work would have been still largely unfinished and it was suggested that his pupils, not fully understanding their master's intentions, had completed the painting. Also during the nineteenth and twentieth century, most authors considered the black shadows as 'colouristic impurities', for which Raphael's pupil Giulio Romano was held accountable. The technical investigation conducted during the last restoration (1972–1976), however, uncovered facts that cast an entirely different light on the genesis of the painting (Mancinelli 1977). It appeared that the work was not completed in various places: the shapes in these places are sketchily laid on in a single paint layer and lack the elaboration characterising the other areas of the painting–a practice that is known also from other unfinished paintings by Raphael. This indicates that

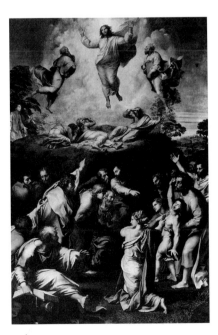

Figure 1. Raphaël, Transfiguration of Christ *(panel, 4.05 × 2.78 cm). Rome, Pinacoteca of the Vatican Museum.*

Figure 2. Cartoon for the face of the disdainful apostle in the middle. London, British Library.

Figure 3. Cartoon for seated apostle at the left. Vienna, Albertina.

Figure 4. Face of the disdainful apostle in the middle, detail of the Transfiguration *by Raphael, after restoration.*

Raphael's pupils did not attempt to complete the painting in his style after his death. Because the painting was produced under competitive circumstances, it is even more plausible that Raphael was not assisted by his pupils. For these reasons it is now assumed that the *Transfiguration* was painted entirely by Raphael. This confirms Vasari's version of the genesis of the work. He emphasised that Raphael was solely responsible for the painting and allowed no one else to work on it (Milanesi 1879).

Since the restoration, the use of colour in the painting has once again received a great deal of attention; just as in the older investigations, the meaning of the black shadows and the abrupt transitions between light and dark occupy a central role. The difference, however, is that while formerly the shadows were considered problematic, they are now positively judged since having been deemed autograph. Marcia Hall expressed the currently accepted interpretation in *Colour and meaning* (1992) as follows: at the end of his life Raphael began exploring new means of rendering colour and light and shadow 'searching for a color style appropriate to the content of the depiction.' In this line of reasoning, Raphael deliberately chose strong contrasts between the highlights and shadows –the so-called chiaroscuro mode–to obtain a theatrical effect. 'The shadows are blackish, dark and deep in tone. [...] The transitions are as a rule abrupt to maximise the drama.' According to Hall, as well as other authors, including Caron, Oberhuber and Mancinelli (1977), this theatrical effect served to accentuate the apostles' failed attempt to heal the possessed boy. Raphael used this treatment of light as a metaphor of earthly impotence to accentuate the contrast with the divine victory of Christ (Hall 1992).

It is striking that neither Hall nor the other modern authors who have interpreted the nature of the shadows in the *Transfiguration* address a comment by Vasari on precisely this subject. In the second revised edition of his Vite (1568), Vasari discussed the shadows in the *Transfiguration* at length.

> And if he [Raphael] in this work, as on a whim, had not used the soot of the printers [lampblack] (which, as has been noted more than once, by nature darkens steadily in the course of time and spoils the other colours with which it is mixed), then this painting might have looked as fresh as when he painted it, while presently its appearance differs greatly (Milanesi 1879).

Because the figures in the top half are illuminated by the vivid divine light whereby most shadows are faintly coloured, Vasari's remark will have referred to the dark areas in the lower half of the painting. The black shadows and resulting abrupt transitions so prized in the modern literature, according to Vasari were not so intended by Raphael. Quite the contrary, they are the result of discolouration caused by the use of improper material! Hence, we are faced here with two contradictory views as to the original appearance of the painting. These differences have far-reaching implications for the interpretation of the image with respect to Raphael's stylistic development as well as for the iconography. There are consequences as well for the more general interpretation of the treatment of light and colour in sixteenth-century painting. If the handling of light as we now observe it was ever intended by Raphael, this would mean that in the beginning of the sixteenth century light was ascribed a strong expressive – dramatic and theatrical – charge. The question of who is right here, Vasari or the modern authors, assumes great importance. Do or do not the dark shadows agree with Raphael's intentions? This article presents a way of answering these questions.

Comparison of the Transfiguration *with preliminary studies and the copy by Penni*

Insight is gained into Raphael's intentions with respect to the treatment of light in the *Transfiguration* by looking at preliminary studies for this painting (Oberhuber 1962). Especially the auxiliary cartoons for the faces of the apostles in the *Transfigurations* are extremely valuable for this purpose. These drawings functioned as an intermediary-stage between the cartoon and the final painting and were used by Raphael for determining the modelling, light and shadow (Fischel 1937). In these drawings, the direction of the light is always identical to that in the painting. In a few of the drawn apostle heads, the modelling is indicated in gradual

Figure 5. Overexposed detail during restoration of the head of the seated apostle at the left. Photograph: archive of the Laboratorio di Restauri Monumenti e Musei delle Galleria Pontefici of the Vatican Museum.

Figure 6. Giovanni Francesco Penni, detail of Transfiguration of Christ *(2.36 × 2.63cm). Madrid, Prado Museum. Photograph: Madrid, Prado Museum.*

transitions, but in other cartoons there is a clearer contrast between the light and shaded areas. These shadows, however, are significantly less dark than those in the painting and suggest shapes and curves through tonal variations in which the play of the reflections in the shadows assume an important role. In the study for the disdainful apostle in the middle, his beard and the right half of his head are modelled in various tones of grey (See Fig. 2). In the cartoon for the seated apostle at the left, the reflections in the shaded areas, such as the neck and ear, sleep and the profile are clearly indicated (See Fig. 3). These details are difficult to distinguished in the painting (See Fig. 4). The shadows are so dark that they hardly contain any information about the modelling of the shaded shapes, which can only be discerned in very strong light (See Fig. 5). This would seem to indicate that the shaded areas in the painting have darkened considerably. The contrast between light and dark has thus become greater than Raphael ever intended.

In the Prado is a copy of the *Transfiguration* in oil (panel, 3.96 × 2.63cm) by Raphael's pupil Giovanni Francesco Penni (See Fig. 6). According to Vasari, this copy was made shortly after Raphael's death in order to be sent to France instead of the original (Milanesi 1879). Penni introduced a number of changes with respect to the original, for instance the drapery of the kneeling woman and seated apostle at the left is pink rather than blue and the trees in the background have been omitted. On the other hand, Penni actually followed Raphael very closely in the elaboration of the modelling in the drapery and in the flesh tones. The curves and the flow of the folds agree down to the finest details. While the copy in turn has also aged, it can still provide clues to Raphael's original intentions with respect to the handling of the shadows. Despite the fact that Penni's painting is covered with a dirty and yellowed varnish, one can see that many of the shaded areas are less dark than those in the original. The back of the head and upper body of the apostle in the yellow gown pointing to the possessed youth can be clearly distinguished from their surroundings, while in the Raphael they simply merge into the black background. In the face of the young, bent-over apostle in Penni's copy the contrast between light and dark is less strong than in the original and in these shadows, just as in the cartoons, more nuances can be distinguished. Other details, too, confirm the conjecture voiced above that the shaded areas in Raphael's painting have discoloured considerably.

Examination of the paint surface

Material changes have occurred in the surface of Raphael's painting which confirm that the tonal balance has changed markedly (Brandi 1975).[2] Particularly in the bottom half, large parts of the surface exhibit craquelure which often reveals the underlying paint layer or the white of the ground. The paint has contracted into islets in a way typical of shrinkage cracks caused by drying.

In the *Transfiguration* these cracks appear mostly in the dark areas. The surface of the light passages, where the paint is mixed with lead white, is on the whole still smooth. Cracks are visible in large sections of the landscape, in the foreground and locally in the shadow areas of figures in the top half of the painting. Most of the cracking occurs in the bottom half. Virtually all of the figures have craquelure to a greater or lesser extent in much of the shaded areas. Pronounced fissures, sometimes several millimetres wide, are visible in the black shadows of the blue robes of the kneeling woman and the sitting apostle (See Fig. 7). The shadows in the yellow robe of this same apostle also show craquelure in many of the dark passages, as do the robes painted in red lake of the apostle pointing upwards and of the kneeling woman. These last examples have finer cracks. The flesh tints, too, frequently reveal shrinkage cracks in the shadows. These are particularly noticeable in the dark area at the neck and profile of the sitting apostle (See Fig. 5). At various points in the areas of cracking a 'blanching' effect can be seen on the surface.[2]

Shrinkage cracks occur for various reasons, such as when fast-drying paint has been applied over layers that have not thoroughly dried or when pigments that retard or even prevent the drying of the oil, such as bitumen, have been used. Excessive use of siccatives, which accelerates the drying process unduly, can also cause premature cracking (Hess 1965). In the case of the *Transfiguration* the cracking might be related to Raphael's choice of pigments (red lake, azurite,

Figure 7. Photograph during the restoration of the blue cloak of the woman kneeling. Photograph: archive of the Laboratorio di Restauri Monumenti e Musei delle Galleria Pontefici of the Vatican Museum.

ochres and black pigments) for the shaded areas that all required a large amount of oil to make them into paint and also produce a very slow drying paint. It is conceivable that for these passages, as advised by historical sources on painting techniques, Raphael used a 'drying' pre-polymerised oil, possibly in combination with siccatives (e.g. Berger 1973). A few points where the paint has run down in the bottom half of the work do indeed suggest such a smooth-flowing, bodied oil. The thick, impastoed application of the paint in these dark areas may also have contributed to the craquelure, since the areas where dark paint has been put on very thinly are generally free of cracks.

Given that the cracking is connected to the drying of the paint, it must have occurred quite soon after the completion of the work. It has often been noted that dark areas in paintings that show premature cracking, have often darkened considerably.[3] And, this is what seems to have happened in the case of the *Transfiguration*: where there is craquelure, the paint surface has an even and dark appearance. The high oil-absorbing capacity of the pigments used–possibly in combination with a pre-polymerised oil and siccatives–may indeed have resulted in rapid darkening (Eibner 1928). The cracked and dark areas correspond to those passages which – through comparison with drawings and copies – were known to have darkened considerably. If these changes did take place shortly after the work was finished, this would confirm Vasari's observation that it had darkened noticeably within a time-span of some forty years after its completion.

Lampblack as a possible cause of discolouration

Vasari had a clear-cut view as to the cause of the darkening of the shaded areas. According to him, it was due to Raphael's use of 'printer's soot' or lampblack. Consisting largely of carbon, lampblack was made by burning oil, tar, pitch or resin in an enclosed space. Incomplete combustion produced a large amount of soot that was deposited on the walls and could then be scraped off. The end product was a very fine, slightly greasy, deep black pigment which was used chiefly in book printing (Kittel 1961: Winter 1983).

Microscopic examination of cross sections of paint samples during the restoration (1974) revealed that Raphael used black pigments in the shaded passages of the *Transfiguration*. However, lampblack was not identified (Brandi 1975). The obvious conclusion would seem to be that Vasari was mistaken. However it must be remenbered that the extremely fine lampblack is only visible under very high magnification, which may explain why it was not detected during the restoration. Re-examination of the old cross-sections may yield new information. Unfortunately, at the time of writing these cross-sections were not available for examination and no new sample could be taken. As Vasari's information about both the authenticity and the darkening of the *Transfiguration* prove to be reliable, there is every reason to examine more closely his remark about the discolouring of paints containing lampblack. Vasari could have been well informed about the pigments Raphael used because he was personally aquainted with Giulio Romano, who was a pupil of Raphael at the time that Raphael was working on the *Transfiguration*.

According to Vasari, lampblack had caused the discolouration of works by other artists as well. Discussing the shaded areas in a painting by Fra Bartolomeo in which lampblack and ivory black were said to have been used, he wrote:

> and at present this panel has greatly darkened, [it is] darker than when he made it because of the blacks mentioned, which always turn darker and blacker. (Milanesi 1879).

Vasari was not alone in his belief that lampblack caused paint to discolour during ageing. A review of sixteenth- and seventeenth-century texts on oil painting shows that artists must have encountered many problems with this pigment. De Mayerne (1573–1655) stated that it yellowed[3] and the Brussels Manuscript (1635) warned that it 'is venom to the other colours' (Merrifield 1967). The English painter Henry Gyles (1645–1709) noted that: 'Some will use no lampe blacke in their pictures in oyle [...] for say they it will fade in time' (Gyles 1660). The Dutch painter Eikelenberg observed at the end of the seventeenth century that passages in which

lampblack was mixed with lead white could obtain a whitish appearance (*witachtig uitslaan*) as though weather-stained' (*als was het weder in*) (Eikelenberg 1679–1735). This phenomenon may be similar to the 'blanching' that has appeared locally in Raphael's painting.

The precise causes of the discolouring mentioned in the sources (darkening, yellowing, whitish appearance) have not yet been established. These problems may be related to the high oil-absorbency of lampblack and to the very slow drying process of the paint. The sources warn that the paint never dries of its own accord and must always be treated with a 'drying' oil, possibly in combination with siccatives (Berger 1973). In addition, because burning could not be precisely controlled, lampblack in the past contained a high proportion of tar and other hydrocarbon compounds (Stijnman 1998). These contaminants could retard the already slow drying process still further and permeate or 'bleed' into other paint layers (Kittel 1961: Hess 1965). Thus the use of a pure pigment was of the greatest importance in oil painting. From the beginning of the seventeenth century the sources draw a link between the purity of lampblack and the durability of the paint. There were also methods for 'burning' lampblack to ensure a long-lasting result. De Mayerne noted for example: 'Lampblack discolours yet if put in a well-sealed pot and set on coals and burned, it discolours not at all' (Berger 1973). Henri Gyles (1660) left lampblack glowing in an open pan on hot coals until it stopped smoking 'then it will continue well in oyle painting otherwise it will not.' Both methods, particularly that of Gyles, are extremely primitive compared with the advanced techniques that came to be used later (Kittel 1961: Stijnman 1998). Burning lampblack seems to have been a relatively new technique which painters themselves practised. This process may not yet have been in use in Raphael's time, and the discolourations which were noted not much later may have been linked to the impurity of the black.

Conclusion

In interpreting the dark passages in Raphael's *Transfiguration*, it appears to be essential to distinguish between those aspects of colour that were intended by the painter and those caused by ageing. In the modern literature it is assumed that the dark shadows and abrupt transitions between light and dark were intended by Raphael. A comparison with studies and copies reveals, however, that the tonal balance in Raphael's *Transfiguration* has changed markedly. The shaded areas have darkened considerably, so that now they contain little information about the modelling of the forms in shadow. This discolouration appears to have taken place quite soon after the work was completed. This supports Vasari's observation that within forty years the painting was badly discoloured locally. The darkening of the shaded passages has had the effect of increasing the contrast between light and dark, leading to the suggestion of theatrical, dramatic lighting. However, this effect, regarded in the literature as an significant feature of the work with an expressive meaning, was not intended by Raphael. It is clear from a survey of sixteenth-century Italian theoretical writing that the handling of light and shadow did not have this kind of expressive association at that time. The function of illumination in paintings must instead be sought in the depiction of rilievo; the convincing three-dimensional representation of objects on a flat surface. Once we accept that the present appearance of light and shadow in the *Transfiguration* is due in part to ageing, the lighting in the bottom half of the painting turns out to accord well with the ideas about rilievo in Raphael's time. This will be the subject of a forthcoming publication.

Acknowledgements

I am greatly indebted to Professor Maurizio de Luca, head of the Laboratorio di Restauri Monumenti e Musei delle Galleria Pontefici of the Vatican Museum, who made it possible for me to examine the *Transfiguration* and who kindly allowed me to consult the – partly unpublished – restoration reports. I also thank Professor Ernst van de Wetering and Michiel Franken of the University of Amsterdam, Karin Groen of the Netherlandish Institute for Cultural Heritage and Arie Wallert from

the Rijksmuseum, Amsterdam for reading and commenting on the text. Lastly, I am grateful to Ad Stijnman of the Netherlandish Institute for Cultural Heritage for his help with the research into lampblack.

Notes

1. A survey of the reception history of the dark areas will be published elsewhere.
2. In this connection the observations of Luigi Brandi were of great value; he examined the surface of the painting minutely during the last restoration.
 Brandi L.1975. Osservatzione di tutti i danni e delle particolarita di ogni natura fatte sull'intera superficie cromatica delle Trasfigurazione di Raffaello da Urbino dopo la pulitura della restauro della Trasfigurazione.(unpublished report).
3. For example in *The poacher* [1857] of Decamps. [Mesdag mueseum inv.108, The Hague] verbal communication: Rene Boitelle, Van Gogh Museum, Amsterdam.

References

Berger E. 1973. Quellen für Maltechnik während der Renaissance und deren Folgezeit. Walluf bei Wiesbaden 1973 (1e editie, München 1901).

Brandi L.1975. Considerazioni sulla tecnica tenuta da Raffaello[...]Bollettina dei Musei Vaticani.s.d.

Dussler L.1971. Raphael: A critical catalogue of his pictures, wallpaintings and tapestries. London. New York.

Eibner A. 1928. Entwicklung und Werkstoffe der Tafelmalerei.München.

Eikelenberg S.1679–1735. Aantekeningen over Schilderkunst. Gemeente Archief Alkmaar.

Fischel O. 1937. Raphael's auxiliary cartoons. The Burlington Magazine 71: 167–168

Gyles H. about 1660. Henry Gyles notebooks. Harley M.S.6376. British Library

Hall M. 1992. Color and meaning, practice and theory in Renaissance painting, Cambridge.

Hess M, ed. 1965 Paint film defects, their causes and cure. London.

Kittel H. 1961. Pigmente, Herstellung, Eigenschaften, Anwendung. Stuttgart.

Mancinelli F.1977. A masterpiece in close up: the Transfiguration by Raphael[...]Vatican City.

Merrifield MP 1967. Original treatises on the arts of painting.dl.2 New York.

Milanesi G. 1879. Le vite [...]. Florence.

Oberhuber K.1962. Vorzeichnungen zu Raffaels Transfiguration.Jahrbuch der Berliner Museen. 4:116–149.

Oberhuber K.1972. Entwürfe zu Werke Raphaels und seiner Schule im Vatikan 1511. Berlin.

Stijnman A. 1998. Lampzwart in bronnen over de boekdrukkunst.(unpublished report) Netherlandish Institute for Cultural Heritage.

Winter J.1983. The characterization of pigments based on carbon. Studies in conservation 28: 49–66.

Sculpture and polychromy

Sculpture et polychromie

Résumé

Il s'agit de la conservation-restauration d'un retable baroque dont on ne connaissait pas le montage original, constitué de deux retables différents et dans un très mauvais état de conservation. Après avoir étudié les morceaux du retable démonté, des photos et des archives, désinsectisé et consolidé le bois, dégagé des repeints et refixé la polychromie, il fallut remonter un retable plausible en reconstituant les manques indispensables à la solidité et à la lisibilité de l'œuvre. Après le remontage à l'aide d'une structure de soutien à l'arrière, une réintégration non illusionniste des réfections fut effectuée.

Mots-clés

sculpture, retable, bois polychrome, 18ème siècle

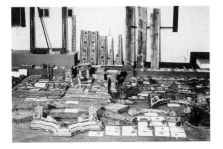

Figure 1. Le retable démonté à l'atelier; premier inventaire des morceaux

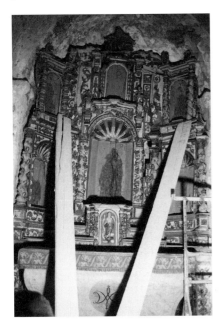

Figure 2. Le retable avant démontage.

Problématique et traitement de conservation-restauration d'un retable baroque catalan

Isabelle Desperamont-Jubal
Centre Départemental de Conservation-Restauration des Œuvres d'Art
150 av. de Milan, zone Saint Charles
66000 Perpignan
France
Fax : + 33 04 68 54 45 61

Introduction

Le département des Pyrénées Orientales conserve dans ses églises un patrimoine immense en sculptures de bois polychrome. Les retables seraient environ un millier, parmi lesquels la période baroque (fin 17ème–1ère moitié du 18ème siècle) est particulièrement bien représentée.[1]

Le Centre Départemental de Conservation-Restauration des Œuvres d'Art dans le cadre duquel s'est effectué le traitement du retable, est une structure au service des communes du département, dépendant entièrement du Conseil Général, et dont les prestations sont prises en charge à 90 ou 95% par celui-ci.[2]

Le retable est dédié à Saint Martin et occupe la place du maître-autel dans l'église paroissiale de Nohèdes, petite commune montagnarde des Pyrénées Orientales. Ce monument est représentatif de la fièvre bâtisseuse des 17ème et 18ème siècles, où chaque commune du département, même la plus pauvre, se dota d'un ou plusieurs retables en bois sculpté, polychromé et doré.

Le très mauvais état de ce retable et sa problématique nous amenèrent à étaler sa restauration sur plusieurs années et à adopter une méthode particulière. Nous exposerons comment l'étude, la conservation puis la reconstitution de ce retable ont été menées et nous évoquerons également les questions que peut poser ce type de restauration.[3]

Premier bilan de la situation

Le retable fut pris en charge, démonté et amené dans les locaux du Centre avant que je ne travaille moi-même pour cette structure. Un premier dépoussiérage, tri et inventaire des morceaux, au nombre de 130 (voir Fig. 1), ainsi qu'un traitement de désinsectisation par voie liquide, avaient également été effectués. Chaque partie avait reçu une lettre et un numéro que nous conservâmes par la suite : les niches portaient par exemple la lettre « N », les colonnes « C », les éléments sculptés « ES », puis suivait un chiffre donné par ordre d'arrivée.

A partir de là, nous avons mis au point des fiches individuelles : dimensions, numéro d'inventaire, description de la forme, du support, de la polychromie, localisation avant démontage et celle supposée bonne, état de conservation, intervention sur le support et la polychromie. Après une première étude de chaque morceau et des photographies avant démontage, on put faire un premier bilan de la situation et envisager la démarche à suivre pour le traitement.

L'examen de la photo avant démontage (voir Fig. 2) permit de constater qu'il s'agissait d'une reconstruction de retable, totalement fantaisiste, ne respectant pas du tout l'emplacement réel des différents morceaux : quart-colonnes assemblés deux à deux pour former des demi-colonnes, montants verticaux placés horizontalement, « guardapols » au milieu de la construction, ...[4] De plus, le retable, dont on avait déjà retiré les statues, semblait en phase d'effondrement, retenu par devant à l'aide de grandes planches.

Les morceaux nous apparurent dans un état ruiné : le bois était localement très fragilisé ou avait tout à fait disparu suite à une attaque importante d'insectes xylophages (type petites vrillettes) et à une très grande humidité;[5] de nombreux

Figure 3. Montants de la niche centrale, avant traitement : découpages «sauvages », bronzine oxydée sur les reliefs dorés.

reliefs étaient décollés (hydrolyse de la colle) ou arrachés, souvent perdus parfois recloués de manière fantaisiste; les planches étaient fendues, déformées, les assemblages disjoints; des découpages sauvages avaient mutilé la quasi-totalité des éléments (voir Fig. 3), sans doute pour les adapter au nouveau montage; l'ensemble était très encrassé; des repeints de très mauvaise qualité empâtaient les reliefs, débordaient sans respecter les volumes et s'écaillaient; de la bronzine extrêmement oxydée, de couleur brune à verdâtre, couvrait la majorité des reliefs sculptés; enfin, le démontage, probablement un peu trop rapide, avait contribué à accentuer la dégradation avec de nombreux arrachements autour des clous.

Le retable s'avéra constitué de deux retables différents que nous nommerons retable 1 et retable 2.

- au niveau de la structure : l'ensemble est en bois de résineux présentant de nombreux nœuds; les planches peuvent atteindre 5cm d'épaisseur pour le retable 1; les assemblages originaux sont réalisés par tenons et mortaises, queues d'aronde, chevilles de bois, clous et collages (colle de nature protéique). Sur les faces non visibles, des tracés gravés ont été effectués pour repérer les assemblages.
- au niveau de la sculpture : le retable 1 présente des motifs en haut relief, parfois même presque détachés du support, qui montrent une grande maîtrise du travail; certains sont sculptés dans la masse lorsque les planches sont épaisses; les motifs sont végétaux (acanthe, laurier), floraux (rose, type fleur de pavot, de chardon, ...) et fruitiers (raisin, grenade, type coing, ...); quatre têtes d'angelots ailées ornent le tabernacle.

 Le retable 2 présente des motifs en bas et moyen relief, beaucoup moins variés et raffinés, mais toutefois d'une bonne facture; on y retrouve des feuilles d'acanthe, des roses et autres petites fleurs; la tendance est à une géométrisation et une stylisation du décor.
- au niveau de la polychromie : les repeints, au nombre de quatre, sont les mêmes sur tous les éléments; le retable était déjà remanié lors du premier repeint (parties originales masquées et donc jamais repeintes) et ensuite les modifications semblent avoir été beaucoup moins importantes; ils sont tous de qualité assez médiocre; la bronzine doit être contemporaine du dernier repeint.

 Les polychromies originales sont du même type sur les deux retables : préparation blanche, dorure à la détrempe majoritairement polie sur assiette rouge pour les reliefs sculptés et les moulures, couleur à la détrempe, blanche pour le retable 1, bleu clair pour le retable 2 avec un fini poli donnant une nuance légèrement jaunâtre, couvrant tous les fonds; des motifs floraux peints, rouges et bleus, ornent le fond des niches; sur le retable 1, on trouve quelques reliefs et un devant d'autel argentés à la détrempe; sur ce dernier la préparation a été décorée de motifs gravés; il y a aussi quelques rehauts colorés sur le soubassement et le gradin.
- au niveau de la construction générale [6] : le retable 1 présente une forme triptyque légèrement refermé avec un soubassement et deux registres supérieurs, six niches, des colonnes torses, un autel rectangulaire et des entablements très proéminents rythmant fortement l'ensemble. Le retable 2 devait être plus petit, triptyque plan avec un soubassement, un seul registre à trois niches et un couronnement avec une fausse niche, des colonnes droites et un baldaquin au centre.

Petit historique

Avant de prendre une décision sur le traitement à effectuer, nous fîmes quelques recherches en archives pour tenter de comprendre la situation actuelle :

- en 1736 est béni un retable dédié à la Vierge; [7]
- en 1739, le peintre Félix Escriba , reçoit de l'argent pour la polychromie-dorure du maître-autel de l'église de Nohèdes;[8, 9]
- vers 1870, le maître-autel est repeint deux fois de suite.

La date de sculpture du retable 1 se trouve sur le gradin : 1707.

On peut supposer que le retable 1 est l'ancien maître-autel dédié à Saint Martin. On peut l'attribuer d'après le style, la date et la présence de Félix Escriba, au

sculpteur Joseph Sunyer, sculpteur baroque le plus connu de notre département.[10] Les trente années écoulées entre la sculpture et la polychromie n'ont rien d'étonnant car il fallait souvent reconstituer la trésorerie pour pouvoir entamer la deuxième tranche des travaux, en général encore plus chère. Le retable 2 pourrait alors être le retable dédié à la Vierge et il aurait également été peint par Félix Escriba autour de 1739. Que s'est-il passé ensuite? Nous ne le savons pas. Les deux retables ont certainement dû subir de graves dommages pour ensuite être recombinés de la sorte (écroulement partiel ou total dû par exemple à un tremblement de terre, démontage volontaire lors de la Révolution – mais ceci est peu probable – ?). Le remontage doit être antérieur à 1870.

Traitement de conservation-restauration

Nous avons effectué une consolidation du bois dans les zones très attaquées afin de pouvoir manipuler les différents éléments sans risquer de nouvelles pertes de matière. Un système de goutte à goutte avec du Paraloid B 72 à 15% dans du xylène fut mis au point.

Avant de prendre une décision sur le remontage, nous choisîmes de dégager une partie des repeints et d'effectuer le nettoyage. Nous nous arrêtâmes au deuxième repeint, de couleur bleu céruleum, et ceci pour plusieurs raisons :

- nous éliminions les deux derniers repeints particulièrement inesthétiques, peu adhérents, mal conservés et relativement aisés à dégager; la bronzine était retirée sur la dorure;
- le deuxième repeint était lui pratiquement impossible à éliminer car beaucoup plus résistant que l'original et le premier repeint;
- ce bleu présent sur tous les morceaux gardait un aspect homogène au retable sachant que nous serions probablement obligés de réutiliser dans notre remontage les retables 1 et 2;
- la dorure, en très bon état de conservation, redonnait éclat aux reliefs et moulures, une fois dégagée;
- ce nettoyage et ce dégagement nous permettait de retrouver les limites originales de la polychromie et de mieux comprendre les assemblages et les dispositions de départ.

Nous étions cependant conscients que cette opération n'était pas totalement satisfaisante puisqu'elle ne permettait pas de retirer toutes les épaisseurs qui empâtaient les formes, qu'elle conservait un repeint de piètre qualité qui nécessiterait par la suite de nombreuses retouches et qu'enfin, l'aspect du retable serait très différent de ce qu'il fût en blanc et or ou en bleu clair et or.

Pour la peinture, le dégagement a été effectué avec des mélanges de solvants aqueux, ou à sec au scalpel, et pour la bronzine, à l'aide de mélanges plus décapants (toluène et diméthylformamide principalement).

Reconstitution du retable

Il fut décidé de remonter un seul retable avec tous les morceaux dont nous disposions. Les deux retables semblaient en effet chacun trop lacunaires pour en envisager un remontage séparé. D'autre part, nous ne pouvions restituer le retable tel qu'il était avant démontage et il nous fallait donc tenter de refaire un retable baroque plausible, qui soit lisible et cohérent.

Pour cela, nous avons rassemblé un petit dossier photographique de retables locaux de la même période et certains du même sculpteur.

Première étape : nous avons positionné les éléments à plat, sur le sol, afin de reconstituer grossièrement le retable. On commença par les parties les plus faciles tels que les soubassements, les colonnes, les niches, l'entablement et on termina par les plus problématiques. Parallèlement, chaque élément fut représenté schématiquement et découpé dans du bristol quadrillé (échelle au 1/10ᵉ) puis positionné au fur et à mesure sur du papier millimétré. Ceci pour éviter la manipulation inutile des éléments du retable lui-même et vérifier la faisabilité de notre construction. Nous nous rendîmes compte rapidement de l'étendue des manques et nous eûmes une première idée des dimensions du retable qui devaient

Figure 4. Montants de la niche centrale, après dégagement des derniers repeints, nettoyage et restitution en bois des parties manquantes.

correspondre, rappelons-le, à celles de l'abside de l'église. La priorité fut donnée aux éléments du retable 1 (voir Fig. 6) et plusieurs morceaux, en double, provenant du retable 2 furent laissés de côté. Nous avons choisi de garder la table d'autel présente et de ne pas tenter de réutiliser le devant d'autel du retable 1 (découpé en 7 morceaux et incomplet).

Deuxième étape : nous avons effectué un dessin technique du retable (voir Fig. 5) en le reprenant élément par élément, avec une vue en élévation et plusieurs coupes. Seule la moitié gauche du retable fut dessinée, sachant que dans l'ensemble ces constructions sont assez symétriques.

Nous avions à ce moment-là une idée précise de la configuration du retable à remonter ainsi que les dimensions des manques.

RESTAURATION DU SUPPORT

Le parti d'une restauration illusionniste avait été éliminé. Il fut donc décidé de reconstituer les parties indispensables à la stabilité du retable et à sa lisibilité, c'est-à-dire tous les « trous » apparaissant sur la vue en élévation ainsi qu'une grande partie des moulures manquantes (voir Fig. 6). Aucun relief décoratif ne fut reconstitué mais on reproduisit pour animer les parties refaites, le bandeau légèrement surélevé qui encadre tous les cartouches décoratifs.

Nous effectuâmes la restauration en commençant par le soubassement, puis en repartant de l'entablement principal qui nous donnait les alignements verticaux des premier et deuxième registres ainsi que les angles des travées latérales avec la travée centrale. Nous avons vérifié au fur et à mesure le dispositif imaginé sur le papier. Nos locaux ne nous permirent malheureusement pas de faire des essais de montage et celui-ci ne fut vraiment sûr que lors du remontage définitif dans l'église.

Les manques furent reconstitués en bois de pin (voir Fig. 4), le plus sec possible et traité contre les insectes (perméthrine à 0,65%) sauf les plus petits qui furent, lorsque cela était nécessaire, simplement mastiqués.[11] Les collages ont été effectués à l'acétate de polyvinyle. Rien ne fut éliminé du bois original malgré la difficulté pour réaliser certaines greffes.

Les assemblages ont été, dans la mesure du possible, refaits à l'identique (tenons-mortaises, queues d'aronde, ...), sauf les systèmes à clous qui furent remplacés par des vis pour des raisons évidentes de réversibilité et d'économie de vibrations.

Dans la réalité, notre dessin se révéla en grande partie exact, mais la symétrie dans ce genre de construction est loin d'être parfaite.

Toute cette étape fut complexe, longue et délicate. Il était essentiel de trouver des solutions pour respecter l'original et ne pas faire pâtir la polychromie des opérations effectuées sur le bois.

Il fut décidé de réintégrer toutes les parties refaites ainsi que les lacunes de polychromie trop visibles, une fois le retable remonté, pour avoir une meilleure idée de l'effet visuel à donner.

REMONTAGE IN SITU

Nous avons décidé très tôt qu'une structure viendrait à l'arrière soutenir et maintenir le retable en raison du nombre important de réfections et de la fragilité des parties originales. Cette structure métallique, composée de deux barres horizontales, niveau prédelle et entablement principal, fixées de part en part dans l'abside, de six montants verticaux fixés au sol et sur les horizontales et de deux demi barres centrales, fut montée en premier.

Au fur et à mesure du montage, nous plaçâmes des équerres en contreplaqué marine destinées à soutenir et/ou retenir le retable aux endroits stratégiques. Certaines équerres furent fixées sur le retable dans les parties refaites, par l'intermédiaire de platines vissées. Les platines, également en contreplaqué marine, servent à mieux répartir les forces sur les éléments du retable. Les équerres sont maintenues sur la structure métallique par l'intermédiaire de boulons (voir Fig. 7).

L'ordre de montage a été le suivant : le centre du retable jusqu'à l'entablement principal, puis, les côtés du premier registre et du soubassement, ensuite le deuxième registre, les côtés et le centre, et enfin les couronnements.

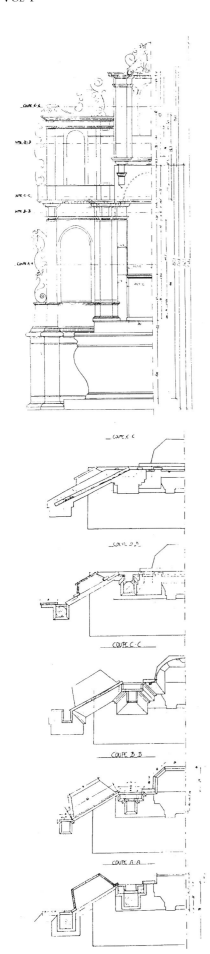

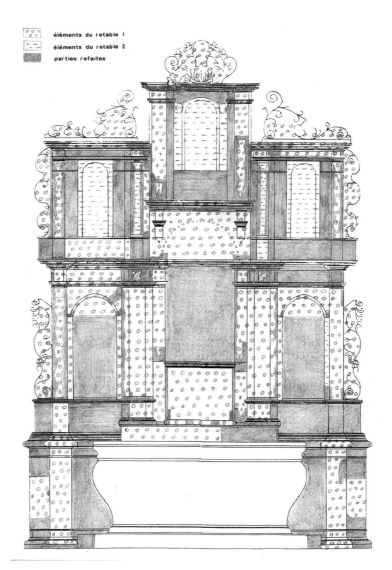

Figure 6. Le retable remonté : localisation des parties provenant du retable 1, de celles provenant du retable 2 et de celles refaites.

RÉINTÉGRATION PICTURALE

Le parti pris de ne pas refaire les décors sculptés, nous obligeait à poursuivre dans la restauration non illusionniste. De toute façon, nous avons pensé dès le début, que le retable était trop dégradé et notre intervention trop importante pour que celle-ci fut invisible. Il s'agissait donc d'intégrer les parties neuves afin de mettre en valeur l'original et de ne pas créer de ruptures trop visibles entre les deux états (voir Fig.8). Par ailleurs la polychromie bleue passée de façon irrégulière sur le retable, avec des éléments positionnés différemment nécessitait également une retouche. Quelques lacunes étaient également trop visibles.

Après divers essais sur des planchettes, l'intervention fut la suivante :

- retouche à l'aquarelle ton bois modulé dans les lacunes;
- retouche à l'aquarelle de type illusionniste pour compléter le repeint bleu;
- une première couche de Paraloid B 72 à 10% sur les parties refaites, puis une couche de cire d'abeille/carnauba en deux tons : ton chêne clair pour les zones originellement dorées (moulures) et ton noyer pour le reste. Nous souhaitions ainsi tout en protégeant le bois lui donner une teinte qui souligne le rythme du retable et reste suffisamment en retrait par rapport à l'original. Nous devons avouer que le résultat final ne fut pas tout à fait à l'image de ce que nous avions imaginé, toutefois le but semblait atteint.

TRAITEMENT INSECTICIDE

Il fut effectué de manière généralisée sur tout l'arrière du retable, par pulvérisation de perméthrine à 0,65% dans de l'heptane.

Figure 5 : Dessin technique pour le remontage.

Figure 7. Revers du retable remonté : détail du système de soutien à l'aide d'une structure métallique et d'équerres en bois.

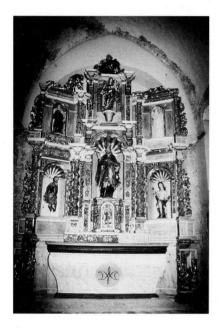

Figure 8. Le retable après restauration.

Les statues

Nous n'avons pas évoqué jusqu'à maintenant les statues qui doivent occuper les niches du retable et nous ne parlerons pas de leur restauration.

Quelques années avant le démontage, il ne restait d'original que la statue de Saint Martin au centre et le buste de Dieu le Père au couronnement. Les autres étaient des plâtres saint-sulpiciens. Nous avons pu remettre en place Saint Martin et Dieu le Père ainsi que deux statues de même facture. Deux autres, d'origine différente, ont pu trouver place dans le retable et il reste une niche vide (voir Fig.8).

Toutes les statues ont été assurées dans leur niche à l'aide d'un crochet.

Conclusion

Cette restauration était un cas délicat qui mit sans cesse à l'épreuve notre déontologie de la conservation-restauration. Certains trouveront que nous sommes allés trop loin, d'autres pas assez, d'autres encore que c'était une restauration à ne pas faire ou bien à mener d'une autre manière.

Nous nous sommes effectivement demandé à plusieurs reprises si, passé un certain stade de dégradation, il ne fallait pas décider de ne plus intervenir. Le temps consacré à cette restauration aurait pu nous permettre de travailler sur un grand nombre d'objets ou même plusieurs retables.

Un fait paraît certain : un atelier privé n'aurait jamais pu effectuer cette restauration telle que nous l'avons menée car la commune n'aurait jamais pu en assurer le financement.

Il reste la satisfaction d'avoir relevé une sorte de défi, d'avoir personnellement énormément progressé dans la connaissance des retables baroques locaux et d'avoir en quelque sorte sauvé une œuvre d'une valeur artistique certaine pour l'art de notre département, le patrimoine et la mémoire de ce village.

Notes

1. Cortade E. 1973. Retables baroque du Roussillon. Perpignan.
2. Pour cette restauration, la commune a bénéficié de la gratuité qui était l'ancien système.
3. Travail effectué entre 1991 et 1998 par Evelyn Stier et Isabelle Desperamont-Jubal avec la participation de Jean-Bernard Mathon, responsable du Centre et Sylvie Dauvergne, stagiaire.
4. Terme catalan qui désigne les parties, souvent ajourées, qui décorent le pourtour du retable ; littéralement : protège-poussière.
5. L'église, à moitié enterrée, a connu de gros problèmes d'infiltrations d'eau.
6. Ces schémas sur la disposition originale de chacun des deux retables, se sont affinés tout au long du travail de restauration et ne nous sont pas apparus lors de la première étude des morceaux.
7. Archives départementales, 46 J 3 et 4, livre de comptes de l'église de Nohèdes.
8. En activité dans la première moitié du 18ème siècle, fils d'un peintre-doreur, travailla à plusieurs reprises avec Joseph Sunyer, son beau-père sculpteur.
9. Archives départementales, idem précédent.
10. (vers 1660–1751), né à Manresa (Catalogne sud), son activité fut intense dans le département entre 1696 et environ 1720.
11. Mélange de sciure de bois et d'acétate de polyvinyle ou bien de sciure, plâtre, craie et acétate de polyvinyle.

Ivoires gothiques: Polychromie originale et repeints

Résumé

Le texte aborde le problème de la distinction entre la polychromie originale et les repeints sur les ivoires gothiques. Les principales caractéristiques de la polychromie sur ivoire au XIIIe et au XIVe siècles sont brièvement exposées : localisation des décors, relevé des motifs, techniques d'exécution et couleurs employées. Différents types de repeints sont ensuite étudiés et commentés à travers l'étude d'une dizaine d'œuvres médiévales conservées dans des collections publiques françaises et étrangères.

Mots-clés

ivoire, polychromie, repeints, gothique, néo-gothique

Juliette Levy★
30 rue Beaubourg
F-75003 Paris
France

Agnès Cascio
52 rue Guy Moquet
F-92240 Malakoff
France

La polychromie des ivoires médiévaux, longtemps délaissée par les chercheurs, suscite aujourd'hui un interêt croissant. Diverses études en cours, aussi bien en France qu'à l'étranger, révèlent un engouement nouveau pour ce domaine. De récentes publications témoignent cependant du danger à entreprendre trop rapidement une telle recherche, qui ne peut être menée qu'avec méthode et prudence. En effet, à la différence des sculptures en pierre ou en bois, entièrement peintes, la couleur n'est ici présente que pour magnifier la beauté naturelle de l'ivoire, sous forme de touches parcimonieusement réparties, qui accentuent la préciosité des œuvres. L'un des obstacles à l'étude de la polychromie est donc lié à la très faible quantité de matière picturale conservée. Dans la plupart des cas, ceci interdit la pratique de prélèvements pour analyses et impose le recours à des méthodes non destructives. D'autres éléments concourent encore à rendre cette recherche particulièrement complexe. L'on sait qu'en raison de leur petite taille, les ivoires passaient de mains en mains ; il n'est pas rare qu'ils aient subi, au cours de ces manipulations, toutes sortes d'interventions. Citons par exemple le nettoyage, autrefois effectué au moyen d'eau savonneuse ou de poudres abrasives, ou encore le lustrage, souvent exécuté par application de cire ou d'huile. Parfois même les objets étaient moulés, ce qui impliquait l'usage d'agents démoulants. De plus, l'on n'hésitait pas à redorer ou à repeindre les ivoires, pour dissimuler les altérations de la polychromie ancienne ou simplement pour les mettre au goût du jour. Or, la surface des objets garde généralement la trace, même infime, des produits appliqués et des repeints, qu'il convient impérativement de distinguer des restes de polychromie originale.[1] Là réside l'un des obstacles majeurs de la recherche. Le risque de confusion dans l'interprétation des traces conservées – et la difficulté est encore accentuée par le caractère ténu de celles-ci – peut en effet mener à une vision faussée des œuvres, susceptible parfois d'être lourde de conséquences sur leur traitement de restauration ultérieur.

Ainsi, avant même l'identification par analyse des grains colorés décelés à la surface des objets, faut-il se livrer à un examen visuel approfondi des œuvres et définir une méthode de travail. Une première démarche a consisté à procéder à différents examens couramment pratiqués sur la sculpture monumentale. L'observation à l'œil nu a permis d'apprécier la palette des couleurs et leur répartition : ce dernier point peut très vite amener à identifier un repeint appliqué, par exemple, sur une cassure; la lumière ultra-violette a mis en évidence des réfections formelles et parfois des décors invisibles en lumière du jour, ce qui ne constitue pas pour autant un gage d'ancienneté ; enfin, l'examen sous loupe binoculaire a parfois révélé la stratigraphie des couches de polychromies successives. Il a permis aussi d'approcher leur composition. La deuxième étape du travail, plus décisive, est la confrontation entre les premières informations ainsi collectées et les connaissances acquises lors de nos précédentes recherches effectuées sur une centaine d'objets.[2] Cette enquête, dont les grandes lignes sont brièvement exposées ici, avait abouti à dégager plusieurs caractéristiques spécifiques aux polychromies sur ivoire : localisation des décors, relevé des motifs, répertoire des couleurs et techniques picturales employées.

★Auteur auquel la correspondance doit être adressée

Figure 1. Un exemple de polychromie originale : Vierge de l'ancienne collection Timbal, Paris, musée du Louvre. Détail de l'orfroi du manteau, aux motifs dorés sur mixtion encadrés de deux lignes d'or.

Figure 2. Sainte Anne trinitaire, *Compiègne, musée Vivenel. L'ivoire, complètement masqué par le repeint, n'apparaît que dans les lacunes.*

Caractéristiques principales des polychromies gothiques sur ivoire des XIIIe et XIVe siècles

La répartition des décors est l'un des points les plus éloquents. Sur l'extérieur des vêtements, l'ivoire est toujours laissé apparent, à l'exception des bordures soulignées de fins orfrois dorés, parfois rehaussés de glacis rouge ou vert. Les doublures, en revanche, sont traitées en aplats bleus, plus rarement rouges, créant une opposition qui accentue le contraste entre le revers et l'extérieur des vêtements et en facilite la lecture. Des motifs disposés en semis n'ont été observés que sur les fonds de polyptyques, où sont parsemées des fleurettes à cinq ou six pétales. Sont également relevés de motifs colorés les trônes, les attributs et les accessoires vestimentaires tels que les ceintures, chaussures, couronnes, diadèmes, fermaux... Les chevelures sont généralement dorées. S'il est fréquent de trouver des traces de bleu dans les yeux, de rouge sur les bouches et d'or à l'emplacement des sourcils, des incertitudes demeurent à propos du traitement des chairs. Il semble que, dans la plupart des cas, l'ivoire, laissé nu, ait suffi au rendu des carnations. Cependant des traces rosées, conservées en quantité infime sur quelques statuettes, laissent la question ouverte. Enfin, les fissures, altérations fréquentes et souvent inévitables sur de grands blocs d'ivoire, ont engendré un type de décors spécifique à ce matériau. Il fallait, en effet, masquer ces imperfections qui nuisaient à la préciosité de l'œuvre : ainsi des rameaux végétaux dorés étaient-ils peints le long des fissures. Ce genre de décors ne trouve pas d'équivalent sur d'autres matériaux tels l'albâtre et le marbre, dont la polychromie a cependant pu être mise en parallèle avec celle des ivoires.

Bien que certaines œuvres aient été complètement décapées, il est rare que l'observation minutieuse des objets ne révèle pas la présence de motifs, uniquement localisés sur les orfrois. En effet, liants et pigments, en pénétrant dans l'ivoire, l'ont imprégné d'une coloration brune plus ou moins foncée qui révèle leur présence et permet de lire un motif, même lorsque toute matière picturale a disparu. A l'inverse, c'est parfois la polychromie elle-même, qui, ayant préservé l'ivoire des salissures et de la patine, met en évidence, après sa disparition, l'orfroi dont le dessin apparaît, par contraste, en plus clair. S'inscrivant le plus souvent entre deux lignes, les orfrois sont constitués de petits motifs géométriques ou d'inspiration végétale qui se répètent et se combinent régulièrement pour former des galons.[3] Bien que de dimensions très réduites, ils témoignent toujours d'une grande habileté et d'une précision remarquables dans leur tracé (voir Fig. 1).

Très restreinte, la palette chromatique de ces orfrois est essentiellement composée de dorure, parfois associée à des rehauts colorés. Les feuilles d'or sont appliquées sur une assiette à liant huileux, couramment désignée sous le nom de mixtion. Cette couche ambrée, généralement translucide au XIIIe siècle, tend, par la suite, à être chargée de pigments qui la rendent plus ou moins ocrée. Employés en touches colorées, le rouge et le vert sont d'un usage plus limité que le bleu qui, le plus souvent, revêt entièrement l'intérieur des vêtements. Il est vrai que, dans la plupart des cas, le bleu n'est aujourd'hui visible que sous forme de traces, vraisemblablement en raison de la nature protidique de son liant, qui lui confère une moindre résistance. L'identification des pigments a montré que les bleus sont obtenus à partir de lapis-lazuli ou d'azurite, tandis que les verts sont à base de cuivre.[4] L'analyse des rouges met en évidence du vermillon ou des colorants d'origine organique tels que la garance ou la cochenille. Mais quelles que soient la couleur ou la technique d'exécution, les observations ont montré que la polychromie est directement appliquée sur l'ivoire, sans l'intermédiaire d'une préparation blanche. Cette particularité semble inhérente au caractère partiel de ces décors, auxquels font écho la sobriété du répertoire des couleurs et la grande légèreté de l'exécution, deux qualités qui font souvent défaut aux repeints, fussent-ils de fidèles imitations.

Les repeints complets

Dès la fin du Moyen Age et principalement au XIXe siècle, les décors polychromés ont été l'objet de reprises, d'importance et de qualité variables. Les repeints complets, masquant entièrement l'ivoire, sont d'emblée les plus reconnaissables. Souvent médiocres, comme sur la *Sainte Anne trinitaire* (voir Fig. 2)[5] conservée au musée Vivenel de Compiègne, ils ne laissent aucun doute sur leur exécution

Figure 3. Vierge du Tabernacle du musée des Beaux-Arts de Lille. Exécutée avec soin, cette riche polychromie recouvre entièrement l'ivoire, ce qui n'est pas conforme à la facture des décors gothiques.

Figure 4. Le groupe du Couronnement de la Vierge *est aujourd'hui orné d'un repeint de semis de motifs, caractéristique du style néo-gothique.*

Figure 5. Détail de la Figure 4, manteau de la Vierge : semis de motifs héraldiques dorés (fleurs de lys et bars). Le voile est bordé d'un large galon noir et or.

récente : la couche picturale, qui est probablement le fruit de la même campagne que la réfection de la tête en bois de la Vierge, est sombre et opaque, et occulte complètement la qualité de traitement de la statuette. Tout aussi couvrante, la polychromie du *Tabernacle* du musée des Beaux-Arts de Lille est plus séduisante (voir Fig. 3).[6] Il s'agit bien ici d'une interprétation dans le goût médiéval, vraisemblablement l'œuvre d'un artiste du siècle dernier. L'or, utilisé ici de manière excessive, revêt entièrement le manteau de l'Enfant et sert de fond, sur la robe de la Vierge, à un décor d'arabesques en glacis rouge cerné de noir. La gamme chromatique s'étend à des couleurs habituellement bannies : noir, brun et surtout blanc du voile de la Vierge, que l'éclat naturel de l'ivoire rend terne et sans objet. De même, les teintes pastel, comme le bleu ciel, ne font pas partie de la palette gothique telle que nous avons pu la définir. Le goût des détails anecdotiques se manifeste dans l'ornementation des sols et dans la représentation du collier. Or, les bijoux, sur les statuettes d'ivoire du Moyen Age, ne sont guère représentés, à l'exception de quelques fermaux sculptés, et l'on n'a pas relevé de bijoux peints d'origine. En outre, le Tabernacle de Lille permet d'envisager les repeints sous l'angle de la stratigraphie. En effet, l'examen sous loupe binoculaire révèle, sous les carnations visibles, l'existence d'une première couche sous-jacente qui, d'après sa localisation et sa facture, n'est pas non plus médiévale. Sous ce niveau, de rares traces d'une dorure gothique sont encore conservées, mais elles ne sont pas repérables à l'œil nu. Peut-être ont-elles été, pour la plupart, soigneusement éliminées avant l'application d'un nouveau décor.

Repeints de semis de motifs

Le *Couronnement de la Vierge* conservé au musée du Louvre, a vraisemblablement subi un sort analogue, puisque rien, apparemment, ne subsiste de son décor d'origine (voir Figs. 4, 5).[7] Sur ce groupe célèbre, autrefois cité en exemple pour sa polychromie exceptionnelle,[8] les vêtements sont richement parsemés de motifs héraldiques. Cette distribution des décors n'est pas conforme à la polychromie traditionelle des ivoires gothiques. Les décors, disposés en semis dense et régulier, prennent le pas sur les formes sculptées, que le regard perçoit mal. L'œil est attiré par le dessin rigide des motifs héraldiques figurant des châteaux, des bars, des étoiles et des fleurs de lys. Or, seules ces dernières appartiennent au vocabulaire ornemental des ivoires du Moyen Age, où elles ne sont représentées que sur les orfrois, en tant que motifs décoratifs et non, semble-t-il, dans un but héraldique. La dorure du groupe du *Couronnement de la Vierge*, appliquée sur une assiette grisâtre chargée de pigments, se distingue aisément des mixtions translucides et ambrées des XIIIe et XIVe siècles. De même, l'introduction de couleurs opaques, telles le brun et le bleu foncé, la lourdeur des carnations, la profusion de détails, évoquent le goût néo-gothique. La date précise de cette polychromie est inconnue, mais elle est certainement antérieure à 1861, année d'entrée au musée de ce groupe, dont la polychromie avait alors été célébrée. Acquise en 1862, la *Vierge à l'Enfant* du musée national du Moyen Age donne une autre version de décors en semis vraisemblablement exécutés au XIXe siècle.[9] Sur cette statuette, des traces sous-jacentes sont encore bien conservées, révélant que la polychromie initiale était constituée de délicats orfrois dorés, aujourd'hui masqués par un large galon doré strié de glacis rouge. Les carnations, très grises, sont à rattacher à la même intervention.

Le groupe de *l'Annonciation* conservé au musée du Breuil de Saint-Germain à Langres est également orné de semis de motifs, mais d'un style différent (voir Fig. 6).[10] Très chargés, ils témoignent d'une certaine fantaisie, et relèvent d'un répertoire particulier. Sur le plan technique, la présence d'une préparation blanche sous le bleu de l'intérieur des vêtements confirme le caractère récent de cette polychromie qui est toutefois antérieure à 1842, date de l'entrée du groupe au musée. Ainsi la connaissance des dates d'acquisition de ces œuvres montre-t-elle, dès la première moitié du XIXe siècle, un engouement particulier pour les semis de motifs.

Repeints à l'imitation de la polychromie gothique

A côté des repeints complets ou disposés en semis, certaines reprises témoignent du souci réel d'imiter la polychromie ancienne. L'étude stratigraphique, par

Figure 6. Sur le groupe de l'Annonciation de Langres, les vêtements sont chargés de lourds motifs dorés et leurs doublures sont peintes d'un bleu sombre.

Figure 7. Tabernacle du musée du Louvre. La facture rigide des motifs d'orfrois laisse supposer que le décor est le fruit d'une réfection.

observation sous loupe binoculaire, permet de mettre ces repeints en évidence lorsque les couches sont superposées. C'est le cas sur la *Sainte Marguerite* du British Museum de Londres, où deux interventions successives, bien visibles le long des fissures, reprennent la polychromie initiale dessinant des rameaux terminés par des trèfles.[11] La dorure d'origine, reposant sur une assiette ocre jaune, se distingue nettement de celle des repeints, à la facture plus grossière, qui sont appliqués sur une mixtion d'un brun opaque. Les carnations, elles aussi d'exécution sommaire, sont contemporaines du second repeint. Les reprises effectuées sur le *Tabernacle* du Victoria et Albert Museum reflètent également la volonté de reproduire les décors anciens, mais ils ne prêtent pas non plus à confusion.[12] La polychromie originale, bien conservée sous le repeint, est encore très lisible. Sous éclairage rasant, le léger relief des fins orfrois dorés se discerne aisément sous l'épais galon doré qui les recouvre. L'observation sous loupe binoculaire offre une stratigraphie sans équivoque, notamment pour les dorures, où deux niveaux sont superposés. Ici encore, la première est posée sur une mixtion ocre translucide, tandis que la seconde repose sur une mixtion épaisse et blanchâtre. Sur l'encolure, où l'orfroi d'origine est simplement ravivé par une nouvelle dorure, la lourdeur du trait trahit une réfection, que dénonce aussi l'emploi des couleurs: un rose et un bleu pâle se côtoient dans les parties architecturales.

Le *Tabernacle* du musée du Louvre offre un exemple plus complexe, car il témoigne d'une connaissance approfondie des techniques médiévales, ainsi que d'un réel souci de fidélité au décor ancien (voir Fig. 7).[13] La stratigraphie ne peut être établie avec précision : en effet, le repeint n'est clairement décelable qu'à l'intérieur du manteau de la Vierge, où un rouge vermillon recouvre le bleu original, du lapis lazuli. Sur les orfrois, en l'absence de superposition des couches, seul le tracé un peu raide des motifs signale une possible reprise. Mais ce critère seul suffit-il à remettre en cause leur ancienneté? Il faut sans doute relativiser ce jugement, comme l'atteste l'attrayante polychromie de la *Vierge à l'Enfant* du Metropolitan Museum (voir Fig. 8).[14] Le regard est tout d'abord séduit par la finesse et la variété des orfrois dorés, dont l'emplacement est bien conforme au modèle gothique, tout comme la palette des couleurs limitée à l'or, au bleu, au rouge et au vert. Un examen plus attentif révèle néanmoins certaines anomalies. Un certain éclectisme se dégage en effet du large répertoire des orfrois, qui inclut aussi bien des imitations fidèles d'originaux gothiques (bord du voile), que des versions plus fantaisistes, dérivées de sources variées (couronne, bordure des vêtements). Sur la robe de l'Enfant, les orfrois sont bordés d'une triple ligne, ce qui n'est pas conforme à la tradition selon laquelle la Vierge est plus richement vêtue. Des arguments d'ordre technique retiennent également l'attention: l'or de la chevelure est appliqué sur une préparation blanche et la mixtion est d'une singulière couleur rouge brique; le bleu est très clair, le rouge et le vert ont un aspect opaque au lieu des glacis translucides habituels. En l'absence de stratigraphie, aucune certitude n'est acquise, mais la convergeance de ces observations suggère une polychromie néo-gothique. Du reste, ces conclusions sont confirmées par l'attribution de la statuette à un habile faussaire du siècle dernier.

Ainsi, face à la multiplicité des œuvres et de leur histoire, ne peut-on tout au plus que suggérer des pistes. Un faisceau de données relatif au style et à la facture de la polychromie apporte souvent une contribution déterminante à l'identification des repeints : les caractéristiques des polychromies gothiques décrites plus haut (localisation des décors, répertoire des motifs et des couleurs, techniques utilisées), l'observation minutieuse des couleurs, leur broyage, la qualité de la mixtion, peuvent orienter vers une réponse. L'appréciation de la finesse et de la sûreté du trait a également son importance.

Apport des analyses de laboratoire

Finalement, ce n'est que dans une seconde phase que les analyses physico-chimiques des pigments et des liants peuvent intervenir. Il arrive alors que les résultats débouchent directement sur la mise en évidence d'un repeint : c'est le cas sur le *Nicodème* du groupe de la *Descente de croix* conservé au musée du Louvre, dont la doublure du manteau a été repeinte en bleu à deux reprises.[15] Mais aucune de

Figure 8. Vierge à l'Enfant, *Metropolitan Museum: cette statuette, exécutée au XIXe siècle, témoigne de la connaissance des polychromies gothiques à cette période.*

ces deux interventions n'est originale, puisque le premier bleu, appliqué à même l'ivoire, a été identifié comme un bleu de smalt.[16] Or, ce pigment n'étant apparu qu'à la fin du XVe siècle, il s'agit d'un repeint exécuté au plus tôt deux cent ans après la polychromie originale. Sur l'*Ange de l'Annonciation* du musée du Louvre en revanche, l'identification du bleu ne résoud pas, à elle seule, la question.[17] En effet, c'est un bleu lapis lazuli, posé sur une préparation blanche, qui a été identifié en premier lieu. Mais la présence inhabituelle de cette préparation a incité à approfondir l'examen stratigraphique, qui a révélé l'existence d'un autre bleu sous-jacent, cette fois-ci original, également constitué de lapis-lazuli.[18] L'emploi de ce pigment précieux, décelé dans deux couches successives, montre que son identification n'est pas un gage d'authenticité, et que les polychromies originales ont pu être repeintes dans un délai très court après leur exécution. Leur composition peut alors être très proche de celle des repeints anciens. Le risque d'erreur est encore accru pour la plupart des autres pigments, dont l'usage s'est continuellement poursuivi du Moyen Age jusqu'à nos jours. Ainsi, si le recours aux analyses est fondamental, les résultats obtenus demandent-ils à être nuancés et intégrés dans un ensemble de données aussi bien stratigraphiques que stylistiques.

Il est rare que les sculptures médiévales en ivoire n'aient pas subi de repeints, et le risque de confusion est considérable, même pour un œil averti. L'engouement pour les ivoires peints des collectionneurs du XIXe siècle a souvent entraîné la réfection des polychromies médiévales, ce qui a fortement contribué à en fausser l'interprétation. Mais ces repeints tardifs, qui constituent un jalon de l'histoire des œuvres, méritent l'intérêt et ne seront jamais aussi préjudiciables que l'élimination irréversible des traces de polychromie ancienne.

Remerciements

Nous remercions tout particulièrement Danielle Gaborit-Chopin, conservateur en chef du Patrimoine au Département des objets d'art, musée du Louvre, pour les conseils et le soutien qu'elle nous a prodigués tout au long de ce travail. Notre reconnaissance va également aux conservateurs des musées français et étrangers qui nous ont accueillies avec bienveillance : D. Alcouffe, E. Blanchegorge, A. Erlande-Brandenburg, V. Huchart, M.H. Lavallée, C. Little, N. Stratford, P. Williamson.

Notes

1. E. Cristoferi. 1990. Indagini e restauri. In: Avori bizantini e medievali nel museo nazionale di Ravenna.
2. A. Cascio, J. Levy. 1998. La polychromie des statuettes d'ivoire du XIIIe siècle et des premières décennies du XIVe siècle. Coré nl 5 (bibliographie).
 Les objets en ivoire et en os d'origine italienne (atelier des Embriachi), dont la polychromie est particulière, n'ont pas été pris en compte dans le cadre de cette recherche, non plus que ceux de la fin du XIVe et du XVe siècle. Les œuvres mentionnées ici sont identifiées, dans les notes, en fonction du corpus de R. Koechlin, Les ivoires gothiques français, 3 vol., Paris, 1924. (2e édition), Paris 1968, et sont indiquées par K, suivi du numéro du catalogue (vol. II).
3. Op. cit. note 2, tableau des motifs originaux: 18.19.
4. B. Guineau. Etude des couleurs dans la polychromie des ivoires médiévaux In: Bulletin de la société nationale des antiquaires de France (séance du 17 Avril 1996), à paraître.
5. *Sainte Anne trinitaire,* XIVe siècle, Compiègne, musée Vivenel, inv : V 331 (K 710).
6. *Tabernacle,* XIVe siècle, Lille, musée des Beaux-Arts, inv : A 109. (K 150)
7. *Couronnement de la Vierge,* Paris, musée du Louvre, inv. OA 58 (Vierge et Christ) et inv. OA 3921 et OA 3922 (anges) (K 16).
8. E. Molinier 1896. Catalogue des ivoires du musée du Louvre: 109–113.
9. *Vierge à l'Enfant,* Paris, musée national du Moyen Age, inv: CL. 7613.
10. *Ange et Vierge de l'Annonciation,* Langres, musée du Breuil de Saint-Germain (K 850).
11. *Sainte Marguerite,* Londres, British Museum, inv. MLA 58, 4–28, 1. (K 709)
12. *Tabernacle,* XIVe siècle, Londres, Victoria & Albert Museum, inv. 4686. (K 154)
13. *Tabernacle,* XIVe siècle, Paris, musée du Louvre, inv. OA 2587 (K 156).
14. *Vierge à l'Enfant,* Metropolitan Museum, New York, inv. 17.190.296.
15. Groupe de la *Descente de croix,* Paris , musée du Louvre inv: OA 9443. (K 19).
16. Op. cit. note 4.
17. *Ange de l'Annonciation,* Paris, musée du Louvre, inv. OA 7507. (K 20)
18. Op. cit. note 4.

Abstract

This paper briefly describes the history, materials and techniques of manufacture of Buddhist sculptures in Japan.

Keywords

Japanese sculpture, polychromy, wood, technique

Polychrome wooden Buddhist sculptures in Japan: History, materials and techniques

I. Nagasawa, T. Shida, H. Oshima
Tokyo National University of Fine Arts
12-8 Ueno Koen, Taito-ku
Tokyo 110-8714
Japan
Fax: +81-3-5685-4032
Email: nagasawa@fa.geidai.ac.jp

Masako Koyano★
Art Conservation Lab.
Kaigahozon Kenkyusho
4-27-4 Honcho, Nakano-ku
Tokyo 164-0012
Japan
Fax: +81-3-33-3-9116
Email: koyano@pop02.odn.ne.jp

Frank D. Preusser
Frank Preusser & Associates, Inc.
6434 Pat Avenue
West Hill, CA 91307
USA
Fax: +1-818-348-1764
Email: fdp@aol.com

The history of Japanese sculpture

The history of Japanese sculpture started when Buddhism was introduced into Japan from China through the Korean Peninsula in the middle of the 6th century.

In the Asuka Period (538–645), wooden and bronze sculptures in Chinese style were executed by sculptors from China. The wooden sculptures were made of camphor wood in the *ichiboku-zukuri* technique (see below) and are characterized by their frontal view, relief like expression and strict and mysterious faces.

In the Nara period (645–794), sculptures with different materials, such as clay or dry lacquer, were made using new techniques and the sculptures gradually obtained a distinctive Japanese style. The strict faces changed to calm, innocent faces and the bodies acquired naturalistic softness. At the end of this period, sculptures appeared with hollowed interiors, executed in the *ichiboku-zukuri* technique (see below).

The predominant development in wooden sculptures occurred in the Heian period (794–1185). *Ichiboku-zukuri* was popular at the beginning of the Heian period, and various sculptures were made in this technique, such as massive figures with strict faces and raging figures that had not existed before. In the later Heian period, a different fabrication technique, *ichiboku-warihagi*, was used and developed to *yosegi-zukuri* (see below). As a result, Buddhist sculptures in an entirely Japanese style appeared, which were executed in the *yosegi-zukuri* technique. This method is original to Japan and is popular even at present.

The Kamakura period (1185–1333) was the golden age of wooden sculptures made in the *yosegi-zukuri* technique (See Fig. 1). From the end of the Heian period the "glass eye technique", *gyokugan*[1] was important for realistic appearance. In addition to *gyokugan*, various techniques ranging from metal nails [2], real clothes to polychromy appeared. A famous example of *yosegi-zukuri* is the Nio figure (8.5m in height) at the Nandaimon (Great South Gate) of the Todaiji Temple.

In the Muromachi period (1336–1573), the art of Buddhist sculpture declined and masterpieces of portrait sculptures (*soshizo*) appeared. In the Momoyama and Edo periods (1573–1868), the religious power of Buddhism weakened and there were no new developments in Buddhist sculpture. However, skillful works were

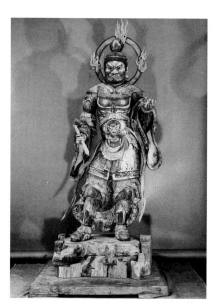

Figure 1. Shitenno *(Four Guardians). Example of a* yosegi *figure, Shinyakushi-ji Temple.*

★ Author to whom correspondence should be addressed

still made. Buddhist sculptures in the Edo period, made by priest sculptors, show innovative trials although there are some inferior examples.

During the Asuka and Edo periods, most sculptures were related to Buddhism. Sculptures truly free from Buddhist influence started to appear in the Meiji period (1868–1912). Since the new Western culture was introduced into Japan and modernization occurred, Japanese traditional sculpture declined, and new movements appeared, developing new sculpture techniques through competition between wooden and clay sculpture. Since then, various new materials and techniques continued to appear in the Showa period and at the present time.

The materials of Japanese Buddhist sculptures are bronze, clay, dry lacquer (*dakkatsu-kansitsu* and *mokushin-kansitsu*), stone and wood. In particular, the number of wooden sculptures is large.

Materials and techniques

Materials

The different woods used for sculptures varied depending upon the period. *Kusu* (camphor wood) was used in the Asuka period. *Hinoki* (Japanese cypress) appeared in the Nara period and was popular (in more than 90% of the works) in the Heian period and later. During those periods, saws to cut timber lengthwise were not available and therefore *hinoki* was preferred, since it could be split straight from the cut end using a wedged tool. Other reasons were its fine color and gloss in addition to its durability. Small quantities of *sakura* (cherry), *kaya* (Japanese *torreya*), *katsura* (*judas*), *nire* (elm) and imported *byakudan* (sandalwood) were also used. *Keyaki* (*zelkova*) was not chosen for Buddhist sculptures.

The following pigments were used for polychromy according to analytical studies:

- White: *hakudo* (aluminum silicate) and *gofun* (calcium carbonate, mainly after the middle of Muromachi period)
- Red: *shu* (mercury sulfide), *entan* (lead oxide) and *bengara* (iron oxide)
- Yellow: *odo* (iron oxide hydrate) and *mitsudaso* (lead oxide)
- Green: *iwarokusho* (basic copper carbonate)
- Blue: *iwagunjo* (basic copper carbonate)
- Purple: a mixture of inorganic pigments
- Black: *sumi* (carbon, soot)

Techniques

Polychrome wooden Buddhist sculptures have a wooden core with *urushi* (Oriental lacquer), cloth, ground and polychrome layers applied on it. *Kirikane* are strips of gold leaf placed on the polychrome layer. The method for applying the gold leaf is called *shippaku*, and *urushi* is used as adhesive. The faces of Buddhist figures are covered with two to seven layers of gold leaf to create a deep golden color.

WOODEN CORE

Three techniques were used to create the wooden cores, *ichiboku-zukuri* in the early time; followed by *ichiboku-warihagi-zukuri*; and *yosegi-zukuri* which was popular during the golden age.

In *ichiboku-zukuri* the main part of the sculpture was sculpted from one piece of wood. Usually, the head and body were carved from the same wood. *Ichiboku-warihagi-zukuri* is a modified method of *ichiboku-zukuri*. A sculpture was cut in half, usually parallel to front and back. Then the inside of each piece was hollowed out, and the pieces were joined back together. This method decreased the weight of figures and reduced the risk of warping and cracking. To join the pieces, clamps were used rather than adhesives.

Yosegi-zukuri (See Fig. 2) was the most popular method. At first, wood pieces were joined temporarily to define the outline of a sculpture. Then they were taken apart and carved separately by different priest sculptors (See Fig. 3). After the inside of each piece was hollowed, all the pieces were joined together. The details were

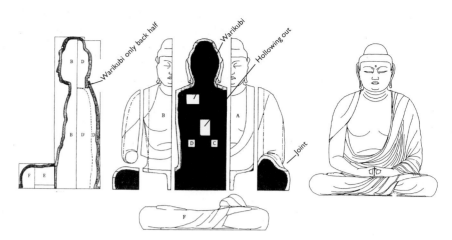

Figure 2. Construction of yosegi *figures,* amida-nyorai *sitting figure in Byodoin Temple. Drawing by K. Nishikawa.*

carved at this stage. For the final shape, *kokuso-urushi*[3] was applied to correct the shape and more details were carved with sharp knives. The sharpness of the knives was important because the surface was never sanded. Different methods were used to join the head to the body, including such as *sashi-kubi*[4] or *wari-kubi*.[5]

Yosegi-zukuri had many advantages. It required only small pieces of wood, even for a large sculpture, needed a relatively short time due to the division of labor, decreased the risk of splits and warpage, and reduced the weight of the sculpture, although there were some problems such as a tendency of areas near the joins to degrade faster.

URUSHI LAYER AND CLOTH APPLICATION

First a thin *urushi* layer is applied on the surface of the carved sculptures (*kigatame*).

Then thin linen cloths are applied. They cover grooves at joins and surface irregularities, and create a smooth surface. The size of the cloths varies from 1.5 × 3cm to 20 × 30cm depending on the purpose. The cloth is put on a wooden board and *mugi-urushi*[6] is applied and rubbed in with a spatula. The back of the cloth is treated in the same way. This cloth is placed with tweezers on a sculpture, and *sabi-urushi*[7] is applied with either a brush or a spatula when the cloth is dried. This layer is very stiff and called *kataji*. This technique was used from the Heian period to the Muromachi period.

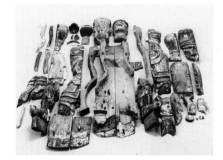

Figure 3. Shitenno Komokuten, *dismantled.*

GROUND

If gilding is planned, *ki-urushi* (raw lacquer) is applied on the above-mentioned *sabi-urushi* layer and gold leaf is placed on the *ki-urushi*. There are at least two layers of gold leaf, and when a deep golden color is desired, up to seven layers of gold leaf are applied.

The ground for polychromy is prepared as follows. A paste of *hakudo* (aluminum silicate with a 12% animal glue solution) is applied on the *sabi-urushi* layer with a brush. It is applied one to three times until it achieves 0.1mm thickness, and sometimes sanded to make the surface smooth. It requires about one day to dry before the colors can be applied.

POLYCHROMY AND *KIRIKANE*

The paint for the polychromy consists of pigments, such as *iwaenogu*[8] in a 10% animal glue solution and is applied with brushes.

Patterns drawn with thin strips of gold leaf on the polychrome layer are made with a decorative technique called *kirikane* (See Fig. 4). Stacked layers of gold leaf are cut together with a bamboo knife into thin strips or small pieces in the shapes of triangles, squares, hexagons or diamonds, and are adhered on the patterns with a paste (*funori*[9] or animal glue). Because the sharp thin lines appear very shiny and decorative, *kirikane* has been used for Buddhist sculptures since the Asuka period and flourished in Heian and Kamakura periods.

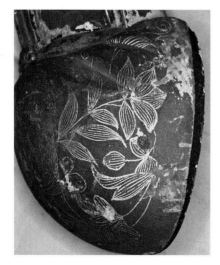

Figure 4. Kirikane, *leaves on blue-green base color. Underdrawing exists and white ground is seen in losses.*

Conclusion

In order to understand the condition of artworks, it is indispensable to be familiar with the materials and techniques with which the work was made. When working

on Japanese polychrome wooden Buddhist statues, such knowledge should include information on the materials, sculpting wood, preparation of ground, application of gold leaf and coloring techniques during the various periods of Japanese history.

Acknowledgements

The authors are indebted to Mr. Park Hee Hwan of the sculpture conservation laboratory of the Tokyo National University of Fine Arts and Music for data documentation; to students of the sculpture laboratory for their assistance; and to Professor R. Sugishita of the university's Conservation Science Laboratory for valuable advice. We also wish to thank Dr. Takashi Koyano and Ms. Mika Koyano for translation.

Notes

1. *Gyokugan*: A technique to insert eyes made of quartz into the wooden statue. First, the face is cut and separated from the head. The eye positions are carved out after hollowing out the inside of the face, lens-shaped quartz eyes are fitted in, and then the eyes are fixed by pressing with paper cotton and wood. This technique adds a realistic impression to the statue and has been used frequently since Kamakura period.
2. Metal Nail: A technique introduced from Sung (China) in the Kamakura period. The nails are made from copper plate and are adhered to the statue using *urushi*.
3. *Kokuso-urushi*: A mixture of *ki-urushi* (raw lacquer), wood powder and water used for adhesion, shape correction and filling. For adhesion, the mixture should have a larger amount of lacquer and water to flow smoothly, and for filling, it should have more wood powder to control hardness.
4. *Sashi-kubi*: Head and body are made separately, and the head is inserted into the body. This method has advantages of shortening the working time, saving materials and making use of *gyokugan* possible.
5. *Wari-kubi*: The head of a roughly carved statue is separated using a chisel. After the inside of the head has been hollowed out, the head is placed back. This method has the advantage of allowing control of the angles, decreasing the weight and reducing cracking and warping.
6. *Mugi-urushi*: Paste *urushi* (lacquer) made from *ki-urushi* with addition of wheat flour (or rice flour).
7. *Sabi-urushi*: A mixture of *ki-urushi* and *tonoko* (fine clay produced from igneous rocks). After kneaded with a spatula, it is applied with either a spatula or a brush. Used in various stages of fabrication.
8. *Iwaenogu*: Natural mineral pigments made from minerals such as azurite (for *iwagunjo* blue) and malachite (for *iwarokusho* green).
9. *Funori* (seaweed glue): 6g of dried seaweed are soaked overnight in 200ml of water. Then it is cooked in a pan over low heat until the seaweed is well dissolved and the liquid is strained through a medium coarse cotton cloth.

Résumé

Analyse de la polychromie du retable de Saint Jean Baptiste à Hernani, d'après le contrat réalisé avec le maître polychromeur et doreur Agustin Conde en 1742, les analyses chimiques et l'étude effectués lors de la restauration en 1992–3. Examen des techniques utilisées, des pigments et des liants, ainsi que des motifs décoratifs, qui situent la polychromie dans la plénitude de la période baroque.

Mots-clés

polychromie, Agustin Conde, retable, baroque, sgraffito, *estofado*

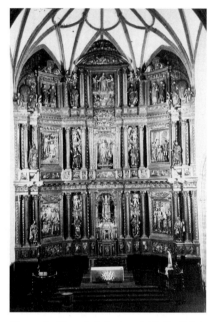

Figure 1. Vue générale du retable de Saint Jean Baptiste.

La polychromie du retable de Saint Jean Baptiste de Hernani, Gipuzkoa, Espagne. Contrat et analyse

Maite Barrio Olano, Ion Berasain Salvarredi, S.L. Albayalde★
c/ Río Deba, 7 bajo. 20012
San Sebastián
Espagne
Fax: + 34 943 28.78.00
Email: albayalde@euskalnet.net

Le retable de Saint Jean Baptiste (voir Fig. 1) occupe l'abside de l'église paroissiale de Hernani. De grandes dimensions (21 × 17 mètres), il fut construit entre 1651 et 1656 par Bernabé Cordero, maître architecte né à Madrid, qui a produit un grand nombre de retables en Gipuzkoa, et dont l'œuvre, classiciste, peut s'inscrire dans la première période baroque.[1]

Le retable est divisé horizontalement en trois travées principales partagées en deux registres et une attique, avec une prédelle interrompue par un tabernacle en forme de temple. Il comporte des reliefs et des sculptures, consacrés à Saint Jean Baptiste, à La Vierge et au Christ, ainsi que des représentations des saints apôtres, des martyrs, des allégories, etc...

La polychromie du retable a été realisée presque un siècle plus tard, en 1742 par Agustín Conde, maître doreur et polychromeur né à Bilbao en 1718 et auteur de la dorure de nombreuses œuvres. Son travail à Hernani est très détaillé dans le "Contrat pour la Dorure" accordé à l'avance pour la paroisse contractante.[2]

Jusqu'à maintenant, étant donné le manque de documents, on pensait que le retable était resté presque un siècle en bois nu, ce qui d'ailleurs n'est pas un phénomène rare, puisque l'exécution d'une œuvre de si vastes proportions engendrait une dette considérable qui souvent empêchait la suite des travaux. Et pourtant, d'après le contrat, Conde s'engage à éliminer la polychromie précédente et à refaire le tout d'une manière homogène. De plus, on y énumère une à une les zones polychromées précédemment. L'étude réalisée pendant la restauration a permis de compléter cette liste, ajoutant certains reliefs qui comptent aujourd'hui deux polychromies superposées.

Ce qui nous montre deux faits:

1. Même si à l'heure actuelle nous ne possédons pas de documents qui en témoignent, il existait déjà avant 1742 une polychromie partielle du retable, se limitant sûrement aux parties principales.
2. Le maître polychromeur n'a pas accompli les exigences du contrat et a effectué sa polychromie sur la précédente, sans éliminer celle-ci.

Le contrat "sur la dorure" donne des renseignements précis sur les conditions techniques que le polychromeur devait respecter.

Tout d'abord Conde est obligé d'"enlever la poussière du retable une et plusieurs fois",[3] après quoi il devait appliquer une "couche de colle bien chaude" avec de l'ail, pour laver et dégraisser l'œuvre.[4] Ensuite il était tenu d'appliquer l'apprêt ou préparation blanche, d'abord plusieurs couches de *ieso grueso*, réparées avec des fers, suivies de plusieurs couches de *ieso matte*.

D'après les analyses chimiques, on trouve en effet deux strates de préparation différenciées, la première de couleur brun gris, composée de sulfate de calcium et de terres, avec une épaisseur de 100 à 200 microns, et une seconde couche de sulfate blanc, de 100 à 250 microns.

Même si ce n'est point spécifié dans le contrat, le polychromeur a collé des fragments de toile de lin sur les joints des panneaux, sur les défauts du bois, sur les

★ Auteur à qui la correspondance doit être adressée

Figure 2. Motif décoratif géométrique gravé sur la préparation et postérieurement doré. Carrés, cercles et zig-zag entre lignes.

Figure3. Sgraffito de feuilles d'acanthe sur la bordure d'un manteau. Décor de poinçonnage.

Figure 4. Dessin d'un vase de fleurs réalisé avec la technique du estofado sur le manteau de la Vierge. Décor de poinçonnage sur les fonds dorés.

nœuds et sur les trous, aussi bien sur l'architecture que sur les reliefs et les sculptures. De même, il les a appliqués afin de compléter les formes (manteau de Saint Jean Baptiste), ou encore pour adapter certaines figures à leur cadre architectural (Saint Thomas). Ces éléments en toile ont été dorés et polychromés de la même façon que l'ensemble de l'œuvre.

Après cela, les polychromeurs ont gravé des motifs sur la préparation en y faisant des incisions réalisées sur les panneaux dorés de l'architecture, sur les niches et les arrière-plans des sculptures du premier étage (voir Fig. 2). Les motifs décoratifs déployés peuvent être géométriques (carrés, points, losanges), végétaux (petites fleurs, feuilles d'acanthe, rinceaux) ou mixtes. Ils apportent un grand dynamisme aux fonds dorés. L'effet est accentué par l'alternance d'or poli et d'or mat et par des lignes en zigzag gravées au moyen d'une gouge sur les surfaces mates.[5] Cette technique souligne les dessins réalisés et créée des contrastes d'ombre et de lumière.

Toujours d'après le contrat, sur la préparation blanche, les parties destinées à être dorées ou argentées devaient recevoir une couche de bolus rouge ou assiette à dorer "bol de llanes".[6] Nous avons trouvé deux sortes de bolus: le rouge, d'une épaisseur de 15 à 25 microns, appliqué pratiquement sur la totalité de la surface du retable (sauf sous les carnations); et un autre bolus jaune, plus rugueux, sur certaines zones de l'architecture, généralement là où l'or mat devait être posé.

Après ces couches de préparation, on y appliquait les feuilles métalliques, qui recouvrent presque l'ensemble de l'œuvre. Sur le contrat, on spécifiait avec un soin scrupuleux les parties qui devaient être dorées, détaillant minutieusement les parties polies et mates. A partir des sources d'archive, il ressort que dans ce retable on a employé 210.000 feuilles d'or "apportées de la Ville et de la Cour de Madrid".[7] Elles mesurent 8 × 8cm et ont une épaisseur en tout cas inférieure à 10 microns.

Le polychromeur a aussi utilisé des feuilles d'argent, destinées à l'imitation d'objets métalliques (épée, ancre, tenailles, etc...). L'argent apparaît aussi recouvert de glacis colorés: vert (chlorure de cuivre) sur les palmes des martyrs, et rouge sur la grille de Saint Laurent.

Les décors peints sur les feuilles métalliques occupent une place prépondérante dans le retable, recouvrant la totalité de la surface dorée des reliefs et des sculptures.

La technique du sgraffito particulièrement intéressante, consiste à appliquer une couche picturale sur une surface d'or ou d'argent poli et, après séchage partiel, à graver la couche colorée afin de faire réapparaître la feuille métallique sous-jacente.

Nous groupons sous le terme *sgraffito* les motifs où la couche colorée est uniforme, d'une seule couleur et le dessin est créé uniquement grâce au motif gravé. Dans ce retable, le sgraffito, quoique abondant, occupe seulement la surface des objets et des symboles, les revers des manteaux, des bordures et des frises. Il est donc utilisé plutôt pour organiser les surfaces, encadrer et séparer des éléments.

Les motifs peuvent être très simples ou très élaborés. Dans le cadre des motifs géométriques, nous trouvons le *rajado o rayado* [8] ou sgraffito ligné; *l'ojeteado* [9] ou petits cercles; *l'escamado*,[10] ou dessin de petites écailles dans des rangées alternées ornées ou non à l'intérieur; le zig-zag, imitant un tissu de moiré; les carrés, losanges, triangles, cercles non fermés et les spirales continues.

Les motifs végétaux sont plus nombreux, on peut trouver des rinceaux de feuilles d'acanthe (voir Fig. 3), plus ou moins stylisées, des fleurs et d'autres formes plus abstraites dont l'identification est difficile. Les ornements sont de dimensions très variables, mais peuvent parfois s'étendre sur 33cm de hauteur. Habituellement c'est le dessin même (feuille ou fleur) qui est gravé, c'est-à-dire, doré, tandis que les fonds demeurent colorés, mais il est possible aussi de trouver le négatif ou encore le motif en couleur cerné de dorure.

Nous classons dans le terme *estofado* [11] les décors où la couche colorée sur l'or est très élaborée, avec des motifs peints. En réalité, ici, le sgraffito n'est plus qu'un complément du décor.

Dans le retable de Saint Jean Baptiste, cette technique est privilegiée dans l'ensemble de la décoration aussi bien par la quantité de la surface ornée que par la qualité des représentations.

Les motifs sont très variés et revêtent un caractère naturaliste évident. Nous trouvons des fleurs et des motifs végétaux, présentant une variété et une richesse extraordinaire et qui occupent presque la totalité des manteaux et des tuniques des personnages. On peut aisément identifier des pivoines, des anémones, des lys, des

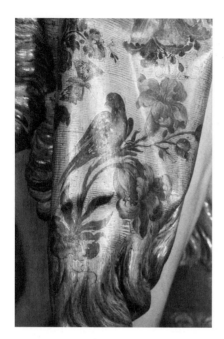

Figure 5. Décor estofado d'oiseaux et de papillons sur la tunique de Saint Jean Baptiste.

Figure 6. Petits anges portant les attributs de Marie repris des litanies du Cantique des Cantiques sur la bordure du manteau de la Vierge.

œillets; ces fleurs sont mélangées, entrelacées ou indépendantes. En règle générale, leur distribution sur un plan ne respecte pas un axe symétrique, leur répartition suit plutôt le hasard d'une composition en rapport avec la forme particulière de la surface décorée. Le sgraffito complète les fleurs, les entoure, suit leur silhouette, accentue les principales lignes, les pétales ou la corolle.

Accompagnant ces motifs végétaux, nous trouvons la représentation de vases, d'urnes, ou de paniers d'où sortent des rameaux de fleurs et de feuilles (voir Fig. 4).

Ces motifs peuvent être aussi de grandes dimensions: des vases de 22cm ou des fleurs avec tige de 63cm de hauteur.

Avec le goût des représentations naturalistes qui se développe à partir du Concile de Trente, nous voyons apparaître certains animaux, principalement des oiseaux, volant sur le ciel, ou posés sur de petites branches, accompagnés de papillons sur la tunique de Saint Jean Baptiste (voir Fig. 5). On trouve aussi un héron sur le fond du relief de la Visitation et un chien sur le fond du relief de la Décapitation. Dans tous ces cas, le sgraffito rehausse le dessin de l'animal et souligne les courbes essentielles de son corps.

Les représentations anthropomorphiques ne sont pas très abondantes et se trouvent pour la plupart sur les fonds décoratifs des reliefs. En général, elles ont un caractère sacré et montrent de petits anges ou des chérubins.

Parmi ceux-ci, nous voudrions signaler la richesse décorative des six anges qui ornementent la bordure du manteau de la Vierge, et qui portent chacun les différents attributs repris dans les litanies du Cantique des Cantiques (voir Fig. 6): un arbre (arbre de Gessé ou cèdre du Liban), une fontaine (fontaine de mes jardins, source d'eau vive), un phylactère avec les paroles "Rose mystique" (rose de Shalon), etc... Ils mesurent entre 20 et 25cm de hauteur. Ils sont peints sur les fonds dorés et les corps et les symboles sont décorés au moyen d'un sgraffito réalisé avec de petites hachures parallèles.

Sur le dessin de l'architecture du fond du relief de La Décapitation de Saint Jean-Baptiste, étendue sur une voûte, se trouve aussi une femme nue, légèrement voilée, qui se regarde sur un miroir. Il s'agit sûrement de l'allégorie de la luxure, étant donné le symbole qu'elle porte et le rapport évident avec la scène représentée.

Les images des cartouches ou de médaillons sont exceptionnelles. Nous avons seulement une rocaille ornée de feuilles d'acanthe, avec la croix de Saint Jacques, comme symbole du Saint, et un cercle entouré de laurier portant le monogramme de la Vierge, avec les lettres et la couronne de Marie.

Les fonds unis des reliefs constituent des espaces très appropriés pour développer des décors figurés, en trompe-l'œil, qui aident à situer les images sculptées dans leur contexte. Dans ces cadres se découvrent des espaces intérieurs, soit très simples, avec le dessin du carrelage du pavement, ou des rideaux, soit plus complexes, avec des architectures compliquées, des colonnes, des voûtes,etc... qui donnent une grande perspective à l'ensemble.

De même nous assistons à l'apparition d'espaces extérieurs, à travers une colonne ou un arc, une fenêtre ouverte qui permet à l'auteur de recréer un paysage plus ou moins défini, avec des arbres, des montagnes, des châteaux, des tours et même des statues. Ces espaces servent aussi pour souligner les symboles des images sculptées, ainsi la fontaine dans la représentation de la Tempérance, les châteaux et les armes dans le relief de la Force ou la marine avec des galions espagnols sur l'arrière-plan de l'Espoir (voir Fig. 7).

Figure 7. Marine avec galion espagnol du XVIIIe siècle sur le fond du relief de l'Espoir.

Les stratigraphies de ces *estofados* sont plus complexes, puisqu'aux couches habituelles des sgraffitos (c'est-à-dire, les couches de préparation, feuilles métalliques et couche de couleur) il faut ajouter les différents strates de peinture appartenant au dessin au pinceau, pouvant compter trois ou quatre couches superposées.

Le poinçonnage complète le décor des vêtements. Il a été realisé sur les sculptures et reliefs plus proches de l'observateur (prédelle et premier étage, avec une exception à l'attique). On a pu repérer six poinçons différents : un point rond, deux points carrés (1,8mm de largeur) probablement sur une roue, trois points (2,5mm de largeur) probablement sur une roue, quatre points carrés 2 × 2 avec les angles extérieurs légérement arrondis (2 × 2mm), seize points carrés, 4 × 4 (4 × 4mm), un rectangle de 8 × 3mm avec 8 ou 9 lignes à l'intérieur, et une pointe rectangulaire.

Le poinçonnage est localisé surtout à l'intérieur des motifs végétaux, remplissant la surface dorée, ou accentuant le contour ou les différents éléments des fleurs. Il délimite aussi les bordures.

Les yeux en verre des sculptures et des reliefs du premier étage ont été appliqués par Agustin Conde, suivant les exigences de son contrat.[12] Etant donné que la taille en bois était achevée complètement, Conde a été obligé d'évider le support à l'endroit des yeux pour y introduire les globes en verre. Une fois les yeux positionnés, des paupières en stuc sont modelées. Plus tard, cela a provoqué des fissures et la perte de certains fragments.

Quant aux pigments utilisés, on rencontre le blanc de plomb, des terres, le vermillon et des laques organiques, le chlorure (résinate ?) de cuivre, l'azurite et l'indigo. Les couleurs sont plus variées qu'aux époques précédentes et on y trouve aussi des couleurs mélangées qui donnent les variétés de tons roses, saumon, orangé, les différentes gammes de vert et de bleu, le violet et le noir.

Comme liants, la colle animale a été identifiée dans les couches de préparation, la tempera dans le bolus et l'huile dans les couches de couleur. On a aussi décelé de la colle animale sur toutes les couches, ce qui peut être le résultat d'un processus de restauration précédent.

Les carnations des figures sont actuellement très altérées à cause de nettoyages précédents excessifs.[13] D'après les analyses chimiques, elles ont été exécutées en une seule couche à l'huile, et présentent un aspect très compact qui retient fortement la lumière. A la recherche d'un plus grand réalisme, les polychromeurs soulignent les veines des bras, des pieds et des cous avec du bleu, surtout sur les figures masculines. Sur les visages, les joues sont légèrement accentuées par du rose. Les hommes rasés ou tonsurés ont reçu un ombrage grisâtre. De la même manière, la naissance des cheveux, les cils, les sourcils, les iris et les points lacrimaux sont précisés avec des coups de pinceaux marrons, noirs et rouges.

Nous voudrions signaler le grand soin et la minutie des polychromeurs, qui ont dû s'adapter à une œuvre créée un siècle auparavant. Nous assistons à une intéressante symbiose entre le polychromeur et le sculpteur puisque le premier complète et corrige le travail du second. A cet effet et pour citer un exemple, sur le relief de la Décapitation il est curieux de constatez que, le polychromeur a peint le pied d'Herodias, mère de Salomé, sur le fond uni, alors que le sculpteur n'avait pas considéré nécessaire de représenter ce pied.

La paroisse a été tellement satisfaite de la polychromie exécutée par Agustin Conde qu'elle a considéré superflu l'examen habituellement réalisé par des spécialistes à la fin des travaux comme l'atteste un document.[14]

Conclusion

La polychromie du retable de Saint Jean Baptiste de Hernani appartient entièrement à son époque, c'est-à-dire, au style baroque dans sa plénitude, avec des éléments qui annoncent déjà l'art rococo. Elle réflète une deuxième phase de la peinture de la Contre-Réforme. Les motifs typiques de la Renaissance (*grutescos*) ont été abandonnés pour laisser la place à un décor inspiré de la nature et "des choses vivantes",[15] avec l'apparition des motifs végétaux (*rameados*) comme des éléments qui articulent l'espace.

Nous trouvons des décors qui prolongent la tradition du XVIIe siècle, comme le répertoire de fleurs sur des fonds rayés imitant les fils d'or des vêtements de l'époque. Mais le coup de pinceau de l'artiste est déjà assez libre, la rigidité des

décors des époques précédentes, plus fidèles aux patrons textiles. Les éléments qui annoncent le style rococo sont abondants: la gamme de couleurs s'élargit et les représentations des animaux apparaissent ainsi que des oiseaux et des papillons propres à la peinture galante, ou encore des cartouches, des médaillons en forme de rocaille, etc... Polychromie donc, d'une grande qualité et d'une énorme richesse décorative, propre à son époque quant aux techniques et motifs décoratifs même si elle est appliquée sur une sculpture plus ancienne.

Notes

1. Contrat de construction du retable avec Bernabé Cordero. Archivo Histórico de Protocolos de Gipuzkoa. SS.P.1090 259–261v.
2. Escritura de concierto con Agustín Conde sobre la doradura del retablo mayor de la parroquia de esta villa y obligación para su ejecución. Notario: Miguel Antonio de Ugalde. A.H.P.G. SS. P. 1355.
3. Phrase du contrat.
4. Idem.
5. Sorte de guillochage semblable à l'effet du tremolierungen sur le bois.
6. Phrase du contrat.
7. Archivo de Hernani, A, Neg.1 libro n°9. L'or est apporté de Madrid, car à l'époque il était considéré de meilleure qualité que celui provenant de Pamplona, Valladolid, ou Zaragoza, largement utilisé pendant le XVIIe siècle.
8. En espagnol.
9. Idem.
10. Idem.
11. Idem.
12. Afin que les figures "se aparezcan al natural". Au contrat.
13. D'après le contrat les carnations devaient être faites "con mucho gusto apulimento con azeite de/ nuezes".
14. Archivo de Hernani. Secc.E, Neg.4, Serie I, exp. 32.
15. "Del natural o de la cosa viva". Termes qui aparaissent souvent dans les écritures de cette époque (Echeverría Goñi, 1993).

Références

Pour la polychromie baroque

Echeverría Goñi, P. 1993. Policromía renacentista y barroca. Cuaderno de arte español. Madrid. 48:26.
Payo Herranz, R. 1997. El Retablo en Burgos y su comarca. Burgos.
de la Peña Velasco, C.1992 El retablo barroco en la antigua diócesis de Cartagena 1670–1785. Murcia. Asamblea Regional et al.
Vélez Chaurri, J.J. 1990 El retablo barroco en los límites de las provincias de Alava y Burgos (1600–1780). Vitoria. Diputación Foral de Alava.
Vélez Chaurri, J.J.et. al. 1998 La policromía de la primera mitad del siglo XVII ebn Alava. Pedro Ruiz de Barrón y Diego Pérez y Cisneros (1602–1648). Miranda de Ebro. Instituto Municipal de Historia.

Sur les techniques et styles de polychromies en sculpture

Echeverría Goñi, P. 1992. Policromía del Renacimiento en Navarra. Pamplona. Diputación Foral de Navarra.
Gómez Moreno, Mª Elena. 1943. La policromía de la escultura española. Madrid.
Martin González. 1953. La policromía en la escultura castellana. Archivo Español del Arte.
Palomino Páramo
Sanchez Mesa, D. 1971. Técnica de la escultura policromada granadina. Granada. Universidad de Granada.

Auteurs de traités

Nunez, Felipe. 1986. Arte da poetica, e da pintura e symetrya con principios da perspectiva. (Lisboa 1615) De. de Zahira Veliz, Artists'techniques in Golden Age Spain. Six treatises in translation. Cambridge.
Pacheco,F. 1957, Arte de la Pintura, Edic. del manuscrito original de 1683 llevada a cabo por F.J. Sánchez Cantón. Madrid.
Palomino de Castro, A. 1947. El museo pictórico y escala óptica con el Parnaso Español Pintoresco Laureado, (Madrid 1715–1724) Madrid.

Abstract

This article describes the conservation of 50 earthen bas-reliefs detached from the façade of one of the Royal Palaces at Abomey. It explains the methodology used, its various components including documentation, material testing and analysis, conservation treatment, monitoring and maintenance, training, and the exhibition of the bas-reliefs. In 1988, the building decorated with these bas-reliefs was razed due to structural damage and the bas-reliefs were detached. Although the detachment was very drastic and damaging, it saved the bas-reliefs, considered original, from being lost. In 1993 the Getty Conservation Institute (GCI) and the Ministry of Culture and Communication (MCC) of the Republic of Benin undertook a project to preserve them. By the end of this four-year collaboration, the bas-reliefs were conserved using a methodology that will serve as a model for other similar projects in Benin, and MCC personnel were trained in all aspects of the work.

Keywords

bas-reliefs, earthen, conservation, Benin, fixing, consolidation, reintegration, documentation

PLAN OF ABOMEY MUSEUM

Figure 1. Diagram showing the Republic of Benin and Abomey. In the inset: Plan of the Historical Museum of Abomey indicating the location of Adjalala of King Glélé.

The conservation of polychrome earthen bas-reliefs from the Royal Palaces of Abomey in the West African Republic of Benin

Francesca Piqué[*] and Leslie Rainer
The Getty Conservation Institute
1200 Getty Center Drive, Suite 700
Los Angeles CA 90049
USA
Fax: +1 310 440-7709
Email: FPique@Getty.edu

Introduction: The bas-reliefs

Several earthen buildings constitute the complex of the Royal Palaces of Abomey in Benin. The first palace was constructed in 1645 and thereafter, each king had his palace built near that of his predecessors. Earthen polychrome bas-reliefs are characteristic features of the palaces and other architecture found in and around Abomey. A portion of the palace complex now is the Historic Museum of Abomey (See Fig. 1).

Architectural decoration of palace buildings consists of wall paintings, encrusted shells and pearls, and bas-reliefs. Among these, the polychrome earthen bas-reliefs are the most remarkable (See Fig.2). They show mythical and symbolic animals, weaponry and battle scenes as well as abstract forms which tell the rich history of the Fon people (See Fig. 3). Apart from their fine artistic quality, the bas-reliefs constitute a document of exceptional historic value. This art form gave rise to a prodigious iconographic tradition that developed rapidly and that remains alive today.

The bas-reliefs decorating the long multi-portal *adjalala* (palace) buildings on the external walls of the royal palace are part of a long-standing bas-relief tradition in this region, with related forms found in the various private "princely" palaces of Abomey and in local and regional voodoo temples (See Fig. 3). Of these, the bas-reliefs in the Historic Museum of Abomey are among the most historically important. The bas-reliefs were first documented in 1911 by Em. G. Waterlot who visited Abomey and made casts of 36 of the bas-reliefs from the Adjalalas of Guezo and Glélé (Waterlot 1926). Today, a set of the casts is exhibited at the Musée de l'Homme in Paris and others are on exhibit and in storage at the Historic Museum of Abomey.

Original materials and techniques

The bas-reliefs, made with the addition of earth to create the modeled figures, were set into niches carved into massive earth walls (See Figs. 3, 4). The original earth used to make the bas-reliefs came from local sources. It was dried, crushed, and mixed with the residue from palm oil production. Palm fibers were added to increase tensile strength.

The decoration is polychromatic. The stratigraphy of the paint layers on all the bas-reliefs was examined visually during the condition survey. It was evident that the bas-reliefs had been repainted several times. Some paint cross-sections showed up to six paint schemes. All cross-sections indicated an accumulation of local red earth on the surface. Most colors were made with organic dyes and inorganic earth pigments (ochres). The green is composed of a mixture of Prussian blue with the addition of yellow earth. Some types of blue were identified with polarized light microscopy to be synthetic ultramarine and others as washing blue (*bleu de lessive*) also known as Ricketts blue. In the upper layers, the pigment particles were very fine, indicating synthetically prepared materials. Therefore, the paint layers were composed of both locally available pigments and synthetically prepared paints.

[*] Author to whom correspondence should be addressed

Figure 2. Historical Museum of Abomey, newly reconstructed Adjalala of King Glélé. Bas-reliefs are a characteristic architectural decoration of the Royal Palaces of Abomey. They are set into niches carved into the earth walls and decorated with polychromy.

Figure 3. Detached bas-relief (after treatment) depicting a horse with a head hanging from his neck. This bas-relief tells the story of the defeat by the Abomey warriors of the Nago horsemen, a neighboring enemy. The Abomey warriors cut off their heads, attached them to the neck of their horses, and took them back to Abomey. This figures also shows the reintegration policy: Only the background was reintegrated while the losses to the polychrome relief figures were left untouched.

The organic components of the earth layers were compared with the traditionally used binding media using infrared spectroscopy. This confirmed that the water/oil dispersion remaining from palm oil production was used as a binder.

Conservation history

Background research continued throughout the project, and included information on the history and significance of the bas-reliefs, the palaces, and the site. An important objective was to find information on the extent and type of changes the palaces had undergone over time and relate these to the condition of the bas-reliefs.

The bas-reliefs of the Adjalala of King Glélé likely were fabricated during his reign between 1858–1889. In 1894, when the French army conquered Abomey, King Behanzin burned the royal palaces. Historical photographs of different periods indicate that the bas-reliefs were repaired and repainted many times. The first occasion was most likely under the reign of Agoli-Agbo, who was enthroned in 1894 by the French after their conquest of Abomey. Unfortunately, no records are available to determine the extent of his efforts. The French restored the palaces at the beginning of the 20th century under the colonial administrator; again, the extent of the work is not certain. They were restored again in the 1930s under the colonial governor, who modified the roof structures from low overhanging thatch roofs to short, high-pitched corrugated metal roofs.

In 1982, Benin ratified the World Heritage Convention, and the Royal Palaces of Abomey were included as a cultural site on the UNESCO World Heritage List. In 1984 they were added to the List of World Heritage Sites in Danger. In 1988 the staff of the Historic Museum of Abomey determined that the Adjalala of Glélé needed to be reconstructed. Other royal palaces within the precincts of the museum had already been reconstructed, leaving the Adjalala of Glélé as one of the only intact original structures with bas-reliefs on the site. The Museum staff sought the advice of an architect working for the German Embassy in Benin, who suggested that the historical value of this last group of bas-reliefs made them worthy of preservation. The bas-reliefs were cut from the walls and mounted as individual panels in heavy casings of earth-based material strengthened with cement (See Figs. 3, 4). Wooden frames kept them stable and standing in an upright position in storage areas.

The conservation project

In 1993 the Getty Conservation Institute (GCI) and the Ministry of Culture and Communication (MCC) of the Republic of Benin began a collaborative project to conserve the bas-reliefs that had been detached from the Adjalala of Glélé in 1988. The components of the conservation project included training of local conservators, documentation, material testing and analysis, conservation treatment, preparation of a museum exhibit, and the design of a long-term monitoring and maintenance plan.

Training

Training was one of the most important objectives and was integrated into all aspects of the project. Three members of the professional staff of the Department of Cultural Patrimony (DPC) were selected to be trained as conservation technicians in practices directly related to bas-relief conservation. These people had prior training in preventive conservation through the ICCROM-PREMA course held in Benin in 1992. During this project they received training in documentation techniques, conservation principles and practice, as well as transport, handling, and long-term maintenance of the bas-reliefs. Later, three members of the museum staff were also trained in long-term maintenance. In addition, the technicians and one museum staff member were given intensive training in techniques of photographic documentation, and the unused museum photography laboratory was refurbished.

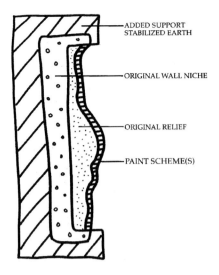

Figure 4. Section of a detached bas-reliefs showing the relationship of the various components. Once detached from the walls, the bas-reliefs were encased in stabilized earth—a mixture of local earth and cement. With the added support the bas-reliefs weighed an average of 300kg.

Figure 5. Technician Leonard Ahonon recording graphically the bas-relief condition using transparent overlays over black and white photographs.

Conservation documentation

The project was extensively documented. Because of the important training component, special attention was given to the systematic recording of all elements of the conservation process, including historic and technical research, and condition and treatment documentation in graphic, photographic, and written form.

Documentation prior to treatment identified each bas-relief, its original location on the palace façade, current storage location, any existing historic references, and present condition. The condition was recorded in written, graphic and photographic form following preset standard procedures. Each condition was defined and recorded graphically using a set of symbols adapted from graphic keys used on similar conservation projects. The structural and paint layer condition was recorded separately with transparent overlays over black and white 8" × 10" photographs (See Fig. 5). Treatment was subsequently recorded using the same process. Photographs of each bas-relief were taken before and after treatment in color (slides) and black and white (prints). The nomenclature included three scales (black and white, color, and centimeter), the date, the number of the bas-relief, and the state of conservation: before (*avant* – AV), or after (*après* – AP) conservation (See Figs. 6, 7).

Problems and causes of deterioration

At the beginning of the project, the 50 detached bas-reliefs were in varying states of disrepair and were stored in various indoor and outdoor locations. Deterioration was ongoing, and the need for treatment was clear, as evidenced by traces of animal activity, weathering, and broken pieces of relief and support. As a result of the historical research and the examination of all bas-reliefs, the following three factors were identified as causes of deterioration:

ORIGINAL LOCATION ON FAÇADE
The majority of the bas-reliefs were set into the exterior facade of the Adjalala of Glélé in three rows (See Fig. 2). The building originally had a steep pitched roof that extended nearly to the ground. This greatly protected the bas-reliefs from the elements. However, the change in the 1930s to a metal corrugated roof left them exposed. Those on the bottom row were the most deteriorated and showed signs of salt efflorescence, remodeling with cement plaster, and numerous repainting schemes. There were surface drips and accumulations of red earth, originating from roof leaks and water splashing and running down the façade during heavy rains common in the region.

ORIGINAL AND ADDED MATERIAL
Material failure of the bas-reliefs was due to two main factors: erosion of original material by exposure to the elements and the incompatibility of original and added repair materials. While the local earth originally used was stable and quite sturdy, the materials used in the successive remodeling and repairs were not always compatible with it, and there were problems of deterioration and detachment. The commercial paints with different chemical compositions, which had replaced the traditional paints, may, in some cases, have caused the delamination of layers. Certain colors, especially the blue, red, and white, were powdering.

DETACHMENT AND TRANSPORT
A bicycle chain had been used as a saw to extract the bas-reliefs from the façade of the building. Once they were detached, earth was removed from the back of the bas-reliefs before they were encased in cement-stabilized earth supports (See Figs. 3, 4). It should be noted that each bas-relief measures between 70–100cm × 80–110cm and weighs on average 300kg. Nearly all of the bas-reliefs from the top row of each column were damaged along the upper edge, indicating that the removal had not been completely successful. The ragged upper edge of these panels had been systematically filled with the cement-stabilized earth mixture. Damage

Figures 6 (top) and 7 (bottom). Example of one bas-reliefs before (top) and after treatment (bottom). This shattered bas-relief required the addition of an internal metal armature. The metal elements of the armature were first coated with an acrylic resin (Paraloid® B-72) to avoid possible corrosion. The stabilized earth was then built up around the metal to reconstruct the bas-relief support. Only the background was in-painted in areas of loss to reinstate the harmony of the panels as an ensemble.

to other bas-reliefs from the interior gallery probably occurred during their removal from the building. In these cases, only the relief figures had been saved and the background portion had been filled with the stabilized earth mixture.

In the subsequent transport from one area of the museum to another, certain bas-reliefs suffered further damage, mostly to the bases of the added support, which were found cracked and shattered (See Fig. 6).

Conservation treatment

Conservation procedures were determined after testing the following:

- composition of earth mix for fills in original earth and in the added support;
- composition of liquid mortar for grouting;
- type and concentration of adhesive to re-adhere delaminated paint layers;
- type and concentration of consolidant for powdering paint;
- inpainting materials and methods;
- cleaning methods to remove surface accumulation;
- removal of stains from the added support; and
- salt removal.

The procedure and results of these tests are documented in the project reports.

Conservation treatment was to be carried out with minimal intervention, using locally available materials. The objective was to stabilize the bas-reliefs–reconstruction or restoration of missing parts of relief or paint losses of on the figures would not be carried out (See Figs. 3, 7). Although a general conservation treatment plan was developed, due to the varied condition of the bas-reliefs, treatment of each one was considered individually. The conservation treatment included the following operations:

- Emergency stabilization – This procedure was necessary to ensure safe transport of the heavy bas-reliefs from the storage area to the atelier for the conservation treatment. After being cleaned with soft, dry brushes and air bulbs, the painted surface was protected with Japanese paper facing. Dangerously loose fragments and flakes were reattached using the method described below (reattachment of paint). Any loose fragment was removed after documentation of its correct position. The bas-relief was then protected with soft cheesecloth and additional padding for transport.
- Structural repairs – On the most damaged bas-reliefs, especially those with broken bases or frames, structural repairs were made before they were transported (See Fig. 6). For the few shattered bas-reliefs, this required the addition of an internal metal armature. The metal elements of the armature were first coated with an acrylic resin (Paraloid® B-72) to avoid possible corrosion of the metal. The stabilized earth was then built up around the metal to reconstruct the support of the bas-relief.
- Treatment of previous repairs – Unstable, inappropriate or awkward fills made in the past were replaced with new ones. Those that were stable but unsightly were leveled to just below the original surface, then filled and reintegrated with the surrounding area. A variety of tools – scalpels, micro-chisels and mini drills with grinder bits attached – were used for this operation.
- Filling of losses – Losses in the earth plaster and support layers were filled using a mortar made with local sieved earth mixed with water. Fills to the added support were made using a mixture of earth with 10% hydraulic lime (chaux blanche Lafarge®) to match the strength, color and texture of the surrounding area.
- Grouting – An earth-based grout contained 85% finely sieved earth, 10% hydraulic lime and 5% acrylic resin (Rhoplex® AC33) in water dispersion. In voids behind the surface that were otherwise inaccessible, syringes with large cannula or perfusion tubes were used to introduce the grout.
- Reattachment of paint – Flaking paint was reattached using Rhoplex® AC33 (20%) in water dispersion as an adhesive. The paint flake was first protected with Japanese paper. The adhesive was then applied by syringe through the Japanese paper and the flake was gently pressed back into place. Some flakes

Figure 8. Technician Justin Alaro making fills with a mortar made with local sieved earth mixed with water. Fills to the added support were made using a mixture of earth with 10% hydraulic lime (chaux blanche Lafarge®) to match the strength, color and texture of the surrounding area.

were so distorted that it was not possible to replace them in their original position. In this case, a liquid mortar of finely sieved earth and Rhoplex® AC33 was introduced behind the paint flake to provide adhesion and bulk.
- Consolidation of paint – Powdering paint was consolidated using 3–5% Paraloid® B-72 in acetone. Consolidation was done only in localized areas where the paint was no longer cohesive. These were mainly the areas of white, red, and blue paint.
- Cleaning – After fixing and consolidation, a gentle cleaning with water and cotton swabs or natural sponges was performed to remove the surface accumulation of drips and stains of local earth and dust.
- Aesthetic reintegration – Reintegration addressed the aesthetic presentation of the bas-reliefs, including areas of loss to the support, plaster, relief, and paint layers. Fills to the original and added support were made using earth mixtures similar in color and texture to the surrounding areas. Losses to the painted surface were treated minimally. Because the paint was built up in numerous layers, the choice was made to leave all losses to the polychrome figures as they were (See Fig. 3). The background was inpainted in areas of loss to reinstate the harmony of the panels as an ensemble (See Figs. 6, 7). The loss areas were filled with a paste composed of slaked lime with kaolin, red and yellow ochre, and raw sienna added to match the background color. A thin patina of extra finely sieved earth in water was then applied to blend with the surrounding area, where necessary.

Exhibit

Twenty-one of the conserved bas-reliefs are now an integral part of the Museum and are exhibited in the former French Governor's Quarters, directly behind the newly constructed Adjalala of King Glélé. The bas-reliefs exhibit focuses on their conservation and on the collaboration between the GCI and the MCC.

Monitoring and maintenance

As part of the conservation project, a program of inspection and maintenance was designed to ensure the long-term stability of the conserved bas-reliefs. Inspection protocols were developed to address not only the bas-reliefs but also the buildings housing them. Particular attention was given to recording early signs of damage due to water infiltration and animal infestation. Due to the harsh environment and the fluctuating climatic conditions in Abomey, the schedule specifies three inspections per year. The program includes regular maintenance, such as surface cleaning and repair of damage.

Conclusions

In addition to conserving the bas-reliefs, a major goal of the project was to develop a methodology that could be applied to similar projects for the conservation of the cultural heritage in Benin. This was achieved in two ways: first, by developing a plan compatible with the resources available locally, and second, by including training as an integral component.

Conservation treatments were developed to use locally available materials as much as possible. Complicated procedures requiring special chemicals and equipment were kept to a minimum. This was designed so that the trained conservation technicians could be responsible for the monitoring and maintenance of the bas-reliefs and carry out other work after the completion of the project.

The Beninois are now in charge of the maintenance of the bas-reliefs. They are also responsible for the site of the Royal Palaces of Abomey, and can apply these preventive conservation and treatment methods to other earthen bas-reliefs.

In a larger context, this project has raised the awareness of the significance of the bas-reliefs of the Royal Palaces of Abomey among the people of Benin. This is a very important result because it is the people of Abomey and of all Benin who will ultimately be responsible for the preservation of this heritage and who will see that it remains an integral facet of the culture, part of a living tradition.

Acknowledgments

The Abomey Project owes its success to the working relationship of the partners throughout the project. Special acknowledgements must be made for the hard work and commitment of the team members who participated in the project over the four years: Valerie Dorge, GCI training coordinator, Susan Middelton, photographer, and the conservation technicians: Léonard Ahonon, Dorothe Mizéhoun, and Justin Alaro. Thanks are due to conservators Michel Hebrard, Stephen Rickerby, and Sophie Small for their valuable contribution to the project. The authors would like to acknowledge the Getty Conservation Institute and the Ministry of Culture and Communication of the Republic of Benin and the Historic Museum of Abomey for their full support of the project.

References

Waterlot G. 1926. Les Bas-Reliefs des Batiments Royaux d' Abomey. Paris, Institut d'Ethnologie.

Materials

Rhoplex ®AC-33 (copolymer of methyl methacrilate and ethylmethyl acrylate), Paraloid ® B-72 (copolymer of ethyl methacrylate and methyl acrylate), Conservation Support System, 924 West Pedregosas St., Santa Barbara CA 93101 USA, tel 1-805 682 9843, fax 1-805 682 2064.

Chaux Blanche Lafarge, C.T.S France, 26 Passage Thiéré – 75011 Paris, tel + 33 - (1) 4355 6044, fax + 33 - (1) 4355 6563.

Résumé

Le retable de Bethléem,vaste décor en pierre sculpté redécouvert en 1982 dans un mur de la cathédrale de Narbonne, présente une polychromie originale du XIVème siècle relativement bien conservée et peu surpeinte. Etudiée en 1994, cette polychromie s'est révélée d'une qualité hors du commun tant par le soin apporté à sa mise en œuvre que par la profusion remarquable de décors peints. La grande recherche du traitement des textiles est à relier avec l'activité économique de Narbonne, ville de drapiers au XIVème siècle. Chaque décor polychrome relevé sur le retable trouve un écho dans des collections de tissus ancien ou dans la peinture contemporaine. Leur attribution aux différents personnages répond à un programme précis. La technique picturale a également été étudiée : organisation du chantier, procédés d'exécution, liants et pigments des différentes couches picturales.

Mots-clés

polychromie, XIVème siècle, pierre, sculpture, Narbonne

Un ensemble monumental en pierre polychromée du XIVème siècle dans la cathédrale de Narbonne

Geneviève Rager★
116, rue des Pyrénées
F-75020 Paris
France
Tel/fax: +33 1 40.09.22.10

Marie Payre
39, rue Baron Le Roy
F-75012 Paris
France

Introduction

Le décor monumental de sculptures en pierre polychromées du XIVème siècle redécouvert en 1982 dans la cathédrale de Narbonne est connu sous le nom de « Grand Retable de Bethléem » (actes du colloque, Narbonne 1998).

Avant sa disgrâce au XVIIIème siècle, époque à laquelle il fut occulté par un nouveau décor, cet ensemble était disposé en triptyque contre le mur de la chapelle, et se composait de deux registres historiés surmontés de gâbles et de statues (Voir Fig. 1).

Le premier registre avait l'aspect d'une frise. Il était consacré aux lieux souterrains du séjour des morts: de gauche à droite le purgatoire, l'enfer et les limbes. Le second registre représentait pour les parties latérales six scènes de la vie du Christ et comportait peut-être dans la partie centrale une Vierge de Miséricorde réunissant à ses pieds des élus en prière; cette scène aurait symbolisé le Ciel. Six gâbles scandés par huit statues d'anges musiciens et de saints couronnaient ces deux registres.

En 1994 nous a été confiée l'étude approfondie de la polychromie de cet ensemble. Les premiers examens ont révélé immédiatement la présence sous plusieurs surpeints d'une polychromie originale du XIVème siècle bien conservée et d'une qualité hors du commun. Pour cette raison, mais aussi parce qu'elle concernait un chantier de grande ampleur, impliquant une organisation préalable, un dessein directeur et une mise en œuvre subséquente, l'étude s'est révélée particulièrement intéressante. A la fin du travail, en décembre 1994, la polychromie

Figure 1. Reconstitution du retable de Bethléem.

★Auteur auquel la correspondance doit être adressée

Figure 2. Présentation au Temple : vue d'ensemble, registre supérieur dextre

Figure 3. Les âmes dans la cuve : vue d'ensemble, registre inférieur dextre.

Figure 4. La Crucifixion, détail : bouclier d'un soldat avec tête de monstre tracée à fins coups de pinceau.

du retable de Bethléem a été présentée à l'occasion d'un colloque d'histoire de l'art local consacré aux arts picturaux à Narbonne au moyen-âge dont les actes sont à paraître. Néanmoins, il nous apparaît que cette recherche doit être portée à la connaissance d'un public plus spécifiquement concerné par l'histoire des techniques artistiques afin de pouvoir être confrontée à d'autres expériences et constituer un apport à la compréhension des grands décors monumentaux sculptés du moyen-âge.

Technique picturale[1,2]

La structure de la stratigraphie est classique : un bouche-pore jaune est appliqué sur la pierre, puis une préparation blanche, qui fait office de couche dans les zones blanches. Cette préparation est passée partout, sauf dans les grandes zones d'application d'azurite (fonds bleus). Vient ensuite l'application de la dorure à la mixtion, des plages colorées puis des décors.

Encollage

La pierre avant d'être peinte a subi un encollage léger de nature protéinique, destiné à une première imperméabilisation.

Bouche-pore

Le bouche-pore est présent sur tous les reliefs (Voir Figs. 2, 6). Il est constitué d'un liant protéinique chargé d'ocre. Sa couleur varie du jaune clair à l'ocre soutenu, et son épaisseur est variable. Il est passé largement, à coups de brosse sans orientation mais n'atteint pas les zones de retour très accentuées.

Sous-couches

La sous-couche blanche : il s'agit d'une fine couche blanche, lisse, légèrement satinée composée de blanc de plomb mêlé à de l'huile. Elle est présente sur toutes les zones, à l'exception des surfaces destinées à recevoir l'azurite. Elle fait donc office de préparation; mais dans les plages colorées blanches, elle prend directement la fonction de couche visible (Voir Fig. 3).

La sous-couche beige : les scènes plus sombres de l'Enfer présentent une préparation beige plus fragile, moins cohérente que la sous-couche blanche, qui s'apparente à un bouche-pore plus chargé.

La sous-couche noire est liée à la technique classique de pose de l'azurite. C'est une couche noire, très fine, mate, composée de noir de carbone.

Feuilles métalliques

La feuille d'or est utilisée avec réserve. On la trouve sur certaines moulures d'architectures, sur les cheveux et barbes de certains personnages. Elle n'est jamais incluse dans un décor hormis sur les bordures. Elle est posée sur une mixtion d'épaisseur variable chargée de massicot dont la teinte va du jaune au jaune orangé.

L'utilisation d'autres feuilles métalliques n'a pu être mise en évidence. Néanmoins, l'aspect de certains décors évoque l'utilisation d'une feuille d'argent ou d'étain (draperie de l'Annonciation, un roi mage...).

Couches picturales : tons de base

Sur les scènes historiées et les statues, les couches picturales sont fines et lisses, sauf dans des cas particuliers ou l'empâtement de la couche sert de forme au décor (chevaux pommelés, Voir Fig. 5). Leur aspect est parfois moins soigné sur les gâbles. La couleur est toujours passée en à-plat mais avec des effets de transparence selon l'épaisseur des couches. La gamme des tons de base est restreinte: rouge (vermillon et oxyde de fer), vert (vert au cuivre), bleu (azurite), ocre et brun (terres), noir (noir de carbone). La variété des couleurs vient du mélange de ces différents pigments. Nous trouverons alors une gamme de rouges allant du rouge

Figure 5. Les rois mages, détail : un écuyer dont la position sociale est signalée immédiatement par un bliaud court à rayures roses et rouges.

Figure 6. L'Annonciation, détail de la dalmatique : le motif est constitué par la répétition de médaillons complétés par des oiseaux et des feuillages. Ici, un médaillon noir, rouge et blanc sur fond vert.

vif au rouge orangé, des valeurs différentes de vert, des grenat et lie de vin, du rose, du violet, du gris... On note l'absence intéressante de jaune dans cette gamme de couleurs.

Par ailleurs, un glacis rouge a été observé sans que les analyses permettent d'identifier sa composition. Une laque verte (« résinate » de cuivre) est employée pour l'obtention des feuillages de certains décors.

Les différents rouges ne semblent pas se répartir de façon systématique en fonction du prix du pigment : les fonds rouges des fenestrages des gables accusent tantôt la présence de vermillon, tantôt celle de l'oxyde de fer.

L'aspect des couches varie du mat au satiné : ceci est dû à l'utilisation de différents liants, et dans une moindre mesure à l'état d'altération dans lequel ils nous sont parvenus. Leur identification est délicate: il pourrait s'agir de liants huileux ou mixtes dont le rapport change suivant l'aspect désiré. Certains brun-rouges apparaissent presque mats, les carnations et les couches vertes en revanche sont denses et satinées. Seul l'azurite est systématiquement utilisé avec un liant aqueux.

Le rôle de la couleur

La couleur raffermit la cohérence de ce grand ensemble en organisant des rythmes colorés d'une séquence sculptée à une autre : les grandes statues sont toutes sur fond rouge, les fenestrages sont alternativement bleus et rouges. Elle contribue à lier entre elles les scènes historiées : dans le registre supérieur, les scènes de la Vie du Christ sont scandées par des colonnes, mais ont toutes un fond bleu uni (Voir Fig. 2). Dans le registre inférieur, les fonds sont également bleus (Voir Fig. 3), sans interruption formelle: la couleur contribue à faire de ces séquences une grande frise narrative. Seules les scènes centrales concernant l'Enfer se distinguent par leur fond brun très sombre.

La couleur joue simultanément un rôle symbolique très défini : ainsi dans l'exemple ci-dessus, les seules scènes à posséder un fond sombre et une gamme de couleurs assourdie sont celles de l'Enfer, que nulle rédemption ne peut éclairer. Dans le royaume du divin, en revanche, nous trouverons des couleurs claires et des rehauts d'or.

Le traitement des vêtements repose sur des critères préalablement définis. Les vêtements de la Vierge ont les couleurs symboliquement traditionnelles (bleu pour le manteau, rouge pour la robe) et sont unis à la différence de tous les autres: au moyen-âge, l'uni reflète la pureté, voire l'exception (Pastoureau 1995). Les personnages proches du Christ ou ayant une fonction importante dans la liturgie ont des vêtements amples richement ornés; en revanche, les laïcs ou les personnages du peuple ont des habits plus simples. Les soldats et cavaliers portent des bliauds courts, généralement rayés ou bicolores (Voir Fig. 5). Ici, couleur et attribution des décors renforcent ou précisent des critères sociaux ou religieux en partie évoqués par la forme sculptée.

Les décors polychromes

Décors naturalistes

La polychromie complète la forme sculptée dans le traitement des matières et dans de nombreux détails naturalistes.

Le traitement des carnations semble prendre en compte de façon systématique des critères sociaux pour l'attribution de caractères physiques répétitifs (sourcils fins ou épais, dorure ou non des cheveux...Voir Fig. 8). Les robes des chevaux, les rochers, les touffes d'herbe, les éléments en bois sont traités avec un sens narratif plein de saveur. Certains objets secondaires prennent toute leur importance par leur traitement polychrome: ainsi le bouclier d'un soldat de la Crucifixion, orné d'une tête de monstre menaçante, participe à l'ambiance dramatique de la scène (Voir Fig. 4).

Décors textiles

C'est dans les vêtements des personnages que l'on trouve les exemples les plus spectaculaires de décors polychromes. Narbonne était une ville de drapiers de

Figure 7. Présentation au Temple, détail du drapé du prêtre: la souplesse du tissu et le motif à ramages rouge et orangé fait référence aux lampas de soie italiens du XIVème siècle.

première importance au XIVème siècle. Elle produisait et exportait des vêtements de laine ; elle était à la fois située sur les axes commerciaux Italie-Espagne, et fréquentée par les marchands flamands qui y faisaient étape sur la route de Barcelone. Dans ce contexte, on conçoit aisément l'importance attachée au traitement des tissus par les artistes du retable de Bethléem.

On peut regrouper les motifs polychromes selon leur définition picturale. Quatre « familles » semblent en effet se dégager :

- des décors à bandes ou rayures
- des décors géométriques
- des motifs floraux
- des motifs dits « à ramages »

Les bandes et rayures, traitées en dégradés ou en aplats et éventuellement rehaussées de pois, sont attribuées spécifiquement à certains personnages (Voir Fig. 5).

Les décors géométriques et floraux, parfois combinés, comportent parfois jusqu'à cinq couleurs. Ils sont disposés selon une organisation spatiale déterminée (selon le cas perpendiculaire, diagonale, en quinconce...) et concernent également les bordures des vêtements. Les motifs à roues ou à médaillons sont les plus fréquents : médaillons souvent tangents pour les draperies des fonds, distants pour les vêtements (Voir Fig. 6).

Le dernier type, moins fréquent, est réalisé en deux couleurs qui investissent toute la surface concernée (Voir Fig. 7).

Rapprochements avec des textiles contemporains du retable

De nombreux motifs polychromes représentés sur le retable peuvent être mis en relation avec des tissus conservés dans des collections de textiles anciens.

Dans les collections textiles anciennes italiennes et espagnoles, par exemple, il est aisé de retrouver des exemples d'étoffes à rayures et à bandes. Les motifs à rouelles et à médaillons se rapprochent de tissus comportant en général des animaux affrontés ou des personnages, plus rarement des motifs géométriques. Néanmoins, on en trouve des exemples dans des collections textiles espagnoles (étoffes de soie espagnoles du XIVème). Le motif à fleurons rayonnants du manteau de saint Paul peut aussi être rapproché d'un textile italien du XIVème siècle conservé à Berlin (Klesse 1967).

Dans la scène de la Présentation au Temple, le prêtre est vêtu d'un manteau rouge qu'un motif de feuilles trilobées et de vrilles permet d'identifier assez précisément (Voir Fig. 7). Il s'agit d'un lampas de soie que l'on peut dater du milieu du XIVème siècle et qui s'apparente aux productions des ateliers de Lucques (Mayer Thurman 1989: catalogue Lucques 1989).

S'il reste parfois malaisé d'identifier précisément un tissu représenté en polychromie, des ponts peuvent souvent être établis grâce à la peinture de la même époque. Ainsi, même si le lien direct avec les tissus anciens eux-mêmes n'est pas toujours possible, il ne faut pas négliger ce moyen de replacer les motifs polychromes du retable de Bethléem dans un contexte artistique plus général : ainsi le motif rose à rameaux de la robe d'un des personnages de l'Entrée à Jérusalem trouve un écho dans un tableau italien du XIVème siècle conservé à Florence.

Ces analogies se doublent parfois d'informations intéressantes sur la facture des textiles représentés. De petits motifs parsemés signalent sans doute un tissu brodé (scène des Rameaux), des bandes très ornées un travail de passementerie (Rois Mages), des pois alignés une couture décorative à gros points (soldats de la Crucifixion).

Attribution sociale des décors polychromes

Comme nous l'avons évoqué, l'attribution des décors polychromes est liée à l'importance iconographique ou sociale des personnages. Les vêtements des gens du peuple, soldats de la Crucifixion ou écuyers des rois mages, en sont un exemple indéniable : leurs bliauds ne sont pas ornés de motifs mais généralement de rayures ou de bandes de couleurs alternées (Voir Fig. 5). Or, les étoffes rayées portaient au

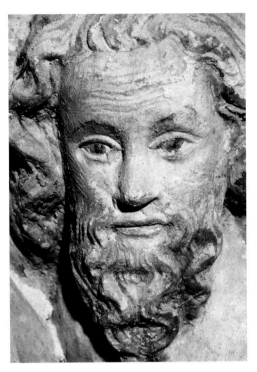

Figure 8. Les limbes des patriarches, détail : rehauts d'or dans les cheveux et la barbe, fins sourcils.

Figure 9. Exemple de fiche décor

moyen-âge des connotations précises : elles étaient prescrites pour certaines catégories de réprouvés : bâtards, serfs, condamnés, prostituées, jongleurs, bouffons, bourreaux, hérétiques, et interdits aux clercs et ecclésiastiques par des décrets et des lois à répétition (Pastoureau 1995). En Angleterre, en 1352, les prostituées ne pouvaient porter que des chaperons d'étoffes rayées; les voleurs de grands chemins portaient des manteaux rayés (Michel 1852).

L'organisation du chantier

L'observation de l'œuvre permet plusieurs remarques d'ordre technologique sur l'organisation du chantier. Il apparaît évident que la peinture s'est faite une fois en place et le travail des sculpteurs achevé : les mortiers qui jointoyent les scènes entre elles, exécutés après la pose, sont recouvert de polychromie originale. Les plages de couleurs couvrant plusieurs registres (colonnes) se poursuivent en continu. D'autre part, les zones en haut relief aux creux très accentués, ou difficiles d'accès une fois le retable en place, ne présentent aucune polychromie. Ainsi sur le fond plat des Rois Mages, une bande de pierre nue témoigne de l'emplacement d'une colonne, élément rapporté au montage et rendant toute polychromie impossible après sa mise en place.

Le travail du sculpteur et celui du polychromeur semblent être indissociables et répondre à un programme rigoureusement préétabli. Dans la scène de la Présentation au Temple (Voir Fig. 2), la finesse et la souplesse de la soie identifiée par le motif (Voir plus haut), est en parfaite adéquation avec la forme sculptée : le plissé est en effet fin et régulier. En revanche, le manteau de la Vierge en vis-à-vis est un vêtement uni, traditionnellement bleu avec ici un revers rouge. Ce manteau est probablement en simple drap : l'étoffe tombe en larges plis de façon très différente du manteau du prêtre. Cette complémentarité entre forme sculptée et polychromie donne à réfléchir sur les rapports entre maîtrise d'œuvre, sculpteurs et polychromeurs autour d'une œuvre de ce type. Le plasticien a-t-il pour mission de sculpter un manteau de soie afin que le peintre puisse y apposer un décor à la mode? Ou est-ce ce dernier qui s'adapte au modélé proposé et, reconnaissant la lourdeur du drap ou la finesse de la soie, l'enrichit du motif adéquat?

L'habileté des peintres force l'admiration : dans les sombres scènes de l'Enfer, où la gamme de couleurs est réduite, ils savent par un subtil jeu de glacis, laisser entrevoir les couches sous-jacentes, laissant vibrer les nuances. Les décors sont

amenés d'un geste sûr, distribuant les rehauts et les accents avec rapidité et efficacité : la robe pommelée d'un cheval gris sera marquée par les empâtements ronds et blancs, la répartition des petits pointillés blancs émaillant les décors est régulière et sans repentir, les variations de couleurs dans certains vêtements sont maîtrisées dans des dégradés subtils ...

Nous noterons enfin que la polychromie n'a pas été exécutée par une seule personne, mais par une équipe à la hiérarchie probablement bien définie. Dans la scène des Rameaux, par exemple, les feuillages se prolongent sur le fond du gable : la sculpture en est plus grossière, la polychromie plus fruste. Néanmoins l'homogénéité générale laisse présager une équipe de personnes habituées à travailler ensemble.

Conclusion

La polychromie originale du retable s'est donc révélée d'extrême qualité. Sa richesse, sa composition, sa minutie jusque dans les toutes petites plages de couleur s'accordent parfaitement avec l'art du sculpteur, montrant avec éclat que ces différents aspects de l'exécution de l'œuvre sont indissociables.

L'ampleur et le complexité de cette association à l'échelle du retable de Bethléem permettent d'affirmer qu'un maître d'œuvre régit l'ensemble du chantier. Reste à comprendre au sein de quelle instance s'élabore une œuvre aussi complexe et comment en est organisée la réalisation matérielle. L'imbrication mise en évidence au cours de cette étude entre le programme iconographique, la composition d'ensemble et l'exécution, ceci jusque dans les moindres détails, implique des contacts étroits entre les commanditaires et les artistes, quelle que soit la marge de liberté laissée à ces derniers. Chaque acteur dans son domaine avait magnifiquement su épouser l'essence même du projet.

Notes

1. L'examen des couches picturales a été réalisé sous loupe binoculaire. L'aspect original de la polychromie a été reporté à l'aquarelle sur dessins pour chaque scène, gâble ou statue. Chaque décor polychrome reconstituable (plus d'une quarantaine) a été relevé sur calque et reproduit en grandeur réelle sur une fiche comportant le plus d'informations possibles : stratigraphie détaillée, aspect, structure et répartition du décor, rapprochement avec des textiles ou des motifs picturaux contemporains, bibliographie. Le texte de l'étude et les relevés aquarellés sont conservés à la D.R.AC. de Languedoc-Roussillon.
2. Le Retable de Bethléem comporte en plus de la polychromie originale deux surpeints complets très lacunaires.

Références

Klesse B. 1967 Seidenstoffe in der italienischen Malerei des 14. Jahrhunderts. Bern.
La seta, tesori di un'antica arte lucchese. Cataloga della mostra a cura di Donata Devoti. Lucca. 1989.
Le grand retable de Narbonne. Dans: Actes du 1er colloque d'histoire de l'art méridional au Moyen-Age. Narbonne, 2–3 déc. 1988.
Mayer Thurman CC. 1989. Recent acquisitions: a collection of thirteenth and fourteenth-century woven fabrics in Chicago. Dans : Textile history 20 (2), 249–263.
Michel F. 1852. Recherche sur le commerce, la fabrication et l'usage des étoffes de soie, d'or et d'argent, et autres tissus précieux en Occident pendant le moyen-âge. Ed. de Crapelet.
Pastoureau M. 1995. Rayures, une histoire des rayures et des tissus rayés. Paris : Seuil.